Henry Mayr~Harting

OTTONIAN BOOK ILLUMINATION

The present study on
OTTONIAN BOOK ILLUMINATION
was originally published in two separate volumes.
This new edition combines both parts
in one volume

Henry Mayr~Harting

OTTONIAN BOOK ILLUMINATION

AN HISTORICAL STUDY

PART ONE:
THEMES

HARVEY MILLER PUBLISHERS

HARVEY MILLER PUBLISHERS
Suite K101, Tower Bridge Business Complex
Clements Road, London SE16 4DG

An imprint of G+B Arts International

British Library Cataloguing in Publication Data
A catalogue record for this book
is available from the British Library

First edition of Parts One and Two 1991
Second revised one-volume edition 1999

ISBN 1872501745 (cloth bound)
ISBN 1872501796 (paperback)

© 1991, 1999 Henry Mayr-Harting

Colour origination by Neue Schwitter AG, Basle, Switzerland
Colour printing by Buchdruckerei Holzer, Weiler-im-Allgäu, Germany
Monochrome printing by Clifford Press Ltd, Coventry
Bound by MPG Books Ltd, Bodmin, Cornwall

tk

Contents of Part One: Themes

To the Memory of
my Mother and Father
and of my Colleague
Tim Mason

The Author and Publishers wish to thank
all Libraries, Museums and Institutions who have made
photographs available for this publication and given their permission for reproduction.

Preface to the Second Edition

IF AN AUTHOR thinks that his purpose has been misunderstood, he has only himself to blame for not making it clear enough. The opportunity of a preface to a second edition in such circumstances is naturally a god-send. Not every reader or reviewer, by a long chalk, misunderstood my purpose. Rosamond McKitterick, for instance, wrote, 'the aims of art, religious devotion, and political ideology are shown to be inextricably intertwined'. That was exactly right. My object was to show that it was nonsense to speak of a religious political ideology, such as the Ottonians developed, without seeing it as the interest, so to speak, drawn on a capital of religious culture and devotion which suffused the whole society. Many may see this as a roseate view of a society whose aristocracy, secular and ecclesiastical, were ridden with resentments, feuds and violence, as Karl Leyser so brilliantly showed. What I present is not at all a contradiction to this, but a paradox of Ottonian society: the greater its conflicts, the greater also its longing for a heaven at once Christ-centred, magnificent and unified. Much of Ottonian Art was the striving to catch glimpses of that heaven.

Moreover, one must remember that the Ottonian age was one of continuous, one might almost say rolling, monastic reform. That very much includes the enhancement of liturgy, together with its music and its art indeed, and the intensification of a life of prayer. Monasteries were filled with aristocrats, often from the same families, before and after reforms or so-called reforms. Monastic reform, on the scale one apparently perceives it, could never have succeeded therefore, had the religious aims of the reforms not appealed to a sizeable section of aristocratic society. And by aristocratic society I mean not only men but also women, as can be seen from more than one chapter of this book. Thietmar of Merseburg highlights in himself the dichotomy between secular and religious in the Ottonian aristocracy. Proud of his forebears and their military exploits, he also cared deeply about how prelates celebrated mass.

Even some of the friendliest of my reviewers tended to think of my work as being a series of more or less disconnected essays on Ottonian illustrated books. That was exacerbated by its being originally published in two volumes, especially by those who perhaps concentrated on the first volume and saw the six chapters of Volume Two as most afflicted by disconnection. Hence I rejoice in the two volumes coming together here as one. But being a study of a religious culture, and of how that culture expressed itself in art, as well as forming the basis of political ideology, it was the study of something that was far from monolithic. Reichenau, Regensburg, Trier, Cologne, Fulda and Corvey, to give the major examples, did not have their religious culture served to them from above. It developed from their individual circumstances and *genius loci*. Walter Berschin in his marvellous

book *Eremus and Insula* (1987), has contrasted the literary culture of St Gall and Reichenau, separated by no more than about thirty miles from each other. It is such contrasts that forced me to diversify my treatment of the religious/artistic culture, particularly in the second half of the work.

It has been rightly pointed out that I have not explicitly said, as I should have done, that whereas the Carolingian rulers had a court school producing manuscripts and other works of art for them, the Ottonians had no such thing. Nonetheless I have argued that from Otto I's time, the ruler and his court were an important stimulus in the production at monasteries of fine manuscripts, and not least because of the sudden swelling of demand for liturgical books occasioned by Otto I's establishment of the church of Magdeburg as an archbishopric in 968, together with several suffragan sees. The heights of Ottonian book art were reached under Otto III and Henry II, when the monasteries of Reichenau and Regensburg produced for the rulers such works as the Aachen Gospels, the Gospel Book of Otto III, the Bamberg Apocalypse, the Sacramentary and the Pericopes Book of Henry II, all with astonishing visual images of royal power. This has raised the question whether such iconography was developed by the monasteries concerned, 'to win favour', or whether it mirrored a court ideology. My answer would be, in *fact* is in my book, (and I hope in the future to develop it at greater length), that given the implications of the royal *iter*, i.e. itinerant kingship, and *familiarities*, ie. the nature of the relationship existing between kings and their friends, it must have been developed through bilateral consultation and exchanges of view.

Certainly one should not be too sceptical about royal/imperial input. To give one example of many possible, in the Aachen Gospels (which *pace* Fried, I would still date to around Otto III's imperial coronation of 996), the Christ-like Otto III is shown seated in majesty at the top of the picture. This follows a characteristically Byzantine iconography of the Ascension, which shows Christ *seated* as he ascends to heaven. Now Otto III was crowned emperor in Rome on Ascension Day, and it is not very likely that Reichenau had any influence in determining that date!

In the final analysis, perhaps, it is not what it tells us about history that is the most important and enduring feature of Ottonian Art, but the brilliance of its purely artistic achievement. Perhaps a sign that it has established itself in the minds of educated people as a great phase of European art, will be when finally they cease to assume that Ottonian must be a misprint for Ottoman!

Feast of St Augustine of Hippo 1998
HM-H, Oxford

Preface to the First Edition

TO PUT AN EXACT YEAR on the origins of a book which has been in the vats as long as this one, is not at all easy. I think it was in 1975 that I decided to write it, though its genesis lies further back in a Special Subject on the Ottonian Empire, which I put on as a Lecturer at Liverpool University in 1962. In September of that year I was allowed to spend a morning with the tenth-century Fulda Sacramentary in the library of Göttingen University, my first direct contact with an Ottonian manuscript. My Liverpool pupils, one and all of whom I remember with pleasure and gratitude, were always keen to push me and themselves as much as possible on to the art aspect of the subject, perhaps because they felt it to be a peculiarly satisfying way of defining the culture which we were studying. When I came to Oxford, there was the stimulus of Karl Leyser's teaching on the Ottonians, through his seminar papers, his published writings, and chats when we met in the covered market and such places. All scholars would agree that nobody has done more, in any language, to lay the foundations of our understanding of Ottonian society than he has. The first chapter which I wrote in draft was that on the Bamberg Manuscripts of *c.* 1000 in the summer of 1979, having given it as a talk at a symposium of Bonn and Oxford historians at Bonn in April of that year. The Gospel Book of Otto III followed, after my spell as Chairman of the Oxford Modern History Faculty Board, in 1983, as did the Excursus on the date of the Bamberg Apocalypse. In 1986 I was elected to give the Slade Lectures at Oxford in Michaelmas Term of 1987, and am deeply grateful to the electors for doing me an honour which also provided an invaluable incentive to getting my book into order. Most of the rest of it was written during leave in the first half of 1987 or during the long vacations of 1987 and 1988. My college generously gave me a fortnight's remission of duties in the middle of a busy term to write the one section of a chapter then still unwritten, on the Pericopes Book of Henry II, in November 1988.

In the course of giving many lectures on Ottonian book illumination, I have encountered some salutary critics. One of these, quite recently, to whom I admitted that I was rather a positivist and weak on conceptual framework or method, replied to me, 'Oh, you have your method all right!' Perhaps indeed I have. If so, it is to take the religion of other people and other ages seriously as religious. It is too easy to see particularly a highly ritualized religion as largely a form of political image-making and social control, its art and liturgy as fostering and encouraging allowable emotions and excluding non-allowable ones, to see it as an exercise of magic or an attempt above all to command and channel supernatural forces into ducts which sustain the power of a ruling élite. This is an anthropological theory

3

of religion, but it is not any longer found sufficient in itself by (at any rate) British anthropologists, such as Mary Douglas, Godfrey Lienhardt and John Beattie, who emphasize that 'magical' religion is not so much a matter of coercing supernatural powers, the natural world and human beings, as an expression and symbol of the rythms, desires, and moral attitudes of a society. I take Ottonian religious ritual to be expressive of religion as a phenomenon in society which has an existence independent of its functions of political and social control. One must remember that in Ottonian religion, private devotion and public liturgy drove one another on, as if they were two musical instruments answering each other in ascending phrases (like the violin and viola in the slow movement of Mozart's Sinfonia Concertante, K 364). My work will have many examples of this, whether in connection with the Gorze monastic reform, or the art of Mary's assumption into heaven, or the religious life of Otto III, or the books of Archbishop Egbert of Trier and Abbess Hitda of Meschede.

If we would attribute a quality of magic to Ottonian religion and ritual, there is still another side to the coin. Ottonian society had not the homogeneity of attitudes characteristic of the primitive societies studied by most anthropologists. A sizeable class of educated men were steeped in the traditions of Christian scholarship and intellectual achievement, as were the Carolingians earlier. There was therefore plenty of scope for religious and ideological conflict. No mistake would be greater than to suppose that Ottonian art could be studied without the dimension of religious thought, as if a model of primitive (or non-primitive) magic were in itself sufficient.

The reader may wish to know how I view my relationship to German art-historical scholarship in my field. I could not have begun to write without it, but as I have never formally studied art history (except for attending the wonderful seminars of Otto Demus in Vienna during a term's leave in 1966), my teachers have been various authors: in iconography pre-eminently Wilhelm Vöge, Albert Boeckler, Peter Bloch and Hermann Schnitzler; in Ottonian aesthetics, Arthur Haseloff and Hans Jantzen, the one nurtured on the Impressionists and the other on the Expressionists; in understanding how to relate Ottonian religious culture to its iconography, Florentine Mütherich and Rainer Kahsnitz; in palaeography and codicology, Bernhard Bischoff and Hartmut Hoffmann; in how to understand the manuscript art of a school (Echternach), the Swedish scholar Carl Nordenfalk; in political ideology or theology as expressed in art, Ernst Kantorowicz and the American Robert Deshman. This in no way exhausts the brilliant writings which it has been my good fortune to read. In Germany much of the progress on Ottonian art studies has been made during recent decades through facsimile editions and fine exhibition catalogues, or through works on individual schools. Curiously enough I know of no book ever before to have been devoted exclusively to an overall study of Ottonian book illumination. My approach, therefore, has perhaps enabled me to treat art more comprehensively as part of a larger religious culture than would be common in Germany. The main reason, however,

why this book for better or for worse does not read like a work of German art history is that it is grounded in an English tradition of writing history which does not allow cultural and political life to float free of each other, and which assumes that they are interlocked. By political life I do not mean only ideology, but also real politics, royal, aristocratic, ecclesiastical, monastic and missionary. This is a tradition which goes back in Oxford to Stubbs, and in my time two of its greatest representatives among Oxford medievalists have been Sir Richard Southern and Beryl Smalley. Whether I follow in this tradition worthily or not is for others to judge, but being entirely Germanic by heredity and entirely English by environment, I have felt a certain qualification (if only of empathy rather than of intellect) to write about my subject in this way.

Many persons have given me help, information and encouragement, of various kinds, over the past fifteen years. I record the names of those whom I can remember, and beg anyone whom I have overlooked to forgive me and accept my heartfelt gratitude; Gerald Aylmer, Walter Berschin, Luigi de Biasio, Paul Binski, Leonard Boyle, Michael Brandt, Christopher Brooke, Peter Brown, Juan Cervello-Margaleff, Ralph (R.H.C.) Davis, Lily Dear, Bernhard Gallistl, Richard Gameson, David Ganz, Peter Ganz, Johannes Gassmann, Margaret Gibson, John Gillingham, Peter Godman, Barbara Harvey, Francis Haskell, Larissa Haskell, Hermann Hauke, Tim Hunter, Paul Hyams, Martin Kauffmann, John Kenyon, Conrad Leyser, Henrietta Leyser, Karl Leyser, David Luscombe, Robert Markus, Donald Matthew, Caroline Mayr-Harting, Felix Mayr-Harting, Ursula Mayr-Harting, Wilfred Meyer, Patricia Morison, Florentine Mütherich, Alexander Murray, John Nightingale, Reiner Nolden, Veronica Ortenberg, Philip Parks, Nicholas Penny, Liselotte Renner, Anton Scharer, Bernard Schemmel, Wilhelm Schonath, Ludwig Schuba, Sir Richard Southern, Eric Southworth, Amelio Tagliaferri, Heinz Thomas, Ilo Vignono, Billy Watson, Hiltrud Westermann-Angerhausen, Christopher White, Rosemary White, David Whitton, Margaret Wind and Patrick Wormald. My wife, who has made many good comments over the years, and my son and daughter, all named above, have shown praeternatural sympathy with my efforts. To work with Elly Miller my publisher, and Isabel Hariades, in seeing this book through the press was a pleasure and an education; Harvey Miller also has been a congenial party to my hospitable reception on more than one occasion. Colleen McMillan, then Fellows' Secretary at my college, but since promoted (Ottonian Art has its own spin-off!), typed everything onto a word processor with scarcely believable accuracy and good nature. Virtually all the constant retyping which she did was caused by my ditherings and tergiversations, and not by any failings on her part.

It will be seen that some outstanding photographers are amongst those to whom I am indebted for illustrations. I have not dealt with them all personally, but of those with whom I have, I acknowledge Ann Münchow of Aachen, Alfons Steber of Bamberg, Elio Ciol of Casarsa Della Delizia,

5

Lutz Engelhardt of Hildesheim, Charles Braybrooke of the Bodleian Library in Oxford, and Cyril Band and his colleagues in the superb Photographic Section of the Nuclear Physics Laboratory, Oxford.

I have been very moved by the generosity of three bodies: the British Academy and St Peter's College both gave me outright grants, which in the event largely covered the cost of the black and white photographs and colour transparencies; while the Marc Fitch Fund gave me a very large interest-free loan towards the cost of the colour plates, without which publication in this form could not have gone ahead. Over the years I have had several grants from the Faculty Board of Modern History, Oxford, to help with the expenses of visiting libraries abroad, while a handsome grant for the same purpose was attached to my election to the Slade Professorship in Oxford, for which I also offer my heartfelt thanks to the Electors.

Some important works of scholarship appeared or came to my attention too late to be used in this book. Among those were: Helmut Beumann, *Die Ottonen* (Stuttgart, 1987); Johannes Fried, *Otto III und Boleslaw Chrobry: Das Widmungsbild des Aachener Evangeliars, der 'Akt von Gnesen', und das frühe polnische und ungarische Königtum (Frankfurter Historische Abhandlungen,* Band 30, Stuttgart, 1989); the facsimile edition of Hanover MS 189, Saints' *Lives* illustrated at Fulda, with commentary by Cynthia Hahn (Graz, 1988); *Monastische Reformen im 9. und 10. Jahrhundert*, ed. R. Kottje und H. Maurer (Sigmaringen, 1989); *Studien zu Corveyer Gedenk-Überlieferung*, ed. K. Schmid und J. Wollasch (1987); and Hiltrud Westermann-Angerhausen, 'Spolie und Umfeld in Egberts Trier', *Zeitschrift für Kunstgeschichte* 3 (1987), 305-36. I have managed at the last minute to insinuate into my work a little of Donald Nicol's *Byzantium and Venice: a study in diplomatic and cultural relations* (1989); but this book has really opened my eyes to the new political initiative which Byzantium was gaining in Italy during the 990s (see also Chapter 4, note 30), and that could have a bearing on the heightened imperial ideology under Otto III and Henry II. Robert Deshman, 'Servants of the Mother of God in Byzantine and Medieval Art', *Word and Image* 5 (1989), 33-70, would have effectively reminded me that the combination of Mary's Dormition and heavenly Glorification (see Chapter 3) is found in the Benedictional of St Ethelwold, at least two decades earlier than any of the surviving Reichenau depictions, although the Winchester and Reichenau iconographic developments are divergent from each other, since at Winchester the glory lies more in coronation (a theme also of the Prüm Antiphonary of *c.* 1000), whereas at Reichenau it is expressed purely and simply in the spiritual assumption.

CHRONOLOGY
Chronological Table of Political History

800 The Frankish Charlemagne crowned as Emperor in Rome by Pope Leo III. A landmark in the development of the Holy Roman Empire and the idea of universalist rule on the basis of Christianity and the Church.

843 Treaty of Verdun, the most important division of Charlemagne's empire amongst his three grandsons: the West Frankish kingdom was France in embryo; the East Frankish kingdom was to become Germany; and in the middle was Lothar's kingdom, i.e. Lotharingia, Burgundy, Provence and Lombardy, an object of rivalry between eastern and western kingdoms in their efforts to recreate Charlemagne's empire in subsequent centuries.

919 Henry I (the Fowler) becomes king of the East Frankish kingdom. Thus did a Frankish kingdom pass to the rule of a Saxon family, the Liudolfings.

936 Coronation of Otto I as King at Charlemagne's centre of Aachen.

951 Coronation of Otto I at Pavia as King of the old Lombardic kingdom of Italy, after a campaign of conquest in North Italy.

955 Defeat of the Hungarians by Otto I, leading an army of ducal contingents at the Battle of Lechfeld. The mastering of external threats was an important basis of Saxon supremacy within the East Frankish kingdom and over its duchies (Saxony, Bavaria, Swabia, Franconia, Lotharingia).

The Liudolfings

936-973 Otto I, son of Henry I

973-983 Otto II, son of Otto I

983-1002 Otto III, son of Otto II

1002-1024 Henry II, second cousin of Otto III, son of Henry the Quarrelsome, duke of Bavaria, and grandson of Henry, duke of Bavaria and brother of Otto I. These Henrys were the principal rivals of the Ottos for the East Frankish, or German, kingship.

962 Coronation of Otto I as Emperor in Rome by Pope John XII, an important moment in the doubtless conscious recreation of Charlemagne's empire.

968 Establishment of the new archbishopric of Magdeburg, with suffragan sees, a keystone of the policy of Christianization and spread of Saxon influence amongst the Slavs to the east of the Elbe. The geographical position of the Saxons within the East Frankish kingdom enabled them to expand eastwards and enrich themselves with tributes from the Slavs.

972 Marriage of Otto II in Rome to Theophanu, a Byzantine princess, an occasion for the increase of Byzantine political, religious and artistic influence in the West.

973 Establishment of a bishopric at Prague, just before Otto I's death, for the Bohemian Slavs.

996 Coronation of Otto III (aged sixteen) as Emperor by Pope Gregory V, the first German pope.

998-1001 Otto III sets up an imperial residence in Rome and imitates the *bulla*, or seal of 800, on which Charlemagne used the words RENOVATIO IMPERII ROMANORUM. The culmination of the Roman empire under the Saxons.

1014 Coronation of Henry II as Emperor in Rome by Pope Benedict VIII after wars with the Slavs and the Burgundians, necessary to retain his imperial standing.

1024 Change from Saxon to Salian dynasty, who developed artistic links with the monastery of Echternach. Henry II, without children, was succeeded by Conrad II, and Conrad by his son Henry III (1039-56).

The Principal Ottonian Illuminated Books on which this study is based

REICHENAU

*c.*960	Karlsruhe, Landesbibl. Aug. XVI Homeliary
*prob.*965-69	Darmstadt, Landesbibl. MS 1948 Gero Codex
*c.*970-80	Heidelberg University, Sal. IXb Petershausen Sacramentary
*c.*970-90	Solothurn, St Ursus, Cod. U1 Hornbach Sacramentary
977-93	Cividale, Museo Archaeologico MS.CXXXVI Egbert Psalter
*c.*970-90	Paris, BN lat. 10514 Poussay Pericopes
*c.*970-90	Mainz Cathedral, Kautsch 3 Epistolary
977-93	Trier, Stadtbibl. MS 24 Codex Egberti
*c.*996	Aachen, Cathedral Treasury Aachen Gospels
998-1001	Munich, Bayer. Staatsbibl. Clm. 4453 Gospel Book of Otto III
*c.*1000	Bamberg, Staatsbibl. Bibl. 22, 76 OT Commentaries
1001	Bamberg, Staatsbibl. Lit. 5 Troper
1001-02	Bamberg, Staatsbibl. Bibl. 140 Bamberg Apocalypse
prob. 1007-12	Munich, Bayer. Staatsbibl. Clm. 4452 Pericopes Book of Henry II
*c.*1000-20	Munich, Bayer. Staatsbibl. Clm. 4454 Pericopes
*c.*1000-20	Munich, Bayer. Staatsbibl. Clm. 23338 Pericopes
*c.*1000-20	Wolfenbüttel, Herzog August Bibl., MS 84, 5 Aug.2° Pericopes
*c.*1000-20	Cologne Cathedral, MS 218 Limburg Gospels
*c.*1000-20	Hildesheim, Dombibl. MS 688 Collectar
*c.*1000-20	Oxford, Bodl. Canon. Liturg. 319 Sacramentary
*c.*1000-20	Paris, BN lat. 18005 Sacramentary
*c.*1000-20	Augsburg, Bischöfl. Ordinariat, MS. 15a Pericopes
*c.*1010-40	Cologne Cathedral, MS 12 Hillinus Gospels (Seeon script)

FREISING/REICHENAU

*c.*980-90	Munich, Bayer. Staatsbibl. Clm. 6421 Sacramentary of Abraham of Freising

PRÜM

late C10	Paris, BN lat. 9448 Antiphonary

MAINZ

*c.*990	Bamberg, Staatsbibl. Pommersfelden Prayerbook of Otto III
*c.*1000	Mainz Cathedral, Kautsch 4 Sacramentary

ST. GALL/MINDEN

1022-36	Berlin (East), Staatsbibl. MS theol. lat. fol. 2 Sacramentary of Bishop Sigebert of Minden
1022-36	Berlin (West), Staatsbibl. MS theol. lat. qu. 3 Miniature of seated Bishop Sigebert

SEEON

1007-14	Bamberg, Staatsbibl. Bibl. 95 Pericopes
1007-24	Bamberg, Staatsbibl., MS Lit. 53 Pontifical

REGENSBURG

*c.*990	Bamberg, Staatsbibl., MS Lit. 142 Monastic Rules
1002-14	Munich, Bayer. Staatsbibl. Clm. 4456 Sacramentary of Henry II
1014-24	Vatican, Bibl. Apost. Ottob. 74 Gospels
*c.*1020	Munich, Bayer. Staatsbibl. Clm. 13601 Uta Codex, Pericopes

? PRAGUE

early C11	Wolfenbüttel, Herzog August Bibl., MS 11.2 Aug. 4° Life of Wenceslas

CORVEY

*c.*900	London, BL, Egerton MS 768 Gospels
mid C10	New York, Pierpont Morgan Lib. M 755 Gospels
mid C10	Wolfenbüttel, Herzog August Bibl., MS 84.3 Aug. 2° Klus Gospels
late C10	Wolfenbüttel, Herzog August Bibl., MS 16.1 Aug. 2° Gospels, drawings
late C10	Wolfenbüttel, Herzog August Bibl., Helmstedt MS 426 Gospels
late C10	Munich, Bayer. Staatsbibl. Clm. 10077 Sacramentary

FULDA

*c.*970	Berlin (East), Staatsbibl., MS theol. fol. 1 Codex Wittekindeus, Gospels
*c.*970	Aschaffenburg, Schloss, Cod. 2 Pericopes
*c.*975	Göttingen University, MS theol. 231 Göttingen Sacramentary
late C10	Hanover, Landesbibl., MS 189 Saints' Lives
late C10	Cologne Cathedral, Cod. 88 Sacramentary
late C10	Udine, Archivio Capitolare MS 1 Sacramentary
prob. 997-1014	Bamberg, Staatsbibl., MS Lit. 1 Sacramentary
972	Wolfenbüttel, Staatsarchiv Marriage Roll of Theophanu (Fulda Script)

HILDESHEIM

1011	Hildesheim Cathedral Treasury, MS 18 Gospels of Bishop Bernward
1014	Hildesheim Cathedral Treasury, MS 19 Sacramentary of Bishop Bernward
*c.*1015	Hildesheim Cathedral Treasury, MS 61 Bible of Bishop Bernward

COLOGNE

984-99	Cologne Cathedral, Cod. 143 Epistolary of Archbishop Everger
*c.*1000	Paris, BN lat. 817 Sacramentary of St Gereon
*c.*1000-20	Darmstadt, Landesbibl., MS 1640 Hitda Codex, Gospels
*c.*1020	Giessen University, Cod. 660 Gospels

TRIER AND ECHTERNACH

TRIER: GREGORY MASTER

972	Wolfenbüttel, Staatsarchiv Marriage Roll of Theophanu (cf. FULDA)
977-93	Trier, Stadtbibl., MS 24 Codex Egberti, early miniatures (cf. REICHENAU)
*c.*975-80	Chantilly, Musée Condé, MS 1447 Lorsch Sacramentary
*c.*984	Chantilly & Trier Fragment of Gregory Register
*c.*984	Paris, BN lat. 8851 Ste-Chapelle Gospels
*c.*1000	Manchester, Rylands Lib. MS 98 Gospels
*c.*1000	Paris, BN lat. 10501 Trier Sacramentary

TRIER: OTHERS

*c.*950-75	Trier, Stadtbibl. MS 2209/2398 Gregory, *Moralia*
*c.*980-90	Berlin, Staatsbibl. MS theol. lat. fol 34 Epistolary

ECHTERNACH

*c.*1030	Nürnberg, Nat. Germ. Mus., Codex Aureus Gospels
1039-43	Bremen University, MS b.21 Pericopes for Henry III
1045-46	Escorial, Cod. Vitr. 17 Speyer Gospels
1047-56	Uppsala University, MS C. 93 Goslar Gospels

References to the illustrations are indicated by italic numerals
in the margins of the Text. Centuries are referred to as C9, C10, etc.
Authors and publications are cited in an abbreviated form in the Text and Notes,
but full details are given in the Bibliography.

The Notes to the Text of Part One will be found on pp. 213-230.
The Index to this Part, as well as the Bibliography and List of Illustrations,
has been combined with that of Part Two, and is now placed at the end of the book
following the Text and Notes to Part Two. A Map showing the
centres of Ottonian Culture is on pp. 2-3 of Part Two.

Introduction

T HE POLITICAL CONTEXT of this book is the creation of the German kingdom and its association with what would come to be called the Holy Roman Empire.[1] The German kingdom, still more generally referred to as the East Frankish kingdom by historians of the tenth century, was the easternmost of the three kingdoms into which the empire of Charlemagne split in the ninth century. From 919 to 1024 it was ruled not by Franks but by the Saxon ruling dynasty, the Liudolfings, and three of these were called Otto — Otto I (936-73), son of Henry I (919-36), Otto II (973-83), Otto III (983-1002), — hence the Ottonian or Saxon Empire. The art of the reign of Henry II (1002-24), however, is always understood to be included in the term Ottonian art. Indeed there was a theme of political propaganda in the tenth century which maintained that the Henrys had been unjustly deprived of rule by the Ottos, and that only with Henry II had they achieved the exaltation which rightfully followed their humiliation.[2] For in 936 Mathilda, the mother of Otto I and Duke Henry of Bavaria, a *grande dame* whose piety added to rather than detracted from her political formidability, wanted the latter to succeed his father, Henry I, there being no established rule of primogeniture in succession. He was not loath and rebelled against Otto for the kingship in 939. His son Henry of Bavaria, Henry the Quarrelsome, made bids for the kingship in 973 and again in 984 against his Ottonian cousins, and then *his* son, Henry, won through after a sharp dispute in 1002, Otto III dying at the age of twenty-one without issue.

The first half of Otto I's reign was a struggle for survival. The conquest of the Slavs to the east of the River Elbe was necessitated by the need to control the Elbe basin, vital to communications and economic activity in East Saxony. There were rebellions by the dukes who were members of the ruling Saxon or Frankish dynasties, Henry of Bavaria in 939, Liudolf of Swabia (Otto I's eldest son) in 953, the Conradiner of Franconia in both years, supported by lesser men with grievances, particularly, no doubt, about the way in which the lucrative commands in the Slav wars on the eastern frontier had been divided. There was the early rebellion of Thangmar, Otto's half-brother, disappointed over one of these frontier commands; and there were threats from the West Frankish kings; these were but some of Otto I's troubles and the rebellions he faced. With his final defeat of the invading Hungarians, however, the brunt of whose attack had already been successfully warded off by Henry I, and his victories at the same time against their Slav allies, there came a turning point. The chronicler, Widukind of Corvey, said that with Otto's victory over the Hungarians at the Battle of Lechfeld in 955, he earned the fear and favour of many peoples and received wonderful gifts from all over the world.[3]

The 960s were a decade in which Otto could afford to lay broader cultural foundations for his rule. He was becoming increasingly wealthy from the exploitation of silver mines in the Harz Mountains. In 962 he was crowned Holy Roman Emperor, while just before that he had brought off what he would surely have regarded as his biggest diplomatic coup, the acquisition of the body of St Maurice, the early soldier saint, from the kingdom of Burgundy. The venerable relic lay in state at the Christmas court of Regensburg in 960 before being moved solemnly to Magdeburg, the Church which Otto had founded as the ecclesiastical focus of his wars and missionizing amongst the Slavs. St Maurice, now patron saint of Magdeburg, would carry on the struggle to the East most effectively; the military resources of heaven would be harnessed to his shrine at Magdeburg.[4] An ivory panel of this period, made for the altar frontal at Magdeburg itself, shows a little Otto, clutching a model of the church of Magdeburg, being ushered by a large and reassuring Maurice into the majestic presence of Christ (see p. 180).

105

The 960s also witnessed a burgeoning of historical writing focussed on, and elevating, the Saxon dynasty. Widukind wrote his *Res Gestae Saxonicae* in 967-68; Adalbert, first Archbishop of Magdeburg from 968, wrote his continuation of Regino of Prüm's chronicle about the same time; Liudprand of Cremona, who had written his *Antapodosis* in the 950s, gave us his lively account of a Legation to Constantinople in 969; while in the late 960s Ruotger, schoolmaster of the monastery of St Pantaleon of Cologne, wrote his Life of Bruno (ob. 965), Otto I's younger brother and Archbishop of Cologne, a work which itself treats learning in the liberal arts as fundamental to the capacity to rule effectively. 'In study (i.e. *otio*) nobody seemed more involved in affairs; in affairs he never ceased to study.'[5] This was the paradox, itself Ciceronian, in which Ruotger expressed the integration of rule and culture in the later part of Otto I's reign. It was also the cultural/political context in which Ottonian manuscript art was born.

Ottonian rule is not easy for us, in the twentieth century, to grasp — or it was not so before the writings of Beumann, Brühl, Fleckenstein, Leyser and others transformed our understanding. One difficulty is that it lacked an administration and bureaucracy, which historians have generally tended to think of as the spine of any body politic which they study; and connected with this, it lacked a capital (such as Constantinople in the East) where administration was centred and the major political events occurred. It was based on an itinerary, the ruler being accompanied in this by a huge and changing entourage of laymen and chaplains, and he would wear his crown ceremonially to show himself on his journeys. Sacrality was a substitute for bureaucracy, as Karl Leyser (1981) has said. The Ottonians were represented in the localities not by those on whom they had conferred legal/constitutional authority, a concept of dubious applicability, but by those who enjoyed their *familiaritas*. It is not hard to see the relevance of this kind of rule as a setting for an art which expresses magical power

(and whoever reads my preface will see that I do not use this phrase with any derogatory connotation of primitivism) over and above every consideration of naturalism and illusionism.

Another reason why Ottonian rule can be so difficult to understand is that Ottonian politics is not for the most part about policies, parties and factions, nor even about wars and taxes (though there were policies and constant external wars), but about royal and aristocratic inheritances. It is a very fragmented story based, as we might at first sight think, on a principle of chaos. The uncertainties and violent feuds arising from *cohereditas*, the sense that every member of the family, male or female, secular or religious, had the right to a cut, in quite unspecified proportions (and all this applied even to the ruling dynasty itself), kept the ruler very busy with what has rightly been described as his face-to-face, or patrimonial (rather than bureaucratic) politics. He was drawn into inheritance disputes as kingly judge, and often could not remain above them because he was himself a kinsman of so many of the aristocratic disputants. Historians have on the whole ceased to take the formerly popular view that Otto I used the Church (which itself contained no bureaucracy) to counteract the power and rebelliousness of the secular aristocracy. Such an antithesis is a grave over-simplification. Here we would only observe about Otto's use of the Church, since surviving Ottonian manuscript art is entirely Church-centred, that on the one hand we cannot speak of the Ottonian Church as monolithic, and that churchmen often had their own reasons for rebelling, such as Archbishop Frederick of Mainz whose church lay in the heartlands of Conradiner influence,[6] and who cannot have been delighted to attempt to exercise primatial authority in a kingdom whose core had shifted from his own Franconia to Saxony. Yet on the other hand Otto could never have overcome the rebellions which faced him without the political and military support of powerful Churches within the regions, such as Lorsch in Franconia or Reichenau and the bishopric of Augsburg in Swabia; and for this support to materialize he had to put in hard work in a political and religious sense (e.g. pp. 37, 138).

A hotly debated question about Otto I is why he sought the position of Roman Emperor and involved himself in so ruthless an effort to master the papacy in order to get it. The imperial policy was one spectacularly developed by his successors, and it is of no small importance for the theme of this book, because Ottonian art was to a large degree the cultural expression of this basic fact, or instinct, of political life in our period. Many historians in the first half of this century saw the question as being whether the interests of the nascent German state were advanced or retarded by the policy, and some put forward reasons why it had practical advantages, and was seen to have them at the time. They have all failed to carry conviction. Historians of the post-war decades, who had heard more than enough about the supposed interests of the German state in the twentieth century, have rightly questioned whether there was such a state in the tenth. They have stressed that Henry I's acquisition of Lotharingia vir-

tually committed the Saxon rulers to an imperial policy, for this was part of the Middle Kingdom of the three into which Charlemagne's empire had been divided (consisting of Lotharingia, Burgundy, Provence and the old Lombard Italian kingdom); this kingdom retained the strongest imperial associations, having in it both Charlemagne's centre at Aachen and in theory also Rome, while the various parts of it had continued to have strongly interconnected politics. Post-war historians, and particularly Helmut Beumann in his fine millenniary paper of 1962 on the imperial coronation of Otto I, have been inclined to see the imperial policy as having a momentum of its own, almost an *a priori* fact of tenth-century politics. The validity of attempts to recreate the empire of Charlemagne, though not unchallenged, appear to have needed no justification beyond themselves in Ottonian ruling circles.

Nobody would argue that the imperial policy in its motivations was altogether outside the world of practical politics. Otto I certainly thought that a position as emperor would help him to get Magdeburg made into an archbishopric, while Otto III saw the emperorship as a means of handling his relationships with the Poles (see pp. 160-62). But if there was one overriding practical point to what was essentially a political vision, it lay in this: Europe between the ninth and tenth centuries saw a changing political context, with the emergence of new ruling dynasties all over the once-unified empire of Charlemagne, like the Saxon Liudolfings, one of whose principal qualifications to rule was their capacity to defeat external enemies, like the Hungarians. Hence there was an increasing need to validate or canonize, through symbol and ritual and art, power actually achieved in these fluid circumstances. The ritual of emperorship could be seen as such a canonization.

It was only by hard work that the imperial position could be acquired and retained. Otto I had been refused the emperorship in 951 because the family ruling Rome at that time, the family of Theophylact, thought that Rome could achieve its own greatness without needing the help of Germans with their — to the Romans — alien pretensions.[7] When the grip of this family was sufficiently weakened in 962, and he could be crowned, Otto clearly recognized the dangerous and risky enterprise in which he was engaged. On the morning of his imperial coronation in Rome, he said to his sword-bearer, Ansfrid, who was to become Bishop of Utrecht (995-1010):

> 'today, while I pray at the tomb of the apostles, you
> hold the sword continuously above my head, for I know
> how much my predecessors have trusted the Romans,
> and it is prudent to anticipate trouble; only when we return
> to Monte Mario can you pray to your heart's content.'[8]

To have any verisimilitude as an emperor, one had to control the routes to Rome, the city itself, the pope who conferred the coronation, and the old imperial lands in southern Italy. Once crowned Emperor, Otto I was

drawn, by a combination of diplomatic activity in Constantinople and military activity in the Byzantine lands of South Italy, into seeking from the Byzantine emperors (who claimed to be the true successors of the ancient Roman emperors) some sort of acceptance or recognition of his position: hence, for instance, the marriage of the Byzantine Princess, Theophanu, to his son, Otto II, on Easter Sunday 972. In general, the effect of Empire in the early medieval West was to draw its holders into herculean efforts to give their position verisimilitude, almost regardless of whom such efforts did or did not impress.

One might well be inclined to sympathize with the Romans who were trampled upon, as were the Slavs, in order that these thrusting foreigners should be able to realize their imperial vision. In a culture where art, religion and politics were inextricably intertwined with each other — it is one of the main purposes of this book to show the various ways in which this was so — art and religion may come to seem rather unlovely engines of this harshness and aggression, however beautiful they appear when considered in isolation from the political world. In one sense it is obvious that politics and religion (and also art) should be intertwined since in most societies religion has helped to sustain hierarchical authority. Do not the oracles of a chieftain amongst the Azande trump the others, thus reinforcing his power? No doubt, but we still need to take the religion of any society seriously as such in order to understand how exactly it gives moral force to the rulers and the ruling *élite*, and how it might also act as a restraint upon their power, which was an important aspect of Ottonian Christianity. That is quite apart from the intrinsic interest of any religious culture and its place in the history of the human spirit.

In this book I try to explain the political and religious forces which generated so magnificent a movement of art and impelled it along its path of development; and I also try to show, in relation to the other evidence of Ottonian civilization, what art says to us about that society. One cannot explain the finest manuscript art of the period without reference both to the politics and to the religious culture of the Empire. Thus my primary concern is not to establish styles and localize manuscripts, though I use with gratitude the work of art historians and palaeographers who from Vöge and Haseloff onwards have put these matters, and Ottonian iconography in general, on wonderfully firm foundations. Nor is it to establish the main lines of political and social structure amongst the Ottonians, where again fine work has been done, not least by Karl Leyser. Perhaps it can most accurately be described as cultural history, but with nothing, I hope, which is irrelevant to the social and political concerns of historians. It seeks to establish the cultural framework, or 'mental set', within which artists worked and others looked at their work. That is not to say that art is seen as a mere reflection of other evidence for society and politics; rather, like the closely related subject (in this age) of ritual and ceremony, it adds its own mode of expression, and that not only through its iconography but also through its aesthetic ideals.

15

In a discussion of this kind we come up against a problem. Art historians of most periods have the advantage of being able to posit or study a 'public', or at least they have evidence outside the art itself of what some patrons wanted and how they reacted to what they got. Unless such scholars are very unlucky, their society will normally have witnessed debate about the principles which should inform art, as we find earlier amongst the Carolingians. Except by implication in certain descriptions of bishops and abbots beautifying their churches, however, the evidence is a virtual blank on this side of the matter in the Ottonian period. Why, it is not easy to say. The chances of survival are unlikely to be the whole answer, but perhaps the fact that the Ottonians showed a marked preference to articulate their thoughts through liturgy rather than philosophical writing (see p. 64) has something to do with it. What this means for art historians or historians working with art in this period is that, while we must be ever alive to the function of art, how it was used and by whom it was meant to be seen, what the relation was of illustration to text, what sort of persons the artists were and how close to the patrons in mind they were likely to be, the nature of the evidence forces us to look primarily at, and interpret, art as the act of expression, since we lack the means to study the process of ingestion.

It is even impossible, so far as I am aware, to name with certainty the artist of a single Ottonian manuscript painting, for when a person like Ruodpreht or Liuthar is seen in a frontispiece presenting the book, he might be the scribe and not the painter. It tells one something about the rather lowly place of manuscript painting amongst the arts, to which we return (e.g. pp. 48-49), that the function of the textual scribe was rated more highly than that of the artist; just as it may surprise historians of a thousand years hence that in our church services the person who preaches the sermon is generally considered to have a more important function (and one requiring more skill) than that of the organist. We know, of course, that scribe and painter could be one and the same person, but equally we know that this was by no means necessarily so, and it has always been difficult to determine which was the case in a particular instance.[9] This much, however, we can say about the painters: there is clear evidence either that they were persons of education themselves or that in most of our manuscripts they were at least directed by such (see pp. 95-105, 178).

Educated people talk, and learn from their conversations. At several points in this book the reader will meet the suggestion that similarities in the art of different scriptoria and ateliers are to be accounted for by the talk of artists, or of patrons such as Otto III and Bishop Bernward of Hildesheim. I have encountered not unreasonable objections to the idea that talk, of which there is no direct evidence, should be given this hypothetical importance; the most telling query against it is whether anyone at the time would have had the vocabulary to engage in artistic talk. The objectors have not entirely persuaded me. Obviously the Ottonians could not have

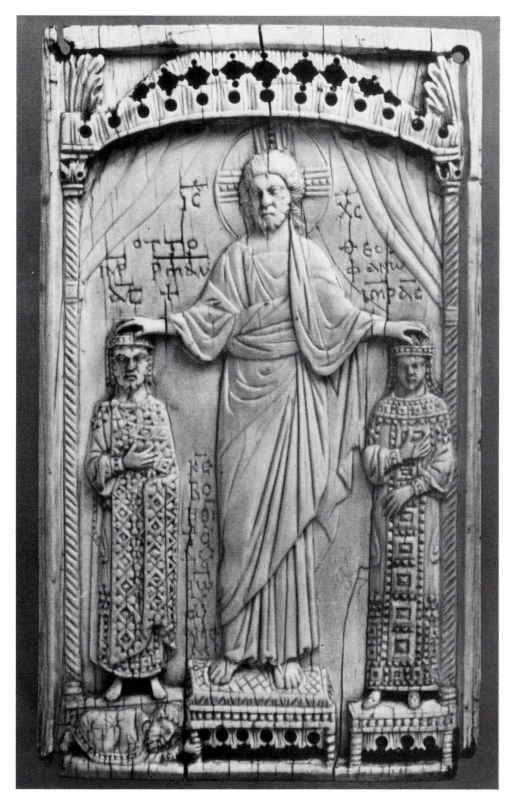

1. Otto II and Theophanu crowned by Christ. C10 Byzantine ivory.
Paris, Musée de Cluny

conversed with the full panopoly of aesthetic language which has developed over the last five centuries. I have suggested, however, that their talk was about such matters as colour and how to combine various colours in (say) an evangelist 'portrait', theological questions such as the appropriate imagery with which to represent the church, or devotional postures such as that of Mary Magdalen at the feet of Christ. That they could have talked about colours is clear from the fact that Bede had already done so in his widely read works, referring, for instance, to the whelks around British coasts from which an unfading crimson dye was produced, and explaining in his Commentary on the Acts of the Apostles, why the angels present at the Ascension are said to wear white, while nothing is said of the colour of clothes worn by the angels of the Nativity story.[10] It is also implicit in the awareness of colour and colour symbolism shown in early medieval treatises on art and on the nature of precious stones.[11] They engaged in theological talk, about the sort of ideas, for instance, which they found in the writings of Pope Gregory the Great, on which Abbot John of Gorze was used to discourse to the monks of his monastery.[12] And devotional talk must have been second nature to those who apparently knew their homeliaries and were keen on making collections of prayers. In other words I have supposed that Ottonian artists and patrons talked as theologians or men and women of prayer or craftsmen, not as aesthetes.

It will become clear that this was a particularly liturgy-minded age (see pp. 60-67), and the surviving Ottonian manuscripts on which the richest materials and greatest artistic power were lavished are with very few exceptions of a liturgical character. One might ask, however, whether it is not simply because of the survival of these wonderful manuscripts that Ottonian art and culture have assumed such an exclusively liturgical appearance. Much of what one could call the underworld of Ottonian manuscript art, drawings for classical plays, rapid sketches of Prudentius's virtues and vices,[13] animal and human figures done as *jeux d'esprit*, must have disappeared; but then, so also have many Ottonian (and Carolingian) books which were amongst the finest. We know, for instance, from the chronicler Thietmar of Merseburg, that Henry II granted a gospel book to the church of Merseburg;[14] it is unlikely to be one of the surviving corpus of Ottonian manuscripts. Many gospel books, antiphonaries, mass books and others are mentioned for their rich covers in the treasure-lists of churches (see p. 48); a good proportion of these probably had illuminations, and a large number of them must now have disappeared. The monastery of St Maximin of Trier had in the Middle Ages a Carolingian Bible adorned with splendidly executed initial letters; but because such art was not fashionable in the fifteenth century, the monks of that time stuffed its parchment pages into the bindings of their brand new incunabula. Such losses could occur in any period of the last thousand years, for even in the Second World War, Ottonian and other illuminated manuscripts disappeared. In some cases, scholars can deduce the existence of a manuscript which has not survived, because it must have served as a model for one

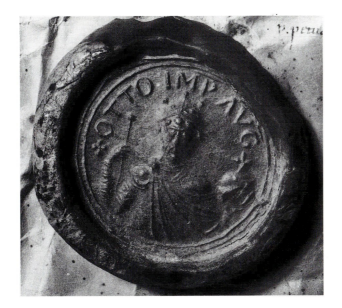

2. Imperial Seal of Otto I.
Munich, Bayerisches Hauptstaatsarchiv

which has, for instance in the case of the Bamberg Apocalypse. Thus if by some miracle every lost Ottonian manuscript, of whatever description, could be restored, it is likely that we would see, even more clearly than we can in the actual state of things, how ceremony and liturgy attracted the highest art in the world of manuscripts. We speak only of manuscripts. The real losses which distort our vision of the Ottonian cultural world are those of the goldsmith's art, objects which have been melted down or re-used for their intrinsic value (see p. 51). This art also served the Church and the liturgy, of course, but we must have lost great numbers of jewelled and finely worked sword handles, and sheaths such as that remarkably surviving at Essen, many golden or silver collars, vast quantities of female ornament, in fact virtually the whole art of Ottonian secular society.

As with all art, the liturgical or ceremonial art of the Ottonians must be interpreted with a meticulous regard for its own conventional symbols. To give an analogy, only when we understand the conventions and clichés of eighteenth-century opera, for instance, can we appreciate the genius with which Mozart handles them. It is possible to give a simple illustration of the dangers of overlooking the pervasive ritualism and symbolism of Ottonian art. It comes in a Reichenau pericopes book (i.e. a book of gospel readings for mass during the liturgical year), which is of the early eleventh century and of the Liuthar Group. Reichenau was the greatest centre of Ottonian manuscripts and the Liuthar Group (see pp. 57, 205) forms the apogee of its development. Our manuscript, now at Wolfenbüttel, probably comes a little after the high-water mark of Reichenau, which is reached with the Gospel Book of Otto III, the Bamberg Apocalypse and the Pericopes Book of Henry II; it is considered by art historians as a *Schulhandschrift*, a more routine manuscript of the school, but for all that it has a fine and thoughtful series of illustrations.

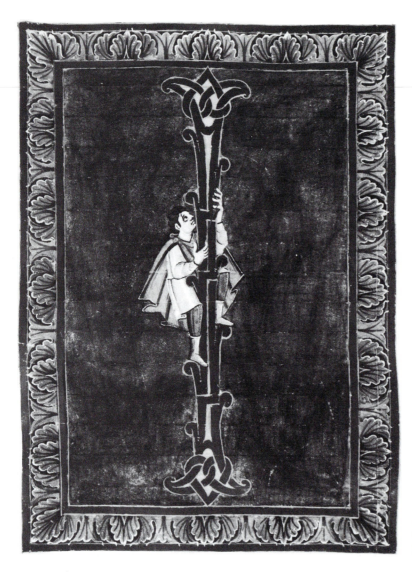

3. Initial I. Pericopes Book,
Reichenau, early C11.
Wolfenbüttel, Herzog August Bibl.,
MS 84.5 Aug. 2°, f. 41

3 This Wolfenbüttel Pericopes Book devotes a whole ornamental page to
the single initial letter I, for the first mass of Easter Sunday. The gospel in
question does not even begin with the letter I, but with V: *Vespere autem
sabbati, quae lucescit in prima sabbati* (In the end of the sabbath, as it began
to get light toward the first day of the week ... Matthew. 28:1). The deco-
rated I is brought in, unusually, for the words which denote the festival
day: *In sabbato sancto*. Lovely Vs can be found in Ottonian manuscript
illumination, but our artist was evidently very keen to have this I on which
to lavish his craft. The page has a nicely coloured acanthus frame, con-
taining a purple ground, in the middle of which is a golden I with stumps,
and a rather comic-looking and purposeful little man climbing up them
as if they were lopped-off branches of a tree. It might almost be an informal
snapshot of Zachaeus, before the normal iconographic action of his ex-
change with Christ began. There is nothing quite like it in any other
Ottonian manuscript.[15] The German editor of the facsimile edition in the

1920s declared, in a delightful evocation of his own period, that it was an example of 'Gothic anxiety' (*gotische Angst*).[16] More recently a distinguished English scholar has thought it most likely to be 'simply a product of the artist's fantasy and humour'.[17] Yet humour in Ottonian art is a commodity generally and doggedly in very short supply. This is not East Anglia in the fourteenth century, where psalters keep up a stream of socially satirical comment in their marginal pictures.

Now there survive from the early eleventh century, the same period as the Wolfenbüttel manuscript, a pair of silver candlesticks which Bishop Bernward of Hildesheim had cast, and which are still to be seen in the Cathedral Treasury of Hildesheim. They were doubtless intended to stand on an altar. Up their foliated stems climb men, their gaze directed upwards like that of the Wolfenbüttel man, intent on reaching the light at the top of the candle.[18] That position has already been achieved by those 'lizards' which hold up the grease pan, and peer over it towards the light of the candle itself. Considering how much Pope Gregory the Great wrote about light, and access to heavenly light,[19] in his *Moralia in Job*, one of the most treasured texts in Ottonian culture, one can hardly doubt the end for which these clambering men on Bishop Bernward's candlestick are striving. Gregory also cites the Book of Proverbs (30:28): 'the lizard climbeth with his hands, and is in kings' palaces', signifying the ordinary man who can attain heaven by daily practice and piety.[20] Once one sees a word connoting light in the first sentence of the gospel in question — *lucescit* — and thinks of the Easter candle, the *lumen Christi*, and the well-known ceremony of Easter Night surrounding it, we are surely right in thinking of the initial I in the Wolfenbüttel manuscript as a sort of candlestick with all that such an image expresses. It symbolizes the journey of man towards the divine light; it marks the time of year when (as Bede said of Easter) light has begun to conquer darkness in the balance of day and night. It expresses the ritual placing of candlesticks on an altar, as Henry II had given two silver candlesticks to the altar of the church of Obhausen for the soul of Count Esico of Merseburg in 1004.[21] There is here something of what Richard Gameson has called a 'co-ordinated environment',[22] in which one medium of art echoes another in the service of the same social or liturgical function. Similarly (*si parva licet componere magnis*), the swags and garlands in the plastered ceiling of an Adam dining-room might be answered by those of an engraved silver salt cellar placed on the dining table.

In what ways gestures and symbols could be transposed from one context to another in Ottonian art is a subject which deserves a more intensive study than it has ever received, or receives here, but it is something to which we must be alert. Fundamental in this area is the masterly examination by Robert Deshman of the interchangeability of Christ and emperor symbolism. The problem confronts us elsewhere sometimes in quite surprising forms. We note, for instance, that the birth of John the Baptist is represented in a very unusual way in the Pericopes Book of Henry II, to give it a certain magnificent effect, and that this way is most

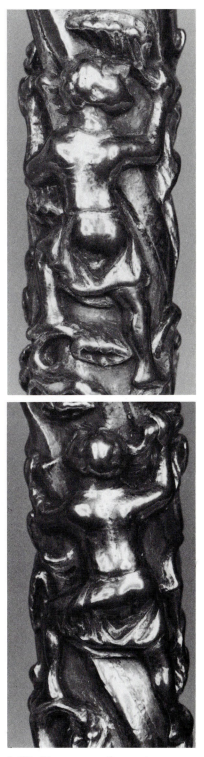

4. Climbing men on the candlestick of Bishop Bernward of Hildesheim, early C11. Hildesheim, Cathedral Treasury

21

Col.Pl. XXV likely to be derived from earlier depictions of his *burial* (p. 186). One might not have thought that such a transposition from death to birth would be within the permitted rules of the iconographic game or their interpretation, but one has to remember that with a saint — and John the Baptist was considered one of the greatest saints — death and burial were the equivalents, as rites of passage, to birth in heaven. The day of a saint's death, or the putative day, was what the Church celebrated as his feast, and it was designated in the liturgical calendars as his birthday, his *natale*.

Again, in two other 'school manuscripts' of the Liuthar Group, both early eleventh century, namely in the Reichenau Sacramentary at Oxford *5* (Canon. Liturg. 319) and in the Limburg Gospels at Cologne, one of the angels of the Ascension scene puts his arm round Peter's shoulders in a most unusual gesture. In the Oxford manuscript, Peter himself seems to find it strange and to shy away from this act of unwonted familiarity. This must surely be a transposition of the *Geleitmotif*, well known in the West from at least the sixth century,[23] by which a patron saint would bring a pope or ruler, arms round his shoulders, into the presence of Christ, as St *105* Maurice brings Otto I in the ivory which we have mentioned, or by which a patron would bring his protégé into some other august presence. In the Ascension scenes, therefore, Peter is honorifically singled out from amongst the other apostles, as he is in scenes where Christ hands over the *101* key of the kingdom of heaven to him in Ottonian gospel books (see p. 173), to be specially lead by the angel into the presence, as it were, of the majestic, ascending Christ. It has to be remembered that Peter was not yet to the Ottonians, as he would later become, the patron saint of a church, the Church of Rome, which challenged the Emperor for world rule; rather was he the patron saint of the Church from which the Ottonians derived their imperial standing, and of several important churches within their own kingdom.

Enough has been said, we hope, to indicate the political context, the difficulties, and the intriguing possibilities of our study ahead. One warning should be given to the reader. There are some eleventh-century developments from the central story of Ottonian manuscript art which I have not traced, but on which there is excellent if in some cases old literature. On Fulda influence at Werden in the eleventh century, Rainer Kahsnitz has written superbly; on Regensburg influence at Salzburg there is Georg Swarzenski (1913) and on the influence of various Ottonian and Carolingian schools at Liège there is Max Schott (1931). The artistic developments at Salzburg and Liège were surely stimulated by Henry II's court chapel, if one considers those of his chaplains who were trained at Salzburg and thus had connections with Salzburg as members of his chapel, and if one bears in mind that another of his chaplains, the Lotharingian Wolbod, became Bishop of Liège in 1018.[24] I have not followed Korteweg, in her admirable study of the Bernulph Codex at Utrecht, by considering at length the latest phase of Reichenau book illustration, though some years ago I made a careful study of the Pericopes Book at Brescia; nor have I

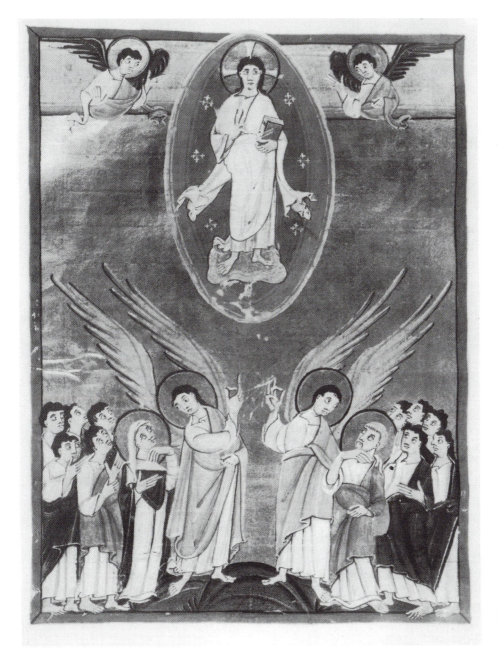

5. Ascension. Sacramentary,
Reichenau, early C11.
Oxford, Bodleian Library
MS Canon. Liturg. 319, f. 110v

followed Bloch and Schnitzler into the world of later Ottonian Cologne, after the great phase of the St Gereon Sacramentary and the Hitda Codex, though their treatment of the often arresting miniatures is always exemplary; nor have I attempted to reproduce the majestic sweep of scholarship which Kahsnitz (1971), again, has applied to Essen and the Gospel Book of its Abbess Svanhild from the second half of the eleventh century. My aim throughout has been to speak historically about the great works rather than to broach art-historical novelties about the less well-known ones.

23

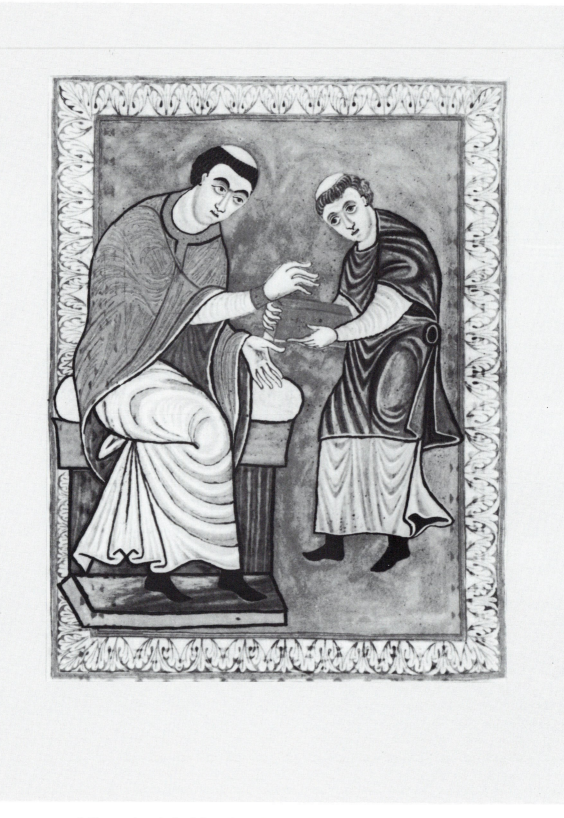

6. Gero receives the book from the scribe Anno. Pericopes Book, Reichenau, *c.* 965-70.
Gero Codex, Darmstadt, Landesbibl., MS 1948, f. 7v

The Origins of Ottonian Art

1 *The Gero Codex and the Codex Wittekindeus*

The beginnings of Ottonian manuscript art, leaving aside the Corvey manuscripts at present, may be considered the Gero Codex of Reichenau, probably 965-69, and the Codex Wittekindeus of Fulda, from about the same period.

The Gero Codex is a book of gospel pericopes. Before the liturgical texts, with their finely ornamented initials, there are full-page miniatures illustrating each of the evangelists with his symbol, followed by a Christ in Majesty, and then pages showing Gero offering the book to St Peter, and the scribe Anno offering it to Gero — the patron after whom the book is named, seven full-page miniatures in all. We may take it that Gero was the person of that name who was archbishop of Cologne from 969 to 976, and that he took possession of the book in the period immediately before that, when he must have been *custos* of Cologne Cathedral which was dedicated to St Peter. For the Gero here represented wears no pallium and is therefore not an archbishop.[1] Opposite each miniature is a page with acanthus border in which verses appropriate to the illustration are written in letters of gold on purple grounds. Those accompanying the evangelists are reminders of the content of the gospels and comments on the significance of the evangelical symbols. For Peter, the verses hail him as the doorkeeper of heaven and refer to his supreme power on earth in terms which would have satisfied the papal reformers of the following century. Opposite the page showing the scribe Anno presenting his book to Gero, the verses say: 'when you celebrate the divine mysteries with this book, pray that its scribe will deserve pardon from God, so that he may become a participator with you in the sight of the Almighty'.[2] By creating the book, the scribe seeks to participate in the liturgy for which it will be used.

The art of this book may lack the accomplished professionalism of the Gregory Master, working in subsequent decades (see pp. 39-42). A certain awkwardness in the handling of the figures perhaps bespeaks new beginnings. But it would be wrong to call these grandly conceived pages provincial. The best quality parchment was selected, especially for the first two quires with their pictures and ornamental sides, and for the double leaves with important initial letters in the rest of the book; although the gold backgrounds of the Gregory Master and of the high period of Reichenau had not yet appeared, a quantity of gold was applied to the figural pages and to the body of the large initial letters; and the fine minuscule script and careful lineation suggest the well established practice of a good scriptorium.[3]

6

7. St. Matthew. Lorsch Gospels, *c*. 815. Alba Julia, Documentara Batthayneum, f. 13v

8. St. Matthew. Gero Codex, Darmstadt, Landesbibl., MS 1948, f. 1v

It is an established certainty that the evangelist portraits of the Gero Codex had as their direct model those of the Lorsch Gospels (*c*. 815), the last in the line of great gospel books from the Court School of Charlemagne. The presence of the latter book at the monastery of Lorsch, near Worms and the Rhine, is already attested in the ninth century. This book plays a vital part in the earliest promptings towards figural art at Reichenau, since there is no evidence of earlier figural art than that of *Gero* in the Ottonian manuscripts of Reichenau. Haseloff in his masterly book on the Egbert Psalter (1901), which surveyed the whole achievement of the early Reichenau school, already noted the connection between *Lorsch* and *Gero*.[4] But he thought *Lorsch* a tenth-century manuscript related to the Charlemagne Court School (or the Ada Group within it), an understandable error since he knew only the last half of it in the Vatican Library. The first half of it, in Julia Alba (Romania), shows beyond doubt that it is a Charlemagne manuscript. Thus Haseloff thought that the *Gero* artist or artists worked in a live tradition stretching back to the time of Charlemagne. It was Köhler who showed in 1926, more fully than had Haseloff, that *Gero* was directly beholden to *Lorsch*, indeed a new Ottonian beginning using an old Carolingian prototype, and that *Lorsch* was indubitably Carolingian.[5] There were no intermediaries to join the Lorsch Gospels and Gero Codex in a living tradition across the century and a half which divided the two manuscripts.

26

9. St. Mark. Lorsch Gospels,
c. 815. Alba Julia,
Documentara Batthayneum, f. 74v

A comparison of *Lorsch* and *Gero*, however, reveals that already in the 960s there is an apparently conscious drive towards a new aesthetic in the Ottonian manuscript, away from Carolingian spatialism towards two-dimensionality, or *Flächenkunst*, i.e. flat surface art. In the *Gero* St Matthew, *8* it is true, where the *Lorsch* colours are broadly followed, the *Lorsch* spatially *7* illusionistic background is also attempted. But here the rigid differentiations of colour between one ridge and another, and the less painterly more sharply drawn trees, achieve a less illusionistic effect and a stronger element of surface pattern. Indeed by adding a little undulating scene of trees at the feet of the evangelist where it can carry no spatial conviction, the *Gero* artist ensures that we take the whole page as pattern rather than space. In any case, all landscape is abandoned in the subsequent evangelist pictures of *Gero*. The window shadows, still retaining a vestige of light and shade in *Lorsch*, have become a pure pattern in *Gero*. The *Lorsch* St Mark, for all its deliberate distortions of angle, still suggests real thighs *9* under the clothes, and buttocks of real weight against the admittedly unyielding cushion. In *Gero*, the same figure is a two-dimensional 'cut-out', floating in front of stool, cushion and wall alike. One may note that here, as against the Matthew, the colours radically diverge from those of *Lorsch*. *Col.Pl. II* The colours of the *Gero* St Luke are also unlike those of the corresponding page in *Lorsch*, and here the *Lorsch* drawings of landscape background have been completely eliminated.

27

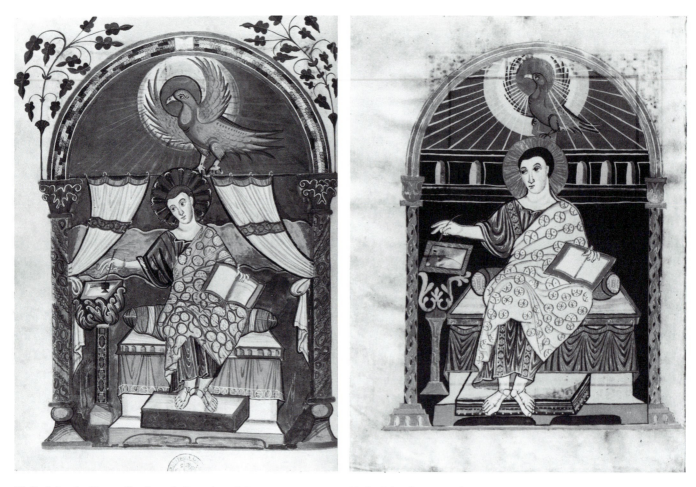

10. St. John the Evangelist. Lorsch Gospels, *c.*815.
Vatican, Bibl. Apost., MS Pal. Lat. 50, f. 67v

11. St. John the Evangelist. Pericopes Book, Reichenau,*c.* 965-70.
Gero Codex, Darmstadt, Landesbibl., MS 1948, f. 4v

Most telling are the little strokes by which *Gero* has flattened out the
10,11 *Lorsch* St John. This comparison gives us a remarkable opportunity to test
the reactions of an earlier Ottonian artist to his Carolingian predecessor.
The architectural effects of the marbled pillars have gone in favour of a
surface interlace of gold and silver; so has any attempt to reproduce the
admittedly crude effect of undulating terrain behind John. Gone is the
sense that the eagle stands in space. The rays from its roundel, rays of
light in *Lorsch*, have been made to form a geometrically articulated surface
in *Gero*, and, by a most significant touch, the eagle stands no longer on a
curtain rail *behind* John, giving some sense of depth to the picture, but on
John's nimbus. The foliated inkstand, which in *Lorsch* looks as if it might
just have the body to bear an inkwell, has become a piece of purely linear
symbolism on the page of *Gero*.

Some of the above may be small differences, albeit significant. But if
one compares the most spatialist evangelist pictures of the Charlemagne
12 Court School, such as the Matthew of the Trier Gospels (*c.* 800-10), in an

28

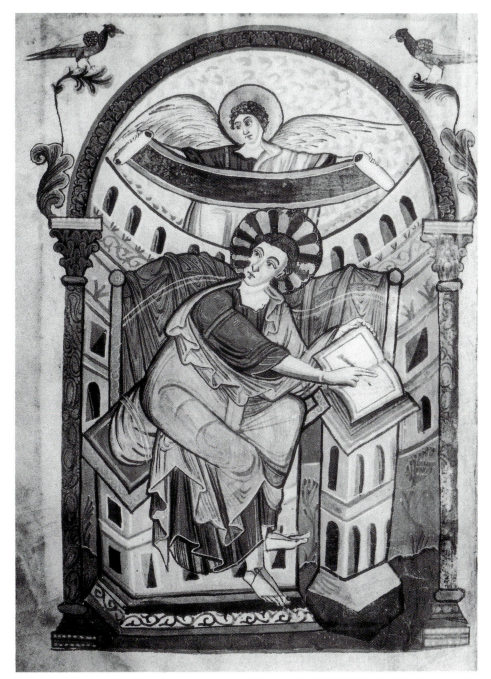

12. St. Matthew.
Ada Gospels, *c*. 800-815.
Trier, Stadtbibl., Cod.22, f. 15v

architectural setting, not to speak of the four evangelists working in a rocky landscape in the Aachen Gospels of Charlemagne's time,[6] with any comparable Ottonian scene, it is clear that the retreat from spatialism fundamentally differentiates Ottonian from Carolingian art, to which it owed so much. Why did this feature develop? We are on tricky ground here, not least because of the virtual lack of all theorizing (or surviving theory) about art in Ottonian times. The art itself is the primary source

29

13. Pope Gregory the Great. Frontispiece to Gregory's Letters, Gregory Master, prob. 983-84.
Trier, Stadtbibl., MS 171/1626

for our understanding of the aesthetic ideals of this society, a source not easily interpreted uncontroversially or without subjectivity. But one might start by observing the danger of assuming a mere technical incapacity or loss of competence in *Gero*. This would come close to being a historicist fallacy, whereby one posited a classical ideal of spatialist art, ultimately victorious in the Italian Renaissance, and then proceeded to judge earlier artists by their approximation to this historically triumphant ideal, the Carolingians clinging to it while the Ottonians failed to do so. We should rather give the Ottonian artists credit for having their own positive, non-spatialist intentions.

There is an aesthetic psychology at work in *Gero*, whose origins are hard to explain, but which runs deep in Ottonian art. Boeckler showed, for instance, how the artist of the Raising of Lazarus in the Gospel Book of Otto III must have used a late antique model in which the scene was conceived all on one level in three-dimensionally organized space; but the Ottonian artist denied the illusion of depth by superimposing one level of figures vertically on another and making everything frontal.[7] The Gregory Master, an artist based in Trier in the last decades of the tenth century, had more grasp of spatialist and illusionist techniques than any of his contemporaries. But even he, in his famous picture of Pope Gregory (prob- *13* ably 984), preferred to proceed by the construction of what Otto Pächt calls 'parallel, flat layers',[8] rather than employ the kind of spatialist interior of antique derivation which was the Carolingian norm. The two-dimensionalism of *Gero* is related, as if telepathically, to yet another feature of aesthetic psychology in the high Ottonian period — the feeling that corporeality should be diminished to make allowable the pictorial depiction of the Life of Christ, who was man but also God. More of this will be discussed in the next chapter. With the complete flattening of so many spacialist backgrounds, moreover, we are getting a taste of the rationale of gold backgrounds, which, leaving aside for the present the Egino Codex of *c*. 800,[9] come into the West with Ottonian art, and impart spacelessness and timelessness to the actions and gestures of Christ.

One can see another anticipation of the high period of Ottonian art in the *Gero* evangelists. The greater monumentality and frontality of these evangelists compared with those in *Lorsch*, achieved by making the whole space more two-dimensional, and also by enlarging the space which they occupy in relation to the picture surface as a whole, prepares the way for the great representations of rulers and of Christ in Majesty. The historian Widukind, in his *Res Gestae Saxonicae*, was creating monumental figures out of men like Otto I, Conrad the Red, and the Wichmanns father and son, in a similar way at just the same time (967-68).[10]

After the evangelists in *Gero* comes the *Maiestas*, i.e. Christ seated in Majesty. Everything indicates that this too is derived from the *Lorsch* *15* *Maiestas* — roundel, throne, posture, and draperies. Only the colours and some details in the design of the roundel are varied. But in *Gero* the roundel *16* is greatly expanded so that it breaks the bounds of the acanthus frame,

31

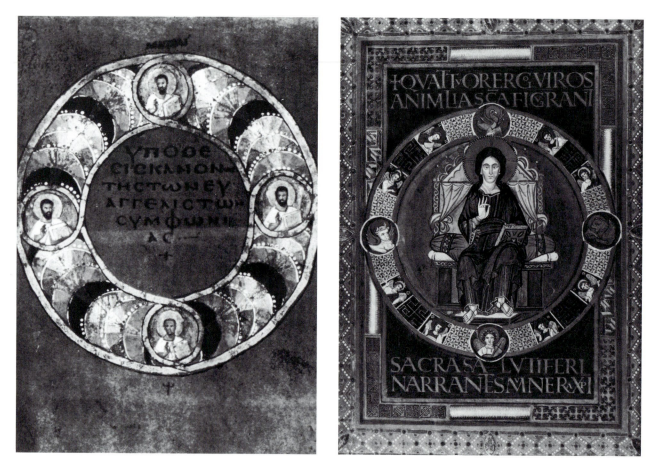

14. Title page.
Rossano Gospels, C6.
Rossano Cathedral, f. 5

15. Christ in Majesty.
Lorsch Gospels, *c.* 815.
Alba Julia, Documentara
Batthayneum, f. 18v

14

and once again (as with the evangelists) the monumental figure of Christ is given an enlarged proportion of the picture surface. The roundel was a feature of book art going back to late antiquity, particularly as the frame for the title of the gospels. There is an example of this in the sixth-century Rossano Gospels. The Ottonians would appear to have developed a perception of the early Christian art behind their Carolingian (and a little later their Byzantine) models. The ornamental pattern of the Rossano roundel, a series of partly obscured coloured discs, was used in later Ottonian manuscripts,[11] and it may be to something like this roundel that the reduction of the number of figures in the *Gero* roundel as against *Lorsch* is due. Not much later than the 960s the Rossano Gospels itself could well have been known in Ottonian circles. For when Otto II fought his disastrous campaign against the Saracens in South Italy during 982, he left his (apparently art-loving) Byzantine wife, Theophanu, and various court officials and chaplains, in Rossano;[12] and there is no sign that this wonderful book was ever anywhere else. Otto II himself was at Rossano on 31 July 982, and moreover he was there with his book-loving chancellor or *consecretalis*, John Philagathos, whom he was shortly afterwards to make Abbot of Nonantula in central Italy.[13]

32

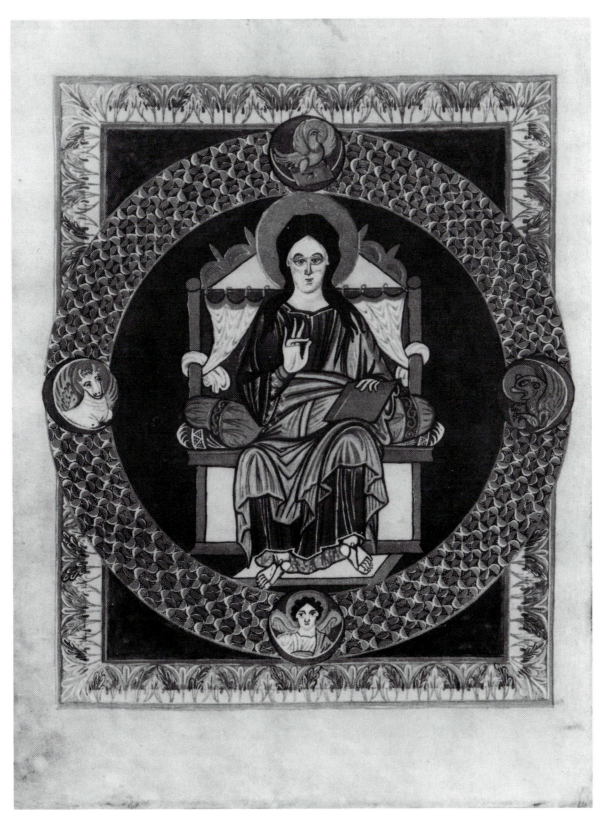

16. Christ in Majesty. Pericopes Book, Reichenau, *c.* 965-70.
Gero Codex, Darmstadt, Landesbibl., MS 1948, f. 5v

The Codex Wittekindeus was in all probability produced in the monastery of Fulda during the reign of Otto I. This, unlike *Gero*, is a book of the four gospels, not just of the liturgical gospel readings. It contains, therefore, not only full-page miniatures of the evangelists, but also a series of splendidly ornamental canon tables, tables devised by Eusebius for listing the concordant passages between the various gospel narratives. *Wittekindeus* certainly used a now lost gospel book of the Charlemagne Court School for its evangelists. The same gospel book was also used for the canon tables and the Matthew and Mark (but not the Luke and John) of a ninth-century gospel book in the Erlangen University Library. If one compares *Erlangen* and *Wittekindeus*, they are closer to each other than is either to any other surviving manuscript of the Ada Group.[14] In *Wittekindeus*, however, Boeckler noted (as we have just seen in the case of *Gero*) the diminution of the bodily element compared with the Carolingian prototype. The corporeality of the latter, he said, had relaxed into fleshly flabbiness.[15]

8,17 When we compare the evangelists of *Gero* and *Wittekindeus*, we are obviously inhabiting the same world. The Matthew in each book faces the same direction, has a similarly monumental character with writing hand raised high, and is set against a similar architectural background. Mark in

Col.Pls. II,III each case faces the opposite direction to Matthew and is depicted with similarly agitated draperies. No doubt our sense of these two as being cognate manuscripts is largely accounted for by the fact that each was activating its own model of the Charlemagne Court School.

There is one point of relationship between these two manuscripts, however, which is not explicable by their Carolingian models. We have observed that whereas the *Gero* Matthew follows the colours of the *Lorsch* Matthew, the Mark does not follow its opposite number in this respect.

Col.Pl. II Where the colours of *Gero* diverge from those of *Lorsch*, they show a marked proclivity to resort to the greens and lilacs so favoured at Ottonian

Col.Pl. III Fulda and already evident in *Wittekindeus*. It must be admitted that the tones of these colours do not always correspond closely as between *Wittekindeus* and *Gero*. The approximations lie more in the idea of the colour schemes, as if conversation had taken place between Reichenau and Fulda monks on neutral territory, rather than as if they had actually visited each others' atelier.

It is a moot point whether the artists of *Gero* and *Wittekindeus* knew that they were using models which went back to Charlemagne's time. But given the lack of evidence for any continuous tradition of figural art at either Reichenau or Fulda in the period before the 960s, they surely knew that these models were Carolingian, and in that case they could well have equated the Carolingian age with Charlemagne. Otto I's reign, and particularly its last decade after his imperial coronation at Rome in 962, saw a notable revival of the memory of Charlemagne. In the 960s Bishop Bernhard of Halberstadt produced a forged charter in the name of Charlemagne, giving the boundaries of his diocese in detail, in an effort to forestall the loss of part of his diocese to the newly projected bishopric of

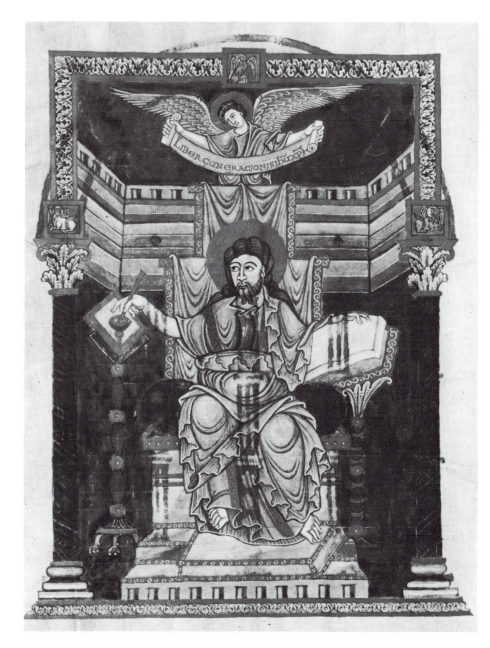

17. St. Matthew.
Gospel Book, Fulda, *c.* 960-70.
Codex Wittekindeus, Berlin (East),
Staatsbibl., MS theol. lat. fol. 1, f. l4v

Merseburg.[16] Widukind of Corvey, probably writing in 967-68, considered
Charlemagne to have become an emperor from the time when he incor-
porated the Saxons into Frankish rule.[17] Otto I's diplomas in favour of the
church of Aachen during the years 966 to 972 make several references to
Charlemagne, in whose seat at Aachen he had himself been enthroned in
936; one of them dated 17 January 966, refers to the church as having been
built by Charlemagne in order to be the highest summit of his empire.[18]
These testimonies of devotion to Charlemagne's memory fall exactly in
the right years to express the likely attitude of artists working on *Gero* and
Wittekindeus in close proximity to the court circle of Otto I. The manuscripts
themselves may be regarded as an aspect of 'le souvenir et la légende de
Charlemagne' under the Ottonians.

2 Manuscript Art and the Court Circle of Otto I

It is a case which still needs to be made that at the hub of these new beginnings was Otto I and his court circle. First we must look at the court chapel and the chaplains. Gero of Cologne, for whom the Gero Codex was made, was himself one of these. Now it has been suggested that the Gero in question (of whom the codex itself tells us no more than that he was *custos* of a church of St Peter) need not have been the court chaplain, *custos* of Cologne, and future Archbishop of Cologne. Another Gero has been dredged up who was *custos* of Worms (a cathedral also dedicated to St Peter) in the late 950s.[19] A *custos* of Worms, who must have been an aristocrat, was assuredly not an unimportant man, and there are a few later instances of illuminated books being made for clerics of high standing who were nonetheless not bishops, for example the Sacramentary of St Gereon, Cologne, for a canon of that church, and the Hillinus Codex, for a canon of Cologne Cathedral.[20] But at this early stage of Ottonian book art, in the case of a book of the utmost sumptuousness for its period, when the patron is clearly (from his picture) not a bishop, we are surely looking for a Gero who was otherwise of great importance in Ottonian society. Gero of Cologne was the son of the Saxon count Christian and nephew of Margrave Gero, the greatest of Otto I's war-lords on the eastern frontier of Saxony with the Slavs. He was a court chaplain in the period after the death of Bruno of Cologne (ob. 965), when, as Fleckenstein has shown, court chaplains began to be promoted to bishoprics in significant numbers, the most important avenue to promotion having earlier been membership of Bruno's own circle.[21] Compared with Gero of Cologne, Gero of Worms was a nobody. And although Worms was geographically very close to Lorsch, the church of Cologne had a special relationship with this monastery, going back to Bruno of Cologne's reform.[22] Another court chaplain of Otto I, besides Gero of Cologne, was the art patron Egbert, later chancellor of Otto II and Archbishop of Trier; Fleckenstein points out that in these early days of Ottonian book painting, the court chaplains were the men who would understand art and know where the best scribes and painters of the empire were to be found.[23] Thus if it was not directly Otto I himself who put the Lorsch Gospels in the way of the *Gero* artist, then it was doubtless Gero, his court chaplain.

Next we may consider more broadly the place of Otto I's court amongst the cultural institutions of his empire, in order the better to understand why a Carolingian manuscript belonging to Lorsch could come to be used as a model at Reichenau. It is true that Lorsch and Reichenau must at least have fallen within each other's cultural field of vision, so that strictly speaking there is no need to posit a third party to mediate Carolingian art from one to the other. But all great monasteries in the empire had far-flung connections by this time, and these connections in fact seem to have been insufficient in themselves to explain the origins of Ottonian book illumination, though they no doubt provided an important framework for its

development and for the transmission of artistic influences. On the other hand, the court of Otto I was an obvious source of stimulus.

Both Lorsch and Reichenau had very close relations with Otto I. Lorsch was one of those monasteries which his brother, Bruno of Cologne, had reformed with royal approval, and it is described by Ruotger, biographer of Bruno, as 'ennobled by royal munificence'. One piece of munificence was a large grant of land in Alsace, which had belonged to an outlawed Swabian count, Guntram. Otto gave it, obviously to consolidate his support, at the moment when he was besieging Mainz in the great rebellion of 953. Earlier, in the other great rebellion of 939, Otto had placed his English wife, Edith, in Lorsch while he suppressed the rebellion.[24] In the mid 960s, he appears to have used Abbot Gerbodo of Lorsch (951-72) as a reforming Visitor to the monastery of St Gall.[25] There is reason to think that an intervention of Abbot Ruodmann of nearby Reichenau had brought the problems of St Gall to a head. In 981 Lorsch contributed fifty armed knights to Otto II's Italian expedition, more than any other monastery except Fulda, Reichenau and Weissenburg.[26] This highlights one reason for a ruler to give land to a well run monastery. That Lorsch was a centre of culture and education, which a ruler might be glad to use, in the third quarter of the tenth century, is shown not only by its considerable library, but also by a list of its monks which happens to survive in one of its manuscripts from the abbacy of Gerbodo. There were 48 monks, of whom 12 were priests, 12 deacons, and 9 subdeacons: a considerable proportion, that is, in higher clerical orders.[27]

A question mark has been placed over the closeness of Reichenau's links with the court,[28] but the most cursory glance at the evidence leaves no doubt of their strength. Reichenau was one of the two greatest contributors to the military levy of Otto II in 981. Like Lorsch, it had benefited enormously in land grants from its fidelity to Otto I in the rising of 953, as well as from the accidents of Swabian dynastic history.[29] A Reichenau monk, Hoholt, seems to have been associated with the scriptorium of Bishop Poppo of Würzburg while the latter was Otto I's chancellor, and to have written Otto's privilege of 965 for Reichenau itself.[30] And although it has been eagerly pointed out by those who would diminish its role, that only twice in the tenth century do royal diplomas actually testify visits of the ruler to Reichenau (as distinct from the visits of Reichenau abbots to the court), these two visits were those of Otto I in 965 and 972.[31] One could not ask for more perfectly timed evidence of the mutual involvement of court and monastery, exactly in the period of the Gero Codex.

The liturgical calendar of the Gero Codex offers a remarkable symptom of the royal outlook. The only two festivals in it which are not New Testament based, i.e. of Our Lord, Mary, John the Baptist and the Apostles, are those of St Lawrence and of the Maccabees.[32] Were St Lawrence the only exception, one would attach little significance to it, for already in Carolingian manuscripts the martyrdom of this extremely popular saint was being represented alongside those of Saints Peter and Paul.[33] But St

Lawrence and the Maccabees together are another matter. The resistance of the Maccabees to the Seleucids was seen as a biblical type of the resistance of tenth-century men to the Hungarians.[34] That seems the obvious significance of the illustrated *Maccabees* of *c.* 925 (Leiden, Cod. Perizoni 17), a book illuminated at St Gall but actually in the possession of Reichenau when the Gero Codex was made.[35] And the festival of St Lawrence was that on which Otto I had achieved his great victory of the Lechfeld over the Hungarians.[36] The two festivals between them symbolize the defeat of dangerous external marauders which the early Saxon rulers regarded as one of their great achievements. The harangue of a papal document of 962, which doubtless reflected the thinking of Otto I himself, maintained that Otto had earned the Roman imperial crown above all for his victories over the Slavs and the Hungarians who had threatened Christendom.[37]

The relations between Fulda and the court of Otto I also come into question here, for if there is anything in our supposition that the artists of Fulda and Reichenau were in touch with each other, at least on 'neutral territory', what more likely neutral territory could there have been than the constantly itinerant court of Otto I? Fulda was perhaps the greatest and richest monastery in the whole empire, and its court connections were manifold. Abbot Hadamar (927-56), during his later years, was a key figure in Ottonian politics,[38] and there are numerous testimonies to the presences at Otto I's court of Abbot Hatto (956-68) and Abbot Werinher (968-82) during the 960s and 970s, presumably always with some monks and other dependents.[39] It is impossible to determine whether the Charlemagne Gospels of the Ada Group, used by the Codex Wittekindeus as a model, came to Fulda during the reign of Otto I, or had lain there since Carolingian times. Either way we are still left with the question, as with the Lorsch Gospels at Reichenau: what was the stimulus to its use in new artistic production after lying dormant for so long? Part of the answer would appear to be the quickening of Charlemagne's memory at Otto I's court which we have noted for the relevant period: but only part.

Otto I may not have been particularly book conscious in his earlier years; a gospel book which he had occasion to present to Athelstan, King of the English (ob. 939), was exiguously decorated and was 'improved' by Athelstan before he presented it to Christ Church, Canterbury.[40] But that appears to have changed in his later years as his perspectives of rule expanded. Widukind actually says that after the death of his first queen, Athelstan's sister Edith (ob. 946), Otto learned to read and to understand books fully.[41] One development above all others must have fostered his awareness of the need for books: the foundation of the archbishopric of Magdeburg, to be the mainspring of the missionary drive to the Slavs east of the Elbe. The date of this foundation was 968, but the scheme had been in his mind since at least 955.[42] The monastery of St Maurice, Magdeburg, founded in 937, which was transformed with its endowments into the archbishopric, already had some finely ornamented books by 968 when the clerics of the new cathedral took them over.[43] So important a church

SE͞Q S͞CI E͞U SE͞C MAT͡H

V
M

ESSET DESPON

SATA MATER IH͞V

I. Initial C. Pericopes Book, early C11. Munich, Bayerische Staatsbibl., Clm. 23338, f. 2

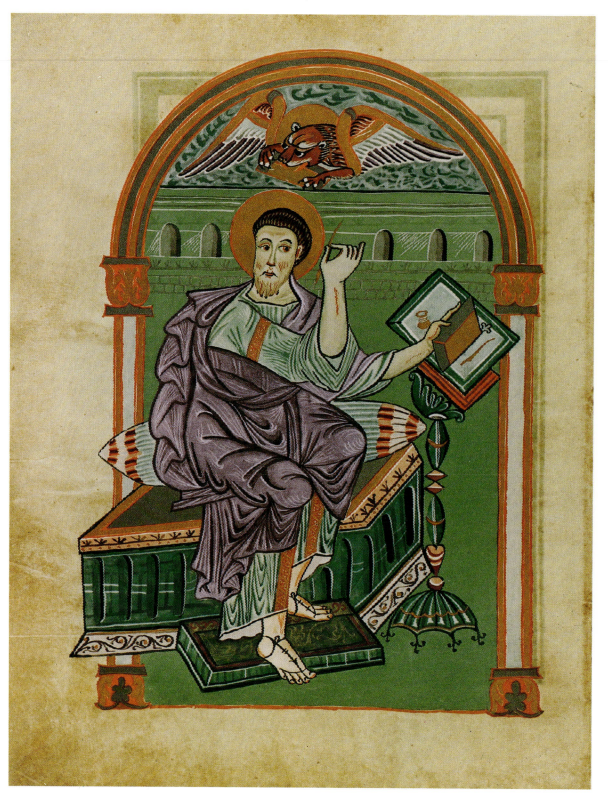

II. St. Mark. Gero Codex, *c.* 965-70. Darmstadt, Landesbibl., MS 1948, f. 2v

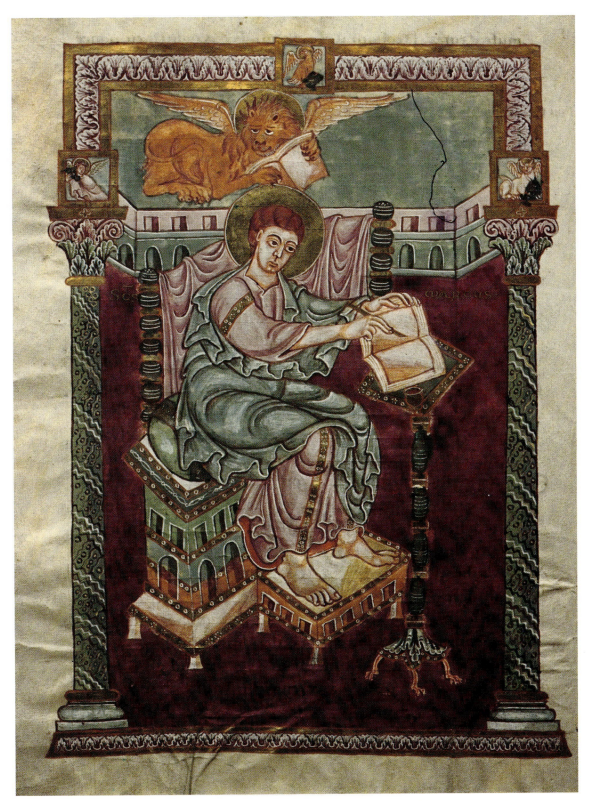

III. St. Mark. Codex Wittekindeus, *c.* 970. Berlin (East), Staatsbibl., MS theol. lat. fol. 1, f. 45v

Et tfiet unu ouile, et unuf paftor,

DOM II SEC IOHANNEM

Nillo temp, Dixit ihf difcipulif fiuf,
odicium etiam nonuidebitif
me, et iteru modicu etuidebi
tif, quia uado adpatre; Di
xerunt ergo exdifcipulif eiuf eiuf ad
inuice; Quid e hoc quod dicit no

IV. Initial M. Poussay Pericopes, *c.* 970-90. Paris, BN, MS lat. 10514, f. 60

V. Detail of text page. Lorsch Gospels, *c.* 815.
Vatican, Bibl. Apost., Pal. Lat. 50, f. 61v

cum. et ueniebant adeum et dicebant Aue
rex iudeorum. Et dabant ei alapas. Exiuit
ergo iterum pilatus foras. et dicit eis. Ecce ad
duco uobis eum foras. ut cognoscatis. quia ineo
nullam causam inuenio. Exiit ergo ihs postans
spineam corona. et purpureum uestimentu.
et dicit eis. Ecce homo.

Cu ergo uidissent eu pontifices et ministri. clama
bant dicentes Crucifige. Crucifige eu Dicit eis

VI. Pilate and Christ, Ecce Homo. Codex Egberti, 977-93. Trier, Stadtbibl., MS 24, f. 82v

VII. Initial C. Gero Codex, *c.* 965-70.
Darmstadt, Landesbibl., MS 1948, f. 11

VIII. Initial S. Gero Codex, *c.*965-70.
Darmstadt, Landesbibl., MS 1948, f. 103

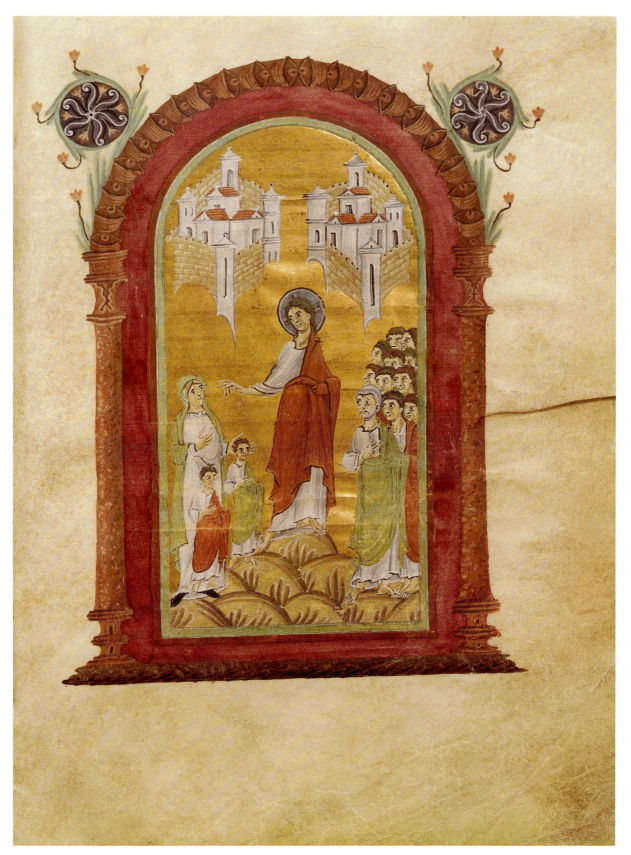

IX. Jesus and the Sons of Zebedee. Aachen Gospels, *c.* 996. Aachen, Cathedral Treasury, p. 115

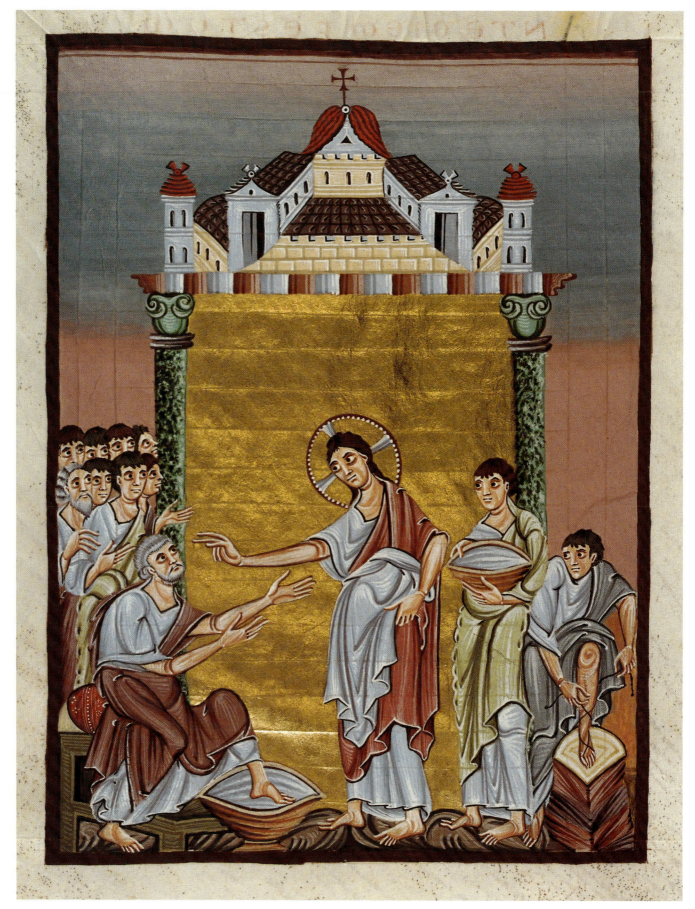

X. The Footwashing of St. Peter. Gospel Book of Otto III, 998-1001. Munich, Bayerische Staatsbibl., Clm. 4453, f. 237

needed the most splendid liturgical books, more and finer specimens than it can have taken over from the monastery which it supplanted. When one brings into the calculation the dependent bishoprics and monasteries of Magdeburg, which altogether represented a huge enlargement of the Saxon church, the demand for such books must have become very considerable. And there is no evidence from the Ottonian period that Magdeburg or any of its dependent churches ever produced illuminated manuscripts; they must have imported virtually everything in this line which they needed. The Codex Wittekindeus formerly belonged to the church of Enger, a church having intimate connections with the Saxon dynasty. Enger belonged to the archbishopric of Magdeburg from 968.[44] It is most likely that *Wittekindeus* began life as one of the books which Otto I granted to Magdeburg — Thietmar of Merseburg (a former pupil there) is explicit that he granted many[45] — whence it passed by a natural route to Enger. The need to face up to the requirements of Magdeburg, and its dependent churches, at just the moment when our evidence tells us that the real movement of Ottonian manuscript art was beginning, would by itself be a sufficient explanation of why the court of Otto I should be an important stimulus to the production of fine books at this period.

The work of the Gregory Master perfectly exemplifies, and indeed demonstrates, the central role of Otto I's court in early Ottonian manuscript art. The Gregory Master was one of the most important of all Ottonian masters, and he was easily the most accomplished manuscript illuminator (he was probably a goldsmith as well) working in the 980s and 990s, between *Gero* and *Wittekindeus* on the one hand and the Gospel Book of Otto III (998-1001) now in Munich on the other.[46] We cannot name him, nor can we tell, even, whether he was a monk or a layman.[47] His main connection came to be with Archbishop Egbert of Trier, but he was clearly peripatetic. It is generally accepted that apart from the Gregory page from which he derives his name, he was the artist of the Ste Chapelle Gospels, *19* (Paris, BN, MS lat. 8851) which must be virtually the same date as the Gregory page and is dateable to 984. The Ste Chapelle Gospels was made for Egbert of Trier. Earlier than that he had worked on a sacramentary for Lorsch, in which the ornamental tendrils of the initial letters have grace and freedom. Later he illuminated a gospel book (996 or soon after), now in Manchester, which would form the model for the decorative pages of the Cologne book artists, and still later he worked on a sacramentary for Trier. At some time impossible to date more precisely than in the archiepiscopate of Egbert of Trier (977-93), he painted the first five miniatures of the Codex Egberti and two others including Christ and the Centurion.[48] This book, as its dedication shows, was a gift from Reichenau to Egbert, and Nordenfalk makes the apparently unavoidable supposition that the master must have visited Reichenau and worked there for a time.[49] Already, therefore, we have Otto I's one-time chaplain Egbert of Trier, and also Lorsch and Reichenau, in his net. Thanks to Hartmut Hoffmann we can now add Fulda.

18. Marriage Roll of the Empress
Theophanu, 972. Wolfenbüttel,
Staatsarchiv, 6 Urkunde 11

Hoffmann has recently identified the Gregory Master's script and extended the corpus of works attributable to him. In particular he has argued
18 persuasively that the Marriage Document of Theophanu (972) comes from
his hand.[50] This magnificent document, in the tradition of Byzantine purple
documents, is written in golden letters on a background of purple medallions, in imitation of silk textiles. Drawn in these medallions, as if stitchings
in the silk, are griffins or lions riding on the backs of hinds; these drawings
show an astounding sureness and freedom of line, like the Gregory Master's evangelical symbols with their physical vibrancy, in the Ste Chapelle
Gospels. Tendril ornament of clarity and lightness, also comparable to

40

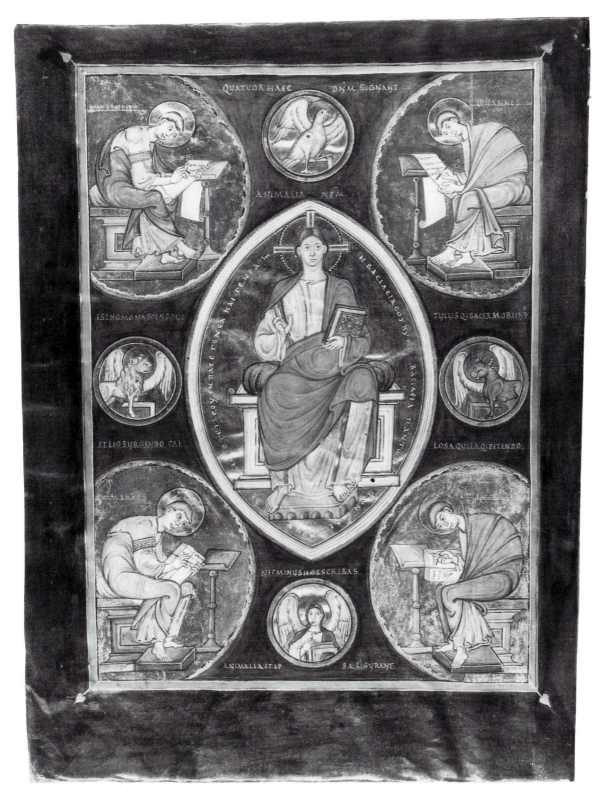

19. Christ in Majesty. Ste-Chapelle Gospels, *c.* 984.
Paris, BN, MS lat. 8851, f. 1v

other known work of the Gregory Master, occupies the space between these medallions, or roundels. The Fulda connection comes in here, because the script of this document is identifiable as that of a Fulda hand.[51] But most important for our purposes is that the Theophanu document becomes the earliest known work of the Gregory Master, and it must have been made under the patronage of Otto I. How else could one explain a document unrolled (so to speak) in his presence at the marriage of his son to Theophanu in St Peter's, Rome, on Easter Sunday 972![52] The court treasure of Otto I would in any case be by far the likeliest source for the motifs of the medallions, which can be exactly paralleled in the engravings of a fifth-century A.D. Persian silver dish.[53] This was the kind of gift which Otto I, as we know from Widukind, will have received from foreign potentates.

The whole work of the Gregory Master as we know it, therefore, would seem to be expanded along those spokes which linked Trier, Lorsch, Reichenau and Fulda to the hub of Otto I's court, and no doubt to the courts of Otto II and Otto III after him.

One last point about the role of Otto I's court in early Ottonian manuscript art concerns the mid- to later tenth-century manuscripts of the monastery of Corvey, Widukind's monastery. Widukind's *Res Gestae Saxonicae* was scarcely designed simply to laud the Liudolfings, with whose enemies he more than once found himself in sympathy.[54] But he worked close to court circles. So did the artists of Corvey's scriptorium (which is dealt with in Part II). Florentine Mütherich has pointed out that several Corvey manuscripts were made for the great royal nunneries whose abbesses were related to Otto I — Quedlinburg, Gandersheim, and Essen — and draws what appears to be the only possible conclusion, that Corvey too worked for the court of Otto I.[55]

The most important contribution of Otto II (at least the initiative was probably his) to the royal patronage of manuscript art, was to propagate through it the image of the ruler, and in Byzantine fashion, his consort. For he gave to Magdeburg a book (one supposes a gospel book) which had in it (or on it) his own image and that of the Empress Theophanu splendidly fashioned in gold. We may also refer here to the Byzantine *1* ivory, now in Paris, showing Otto II and Theophanu being crowned by Christ, a kind of image which, to judge by Fulda art (to be discussed in Part II), must have been well known in the late tenth-century West.

What can we say more generally about the relations of court and artists under the Ottonians? The fundamental fact here is that the court was an itinerant one, to a degree unknown even among Carolingians. It travelled from palace to palace, or, beginning with Henry II (1002-24), more from bishopric to bishopric, rarely stopping for long, having a huge entourage in train, and making its presence felt militarily, judicially and ceremonially wherever it went. The capacity to cover great distances in Germany and Italy and always have somewhere to stay, at a palace or elsewhere by right of hospitality, was in itself a demonstration of power. The court travelled

42

heavy; the chapel with all its accoutrements and a large treasure went with it everywhere. Now artists were generally persons of education and intelligence, and some of them were clearly laymen. Laymen were obviously very mobile, but so indeed were monks in an age when confraternities of prayer and reforming links were bringing monasteries all over the empire into close relations with each other. There is no difficulty, therefore, to think of artists at one time travelling with the court, talking with the ruler or with others present; at another time establishing themselves at a monastery (perhaps where they were members or had a connection) to work for a period; and at yet another time being drawn into the court circle because it had travelled into the vicinity where they were established.

Very fine scholarly work has been done in the past twenty-five years on the royal itinerary, or *iter*, but earlier still Jolliffe provided a model from English history of how medieval itinerant kingship worked, in his masterly book, *Angevin Kingship*.[57] Particularly relevant for the reconstruction of artist-court relations which we have just suggested is Jolliffe's demonstration that such a kingship in Angevin England would plant in the localities a network of agents and agencies of various kinds, which would be drawn into the court physically when it was travelling in their neighbourhood, but whose link with it when it travelled elsewhere was still very important, the link of *familiaritas*. This word was used much in the tenth-and eleventh-century empire, as in twelfth-century England, and our word 'familiarity' would be a very weak translation of it.[58] The *familiares* were the closest friends and associates in rule of a king or emperor, but in order to have his *familiaritas* it was not necessary to be always in the entourage of a ruler. One of the principal meanings of the word in the Middle Ages was to denote a special bond between men amidst the necessities imposed by geographical distance, in a society which lacked the bridgings of distance provided by motor cars, railways, aeroplanes and telephones. Perhaps a reason why the greatest Reichenau manuscripts which were made for the ruler cover the traces of their origins so effectively, was that what mattered to the artists with respect to their work was not so much the membership of or connection with a particular religious house as their *familiaritas* with the king or emperor. Moreover the court offered great scope for the practical studies of artists and craftsmen, because books and artefacts worthy of study were a part of its constantly moving treasure.

This last point is made strikingly clear from a passage in Thangmar's *Life* of the artist and art patron, Bishop Bernward of Hildesheim (993-1022). The passage deserves to be quoted, because although reference is made to the royal court only in passing, the mention shows that Bernward saw it as an institution of artistic interest where the education of his pupils in matters of art could be furthered. These are the words of Thangmar:

> Whatever he [Bernward] could seek out in the way of painting, sculpture and the art of the goldsmith or of cloisonné work, when it was in the best taste (*elegantius*), he never allowed it to be neglected. Whatever he perceived to be unusual or excellent, in particular among the foreign and Irish artefacts (*vasis*) which were given to the royal majesty as special presents, he would not allow to be passed over without study [another student of the royal treasure to match the Gregory Master]. He would either take clever boys and those of exceptional talent to court (*ad curtem*), or he would travel far and wide generally, and he urged them to the practice of whatever he discovered that was worthy of it in any form of art (*in ulla arte*).[59]

3 The Art of Initial Letters

Ottonian art was very much an art of ornamental initial letters as well as of human figures, of calligraphy as well as illustration. Indeed in the early days of *Gero* and *Wittekindeus* it was more calligraphic than figural. The evangelists in these books are grandly conceived, and in that sense not at all provincial, but they look like beginnings. The initials neither are nor look like anything of the sort. Hans Jantzen has seen the Ottonian period as the apogee of the word, with its initial letter especially prominent, given positively sacral effect by being turned into a splendidly framed picture occupying a whole page. Thus is its function as the beginning of a gospel or a psalm emphasized. As symbols the word and letter become more important for their sacredness than for their actual legibility, but when into the bargain the shape of the letter remains easily discernible amidst the pictorial magnificence (the Egbert Psalter and the Gospel Book of Otto III are Jantzen's principal examples of this), then the impression is one 'as of absolute music'.[60]

The high road of the early medieval initial letter takes one from Ireland and Britain to the Carolingian courts, from these to the Carolingian monasteries and especially to St Gall, and thence to Ottonian Reichenau. The capital Q which introduces Psalm 51 (*Quid gloriaris in malitia*) in the mid ninth-century Folchard Psalter of St Gall is filled with splendid interlace, but a critic might argue that the interlace threatens to create the shape of

a cross to the eye of the beholder, a shape which might raise itself up against the shape of the Q.[61] In the Q which opens a sermon in a Reichenau homeliary probably of the third quarter of the tenth century, a book rich in initial ornament but with no human figural art and dating probably from just before *Gero*, the character of the interlace, the sickle-shaped shoots on the tendrils, and the fleur-de-lis (or calycinal flowers, or *Kelch-blüte*) finials are all taken over from the repertoire of St Gall ornament.[62] But because of the strong blue which is the background colour for the inside of the letter, the use of acanthus in its shape, and the interlace being confined to strategic points on the letter rather than covering it like a net, the shape of the initial stands out more clearly than it does in St Gall. The two great characteristics of Reichenau initial ornament were ornamental virtuosity and clarity of letter shape.

Let us look at not too highly wrought an example, yet a fully developed one, of Reichenau initial art from the early eleventh century: the initial C (*Cum esset desponsata*) of the gospel reading for Christmas Eve in a peri-copes book (Clm. 23338). The letter and opening words of the texts are placed on a purple background in a frame of acanthus and *Mäander* motifs. The shape of the letter is picked out in gold and minium red,[63] and is reaffirmed by a single interlace knot *on*, rather than *inside*, it. There is a differentiation between dark blue and slate blue inside the letter shape, but in such a way that the dark blue appears to be set inside, and subor-dinated to, the slate blue, in compartments as if of enamel, compartments defined by the inner scrolls of the golden tendril ornament. Thus while

21

20. Initial Q for Psalm 51. Folchard Psalter, St Gall, mid C9. St Gall, Stiftsbibl., Cod. Sang.23, f. 135

21. Initial Q. Homeliary, Reichenau, *c.* 950-70. Karlsruhe, Landesbibl., MS Aug. XVI, f. 49v

Col.Pl. I

the colour effect of the whole is enriched, there is in this no detriment to the letter shape. The sickle-shaped shoots of the earlier St Gall/Reichenau tendrils have become bulbous instead (to form *Knollenblattranken*) and some of the tendril finials have developed arrow heads (*Pfeilspitze*). Everything about this initial, a by no means exceptional representative of its period, in not one of the greatest Reichenau manuscripts, demonstrates how this sort of art developed in the previous decades. It could very well be, incidentally, that the arrow heads were drawn into the Reichenau ornamental repertoire from the Lorsch Gospels. One may suppose that it was not only the evangelist portraits which were eagerly studied in this Carolingian manuscript, so rich also in decorative frames to the texts, when *Col.Pl. V* the Reichenau artists had the use of it around 970. Folios 61 verso and 62 recto of the Lorsch Gospels, a fine pair of text pages, have frames with a motif of arrow heads (*Pfeilspitze*) in black on a silver ground.

To discover what place the Gero Codex occupies in the development of *Col.Pl. VII* Reichenau initials, let us look at its C for Christmas Eve. This letter is placed on the page in a fine *Mäanderband* border; its interlace knots are of controlled richness. The sickle-shaped shoots and fleur-de-lis finials of the tendrils persist; only in the Ruodpreht Group of Reichenau manuscripts *Col.Pl. IV* (e.g. the Poussay Pericopes and the Egbert Psalter), *c.* 975-95, do the bulbous shoots and arrowheads come in. The shape of the letter is less effectively picked out than in the early eleventh-century example, but there is an attempt to differentiate the inside of the letter, with its deep green background to the tendrils, from the form of the letter itself with its lilac acanthus pattern. The strategically placed interlace now helps to achieve *Col.Pl. VIII* the same effect. Within the curves of a capital, full-page S, later in the book, the dark blue and deep red against the lilac acanthus shape of the letter itself at once increases the richness and the clarity of the effect. The frame is brought into the act, containing as it does a panel of answering lilac acanthus, and opposite it a plain lilac panel on which is set the next letter, an I, now executed in gold and minium red. It is almost as if within the book itself the artist were skilfully and energetically experimenting with ornamental letter forms.

Still with Reichenau, but now advancing from the Anno Group, the earliest group of Reichenau manuscripts with *Gero* in it, to the Ruodpreht Group (see pp. 57, 207), the Poussay Pericopes Book contains, apart from *Col.Pl. IV* many large initials, no fewer than 105 smaller ones for the gospel readings of lesser feasts. The miniatures in this book represent a small and early Christ cycle, not without effect, but far behind the initial letters in their mastery. These letters, picked out in gold and minium red, embellished with gold or silver tendrils with bulbous shoots and arrow heads, are a testimony to the dominance of initial art over figural art at Reichenau, until we reach the Liuthar Group (e.g. the Aachen Gospels and the Gospel Book of Otto III) when parity is at last achieved, not by any means because of a decline in the initials, but because of the development of the great cycles of New Testament illustration.

The initial art of *Wittekindeus* is of a different character from that of *Gero* and much more restricted, because the only significant occasions for really fine initials are the beginnings of the four gospels. But one cannot look at the golden Q of *Quoniam quidem* at the start of St Luke's Gospel, glowing on the deep purple ground of the page, with its well handled interlace and floral pattern inside it, without being reminded of the sumptuous effect of the Theophanu Marriage Document. Nothing here is allowed to *18* detract from the clarity of the letter shape on the page.

The persistent emphasis on calligraphy as equal to, or even greater than, figural illustration is very important in Ottonian culture. The Ottonians inherited, though in nothing like the same degree, inhibitions about figural art from the Carolingians. Charlemagne had image-worship condemned in the *Libri Carolini* (794), reacting against Byzantine iconodulism as he saw it.[64] This work condemned all veneration of images as superstitious. It allowed illustration for didactic purposes, but allowed it with no good grace. There was nothing in Scripture of importance which words could not explain better than pictures;[65] pictures might remind one of historical events, but words were necessary for true understanding. Writing and not images were given for the instruction of our faith. Thus a certain attitude developed whereby art should be devoted to letters and script rather than to the human figure. The scribe Dagulf, in the colophon of a psalter for Charlemagne, wrote: 'Behold the golden letters paint David's psalms. Songs like these should be ornamented so well. They promise golden kingdoms and a lasting good without end'. Hrabanus Maurus, Abbot of Fulda (822-42) wrote a poem about the superiority of script to illustration.[66] Carolingian artists lavished beauty and gold on the opening words of St John's Gospel: 'In the beginning was the Word'.[67] It is not surprising, then, that the initial letter should be given such prominence under the Ottonians; yet when one sees single letters, or scarcely more, of such bravura swirls occupying a whole page, very unlike the noble and simple style of classical epigraphy with which (say) the opening page of St John in the Lorsch Gospels is written, one wonders whether Ottonian artists (and many Carolingian artists before them) did not turn from one kind of superstition into the arms of another, the magic of the letter. We shall have to wait for their retreat from this sort of magic until the 1030s and the last chapter of this study.

4 France and Germany Contrasted

Between England and the Ottonian Empire there were important parallel developments in iconography and some striking contrasts of style. But thanks to fine scholarly work, above all that of Robert Deshman (1976), this is becoming a well known subject. For this reason, and because such a comparison would involve a lengthy discussion, we take leave of Anglo-Saxon art in our period. French art at this time, on the other hand, is less well known, and the contrast between France and the Empire has great

value for pointing up the character of Ottonian manuscript illumination. Why did no such phenomenon as Ottonian manuscript illumination develop in France, or the West Frankish kingdom of the old Carolingian Empire, at the same period?

In the first instance we must understand that in the whole of the West during the tenth and eleventh centuries manuscript illumination was rated of much less importance amongst the arts than was metalwork, especially in gold. Once it is clear that metalwork was the primary and indispensable form of art, the extraordinary disparity in the standard of book illumination between one part of Europe and another will no longer seem so difficult to explain, nor so indicative of different levels of culture. In addition, the survival rate of metalwork artefacts is not at all good because of their intrinsic material value in subsequent periods. This will cause us, unless we are careful, to underrate the culture of the metalwork producers compared with that of the book illuminators.

It is a galling fact to the student of Ottonian manuscript illumination that while we are for the most part more interested in the insides of these books, the Ottonians themselves were more interested in the outsides, i.e. the precious bindings. One is about as likely to see comments on manuscript illumination in the Ottonian period itself as one is to see critical appreciations of the design of dust-wrappers in modern book reviews. Bernhard Bischoff has compiled an edition of German treasure lists in the early Middle Ages, lists drawn up to commemorate the munificence of a benefactor to a cathedral or monastic church, or to record the most valuable possessions of a cathedral entrusted to a new *custos* when he took office. Such lists often mention fine liturgical books, of a kind which would in many instances be splendidly illustrated. I cannot find one mention of the art *inside* these books in the whole of Bischoff's edition, except occasional references to their being written in golden letters.[68] But there are no fewer than two dozen allusions to liturgical books which are bound in gold or silver and, in many cases, studded with gems![69] The magnificent book covers which survive, like those of the Codex Aureus of Echternach at Nürnberg, or of the Gospel Book of Otto III now at Munich, or of the Abbess Theophanu of Essen (a granddaughter of the empress of that name), show that these lists in no way fantasized.[70] In the late tenth-century the abbey of Prüm produced illumination which was pleasing, if not of the highest order by contemporary standards. There is a profusely illustrated Antiphonary, from this abbey, now in the Bibliothèque Nationale, Paris.[71] A treasure list of Prüm, dated 1003, mentions both a troper and an antiphonary, but only to say of each that it had ivories on its covers.[72] In 1127 a *custos* of Bamberg Cathedral drew up a treasure-list. Amidst the gold and fine glass chalices, the silver candelabra, the gold crosses, and the embroidered ecclesiastical vestments, he has no more than this to say about the service books: 'twelve books adorned with gold and gems ... and because the books without gold or silver or ivory committed to me are for the most part not valuable, I have never thought it worth

92

listing them individually'.[73] Amongst the books referred to in this passage, adorned or unadorned with gold and gems, must be several which are now accounted amongst the masterpieces of Ottonian art, and indeed of all book art. C. R. Dodwell has brilliantly shown how the art of the gold-smith was incomparably more valued than that of the book illuminator amongst the Anglo-Saxons though fewer examples of the former have survived, because of their bullion value down the ages.[74] One could not ask for a better indication than these treasure lists of the same feature in Ottonian culture. When the chronicles of bishoprics and abbeys praise the beautification of their churches by former bishops and abbots, they refer to fine bindings of books, to architecture, to wall-painting in that connection, to the building up of libraries with learned books. Never, it seems, do they mention book illumination. That is so of Purchard's poem on Abbot Witigowo of Reichenau, of the Lorsch Chronicle, of Thangmar's *Life* of Bernward of Hildesheim, of the Petershausen Chronicle's praise of Bishop Gebhard of Constance for the 'Venetian' blue which he used to great effect on the walls of that monastery.[75] Reichenau, Lorsch, Hildesheim and Petershausen were all producers or importers of finely illuminated manuscripts.

It is not altogether surprising that the external splendour of gospel books in particular, which had an assumed primacy amongst liturgical texts, should have been so much more highly rated than the illumination within them. Quite apart from the proverbial love of gold amongst the Germanic peoples and its place in their heroic ethic, gospel books were in themselves symbols of Christ and as such they were more often carried closed than open in ecclesiastical ritual. The earliest Roman *ordo* (c. 700), i.e. order of service, makes this clear. When the book is carried in procession at mass before the gospel, the deacon must have ready the place in the book where the gospel is to be read; the subdeacon who is without a censor opens the book at the right place; the deacon, who reads (or chants) the gospel, is then to ascend the ambo with his finger in the place.[76] A later *ordo*, which comes from mid-tenth-century Mainz, prescribes that all should turn towards the gospel book or bow their heads to the cross (two equivalent ways of honouring Christ) during the singing of the *Gloria Laus* on Palm Sunday.[77] When Otto III visited the Italian monastery of Farfa he was received in procession with lighted candles and a gospel book, symbolizing his own Christ-like character as a ruler; the book was proffered to him for his kiss.[78]

Much of the vigour of French art at this time lay in its metalwork, doubtless in gospel books, but according to our evidence above all in its reliquaries. Men and women in the early Middle Ages did not regard the supernatural, whether of the heavenly or the hellish sort, as confined to the stratosphere or the bowels of the earth. The concept of a dividing line between the natural and the supernatural worlds was quite foreign to them. It was as if the world were continually strafed by powerful electricity which constantly ignited, and nowhere did the heavenly electricity more

49

often ignite than where the physical remains of the saints now in heaven were located. It was right, therefore, to encase these remains in the finest reliquaries which human art could afford. The gold and gems of these artefacts have long since ensured that they would in most cases be stripped and melted down. But they feature all over the written sources of the time. The great statue-reliquary of St Faith at Conques, according to Bernard of Angers was only one of many such statues, or *maiestates*, venerated in the South of France.[79] 'Majesty' was the right word. St Faith, sitting grandly in the treasury at Conques to this day, has always been famous for her gold and jewels, her terrifying eyes, and her unyielding posture of an oriental despot. The mere thought of her gave local men nightmares, and the monks of Conques had only to carry her out to a disputed manor, and it was theirs.[80] When St Corentin's relics were taken to Tours but worked no miracles, his monastic custodian addressed him with a disrespect commonly accorded to unresponsive deities in the history of primitive religion. He maintained in particular that the saint was showing his jealousy of other more glamorous reliquaries.[81] Everywhere we look, we encounter not only mentions of precious reliquaries but also the assumption that they were numerous in this culture. Whatever the state of its manuscripts, France was certainly not deficient in the staple metalwork diet of tenth-century art. The Capetian king, Robert the Pious, had plenty of fine reliquaries made; he kept them empty so that those swearing oaths on them could not commit perjury and endanger their souls.[82]

Art in the service of saints' cults is a universal phenomenon of the tenth and eleventh centuries, and is far from unknown in the Ottonian Empire, either in metalwork or in book illumination.[83] But it was of overwhelming importance in France. That is not surprising. If one considers the breakdown of public authority in France, at the same time as it was on the up in Germany, one of its principal features was the domination of many localities by local aristocrats from newly built castles. Count Raymond III of Rouergue, for instance, tried to force his lordship over Conques with such a castle. Against the domination and exactions of castellans, local communities sought to close ranks.[84] Saints' shrines, and the monasteries which owned them, could protect wider interests than just those of the monastery. These shrines could sometimes become almost the principal focus of law and order and an important source of relief for the sick and troubled. They could give judgment about land or personal crimes by the supernatural interventions attributed to the saint, where no impartial earthly justice could be sought; they could give hope that illnesses might be miraculously cured for which no earthly remedy was known; they could scare the castellans through the rituals of anathema centred on these glimmering objects, or if the castellans were too hard-bitten to be scared, they could at least focus and orchestrate the criticism and opposition of the whole community.[85] When there was no powerful king or duke to call upon, and when a bishop or abbot was likely to be merely a scion of a local aristocratic family,[86] recourse to a saint's shrine might seem the only

way. In France of the tenth and early eleventh centuries, spiritual power lay predominantly in the physical remains of dead saints. Of course there were living saints too — King Robert the Pious, Odo of Cluny, Gauzlin of Fleury — whose hagiographers presented them more as exemplars of virtue than as sources of miraculous power. But such men, important and influential as they were, could not cover the whole ground the whole time; and spiritual power was much more evenly distributed between living and dead saints in the empire than it was in France. In France, where dead saints and their shrines were concerned, it was not too much to lavish the richest materials and the best craftsmanship on objects which were symbols of resistance, and shapers of communal identity, in a tumultuous political world.

In the tenth- and early eleventh-century West, therefore, finely illustrated books should be regarded, not like metalwork as an ordinary function of art, but as a bonus. The demand for metalwork was endless. In the liturgy it involved processional crosses, candlesticks, hanging *coronae* for candles, chalices, thuribles,[87] altar fronts, and, as we have said, reliquaries and book covers. In the secular world it involved jewellery, and the ornamentation of fine military weapons like the Ottonian sword which (remarkably) survives in the Minster Treasury of Essen.[88] It is small wonder that churchmen delighted to display golden artefacts when their secular relations took such pride in theirs. Thietmar of Merseburg's grandfather evidently glowed with pleasure when he disported the collar of gold given to him as a present by Otto I, 'to the joy of his friends and the sadness of his enemies', for placating the Emperor when the latter was angered by Archbishop Adalbert of Magdeburg.[89] The demand for sumptuous books was more rarified. We do not need to explain their absence when they are absent, so much as their presence when they are present.

Without seeking to pre-empt much of the remainder of this book by giving a single over-arching explanation of their presence at once, we may make a suggestion at this point. Karl Leyser has acutely observed, in describing the rise of the sacral kingship of the Ottonians that, while Henry I and Otto I, and Athelstan of England also, collected relics with avidity as a sign that they were endowed with divine favour, Hugh the Great in the Ile de France and Rudolf of Burgundy appeared to let them go to these ardent collectors with an easy mind. He says: 'It seems as if the expanding and aggressive aristocratic societies round the Liudolfings and Alfred's successors were more interested and influenced by these imported cults than the princes of Francia, fighting their long wars of attrition with the last Carolingians.'[90] Now almost every illustrated book of any importance in this period, whether in the Ottonian Empire or in England, was either intended for a royal court or for a church or churchman closely associated with royal rule. It looks as if the laws governing the rise of scriptoria as great artistic centres, are related or analogous to those governing the movement of relics at kingly and princely level.

It should certainly not be supposed that the difference between France

22. Reliquary of St Faith. Conques, C10

51

and the Empire in manuscript production can be accounted for by a disparity of available material resources. It is true that without huge wealth an important centre of book art was an impossibility. But it does not at all follow from this that every rich centre produced sumptuous books of high art. In Germany, Magdeburg seems to have imported all its illustrated manuscripts. Henry II got almost every existing artistic centre in the empire working to produce a worthy collection of great liturgical manuscripts for his newly founded bishopric at Bamberg (1007),[91] for which, despite its enormous wealth, nothing has been claimed as its own creation other than one or two manuscripts of inferior quality.[92] At Fleury in France, where Andrew's *Life of Abbot Gauzlin* (1004-30) provides us with marvellous evidence for the landed and artistic endowment of a great monastery, on friendly terms with King Robert the Pious, we are treated to an extraordinary spectacle of conspicuous wealth. Again and again, the sums which Gauzlin paid in gold and silver to secure lands and churches are paraded before the eyes of the gasping reader. And the mind boggles, in so far as minds attuned to the treasure lists of that age can still boggle, at the presents which Gauzlin received and the acquisitions he made of golden and jewelled altar frontals, gilded thuribles, albs stitched with gold, candelabra, reliquaries, Spanish copper plaques, and, of course, richly covered books.[93] Nor can the resources to illustrate books with figural art, in particular, have been lacking to Gauzlin. For he appears to have had no difficulty in finding a painter, Odelric, from nearby Tours, to execute a large scheme of wall-paintings, with scenes from the Apocalypse and the Life of St Peter, in St Peter's church at Fleury.[94] Carolingian illustrated Apocalypses were certainly available in French libraries to serve as models;[95] and for the Life of St Peter, Gauzlin may have had an illustrated copy of Arator's *History of the Apostles* — Bede earlier mentions such an Italian manuscript.[96] Yet Fleury produced nothing of manuscript art which matches the work of the great Ottonian centres. One example of its work

23. Initial F. Troper of
St Martial, Limoges, late C10.
Paris, BN, MS lat. 1121, f. 24v

in this medium before the mid-eleventh century, and the only eleventh-century French manuscript known to have been made at royal command, is a gospel book which Porcher characterized as being in a pure Lombard style, reminding one that Gauzlin himself had acquired a painter called Nivard from Lombardy who made a crucifix for him.[97] The Italian influence, however, did not apparently stimulate fruitful indigenous development at Fleury, as it had done in the Court School of Charlemagne and as it did at Reichenau in the Ottonian period.[98] Not exiguous resources, therefore, but a difference of interest, must explain the lack of any manuscript art at Fleury comparable to that of the great Ottonian centres.

We must not become too absorbed in the now largely disappeared artefacts of the French goldsmiths' ateliers, and miss the particular glory of French manuscripts contemporary with the Ottonians, their initial letters. The West Frankish kingdom was as much cultural heir to the Carolingians as the East Frankish. The best French initial ornament of the Ottonian period, however, is less insular than the Ottonian and more zoomorphic,[99] in an indigenous tradition exemplified by the eighth-century Gelasian Sacramentary and the Gellone Sacramentary.[100] Splendid representatives of the tradition are the lion forming an F in a late tenth-century 23 troper of St Martial, of Limoges, and the winged peacock-dragon with a deer in its claws and a fish in its beak, forming a C in a lectionary of the 24 same monastery.[101] When human figures appear in French manuscripts of this time, sometimes in or to the side of initials, they tend, even if lively, to be in crude versions of Carolingian provincial style.[102] The late tenth-century Limoges *Tonarius*, whose personifications of the eight musical modes, a subject so subtly represented on the stone capitals of Cluny a century and a half later, are however related more to Mozarabic and Catalan manuscripts, have brought forth words such as 'clumsy' and 'primitive'.[103] Except for a few northern centres heavily influenced by Anglo-Saxon art, one has to wait for the mid-eleventh century before human figural art begins to pick up in France.[104]

24. Initial C. Lectionary of St Martial,
Limoges, late C10. Paris, BN,
MS lat. 5301, f. 90

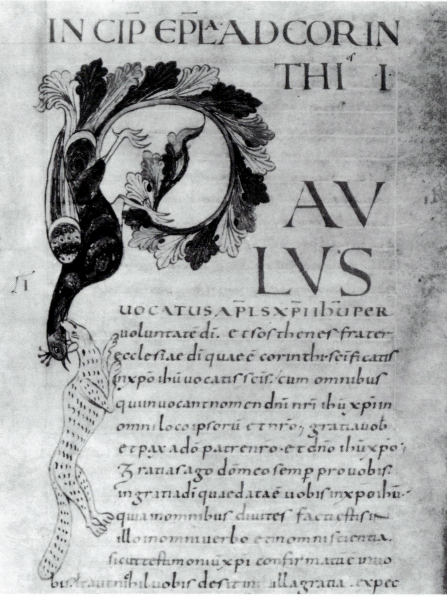

25. Initial P. First Bible of
St Martial, Limoges, *c.* 1000.
Paris, BN, MS lat. 5, vol. 2, f. 194v

Perhaps the finest French manuscript of our period is the late tenth-century 'First Bible' of St Martial of Limoges. Drawn up in two massive volumes, it anticipates the eleventh-century giant Bibles by its very fidelity to the principles of Bible production in Carolingian Tours.[105] It is rather noteworthy, therefore, that it uses none of the narrative miniatures from the Tours Bibles;[106] its art lies in the canon tables and the series of initial letters for the openings of the biblical books. The letters are formed with a remarkable repertoire of palmettes, fans, peacocks, dragons, dogs, snakes, etc. in colour tones of green, red, yellow, ochre, dark and turquoise blue. The animal letters are formed with a sometimes crazy inventiveness, as with the P for I Corinthians where a peacock joins heads with a dog,

25

54

while its tail is all fashioned from palmettes. The flowing lines of the foliage ornament are sometimes worked up into lovely rhythms. When one contemplates the accomplishment of these initials and the inheritance of the Carolingian scriptoria and their discipline in this book, it is hard to believe that the artistic capacity to produce good figural art was lacking. But what mattered to the artists at Limoges, and at other centres like Narbonne and Clermont-Ferrand,[107] was the art of the letter and the word. *26* This was the bedrock of tenth-century manuscript illumination and the French for the most part rested on it. French artists might well have been surprised could they have heard us opine that their lack of human figural art was a positive impoverishment, which they perhaps regarded as an optional, and not necessarily desirable, extra. Why the Ottonians came to take a different view involves our looking at their Christ-centred kingship.

26. Initial A. Homeliary, *c.* 1000. Clermont-Ferrand, Bibl. Municipale et Universitaire, f. 1

27. Passion Scenes. Codex Egberti, 977-93. Trier, Stadtbibl., MS 24, f. 80v

CHAPTER TWO
Christ-centred Art

W E PASS NOW from the early 970s to some of the high points of Ottonian art in the 980s and 990s. The earliest group of Reichenau manuscripts, the Eburnant or Anno Group (after scribes named in them) are notable for their pages representing evangelists, *Maiestas*, and dedications, but their figural art does not yet run to New Testament scenes. We refer principally to the Gero Codex, the Petershausen Sacramentary (Heidelberg) and the Hornbach Sacramentary (Solothurn). Only when we come to the next group, the Ruodpreht Group, in which the characteristic bulbous tendrils with arrow-head finials are developed in the initial ornament do we encounter a figural art which includes scenes of the Life of Christ. This group includes the Egbert Psalter, now at Cividale del Friuli, in which Ruodpreht (or Ruodprecht) is seen presenting the book to Archbishop Egbert, and the Poussay Pericopes Book in Paris, while closely related to it is the Codex Egberti in Trier. The period of this group, therefore, is roughly the archiepiscopate of Egbert of Trier (977-93), or Otto II's reign and the minority of Otto III. The Egbert Psalter lacks New Testament illustrations, but the Poussay manuscript has a small cycle: Nativity, Epiphany, Crucifixion, Foot washing of Peter, Two Women at the Tomb for Easter, Ascension, and Pentecost. Haseloff showed — and the demonstration has been universally accepted — that the artist of the early illustrations in the Egbert Psalter was the same person as that of the *Poussay* cycle. Not only the figural style, but also the frames of the full-page miniatures, are astonishingly close to each other in the two manuscripts. Haseloff further argued, especially from the Foot washings, that *Poussay* was related, in terms of the model or models which it was using, to the much larger Christ cycle (of over fifty scenes) in the Codex Egberti. In other words, the Egbert Psalter was related to *Poussay* by style, the Codex Egberti by iconography.[1] On these grounds the three manuscripts hang together. The Codex Egberti, with its atmospheric backgrounds and its fine handling of late antique interiors and human figures, was given to the archbishop by Reichenau. The Codex Egberti carries us on to the full tide of Reichenau art in the Liuthar Group, beginning with the Aachen Gospels (*c.* 996). But before we consider the Christ cycles in the manuscripts of this group, we must look at the political ideology behind them.

HOC AUGUSTE LIBRO

TIBI COR DS INDUAT OTTO

QUEM DE LIUTHARIO . TE

SUSCEPISSE MEMENTO

28. Liuthar presenting his Gospel Book to the Emperor Otto III.
Aachen Gospels, *c.* 996. Aachen Cathedral Treasury, f. 15v

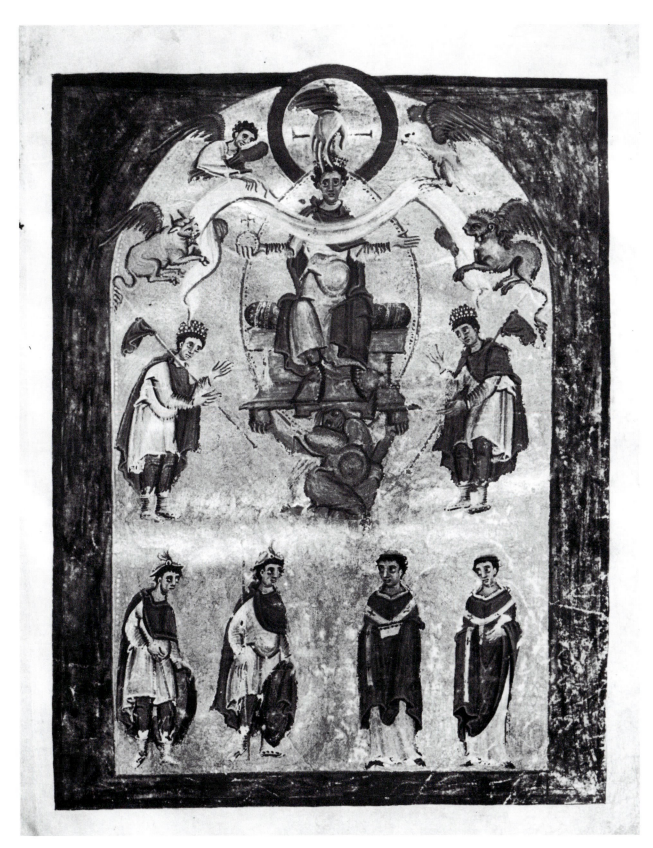

29. The Emperor Otto III seated in Majesty.
Aachen Gospels, *c.* 996. Aachen Cathedral Treasury, f. 16

1 Christ-centred Kingship

As a result largely of the publication of Ernst Kantorowicz's book, *The King's Two Bodies* in 1958, the idea that Christ-centred rule developed in the West during the tenth century has become a commonplace. The ideal of Carolingian kingship had been based on Old Testament kings. They were anointed as were the kings of Israel; Charlemagne was 'the new David'; Smaragdus of Verdun's treatise on kingship, his *Via Regia*, illustrated each kingly virtue with a chain of examples from the Old Testament. Prudence, for instance, was shown by David in his doing prudently what had been committed to him by Saul; simplicity in the saying that Job was a simple man; patience in Solomon's aphorism that a prince is made mellow by patience.[2]

The Saxon emperors of the tenth century, exercised by the canonisation of power already achieved, did not dispense with this Old Testament basis, but they heightened their ideology of rule with the notion of Christ's kingship as well. Kantorowicz exemplified his idea with an iconographic exposition of the 'ruler portrait' in the Aachen Gospels,[3] which should probably be dated to around the time of Otto III's imperial coronation of 996.[4] The whole image is like a *Maiestas* of Christ, and such a glorification of the emperor far surpasses anything customary in eastern or western art. The emperor's 'two bodies' are his humanity by nature and his divinity by grace; his divinity is signalized by the hand of God which places a crown on his head, and by his position of great height (*ad coelum erectus*). The veil, held over his chest by the symbols of the four evangelists, is an allegory of the separation of earth (a personification of which strains to hold up his throne) and heaven, just as Bede gave the same significance to the veil of the Temple which divided the Holy of Holies, or Tabernacle, from the rest of the Temple; above the veil are the emperor's head, breast, shoulders and brachial joints, the parts of his body anointed with holy oil at his royal coronation; below the veil the trunk and limbs are those of an ordinary man. Kantorowicz cited Augustine's well known commentary on the Psalms to explain this: 'Oh Christ, who sittest in heaven on the right side of the Father, but art with thy feet and limbs struggling on earth'. 'The head means the godhead of Christ', wrote Cyril of Jerusalem, 'the feet his manhood.'

On the opposite page to the emperor portrait, as the book lies open, the monk Liuthar is seen in a quatrefoil approaching the emperor to present him with the book. It is after this Liuthar that the great manuscripts of Reichenau from the last years of the tenth century and the early years of the eleventh have been given their name as a group.[5] On purple strips, written in golden letters above and below Liuthar are the words: 'May God clothe your heart with this book, august Otto, and remember that you received it from Liuthar.' For all his exaltation, the emperor is here given a lesson in humility.[6] Some scholars would use this sermon of the scribe to put a damper on the exhilarating elaborations of Kantorowicz's

iconography. It offers a simple explanation of the emperor portrait: the four evangelist symbols clothe the emperor's heart with their book by holding it in the form of a veil (intended to look like a scroll), precisely over his heart.[7] Even for those who would stop there — and the present writer is not amongst them — this emperor page, taking the place of the Christ *Maiestas*, remains an extraordinary depiction of the Christ-image of rule.

Since Kantorowicz wrote, the interweaving of Christ and ruler images in the tenth century has been given a new depth in our understanding by the researches of Robert Deshman, while Karl Leyser has set the phenomenon of Ottonian sacral kingship within the political and social structures of the East Frankish kingdom as a whole.[8] Indeed the ground bass of this chapter and the next is Leyser's theme that sacral kingship, in all its richness and slow maturing, answered a much more deep-felt need in Ottonian culture than could have been met only by the anointing, and the anointed character, of kings.[9] It was a much more pervasive feature of the whole culture. Its fabric was composed of relic collection and church building, of public gestures and of ritual such as the celebrations of Palm Sunday at Magdeburg, and of miraculous visions such as that of Otto I which caused him to appoint Gunther Bishop of Regensburg in 940, of *vitae* composed about saintly members of the royal blood. It was 'a sacral procession from holy day to holy day, from one church dedication to another'. The preaching of bishops, the king's own ancestry, ancient Rome, all played a part in it.[10]

The development of Christ-centred kingship in the West certainly took place partly under the influence of Byzantine ideas, however much the background of western monastic religion made them the easier to digest. Otto III, whose mother was the Byzantine princess Theophanu, came to style himself in his diplomas *Servus Jesu Christi*, the servant of Jesus Christ.[11] The same association of imperial rule with Christ's world-rule is already found on a gold coin of the Byzantine Emperor Justinian II from the 690s. On the obverse is Christ as the king of kings (*rex regnantium*); on the reverse is the emperor as *servus Christi*.[12] Two sides of the same coin. Similarly, in the tenth century, the throne room of the imperial palace at Constantinople had an icon of Christ immediately above the emperor's throne, 'a visual symbol of the relation between the emperor and Christ'.[13] It may be, as Messerer has argued, that the stance of Otto III as he is represented on his first imperial seal of 996-97, so reminiscent of the standing Christ of the Basel Altar (*c.* 1020), is ultimately derived from a Byzantine model.[14] The emperor page of the Aachen Gospels itself is admittedly not all attributable to Byzantine influence. It owes much to Carolingian art of the West. Indeed its artist must have seen the Vivian Bible (846-51) of Charles the Bald (Paris, BN, lat. 1) and could have known the Codex Aureus (870) (Munich, Clm. 14000) of that ruler as well. The high placing of the ruler on the page, with the hand of God above him, is a feature of the dedication page of the Vivian Bible, as is the holding of a veil by

34

30

61

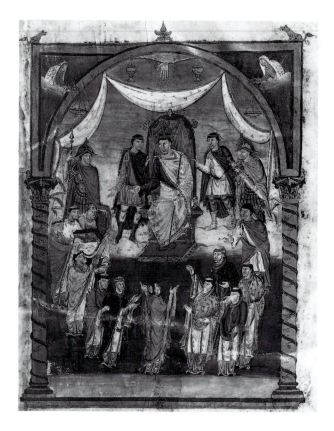

30. Presentation of Bible to Charles the Bald.
Vivian Bible, Tours, *c.* 846.
Paris, BN, MS lat. 1, f. 423

evangelical symbols of the Apocalypse pages of this and other Tours
Bibles. In this latter case they *un*veil the face of the seated Moses, symbo-
lizing how the Evangelists in the New Testament reveal the true meaning
of the Old Testament.[15] The two *subreguli*, or sub-kings, with their postures
of obeisance, seem to be a reminiscence of the personifications of *Francia*
and *Gotia*, the two main regions ruled by Charles the Bald, in the Codex
Aureus.[16] But Kantorowicz, who recognized much of this, also himself
pointed out Byzantine parallels, crowning of rulers by the hand of Christ,
and the like. He might also have mentioned the remarkable ceremonies
by which the Emperor Constantine Porphyrogenitus is said to have re-
ceived ambassadors, as recounted by Liudprand of Cremona on his visit
to Constantinople in 949. When Liudprand was received, he prostrated
himself before the emperor while the latter's throne was at ground level.
When after an interval he tentatively raised his head, the emperor's throne
had been raised in a kind of physical apotheosis to the ceiling (as if *ad
coelum erectus*), while ornamental lions on either side of it began to emit
roaring noises and beat their tails.[17]

There is obviously no difficulty in explaining the advance of Byzantine
political concepts in the West from the marriage of Theophanu to Otto II
(972) onwards. But too much can be made of this as a *terminus a quo* of

62

Byzantine influence. Several churches had Greek contacts, some of them through Rome or South Italy, before Theophanu's arrival or independently of it.[18] Most arresting, in the days (it seems) before Bruno, brother of Otto I, became Archbishop of Cologne (953), he used to run court seminars at which philosophical matters were discussed. The king himself sometimes attended them. So did 'Greeks'. They were amazed at Bruno's knowledge — Ruotger's *Life of Bruno* makes them sound rather patronizing — and carried home wondering reports of it.[19] Here is an important-looking forum of discussion between Greeks and Latins in the mid-tenth century, and it was surely not the only one (cf., for instance Reichenau, pp. 143-44).

Beyond the Byzantine Empire, we have to look back to the whole deified conception of the late antique emperor. Sabina MacCormack has recently written a book about this subject entitled *Art and Ceremony in Late Antiquity*. The idea that art and ceremony are two sides of the same coin represents an important continuity between late antiquity and the early Middle Ages. For instance, the distribution of *largesse* (*largitio*) was a ritual gesture of imperial generosity, praised in panegyrics and provided for by fine *largitio* bowls of silver. In the decoration of the fourth-century *largitio* bowl of Constantius II, the emperor, on horseback, is shown as a sacred image, dissociated from other figures by his greater physical stature and his frontality, as Otto III is in the Aachen Gospels. Ammianus Marcellinus wrote of an emperor in procession; he was untouched by his surroundings, never turning his head to see the multitude, and deaf to the acclamatory shouts which greeted him. Constantius II is shown, also, with his immediate following, as later Christ would be shown between angels and saints, and emperors with their entourage.[20]

31. Unveiling of Moses and Evangelist symbols. Grandval-Moutier Bible, Tours, *c.* 840. London, BL, Add. MS 10546, f. 449

The character of Christ-centred kingship is ceremonial, or liturgical, or ritualistic, a fact more implicit than explicit in Kantorowicz's book. It may be true that the Carolingian concept of a David-like kingship was theocentric whereas the Ottonian idea was Christocentric, but that was not the only difference. Old Testament kings were also real rulers. They could be treated as practical exemplars of kingly actions and virtues. Even some Old Testament figures who were not kings could nonetheless contribute to a model of kingship. Moses had not been a king, as David or Solomon or Josiah had, but he had performed the kingly function of giving laws. Christ, on the other hand, who had not ruled in any worldly sense, could serve only for a purely liturgical projection of kingship. He could heighten the ideology of kingship, he could enlarge the religious and moral perspectives in which the actions of rulers were viewed (an effect certainly not devoid of practical consequences), but he could not by direct example enrich the repertoire of moral and practical *kingly* action as the Old Testament kings could do. Indeed, for kings whose rule needed to be stern, Christ's example of meekness and self-humiliation, valiantly as the Ottonians tried to take it on board, could pose grave dangers.

The tenth and early eleventh centuries were a profoundly liturgical age. Liturgy is central to Christianity, and all Christian ages have been in a measure liturgical, but when we contemplate the considerable theological thinkers of the ninth century such as Pascasius Radbertus and Ratramnus of Corbie, Gottschalk, Eriugena, and Remigius of Auxerre, and observe how difficult it is to match them in the Ottonian period (probably only Rathier of Verona and Abbo of Fleury could be so much as half mentioned in the same breath), we can only suppose that there had been a significant shift of intellectual and spiritual energy from theology to liturgy. The shift was not nearly total, of course. The Carolingians had been absorbed with liturgy, and, as we shall see, there is more theological interest in the Ottonian period than at first meets the eye. But the great scholar Beryl Smalley noted the change of emphasis, and wrote of how creative energy in the later period went into liturgical poetry and drama, and of how Cluniac abbots in their sermons and meditations concentrated on the dramatic and emotional aspects of the Scriptures.[21] In such an age and society we look to art, in conjunction with ceremony, not as an ancillary extra to the literary sources, not as a form of aesthetic buttress to what other sources tell us more directly and effectively about that society, but as a primary mode of expression in its own right. Robin Cormack writes of Byzantine art that it should be seen not just as another source of information somehow on a parallel with literature, but as a means of opening up levels of understanding inaccessible from the study of written texts.[22] The same very much applies to Ottonian art, and never more emphatically than in the emperor page of the Aachen Gospels. A member of a lecture audience once remarked to the present writer that this page was remarkable in the Christ-position which it gave to the emperor and asked whether there was not 'a text for it'. It is surely its own 'text'. But in so far as something outside

ΑΝΔΡΕϹΓΑΛΙΛΑΙΟΙ
ΤΙΕϹΤΗΚΑΤΕΒΛΕΠΟΝ
ΤΕϹΕΙϹΤΟΝΟΥΡΑΝΟΝ

32. Ascension of Christ. Byzantine ivory, C10.
Florence, Museo Nazionale del Bargello

itself helps to explain it, it is not primarily written evidence, but the
evidence of a ceremony. Otto III, aged sixteen, was crowned emperor at
Rome in 996 — on Ascension Day.[23] As Kahsnitz has recently pointed out
in another context, there was a Byzantine iconographic tradition of the
seated Christ ascending to heaven in a mandorla, and it was probably
known at Reichenau.[24] But — and this is the measure of how art and
ceremony were intertwined — perhaps it is rather the Aachen page and
its political theology which help to explain the choice of Ascension Day
for the coronation than the other way around. In the tenth century, kings
even chose liturgically suitable days for battles, if their enemies gave them
any choice.[25]

32

Thietmar of Merseburg gives a classic example of Christ-centred rule
as ceremonial when he describes the coronation of Henry II as emperor
at Rome in 1014. As the imperial procession, making its way from Monte
Mario to St Peter's, reached the Via Cornelia, Henry was surrounded by
twelve senators carrying their staffs of office, six of them clean shaven and
six with beards, 'mystically' (*mistice*) as Thietmar says. What Thietmar
means by the word 'mystically' is that the imagery of the procession now
became that of Christ surrounded by his apostles.[26] It was in fact an old
custom of art, when Christ was shown in majesty with the apostles, to
represent some of the latter as bearded and others not.[27] Perhaps it derived
from late antique representations of the emperor with his courtiers, some
of whom would be bearded and others eunuchs who were clean-shaven.[28]

65

33. Louis the Pious.
De Laudibus Sanctae Crucis
of Hrabanus Maurus.
Vatican, Bibl. Apost.,
MS Reg. Lat. 124, f. 4v

Let us observe Henry II, from the art of his time and indeed of his patronage, in two liturgical postures. One is his appearance in the great Regensburg Sacramentary (1002-14) (Munich, Clm. 4456), being crowned by the hand of Christ, invested with sword and lance by the hands of angels, and supported under his elbows as he raises his arms in prayer by Saints Emmeram of Regensburg and Udalric of Augsburg. It is a sign that Old Testament ideals of kingship had by no means been pushed out in favour of New Testament conceptions, that the saints perform here the role of Aaron and Hur when they raised in prayer the arms of Moses. This manuscript is a mixture of Byzantine and Carolingian stylistic elements; Byzantine, for instance, in its facial modelling, and Carolingian (after the Court School of Charles the Bald) in its rich foliage borders.[29] The ruler standing between two sainted bishops, like a priest between deacons, was a motif used for Charles the Bald.[30] Here it comes in heightened form. The ruler's prayer to God, public and private, was one of his most vital functions. One could not have a better illustration than this Regensburg Sacramentary of the words of Sabina MacCormack on, 'the quasi-liturgical drama by which late antique men sought to articulate the modes of contact between the emperor, his subjects, and his invisible but ever present companion, God'.[31] The other liturgical posture is his appearance, together with the Empress Kunigunde, on the golden altar frontal of Basel (now in the Musée de Cluny, Paris). He is a tiny figure, crouched in adoration at the feet of Christ. The emperor's power in the world was a reflection of the universal power of God; thus in God's actual presence he humbled himself in an act of worship. Just so a mosaic in the narthex of Hagia Sophia at Constantinople shows the Byzantine emperor Leo VI (886-912).[32] This is where the emperor, candle in hand, would prostrate himself in the act of *proskynesis* before entering the church.

34. Henry II and Kunigunde at the Feet of Christ. Basel Altar Frontal, *c.* 1020. Paris, Musée de Cluny

35. Crowning of Henry II by Christ. Sacramentary of Henry II,
Regensburg, 1002-14. Munich, Bayerische Staatsbibl., Clm. 4456, f. 11

Before Ottonian times, the idea of representing a ruler as a type of Christ had already sprouted under the Carolingians, and is seen in the arresting

33 image of the emperor Louis the Pious, standing like the victorious Christ in one of the frontispiece pages of Hrabanus Maurus's *De Laudibus Sancte Crucis*, a manuscript dating from the early 830s. Behind this, 'the first preserved portrait of a Carolingian emperor in manuscript illumination', lies a long tradition of Christ-representations, including a sixth-century mosaic in the archiepiscopal palace of Ravenna, and Christ holding the victory standard and trampling on the beasts (as mentioned in Psalm 90) in the Stuttgart Psalter (*c.* 830) and on an ivory of the Court School of Charlemagne now in the Bodleian Library at Oxford. Louis's dress is not so obviously armour as is that of Christ at Ravenna, for instance, but besides the victory standard of the cross in his right hand, he holds a shield in the left. The Christ character of the king is pointed up in a way which would not be repeated in surviving Carolingian art, for a yellow nimbus around the ruler's head picks out the following letters in four words from the *carmen figuratum* which covers the whole page: TU HLUDOVICUM CHRISTE CORONA, meaning, 'Thou, O Christ, crown Louis'. The Ottonian Aachen Gospels, however, denotes a great heightening of Christ-centred ideology as against the Carolingian portrait of Louis the Pious. The distinction has been well expressed by Hagen Keller when he says that Carolingian rulers remain in this life, while Otto III in the Aachen Gospels has been removed to the supernatural sphere; the dedication scene in the earlier Vivian Bible, with the handing over of the book, is reminiscent of an actual court scene, whereas in the Aachen Gospels the ruler is removed from all contact with Liuthar as he presents his handiwork. Otto III, if anyone, is a sacred figure, dissociated from others and untouched by his surroundings.[33]

2 Cycles of the Life of Christ

The idea that the ruler was an image of Christ and derived a new mystique from this image could scarcely have been convincing or effective, even to its propagators, if it had had no religious capital (so to speak) on which to draw; if political ideology and religious sense had not been part and parcel of each other. Perhaps religion may sometimes be used cynically to bolster political ideology, but it is not easy to dispose in this way of religious notions so closely integrated with political notions in their very conception as they had come to be by the reigns of Otto III and Henry II. In other words, one cannot understand why the ideal of Christ-centred kingship should have had emotive power unless one looks at the place of Christ in Ottonian art and religion. The Ottonian gospel books, and books of gospel pericopes, deployed the previously existing iconography of Christ with such creativity, that the whole subject had obviously become charged with new significance. In the Christ who moves with majesty and drama through their pages, we can see the laying of reinforced concrete foundations of Christ-centred kingship, so to speak, the more so as this was assuredly not the conscious aim of the artists.

After the emperor pages in the Aachen Gospels, there are, besides a rich art of canon tables, evangelist portraits and initial letters, twenty-one full-page illustrations of the Life of Christ (or in one case, of one of his parables, Dives and Lazarus). Each is placed at its appropriate position in the text of the gospels.[34] Each scene, also, is set against a golden background, the first surviving Ottonian Christ-cycle so to be set, though the Gregory Master had earlier (probably 984) used golden backgrounds for the *Maiestas* and evangelists in the Ste Chapelle Gospels.[35] The illustrations are not arranged chronologically across the four gospels; the infancy scenes appear not with the first gospel but with Luke's. Chronological order would come only with the Gospel Book of Otto III in Munich (Clm. 4453) — these artists were ever inventive in their handling of whole schemes of illustration as well as individual pages. But late antique as their models must be in many cases, the Aachen illustrations depart radically from the horizontal format, which was normal in late antique Christ cycles, and which the Gregory Master and his fellows largely observed in the Codex Egberti. Each of the Aachen scenes is set under a tall arch, and each is of striking verticality, as if to mark a transition from a narrative art, which flows *along*, to an art of greater stillness and hieraticism, which tends upwards. In Jesus and the Sons of Zebedee, i.e. the scene in which the *Col.Pl. IX* mother of James and John asked Jesus that they should have the first place in the kingdom of heaven (Matthew, 20:20-28), mother and sons stand on the left, on the right is a steep file of apostles, and high in the centre, as if judge and master, stands Jesus. The two sons below their mother and the lower apostles look across the picture at its base, but the mother's gaze, which Jesus returns, and the glances of the apostles placed furthest back, are drawn upwards towards Jesus. Thus the pyramid effect already in the composition, is enhanced by the exchanges of glance. In other words, the scene is shaped by a psychological as well as by a vertical compression. Above Jesus, on either side in the curve of the arch-frame, two towns (doubtless Capernaum and Bethsaida) 'seem to float in front of the gold ground' (Grimme). They are the beginning of 'baldacchino sculpture' in Ottonian art.[36] Visually they pull the already elongated figure of Christ upwards. The whole area within the frame is integrated and rhythmical.

An even more impressive page is the Healing of the Possessed Boy *36* (Mark, 9:17-29). The urgent glance and gesture of Jesus as he passes by, the swirl of his over-garment, and the slight, recoiling curve of his body, all imply the immediacy with which his miraculous power is activated. Opposite Jesus, while the mother pleads with him, the stricken father supports his convulsive son. The son himself is drawn at a disturbing angle to the other figures on the page, with swollen neck, distended stomach, and bony thighs, and with one shoe on and the other off.[37] It is tempting to wonder whether, centuries later, Rubens, whose travels could easily have taken him to Aachen, and who had a kindred sense of movement and drama, might have seen this page before he painted the Miracle of St Ignatius of Loyola.[38] Grimme has written: 'this page knows no calm

36. Healing of the Possessed Boy. Aachen Gospels, *c.* 996.
Aachen Cathedral Treasury, p.197

place, it sets stillness against movement, and grandeur against demonic terror',[39] while Boeckler has called the group with the boy in it, 'one of the most magnificent dramatic groups in medieval painting'.[40]

It is in the Gospel Book of Otto III, that the new Ottonian creativity is seen at its best, for example in the page depicting the Footwashing of Peter at the Last Supper. *Col.Pl. X*

The scholarly work on the iconography of the Footwashing is not entirely easy to use. Gertrud Schiller's monumental work of reference on Christian iconography is rather too blunt an instrument for my present purpose,[41] whereas, Hildegard Giess's monograph on the subject is rather too fine an instrument. The latter's breaking down of the subject into no fewer than fifty-three categories poses problems for the non-Footwashing specialist who seeks to generalize![42] I propose three broad categories: that in which the preliminary argument about whether Peter should have his feet washed at all is very much in full swing, the *Gesprächstypus* as German scholars call it; that in which Christ already addresses himself to the foot basin, but Peter is still making a deprecatory gesture; and that in which Peter is having his feet wiped after washing and points to his head ('Lord not my feet only, but also my hands and my head'). All Footwashings of the early Middle Ages fit more or less into one or other of these three *37,38* categories, the third being in this period pre-eminently Byzantine and only beginning occasionally to influence the West.[43] The Gospel Book of Otto III has a *Gesprächstypus*, an argument still in progress. Its stylistic origins are late antique; it comes very close to a sixth-century illustrated Iliad showing Homeric scholars in disputation, with the same rolling eyes and exaggeratedly bony fingers.[44] Its iconographic origins are also late antique and undoubtedly western. Schnitzler has shown its relationship to the

40 scene as depicted on fourth-century sarcophagi at Rome, Nimes and Arles.

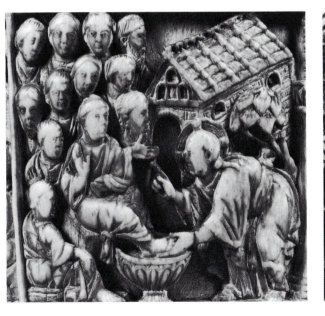

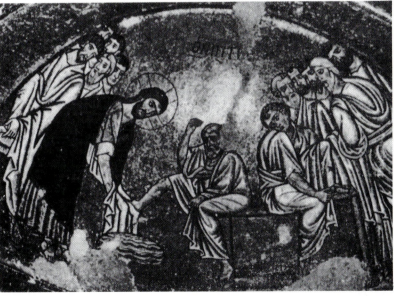

37. Footwashing of St Peter.
Basilevsky *situla*, Ivory, *c.* 980.
London, Victoria and Albert Museum

38. Footwashing of St Peter. 71
Mosaic, C11. Hosios Lukas, Greece

39. Footwashing of St Peter. Sedulius, Carmen Pascale, C9. Antwerp, Plantin-Moretus Museum, MS M.17.4, f. 32

But there are important differences between the late antique and the Ottonian representations. On the sarcophagi, Peter figures as the equal of Christ, stretching out his left hand in a lordly gesture, while Christ has *both* hands on his towel. But in the Ottonian book Christ has become the main figure and he uses his right arm to point at Peter. Schnitzler concluded that somewhere between late antiquity and Ottonian times there was an iconographic missing link.[45]

39 The missing link can in fact be supplied. It is the Footwashing in a ninth-century manuscript of Sedulius's *Carmen Pascale*. This is a very well known manuscript, in the Plantin-Moretus Museum at Antwerp, but as it has been mainly of interest to students of early Anglo-Saxon culture, its importance for Ottonian art has never been appreciated.[46] The *Carmen Pascale*, a famous early Christian poem, was a prime subject for interpretation and illustration with scenes from the Life, Death and Resurrection of Christ.[47] This Footwashing clearly gives us Schnitzler's missing link, in that while the figure of Peter is still (in the antique manner) an equal of Christ's, Christ is now (in the Ottonian manner) engaging in the argument with his right arm. The reason why the manuscript has been of interest to students of early Anglo-Saxon culture is that it appears to have been copied from a manuscript owned by Cuthwine, an early eighth-century bishop of the East Angles, who, Bede tells us, collected books from Italy.[48] So we are probably dealing with a late antique Italian model in the background. It would be pleasant to say that we have here an example of the great

40. Footwashing of St Peter. Sarcophagus, C4. Arles

41. Moses at the Burning Bush.
Bible of Leo Patricius, Byzantine, C10.
Vatican , Bibl. Apost., MS Reg. Gr. 1, f. 155v

circle of cultural influence in the early Middle Ages: from Italy, to the Anglo-Saxons, to the Carolingians, to the Ottonians. Pleasant, but not quite permissible. For who can tell whether the Ottonian books derived their Footwashing from the model of the Antwerp manuscript (perfectly possible since its provenance was St James, Liège, which had a direct link with Aachen under Otto III),[49] or from another (probably Italian) book like it which never had anything to do with the English? But there is virtual proof that Ottonian artists could find in their midst something close to their *Gesprächstypus* in the iconographic repertoire of late antiquity or its Carolingian derivatives.

To stop there, of course, would seem to be the reverse of demonstrating the creativity of the Ottonian artists with regard to the Life of Christ. But one has only to contemplate the sobriety and measured calm of the late antique sarcophagi, and the attempt in a stilted way to reproduce this calm in the Antwerp Footwashing, to see that the Gospel Book of Otto III, and this of all Ottonian books, has transformed the whole subject, by glance and gesture, by the concentrated stare of the groups of disciples hemming in the principal *dramatis personae*, and by the effects of baldacchino architecture and gold ground, into high drama. Moreover, the figure on the right who takes off his sandals to be next in the Footwashing queue, the *Sandallöser* who makes no small contribution to the dramatic intensity and action of the picture, is probably derived from Byzantine models of the period. This would mean not only that the Ottonian Footwashing represented a new deepening of the late antique tradition, but also that it was an astonishingly coherent artistic statement in fact put together from two quite distinct iconographic traditions. For the *Sandallöser* was well known to late antique art in the form of Moses taking off his shoes at the burning bush, and so he appears still in the early tenth-century Byzantine Bible of *41* Leo Patricius now in the Vatican. It is nearly certain that his sideways move into the Footwashing occurred in tenth-century Byzantium.[50]

3 Models of the Cycles

A question which arises about the Ottonian cycles of the Life of Christ is where the models came from. There is no clear evidence on this point. But creative and inventive as the artists were, they could never have developed these large cycles so quickly and magnificently in the 980s and 990s without having extensive models of some kind. In the last century, Vöge answered unhesitatingly that the models were largely late antique and western.[51] Since then many scholars have been inclined to attach much more weight to the middle Byzantine influence (i.e. of the posticonoclastic period beginning in 843), particularly Boeckler, Gernsheim, Cames and Buchtal. Such scholars did not, of course, deny the ultimate derivation from late antique sources, but maintained that these had been mediated to the Ottonians by way of Byzantine works of art. There may seem good general grounds for taking this line. The ninth and tenth centuries were a time when the Byzantines were organizing vast cycles of New Testament illustrations in their lectionaries, or books of readings throughout the liturgical year.[52] Moreover, the earliest surviving Ottonian cycles appear only when comfortably enough time could be allowed for the accumulation of Byzantine influence in the West after the marriage of the Byzantine princess Theophanu to Otto II in 972. Still further, the heightening of liturgy and ceremonial at the Byzantine court is a demonstrable feature of the reigns of Constantine Porphyrogenitus (913-59) and his predecessors.[53] Some part of the same element which we have already noted in Ottonian culture (pp. 61-66) must be due to Byzantine example. This means that Byzantine art could be received in the West within a sympathetic political/cultural context. In recent decades, however, opinion has tended to swing back to Vöge's view. The staunchest advocate of late antique, western models, or rather a single model containing one grand cycle, is Adolf Weis.[54] Our preference also would be for greater emphasis on western derivations, but not to the extent of Weis, since it seems incontrovertible that at least from the Aachen Gospels of *c.* 996 onwards the Reichenau artists (and also those of Cologne and Regensburg) were working with Byzantine as well western models.

We shall see (pp. 80-81) that very large Christ-cycles must have been available to the Carolingians, however diffident they were about using them. These sources could certainly provide one explanation of where the Ottonians got their models from. But perhaps we should also look to Italy. The evidence for Italian art in the early Middle Ages is very patchy, and what survives, particularly in book illustration, often seems very provincial. Moreover, when we reach the late tenth century, as in the Sacramentary of Warmund of Ivrea (Ivrea, Cod. LXXXVI), Italian work is in part already influenced by Carolingian and Ottonian works, so that if we are not careful we treat Italian art as source where it ought to be considered as recipient.[55] There were clearly remarkable wall-paintings in Italy, but the surviving corpus is a tiny fraction of what there must have been.

Nevertheless, after every necessary caution has been made, there does seem to have been what one might call an early medieval Italian artistic canon, as Hans Belting has strongly argued, particularly in matters of figural style, and this was clearly valued, and was found stimulating almost from the start in Ottonian book illumination.[56]

Boeckler showed that Italian stylistic influences were present in the Ruodpreht group of Reichenau manuscripts, i.e. above all in the dedication pages of the Egbert Psalter, which depict Ruodpreht himself.[57] The unusual (in the North) square nimbus which Archbishop Egbert is given both here and in the Codex Egberti had already been shown by Haseloff to be an Italian feature.[58] The Stuttgart Psalter of c. 830, though made probably at St-Germain-des-Prés, is reckoned on strong grounds to have had an immediate Italian precursor, which would be implicit evidence of the existence of a large Italian Christ cycle from c. 800 since this manuscript has so many scenes from the Life of Christ (see p. 80).[59] If the Stuttgart Psalter were taken to represent the Christ/iconographical potentialities of Italian art for the Ottonians, that could explain some features of the Aachen Gospels. For instance, in the Aachen Crucifixion scene, the soldier who *42* wields his cudgel at the legs of one of the crucified robbers from outside the frame, is said by Grimme to occupy this position because the vertical format of the picture allows him insufficient room inside.[60] That may be, but the swinging of various weapons from outside the frame, to give attackers extra momentum against their hapless victims inside it, is a favourite device of the Stuttgart Psalter, whose pictures are very much *43* horizontal in format.[61] In the Aachen Nativity scene one of the shepherds leans on his crook in the way that the 'popular' David does in several scenes of the Stuttgart Psalter.[62] Certain comparisons in the way of modelling the human figure, as between the Stuttgart Psalter and the Codex Egberti, such as the buttocks of Judas in the betrayal scene of both books, should also be noted.

The use of gold grounds, so vital a characteristic of Ottonian manuscripts and first attested in the Ste Chapelle Gospels of the Gregory Master (984) and then about a decade later in the Aachen Gospels, is generally considered to be a direct fruit of Byzantine influence.[63] But it may be that the Lorsch Gospels once again (see pp. 26-32, 47) could have provided the essential, and western, source of inspiration, since the opening of St John's Gospel in this Carolingian book is written in fine capitals of minium red on a background of gold. In addition we should not overlook the Egino *44* Codex (796-99). Egino was a Reichenau monk who had been made Bishop of Verona by Charlemagne. The Codex, now in the Staatsbibliothek of East Berlin, is a book of homilies with author-portraits of Ambrose, Jerome, Augustine and Gregory, on the analogy of the four evangelists. Although these figures have a relation to the evangelist portraits of the Charlemagne Court School, and they sit under rounded arches set in rectangular frames, as do the evangelists of the Godescalc Evangeliary (Charlemagne Court School, 781-83) and those of the Aachen Gospels (c. 996), it is generally

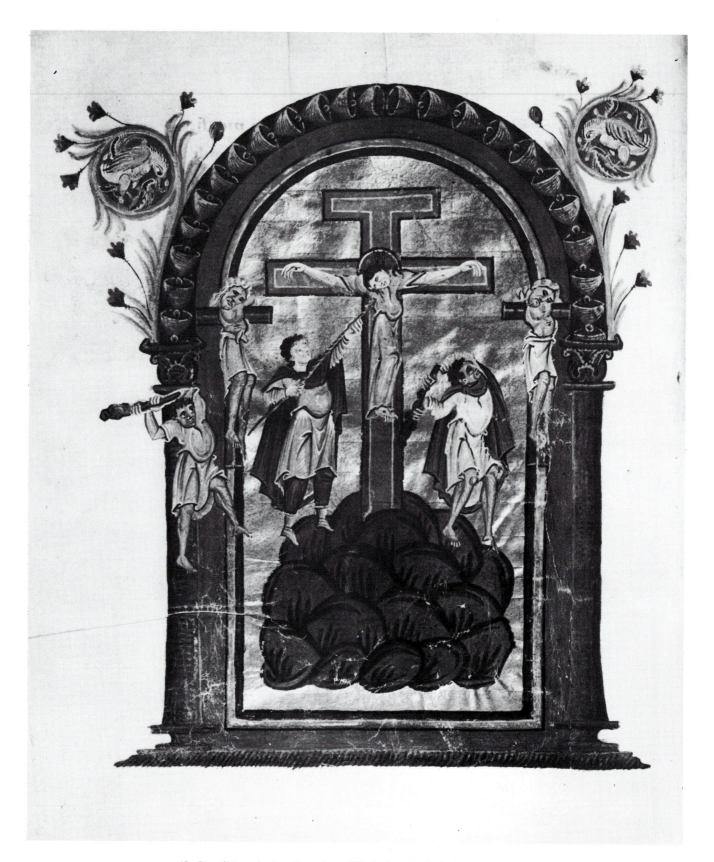

42. Crucifixion. Aachen Gospels, *c.* 996. Aachen Cathedral Treasury, p.468

43. David and Goliath, illustration to Psalm 143. Stuttgart Psalter, *c.* 830. Stuttgart, Württembergische Landesbibl., MS Bibl. Fol. 23, f. 158v

accepted that the Egino Codex is an Italian and not a northern book.[64] And its authors are set against golden backgrounds. This book was probably brought into play in the development of Ottonian art, for it came to Metz in the tenth century, most probably as a present from Bishop Rathier of Verona to Bishop Dietrich of Metz (964-84).[65] Metz was an important centre of the Gorze Reform (see pp. 86-87); it was the domicile of the influential Vivian Bible of Charles the Bald (now in Paris); it was by implication placed amongst the front rank of German churches in a poem written about the 998 journey of Abbot Alawich of Reichenau to Rome (see pp. 154). Dietrich of Metz himself must have had the chance of seeing how eastern arts (as in the gold grounds of Byzantine manuscripts) could be coherently fitted with western art. For though he had not been a royal chaplain himself, he was a nephew of Otto I, and had the delicate task of accompanying Theophanu from Benevento to Rome early in 972 before her wedding to Otto II, and ensuring her a friendly welcome there.

44. Pope Gregory the Great. Homeliary , Verona, *c.* 800. Egino Codex, Berlin (East), Staatsbibl., Phillips MS 1676, f. 25v

Otto II himself was more focused on Italy, both politically and culturally, than his father Otto I had been. Germany and Italy became more integrated in government under him than previously. He had his son Otto III crowned as king jointly by the Archbishops of Mainz and Ravenna; the Italian chancery was drawn more closely into the imperial chapel; and the policy of appointing Ottonian protégés to Italian bishoprics and abbacies was stepped up.[66] The way in which he continued Otto I's *rapprochement* between Italy and northern Europe by the overarching patronage, activity and itinerary of his court is nicely exemplified by the debate between Gerbert of Rheims and Otric, *scholasticus* of Magdeburg about the divisions of learning, which took place under Otto II's presidency at Ravenna in 980.[67] Many Italian books came into the North by various channels in his

time;[68] the *Translatio S. Epiphanii*, for instance, refers to Bishop Otwin of Hildesheim collecting books from Italy.[69] Otto II himself had in general a strong interest in the collection of manuscripts, too strong for the taste of the St Gall monks.[70]

Given that we have no evidence for the use of a cycle of the Life of Christ at Reichenau before the time of Archbishop Egbert of Trier (977-93), and that then we have a very large cycle in the Codex Egberti presumably commissioned by him from Reichenau (since the Gregory Master, his artistic collaborator at Trier, started the ball rolling with its first illustrations), it is worth observing Egbert's place in Otto II's increased integration of Italy into imperial rule. Hubert Schiel has persuasively defended the authenticity of the evidence in the Trier archiepiscopal chronicle that Egbert made a first journey to Italy with Dietrich of Metz collecting relics in the early 970s, which must have put him into the company of Otto I and Otto II there.[71] During 976, still before he was archbishop but as an imperial chaplain, he was functioning equally as chancellor for Germany and for Italy.[72] Later, he was with Otto II in Italy in 983, being present at a sitting of the court in Verona when a trading agreement was made with the Venetians.[73] Dietrich of Metz was also present on that occasion. Egbert's return to the North in 972 would probably have taken him to Reichenau (see p. 141) where he would have established a contact at the period of the Gero Codex and other manuscripts of the Anno Group; his return in 983 could easily have taken him there again.[74]

None of this argues against the use by the Ottonians of cycles of the Life of Christ already present in the North during Carolingian times. It merely suggests that we must reckon with Italy as another possible source, and one where the earlier models could still in their antique forms have provided appropriate inspiration to the Gregory Master, who handled those forms with such skill.[75]

Although we may agree with Weis in his emphasis on western antique models, there is a large question mark over his principal argument that these must all have come in the form of a single late antique pericopes book to Reichenau. To show, however interestingly and painstakingly, that every illustration *could have been* the illustration of a pericope, which is Weis's method,[76] does not exclude its being an illustration in some other form. After all, most passages of the gospels are used for liturgical pericopes. At first sight one of Weis's best arguments appears to be that the *103* parable of the barren fig tree and the healing of the crippled woman are scenes which occupy together one full-page illustration in the Gospel Book of Otto III and also one framed square amongst the illustrations of the sixth-century Italian St Augustine Gospels in Corpus Christi College, Cambridge; and that these two passages together formed the pericope for Ember Saturday in September (Luke, 13:6-17), which was certainly already one of the Roman pericopes at the time of the St Augustine Gospels, since it is treated as a single pericope by Pope Gregory the Great in his Homilies on the Gospels.[77] But it goes badly for Weis's pericopes book argument

that, although the illustration in the St Augustine Gospels may have had a liturgical pericope in mind, this book itself is not a pericopes book but a continuous text of the four gospels (now incomplete), whose illustrations are gathered in a series of little scenes before (in this case) the text of St Luke.[78]

The surviving Mediterranean gospel books, or fragments of gospel books, from the sixth century show us how various were the forms in which antique models could have come to the Carolingians and the Ottonians. Francis Wormald estimated that when the St Augustine Gospels was complete, it must have had at least 72 scenes from the gospels,[79] and though they were small and iconographically rudimentary, such a cycle could easily have formed a basis on which the imaginative Ottonian artists could work. The Sinope pictures, on the other hand, in another continuous text of the gospels, were all incorporated into the foot of the relevant *104* page without frame, rather as the illustrations of the fifth-century Cotton Genesis (London, BL, Cotton Otho B.VI) were incorporated into the relevant place of the Genesis text, this time with frame.[80] The Rossano Gospels had full-page illustrations, gathered (like the much smaller scenes in the St Augustine Gospels) before the relevant gospel — only those for St Matthew survive.[81] The Rabbula Gospels (Florence, Bibl. Laur., Plut. I. 56) has illustrations in the margin of its canon tables.[82] We must reckon with an even greater variety than this, since books other than gospel books could also be important sources of New Testament illustration, such as psalters, and particularly Sedulius's *Carmen Pascale* (see p. 72).

Pericopes books were of course known in the sixth century but no illustrated one survives from so early.[83] The Godescalc Evangeliary (Paris, BN, Nouv. acq. lat. 1203, 781-83), which stands at the beginning of the great books from the Charlemagne Court School, is a pericopes book with decoration, but it has no New Testament illustrations; and this form was in any case abandoned thereafter under Charlemagne in favour of continuous gospel texts. That corresponded with the spirit of Charlemagne's late eighth-century *De Literis Colendis*. Sound learning and the study of the biblical text was here given precedence over its liturgical uses.[84] In the later Carolingian manuscripts, the principal form of the gospel texts are continuous texts, either as gospel books or as part of the Bible. The form of pericopes books with gospel illustrations becomes common in the West, on the surviving evidence, only in the Ottonian period itself. It surely represents the shift from a theological to a liturgical emphasis, from book art as the handmaiden of biblical study to illumination as the enhancement of ceremony in Ottonian society (see pp. 64), and also the promptings which that society received from the new Byzantine lectionaries.[85] When the Ottonians produced their earliest pericopes and gospel cycles, therefore, we must suppose that they had various kinds of model available to them (*least* likely amongst them a full-scale illustrated pericopes book);[86] that the Gregory Master in particular, through his connections with monasteries which had important collections of manuscripts, not to speak of

his Italian connections, could have made a trawl of such various models; and that the artists were persons of sufficient intellectual capacity and artistic gifts not to need everything handed to them on a plate in a single manuscript. Whatever the models, however, they translated the fresh spontaneity and airy atmosphere of late antique narrative style into the hieratic rituals and dramatized rhythms, presented in the colours of the goldsmith and enamel-worker, which we think of as truly Ottonian.

4 Cultural and Religious Milieu of the Cycles

The whole treatment of Christ in Ottonian art is radically different from that of the Carolingians. The series of lavish gospel books made in the Court School of Charlemagne is almost totally lacking in illustrations of the Life of Christ, although models of these were available.[87] Only the St Médard of Soissons Gospels (Paris, BN, lat. 8850) have any, and these are tiny scenes, placed in the spandrels of evangelist-portrait and *initium* pages, to serve as didactic little reminders of the opening matter of the gospel in question. The Drogo Sacramentary of *c.* 850 (Paris, BN, lat. 9428) has a number of Christ scenes, but all of them fitted into initial letters of prayers where nobody but the celebrant of the mass would be able to see them.[88] Our largest surviving cycle of Christ illustrations in Carolingian manuscript art is that of the Stuttgart Psalter of *c.* 830, and these are interspersed among hundreds of illustrations, many of them Old Testament scenes or literal depictions of psalm verses. They show the importance which the Carolingians attached to the didactic functions of art. The general rule in Carolingian illumination is that there had to be some teaching purpose in depicting Christ, especially to show how the prophecies of the Old Testament had been fulfilled in his life and sufferings.[89] The Ottonians felt able, with little need of justification, to place him large and clear in full-page illustration.

45. Initial with Temptations of Christ. Drogo Sacramentary, Metz, *c.* 850. Paris, BN, MS lat. 9428, f. 41

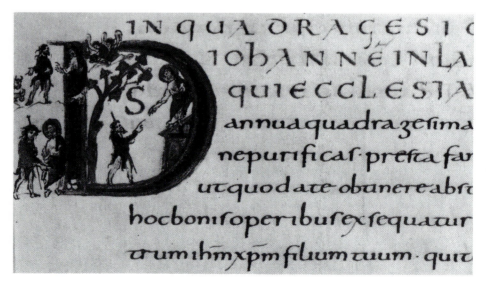

46. *Initium* to St Mark's Gospel. St Médard of Soissons Gospels, *c.* 810-15. Paris, BN, MS lat. 8850, f. 82

There were two features of Carolingian religious culture, which above all explain this state of affairs, and from which the Ottonians to a significant extent shook themselves free. One was the reaction of Charlemagne and his court to what they regarded as the excessive veneration allowed to images — of Christ, the saints, the emperor — by the Byzantine council held at Nicea in 787. This has constantly been an issue of high feeling in Christian history, as between those who feel that imagery is an aid to religious imagination and devotion, and those who think that (at least unless carefully controlled) it is more likely to give rise to superstition and to distraction from the spiritual realities behind the image to veneration of the physical image itself. Charlemagne's *Libri Carolini* of 793, and a whole string of later tracts on the same subject, show that this tension was strongly felt by Carolingian churchmen.[90] The other feature was the Adoptionist heresy which arose in Spain under Charlemagne, and which was vigorously contested by his court and especially by Alcuin. This heresy maintained, in brief, that Christ was not the true Son of God, not a full member of the trinal Godhead, but only the adopted son. It denied the divinity of Christ. Carolingian churchmen felt that this undermined the whole basis of salvation which they preached to their society, and which depended on the saving mission of Christ as God as well as man.[91] Hence the whole weight of Carolingian religious culture was turned to emphasize the divinity of Christ. Representations of the human life of Christ for their own sake can hardly have seemed the ideal means of achieving such an emphasis. These two features of their religious culture must be the principal explanations for the diffidence which the Carolingians show in illustrating the Life of Christ.

Here we must face a difficulty for the argument that between the Carolingian and Ottonian ages there was a swing from non-Christ-centred to Christ-centred art. What of all those wall-paintings with scenes of the Life of Christ, which the Carolingian emperors themselves encouraged, and which for the most part no longer survive?[92] I do not refer here to large cycles with rare iconography such as that of Müstair (*c.* 800) in Switzerland, which is probably exceptional and should be seen as in continuity with eighth-century Italy rather than with the new puritanism of Charlemagne's Aachen,[93] but to the many churches of the Carolingian countryside which must have had quite basic Christ cycles. The important point here is that Carolingian writers regarded such pictures as justified for the instruction of the ignorant and unlettered. There was indeed a danger that the images would be immoderately venerated in themselves, but the risk had to be taken for the sake of devotion and 'to draw the *simplices* and *ignaros* to a love of things invisible', as Walafrid Strabo put it. 'A picture was like literature to the illiterate', he wrote. The *idiotae* (i.e. uneducated) who could hardly be brought to the faith by words, could be reduced to tears of compunction by pictures of the passion and miracles of Our Lord.[94] This kind of talk all went back to a famous letter of Pope Gregory the Great to Bishop Serenus of Marseilles (599); Gregory discountenanced any

suggestion of image worship, but wrote in favour of pictures in church, so that those who were illiterate (*qui litteras nesciunt*) could at least read on the walls what they could not take in from books.[95] Jonas of Orleans (*c.* 840) quoted this letter in his moderate justification of images.[96]

In short, many Carolingian churchmen of high education might enjoy the luxury of iconic restraint (to use a paradox) for themselves, while regarding visual images of Christ's human life as a practical necessity for instructing simple folk in the Christian faith. There is an analogy here to the attitude of Pope Gregory the Great, and also of Bede, to miracles and the use of miraculous narratives. In one of his Homilies on the Gospels, Gregory observed that a rational creature, namely an angel, announced Christ's birth to the shepherds, while a star led the Magi to him; the Jews by their dealings with God had become able to understand reason, whereas the gentiles had to be brought to recognize the Lord not through a voice but through signs and wonders.[97] This is the likeliest reason why Bede included miracles in his widely circulated Ecclesiastical History, but omitted all elements of the miraculous from his History of the Abbots of his own monasteries of Wearmouth and Jarrow, whose monks were very rational men, his own pupils in fact. Some people needed miracles more than others — it was a weakness; some needed pictures more than others.

When we refer to a cultural shift in the art of the human Christ as between Carolingian and Ottonian times, therefore, we must define and limit our meaning. We speak of a world of books and of educated men and women, not of the underworld of rural churches, wall-paintings and simple folk. Where we know of large christological cycles as a feature of Carolingian wall-paintings in educated environments, as at the royal palace of Ingelheim,[98] or in the abbey church of St Gall, they are certainly or probably part of grand intellectual schemes, slanted very much to higher learning rather than allowing any hint of iconicism.

It is never easy to explain why changes in religious sensitivity occur, and I do not wish to pre-empt my argument of the next chapter, which relates such changes in part to the needs and ideals of rule in the Ottonian period.

But it is at least possible sometimes to identify the milieus of these changes. In the Ottonian empire we have above all to consider the monasteries of the so-called Gorze reform, after the monastery of Gorze in the diocese of Metz in Lotharingia, where it began in the early 930s.[99] Some serious question marks have recently been placed over hitherto accepted views of this reform by the research of John Nightingale: in particular over whether Bishop Adalbero of Metz played so vital a role in the reform; whether it involved such far-reaching economic reorganization; and above all whether there was a serious break in the relations between the monastery and Lotharingian aristocratic families, since both before and after the 930s the monastery appears to have played an important part in giving cohesion to Lotharingian aristocratic structure and to the landed holdings of its families.[100] Other questions also arise. Is it rightly labelled the Gorze

reform when the monastery of St Maximin of Trier was so much more important a radiating centre of monastic reform than was Gorze? Is it rightly labelled a reform movement when the connections between one monastery and another were so loose-knit, there being no exemption from the local bishop's authority, bishops indeed often initiating the reforms? What are the criteria for labelling a monastery as reformed when some monasteries — this includes both St Maximin of Trier and Reichenau — seem to have had more than one reform during the tenth century?[101] Whatever answers we give to these questions, however, virtually every significant centre of book illumination in the Ottonian Empire, with the important exceptions of Fulda and Corvey (discussed in Part II) was fairly and squarely within the orbit of a geographically far-reaching monastic reform in a sense recognized by everybody, at the time of its production. That is true of Trier, Reichenau, St Gall, Cologne, Hildesheim, Regensburg and Seeon.[102] Indeed one might observe that arguments about whether books were produced at Reichenau or Trier or Regensburg loose some of their vitality if everyone can agree that their context is in all events this one of monastic reform.

One essential feature of this reform in the 930s was the attempt to establish the *vita communis*, the community of living and worship. Where previously some monks could consider a portion of the monastic endowments as their private prebends, or could live in private houses, *mansiones*, dispensing private hospitality (and perhaps married), the reform at Gorze involved the common refectory and common dormitory for everyone, according to the Rule of St Benedict.[103] This was partly asceticism, for while it is clear that to the reformers poverty did not necessarily mean every form of material self-deprivation, it did mean communal rather than private property. It was not only asceticism, however; it was also the belief that a full-scale monastic liturgy — the other essential feature of all tenth-century monastic reform — was impossible without the full *vita communis*. Illuminated manuscripts, therefore, which are predominantly liturgical, fit into a resurgence of monastic liturgy.

It may seem surprising that we should list Reichenau amongst those monasteries which were included in the orbit of the Gorze reform. The evidence for Reichenau's connection is very thin and inferential, amounting to Abbot Ruodmann's (972-85) personal acquaintance with Sandrat of St Maximin, Trier; a late tenth- or early eleventh-century copy at Reichenau of the influential so-called Sandrat *Consuetudines*; and the abbacy of Immo of Gorze (1006-08) against which the Reichenau monks in fact reacted violently.[104] But it would be anachronistic to judge the tenth-century reform movement in the empire by the standards of constitutionally centralized movements like that of Cluny in the eleventh century or the Cistercians in the twelfth. Such centralization is characteristic of the Gregorian Reform period and its aftermath. In the tenth century, participation in reform might be much more a question of shared religious interests, of personal relations and informal connections, rather than of formal juristic links

or formal adoption of *consuetudines*, which could be a useful guide to the monastic life without being necessarily regarded as mandative. The great Swabian monasteries strove to implement reforming ideals, and fine liturgy, but became jealous of their liberty at any attempt to impose reform authoritatively. That was the problem of Immo of Gorze, that and very likely an attempt to impose harsh customs, and also his personal unacceptability at Reichenau: 'a destroyer of the monastery and expeller of the monks', he was called.[105] As Hallinger has shown (and others before him), affiliation not subjection was the signature tune of the Gorze monastic reform. Certain *consuetudines* might have united Reichenau with other Gorze monasteries, but again as Hallinger says, only in thought and feeling; for the 'isolated monastery' (i.e. the autonomous monastery) lived deep in the common consciousness.[106]

If we divest ourselves of the idea, therefore, that participation in reform is judged by constitutional adherence to an organization, it becomes too bald an assertion to say that 'the art of the Reichenau monastery flourished without the reform'.[107] In terms of affiliation, Reichenau had not only the connection with Sandrat, but also, as the evidence of the Gero Codex and the Codex Egberti show (see pp. 36-37, 205-6), cultural relations with at least two important monasteries of the reform movement, i.e. Lorsch and St Maximin of Trier. Both these monasteries, and indeed Gorze itself, are represented with lists of monks in the ninth-century confraternity book of Reichenau, and further lists were added to this book later.[108] A St Gall tradition had it that Abbot Ruodmann of Reichenau (972-85) was a catalyst for the introduction of reform at St Gall, the instrument there being apparently Abbot Gerbodo of Lorsch.[109] The famous poem on Abbot Witigowo of Reichenau (985-97) by the Reichenau monk Purchard does not mention the *communis vita* by name, but it is implied in the lines about Witigowo's architectural work on the church and monastery, the fine wall-paintings and resplendent altars which he commissioned.[110] It is strongly implicit, for instance, in the following passage:

> He brought to completion a noble and
> lofty church,
> With the residential buildings of the
> monastery (*habitacula claustri*) all around it.
> He added suitable cells for those serving
> the Lord [i.e. the monks],
> So that here they could live safe from
> the whirl of the world.[111]

It is true that in all this the poet responds to the plaints of *Augia*, i.e. Reichenau herself. Before she found this wonderful spouse in Witigowo, nobody championed her and her possessions; her lawsuits went awry; and her buildings were neglected. But *Augia* is being rather inconsistent in her grief here, since she has nothing but praise for Ruodmann (972-85), Witigowo's immediate predecessor, as if the two abbots had similar ideals;[112]

and there was little time in the vacancy between them for much to go wrong. Ruodmann is not to be excluded from the theatre of reform simply because the protagonist of a later reformer exercised the *topos* of denigrating in general terms everything which went before him.

The fact is that before Henry II, who virtually equated monastic reform with the submission of monks to strongly exercised abbatial authority, reform often seems to lie in the desire of a monastery or its episcopal patron to acquire a good abbot — as a university department with its professor — or to be associated with another impressive and observant community. In the case of an established monastery it is no indication that the *vita communis* had previously been imperfectly present; and authority and *consuetudines* were not necessarily at issue. Fundamental to all reform in that age of high liturgical awareness was the effort to enrich the monastic ceremonial, to beautify its setting, and to increase its valuable accoutrements such as altar vessels and books.

Perhaps one of the most worthwhile aspects of studying art in the Ottonian period is that it is itself our principal testimony to the religious aspect or ethos of the 'Gorze' monastic reform, which pervaded the empire. Through art the specifically religious history of the reform can best be understood and articulated. But one can also experience this ethos in a notable work of literature, John of St Arnulph's (Metz) *Life of John of Gorze*, the eponymous initiator of the 'Gorze' reform. Not only does this *Life* emphasize the importance of the *vita communis*, the communal life of buildings, material possessions and above all worship; it is also notably Christ-centred. John and his companions are said to join a hermit called Humbert, with Christ as their leader (*Christo duce*). In their corporal penances they are said daily to follow the author of the cross (*crucis auctorem*), which refers to the suffering Christ and not only to the old veneration of the Cross. Einold, Archdeacon of Toul who became Abbot of Gorze, is said to be the first to be dedicated to the cross and to be clothed with the monastic cowl. Another Archdeacon of Toul, Anstey, became a monk at Gorze under John; he is said to be changed from an archdeacon into a poor man of Christ (*in pauperem Christi*).[113]

Another work of the Gorze reform which conveys a very similar impression is the *Vita Chrodegangi*. Chrodegang was a famous eighth-century Bishop of Metz, and the *Life*, composed anonymously probably in the third quarter of the tenth century, has plenty to say about his founding of Gorze itself.[114] Early on, the author declares that he will teach nothing contrary to Christian authority, exulting to submit himself to the sweet yoke of Peter and thus of Christ. Chrodegang, it is said, preached to monks that they should imitate Christ the poor man (*christum pauperem*) with voluntary poverty; and he admonished the Frankish soldiers in Italy in 753 'not to fear death for the name of Christ'. The author refers to the prayers of those whom Chrodegang had brought to Christ, i.e. to the monastery of Gorze, and twice in the course of his writing he addresses prayers directly to Christ: once on Chrodegang's episcopal election ('O good Jesus! how

Luc. XXII, 19 ff. V.3,

XI. The Last Supper. Gospel Book of Bishop Bernward of Hildesheim, *c.* 1015.
Hildesheim, Cathedral Treasury, MS 18, f. 118

XII. The Crucifixion. Sacramentary of Bishop Abraham of Freising, *c.* 980-90.
Munich, Bayerische Staatsbibl., Clm. 6421. f. 33v

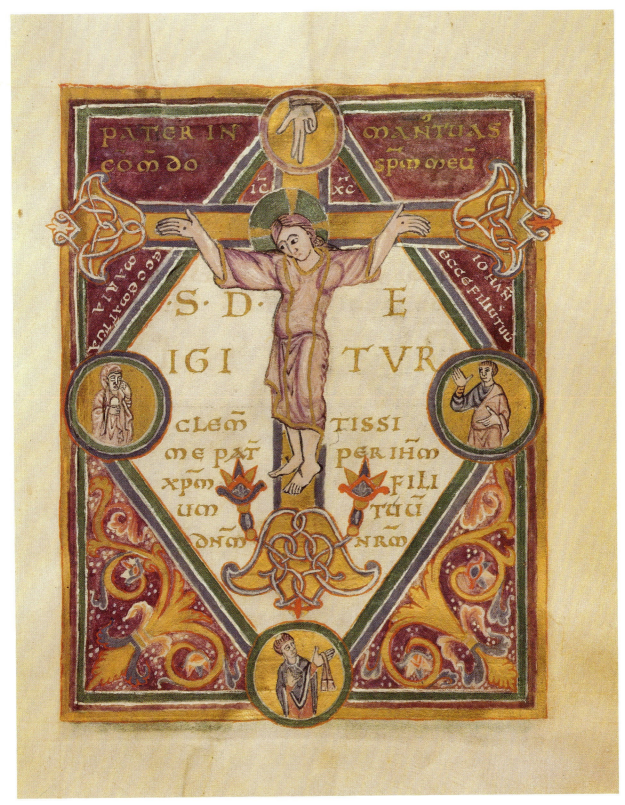

XIII. The Crucifixion. Sacramentary, Corvey, late C10.
Munich, Bayerische Staatsbibl., Clm. 10077, f. 12

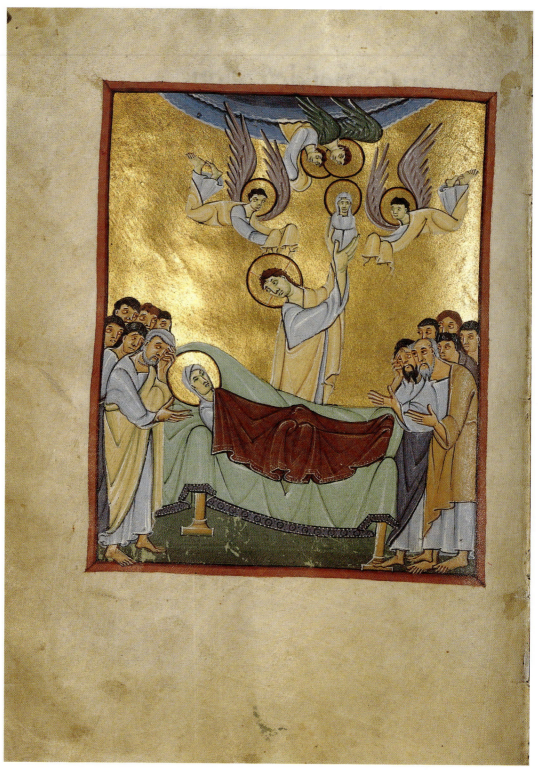

XIV. The Dormition of Mary. Book of Collects, Reichenau, *c.* 1010-1030.
Hildesheim, Dombibl., MS 688, f. 76v

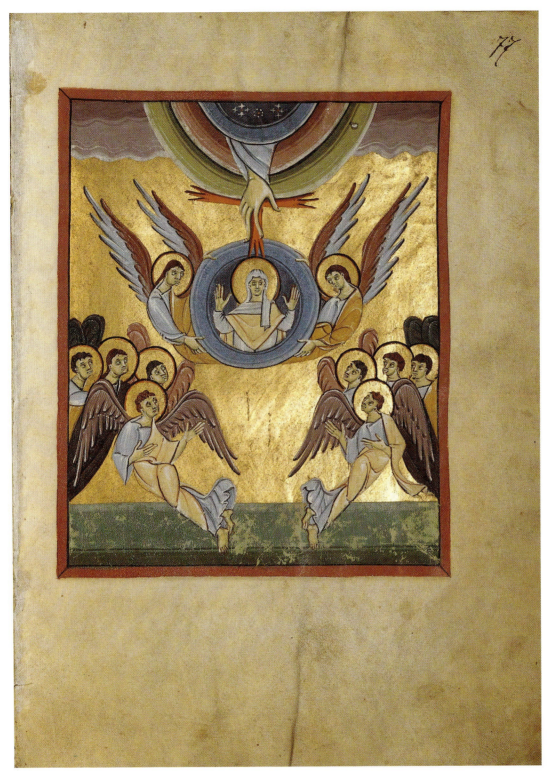

XV. The Assumption of Mary. Book of Collects, Reichenau, *c*. 1010-1030.
Hildesheim, Dombibl., MS 688, f. 77

XVI. Initial V. Book of Collects, Reichenau, *c.* 1010-1030.
Hildesheim, Dombibl., MS 688, f. 77v

N E R A N D A N O
bif ē dñe huiuf diei fef
tiuitaf inqua scā dī ge
nitrix mortem subiit
temporalem nec tamen
mortif nexibuf deprimi
potuit · que filium tuū
dñm ñrm de fe genuit
incarnatum · cuiuf inter
cessione qſ ut mortem
euadere possimus ani
marum · P eundem dñm ·

XVII. *Veneranda* for the Feast of the Assumption. Book of Collects, Reichenau, *c.* 1010-1030. Hildesheim, Dombibl., MS 688, f. 78

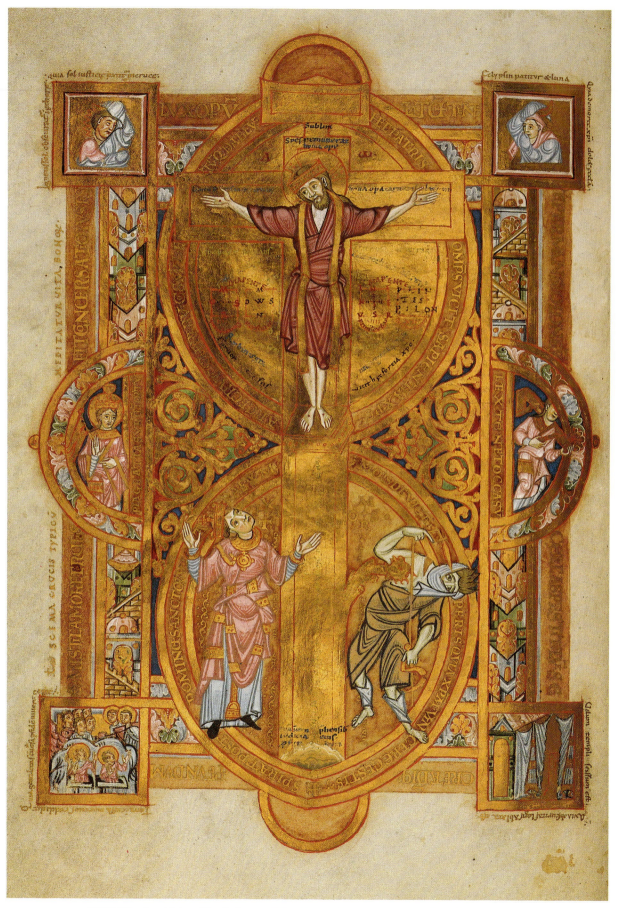

XVIII. The Crucifixion. Uta Codex, *c.* 1020. Munich, Bayerische Staatsbibl., Clm. 13601, f. 3v

much exultation was there', etc.) and again on the miraculous moving of a heavy stone during building operations at Gorze ('These wonders are yours, O Christ; they are your works!'). He notes that Chrodegang would travel around his diocese like a good healer (*bonus medicus*), but at Lent he returned to his own see and celebrated the solemnities of Our Lord's Passion and Resurrection devoutly.[115] Another markedly Christ-centred source from Metz itself, always an important centre of the Gorze reform, is a *Vita S. Clementi* (putative disciple of St Peter and Bishop of Metz), written in metre during the late tenth century. Despite the poet's managing to compose 1068 lines, he had little in the way of hard fact, and lines 116 to 896 are taken up with the sermon which St Clement is supposed to have preached to the people of Metz on their conversion to Christianity. The Old Testament foreshadowings of Christ and his earthly life and miracles are given their full weight in this sermon, and the poem mentions Christ at least eleven times before it reaches line 116: his rule, his peace, his godhead, his sceptre, his elect, etc. Moreover, Jesus is credited with the destruction of the walls of Jericho, and this is treated as a cue to give warnings of fire and brimstone to the 'Sodomite-like' people of Metz.[116]

Now obviously it would be absurd to say that devotion to the person of Christ was lacking in Carolingian monasticism. Indeed the heroic poem about his life, the Heliand, found in a Corvey manuscript,[117] the St Gall translation into Old High German of Tatian's chronological narrative of Jesus's life,[118] and Otfried of Weissenburg's Gospel Harmony,[119] must have helped to lay the foundations of devotion to Christ under the Ottonians. What Tatian did for Jesus's life in prose, the Gospel Book of Otto III did in pictorial art (see pp. 175). Moreover the earliest representations of Christ dead on the cross, with the blood from his side being collected in a chalice by the figure of Ecclesia, are ninth-century. In this case, however, there is as good reason for associating these with the intellectual interest in eucharistic theology between 830 and 850, as for seeing in them straight-forward manifestations of Christocentric piety.[120] In fact the studding of John's *Life* and other sources from the milieu of the Gorze reform with phrases highlighting the humanity of Christ does look like a change of emphasis. The Carolingian books of private prayer, for instance, are for the most part very much orientated towards the glory of God and the Trinity, or towards the confession of sin.[121] One is drawn to Einhard's short tract on the adoration of the cross, in the hope of discovering there a Carolingian example of Christ-centred devotion. And what does one find? A lengthy first paragraph arguing that one should pray to God rather than to Christ; and afterwards a distinction between veneration of the cross which was permissible, and prayer to the cross which was not. Again the fear of idolatry. One should not pray to the cross, because one prays to the invisible God who is everywhere. One may prostrate oneself before the cross in veneration, because one prostrates oneself before him who hung on it and whom we adore with our *inner* eyes.[122]

In moments of religious devotion it seems to be the Old Testament rather

than the New which causes the imagination of Carolingian scholars like Lupus of Ferrières to take off.[123] That is certainly true of Carolingian artists. And although Paulinus of Aquileia, under Charlemagne, wrote in his poem on the raising of Lazarus of how Jesus wept, he took care to add that he wept as man, for as God he could not weep, spreading this theological cognizance over a whole four-line stanza.[124] The *Life of John of Gorze* was written in the 980s, the *Life of Saint Chrodegang* perhaps not much earlier, and they are not perhaps the best evidence for the religious ethos of Gorze as it actually was in the 930s when reform was undertaken there. But if they rather reflect the feelings of the 980s that makes them all the better evidence for our purposes. It brings them into the beginning of the great period of Ottonian Christ-centred art.

5 *Abraham of Freising*

A topic such as emphasis on the humanity of Christ can seem very much up in the air unless we focus on specific communities or individuals who thought all this, which the surviving sources are not always sufficient to allow in the tenth century. Yet here and there the clouds part and we find ourselves looking at the evidence of some fascinating example — like Bishop Abraham of Freising (957-94). Our principal knowledge of Abraham is twofold: an anecdote about him in Thietmar of Merseburg, and the manuscripts (mostly without figural art) which he commissioned or collected for his Bavarian See. He has never entered anyone's calculations as one of the greatest bastions of Ottonian Church or government, despite his long episcopate. Indeed, he has entered the calculations of relatively few historians at all. But the manuscripts show him to have been a cultured man, having wide connections with other Churches of his time,[125] while the anecdote shows him to have had a powerful personality. Thietmar says that after the death of Duke Henry of Bavaria, his widow Judith lived continently with Bishop Abraham, for which she was 'torn apart by the hateful teeth of common gossip'. At her requiem mass, which the bishop celebrated, he turned to the people before communion and said: 'If she ever committed the sin for which she has been defamed, may the Almighty Father cause the saving remedy of his Son's body and blood to bring me to judgment and well-earned damnation, and may it be to the perpetual salvation of her soul.' After this courageous declaration, he took communion 'with innocence of mind and body', the people believed him however late in the day, and the previous detraction was positively turned to his advantage.[126] In the succession dispute after Otto I's death (973), Judith had supported her son, Henry the Quarrelsome, for the kingship against Otto II, and she in turn had been supported by Abraham. This was not the politically successful side, and led to the bishop's being imprisoned for some time in the monastery of Corvey.[127] One particular point of note about the relationship of Abraham and Judith, for the study of a bishop who was interested in the human Christ, is that Judith had earlier in life been on a pilgrimage to the Holy Land.

Amongst Bishop Abraham's surviving manuscripts is one which seems to have a particularly intimate link with him personally, a handbook of material which he regarded as important for the performance of his episcopal duties, including some sermons which interested him.[128] One of the latter is a sermon of noble character about Easter by Liudprand of Cremona, a protégé of Otto I and an Italian bishop of the 960s. Liudprand has not hitherto had any reputation as a theologian, and it is thanks to an edition of this sermon by Bernhard Bischoff and a revealing article about it by Karl Leyser, that we can see him as something more than the racy, not to say scurrilous, historian. As a former student of rhetoric and dialectic in the school of Pavia, Liudprand's sermon is cast in the form of a debate with a Jew. It covers many aspects of Christian teaching. On the Trinity it stresses the oneness of God, and the oneness of God the Son with the other persons of this trinal godhead; they were three in one, like the sun, with its fire and splendour and heat. But in treating of the salvation of mankind, he takes care also to emphasize the humanity of Christ; the immortal God could without detriment to himself take on the humanity he had come to liberate. Leyser points to the likelihood that Abraham and Liudprand knew each other, and suggests that the bishop may even have heard Liudprand deliver his homily in some form.[129] It is possible, indeed, that the sermon was actually composed for Bishop Abraham, given not only that it survives in his handbook, but also that it pulls in the example of the biblical Abraham twice, and rather pointedly, in referring to Abraham's entertainment of three angels and to his words in the parable of Dives and Lazarus.[130]

In Liudprand of Cremona a balance is carefully preserved between the two natures of Christ, his divinity and his humanity. Not so with a cleric called Rihkar, who had been calumniated for his unusual emphasis on the humanity of Christ, and who defended his views in a vigorous letter addressed to Bishop Abraham some time between 966 and 989. God taking pity on human kind, he says, sent from the seat of his majesty his coeternal Son to the Virgin Mary. Humanity was considered worthy of divinity. Rihkar continues in a vein which cannot have been considered by everyone to be in good taste, as we shall see when we discuss how artists thought it appropriate to represent Christ in his humanity:

> From his assumption of humanity, he was affected
> by fasts, overcome with sleep, oppressed by insults
> and jeers, bound, taken captive, scourged, cuffed
> round the ears, held in derision, crucified at the
> end, pierced with a lance, kept down for a space by
> death, buried, and then on the third day, having
> conquered death, he was raised again. This we confess
> by our catholic faith.

Rihkar finally asks Abraham to judge justly between him and his opponents.[131]

89

The importance of this neglected letter is not that in itself it is proof of a generally greater emphasis on the humanity of Christ in its time (for it is not), but rather that it shows how Christ-centred art developed against a background of some debate about how the humanity and divinity of Christ should be balanced. It is admittedly only one letter. Nevertheless, although one swallow may not make a summer, we have a pretty shrewd idea what season it is if we see a swallow at all. The vehemence of tone by Rihkar, the very overstatement of view, and the fact that we know of other genuine clashes in the learned world of *c*. 980 (see p. 77), all suggest that its context is one of real debate.

Sometimes medieval writers adopted the posture of debate merely as a literary affectation to give added interest to their arguments. That this was not the case with Rihkar is proved by some sermons of Rathier of Verona which give a completely different emphasis; and their texts actually sat in the library at Freising. Indeed they are in the handbook of Bishop Abraham which contains the sermon of Liudprand of Cremona. They include one sermon for Easter and one for Lent. The sermon for Easter begins by emphasizing that Christ, the Lamb of God, could only take away the sins of the world in his divinity, as one with the Father and the Holy Spirit, and there is no corresponding emphasis on the humanity.[132] The sermon for Lent positively insists that the divinity rather than the humanity should be emphasized. It is wholly uncompromising:

> At the idea that God was spirit, incorporeal, invisible
> etc., some of our priests said in a murmuring way: 'for
> pity's sake!' [all this may be no bad indication of how
> the high-minded Bishop Rathier conceived of dialogue
> between his clergy and himself] 'What are we to do? Until
> now it seemed possible to know something about God, that
> God cannot be anything if he has not a head, nor eyes,
> nor ears, nor hands, nor feet'. To one of these I produced
> the following reply: 'stolid fellow! do you think that you
> or I have no soul because you cannot see it? What sort of
> a head has your soul?' etc.

There follows a fine passage on God as the radiating centre of all beauty in the universe, of all illumination and power, God the indivisible spirit, who is above all things. 'Is he nothing to you because he does not have a body which you can see?' The compelling rhetoric flows on into a denunciation of idolatry, and then, as if anticipating some words of Rihkar to the contrary, on further into this declaration: 'he Lord, when he was in the womb of his virgin mother, had not left the Father in heaven; at one and the same moment he was in heaven and in the virgin's womb, but in heaven outside time and in his mother temporally. Jesus had replied to Philip's request to show him the Father, that whoever saw him, saw the Father: 'it is with the *interior* eyes that God can be seen'.[133] It takes a theologian like Rathier, whom Hauck characterized as Carolingian in out-

look,[134] to animadvert to this very Carolingian preoccupation of whether God would be seen in heaven with corporeal eyes. Candidus of Fulda had discussed it, not without persiflage, in the ninth century. His answer was a clear no. Men would see the vision of God in spirit rather than in the body. A pure heart, not good eyesight, would be the prerequisite for this vision.[135]

We lack the evidence to tell whether the position of Rathier or that of Rihkar appealed more to thinking people in the tenth century. There was nothing unorthodox about Rathier's sermon, of course. He was not attempting a precise theological formulation of the relation between the two natures of Christ. His was an exhortation to concentrate devotion on the divinity rather than the humanity of Jesus. On the other hand one should not assume that either Rathier's conservatism (though this looks less, when one remembers that his sermon probably dates from as early as the 930s) or his vastly more accomplished presentation, made it seem the preferable approach. A clumsy sincerity can be more than acceptable when it sustains the radical or the fashionable. It is the very existence of debate, and of a particular theological awareness, which matters most for our present purposes.

Which side Bishop Abraham himself came down on, however, is easy to see. It was not on that of Rathier, important as he presumably found his sermons. It was on Rihkar's, in favour of stressing the humanity of Christ. A sacramentary made for Abraham (Munich, Clm. 6421) has a Crucifixion with Mary and John on the page at which the canon of the mass opens, above the words *Te igitur*. The cross on which Jesus hangs is interesting, because it is an *Astkreuz*, a cross with jagged edges or stumps, to look like sawn-off branches. In this way the idea of the Tree of Life is expressed, as if the cross were made of an actual tree. Iconographical dictionaries give earlier examples of this kind of cross, but if one looks at them, they are not very convincing specimens of the type. One may say that this Freising crucifixion is effectively the first surviving example of an *Astkreuz*, with its implications of 'realism', perhaps together with one in a late tenth-century Leipzig leaf which has been claimed both for Reichenau and Corvey.[136] Christ himself is represented as dead, his eyes closed and his head slumped forward on to his chest. Although he is in full length garb, he does not wear the purple collobium, symbol of world rule,[137] as in the sixth-century Syrian Rabbula Gospels;[138] and although his body is straight rather than twisted, the bent and stretched-up arms ensure than there is nothing hieratic about his posture, as it is in so many other Crucifixion scenes of the period. Christ has the crossed nimbus. There is, also, it is true, a chalice under his feet to collect his blood, a feature which seems to come into Crucifixion iconography only with the Carolingians and is continued at Ottonian Fulda and later at Echternach;[139] but this is less a direct symbol of divinity than of eucharistic theology. Otherwise there is no hand of God, nor are there angels, nor emblems of sun and moon, nor any other single indication or symbol of eternity and of the divinity of

Col.Pl. XII

47. Crucifixion (detail of ill. 79). Rabbula Gospels, Syrian, C6. Florence, Bibl. Laurenziana, MS Plut. I. 56, f. 13

91

48. Crucifixion, Sacramentary
of Henry II. Regensburg, 1002-14.
Munich, Bayerische Staatsbibl.,
Clm. 4456, f. 15

Christ. More striking than all this, whereas Christ is raised aloft in most
Ottonian and earlier Crucifixions, and is often significantly greater in size
than Mary and John, here he is hardly removed above these two, and he
is entirely commensurate with them in physical stature. To the onlooker
it appears as if he could easily put his arms round both their shoulders in
a very human embrace. Indeed, even in the mystery of his death, one feels
that that is what he is actually about to do.

92

How remarkable the undiluted humanity of this Freising Crucifixion is, can be noted from a comparison of the scene with any art by which it might have been influenced. The handwriting and calligraphy of the manuscript are pure Reichenau of the Ruodpreht period (*c.* 975-95),[140] but the (stylistically provincial) Crucifixion is clearly not the work of a Reichenau artist. On the other hand, there is another sacramentary, also as it happens in Munich (Clm. 10077), which was made at Corvey. It dates from *Col.Pl. XIII* about the same period as Bishop Abraham's Sacramentary, and it contains a Crucifixion at the beginning of the Canon. In the design of the page, the control of the foliage ornament, the draughtsmanship and the handling of the human figure, it is vastly more accomplished work than that of Freising. But Abraham could well have learned something from this kind of art; from the disposition of Christ's body on the cross, and more particularly from the colour tones. The Corvey Crucifixion has a brownish purple background in its angles; a heavy green round the frame, in the lines of the rhomboid, and in the nimbus of Christ; a light violet for Christ's clothing; streaks of minium red in the right-hand projection of the cross and in the shoots which sprout from its interlace base (someone thought of this cross, too, as a tree of life); and gold in the cross, in the foliage ornament, and in the medallions at the corners of the rhomboid. This is exactly the combination of colours, albeit with deeper and cruder purples and greens, found in the Freising page. It is a combination used with a maladroitness suggesting recently learnt lessons, which were neither thoroughly nor skilfully digested. Only certain blue tinctures in the medallion figures and an occasional dash of pink seem not to be repeated, even in a varied shade, at Freising. Presumably the bishop was able to learn some lessons about art when he was in exile at Corvey, where one should not imagine his life to be too restricted. It was not an infrequent occurrence in the tenth century for a bishop to be confined to some monastery or other after an unsuccessful political episode, and the indignity was normally palliated by his being committed to a tolerably sympathetic custodian.[141] In these circumstances, and with time on his hands, what better way of occupying himself than with art? All this would not necessarily mean that Abraham himself was the artist of the page (though that is quite possible); only that he supervised it, as Bernward of Hildesheim supervised his artistic production.

Yet if Abraham had seen the Corvey Crucifixion, or anything like it, how much of it he ignored! He ignored the hand of God in the medallion above the crucified Jesus. He ignored the device of setting Mary and John in medallions, which makes them eternal images rather than human actors in the story, so leaving only Christ, *solus Deus*, in the lovely rhomboid of plain parchment. He ignored the broad gold bands (intimations of divinity) in the deep green cross, and had the cross made all in green, as if it was filled with the sap of life. He ignored the medallion of a priest, holding the maniple as a symbol of his sacramental function, thereby (very suitably in a sacramentary) relating the Crucifixion scene to the eternal

93

sacrifice of God made man as re-enacted in the mass. He ignored the scriptural phrases placed schematically in the upper angles, particularly the last words of Christ written in golden letters on either side of the hand of God: 'Father into thy hands I commend my spirit' (*Pater in manus tuas commendo spiritum meum*). The association of Christ, in his abasement, with God the Father, was not passed over at Corvey, as it was in the Freising illustration.

All this suggests that Freising was probably not a typical centre of religion in the Ottonian Empire, although when we consider the Crucifix of Gero of Cologne (see pp. 133-34), it looks as if we can match Abraham with at least one other important churchman of his period. Freising should perhaps be seen as a vanguard towards a religion which humanized Christ. But where attitudes are concerned, vanguards can cause shifts in the perceived location of moderate ground, particularly vanguards with many connections like that of Abraham of Freising. To illustrate the life of the human Christ was becoming acceptable to Ottonian churchmen, in a way and to a degree that it would not have been to their Carolingian predecessors. The kind of debate over, and interest in, the person of Christ, which centres on Bishop Abraham, surely helps to explain why this came about.

There is little to connect Abraham directly to the Gorze reform, although since he blessed Hartwig from St Maximin, Trier, as Abbot of Tegernsee in his diocese on 4 March 978, he cannot have been unfavourably disposed towards it.[142] But there is no need to regard the Gorze reform as the single key to the whole phenomenon of Christ-centred piety. The point of interest in Abraham's case is the effect of his missionary responsibility on his attitudes. The diocese of Freising cut a swathe through the South German world, between the dioceses of Augsburg and Salzburg, deep into the lands of the Slavs in Carinthia.[143] These Slavs were not yet all converted to Christianity. We can hear Slav resonances in the names mentioned in a diploma of Otto I dated 3 April 965, as well as see something of the missionary organization which had been extended to Carinthia. In this diploma, the emperor, at the intervention of Judith, mother of Duke Henry (the Quarrelsome), and at the request of Bishop Abraham, grants landed possessions in Wirtschach, Carinthia, in the county of Hartwig surnamed Vualtpoto, and in the deanery of Dean Wolframm, to Negomir, Bishop Abraham's vassal.[144] In the handbook, once again, which contains the sermons of Liudprand and Rathier, are Slavonic texts of missionary purport, the famous *Freising Texts*, written in a Latin alphabet by a hand which also wrote a deed of Bishop Abraham about 980. There is an *Exhortation to Penitence*, which Slavonic scholars regard as the reworking of a homily from the circle of the ninth-century missionaries, Cyril and Methodius, in Moravia; and there are texts based on *St Emmeram's Prayer*, taught to converts before their baptism.[145] The suggestion has even been made that Abraham himself was of Slavonic extraction.[146] If that is true he would not have been singular within the Ottonian Church, for we know that Arch-

82

bishop William of Mainz (954-68), a natural son of Otto I, had a Slav mother.[147]

The conclusion seems clear. A vital question in the debate on how to balance the natures of Christ, in learning and in art, was this: what sort of an image of Christ was it appropriate to present to the unconverted peoples on the missionary edges of the Ottonian Empire? We read in Bede's *Ecclesiastical History*, a text well known amongst the Ottonians, that when, nearly four centuries earlier, St Augustine and his companions met King Ethelbert of Kent, as yet a pagan, they carried a silver cross as their standard, and an image of Our Lord and Saviour painted on a wooden board (*tabula*).[148] Bede does not tell us what sort of an image this was, but perhaps it had some features of Christ as a ruler, for it had to appeal to a king. Amongst the Carinthian Slavs of the tenth century, however, there is not the slightest indication of anything like the centralized authority which Ethelbert had amongst the southern English in 597. It seems that Bishop Abraham judged it appropriate to answer our question with an unusually human image.

6 Bernward of Hildesheim

Let us now look at another Ottonian bishop in whose circle the art of the human Christ was fostered. Bernward, Bishop of Hildesheim (993-1022) in the generation after Abraham of Freising, combined some of the most persistent and some of the highest traditions of the Ottonian episcopate in a degree which has commanded the universal admiration of historians. He was a Saxon aristocrat, a valiant military commander, an alert intellectual, a man of palpable religious devotion, and a pre-eminent lover of art. His biographer Thangmar, who was also his teacher at Hildesheim, wrote about his education which comprised not only the liberal but also the mechanical arts, including manuscript illumination and the craft of the goldsmith.[149] Bernward is the only Ottonian bishop to compare with Egbert of Trier in the range of his activities and patronage across the various arts, and especially in the desire of both to record their names and to be remembered for the works of art which they brought into being. Bernward put his name to almost every work for which he was responsible: the great bronze doors of 1015 in the Cathedral of Hildesheim, the silver candlesticks, a book cover, the silver crucifix, his own gravestone, the Guntbald Gospel Book of 1111, the Sacramentary of Guntbald (1014) and the Gospel Book of *c.*1015, with whose Last Supper we shall be especially concerned.[150] Even a foundation stone of the monastery of St Michael, discovered in 1908 under the south-west tower of that church, was found to bear his 'signature', B + EP and the date 1010.[151]

The analogy with Egbert, however, is limited to the externals of organization and art production; at a deeper level, the contrast between the two men is far more striking than the similarity. Egbert's desire to be remembered appears generally as a form of political image projection (though I do not mean to imply that for the rest Egbert's art lacked a religious

49. Bishop Bernward of Hildesheim
presents his Gospel Book, *c.* 1015.
Hildesheim, Cathedral Treasury,
MS 18, f. 16v

dimension), whereas Bernward's patronage of art seems almost in the nature of a mystical experience, and in this he anticipates Abbot Suger of St Denis over a century later.[152] The theme of sin and repentance is a pronounced one in art and life for Bernward. Thangmar said that he poured out the whole of himself in contrition of soul when he celebrated mass; the penitential aspect of his pilgrimage to Tours in 1007 is also stressed; his Testament of 996 begins, 'I, Bernward … considering the immensity of my sins'…[153] Here sounds the authentic voice of Otto III's tutor (see pp. 163-64, 171-73). It is true that as with Egbert in his Psalter and Codex, an image of Bernward appears as the frontispiece to his gospel

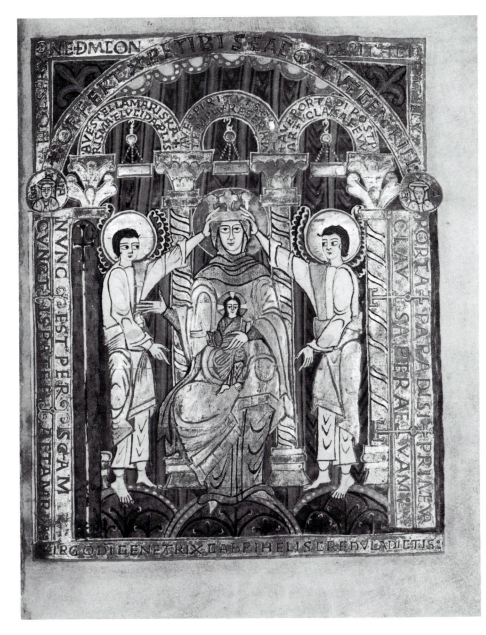

50. Mary receives the Gospel Book from Bishop Bernward, *c.* 1015. Hildesheim, Cathedral Treasury, MS 18, f. 17

book of *c.* 1015. But one must mark the difference. He does not sit stiff, frontal and hierarchic as does Egbert in his books. He stands, vested for *49* mass, with unmistakeable modesty and equally unmistakeable dignity, to present his book (by placing it on the altar) to Mary crowned and seated *50* in Majesty, the perfect example of Pope Gregory the Great's adage that a bishop should be humble but should not so demean himself as to lose his authority. Egbert certainly risked no loss of authority in his frontispieces. The inscription round the scene of Bernward's presentation, in which the bishop contrasts his high name and office with his personal unworthiness, is as follows: 'This gospel book the love of virginity offers to you, Holy

97

51. Triumphal Cross, C12,
containing parts of Bishop Bernward's
earlier cross of *c.* 996.
Hildesheim, Cathedral Treasury

Mary, with a devout mind; Bishop Bernward is hardly worthy of his
singular title, adorned as he is in the pontifical vestments of his great
office.'[154] Yet subtly, Bernward achieves in this picture an almost greater
authority than that of Egbert. By offering a present to the queen of heaven,
he demonstrates his access to the heavenly sphere and Mary's indebted-
ness to him in the manoeuvrings of gift-exchange.

It has been suggested that one can trace a spiritual progression in Bern-
ward's life and art from a sort of triumphalism to an 'internal relationship
with the human Saviour', expressed in the shift from the jewelled altar
51 cross in which he enclosed a relic of the True Cross given to him by Otto
III in 996 at the time of the latter's imperial coronation, to the Crucifixion
of the bronze doors (1015) and to the silver crucifix (considered to be after
52 1007) representing Christ dead, slumped and twisted on the cross.[155] Per-
haps this is to put too much on slender evidence. Rather it seems that the
paradox of glory and suffering, the balance between Christ's divinity and
humanity, was always central to Bernward's religious life. We have the
fulgens mysterium of the jewelled cross from the pen of the same bishop
who, as von den Steinen pointed out, also subscribed his name to a do-
cument with a cross and the words *dominicae passionis signo manu propria
subsignavi* (signed by my own hand with the sign of the Lord's passion).[156]
On the bronze doors now in Hildesheim Cathedral, where various theo-
logical parallelisms between the Old Testament scenes on the left and the
New Testament scenes on the right have often been discussed,[157] Christ as

98

52. Silver Crucifix of Bishop Bernward of Hildesheim, early C11. Hildesheim, Cathedral Treasury

53. Ringelheim Crucifix, *c*. 1000. Ringelheim

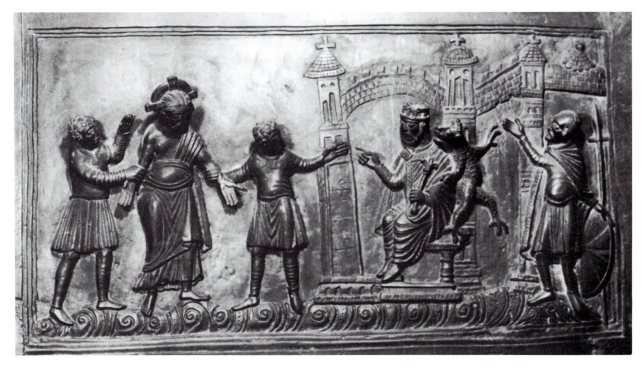

54. Christ before Pilate. Bronze Doors of Bishop Bernward of Hildesheim made for St Michael's Monastery, 1015, now Hildesheim Cathedral

55. Opening of St John's Gospel.
Gospel Book of Bernward of Hildesheim, *c.* 1015.
Hildesheim, Cathedral Treasury, f. 174

54 he stands arraigned before Pilate looks every inch the judge rather than the accused, like God who reproaches Adam and Eve in the Garden of
53 Eden immediately to the left. The wooden crucifix of Ringelheim, where Bernward's sister Judith was abbess until her death in 1000, is a clear case of the same attempt at a balance between divinity and humanity. The figure of Christ, albeit dressed only in a loin cloth, has a stillness and resignation as suggestive of the sublime victor as of the humiliated sufferer (cf. the Gero Crucifix, pp. 133-34, 137-38). This crucifix was temporarily moved from Ringelheim in 1946 and set up in a public park at Salzgitter for the silver jubilee mass of a parish priest, Pfarrer Wilhelm Gnegel. Standing free for once, the interesting discovery was made of a small borehole in the back of Christ's head, into which had been placed a tiny chip of stone from his tomb, a relic brought from Rome by Bernward in 1001, and on the dorse of the small piece of parchment explaining this was found to be written B+ ep.[158]

The human Christ is very much present in all Bernwardine art, not in a simple way, for Bernward was far from being a man of simple piety. The leader of his scriptorium in the high period of the Hildesheim manuscripts

100

56. Opening of St John's Gospel
Uta Codex, Regensburg, *c.* 1020
Munich, Bayerische Staatsbibl.,
Clm. 13601, f. 89v

(*c.* 1010-20) was a deacon called Guntbald (or Guntpold). This scribe (and presumably artist) had evidently been acquired by the bishop to Regensburg and was imbibed with its script and art and the theology which was beginning to penetrate it from the cathedral schools of Northern France (see pp. 128-29), where Bernward himself had been in 1007. The patterned backgrounds, the style of acanthus borders and the rows of fine letters on ornamental strips, all speak of Regensburg influence in the Guntbald Gospels of 1011 and Sacramentary of 1014, as does the mention of St Emmeram twice over in the text of the canon of the mass of the latter book.[159] The great Bernward Gospel Book of *c.* 1015, not apparently the work of Guntbald but nonetheless influenced by Regensburg, depicts the Incarnation in a profoundly theological way, as if to show how the birth of Christ as God made man had reorientated the whole cosmos.[160] It is a meditation on the opening of St John's Gospel, and also an extrapolation from the illustrations on the schematic evangelist page of St John in the Regensburg Uta Codex (*c.* 1020), or rather from their source. Regensburg thus opened up the possibility of giving theological control to the representation of Christ in Hildesheim art (which as art never rose to the heights of Regens-

55
56

burg). But it was very much the human Christ which was being controlled. Konrad Algermissen has shown, for instance, how in casting the bronze doors, Bishop Bernward seems to have had in mind the *Heliand*, the ninth-century Old High German epic about the Life of Christ which he must have known from his Corvey and Essen connections. The setting of the Annunciation scene is very much the *Burg* of Nazareth rather than just Mary's house; Simeon comes *out* of the Temple to meet the child in the Presentation; Pilate wears a crown when Jesus stands before him; all in accord with the *Heliand*.[161]

An inscription on Bernward's tombstone, which he devised for himself,[162] virtually provides us with the theological basis for the depiction of the human Christ in Hildesheim art. Besides a reminder of his own humanity, and of his human fallibility, Bernward cited the Book of Job, 19, 25-27, whose words another Saxon made even more famous 720 years later: 'I know that my redeemer liveth, and that he shall stand at the latter day upon the earth; and though after my skin worms destroy this body, yet in my flesh shall I see God; whom I shall see for myself, and mine eyes shall behold, and not another, though my reins be consumed within me.' *In my flesh shall I see God ... mine eyes shall behold; the ghost of those* Carolingian writers who hesitated to say that God could ever be perceived with corporeal eyes (see p. 91) seems to be laid with this text and inscription.

Most of the manuscripts of which we have evidence, and the bronze doors, and also apparently the candlesticks, were made not for Bernward's cathedral but for the monastery of St Michael, founded by Bernward with the help of monks whom he brought to Hildesheim in 996 from St Pantaleon, Cologne, a monastery of the Gorze reform.[163] It is perhaps surprising that an Ottonian bishop who lead a cathedral chapter of secular canons but whose religious heart was more in the Benedictine monastery of his city, with its *communis vita* centred on the Eucharist (*vide* Algermissen on the eucharistic symbolism of the candlesticks),[164] should not have done what the English reformers of the tenth century did when they turned their cathedrals into cathedral monasteries. Patrick Wormald has rightly commented upon it in the case of Adalbert, first Archbishop of Magdeburg, himself a monk unlike Bernward, whose new archbishopric was to be based on the abbey of St Maurice. As he points out, it was never once suggested that the monastic community could simply become the cathedral chapter.[165] Perhaps this was partly because, with canons far more numerous than monks amongst the royal chaplains in the empire, churches of canons had the important function of training men for the ruler's service — Hildesheim, Magdeburg and Bamberg (founded from the start in 1007 with a cathedral of secular canons and the monastery of St Michael) were all themselves important chapters for the recruitment of royal chaplains.[166] Perhaps also it was partly for the reason given in the *Vita* of Burchard of Worms: 'Every one who fears the Lord and acts justly is acceptable to him, not only the monk but also the canon and even the layman; it is not good that every sailor on a ship should do the same job.'[167] Thus it was felt that

102

a bishop's See should have a variety of institutions with differentiated functions and types of religious experience. Whatever the explanation, however, Bernward's was an art considerably orientated towards a monastery of the Gorze Reform, which was also an episcopal proprietary church, or *Eigenkirche*, of his own foundation.

Bernward's close relations with Otto III and Henry II made him an important link between the religious content of Christ-centred art and the political ideology of Christ-centred kingship. As a young man in his twenties, he was doubtless the '*Bernwardus comes et clericus*' who took part in the Saxon assembly of Asselburg in 984 which championed the cause of the boy Otto III against Henry the Quarrelsome of Bavaria. Some two years later he became a royal chaplain, and in 988 he was chosen by the Empress Theophanu to be tutor to her eight-year old son.[168] We need not doubt the life-long influence over Otto III which according to Thangmar this position gave him, an influence discernible in the sphere of art (see pp. 171-73). He saved Otto from a dangerous Roman uprising in 1001 by his military leadership, and although one must allow for the rhetoric of documentary *arengae*, a diploma of Otto III of that year refers to Bernward in especially fulsome terms.[169] In the succession dispute of 1002 he at first sided with Ekkehard of Meissen, but after Ekkehard's murder he switched to Henry of Bavaria who became Henry II, and received Henry's support subsequently in the *cause celèbre* of Hildesheim *versus* Mainz on who had jurisdiction over the nunnery of Gandersheim, or rather within whose diocese Gandersheim was.[170]

The high point of interest in the depiction of the human Christ at Hildesheim, is the Last Supper in the Bernward Gospels. This book is a text of *Col.Pl. XI* the four gospels, having the Bernward dedication which we have discussed as its frontispiece, and before each gospel a series of full-page miniatures, each divided vertically into two. Of the Luke miniatures, two are Passion scenes, the Crucifixion being repeated among those before John. It may not be quite usual in Ottonian art to associate the Passion scenes with St Luke, though this is exactly what is done in the sixth-century St Augustine's Gospels, but it is entirely explicable. The ox, evangelical symbol of Luke, was a sacrificial beast, and an iconographic equivalent in this respect to the lamb, symbol of Christ's suffering and death. Carolingian and Ottonian *tituli* to St Luke make this clear, for example the verses in a Reichenau gospel book formerly at Bamberg and now at Munich (Clm. 4454):

> *Ruminat ore bovis, Lucas arcana tonantis*
> *Agnus, qui moritur, nova gratia Christi habetur.*
> Luke chews over the mysteries of the Thunderer
> [i.e. Christ] in the mouth of the ox;
> The Lamb who dies represents the new grace of Christ.[171]

The symbol of the ox is placed at Christ's feet in the Luke Crucifixion of the Bernward Gospels, where, most unusually for this scene in Ottonian art, Mary has tears running down her cheeks.

57. Crucifixion and St Luke. Gospel Book of Bernward of Hildesheim, *c*.1015. Hildesheim, Cathedral Treasury, f.118v

103

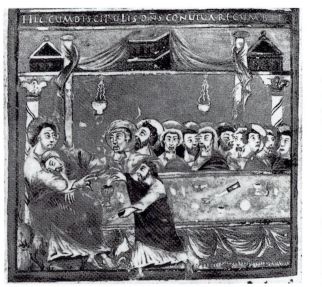

58. The Last Supper. Franco-Saxon Gospel Book, C9.
Prague Cathedral, Cim. 2, f. 185v

59. The Last Supper. Greek Prayer Book of South Italy, *c.* 1000.
Vatican , Bibl. Apost., MS Gr. 1554, f. 178v

The Last Supper represents a group of ten apostles clad in white (with slight tinges of green and yellow) seated at the table on the right of the picture, though on this arrangement all but four of them, including Peter in the foremost position, have slender chance of getting food or drink. On the left, Christ is seated at the head of the table, putting bread with his right hand into the mouth of Judas, the one apostle on the near side of the table, as if in an Apostles' Communion, while the youthful John the Evangelist sits with his head on Christ's bosom. Judas is dressed in green; he is not of the white-clad, heavenly company of the others. The group of Christ, John and Judas is marked out not only by a spacial hiatus between them and the others, but, in addition, by the interposition of a prominent hanging-lamp.[172] The whole scene is enacted before a typically Regensburg patterned background of reddish colour.

For much of the iconography of this Gospel Book, including the Last
58 Supper, it is known that a Carolingian Gospel Book now in Prague (Cathedral, Cim. 2) served as a model. Beissel in 1891 noted the relation of the system of pericopes in these two books.[173] The Prague Gospels, which has the same prominent hanging-lamp, is the very first known representation in Christian art of John the Evangelist with his head on Christ's bosom (or in this case somewhere near Christ's bosom) at the Last Supper. The Hildesheim Last Supper affords the next earliest example. *Prague* is almost certainly based on an eastern prototype, for John is bearded in the Byzantine manner, and the way in which he lies horizontally *along* the table is paralleled in early surviving eastern representations of the eleventh century.[174] The first separation of Christ and John into a separate group occurs in the Last Supper of the Chludov Psalter (Moscow Historical Museum, Cod. 129, ? 815-37), a Byzantine manuscript of the late- or immediately

104

post-iconoclastic period.[175] Bernward himself, or his artist, who was certainly not following the *Prague* model slavishly, could have seen and been stimulated by representations of this sort in Italian Greek manuscripts of his period. There is one such, with John inclining his head towards Jesus, in a South Italian Greek prayer book of around 1000,[176] and another in a *59* central Italian gospel book, whose localization is disputed as between Bologna and Nonantula.[177] The abbacy of Nonantula was held from 982 to 992 by John Philagathos, a Greek monk from Rossano in South Italy and Bernward's predecessor as Otto III's tutor.[178] Bernward as a royal chaplain and Philagathos thus overlapped with each other at court.

When the ninth-century Last Supper of the Prague Gospels is compared with that of Bernward, the contrast of feeling is all the more striking in view of the iconographic similarity. In *Prague*, the ill-handled figure of John seems to flop onto Christ, while every consideration of meaningful gesture is a thousand miles away. With Bernward we are treated to a controlled representation of contrasting relationships — for this whole page is in fact primarily about Judas. Judas's right hand is on Christ's right hand as he takes communion. The trustworthy left hand of Christ, placed gently on John's shoulder as he rests his head on Christ's bosom — this is a new iconographic detail — 'answers' the treacherous hand of Judas. By the highest technical standards of the Ottonians, this page is no great work of art. All the more impressive is its scarcely matched tenderness and poignancy, whereby the onlooker can dissociate himself from the disloyal Judas and identify himself with the human relationship between John the Evangelist and Christ.

7 Interaction of Iconographic, Aesthetic, and Religious Aims

After the lengthy progression of this chapter so far, let us try to put a few reasonable propositions.

Ottonian art brought the divine nature and the imperial image of Christ's person closer together than they had hitherto been in the West.

Ottonian art shifted from the Carolingian inhibition against illustrating the human life of Christ without proper chaperoning (so to speak). The chaperoning agent had been an Old Testament context, or an evidently didactic purpose, or the fact that only one or two highly educated people would see anything. With the Ottonians, the subject came to be allowed out on its own.

But there was a general norm of right behaviour when it was out on its own. Ottonian art, with few exceptions, preserved a Carolingian sensitivity to sustaining the divine nature of Christ.

The imperial image of Christ, and the Christ-centred image of emperorship, together constitute a vital factor in the sustaining of the divine character of Christ in Ottonian art, and both iconography and aesthetics were engaged in its support. It is the atmosphere of rule and emperorship which the Christ of Ottonian illustration breathes. The Christ who moves with

majesty and drama through the pages of the Ottonian gospel books, is admirably congruent with the political imagery of the conquering, expanding Saxon emperors. He is not the meek and humble Christ whom Bede had in mind when he held up his models of Christ-like kingship from the seventh century. He is very much the God of power and might, Christ the worker of miracles, the *Wundertater*. The principal wall-space of St George's church, Reichenau, is occupied by just eight splendid, large-scale scenes of the Life of Christ, all eight of them miracles. Prominent among depictions of Christ's miracles under the Ottonians, are exorcisms of evil spirits, and prayers of exorcism current at the time describe those who functioned in the office of exorcist as 'spiritual emperors'.[179]

In many cases, the Ottonians stressed the aspects of Christ as ruler and judge even more than their late antique models would seem to have done. *61* The story of the Widow's Mite, a rare subject in western art, but one which figures in the Gospel Book of Otto III, is an example of this. There are two earlier Ravenna sources, one a fifth-century ivory and the other a sixth-*60* century mosaic in S. Apollinare Nuovo.[180] In the ivory, Christ sits on a round 'world-seat' at the left of the scene, commending the widow's generosity; in the mosaic, he stands on the right. In the Gospel Book, Christ is seated majestically against a gold ground underneath one of the arches of splendid baldacchino architecture in the centre of the picture. The widow's action here gives way to the fact of Christ's judgment of it in central importance. On the right is the widow, while to the left stands Peter at the head of a group of apostles. Peter makes a gesture, with his hands open and his arms somewhat spread. It could be read as the receiving of Christ's teaching; such gestures of those who received biblical teaching were common in Carolingian art.[181] Or it could be read as a gesture of

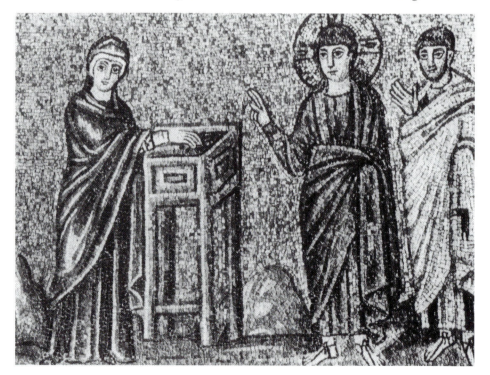

60. The Widow's Mite. Mosaic, C6. Ravenna, S. Apollinare Nuovo

61. The Widow's Mite. Gospel Book of Otto III, 998-1001.
Munich, Bayerische Staatsbibl., Clm. 4453, f. 192

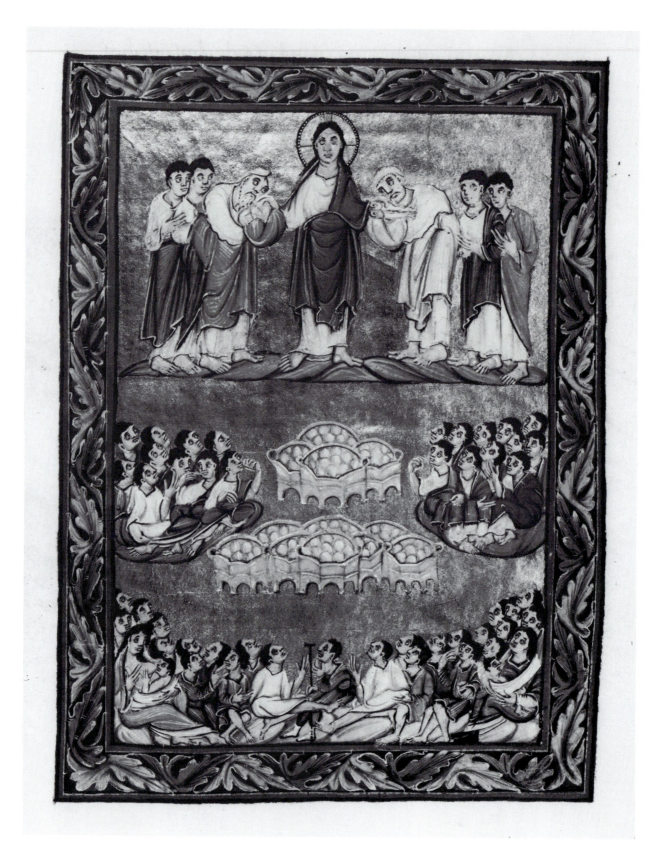

62. Feeding of the Five Thousand. Gospel Book of Otto III, 998-1001.
Munich, Bayerische Staatsbibl., Clm. 4453, f. 163

prayer, such as a priest might make at mass, turning the widow's offering into something sacramental, as it were.[182] Perhaps it was intended to contain both elements. Judicial as is the posture of Christ, his face is evidently intended to convey tenderness towards the widow. One is reminded by the qualities of this figure, of Messerer's perceptive observation on the imperial seal of Otto I: 'Every expression of solemnity and majesty, which *2* was experienced as the identity of power and tenderness, or in the *Leit-worte* of the times, as the unity of *fortitudo* and *clementia*, is grounded in this composition' (i.e. the seal).[183] For centuries *clementia*, or mercy, had been regarded as a virtue which rulers should display towards widows.[184] The combination of justice and fortitude in the posture and positioning of Christ, and the *clementia* in his face, which one sees in the Gospel Book, and which Messerer felt in Otto I's seal, is exactly the combination which Karl Leyser has described in the actions of Otto I. Leyser shows that contemporaries regarded this combination of virtues as essential to effective rule. A ruler had to inspire terror, yet he suffered too many acts of treachery to be able to react with anything but *clementia* to most of them.[185]

When Ottonian art humanizes the Life of Christ, much of the humanization lies in the figures around him, and in their relation with his God-like majesty. The Feeding of the Five Thousand in the Gospel Book of Otto *62* III is a case in point. Christ himself stands, frontal and hieratic. But the lower group of people seated on the ground being fed, with its wonderful movement, like a ripple of gladness running across the lower part of the page, is another matter altogether. The artist has been inventive with this group. Some of the figures in it, the suckling women for instance, may have been drawn from an antique source, but a comparison with other Ottonian 'Feedings' suggest that the group as a whole is not closely founded on any particular model.[186]

Ottonian artists were generally careful not to humanize Christ too much, particularly in their Passion sequences, which might lend themselves too easily to this effect and so allow his physical debasement to be paraded. The Scourging at the Pillar appears once in Ottonian manuscripts, in the Codex Egberti, before being dropped from the iconographic canon, to be taken up again only at Echternach some fifty years later. In the Codex Egberti, Christ stands at the pillar, dressed in a full-length garb of imperial *27* purple, still a picture of divine dignity. Those who had access to Italian art, as the Ottonians had, must have known of other ways of presenting this subject. The ninth-century Stuttgart Psalter, which as we saw may be taken to reflect early medieval Italian art (see p. 75), shows Christ bound to the pillar, stripped to the waist, and with the blood marks from his *63* ordeal showing all over his body. Such a scene might have appealed to Abraham of Freising's correspondent, Rihkar, but it appears to have been strenuously eschewed by Ottonian artists. It surfaces again in Italy, however, with the same kind of physical realism, on the twelfth-century bronze doors of San Zeno, Verona, though being bronze the blood-marks are not shown. The Crowning with Thorns, a subject treated graphically in late

frenduerunt sup me dentibus suis

Dne quando respicies restitue animam mea
a malignitate eorum

63. The Scourging at the Pillar. Stuttgart Psalter, *c.* 830.
Stuttgart, Württembergische Landesbibl., MS Bibl. Fol.23, f. 43v

64. The Crowning with Thorns.
Golden Altar of Aachen, prob. Fulda,
c. 1000. Aachen Cathedral

autem flagellatum tradidit eis: ut crucifigeretur.

65. The Crowning with Thorns. Gospel Book,
Salzburg, *c.* 1020-30. New York,
Pierpont Morgan Library, MS M 781, f. 84v

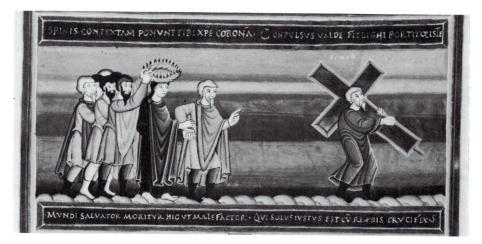

66. The Crowning with Thorns and other Passion Scenes. Gospel Book, *c.* 1030.
Codex Aureus of Echternach, Nürnberg, Germanisches National-Museum, f. 111

medieval art, does not figure in any Reichenau Passion sequence. It is represented on the golden altar of Aachen, but this makes our point better *64* than its absence would have done, for it is given the appearance almost of a *maiestas*, with Christ seated erect, book in hand, the crown of thorns scarcely in evidence. A Salzburg manuscript of *c.* 1020-30 (New York, Pierpont Morgan Lib., M. 781) used the same (possibly Byzantine) prototype. *65* The crown here is very prominent, but far from looking thorny, it gives the impression of a grand honorific symbol. In both these scenes Christ is dressed in dignified undergarment and cloak. So he is in the Echternach gospel books. In the Codex Aureus at Nürnberg (*c.* 1030), for instance, *66* where Christ is none too erect in the scourging at the pillar, again stripped to the waist with blood visible, he subsequently walks in great dignity behind Simon of Cyrene, who carried his cross, while the crown of thorns is held over his head by one of the 'soldiers'. This crown looks more like a victory wreath.[187] The Codex Egberti, alone among Ottonian manuscripts, has the Ecce Homo scene. It contains only two figures, Pilate and Christ *Col.Pl. VI* himself. Christ stands alone in an expanse of otherwise empty space, very much *solus Deus*, and dressed again in the full-length purple *collobium*. The one scene in which the whole general principle is somewhat relaxed is the Crucifixion itself, where Carolingian precedents allowed a greater display of Christ's humanity. But outside Cologne (and its spheres of influence), where the Gero Crucifix seems to have established a particularly 'human' canon, even Crucifixion scenes which lack any sign of divinity — in the *collobium*, or the hieratic posture, or symbols of eternity — are comparatively rare in Ottonian art. For the most part the Christ of the Passion scenes is a figure wronged, but dignified in clothing and deportment.

The way in which the Ottonians continued the Carolingian stress on the divinity of Christ when considering his human life can be interestingly illustrated. In the Prague Gospel Book of the later ninth century from a centre influenced by Franco-Saxon art, perhaps St Vaast rather than St Amand (see pp. 104-5), whose illustrations are unique in surviving Carolingian art, each of the evangelist portraits is preceded by an illustration in the life of the evangelist concerned. In two cases, those of Matthew and John, the scene is also one in the Life of Christ. We have dealt with the John illustration above (see pp. 104-5). That of Matthew is Christ's calling *67* of the future evangelist. The scene is an entirely simple one. Christ beckons Matthew to himself; the customs officer follows eagerly, allowing a handful of gold and silver coins to fall to the ground as he does so; at his feet lies an intriguing sword with elaborate belt and buckle, as if he were in some way giving up the life of the sword. But the scene was too simple for the artist. The all important didactic, theological dimension was missing. This was supplied by a semicircle at the top of the picture. Here two angels, of a lively draughtsmanship not unworthy of their obvious Rheims antecedents, set against a background of heavenly blue, bend down to worship Christ on earth. Round this semicircle is an inscription in gold

67. Christ's calling of St Matthew.
Franco-Saxon Gospel Book, C9.
Prague Cathedral, Cim. 2, f. 23v

letters which reads: *Hic chorus angelicus dominum reverenter adorat* (Here the angelic chorus reverently adores its Lord). Thus was the divinity of Christ not allowed to go by default. This scene was copied, with less 68 realism and on a page reduced almost entirely to surface pattern, at Corvey or Hildesheim, in the late tenth or early eleventh century. But the Ottonian artist saw fit to retain the semi-circle, with its angels and its inscription.

Now we come to the question: Are the religious aims of the Ottonians, to illustrate the human life of Christ in such a way as to preserve his divinity, and their aesthetic aims, to retreat from spatialism to surface art or *Flächenkunst*, connected with each other? This is the hardest of questions, because we cannot speak (so far as I know) with the words of contemporaries in trying to answer it. In the Carolingian age, tracts were written about images and art. This literature was not for the most part aesthetic theory, but at least some deductions about artistic taste are possible from it. Under the Ottonians every deduction about aesthetic aims

112

68. Christ's calling of St Matthew.
Single Leaf of a Corvey Gospel Book,
late C10. Helsinki,
National Museum of Finland

in book illustration has to be made from the art itself. We cannot call on written sources to enlighten us about the art; art itself is our principal source on itself.

It seems inescapable, however, that the Ottonian drive towards surface art was indeed connected with the attempt to pictorialize a divine person. Messerer again, on Otto I's imperial seal of 962, in which an earlier profile was abandoned in favour of a frontal representation, would see a connection between the political intention of this change — to match the Byzantine emperor in his deified image — and what he calls the surface unity (*Flächeneinheit*) achieved by this new seal. Here was a harmony between the towering figure beautifully poised within its roundel, the ample swing of the draperies, and the broad bend of the arm running with the inscription on the border.[188] Seals were of great importance in the projection of images of rule at this period, and we must reckon that they influenced other forms of art. Their medium is one which naturally lends itself to

113

two-dimensionalism rather than to spatialism. In Otto I's seal of 962 an enhanced image of rule and a new achievement of surface design go hand in hand.

The Codex Egberti, early amongst great Ottonian Christ cycles, contains elements of late antique illusionism, not surprisingly since its leading painter, the Gregory Master, was indeed a master of handling his late antique model or models. Hans Jantzen, though acknowledging the retention of some late antique aspects, maintained that spacial illusionism had fallen away even in this manuscript. 'Everything spatial', he wrote, 'is fused into one delicately coloured, richly toned surface.'[189] One would not quarrel with this fine observation, and in any case, the future of Ottonian art did not lie with the Codex Egberti where its residuum of spacialism is concerned. But if corporeality may be related to a three-dimensional concept of space, then it should be noted that corporeality is not entirely absent here. Yet it is not applied to Christ. However well rounded the *69,70* buttocks of Judas as he kisses Christ, however shapely the calves of the *71* leper whom Christ cures, however protruding the belly of the centurion with whom he converses, Jesus himself remains a strictly two-dimensional figure. To him, above all, Jantzen's description of the 'coloured silhouette before a lightly toned background' applies.[190]

The absence of antique corporeality has been noted of Jesus and The *Col.Pl. IX* Sons of Zebedee in the Aachen Gospels. There is here a weightlessness, or rather a weight which seems to come only from the inclination of the head and the gesture of speech. Grimme has said of the figure of Jesus on this

114 69. Judas kisses Christ. Codex Egberti, 977-93.
Trier, Stadtbibl., MS 24, f. 97v

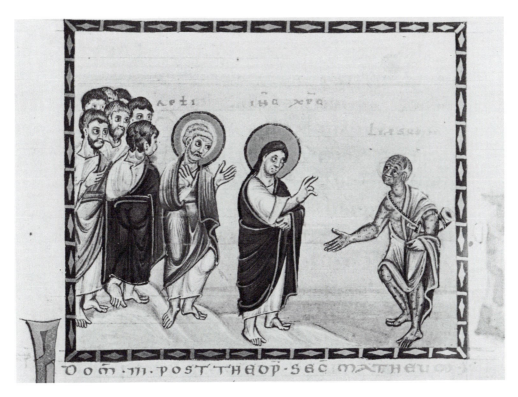

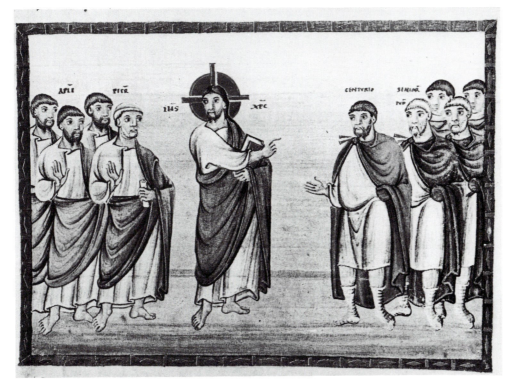

70. Healing of the Leper. 71. Christ and the Centurion.
Codex Egberti, 977-93. Trier, Stadtbibl., MS 24, ff. 21v, 22

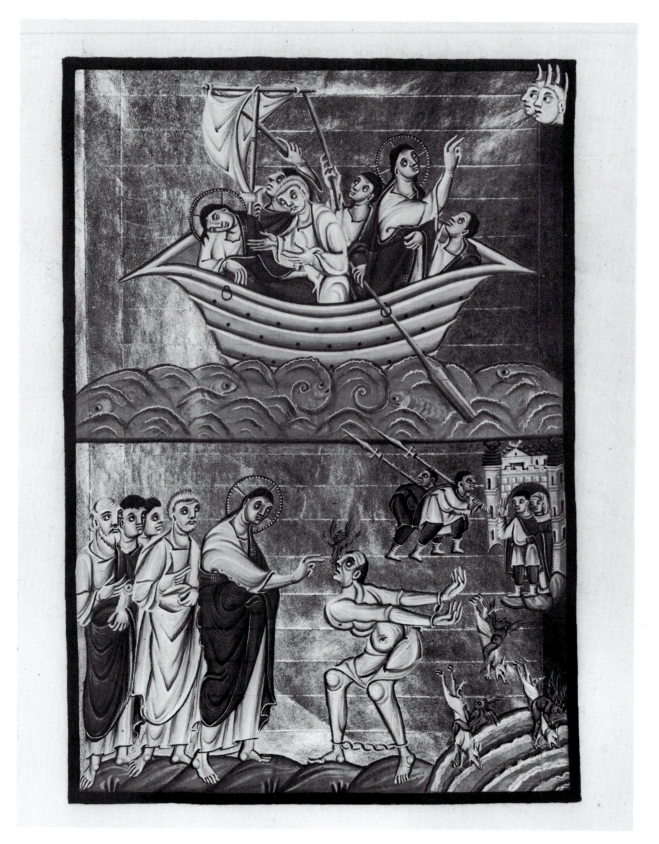

72. The Storm at Sea. Gospel Book of Otto III, 998-1001.
Munich, Bayerische Staatsbibl., Clm. 4453, f. 103v

page: 'The white undergarment and the red cloak cover no modelled body and have no hold on the shoulders'. In this book almost everything seems to become disembodied and spiritualized. Again Grimme has commented that the original idea of placing the evangelical scrolls around the nimbuses of the evangelists is, as it were, 'a spiritual context for the rotulus of the apotheosis picture covering the emperor's heart'.[191]

The Aachen Gospels is one of the earliest Ottonian manuscripts to introduce golden backgrounds. We remarked earlier that the Gero Codex, in its tendency to reduce Carolingian spatialism to flat surfaces, not least in the backgrounds, was logically preparing the way for golden grounds, which are the very antithesis of spatialism. Golden backgrounds can be traced far back to Egyptian ruler representations. Gold was the divine solar light dispensed by Aton. These grounds were a feature of antique mosaics in the West in Rome and Ravenna, and of Byzantine painting of the Macedonian period.[192] A much later Byzantine proem refers to the Ark of the Covenant, which foreshadowed our living Ark, the Virgin recipient of God and Mother of God, as being surrounded and protected by assayed and unadulterated gold.[193] It represents a very old tradition which associates gold with divinity. The function of the gold grounds in Ottonian art was above all to set off the gestures of the figures, particularly those of Jesus. Jantzen rightly stressed the overwhelming importance of gesture in the articulation of Ottonian figures. All kinds of exaggerations and distortions occurred in order to create something of quite expressionistic character, which Jantzen called the *Gebärdefigur*, the Gesture Figure. In order to create the *Gebärdefigur* the picture was emptied of all space, and *Unraum*, i.e. 'spacelessness', reigned.[194] Where there was no space, there was no time either. Spacelessness and timelessness go together. Thus it was no problem to have in one and the same boat, a Christ who was asleep, and another who stood very much awake ordering the winds to cease their blowing. In other words, the gesture, set off against the gold ground gained an eternal significance, or a liturgical significance in the sense of an act removed from its ordinary context in the world and sublimated by ritual. Hence gold, by its divine significance as a substance, by its creation of a superb surface art, and by the magnificent way in which it could eternalize the acts of God made man in the Life of Christ, came into its own in the art of Ottonian books as well as in the other Ottonian arts.

72

117

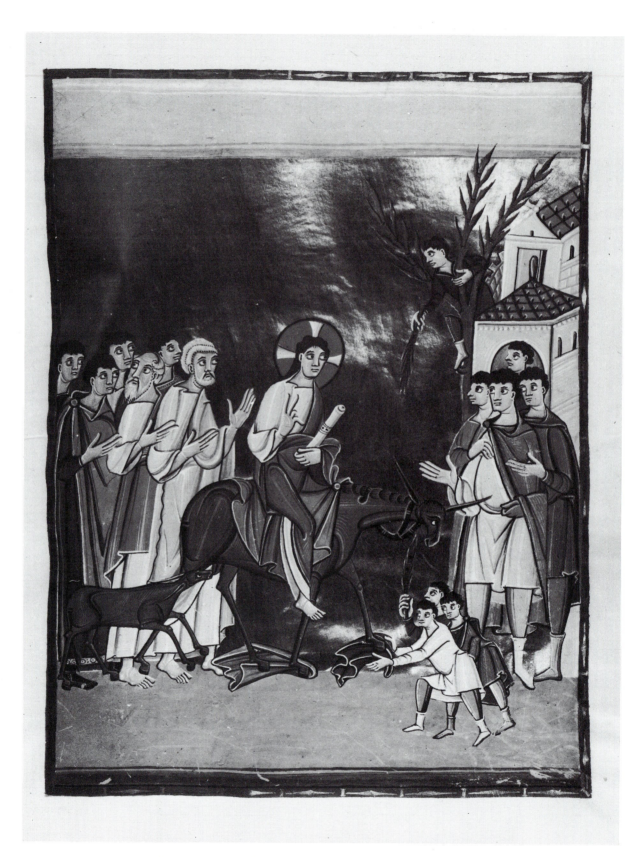

73. The Entry into Jerusalem. Pericopes Book of Henry II, Reichenau, 1002-12,
Munich, Bayerische Staatsbibl., Clm. 4452, f. 78

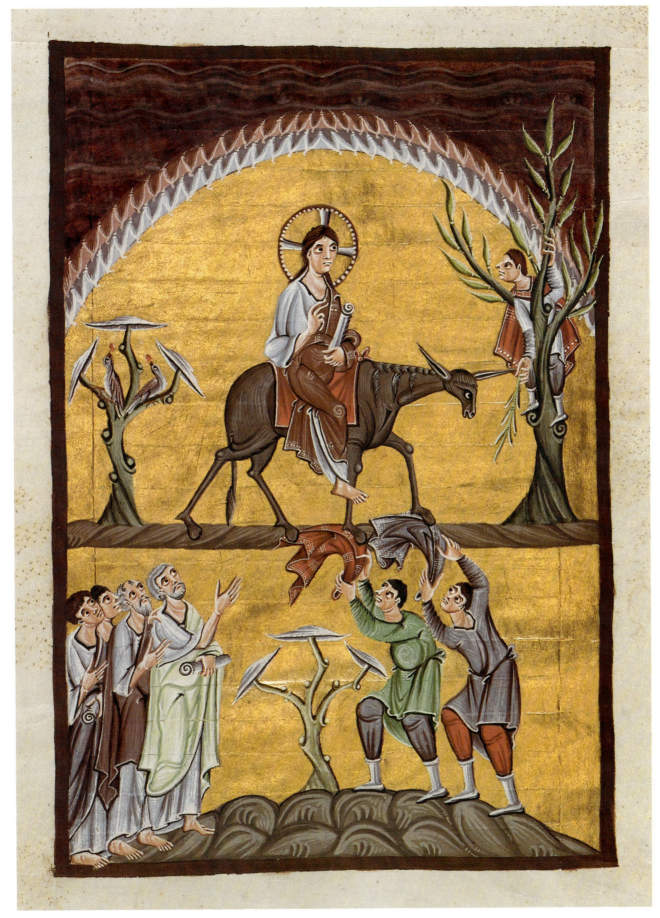

XIX. The Entry into Jerusalem. Gospel Book of Otto III, 998-1001. Munich, Bayerische Staatsbibl., Clm. 4453, f. 234v

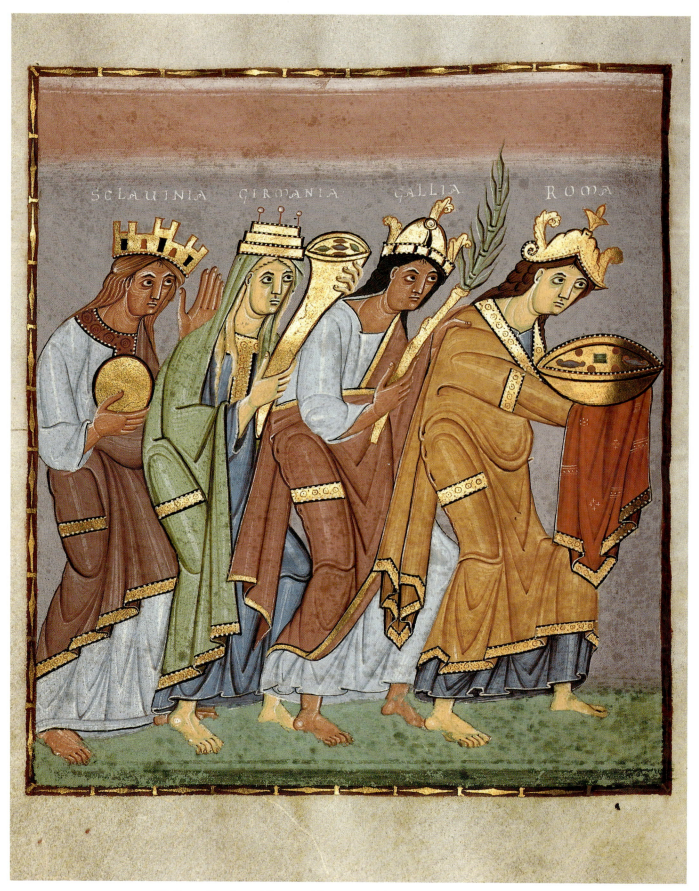

XX. Personifications of Rome and Provinces of the Empire approaching Otto III.
Gospel Book of Otto III, 998-1001. Munich, Bayerische Staatsbibl., Clm. 4453, f. 23v

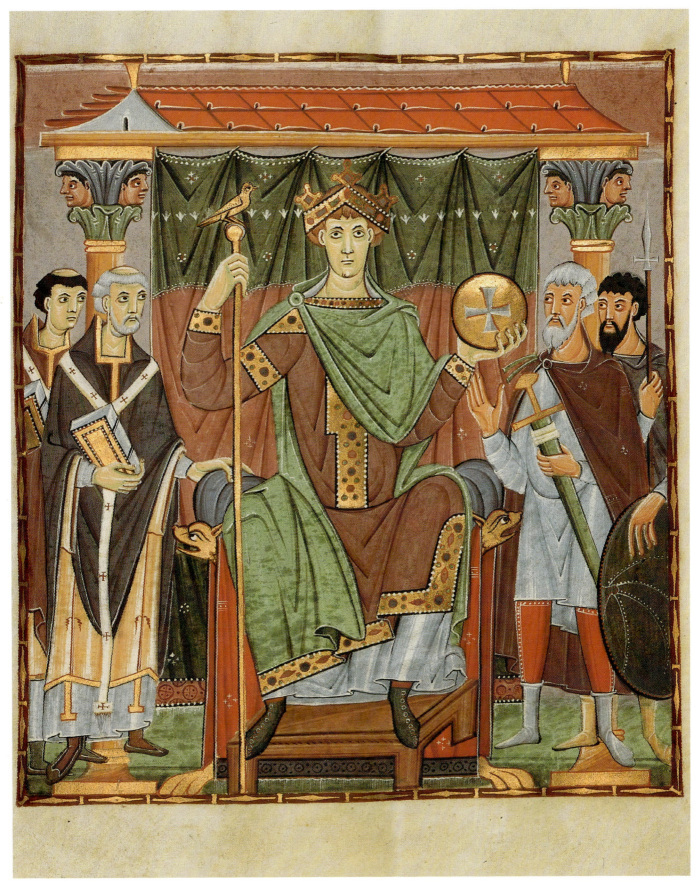

XXI. Otto III seated in Majesty. Gospel Book of Otto III, 998-1001.
Munich, Bayerische Staatsbibl., Clm. 4453, f. 24

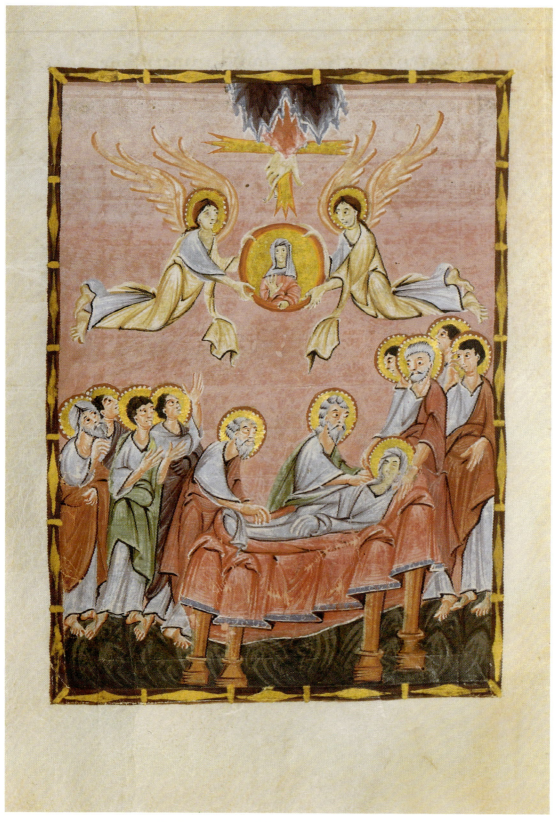

XXII. The Dormition of Mary. Troper, Reichenau, 1001.
Bamberg, Staatsbibl., MS Lit. 5, f. 121v

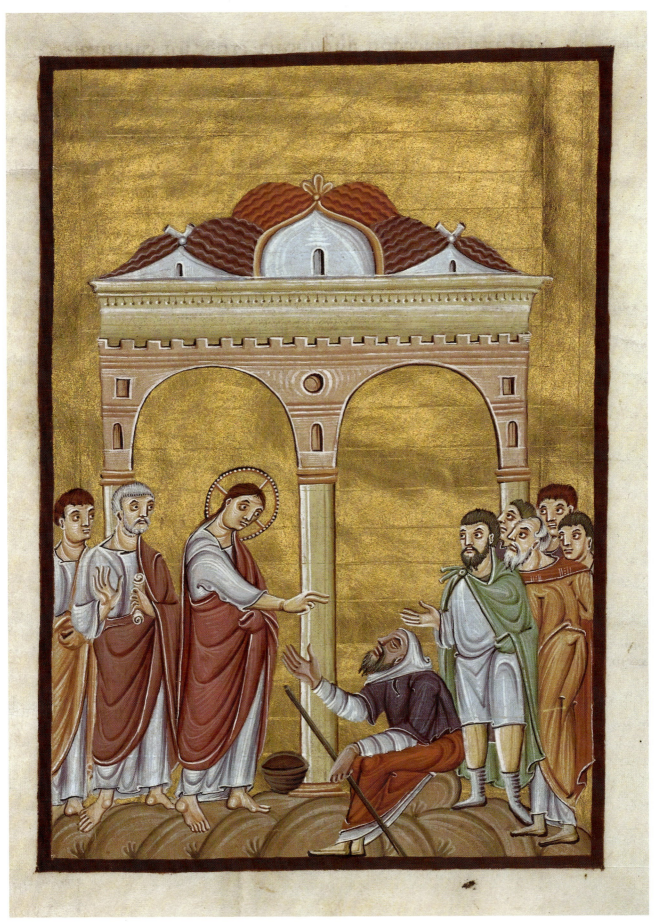

XXIII. The Healing of the Blind Man at Jericho. Gospel Book of Otto III, 998-1001.
Munich, Bayerische Staatsbibl., Clm. 4453, f. 119

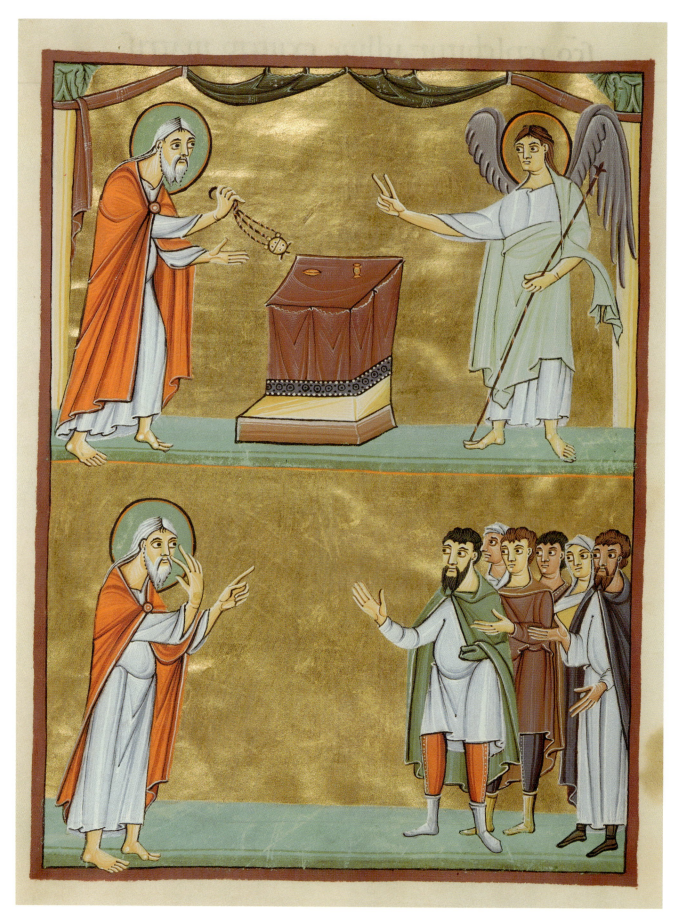

XXIV. Zachary and the Angel. Pericopes Book of Henry II, 1002-12.
Munich, Bayerische Staatsbibl., Clm. 4452, f. 149v

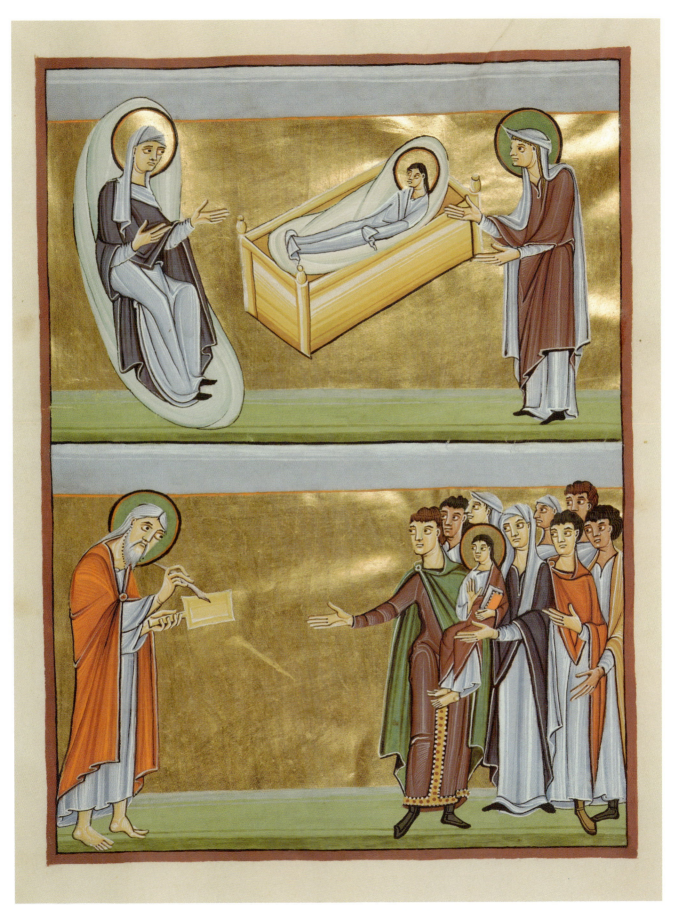

XXV. The Birth of John the Baptist. Pericopes Book of Henry II, 1002-12.
Munich, Bayerische Staatsbibl., Clm. 4452, f. 150

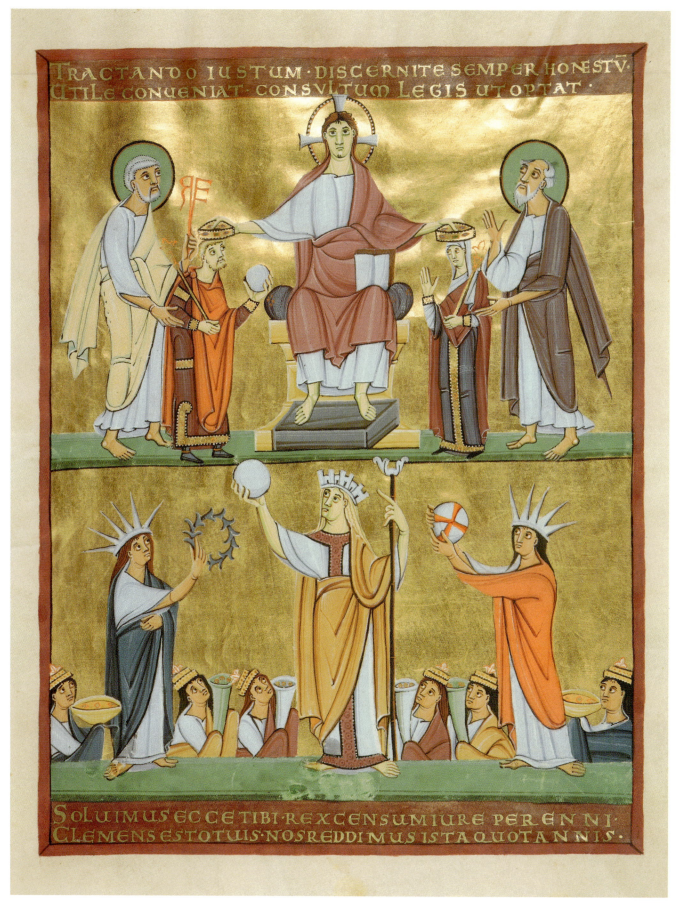

XXVI. Henry II and Kunigunde crowned by Christ.
Pericopes Book of Henry II, 1002-12. Munich, Bayerische Staatsbibl., Clm. 4452, f. 2

CHAPTER THREE
Religion and Politics in Ottonian Art

O NE MAY SINGLE OUT three themes, of importance for the canonization of political authority, which had their roots in Ottonian religious devotion: The Entry into Jerusalem, the Crucifixion, and the Dormition and Assumption of Mary. Each of these themes had a lively existence in Ottonian art, and together they illustrate the way in which religious feeling and political ideology were intertwined.

1 The Entry into Jerusalem

In Antiquity the solemn arrival of an emperor at a city was a ceremony designed to make a great impact on his subjects' imagination. By the fourth century Christ's entry into Jerusalem was being depicted in visual art as an imperial arrival, an association which by no means escaped the Carolingians and the Ottonians, into whose itinerant kingship it fitted well. There was the city, the welcoming or rejoicing multitudes, and the apostles looking like court officials behind the emperor. Palm Sunday, the Sunday before Easter when the entry into Jerusalem was celebrated, offered an exceptionally good occasion to advance the Christ symbolism of kingship and emperorship.[1]

A remarkable Palm Sunday was that of 1002, when the body of the youthful Otto III, who had died in Italy, was solemnly received by Archbishop Heribert of Cologne into his city, as if it were Christ entering Jerusalem. The week, begun in this manner, continued with a no less extraordinary liturgy. On Monday the body was carried to the Church of St Severinus, on Tuesday to St Pantaleon, on Wednesday to St Gereon, and on Maundy Thursday to the Cathedral, where according to the ecclesiastical usage by which sins were remitted to penitents on that day, Otto's soul was granted forgiveness amongst the rest of the congregation. Then, as if to symbolize that the Maundy Eucharist was the last meal which Christ had with his followers before they separated in this world, the emperor's body was taken on Good Friday from Cologne to Aachen where it was buried on Easter Sunday.[2] The timing of the return of Otto III's body to the North, perhaps not uninfluenced by Heribert himself, had given the archbishop a wonderful opportunity to apotheosize the emperor by making his body an image of Christ for the Holy Week ceremonies, and an opportunity to elevate his own city. The chronicler, Thietmar of Merseburg, who reports all this, did not entirely approve of it; he said that it had made Easter, which ought to be an occasion of joy, into an occasion of tears. Perhaps he regarded the ceremonial manipulations of Archbishop Heribert as politically suspect; for Heribert, no supporter of Duke Henry

of Bavaria, was probably using Otto's body as a means of counteracting the ceremonial propaganda with which the latter was making his succession bid.[3] Perhaps, also, Thietmar overlooked the beautiful funeral antiphon, *In paradisum*, an antiphon not without joy, which will have been sung at Otto III's funeral on Easter Sunday: 'may the angels lead thee into Paradise; may the martyrs receive thee at thy coming in and bring thee to the holy city of Jerusalem'. The biographer of Queen Mathilda, mother of Otto I, had not overlooked it in his account of Otto I's death.[4] He had seen Otto I's death as a kind of Entry into Jerusalem. Otto himself would certainly have taken this idea seriously. Probably in 969 when he was in Italy, his anger had been aroused by Archbishop Adalbert of Magdeburg, who had allowed Duke Hermann Billung a solemn entry into his city, with candles and bells, as if he were a Christ-like ruler.[5] The danger which Otto I saw if the liturgy got into the wrong hands is the measure of the force which he attached to its imagery. Besides, the Ottonians themselves favoured Magdeburg for their own celebration of Palm Sunday.[6]

The celebration of the Entry into Jerusalem on Palm Sunday was an extremely old one, but no other feast of Christ was more charged with meaning in the ninth and tenth centuries, to judge by the swell of liturgical elaboration which swept it along in that period. Theodulph of Orleans's *Gloria laus et honor* (Glory, praise and honour be to Thee, O Christ the king), established itself at once as a classic amongst Christian liturgical hymns. Angilbert instituted Palm Sunday processions at St Ricquier in Charlemagne's time, and Hrabanus Maurus followed suit at Fulda in the 820s.[7] Ninth- and tenth-century liturgical books see many new prayers and antiphons for the feast. Amongst the innumerable formulae for blessing the palms from which tenth-century celebrants were able to choose, there was even one for exorcizing the palm frondes, which first appears at Essen in the late ninth century.[8] Liturgical development continued unabated in the tenth century, and royal ceremonial soon became closely and visibly tied to it. A grant of Henry I to Fulda, dated 3 April 920, was made on the Monday after the Palm Sunday when the king 'came there for the first time to pray'.[9] The interest of the elaborate Palm Sunday ritual in Constantine Porphyrogenitus's *Book of Ceremonies* has been commented upon by Averil Cameron, as an example of identification of the Byzantine Emperor with the Christian 'mythology' and the intertwining of royal ceremony with the Christian liturgical year.[10] Western rulers were unlikely to have remained insulated from the attraction and power of this kind of ceremonial. But the role of processions with the palms and of prayers blessing the palms in the tenth-century West imply a sharper focus than in the East on the actual entry of Christ into Jerusalem in the western celebration of this festival.

Certain churches developed their own distinctive ceremonial for Palm Sunday, amounting in some cases almost to a liturgical drama. At Worms in the late tenth century, a procession would go from the cathedral to the monastery of St Andrew for the blessing of the palms and thence to a field

where the choir boys threw their branches and their surplices (*casulae*) before the cross.[11] This kind of ceremony became common in the tenth century; it was the adaptation to local topography which gave it a distinctive look at particular churches. To the imagination of Worms people, their city was supposed to become a piece of first-century Palestine. Worms also had an antiphon for the blessing of the palms, of triumphal character, which is not otherwise known in the Ottonian period: 'rejoice and be glad, Jerusalem! Behold thy king comes, of whom the prophets preached, whom angels ever adore, to whom the Cherubim and Seraphim proclaim Holy, Holy, Holy'.[12]

The most arresting Palm Sunday ceremonies of any church in the Ottonian Empire were performed at Augsburg under Bishop Udalric. Udalric was a high aristocrat, closely related to the ducal family of Swabia, who obtained the bishopric because Henry I could not resist the influence of his family in that region. He held it with distinction for fifty years (923-73); he was one of the great *Adelsheiligen* (noblemen saints) of the period; he played a vital role in the resistance to the Hungarians at Augsburg in 955; and twenty years after his death, in 993, he became the first saint to be formally canonized by a pope.[13]

Amidst the intense prayer and physical austerities of his episcopate, his will to rule, as a trait of character, as well as a just realization of his high social status, is already revealed by a telling episode of his youth. His parents had sent him to the great Swabian monastery of St Gall, to sit at the feet of the grammarian, Waninc. The monks wanted him to join them, but he took the advice of a female recluse called Wiberat who said that he would never rule at St Gall, but he would become a bishop 'in the east where a certain river divides two regions' (a thinly disguised reference to the river Lech and Augsburg).[14] One might expect Palm Sunday, signifying triumph and foreshadowing humiliation, to be a favourite festival of a man who combined the will to rule with the drive toward self-denial.

This is what Gerhard, the author of the *Life of Udalric*, said about the bishop's observance of Palm Sunday:

> On this day at dawn he came to the monastery of
> St Afra, if he had not stayed there overnight.
> He sang the mass of the Holy Trinity and
> blessed the palm branches and various other
> foliage. Then with the gospel book and crosses
> and banners, and *with an effigy of the Lord sitting
> on an ass*, with the clergy and a multitude of
> people carrying palms in their hands, and with
> chants composed in honour of that day, he
> proceeded with great splendour to the hill
> called *Perleihc*. There, with everything
> beautifully done, the choir of canons met him.

The citizens who had remained in the city, and
those who waited to join them there from the
surrounding places (*oppidis*), scattered the way
of the Lord [i.e. of the effigy] with palms and
their own clothes, to imitate the humility of
the children and other people.

After this, the holy man delivered a suitable
admonition to the people about the Lord's
Passion, to the point, often, that he wept and
caused many to weep at his tears. After his
sermon, all praising God came to the cathedral
church and celebrated mass with him, whence
they all went home.[15]

One should not allow the moving account of these ceremonies to obscure
the fact that this is Christ-centred episcopal rule analogous to Christ-
centred royal rule. The effigy of Christ on an ass was probably a painting
on wood, in effect an icon. It was apparently used for the Augsburg
procession in an iconic way, that is not just as a didactic reminder to the
memory of Christ's entry to Jerusalem, but as a sacred object in itself,
mystically signifying the actual presence of Christ. It was the kind of object
which Carolingian churchmen like Claudius of Turin or Agobard of Lyon
would have contemned as superstitious in character.[16] It was also used to
point up the lesson that the bishop was a Christ-figure, acting and being
treated as if he himself were Christ entering Jerusalem.[17] This is not the
first nor the last time that we note the mutual involvement of royal and
episcopal image-making.

Palm Sunday is, however, a very ambivalent feast, because after the
glory and triumph of the palm procession, and the triumphal chants which
Udalric so appreciated, there come the sobering realities of the Passion,
read in St Matthew's version at mass. *Perleihc* was the scene both of Udal-
ric's splendid reception by the canons and of his tears as he preached on
the Passion. Indeed, in the widespread tenth-century ceremonial first re-
corded in an order of service compiled at Mainz before 962, the note of
foreboding is already struck amidst the triumph of the palm processions.

74. The Entry into Jerusalem.
Byzantine, C6. Rossano
Cathedral, Rossano Gospels, f. 1

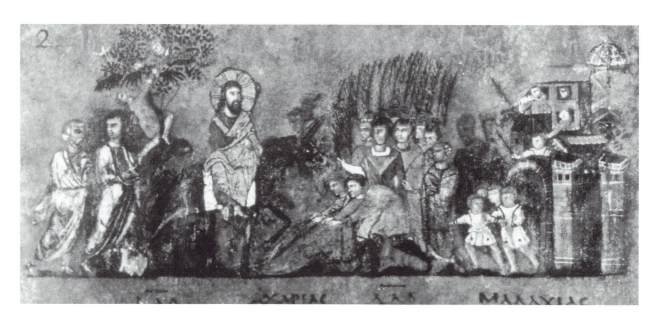

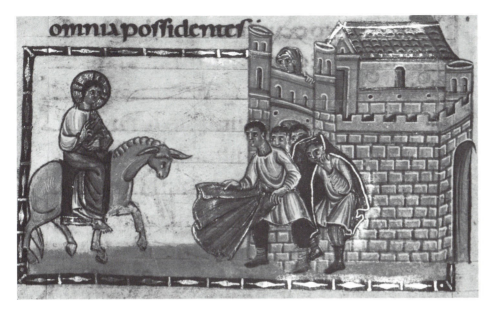

omnia possidentes·

75. The Entry into Jerusalem.
Epistolary, Trier, *c.* 980-90.
Berlin, Staatsbibl.,
MS theol. lat. fol. 34, f. 15v

After the singing of the *Gloria Laus*, the bishop or priest was to prostrate himself on the ground before the crucifix while the clergy sang the antiphon: 'I shall strike the shepherd and the sheep will be dispersed; but afterwards I shall rise and precede you into Galilee; there you will see me says the Lord.'[18] The ambivalence of this one day pervaded the whole religious culture of the Ottonians. Could a society which so readily used the imagery of Christ triumphant to express its concepts of rule, be long forgetful of the same Christ as a sufferer? The first scriptural reading at the mass of Palm Sunday before the Passion was from St Paul's epistle to the Philippians: 'He humbled himself and became obedient unto death, even the death of the cross. *Wherefore* God also hath highly exalted him, and given him a name which is above every name' (Phil.:2,9). The intertwining of triumph and suffering is here put in a nutshell. To experience the full weight of this ambivalence, or paradox, in art, we shall have to move on to the Crucifixion. But the iconography of the Entry into Jerusalem is not devoid of interest in the light of it.

Ottonian artists seem not to have found the Entry into Jerusalem the easiest subject to treat with variety and originality. It offered far fewer opportunities than, say, the Last Supper or the Crucifixion. The rules for its representation had already become somewhat crystallized. It reminds one of the remarks of Haseloff about the 'unyielding subject' of Pentecost as a theme in Christian art.[19] For the most part, therefore, art does not match the impression gained from the liturgical books or from real-life events, that the Entry into Jerusalem was a highly charged subject in this period. Ottonian artists generally stuck fairly closely to a late antique norm, exemplified in the Rossano Gospels, with Christ on a donkey; a *74* group of apostles behind him; and in front of him a city, a crowd of people with palms and clothes, who shout their *Hosannas*, and in general a great

deal of bustle. The scene on the early eleventh-century golden altar of Aachen is of this character. The Codex Egberti gives the priority to many figures (not always the case in this book) and omits any representation of Jerusalem. An early effort to isolate Christ on the donkey, however, in an almost iconic way, is found in the late tenth-century Trier epistolary, now *75* in West Berlin (Theol. lat. fol. 34). It is done by dividing the picture into two halves. On the right the fortified Jerusalem breaks into the top line of the frame and the youths with their garments are placed in front of the building. On the left, therefore, Christ alone, sitting rather upright, seems to occupy the empty space of the framed part of the picture — though his donkey makes eagerly for the nearest available garment. This is unusual amongst Ottonian compositions. One manuscript at least, the Pericopes *73* Book of Henry II, may be said to handle the norm magnificently. The figure of Christ has unusual force and urgency, and while the boys wave their palms and cast their clothes at the feet of the donkey, a reception committee of Jerusalem citizens strikes a contrasting mood as it stands with solemn dignity to receive Christ. But the picture sticks by and large to the norm all the same.

On the other hand in the Gospel Book of Otto III almost everything and *Col.Pl. XIX* everyone has fallen away from the immediate vicinity of Jesus and the donkey. The city and the bustling crowds are completely eliminated. The group of apostles is relegated to the lower register of a picture divided vertically into two; they crane their necks upwards as if they were viewing an opera from the orchestra pit. Also now in the lower region are two youths (only two) stretching up with all their might to reach the ground of the higher level in order to place their clothes at the feet of the donkey. This is a delightful touch, which has led Otto Demus to refer to the ingenious artifices by which the Gospel Book fused the two superimposed halves of a picture of vertical format into one pictorial whole.[20] This illumination is a marvellous example of how originality can be achieved by bold reduction of iconographic elements as much as by multiplication. The effect is that Jesus is left almost alone in the upper register of the picture, against the gold ground under an arch, seemingly in a sudden stillness and silence. God-like he appears in his solemn and majestic posture, but also forsaken, as if his passion had already begun. Above the arch is a wavy and flickering purple atmosphere of unearthly character. Only one figure remains on the same plane as Christ, a solitary man in front of him up a tree, with an eager, morally-aspiring look in his face.[21] He is subtlely different from the corresponding man in the Pericopes Book of Henry II; not at all in festive mood, no bustle in his manner. Forgetful of his palm, he gazes at Jesus with an air of contemplation. Far from breaking the stillness and silence of the upper plane, this figure enhances it.

The stimulant needed to step out of line with well established conventions in this way must have been a strong one. The Gospel Book of Otto III was an earlier work of the same scriptorium or atelier as the Pericopes Book of Henry II, as figural style, frame and colour all declare. But a

124

comparison of the Pericopes Book with other Ottonian representations of the Entry into Jerusalem leaves no doubt that it was this book and not the Gospel Book of Otto III which followed the recognized canon of that scriptorium.[22] The double meaning with which we interpret the representation of Jesus in the Gospel Book — alone in his God-head but forsaken in his manhood — is strengthened if one takes cognizance of certain liturgical facts about Palm Sunday. After the processions, the mass opens with an introit taken from Psalm 21, including the words, 'my God, my God, why hast thou forsaken me', the words on Jesus's lips at the moment of his death. This itself was an abrupt sobering of the prevailing mood of the day up to that point. Moreover one of the standard patristic homilies for Palm Sunday, attributed to Maximus of Turin, had this very psalm for its text. The whole point of the sermon is to contrast Christ's glory and sinlessness as God, and his carrying our sins as man on account of which he was forsaken; and also to say how the light of day (like the triumph of Christ's Entry) terminates in the darkness of night, but the darkness of night again gives way to the sun's brightness. The character of this sermon, brief and effective, is likely to have ensured its use. So also is the fact that it was included in the Homeliary of Paul the Deacon, a popular collection of sermons for the liturgical year in the early Middle Ages. Reichenau itself owned a ninth-century manuscript of this Homeliary. The same Homeliary also included a sermon of the Venerable Bede for Palm Sunday which referred to Christ as the *rex mansuetus*, the meek or calm king residing in the hearts of the humble and of the quiet who fear his words'. The man on the tree accords perfectly with this idea.[23]

To make a suggestion about the liturgy and ideas which influenced this page of the Gospel Book of Otto III, is not to deny also a visual stimulus to its unusual form. Florentine Mütherich rightly repudiates the notion that its vertical format alone can explain its distinctive composition, and she has well said: 'its aim was not to achieve the narrative profusion of a much-loved scene, rich in figures, but the solemnity of a great and significant moment through the isolation of the figure of Christ.'[24] If we ask what visual example of this isolation could have presented itself to a Reichenau artist working around 1000, an answer is readily to hand: some such icon, apparently representing nothing other than Christ on a donkey, as was carried in the Palm Sunday processions of Udalric of Augsburg. Udalric cannot have been totally absent from the thoughts of Otto III and his circle after the papal canonization of 993; and the connections of Reichenau and Augsburg were so close, that around 1030 Berno, then Abbot of Reichenau, followed up Gerhard's *Life of Udalric* with a hagiography of his own.[25] We know nothing of the artistic quality of the Augsburg icon. Would that it were to be discovered in some forgotten cellar! But if it (or something like it) in any way prompted the Gospel Book illustration, then it played its part in the creation of a page which was one of the summits of Ottonian artistic expression.

125

2 The Crucifixion

Much of excellent quality has been written about the Crucifixion in Ottonian art, and we shall say, therefore, only what is necessary to fit the subject into our present theme of the intertwining of political ideology and religious devotion in the period.

The Crucifixion could be represented as the culminating triumph of Christ or the depth of his suffering. Ottonian representations are like a colour disc, in which every shade from one extremity to the other finds its place. The Uta Codex of *c.* 1020 is the greatest example of the scene *Col.Pl. XVIII* conceived as a triumph. Here Christ hangs on the Cross, arrayed in golden crown, clothes of imperial purple, and a stole, to indicate the Priest-King, while his feet rest on a sumptuous suppedaneum. Around him is an oval mandorla with an heroic inscription, on a golden ground. To his right, where he looks, are personifications or images of Sun, Grace and Church; to his left are Moon, the Law (who 'takes a fall' and is blindfolded by the acanthus frame against which she falls) and Synagogue. All these are in square medallions or semi-circles. At the base of the cross stand Life and Death. Life, dressed as an Ecclesia-figure, with crown and golden collar, looks up hopefully at the figure of the Crucified; Death, dressed as a peasant and with the hair of a satyr such as characterized diabolical representations, jerks himself back dramatically from a shoot of the life-giving wood which he cannot stand. Another oval surrounds these two figures. Around Death runs the inscription, *MORS DEVICTA PERIS QUI CHRISTUM VINCERE GESTIS*, i.e. Death, you yourself perish abjectly, who ventured to conquer Christ; around Life we read, *SPIRAT POST DOMINUM SANCTORUM VITA PER AEVUM*, i.e. After the Lord, the life of the saints breathes for ever. These legends relate the picture to the eucharistic liturgy of Easter Sunday, always a great day for Ottonian crown-wearings.[26] On either side of Christ are represented diagrammatically the perfect intervals of music according to Greek theory. They seem to say that it is the Crucifixion which brings into perfect harmony and eternal unity the contrasts and opposites depicted in the picture as a whole.[27]

This manuscript was made in Regensburg, and opposite it, as the book *76* lies open, is a picture of St Erhard, second Bishop of Regensburg, celebrating mass. This is a page of extremely rich imagery, as Boeckler has shown, and we cannot embark upon a systematic description of it here. But one of its themes is closely related to a theme of the Crucifixion page as Christ is there represented, namely Hierarchy, the word written in Greek characters on the top band of Erhard's elaborate *Rationale*. Bernhard Bischoff showed that the artist of this page depended in some points on *The Heavenly Hierarchy* of Pseudo-Dionysius, a work which was translated into Latin by Scotus Eriugena in the ninth century and gathered influence during the subsequent four centuries. The three circles on the *Rationale*, for instance, correspond to Eriugena's preface on the three ages; namely

76. St Erhard about to celebrate Mass. Uta Codex, Regensburg, *c.* 1020.
Munich, Bayerische Staatsbibl., Clm. 13601, f. 4

77. Emperor Henry II seated in Majesty.
Gospel Book, Regensburg, *c.* 1022.
Vatican, Bibl. Apost., MS Ottob. Lat. 74, f. 193v

Col.Pl. XVIII

77

the ages of the Law, of Christ and the Church, and of the Light of Eternal Life.[28] These ideas are all prominent in the depiction of the universal order over which Christ rules on the Crucifixion page. It has also been pointed out that there is a close iconographic relationship between the image of the crucified Christ in the Uta Codex (Munich, Clm. 13601) and an illustration of the Emperor Henry II in another Regensburg Gospel Book which the emperor himself presented to the monastery of Montecassino in the early 1020s (Vatican, Ottob. 74). Both Christ in the Uta Crucifixion and Henry II in the Montecassino illustration wear crown and stole (most unusually for a lay ruler) to indicate the Priest-King. In the Uta Crucifixion, Death recoils from the cross; below Henry II in the Montecassino Gospel Book, a tyrant, generally associated with the rebellious Pandulf IV of Capua, cringes.[29]

It is actually possible, thanks to the researches of Bernhard Bischoff, to name the learned monk of St Emmeram, Regensburg, who planned the iconographical scheme of the Uta Gospels, including the Crucifixion page.[30] His name was Hartwic. He had studied the liberal arts under one of the great teachers of the early eleventh century, Bishop Fulbert of Chartres (1006-28), and some of his intellectual interests are reflected in the Crucifixion page. He brought back to Regensburg from Northern France manuscripts of various works on rhetoric, arithmetic, music and other subjects, as well as concerning himself with the cult of St Emmeram.

128

Hartwic is a good example of the importance of relations between France and Germany in cultural life, whatever the different attitudes of their churches to manuscript art. The Uta Crucifixion represents a convergence of northern French cathedral school learning, by 1020 more advanced than anything in the empire, with the imperial concept of world order and world rule. Moreover it is perhaps no accident that this convergence was experienced at Regensburg, the principal ecclesiastical centre of Bavaria, Henry II's former duchy, where the monastery of St Emmeram was one of the key houses in the spread of the Gorze Reform, as well as being the church at which Henry himself had been educated.[31] Regensburg itself occupied an important position on the Danube route to Byzantium, opened up since the defeat of the Hungarians in the mid tenth century; and Byzantine imperial concepts also played a role in the development of a distinctive manuscript art at Regensburg.[32] Regensburg under Henry II was an appropriate place for the creation of a wholly extraordinary Crucifixion, which was both a glorification of Christ crucified and of imperial rule. One should note that unlike the Christ of the Reichenau Crucifixions, who was always youthful and clean-shaven, this Regensburg Christ is bearded in the Byzantine style. Henry II was always represented in manuscript art as bearded (see Part II, Excursus) though not always on coins: but always on coins minted at Regensburg.[33]

No other Ottonian Crucifixion can compare with that of the Uta Codex for triumphalism, although we have seen in discussing Abraham of Freising what great iconographic variations were possible. The Crucifixion in the early Fulda Sacramentary at Göttingen (c. 975) may serve as an *78* example of a half-way house. There is much to remind one of the human suffering Christ here. He is shown as dead; Longinus and Stephaton are to hand with spear and vinegar sponge, the instruments of his passion; blood flows from his hands, side and feet; the two thieves are shown suffering with him. But there are also symbols of his glory. The sun and moon signify the eternity of his sacrifice, Adam and Eve rising from their graves on either side of the serpent which twines itself round the slender base of the cross signify the conquest of sin and death which arose from the serpent in the Garden of Eden. Except for the Aachen Gospels and the *42* second Crucifixion in the Codex Egberti, the Reichenau Crucifixions are also half-way houses. They do not show the Crucifixion as a triumph, and in several instances include one or both of Longinus and Stephaton, whose places are in effect taken by Life and Death in the Uta Codex. But they do preserve the basics of divine dignity. Christ wears a full-length tunic or *collobium* (an imperial garb) in the Codex Egberti, the Gospel Book of Otto III and the Pericopes Book of Henry II and it is of purple colour picked out with gold embroidery. His posture is straight, or virtually straight, thereby containing a hint of the hieratic.[34] In addition, he is usually represented as alive and with his eyes open, even in the Pericopes Book where Longinus approaches with his spear! Pathos is reserved for the Deposition scenes. In fact the Reichenau Crucifixions adopt the balanced solution of

129

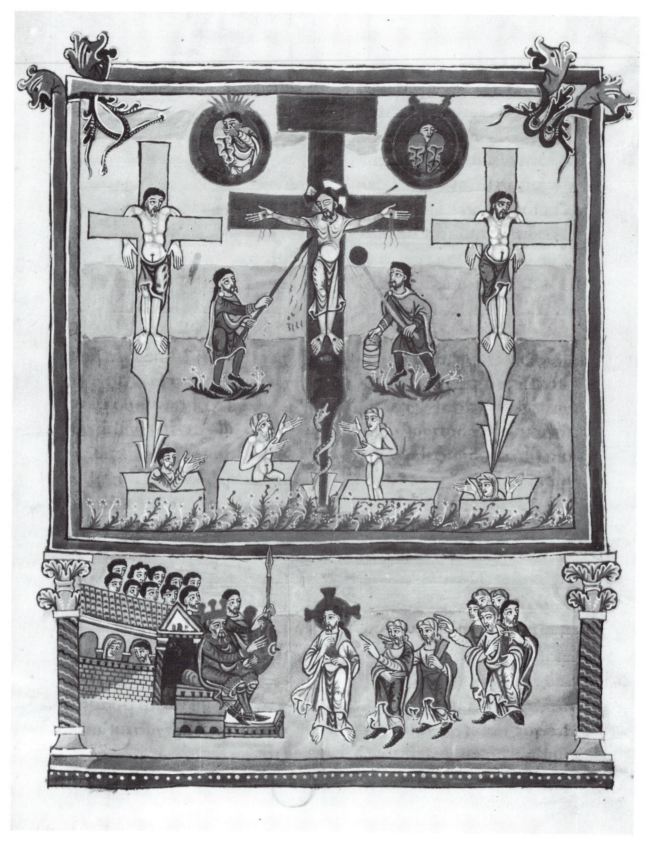

78. The Crucifixion. Fulda Sacramentary. *c.* 975. Göttingen, Universitätsbibl., MS theol. 231, f. 60

79. The Crucifixion. Rabbula Gospels, Syrian C6.
Florence, Bibl., Laurenziana MS Plut. I. 56, f. 13

80. The Crucifixion. Psalter of Louis the German,
c. 850. Berlin, Staatsbibl., MS theol. lat. fol. 58, f. 120v

late antique representations, as in the Rabbula Gospels or the wall-painting 79
of Santa Maria Antiqua in Rome. The Aachen Gospels, however, shows
Christ dead on the cross, his body twisted in agony, and his head slumped
forward. His full-length tunic has nothing of the character of a *collobium*,
either in its colour (which is the same as that of the soldiers' tunics) or in
the way it hangs. There is no symbol of divinity here at all. The Aachen
Gospels is the earliest manuscript of the Liuthar Group, and it looks as if
its mode of depicting the subject (which is also that of the second illustra-
tion in the earlier Codex Egberti), was subsequently abandonned as un-
acceptably extreme in its portrayal of suffering.

The Ottonian school which consistently placed the emphasis in Cruci-
fixion scenes on the suffering humanity of Jesus was that of Cologne. In
Cologne manuscripts he is invariably shown dead, his eyes closed, his 81
body naked but for a loin cloth and twisted to the left. In several cases
blood flows from his hands and side, and this is not treated sacramentally
by the holding or placing of a chalice to receive it; it is a purely physical
feature. Symbols of divinity or eternity are sparse in the Crucifixions of
this school. A single model of the subject was evidently followed by every

81. The Crucifixion.
Gospel Book, Cologne, *c.* 1020.
Giessen, Universitätsbibl.,
Cod. 660, f. 188

Cologne manuscript, and it is a moot point whether it was western or
Byzantine, or western influenced by Byzantium (see ch. 3 on Cologne in
Part II). The very earliest example of Christ with his eyes closed on the
cross seems to be an eighth- to ninth-century icon at St Catherine's, Sinai.
But the humanity is here hedged about with divine securities; angels
descend from heaven to greet him, an inscription above the cross reads
'King of Glory', the *collobium* is star-spangled to drive home its symbolism
of world rule.[36] The Carolingians were already leaving him much more
out on his own in his suffering humanity, in the first half of the ninth
century, whether with his eyes closed (as apparently in the Utrecht Psalter)

132

82. The Gero Crucifix, *c.* 975.
Cologne Cathedral

or open (as in the Psalter of Louis the German). The Psalter of Louis shows *80*
a *Steckkreuz*, a cross with a slender base, which is a feature of several of
the Cologne illustrations.[37] It may well be related to the Cologne model.

The greatest of the Cologne Crucifixions is not in a manuscript at all,
however, but is a wood carving: the Gero Crucifix in Cologne Cathedral. *82*
This is Christ in his unequivocal humanity. He hangs on the cross with
his eyes closed, his head leaning forward onto his chest (slumped would
be too strong a word), his body twisted to the right and naked but for a
loin cloth. What makes this a great work of art is its fine modelling, and
above all its restraint; it is poignant without any suggestion of emotional

133

bludgeoning. The suffering which it portrays is noble and serenely accepted, rather than abject. The association of this figure with Archbishop Gero of Cologne (969-76), whom we have already encountered in connection with the Gero Codex before he was archbishop (see pp. 25, 36), is generally accepted. It is obviously related to the same prototype as the later Cologne manuscript Crucifixions, but among the pointers to its early date is the twist of the body to the right. This is found in several early Ottonian representations, such as the Codex Egberti and Aachen Gospels, and if one looks carefully at the figure in the Fulda Sacramentary at Göttingen (c. 975), a twist to the right in its model is implicit there also. This seems to have been altered before the turn of the millenium at Cologne in favour of a twist to the left, perhaps under the influence of a Byzantine model.[38]

78

There is a remarkable story in Thietmar of Merseburg about doubtless this very crucifix:

> He [Gero of Cologne] had a crucifix, which now stands in the middle of the church where he rests, made carefully of wood. When its head was seen to be split, he sought to have it mended by the Supreme Craftsman and presumed nothing of himself. He placed a portion of Christ's body [i.e. a host], his one solace amongst troubles, and a fragment of the life-giving cross in the crack, prostrated himself, and in tears (*flebiliter*) called on the name of the Lord. He rose and gained its wholeness with a humble blessing.[39]

Flebiliter: did he weep because of the crack? Or because he was moved by the crucifix? Or because he had prayed many times (with the prayers of tenth-century sacramentaries) for the gift of tears? Perhaps it was all three. One need not not assume that these were merely ritualistic tears. In many directions one dimly perceives hints of a crisis of conscience amongst the higher Ottonian clergy: the archdeacons who withdrew to the contemplative life at Gorze, the tension felt by more than one bishop between attendance at court and pastoral duty, the visits of Archbishop Frederick of Mainz to hermits in his most rebellious phases.[40] The passage of Thietmar is interesting for its revelation that Gero, a high-born and courtly ecclesiastic, who we know did not achieve his archbishopric without experiencing the cut and thrust of political competition, was devoted to the Eucharist as well as to the Cross. Gero himself had had an opportunity to drink at the fountain source of Byzantine piety, to experience the pathos in art and religion which Peter Brown has noted to have been developing there already in the sixth century;[41] for Otto I had sent him to Constantinople to bring back Theophanu, bride of Otto II. From that time, presumably, Theophanu developed the close connection with Cologne, which

must partly explain Byzantine influence there, and which led to her being buried at the church of St Pantaleon. But this period is altogether full of bishops prostrating themselves before crucifixes. When Archbishop Heribert returned from Italy to Cologne to die in 1020, he summoned Abbot Elias of St Pantaleon to himself to confess his sins, and then he prostrated himself in prayer all night before the Gero Crucifix in the cathedral.[42]

This discussion of the crucified and suffering Christ might seem rather inappropriate in a chapter about religion and politics. One may see well enough what the Uta Crucifixion has to do with politics, but still wish to enquire about the relevance of the Gero Cross. In fact the Gero Cross is highly relevant. The Ottonians absorbed the ideal of humility and the fact of humiliation into their ideology of rule as these had never been absorbed before. The theme of both the First and Second Lives of Mathilda, queen of Henry I and mother of Otto I, is *dignitas cum humilitate*. Widukind says of Matilda's poor relief, 'she practised such works humbly day and night, yet she never thereby lessened the royal honour'. The Second Life developed the idea that after the failure of Henry of Bavaria to succeed his father Henry I, the Henrys had experienced a *humiliatio*, through which they had finally reached *exaltatio* with the succession of Henry II in 1002. They had gone through troubled times (*angustiae*) to achieve the *culmen regiminis*. The author quoted St Luke, 'he who humbles himself will be exalted'. Thietmar of Merseberg, and the Quedlingburg Annalist around 985, were both aware of this theme in political discussion.[43] There is little enough evidence that any Henry actually humbled himself, which would be going too far, or even of Henry of Bavaria's acquiescence in Otto I's kingship around 941. What is significant is the currency of the idea that humiliation was a valid means to achieve exaltation, which is relevant to us, not whether this idea corresponded to particular political facts. Of course the Venerable Bede had much earlier extolled the virtue of humility in rulers, but for the most part he singularly fails to persuade us that this could lead to the triumph of earthly rule, in which in any case he was uninterested; and most of his kings and noblemen who wanted both to practise humility and to remain alive had to retire to monasteries to combine their two aims.[44] The whole point of the First Life of Mathilda was to stress that this was no longer so. Humility and active royalty could be combined.

In the field of Ottonian art the interrelationship of humiliation and exaltation is expressly articulated in the Lothar Cross at Aachen. This is a *83,84* processional cross, probably made for Otto III. Its front, the side which would have been seen by the people as it was carried in procession, is studded with jewels, connected by finely-worked golden scrolls in a kind of 'living vine'. The centre contains a splendid cameo of the youthful Emperor Augustus, crowned with a wreath. This is the youthful Otto associated with the great imperial age of ancient Rome, as he associated himself when he established his court in Rome in 998 (see p. 160). On the reverse, the side which would have been seen by the emperor himself as

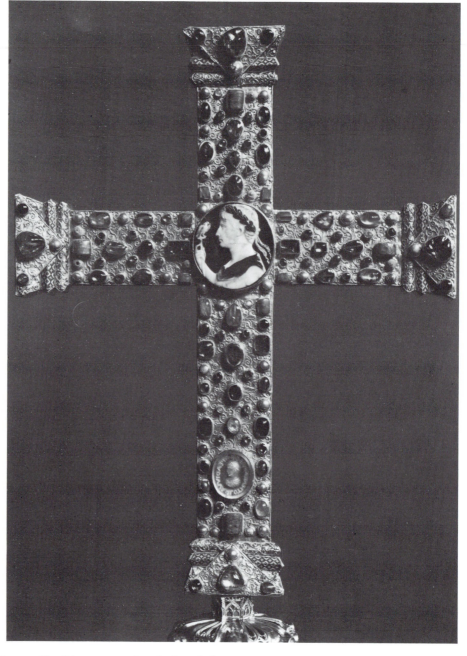

83. The Lothar Cross, *c.* 1000.
Aachen Cathedral. (*Front*)

he walked in procession behind the cross, is a very expressive engraving
of the Crucifixion. Here the signs of victory are not wanting, it is true: sun
and moon, the serpent coiled round the base of the cross, and most of all,
the hand of God placing a circular wreath above the head of Christ. A
dove is depicted in the middle of the wreath, so that Father, Son and Holy
Ghost are all represented in this Crucifixion. Yet Christ himself is shown
as dead, his eyes closed, his head sunk onto his breast, blood flowing from
all five wounds. As a picture of suffering it has a close kinship to the Gero

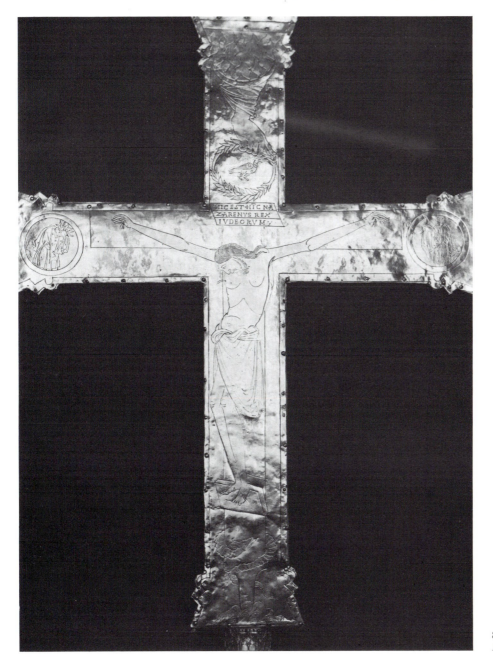

84. The Lothar Cross, *c.* 1000.
Aachen Cathedral. (*Back*)

Cross. The fact that Augustus wears a wreath on one side, while on the
other a victory wreath is placed by the hand of God above the Crucifixion,
shows the close connection of meaning between the ruler symbolisms of
each side. The whole cross represents, in the words of Lothar Bornscheuer,
'the paradox of a victorious death'.[45]

When one considers the Gero Cross more closely, it too is seen as a
partaker in this paradox, for it has been said of the Gero Christ that despite
its earthly and bodily suffering, it is 'nonetheless a picture of an inac-

137

cessible, lordly Crucified'.[46] The Lothar Cross achieves the combination of final humiliation and divine sublimity by its imperial, trinitarian and cosmic signs; the Gero Cross achieves it by purely artistic effect. We have said in respect of Palm Sunday and the Entry into Jerusalem that the ambivalence of this festival, as between Christ's triumph and his passion, pervades the whole of Ottonian religious culture. On Palm Sunday one starts with triumph and moves to suffering, in Ottonian Crucifixions the ambivalence is the same, but one moves in the opposite direction.

Behind the Ottonian art of the Passion lies a signal piece of evidence for its veneration at Reichenau itself. In the 920s Reichenau acquired a double relic of the Holy Cross and the Blood of Christ. A text in a late tenth-century lectionary of the monastery, the *Translatio Sanguinis Domini*, describes how this relic came to Reichenau, at first contained in an onyx bowl and later enclosed in a silver cross.[47] The cross itself has the suffering Christ on one side, and on the other a Greek inscription referring to Hilarion Tzirithon the Deacon. The Tzirithone were an important Byzantine aristocratic family of the tenth century, and so the cross is another brush stroke in the picture of Reichenau relations with Byzantium at this time.[48] In 950 Otto I issued a charter for Reichenau by which he made a grant 'to the holy cross in which the blood of our Lord Jesus Christ is contained'; he granted a church with its tithes, 'in order to restore the *luminaria* [a chapel of some kind] which Abbot Alawich newly built in honour of our Lord and Saviour'.[49] We need not deny that Otto I acted with religious devotion in this matter, but just below the surface lies a strong political motive. Otto's grant followed very closely on the marriage in 949 of his son, Liudolf, to the daughter of Duke Hermann of Swabia who had died in December 948 and was buried at Reichenau. His need to strengthen his support in Swabia and give his son a more solid base to take over the duchy is clear. A Saxon Liudolfing, as Otto was, could not marry his son into the ducal family and expect him to rule in the duchy unless he were more generally acceptable to the Swabian aristocracy. The religious and landed interests of such an aristocracy were closely involved with those of the great monasteries of their region.[50] Udalric of Augsburg, for instance, a member of the Swabian ducal family, took a keen interest in Reichenau's relics, so that Otto's interest can only have commended him to this bastion of royal government (as Udalric proved to be) in Swabia. By associating himself with the veneration of the relic of Christ's Blood, therefore, Otto stood to better his position in Swabia, where the support of Reichenau certainly proved worth having in the rebellion of 953. Moreover, the charter of 950 was a signpost on the way to Christ-centred kingship.

One cannot, therefore, make simple equations between triumph in Crucifixions and political ideology, or between suffering and religious devotion. Triumph may sometimes be chiefly the triumph over sin and death; suffering may be the humiliation which easily turns into 'the culmination of rule', the obedience unto death which precedes the raising up

by God. We might ask, however, *why* the suffering Christ should have been absorbed into the political theology of the Ottonians at all. Why did it create a problem? What was the pressure to take it on board? Why, if they were going to use Christ triumphant in their political ideology, were they forced also to absorb Christ suffering? (I think that the word 'forced' does not beg the question.) The answer that this idea was generated by some internal logic of political ideology would by itself be inadequate. On the other hand there exists a possible answer from an early period of Ottonian religious culture. It is the religious devotion to the suffering Jesus which we have observed at Gorze (see pp. 83-88), at Freising (see pp. 89-95), at Cologne under Gero and afterwards, and at Reichenau, and which we can see at those monasteries which already in the tenth century venerated such relics of the Passion as pieces of the vinegar-sponge.[51] Perhaps this religious phenomenon forced the hands of, or carried in its current, all those who would see in the ruler the type of Christ.

3 *The Dormition and Assumption of Mary*

The idea of Mary's assumption into heaven, indeed of her bodily assumption, after her death (or dormition) on earth, goes back at least to the sixth century in the East. If Mary was of one flesh with her divine son, it seemed to follow that she, like her son, must have been free from the corruption of the grave. This doctrine, though known in the West from the time of Gregory of Tours in the late sixth century, was much slower to take root there. Indeed it was strongly resisted until the twelfth century, when it was still a matter of doubt and debate. The resistance, of course, shows that there must have been some positive belief to resist, but authoritative teaching for the most part treated the bodily assumption with scepticism. A pseudo-Augustine sermon, probably composed in the mid eighth century by Ambrosius Autpertus, Abbot of Volturno, scorned the apocryphal legends about Mary's death and said that no Latin doctor had discussed it. She had lordship over angels and archangels, but whether in the body or out of the body we did not know. This sermon could still be found in tenth-century homiliaries.[52] More important was the pseudo-Jerome letter, *Cogitis me*, since the 1930s generally (though not universally) attributed to Pascasius Radbertus, Abbot of Corbie (842-47).[53] This widely circulated work maintained that Mary's bodily assumption should be regarded as doubtful and 'not known without danger' (*sine periculo nescitur*). If this was not outright dismissal of the doctrine, it was as discouraging as it could be. The counteracting letter of Pseudo-Augustine (not to be confused with the eighth-century sermon), which took a positive view of the bodily assumption, dates from no earlier than the twelfth century.[54]

Scepticism about whether Mary had risen bodily, however, implies no lack of enthusiasm for the idea of her spiritual assumption. Indeed western writers seem almost to have regarded the red light against the former as a precondition for showing the green light to the latter. It was as if a strong

instinct of religious devotion could only be trusted and given its vent if it were first drained of this dangerous corporeal content. The faithful were much devoted to the bodily relics of saints; but no church claimed to have such relics of Mary. That did not mean they could compensate themselves (so to speak) for the lack of earthly relics by supposing her body to be in heaven, thus playing fast and loose with the spiritual concept of heaven, to which many Carolingian thinkers were strongly attached. Compensation was spiritual. The Pseudo-Augustine sermon declares that Mary reigns in heaven with the columns of angels and archangels; the Pseudo-Jerome emphasizes that Mary's soul was taken up to heaven in great splendour. Hrabanus Maurus, in a sermon on the Assumption following the Pseudo-Jerome line, holds that Mary alone was raised in heaven high above the angels. Pseudo-Ildephonsus in the mid ninth century (the wealth of attributions to earlier fathers shows how much Carolingian writers viewed this whole area as a theological minefield) depicts the triumphant ascent of Mary's soul in lively colours, opining that the feast of her elevation is celebrated so festively by the angels that the jubilation obtrudes itself onto Tartarus, causing the devil himself to shudder.[55]

If Mary's body was not assumed into heaven, but only her soul, then one may ask in what way her position differed from that of the saints, the early martyrs for instance, whose souls were believed to be in heaven. The passages which we have just cited seem to give us our answer. Mary was raised so honourably, and to such a high position in heaven, that she became a ruler of angels. Carolingian and Ottonian societies, as their art and literature declare, were very conscious of angels as executors of God's commands amongst men. Men in general had been made 'a little lower than the angels' (Psalm 8, 5); that was the measure of Mary's peculiar glory in becoming queen of heaven.

The Carolingians and Ottonians were at one, as with so many matters of religion and culture, in their zeal for the spiritual assumption. Yet the question of how and why it fitted into their society, of why they provided such fertile soil for this devotion, has been almost entirely overlaid in the scholarly literature by another question — that of the antiquity of belief in the bodily assumption in both East and West. This is not surprising, for the principal writings of Jugie, Barré, Capelle and Wenger all fall within a decade on either side of 1950, the year in which Pope Pius XII solemnly defined the doctrine of the bodily assumption. Our question is: what role did devotion to Mary's Assumption have in ninth- and tenth-century society? We shall find the bodily assumption making its entry. But this does not prompt our question which is already raised by the spiritual assumption; it only adds point to it.

In the sphere of Ottonian political ideology, Mary's apotheosis in heaven was analogous to the apotheosis of earthly emperors. Her rule over angels suffused heaven with brilliance, as their rule (itself a reflection of heavenly rule) suffused the earth. Otto III explicitly associated his rule with Mary's. A poem composed to be sung for the procession in Rome on the Feast of

the Assumption, 15 August 1000, begins, 'Holy Mary, who have scaled the heights of heaven, be kind to your people'. In the poem, Rome weeps for the loss of her beauty which once spread its rays over the earth. Mary is addressed in it, so Schneider remarked rather disapprovingly, as if she were a pagan-city goddess. The poem ends: 'Be not slow to spare your Otto III who offers you what he has with a devout heart; let every man rejoice that Otto III reigns, let every man rejoice in his rule.'[56] Another poem on Mary's assumption, written into a patristic manuscript at Bamberg, begins: 'Behold there shines forth the day, venerated by all men upon earth, on which the holy mother of God ascended to the highest heaven, a virgin as parent, a virgin still, a virgin for ever.' It refers to Mary 'as the helper of your own Henry, ever your pupil', and also *domina per saecula* (ruler for ever). The word 'Henry' (i.e. Henry II) in this manuscript has clearly been written later over an erasure. Originally the poet probably wrote 'Otto'.[57] In Byzantine art there is even an example of Mary crowning the Emperor Leo VI, side by side with him, as she herself would often be shown later, crowned by the hand of Christ.[58] The whole theme of Marian apotheosis had indeed a long Byzantine/papal history by the tenth century, ready made to be taken over by Otto III; the image of the *theotokos* was already identified with the city of Constantinople when its veneration was believed to have saved the city from the siege of Avars and Persians in 626, while in the West a pope as early as John VII (705-07), a Syrian, had styled himself as Mary's servant (*servus Dei Genitricis*).[59] Therefore Mary assumed into heaven was a model, even a source, of imperial rule.

The same applies also to other kinds of rule. An instance of this may be found in the poems of Hrotsvita, Abbess of Gandersheim and cousin of Otto I, whose deeds as Roman emperor she celebrated, Virgilian style, in the most famous of all her poems. Hrotsvita wrote a poem on Mary (not about her assumption) which addresses her thus:

> *Unica spes mundi, dominatrix inclita caeli*
> *Sancta parens regis, lucida stella maris.*
> (Unique hope of the world, glorious mistress of heaven,
> Holy progenitor of the king, bright star of the sea)

Spes et dominatrix is exactly how she also describes Oda, foundress of Gandersheim in the ninth century, and in effect its ruler for fifty years since her daughter was but twelve years old when Oda made her abbess.[60]

Thus, one function of belief in the Assumption, whether spiritual or bodily, in tenth-century society, was to enhance the political ideology of rule, its language and its expression. So far was this the case that we can actually see the Feast of the Assumption becoming caught up in the sacred ritual of the imperial itinerary and of the rulers' military campaigns. It is practically certain that Otto II, together with his new wife Theophanu and his father Otto I, celebrated the Assumption on 15 August 972 at Reichenau, whose patronal feast it was, when the court was returning from Italy;[61] on Easter Sunday earlier that year, in Rome, Otto II had been

married and Theophanu had been crowned empress. We shall shortly see the importance of Reichenau in the art of Mary's Assumption. In the 990s it was a favourite day for the inauguration of campaigns against the Slavs.[62] Karl Leyser has pointed out that under the Ottonians even rebellions had to begin with the correct rituals and in the right place.[63] Similarly, one can see how suitable the Assumption would be as the right date to launch a field venture; early enough to allow a finish before the worst of the winter weather, and late enough for the harvests to be in before forces were seriously engaged. Meanwhile the leaders could bask in the reflected glory of Mary's triumph. Typically for the tenth century, it was through the liturgy and the practice of ritual, rather than through theological thinking, that the idea of the Assumption made ground.

The other function of the belief, was to enlarge the more personal aspects of religion in the age. The *transitus* legends, which recount in vivid detail the passage of Mary from earth to heaven, bring forward the notion of her bodily assumption. This obviously added an exciting dimension to the whole doctrine, but the reader should be advised that it is not a *necessary* element in this second function which we discuss. The most important matter for religious meditation, as it concerned the relationship of human beings with Christ, lay in the death-bed scenes themselves rather than in the actual mode of Mary's assumption into heaven.

The doctrine of the bodily assumption of Mary made its greatest advance in the ninth and tenth centuries at Reichenau itself. Throughout the period when the Pseudo-Jerome, *Cogitis me*, held sway, there had been lying in the library of Reichenau a Latin translation (the earliest known) of the ancient Syriac and Greek legend of the Assumption. This legend, to give the bare bones of a story replete with angelic visitations as well as with conversations and some beautiful prayers, tells how John, and later all the other apostles, arrived at Mary's death bed, the apostles emerging from a cloud in the midst of a thunderstorm. Then Jesus himself entered the house together with Michael the Archangel, and greeted Mary with the words, 'Hail Mary, my mother'. The account continues:

> And opening her mouth, the blessed Mary said,
> 'I bless you, my lord and God, because you have
> fulfilled your promise to me. For you have sent
> to me not only the apostles, but also angels and
> archangels, and in addition you yourself have
> come upon my spirit. Who am I to be worthy of
> such glory!' And so saying, blessed Mary
> completed her earthly course, smiling at her
> Lord. The Lord then took her soul and placed
> it in the hands of the archangel Michael.[64]

The legend carries on with an elaborate account of the burial of Mary and the subsequent deliberations of the apostles. It ends with her rising

on the third day, like Christ, and now there is an explicit reference to the bodily assumption:

> While the apostles were talking, the Lord Jesus
> came in clouds with angels and archangels.
> He took up the apostles into the clouds, with the
> body of Mary, and led them to paradise where
> they placed the body of blessed Mary. And the
> Lord received her soul from the hand of Michael
> the Archangel and restored it to the body of Mary.[65]

To historians of Christian doctrine, it is from such texts as this that the doctrine of the bodily assumption emerged. Although they were in themselves apocryphal writings, their use for liturgical readings supposedly gave the narratives 'a certain doctrinal character'.[66] We see, however, a different sort of interest in them. In the story of Mary's *transitus* from earth to heaven there is another theme besides her apotheosis: her loving relationship with her son and the trust between them. Religious devotion in this legend, which was clearly more widely known in the ninth and tenth centuries than the surviving manuscript evidence would suggest,[67] takes on, by depicting it between mother and son, the character of a human relationship with Christ, which we observed in Bernward of Hildesheim's Last Supper and in the ethos of the Gorze Reform.

Another manuscript which formed part of the Reichenau library (Karlsruhe, Aug. LXXX) is also of great importance for the development in the West of the idea of Mary's bodily assumption. This contains a series of Greek homilies on the Dormition (the compiler was not interested in any other aspect of Mary), all translated into Latin. Several are by Andrew of Crete who may well have preached them in Sion church at Jerusalem with a picture of the Dormition before his listeners' eyes ('consider with the eyes of faith the limbs of the queen in her rest').[68] Four are by Cosmas Vestitor, an obscure Byzantine writer, probably of the late eighth century. Some of his other works are found in tenth-century Greek manuscripts, but not these homilies which survive only in the Reichenau Latin translations.[69] Cosmas affirms the bodily assumption and uses the *transitus* narratives. The second of his homilies emphasizes that mother and son are one flesh and that therefore the mother shares the son's incorruptibility, an argument later used in the Pseudo-Augustine letter which did much to turn the western tide in favour of the bodily assumption.[70] Wenger calls these sermons a *mélange* of improbable legends and doctrinal affirmations.[71] An anonymous homily winds up the collection. This weaves together the four discourses of Cosmas and also uses Andrew of Crete and other sources. It shows an excellent knowledge of Greek and it also shows that there was no slavish copying of Greek texts but a 'live' use of them. This homily draws on the *transitus*, but largely overlooks the aspect

143

of personal relationship with Jesus, being more concerned with the glorification of the Virgin. It breaks out into such passages as:

> O Queen! high throne of all human nature,
> [note the applicability of this imagery to the ruler
> portrait in the Aachen Gospels], elevated gate
> of heaven, who are above all beings except God
> alone. Whose arms will bear you who bore the
> unknowable? Whose hands can bury you who bore
> the creator of all things, him in whom all
> things are contained?[72]

Latent in the Reichenau texts, then, is a dual function of the idea of Mary's assumption: as enhancement for the political ideology of apotheosis, and as food for the more interior aspect of religious devotion in Carolingian and Ottonian society. Neither depends, even in these texts, on the bodily assumption in particular, but this teaching obviously played a major part in stimulating interest in the subject as a whole at Reichenau.

There was formerly some doubt about the date and localization of the manuscript with these Dormition homilies. It had generally been taken to be tenth-century Reichenau, but Walter Berschin has recently established that it is ninth-century and Italian. He allows me to say, however, that in his opinion the likeliest period for it to have come to Reichenau was the late ninth century, or failing that the tenth. It is written in a careful, regular hand (in beautifully laid out pages, on good quality parchment), which makes it not easy to date; and it has lost its first quire which might have given some information about its origin and the translator. But if this manuscript is indeed ninth century, it is likely to have had a living interest for Reichenau monks in the tenth, as must the *transitus*. Their art at the turn of the millenium strongly suggests it, and so does the whole character of their culture, not least their interest in things and people eastern (cf. the narrative about the translation of the Holy Blood relic, p. 138). A tenth-century Reichenau monk wrote a *Life* of a Greek monk called Symeon, who appears to have lived at Reichenau in the early tenth century. Walter Berschin calls this work 'a fine testimony to that mixture of the historical and the poetic, of the legendary and the wondrous, which obviously pleased Reichenau in the tenth century'.[74] Echoes of Wenger's comment on the sermons of Cosmas Vestitor!

It may be thought to tell against the living interest of the homilies contained in our manuscript that the manuscript itself is in pristine condition and not heavily thumbed. But one should be cautious about this kind of deduction. We could well be left with the revered master copy of texts which were extracted and circulated within the monastery in more ephemeral forms. Not every much discussed book is heavily thumbed.

Some scholars would see Reichenau as going through an intellectual trough between the age of the librarian Reginbert and of Walafrid Strabo

in the first half of the ninth century on the one hand, and the revival of art and learning under Abbot Witigowo (985-97) and Abbot Berno (1008-

Otwin of Hildesheim (bishop 954-84), Wolfgang of Regensburg (972-994) and Henry of Trier (956-64) could scarcely have been lacking intellectual stimulus. Witigowo himself had been a monk of Reichenau before he became abbot. The monk who wrote the *Life* of Symeon speaks of his own abbot's initiation into the mysteries of philosophy and his zeal for study. This might well have been (but was not certainly) Abbot Alawich I (934-58), under whom the number of priests in the monastery increased, which could also be a touchstone of a healthy school.[75] A great period in the

Abbot Berno.[76] This activity could hardly have arisen out of thin air. From no point of view, therefore, need we imagine that the *transitus* and the homilies on the Dormition, even if the latter were compiled and translated in the ninth century, were likely to have remained mere dead wood on the shelves of tenth-century Reichenau.

Reichenau in fact has a virtual monopoly of the Dormition and Assumption of the Virgin in the surviving manuscript art of the Ottonians. The only real breach of the monopoly occurs once at Prüm. Even Reichenau by no means pressed the subject into service on every conceivable occasion, despite the fact that its depictions are all implicitly of the spiritual assumption, and do not necessarily imply any question of the then-dubious bodily assumption. We shall observe that there could be no occasion to illustrate the subject in a text of the gospels, where it is not mentioned, and only half an occasion to use it in a book of gospel readings for the liturgical year (see p. 158). But one might have thought that it would figure more readily in sacramentaries. Yet it is absent from the Reichenau Sacramentary at Oxford (Canon. Liturg. 319) as well as from all the Fulda sacramentaries. Speaking positively, however, there are several fine versions of the subject from Reichenau, broadly of two kinds, which emphasize respectively the elements of personal religion and apotheosis.

The first was undoubtedly derived from Byzantium, nothwithstanding that there was probably an example of this type at Rome already around 800, and was based on the *transitus* legend. It shows the apostles standing around the death-bed of Mary, and Jesus himself looking intently at his mother as he hands her soul, represented in the form of a child, over his shoulder (so to speak) to hovering angels waiting to receive it. This is how the subject is depicted on the tenth-century Byzantine ivory placed on the cover of the Gospel Book of Otto III. It is the canonic Byzantine *Koimesis* (Dormition), as found, for instance, in Cappadocian frescoes of the tenth century.[77] The one aspect of the legend not illustrated in this form is the bodily assumption; it is only Mary's soul, represented always as a bust or a naked child or a mummified figure, which is taken up. A western variant of this type, for which Byzantine precedent is attested by other ivories already in the West by *c.* 1000, can be seen in a late tenth-century anti-

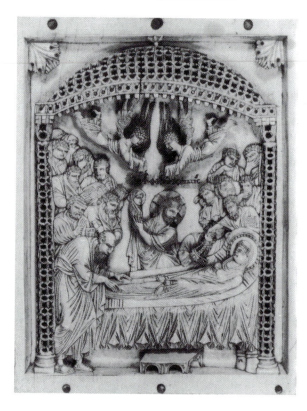

85. Dormition of Mary. C10 Byzantine Ivory
on the cover of the Gospel Book of Otto III.
Munich, Bayerische Staatsbibl., Clm. 4453

86 phonary from Prüm near Trier (Paris, BN lat. 9448).[78] Here Jesus (incident-
ally not looking at his mother) hands Mary's soul to a single hovering
angel, who is again seen higher up in a picture of vertical format offering
the soul to be received by the hand of God. The intention of this seems to
be to bring the scene closer to the details of the *transitus* legend, where
Jesus hands Mary's soul to the archangel Michael. The prominence of blue
and mauve in this picture shows one way in which Prüm, like Trier at the
same time, looked back to the great manuscripts of ninth-century Tours,
though there are also signs in the Prüm antiphonary of Fulda influence.[79]
Indeed Prüm had its connections with Reichenau, but this probably signi-
fies little in the present context, since although the earliest surviving Latin
version of the *transitus* comes from Reichenau, the legends which it con-
tains were (as we have said) known widely.

The Byzantine *koimesis*, which clearly excited the Reichenau artists, was
not slavishly imitated in the West. It was worked into the distinctive modes
of Ottonian art, with its gold grounds, its rythmic handling of the whole
picture surface, and its drama of glance and gesture. Most obviously is
this the case in the Dormition of the Reichenau Pericopes Book at Wolfen-
87 büttel (84.5.Aug.2⁰). Here the apostles are crowded in at each end of the
bed. Above the recumbent Mary, with the space cleared for him, stands
Jesus, glancing sharply at his mother, his tense hands stretched high,
holding up her soul to the angels. These hands are like the apex of a
triangle whose base (consisting of the apostles, Mary and the bed) is

146

curved. Against the top of the golden background two angels fly down-wards to receive the soul. The effect of movement in these angelic figures is enhanced by their being not quite symmetrically placed. Mary would seem to smile, although the artist has not contrived with complete success both to show her to the onlooker and to have her facing Jesus. The drama of this page is perhaps a little obvious and self-conscious to bear compari-son with the finest works of Ottonian art. Nevertheless, its intention is quite apparent: to point up that element in the *transitus* legends of Mary's personal relationship with her son.

The second Reichenau type combines Dormition and glorified Assump-tion. Mary is still shown as she dies, with the apostles present, but now without Jesus standing by the bed. Instead she herself is also shown above in glory, the *imago clipeata*, used to depict the apotheosis of the imperial family in late antiquity or of risen souls on antique sarcophagi. In these last, the roundel containing the soul is upheld by symmetrical angels as in the Reichenau scenes. Kahsnitz imaginatively sees the accounts in saints' lives, such as Gregory the Great's concerning Bishop Germanus in the *Dialogues*, of their souls being carried up to heaven by angels in a ball of fire, in *sphera ignea*, as preparing the understanding of the Reichenau artists for the use of the antique form.[80] The most fully developed example of this type, iconographically speaking, comes in the Pericopes Book of Henry II. Indeed it is developed to an unusual degree because it shows not only Mary but also Christ, seated majestically within a mandorla at the top of the picture. Between the legs of Christ is the bust of the clipeate Virgin in an expansive *orans* posture, the roundel supported by two angels whose hands are covered with an ample drapery. This type, therefore, focuses not on the personal relationship between Mary and Jesus, but on the glorification of Mary. The Christ seated in Majesty is altogether a rare scene in Reichenau; unlike at Cologne or Trier, it never appears on its own. The only real examples of it at all, with Christ in a mandorla and seated on a rainbow, are two in the Bamberg Apocalypse (IV, 2 and XI, 15). This shows the continued apocalyptic feeling in the Pericopes Book of Henry II. Mary is glorified by being carried, in soul, towards the apocalyptic Christ, who appears, to quote Kahsnitz again, 'not as the son of his mother, in the manner movingly portrayed by the legends, but as world ruler enthroned in heaven'.[81]

At either end of the bed, in the Pericopes Book picture, stand the apostles, in groups more solemn than lively. There are two processional crosses, two candlesticks, a thurible held by an apostle doubtless intended to be St John, and a holy water bucket held by another youthful apostle. Of these liturgical accoutrements, only the thurible is seen in the Byzantine ivories. In the Pericopes Book, it is as if we were witnessing the goal of a procession from church to a private house, such as is depicted in the Fulda Sacramentary at Göttingen for the *Unctio Infirmi*, and the ceremony of administering the sacrament of Extreme Unction.[82] The liturgical reson-ances of Ottonian manuscripts are ever present.

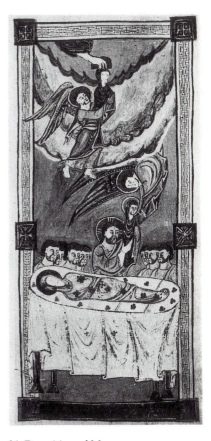

86. Dormition of Mary. Antiphonary, Prüm, late C10. Paris, BN, MS lat. 9448, f. 60v

147

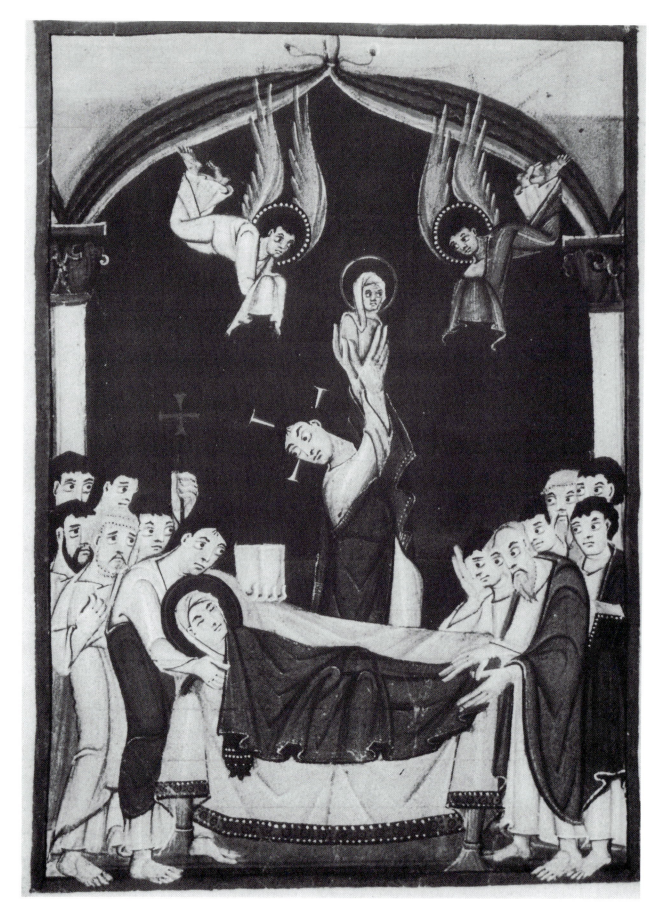

87. Dormition of Mary. Pericopes Book, Reichenau, early C11.
Wolfenbüttel, Herzog August Bibl., MS 84.5 Aug. 2°, f. 79v

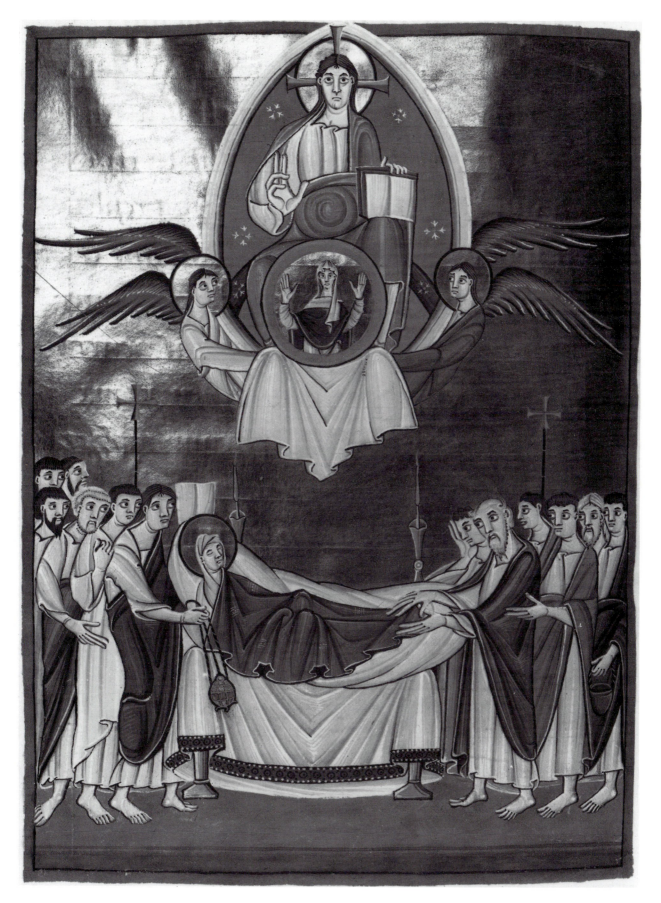

88. Dormition of Mary. Pericopes Book of Henry II, 1002-12.
Munich, Bayerische Staatsbibl., Clm. 4452, f. 161v

Another creative development of this second Reichenau type, combining Dormition and Glorification, is seen in an early eleventh-century collectar at Hildesheim (Dombibliothek, MS 688), which must date from after, but soon after, the Pericopes Book of Henry II. This book of relatively small format has four pairs of full-page illustrations, each on facing pages. They represent the Nativity and Annunciation to the Shepherds, the Three Maries at the Tomb and the Harrowing of Hell (the earliest surviving *Col.Pls. XIV* version of this subject in Ottonian manuscripts), the Dormition and *XV* Assumption of the Virgin, and the Earthly and Heavenly Churches for All Saints. I would question the implication of Kahsnitz, in his admirable work, that the collects in this book were the prayers for the monastic offices.[83] This could have been a secondary use, but its primary use must have been to give the mass collects. Most of its collects are to be found in the Roman sacramentaries, and where a choice of collects is given for the same feast, one must remember that in the Ottonian period there was still considerable latitude afforded to celebrants of mass in the prayers which they recited. There are eighteen fine full-page or quarter-page initials of typical Reichenau design, and these would indicate the normal collects for the feasts where they appear. Presumably the book stood on the altar open at the pair of illustrations from the beginning of mass on the feasts of Christmas, Easter, the Assumption and All Saints, until it was used for the collect. Then the page could be turned, revealing a fine full-page initial and the beautifully written text, on the next facing pages.

In the Hildesheim collectar, the left-hand page (f. 76v) has a Dormition *Col.Pl. XIV* with Jesus standing by Mary's bed, gazing at her while he hands her soul (in bust) to angels flying down to receive it. Here there are no liturgical objects, but there is a great deal of pathos, as Peter at the head of the bed and John at its foot raise their hands tearfully to their eyes. This picture shows how in the matter of personal religion, the onlooker could be encouraged to identify himself not only with Mary in her relationship with Jesus, but also with the apostles in their relationship with her. This page on its own would belong to the first Reichenau type pure and simple, *Col.Pl. XV* based on the Byzantine *koimesis*. But the right-hand page (f. 77) has the Virgin, depicted as an *orans* bust, *in clipeo*, being carried up to heaven in a swirl of angels, two of whom hold up the roundel on either side. Above, ready to receive her soul (the roundel has the force of representing within it a *soul*) is the hand of God, emerging from a half-cosmos and set against *Col.Pl. XVI* a flaming cross. On the other side of the page (f. 77v), a purple background within an ornamental frame carries a golden V with uncial e, the initial letters of the collect beginning *Veneranda*, whose text occupies the whole *Col.Pl. XVII* of the facing page (f. 78). Dom Bernard Capelle has argued that this prayer, the most usual collect for the Assumption at an Ottonian mass, in itself expressed the doctrine of the bodily assumption of Mary into heaven. His argument, however, is not convincing (see Excursus I, pp. 208-9).

The combination of Dormition and Glorification was a novel achievement of Reichenau art. The *orans* Mary in a roundel was not unknown to

89. Assumption of Mary.
Sacramentary, Augsburg, *c.* 1030.
London, BL, MS Harley 2908, f. 123v

Byzantine art, but it is possible that these Glorification scenes owe more
to a western iconography. There is a St Gall ivory of around 900 by the *91*
artist Tuotilo depicting an *Ascensio Mariae* (only in the tenth century did
Assumption replace *Dormition* as the normal title of the festival), where
Mary stands majestically in an *orans* posture between two angels.[84] An
eleventh-century Augsburg illustration develops this tradition with Mary *89*
now in a mandorla, supported by angels. Both motifs, Dormition and
Glorification, would appear to have been known in Rome during Carol-
ingian times. The Liber Pontificalis refers under Pope Leo III (795-816) to
a *vestem chrisoclabam*, presumably an altar frontal, stitched with gold,
showing the *storiam*, i.e. one picture with several figures, of Mary's *tran-
situs*. This was at the church of S. Maria Maggiore, especially for use on
the Feast of the Dormition. For the same church, Pope Hadrian I (772-95)
is said to have had an altar frontal made, depicting the Assumption
(*habentem adsumptionem sanctae Dei genitricis*).[85] This was apparently not a
Dormition and may have been something like the ivory of Tuotilo, himself
influenced by Italian art. It should be stressed that neither of these types
would constitute a breach of the Pseudo-Jerome doctrine expounded in
Cogitis me. Indeed Tuotilo fits well with the idea of Mary's being honoured
spiritually by the angels in heaven.

It happens that the earliest known example of Dormition and Glorifi-
cation together in Christian art is in a Reichenau manuscript of the year
1001. This is a troper (Bamberg, MS Lit. 5), a book of tropes and sequences *90*
for masses of the liturgical year, together with their chants. It is precisely

151

dated because on the one hand a newly composed sequence for St Adalbert refers to Otto III's translation of relics of this saint from Gnesen to Rome which happened only in late 1000, while on the other hand an invocation in a litany shows that Otto III still ruled as emperor when the book was made and he died in January 1002.[86] Moreover whatever arguments there may have been about Reichenau, this manuscript has always stood above them as being inescabably of Reichenau origin. The sequences include those for a series of saints which, taken together, can only mean the Reichenau liturgy (Januarius, Pirmin, Otmar, Blaise, Senesius, Theopontus, Verena, etc.).[87] All these are in the main hand of the manuscript, as are the sequence for St Adalbert and the litany with Otto III's name. There are ornamental initials, like the N for the Christmas *Natus ante secula* with the typical bulbous tendrils and arrow-head points of the Reichenau calligraphy, on backgrounds of deep blue and green, the golden lines of the letters being picked out with minium red. In addition, the manuscript contains five full-page miniatures, depicting: the musical worship of the Old and New Testaments, where, as Peter Klein has pointed out, the facial and figural style is remarkably similar to that of the Aachen Gospels and the Bamberg Old Testament Commentary illustrations;[88] the Nativity of Jesus; Two Maries at the Tomb at Easter; and finally the Dormition and Assumption with which we are particularly concerned. Here, above the

Col.Pl. XXII Dormition scene, two angels carry the bust of Mary in a roundel. Her right hand is raised in blessing, rather than her being represented as *orans*. The hand of God, set on a golden cross, is ready to receive her soul. The picture is on the opposite page to the sequence-chant of the Assumption as the book lies open. The style of this page has a rather primitive look compared with the Pericopes Book of Henry II of at most a decade or so later, but it has a feeling and life of its own. Five of the apostles at the bedside look up ecstatically at the clipeate Virgin, while beside the bed, where Jesus would have stood in the Byzantine *koimesis*, is (presumably) John the Evangelist, touching Mary's shoulder tenderly. The fact that he is shown as a grey-haired old man suggests a special closeness to Byzantine prototypes.[89]

Once again there is nothing in this picture which wanders into the Pseudo-Jerome danger zone. It is purely a representation of a spiritual assumption; that is the significance of Mary being carried as a bust in a roundel by angels. But it is surely a fact too remarkable to be passed over as a mere coincidence, that within a short time of each other, two pictorial versions of the Assumption should be produced at the same monastery, 87 one a new type, and the other (exemplified in the Wolfenbüttel manuscript) a dramatic pointing up of an older type, and at the very monastery which had such *avant-garde* texts propounding Mary's corporeal assumption in its library. It was necessary to be more cautious about orthodoxy in art than in texts, because the former was not subject to moderations of argument, nor was its audience so controllable. One must suppose, therefore, that it was no motive of the Reichenau monks to use art in order to advance

IN ASSVMPTIONE SCE MARIE MATER

CONGAVDENT ANGELOR

Cehori gloriosae uirginis

Quae sine uirili coinmixtione genuit

Filium qui suo mundum cruore medicat

Nam ipsa laetatur quod caeli

Iam conspicatur principem

Interris cui quondam sugendas

uirgo mamillas prebuit

Quam celebris angelis maria

tibi mater creditur

Qui filii illius debitos

se cognoscunt famulos

Qua gloria incaelis ista uirgo colitur

Quae domino caeli prebuit hospicium

90. Sequence with musical notation for the Feast of the Assumption of Mary.
Bamberg Troper, *c.* 1000. Bamberg, Staatsbibl., MS Lit. 5, f. 122

theological doctrine. But the excitement given to the subject by their literature seems to have propelled itself into the creativity of their art.

Finally, for whom, or for what purpose was the Bamberg troper made? There are several suggestions in the manuscript itself that it was made for use at Reichenau, such as the sequence for St George where the saint is asked to pray for the pardon of the inhabitants of Reichenau (the word Bamberg having subsequently replaced that of Reichenau).[90] On this showing the manuscript would have been first used at Reichenau, given later to Henry II, and passed to his newly founded bishopric at Bamberg. This is an eminently reasonable view, but a doubt arises from the surprisingly small format of the manuscript. It gives the impression of being made for an individual who wished to be able to follow the chants. It is too small for the use of a group, and too finely decorated for the use of any but an important individual. It shows a closeness to the particular concerns of Otto III. Quite apart from the Assumption itself, his own rule figures in the Easter litany, and the sequence of St Adalbert, which is so fresh to the translation of his relics that it must have been composed virtually for this book, strikes chords in the closest of Otto's political aspirations.[91] None of this is surprising, given that shortly before our manuscript was created Abbot Alawich II of Reichenau, whom Otto III summoned to Strasbourg in May or June 1000 where he made him bishop, had visited the emperor in Rome, almost certainly in 998. They could have walked together in the Assumption procession on 15 August in that year. At these processions, by tradition, a very sacred image of the Saviour was carried,[92] the iconic character of which could have influenced the development of the iconic treatment of Mary in depictions of the Assumption at Reichenau.

Obviously one sees the force of Peter Klein's objection, applied to Henry II but equally applicable to Otto III, that a dedication exemplar for an emperor would hardly be expected to have this appearance of modest illustration, small format, and utilitarian purpose.[93] It also, in fact, lacks a ruler portrait. But the force of Klein's objection does not seem to me overwhelming: one must distinguish between the liturgical importance of a Gospel Book or a book of gospel readings, which would be ritualistically carried and which symbolized in itself Christ the Word, and a book of chants, whether a *graduale* or a troper, to which none of this applied and which was an inherently utilitarian sort of book. For such a utilitarian sort of book, the Bamberg Troper is not so modestly illustrated. A *graduale* of small format and almost no illustration was made at Seeon for Henry II's use. It happens to have a little (quite unimportant) picture of a king inside an initial, and so it features in Schramm and Mütherich's catalogue of German emperors and kings in pictures of their time.[94] Henry II's book is very vertical in shape, to take ivory covers; we have no idea what sort of covers were originally intended for the Bamberg Troper. Perhaps these would most obviously have signalized the importance of the recipient.

Otto III will certainly have known that his hero Charlemagne took a great interest in the ecclesiastical chants,[95] and he could well have wanted

a manuscript which, in his zeal to renew Charlemagne's empire and mode of rule, would enable him to do the same. An interest in music is likely to have been fired in him by the enthusiasm for musical theory and for the practice of organ playing on the part of his tutor, Gerbert of Aurillac.[96] His political ideology and love of hymnody came together, as we have shown, in the Assumption, the depiction of which breaks such new ground (on our surviving evidence) in the Bamberg Troper.

As to the parade of Reichenau cults and religious concerns alongside those of Otto III, if the book were originally intended for Reichenau use, it would be striking testimony to the intimacy of emperor and abbey. But if it were originally intended for the personal use of Otto III, as we would prefer to think, Reichenau would have had every reason to remind the emperor, through the liturgy in such a book, of his close association with their community. Every effort which the monastery made under Abbots Witigowo and Alawich II to shake itself free from the jurisdiction of the nearby bishops of Constance (and Maurer has wittily shown how at this time it matched the episcopal See church building for church building, privilege for privilege, and embroidered sandal for embroidered sandal in the celebration of high mass) was made by identifying itself whole-heartedly with the ideas and policies of Otto III.[97] For instance, Bishop Conrad of Constance (934-75) founded a church of St Maurice, virtually Otto I's patron saint, and restored the church of St Laurence, on whose feast the Battle of Lechfeld had been won in 955.[98] Witigowo of Reichenau built on the island a church dedicated to St Bartholomew, an apostle specially honoured by Otto III, and under Alawich II the church of St Adalbert (for Otto III's relations with him, see p. 161) was begun.[99] The Assumption of Mary was the most natural religious devotion of all which united Reichenau with Otto III. If the Bamberg Troper, then, were made for Otto III, his untimely death would have caused it to remain at Reichenau for a number of years (the leaves of the manuscript show heavy use at some time) before being passed on to Bamberg, presumably under Henry II.

91. Assumption of Mary. St Gall (Tuotilo) ivory, *c.* 900. St. Gallen, Stiftsbibl.

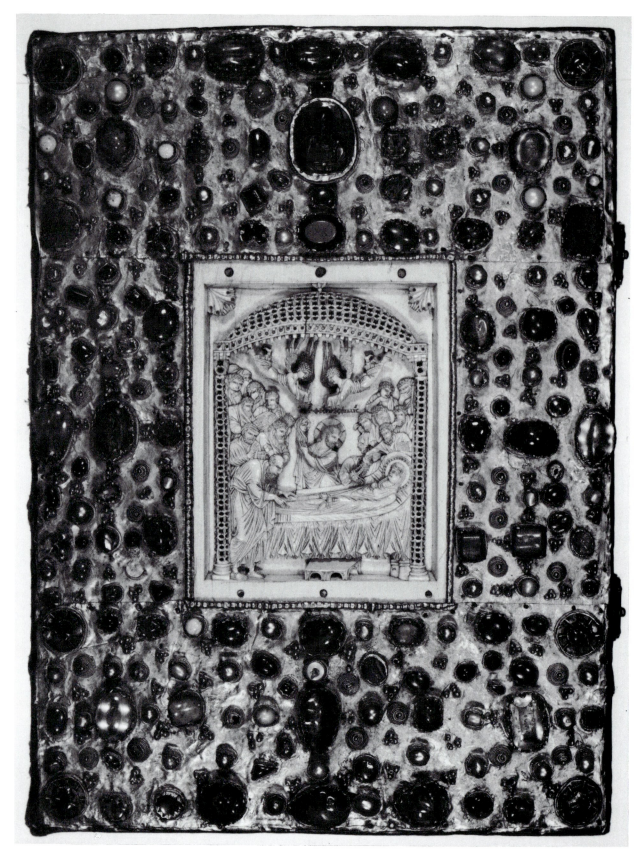

92. Book cover of the Gospel Book of Otto III, 998-1001.
Munich, Bayerische Staatsbibl., Clm. 4453

The Gospel Book of Otto III and the Pericopes Book of Henry II: A Contrast

1 The Gospel Book of Otto III

Otto III represents the culmination of Saxon-Liudolfing rule in the East Frankish, or German, kingdom, and its conjunction with the Roman Empire. Few individuals in the whole of political history can have made a comparable impact by the age of twenty-one, Otto's age when he died in January 1002. This young man exercised a magnetic power over a circle of highly intelligent and seasoned advisers like Gerbert of Aurillac, Leo of Vercelli, Bernward of Hildesheim and Bruno of Querfurt. These, and others, were men of extraordinarily disparate and assertive talents with evident tensions amongst them, and it is not credible to consider Otto a mere cypher in their hands.[1] They could scarcely have achieved any kind of cohesion and effect had they not been held together by the purposes as well as captivated by the character of the young man in their midst. His youth itself positively enhanced the impression which he made upon them. A contemporary noticed that when he was crowned emperor in Rome on Ascension Day 996, he was just developing the first down of a beard.[2] Moreover, we know quite a lot about Otto's actions, and they are not convincingly explained as those of a cypher. When, in 998, for instance, he wanted to make the eremitical monk, Romuald, Abbot of Sant'Apollinare in Classe in Ravenna, he was too diffident to summon the holy man to his presence and went personally to seek him out in his cell. Arriving only in the evening, he was offered and accepted Romuald's own bed for the night, although he jibbed at the austerity of his rough blanket. Then back with Romuald in the royal residence at Ravenna next day, Otto threatened him with excommunication if he refused the abbacy.[3] Such a highly personal mixture of humility, religiosity and decisiveness hardly betokens rule by a committee. Small wonder that he excited marvel and fascination in hardened statesmen. Indeed he was fascinated by himself. He believed that he was a unique mixture of toughness inherited from his Saxon father, Otto II, and subtlety of spirit inherited from his Greek mother, Theophanu.[4]

Otto III's Gospel Book is one of the summits of Reichenau and Ottonian art. Its great richness and its portrayal of the ruler make it clear that the book was created for the emperor, and it can reasonably be dated to the years 998-1001.[5] It is really the second surviving Gospel Book of Otto III,

157

the first being the Aachen Gospels, which, with Hoffmann, we would date to around the time of the imperial coronation of 996.[6] The book must have passed to Henry II and been given by him to the Cathedral of Bamberg which he founded in 1007. There it remained until 1803 and till the secularization of German churches. At that time the commissioners of the Elector of Bavaria were largely interested in manuscripts whose bindings of gold and precious stones made them of material worth, rather than in artistic quality. Hence the Bamberg Apocalypse, for instance, was suffered to remain at Bamberg, while the Gospel Book of Otto III, with its opulent binding was removed to the Bavarian State Library at Munich.[7] The golden

92 cover of this book, studded with gems, is a salutary reminder to those who investigate its illuminations that it was a sacred object in itself whether open or closed; and that if and when it was used in the liturgy, its primary significance would have been to be carried closed in the gospel procession, to be laid on the altar most likely closed, and as a book to be the symbol of Christ. We have to treat its illustrations as a creative expression, indeed, of ideas, feelings and intuitions; but as to the impression they made and who imbibed them, we cannot point confidently to a known public, at least beyond the emperor himself.

85 A tenth-century Byzantine ivory of the Dormition of the Virgin is set into the front of the cover. This subject was highly meaningful to Otto III, as we observed in the previous chapter. There was no place for it amongst the illustrations *inside* the book, since this is a continuous text of the four gospels and the gospels say nothing of Mary's death on earth. Only a book which contained the gospel readings for the liturgical year might illustrate the Dormition, in connection with the feast of the Assumption of Mary, and even then without textual support from the readings themselves. Yet here on the outside the ivory could be seen and venerated when the book was closed. Thus were the claims of this non-biblical subject vindicated, with Greek subtlety, for the devout emperor, on a book of biblical texts.

The lavishly ornamented canon tables, which occupy the first pages of the Gospel Book, are also interesting. Their decoration, not least in the 'roof plants', takes us back to the great canon tables of the gospel books of the Charlemagne Court School. Their form of gables on a frieze echoes that of the Charlemagne Aachen Gospels. From the beginning, therefore, the art of this book announces itself as court art, during the years when Otto III was consciously reviving the empire of Charlemagne.[8]

Col.Pl. XXI The Gospel Book is famed above all for its leaves dedicating the volume to the Emperor. On the right-hand page (f. 24) as the book lies open is seated the young emperor, holding his sceptre and orb, stiff but perfectly poised, with a jewelled crown upon his red hair, and forced as it were into the very front of the picture by the curtain hanging in the quasi-temple before which he sits. We are here partly in the world of the late antique Vatican Virgil, one of whose illustrations shows Latinus sitting before a temple (though he does not sit frontally, nor in the middle of the temple, and the temple is represented, unlike in our Gospel Book, spacially); at

his side stands a weapon-bearer, while five Trojans approach him deferentially.[9] Schramm showed that Otto III was virtually always represented as a young man (the *Jünglingstypus*), Henry II with one explicable exception never (see the Excursus in Part II). To the emperor's left stand two secular nobles who bear his weapons, to his right two churchmen. There is here no hand of God, no allegorical veil, no angel to point up the ruler's divinity; in a scene of consummate art and majesty such stage properties were scarcely necessary. Nor were they necessary in a picture essentially representing a profane rather than a Christian/mystical genre of ruler portraiture.[10]

Facing all this on the left-hand page (f. 23v) there approach four crowned women of various complexions, personifications of provinces of the empire, bearing their gifts and making their obeisances. In the lead is *Roma*, followed by *Gallia* and *Germania*, with *Sclavinia* bringing up the rear. By the tenth century the formula *Gallia* and *Germania* was a normal usage of church documents to signify the Saxon empire in terms of old Roman provinces, *Germania* to the east of the Rhine, *Gallia* to the west and applying principally (though not exclusively) to Lotharingia.[11] We shall come to *Sclavinia* shortly. Unity is given to these two pages by the strips of background colour common to both, by continuity and correspondence of gestures particularly between the raised hand of Otto's sword-bearer on the right and the raised hand of *Sclavinia* on the left, and by the contrasting but harmonious rhythms of female grace and male solemnity. Florentine Mütherich has recently said of the artist of this double leaf, considering the perfection of every detail down to the delicate green shades which give light to the emperor's face, that 'either he painted only this picture in the manuscript, or else he accomplished here a triumph which even he could not again equal'.[12]

The iconography which has influenced this picture is a rich mixture of antique representations of the emperor and his court dignitaries, of provincial personifications such as figured in the *Notita Dignitatum* of which the Ottonians probably had a copy,[13] and of the Epiphany, or manifestation of Christ being approached by the procession of Magi. Such a mixture was of course not new in the tenth century, although it may be doubted whether our artist stuck closely to one particular model. The sixth-century mosaics of Sant'Apollinare Nuovo at Ravenna depict the Epiphany with the Magi followed by a long line of female saints bearing crowns; here is the association of female personifications with the Epiphany scene in a Christian context. Konrad Hoffmann has drawn attention to the fact that the same double aspect, Christian and Roman, of the ruler's image is already forcefully presented in the widely read fifth-century historian Orosius. Orosius wrote of the triumph of Augustus on 6 January, the later Feast of the Epiphany of Christ, 29 B.C., and in the very next chapter describes the legates of the Indians and Scythians paying homage to Augustus at Tarragona.[14] Moreover, the emperor in majesty is placed, in the Gospel Book of Otto III, between the magnificent canon tables and the portrait of St Mat-

Col. Pl. XX

159

thew as the first evangelist, just where in other gospel books the Christ in Majesty is to be found. The most direct antecedent of these two pages in Carolingian art (obviously known to our artist) is the representation, in a splendid setting, of Charles the Bald near the beginning of the Codex Aureus of Regensburg (Munich, Clm. 14000). Here the king sits with personifications of *Francia* and *Gotia* on either side of him and next to the throne warriors on either side who together hold his weapons.[15] The warrior on his right places his hand on the cushion, just as the churchman lays his on Otto III's. The church is not represented in the Codex Aureus and is the new element in the iconography of Otto III, signalizing perhaps the heightened sense of universality which the church gave to Otto III's rule.

Nobody now doubts that these two pages are a splendid pictorial representation of Otto III's *Renovatio Imperii Romanorum*. As against earlier personifications of provinces within the dominion of the Ottos in which Italy figures, here Italy is pointedly replaced by Rome. There are three principal evidences of the *Renovatio*: Otto III's seal of 998, which exactly copied Charlemagne's *bulla* of 800, when he was crowned emperor at Rome, and which bore the legend RENOVATIO IMPERII ROMANORUM; Otto III's Gospel Book; and a poem of Leo of Vercelli.[16] Rome clearly fired the imagination of Otto III, *urbs regia nostra* as one of his documents calls it,[17] with its antique buildings, some of them sheltering Christian churches, and others in ruins but still representing gigantic masses of masonry towering above each other. It also fired the imagination of Gerbert of Aurillac, one of Otto's mentors, who wrote a letter about his empire in the last days of 997, the terms of which neatly fit the provinces depicted here;[18] and it fired others of his circle like his old tutor Bishop Bernward of Hildesheim whose bronze column depicting the Life of Christ took its inspiration from Trajan's column. In 998 Otto actually set up an imperial court in a palace on the Aventine Hill. Here he would dine alone and in state, sitting at the middle of a semi-circular table. Saintly western rulers of this period were praised for not sitting alone at table in lofty isolation; but it was done by the Byzantine Emperor, and while Otto III sought only the Roman past itself in Rome, he was sometimes drawn consciously or unconsciously to borrow his forms and notions of it from Byzantium.[19] But there was more than symbolism to Otto's Roman court. In this way he could exploit the tenth-century revival of interest in ancient titles to draw Roman and central Italian families to the imperial side who were hostile to the Crescentii, the family which most seriously challenged Otto III's control of Rome.[20] In this way, too, he could keep an eye on a pope (Gregory V, 996-99), who, though his own uncle and the first German ever to occupy the papal throne, he came not entirely to trust; for at the same time as setting up his Roman court he renounced the Donation of Constantine, and had his own representatives rule directly over papal territories, above all the five counties of Ravenna.[21]

An integral part of Otto III's Rome policy was his relationship with the

Christian Poles. Hence it is appropriate that where Rome leads, and after the classical Roman provinces of *Gallia* and *Germania*, *Sclavinia* should follow. The rising of the Slav Liutizi to the east of the Elbe (and to the west of the Poles) in 983, and their relapse into paganism, led to an Otto-nian-Polish alliance to resist the danger to each. From this time arose many marriage connections between the Saxon aristocracy and the Piasts, the Polish ruling dynasty, which gave the lie to the idea that with their incipient nationalisms, Germans and Poles eyed each other with nothing but suspicion, or that Otto III betrayed a nascent German state by his friendliness and concessions to the Poles.[22] At the same time the Polish rulers had been developing their own independent links with the papacy, so that for Otto III, a Polish policy, if he was to have influence with the Poles, was in general bound also to be a Roman policy. More particularly, Rome, because of the coalescence there of Latin and South Italian Greek monasticism (in which the devout Otto was especially interested), came to seem an ideal centre for training missionaries to the Slavs,[23] something in which both Saxons and the Piasts had a stake. When Otto was in Rome for his imperial coronation in 996 he met a monk and missionary, the Bohemian St Adalbert, who was to be a decisive influence on him. Adalbert was a Bohemian of the Slavnik family who were rivals of the ruling Premyslids and who remained on friendly terms with the Saxons and the Piasts during the time in which the Premyslids were opposed to both.[24] While Gerbert of Aurillac purveyed to Otto political wisdom, Adalbert, who possessed little of this commodity, stimulated his spiritual yearning. Unable to maintain himself in the Premyslid stronghold of Prague, Adalbert had been exiled from his bishopric of Prague; he had come to Rome and been greatly impressed by the Latin and Greek monasticism at the monastery of St Alessio.[25] He had later been martyred preaching to the pagan Liutizi on 23 April 997. Veneration of Adalbert became a central feature of Otto III's religious life.

The connection between Rome and Poland went still further in Otto III's politics. In the year 1000 Otto went to Gnesen to honour the remains of Adalbert, to acquire relics of him for Aachen, and to agree to the setting up of an archbishopric of Gnesen at the head of a Polish ecclesiastical province owing obedience not to the Saxon Magdeburg but directly to Rome. The first Archbishop of Gnesen was Gaudentius, brother of Adalbert and himself a former monk of St Alessio. At the same time Otto III is reported to have recognized Boleslav II as a brother and *cooperator imperii*, a friend and companion of the Roman people. These are vague phrases and historians have discussed at length what position Otto actually attributed to the Polish ruler. But all are agreed that it was one of honour and not of obvious subservience, in an empire which was regarded as a great confederation of Christian states presided over by the Emperor and the Pope in Rome, rather than as a means by which one state could dominate another. *Germania* could not rule politically and ecclesiatically over *Sclavinia*, but rather the Roman Christian Empire had ex-

161

panded to include a new member. As Fleckenstein has said, Poland was unbound from the German kingdom in order to be more closely incorporated into the higher order of the Roman Empire.[26] That is what the introduction of *Sclavinia* into Ottonian iconography, apparently for the first time in the 990s, seems to say.

One should observe, however, the opposition amongst contemporaries both to the Rome and to the Gnesen policy, an opposition the full extent of which is in the nature of the case not likely to appear in the surviving sources. Thietmar of Merseberg said of the *Renovatio Imperii Romanorum*, with quasi-discretion, *diversi diverse sentiebant* (opinions varied).[27] Thietmar himself, old pupil of Magdeburg as he was, probably disliked the diminution of Magdeburg rights involved in setting up the independent archbishopric of Gnesen. Archbishop Gisiler of Magdeburg naturally opposed it for this reason. So perhaps did Thietmar's cousin and fellow Magdeburger Bruno of Querfurt, whose later writings express the view that Otto III had neglected delectable *Germania*, that the policy of reviving ancient Rome was tantamount to paganism, and that it was nonsense to call Rome the head of the world (a title which belonged to the emperor personally wherever he was) and wrong that the emperor should reside in a city which was properly the domicile only of the pope.[28] Bruno did not break with Otto personally, but he withdrew from the circle of his chaplains to become a monk of St Alessio, and he was to die a missionary bishop and martyr in Hungary. This was opposition to the policy at the most serious level. So was that of Archbishop Willigis of Mainz, whose earlier strained relations with Gerbert of Aurillac and St Adalbert, two of the most influential personalities in shaping the policy, make him unlikely to have been a warm supporter of it.[29] In face of the fact that these pages certainly did not reflect established opinion throughout the Ottonian Empire, one is tempted to brand them as propaganda.[30] The word would be inappropriate, however, not because through art they affirmed and elevated a political ideal within a circle already largely convinced of it, for that is a common characteristic of propaganda; but rather because Otto III would probably have regarded them more as a prayer, a prayer that he should come ever closer to the image of Christ (as well as of a Roman emperor) in which the pages present him. The dedication page of the Aachen Gospels make a prayer explicit. 'May God clothe your heart with this book', says the scribe Liuthar as he presents the gospel book to Otto III, seated in majesty on the opposite page.[31]

28,29

The historical interest of the dedicatory pages in this book are palpable, but that is no reason to assume that only a purely artistic interest (great as that may be) attaches to the twenty-nine full-page miniatures which illustrate the text of the gospels. The second journey of Otto III to Italy in 998-99 came to be accompanied by strong feelings of guilt and remorse, which it scarcely strains the imagination to see reflected in the gospel illustrations. When Otto returned to Rome in 998 after his successes against the Slavs in the previous year, he and Pope Gregory V took savage reprisals

for the rebellion of Crescentius during his absence. These included blinding and mutilating the face of John Philagathos, former Abbot of Nonantula and Crescentius's anti-pope, who had been one of Otto's own teachers but was now in league with the Byzantine emperor, and sending him for a ride through Rome facing backwards on a donkey. Philagathos brought the celebrated Greek ascetic, St Nilus, into the Life of Otto III. St Nilus must have been about ninety at the time, and a certain flavour of his personality in old age may be caught from an incident reported in his *Life*, which was written soon after he died: someone wanted to speak to him and received the message, 'the old man finds himself in the grip of demons and is at present fit to speak to nobody'.[32] Both Nilus and Philagathos had been monks at Rossano in South Italy, so Nilus in the midst of his Lenten fasts journeyed to Rome to plead for his former colleague. He was met by the pope and emperor who each took an arm and led him to a chair between them. After expostulating with them for showing him such humility when it was he who should have abased himself before them, he began to say that he begged not for material goods nor for the enhancement of his own glory, but for a man who had served them well and been badly treated by them, who had acted as godfather to them both and had had his eyes torn out by way of thanks. 'I beg you hand him over to me', he went on, 'let me take him, that we might bemoan together our sins'. Otto, like his great-uncle Bruno of Cologne, had the *gratia lacrimarum*,[33] and at this the tears welled into his eyes.

But the words which had so powerful an effect on Otto III did little to restrain Gregory V from further humiliations of Philagathos. Otto, nervous of the reaction of St Nilus, sent a cardinal to the ascetic to justify himself, but Nilus was not impressed, and the cardinal was told to say on his return that pain had been inflicted not on Nilus himself nor on his colleague but on God, and as the pope and emperor had shown no mercy, so God would show none on their sins. After this Otto was persuaded to go on a penitential pilgrimage to the shrine of St Michael on Monte Gargano in Calabria. This was in Greek territory. Where Otto I had penetrated to fight the Byzantine forces in 969, Otto III came thirty years later as a pilgrim and a penitent. Again he met St Nilus on his journey, presumably at Nilus's monastery of Valleluce. On this occasion he expressed his concern at the lack of provision for Nilus' monks when their abbot should die, and offered him any monastery within his dominions. Nilus laid his hand on the young emperor's breast and replied that he wanted nothing except the saving of Otto's soul, 'for you must die like other men and you too mush render account of your wicked deeds and your good works'. At these words of a saintly man more than seventy years his senior, Otto III burst into tears, took the crown off his head which he always wore as a sign of his anointment, and placed it in the hands of Nilus.[34]

Thietmar of Merseburg, writing in the early eleventh century, exhorted the faithful to pray for the soul of Otto I, Otto III's grandfather, so that God would mercifully overlook the many sins which, amidst his great

responsibilities, he could not avoid.[35] Carolingian councils had already applied this theme to bishops, asking daily prayers for bishops who, in times of troubles and above all of succession disputes within kingdoms, were ineluctably drawn into sin.[36] The impossibility for rulers to avoid sin may appear something of a commonplace, but remorse for his own seemingly unavoidable sins was really felt by the young Otto III, at least periodically, in every nerve. He sighed in his conscience at his many sins, according to Thietmar (on whose showing Otto I left the sighs to others), and there were vigils, prayers and rivers of tears.[37] When he visited the monastery of St Emmeram at Regensburg once after lending an ear to Bishop Gebhard's denunciations of its abbot, Ramwold, the abbot and monks in bare feet prostrated themselves on the ground before him. Otto became afraid, because he said that their unshod feet laid bare his sins (penitence could be an instrument of power on both sides!). Then he sat on a stool in a state of compunction listening to the abbot, and when he returned to his *familiares* they wondered at the change in his face, his tears, and his profuse sweat.[38]

Religious feeling, never unduly low-strung in the vicinity of Otto III, was heightened by a spate of unexpected deaths in 999. First was Otto's aunt Mathilda, Abbess of Quedlingburg, whom he had left as *matricia* or vice-regent in the north. Then on 18 February came Gregory V, still not out of his twenties; his death made a deep impression on Otto since it recalled an earlier prophecy of St Nilus. Most extraordinary of all was the fate of the bishops or bishops-elect of Worms. The tale begins with the youthful Bishop Franco, a close friend of Otto, who held the See for a year and then joined the emperor in Rome. The two friends, dressed in hair shirts and practically in bare feet, descended into a grotto next to the crypt of San Clemente, and there they spent a fortnight in prayer and fasting. During this time they not surprisingly saw visions, and afterwards Franco prophesied the day and hour of his death to the emperor, and forthwith on 27 August 999 he fulfilled his prophecy. A month later Otto named his young friend Erpo of Halberstadt, a former chaplain whom he had made Abbot of Farfa, as Bishop of Worms. Three days later, before he had made a move, Erpo died suddenly and was laid to rest by the side of his abbot predecessors. Next he named another of his young chaplains, who was so keen to be a bishop that he was not above suspicion of simony, and who set out with alacrity from Rome for Worms. At Chur on the way, he also died.[39] This singular succession of sudden deaths clearly added to the self-questioning in Otto III's circle. Thietmar of Merseburg, a great connoisseur of matters episcopal, said that he had never known anything like it.[40]

If we now look at the illustrations of the gospels in the light of all this, we see that tears, remorse and penitence play an important part in the Gospel Book of Otto III. This is particularly so at some of the points where there is strongest reason to believe that the book is most unusual or inventive in its iconography. The Passion scenes are moving indeed and are fuller than in any other Reichenau manuscript. But although the artist or

93. Christ weeps over Jerusalem. Gospel Book of Otto III, 998-1001.
Munich, Bayerische Staatsbibl., Clm. 4453, f. 188v

94. Peter's Denial of Christ. Aachen Gospels, c. 996. Aachen, Cathedral Treasury, p. 458

95. Peter's Denial of Christ. Stuttgart Psalter, c. 830. Stuttgart, Württembergische Landsbibl., MS Bibl. Fol. 23, f. 49

artists never give the impression of uninvolved work, or mere routine, these scenes are thoroughly rooted in late antique and Byzantine iconography, and in arrangement they may owe much to contemporary Byzantine models.[41] They are not therefore the best evidence of what was most

93 significant to the producers of our book. Christ Weeping over Jerusalem, on the other hand, which was the subject of one of the lost Carolingian wall-paintings of St Gall, is represented in the whole surviving corpus of Ottonian art only in this manuscript.[42] Peter's denial of Christ is in itself not an unusual subject to be illustrated, but whereas the earlier Codex

95 Egberti and the Carolingian Stuttgart Psalter show separately Peter's conversation with the maidservant and his going out and weeping bitterly,

96 our book shows Peter warming his hands over a fire while all his three conversations are run together, his antagonists all standing in one doorway. The effect is that three hands, with the usual long, bony, pointing fingers of Ottonian art, all shoot out simultaneously at the miserable Peter, himself very much trapped at the side of the picture. The lowest of these hands almost meets Peter's own, and whether these are limp from cold or from guilt one can hardly say. Never before or after (even in the bronze doors of Hildesheim) did Ottonian art equal the graphic depiction of the accusing conscience achieved here.

One can see how original this picture is if it is compared with the same

94 scene in the earlier Aachen Gospels, which was doubtless in its immediate source. Here the maidservant alone addresses Peter as in the Carolingian scene (but seeming to take him unawares from behind). He warms his hands at the fire. On the other side of the fire a group of servants, with a rather exaggerated forest of hands, warm themselves. Their hands are warming hands and perhaps partly accusing hands too, but they must surely have given the artist of the Gospel Book of Otto III the more dra-

96 matic idea of putting all Peter's accusers in the same doorway with their hands shooting out at him.[43]

166

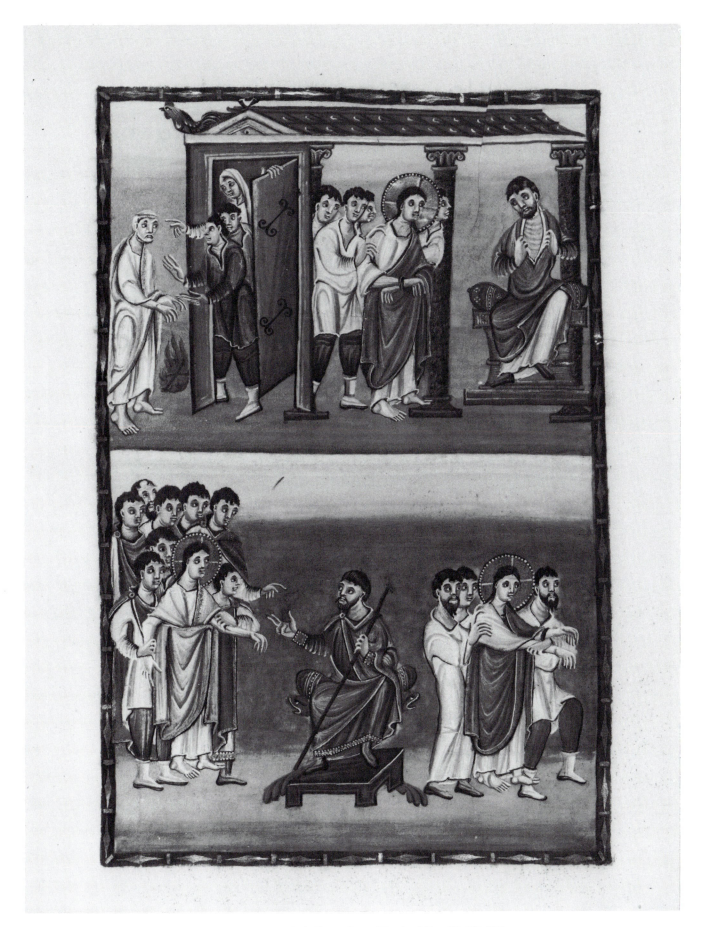

96. Peter's Denial of Christ. Gospel Book of Otto III, 998-1001.
Munich, Bayerische Staatsbibl., Clm. 4453, f. 247

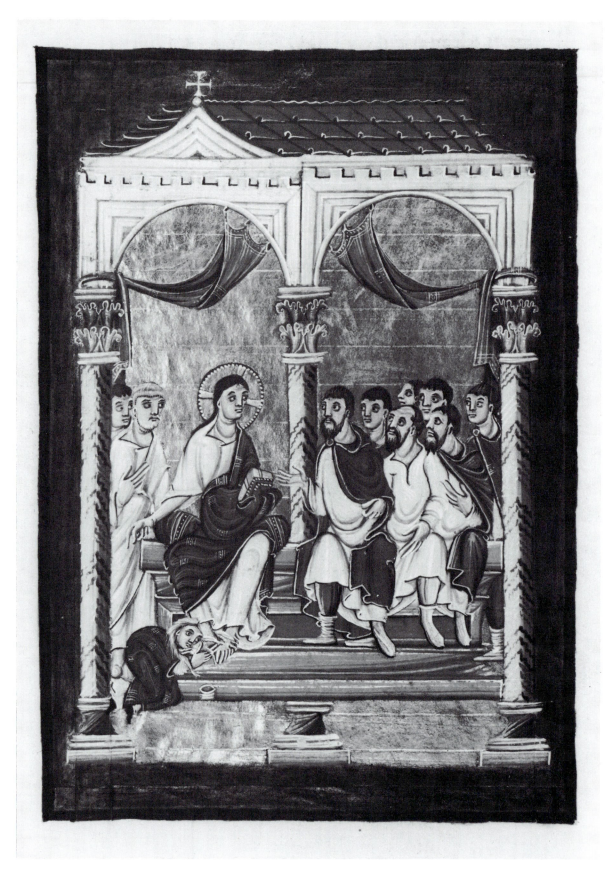

97. The Repentant Mary Magdalen. Gospel Book of Otto III, 998-1001.
Munich, Bayerische Staatsbibl., Clm. 4453, f. 157v

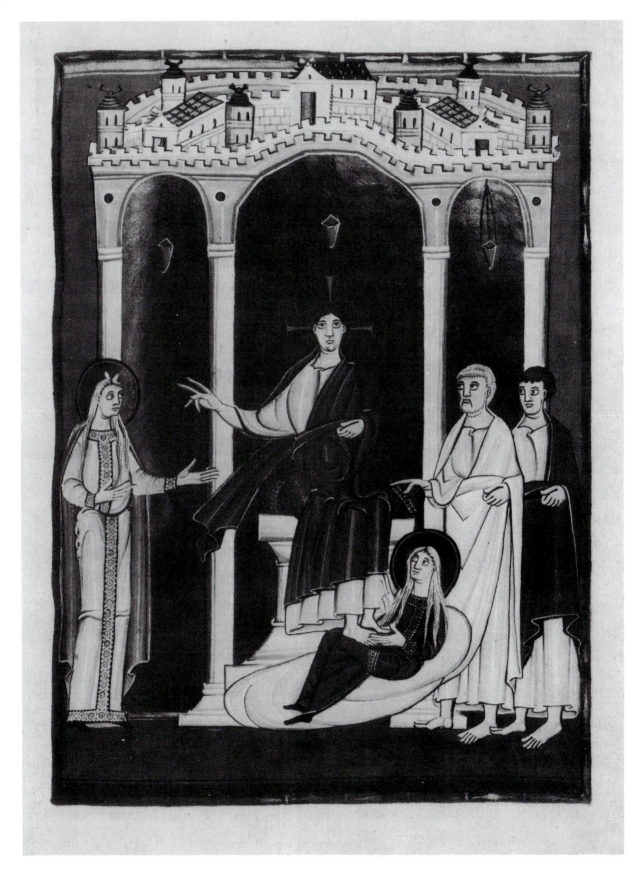

98. Mary and Martha. Pericopes Book of Henry II, 1002-12.
Munich, Bayerische Staatsbibl., Clm. 4452, f. 162

97 Another rare scene in Ottonian art represented in this Gospel Book is the repentant Mary Magdalen washing the feet of Christ with her tears, though this too was the subject of one of the lost frescoes of St Gall. The tiny size of the hunched figure of the Magdalen at the feet of Christ, compared with the figures of Christ and the apostles, is a striking symbol of the humility required of a penitent. But it is more than a symbol; it is dramatic art. The centre of the stage is very much occupied by Christ, his pharisee interlocutors, and two apostles, so that one may not immediately catch sight of the minute figure in the bottom left-hand corner. Once perceived, however, she draws the eye irresistibly to herself. It is the same with the Emperor Henry II and Kunigunde, who humble themselves be-

34 fore the feet of Christ on the Basel Altar (p. 66). What is remarkable in the Gospel Book is the intense intertwining of Mary's fingers with Christ's toes as she rubs her cheek against his feet. We may compare this with the

98 scene of Mary and Martha in the slightly later Pericopes Book of Henry II. The comparison is not in every way satisfactory since it is a different scene, indeed a more popular one in Ottonian art, but as scriptural exegesis generally took the Mary who was commended for sitting at the feet of Christ to be the same person as the penitent Mary Magdalen (herself a composite figure) there is some point in it. Here Mary sits not so much at, as under, the feet of Christ which she holds; the emphasis is on the majesty of Christ who has, so to speak, conquered Mary. In the Gospel Book of Otto III the emphasis is on the human relationship between Mary (notwithstanding her tininess) and Christ. One of the Echternach Gospel Books of Henry III later contained the same scene of the Magdalen's repentance, but the artist was following a different model from that of our book (as were the contemporary Byzantine artists). The contrast is instructive, for there is in the later book little attempt at a tender intertwining of hands and feet, while a heavy table interposes itself between Christ and

99. The Repentant Mary Magdalen.
Codex Egberti, 997-93.
Trier, Stadtbibl., MS 24, f. 65

170

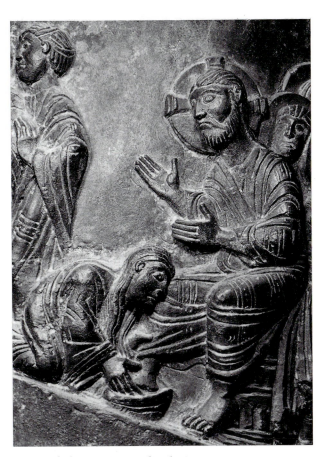

100. The Repentant Mary Magdalen.
Bronze Column of Bishop Bernward of Hildesheim,
early C11. Hildesheim Cathedral

Mary, somewhat blocking the free interactions of their personal relation-
ship.[44] The Codex Egberti, on the other hand, is obviously based on a
related model, and has a touching scene, but one lacking the singular and
concentrated emotion displayed here.

In feeling, the closest repentant Magdalen in Ottonian art is on the
column of Bishop Bernward of Hildesheim, which is not surprising. Bern- *100*
ward though not a convinced adherent of Otto's Roman policy had been
in Rome with the emperor in 1001, was a central figure in Otto's court,
and shared the emperor's mixture of veneration for ancient Rome and
sensitive devotion to the human Christ. Bishop Bernward's column has a
large overlap of subjects with the Gospel Book, and both strike a very
similar balance of miracles of power, miracles of compassion, and New
Testament moral teaching.[45] Given the difference of medium it is not easy
to tell how far Gospel Book and column shared models, but if one is not
careful, one begins to see models around every corner. More important
here is surely that the bishop had been Otto's tutor; they were used to
talking with each other as tutor and pupil. In his *Life* of Bernward, Thang-
mar, who had once taught the bishop, said that when Bernward was
assigned as tutor to the eleven-year old Otto after the death of his mother

171

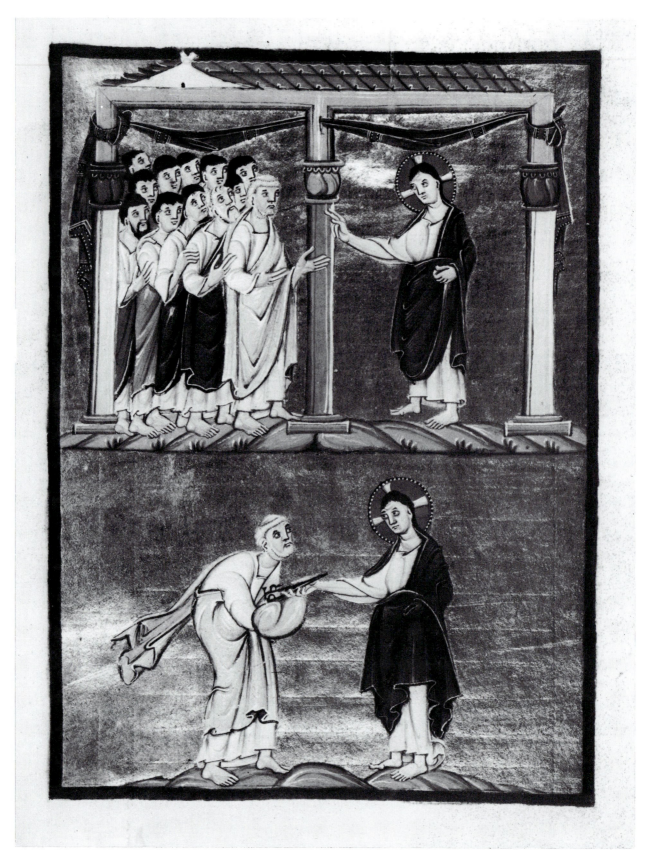

101. Christ hands over the Keys of Heaven to St Peter.
Gospel Book of Otto III, 998-1001. Munich, Bayerische Staatsbibl., Clm. 4453, f. 60v

in 991, the boy embraced his master *praecipua familiaritate*. When Bernward arrived in Rome in 1001, Otto III did not wait for him to come into his presence, but went two miles from his palace to meet him at St Peter's, took him to his hotel (*hospitium*), conversed with him for a long time (*diuque cum illo confabulans*), and then saw him constantly for the next six weeks. In that time Bernward advised him magisterially on how he should behave. Both representations of the Magdalen must have owed something to the common mind and indeed the conversations of their two patrons.[46]

We must consider not only Otto III's personal penances, but also the more general background of his religious culture when we look at this penitence of Mary Magdalen. There survives from the library of Schloss Pommersfelden, a book of private prayers, now in Bamberg, compiled in the diocese of Mainz, written in gold letters on purple grounds, and generally agreed to have belonged to Otto III.[47] A prayer headed 'whoever prays this prayer daily shall not feel the torments of hell in eternity', places stress on the *gratia lacrimarum* and has the following passage: 'be mild to me as you were to Mary the whore, and fill my eyes with tears as you filled hers when she washed your feet and wiped them with her hair'. The prayer carries on, 'I pray you Saint Peter who hold the keys of the kingdom of heaven to absolve me from my sins on this earth'.[48] The Gospel Book of Otto III gives a prominence to Peter's receiving the keys of heaven from *101* Christ, for whereas in other contemporary manuscripts (for instance the Pericopes Book of Henry II) Christ addresses the apostles and hands over the keys to St Peter who stands at the head of their group, all in one scene,[49] here the subject is divided into two vertically separated scenes, in one of which Christ addresses the apostles and in the other Peter, on his own, receives the keys. Mütherich has commented on the significance of marking out Peter so prominently in a gospel book made for an emperor (although she is not explicit about what the significance is).[50] The Prayer Book of Otto III enables us to see that this might not be simply an emphasis on the papacy in a revived empire of which emperor and pope were jointly the heads; it might also relate to Otto III's preoccupation with sin and forgiveness.

One of the most arresting and poignant figures in the whole Gospel Book of Otto III is that of the blind man who was to be healed by Christ. *Col.Pl.XXIII* The figures of Christ and the blind man are placed most appositely against the architectural background, the central pillar setting off the gestures of each. On either side are grouped the apostles. These groups, with their effect of crowding and the intensity of their gaze, seem to exert a psychological pressure on the central drama. Every eye is concentrated on Christ, but the eye of the beholder is drawn swiftly to the blind man by the vivid red, mauve and white of his clothes; and once drawn, it is held by the powerful impression of the face and the steep angle at which it is directed towards the face of Christ,[51] and by a degree of pathos and personal relationship between the two which is not at all achieved or aimed at in the same scene of the Codex Egberti. Since the fine wall-paintings in the *102*

173

church of St Georg, Reichenau, are demonstrably close to the Gospel Book in iconography and actual models used,[52] it is noteworthy that the Reichenau wall-painting of this subject just lacks the peculiar concentration, poignancy and tension of the Gospel Book. This picture, whose Byzantine parallels are not close,[53] seems clearly to bear the mark of religious devotion in Otto III's circle. Perhaps one can be more specific and say that its subject was charged with a special significance, which has caused it to be rendered with rare feeling here, because of what Otto III's exchanges with St Nilus show to have been the painful issue of the blinding of John Philagathos.

No sooner is this said than one realizes that the onlooker, particularly Otto III himself, could have seen in this picture more than one level of meaning. Both Tacitus and Suetonius describe how the Emperor Vespasian miraculously cured a blind man at Alexandria.[54] To blind a man was the work of a sinful human being; to cure a blind man was the action of an emperor. Otto was acutely aware of himself in both capacities. There is a serious doubt whether he could have known Tacitus's *Histories*, the earliest surviving manuscript of which in its entirety is a mid-eleventh-century one from Monte Cassino. But Suetonius, though not common, seems clearly to have been available to his circle. If Tacitus's *Histories* was known anywhere as early as 999, it would surely have been at Monte Cassino, on

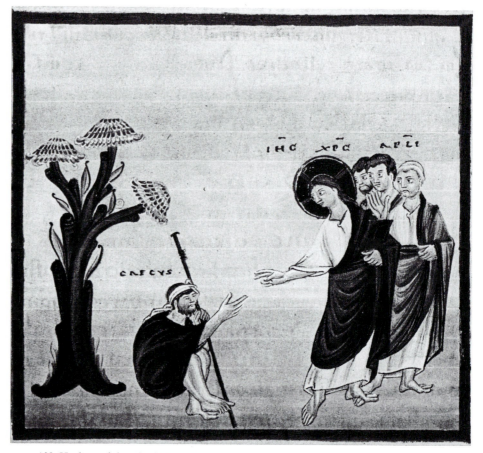

102. Healing of the Blind Man. Codex Egberti, 977-93. Trier, Stadtbibl., MS 24, f. 31

the supposition that the earliest surviving manuscript was most likely to have been a copy of an earlier manuscript already there.[55] Otto III visited Monte Cassino in that year during his penitential pilgrimage,[56] just when the Gospel Book must have been being planned or executed. Amongst the sins standing out in his mind on that pilgrimage was certainly the blinding of Philagathos. If anyone in the monastery had mentioned Vespasian to him, as it would have been natural to do in the circumstances, one can imagine how the impressionable young man must have leapt with interest at the mention. This is admittedly rather speculative, but perhaps worth putting forward to indicate the *possible* levels of meaning, from the viewpoint of Otto III's court culture, on which this Christ Healing the Blind Man could be read. Otto could regard the picture almost as a ritual in art, a Christ-centred act of imperial repentance and 'satisfaction' for his cruelty.

The primary function of the gospel illustrations in our book was not, it goes without saying, to illustrate the preoccupations of Otto III in 998-1000. If one had to state their primary function in a phrase, one would be bound to follow Mütherich and say that it was the harmonization of the gospels.[57] The attempt to show that the four gospels could be used to render a coherent and continuous account of the Life of Christ was one of the concerns of the Fathers, of Augustine of Hippo, and very much of the Carolingians. The Gospel Book of Otto III made a major contribution to the harmonization of the gospels in art by the organization of its twenty-nine illustrations across the four gospels. However difficult it may be to preserve a chronological framework for illustrations interspersed among the four gospels, when the principal infancy narrative of Jesus occurs only at the beginning of St Luke's gospel, and when every gospel recounts passion and death, that is what Otto III's Gospel Book set out to do, as the Codex Egberti had done.[58] This was nothing so rational as an exercise in historical method. The artists of the last great Ottonian school at Echternach blithely jettisoned every consideration of chronology in their series of full-page and half-page illustrations to the Gospel Book made (1043-46) for Speyer Cathedral and now in the Escorial (Cod. Vitr. 17). Here Matthew starts with the Magi and ends with the Garden of Gethsemane; the arrest of Jesus in the garden, the Crucifixion and the Three Women at the Tomb come only at the end of Mark; they are followed by the Nativity at the beginning of Luke; while the illustrations for John close with the Last Supper.[59] The difference is that the Gospel Book of Otto III makes a coherent effort to focus on the person of Christ; the Speyer Gospels focus on the text as it is being read, the more rationalist endeavour of the two.

Whatever the primary function, however, as one studies these illustrations there seem to be so many ways in which their whole religious mood runs parallel to that of Otto III, particularly from 998 onwards, that I have gradually found myself wondering whether this manuscript could conceivably have been made in Rome itself. Proof of this would be impossible, but the purely physical objections would not seem very strong. With distinguished bishops and chaplains from north of the Alps surrounding the

emperor in some numbers at Rome, it is difficult to see why one or two first-rate artists should not have been added to their number, complete perhaps with colours and even parchment. The court on the Aventine (whence the emperor's followers made a safe getaway in 1001) should have provided a secure enough basis for long enough to allow them to finish such a book. If Otto III could call the Italian painter Johannes Italus to Aachen, why could he not call northern book illustrators to Rome?

It is not, however, necessary to insist that the Gospel Book was made in Rome. If one considers Otto III's itinerary north of the Alps in 1000, he was at Regensburg in February, he was at Aachen and in the Rhineland in April and May (near enough to Trier to make the re-establishment of links quite possible), and he was travelling up the Rhine to Chur in June, doubtless in order to cross the Splügen Pass, or another pass near it, on his way back into Italy (which would have made a visit to Reichenau natural).[60] If, therefore, work on the Gospel Book was going on between 998 and 1000, or even 1001, and if its closeness to the emperor himself is strongly suggested by the dedicatory pages, then this itinerary has something to offer to each of the main theories about where our group of manuscripts was produced (but see Excursus I). The conclusion is that emphasis should be not on the particular place, but on the closeness of the manuscript to Otto III. And in this closeness, it begins to take shape as itself a striking historical testimony to the person of this extraordinary young man and the character of his rule.

The purpose for which the book was made must surely have been the personal use of Otto III, to be carried with the treasures of his chapel wherever the imperial itinerary took him. Of course it was, to re-iterate, a liturgical book with its significance in the ritual of the mass. But its pictures can hardly have been intended to make their impact primarily at mass. Apart from the Childhood and Passion cycles, at least four of the scenes illustrate passages which either do not appear in the *capitulare* of gospel readings, or appear only for Sundays after the Epiphany or Pentecost.[61] It is not easy to see why so much art and gold should be lavished on the low liturgical season, at the expense of more in the high season, or of the great occasions like the dedication of a church. The pictures are therefore better explained as intended for the private perusal of the emperor. The book would not in this way become less a sign and an instrument of power, but if anything more so. For while the existence of such a book could hardly be a secret, and many persons might catch glimpses of it in its splendid covers, access to it was the emperor's alone and the privilege of those whom he might favour by turning its pages with them. An emperor was not less an emperor in private than in public, least of all Otto III with his acute awareness of his Christ-like *persona*, his feeling (in all likelihood) of being under constant scrutiny, and his sense of responsibility when he prayed. Perhaps indeed there was little differentiation between public and private in his life; for centuries after Otto, the very bedchamber of a ruler remained an astonishingly public place.[62] Certainly

176

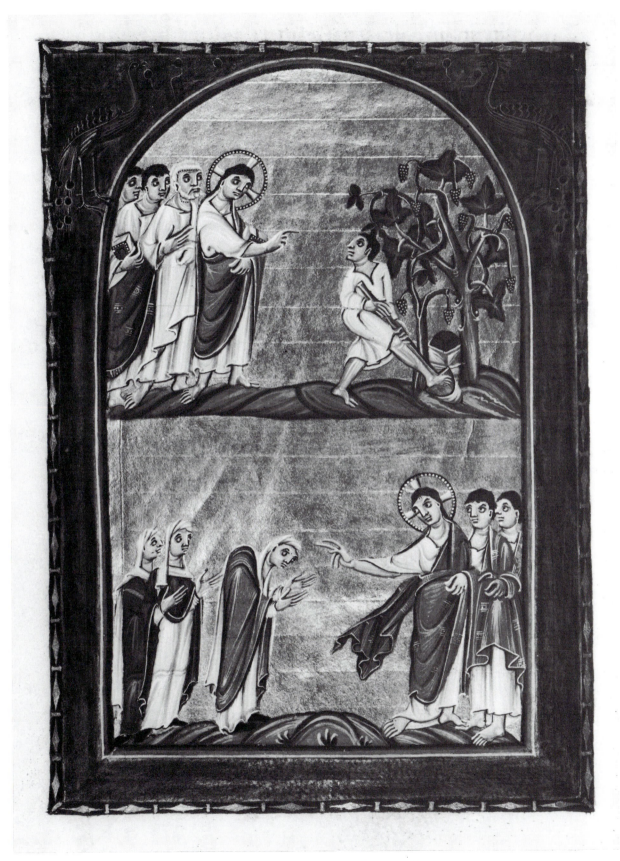

103. The Withered Fig Tree. Gospel Book of Otto III, 998-1001.
Munich, Bayerische Staatsbibl., Clm. 4453, f. 175v

if he perused the book in solitude, Otto need never for a moment have forgotten his own imperial character as reflected in that of Christ. Suppose, for instance, that his eye fell upon the illustration of the parable of the *103* barren fig tree. Whereas in one late antique depiction Christ stands calmly *104* in the company of the estate administrator pointing at the offending tree, here the administrator is omitted, replaced by an intense group of apostles, and the tree is forgotten, while Christ addresses himself with drama directly to the gardener (who turns as if abruptly to confront him), in a manner reminiscent of the healer and exorcist, the latter a spiritual emperor as tenth-century prayers remind one.[63]

We know nothing of the artists who worked on this book, nothing of whether they or Otto III and his advisers were responsible for its iconography. Very likely the distinction is an artificial one. The artists could themselves have been influential members of Otto III's circle, and there could easily have been discussion between them and the emperor. We have some idea of what top-class Ottonian artists were like, little as we know of them. We know that it was not thought inappropriate to combine art with philosophical and theological learning in Bernward of Hildesheim's education.[64] We read that a Trier artist painting in England (at Wilton) in the 980s was not only renowned for his art but also respected for his learning.[65] It has been shown that the schemes of illustration in the Uta Codex of Regensburg were devised by a monk called Hartwic who had studied under Bishop Fulbert at Chartres.[66] We must assume therefore, that artists were capable of engaging in intelligent conversation, grasping ideas and capturing moods. They certainly seem to have managed all these things in the Gospel Book of Otto III.

Finally, the sense of sin, tears and penitence, reflected in this book, is in truth an instrument of power and control. There is no answer to the penitent but to reinstate him, as Pope Gregory VII found at Canossa; there is no answer to tears of holiness but submission.

104. The Withered Fig Tree. Sinope Codex, Eastern Mediterranean, C6. Paris, BN, MS gr. suppl. 1286, f. 30v

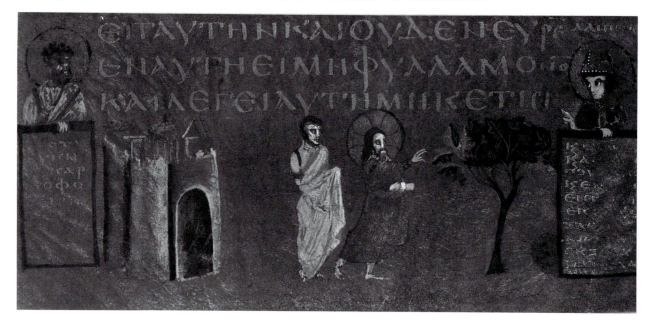

2 The Pericopes Book of Henry II

It would be hard to imagine a greater contrast in character between two books from the same scriptorium, of broadly similar figural style and colour repertoire, separated from each other in time only by about a decade, than that between the Gospel Book of Otto III and the Pericopes Book of Henry II. The contrast lies above all in the much greater stress of Henry II's book on majesty, rule and hierarchy (discussed in Part II). Gone from its New Testament cycle are those miracles of compassion like the Healing of the Leper and the Blind Man of Jericho; gone is the poignant human detail in such scenes as the Massacre of the Innocents and the Feeding of the Five Thousand; gone is the moral teaching graphically conveyed in such parables as the Withered Fig Tree and the Good Samaritan. The Pericopes Book has scenes from Christ's Passion, but even here those of Otto III's book in which Christ and his surroundings are most humanized, as in the Denial of Peter or the Garden of Gethsemane (it does not affect our argument that the humanization of the latter is certainly a late antique *topos*) are dropped, while those in which he appears at his most majestic, as when he stands before the high priest (paralleled in the bronze doors of Hildesheim, 1015, see p. 98-100), are given greater prominence. This contrast in subject matter is not at all due to the fact that the earlier book is a text of the four gospels while the later is a book of liturgical gospel readings. Another Reichenau pericopes book (Munich, *117* Clm. 23338) of about the same time as Henry II's illustrates three parables, and the Codex Egberti, also a pericopes book, which we discuss in the second volume of this study, though lacking parable scenes has a large number of miracle illustrations.

The lack of miracle illustrations in the Pericopes Book in itself sheds light on its character and purpose. Many of the miracles illustrated in the Codex Egberti, a Reichenau book of earlier date, are the subjects of gospels for the ferial days in Lent, a high liturgical season when the popes celebrated public mass daily in Rome, and the pictures in the Codex Egberti were intended to ennoble the similar celebrations of the Archbishop of Trier. Henry II's book, on the other hand, has no illustration for any ferial day in Lent. It was a book made at Reichenau on the king's commission for his new cathedral church of Bamberg (founded 1007, consecrated 1012), and if it had a use beyond being a great treasure, it was to ennoble the celebration of mass on the greatest festivals of the liturgical year, especially in the presence of the ruler himself. It was a king's book more than a bishop's.

It is also a book of unusually large format for its period: it measures 425 × 320mm, and the gold of its backgrounds is applied very thickly, as if it were sheets of gold with the painted figures enamelled on them. If the book sometimes stood open on the altar at the relevant illustration until the moment of the gospel reading at mass, it must have appeared almost more like an altarpiece than a gospel book. Many of its scenes are

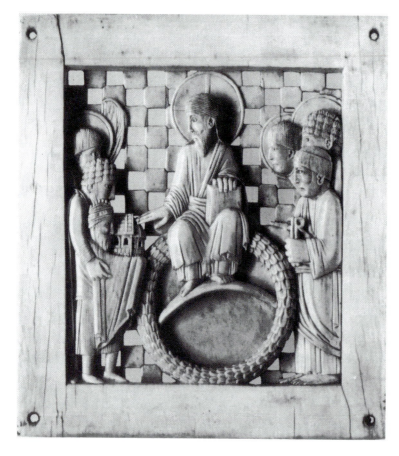

105. Otto I, holding a model of
the church of Magdeburg,
presented to Christ seated in Majesty.
Ivory panel of the Magdeburg Altar Frontal,
c. 968. New York, Metropolitan Museum

divided into two so that they occupy both left-hand and right-hand pages of the open book. Thus the Angel announcing the Nativity to the Shepherds is on folio 8 verso, the Nativity itself on folio 9 recto; likewise with the Procession of the Magi and Christ on his Mother's Knee for the Epiphany, the Three Women approaching the Tomb and the angel seated on it for Easter Sunday, or the scenes of Zachary and the birth of John the Baptist for the feast of this saint (June 24), to name a few examples. Others, like the Presentation in the Temple or the Ascension, have a single-page illustration on the left-hand side and a splendid initial of the fully developed Reichenau type on the right to open the gospel text. This is a heavy book to carry, and in its fine covers, which were made for it,[67] very awkward indeed to carry open. If it were possible to get into a time machine and attend mass at Bamberg on some great festival when Henry II were present, it would not be surprising to find that the Pericopes Book had been left standing open on the altar, while the deacon ascended the ambo to chant the gospel from a more manageable book.

The book begins in splendid style with a frontispiece on a gold ground, in the top half of which Christ, seated in Majesty, crowns both Henry and his queen Kunigunde, who have been ushered into the august presence by Saints Peter and Paul, the patrons of Bamberg Cathedral. Stylistically

112
113
108,109
106,107
Col.Pls. XXIV
XXV

Col.Pl. XXVI

180

this page is a perfect exemplification of the school of Reichenau, but ideologically we have left the classical world of the emperor picture in the Gospel Book of Otto III, with its lack of sacral symbolism, and have re-entered the world of the Aachen Gospels with crowning by the hand of God, the world of the Byzantine ivory which shows Christ crowning Otto II and Theophanu, the late antique, western world of the Magdeburg ivory antependium, one of whose panels depicts Otto I with a model of his *105* foundation being ushered by St Maurice into the presence of Christ, a motif going back to sixth-century Rome.[68] In the bottom half of the page stand three crowned figures, their gaze directed upwards, the central one offering sceptre and plain orb, and those to either side laurel wreath and orb with cross, while below them six crowned women in half-figure offer cornucopiae.

The six figures are probably best explained in terms of Leo of Vercelli's *Versus de Ottone et Heinrico*, a poem which is at once a lament for Otto III and a salutation to Henry II; this poem, as if referring to six stem-lands and their subjection to Henry, names *Bavaria, Franconia, Alemannia* (i.e. Swabia), *Lotharingia, Thuringia* and *Saxony*.[69] The poem also mentions *Italia, Germania* and *Belgica*, and as it must be very early in Henry's reign, most likely being presented to the king by Leo himself at Regensburg in November 1002, these titles were very topical at the time. Arduin of Ivrea had had himself crowned King of Italy at Pavia as early as 15 February 1002, and Leo, a staunch supporter of Henry as he had been of Otto, seeks to persuade Henry to treat the Italian problem as an urgent one: 'Italy the great *creatrix* of kings clamours for you now', he writes, 'run, Henry, hurry, all await you; never let Arduin survive while you rule'.[70] Obviously this is before Henry's Italian expedition of 1004. Again, 'fierce *Belgica* bends the knee' in these propagandist verses, one must suppose, because Henry was still having difficulty to secure Lower Lotharingia when they were written.[71] But by the time the Pericopes Book was made, other issues had come to the fore, such as Henry II's claims to Burgundy and the prospect of the imperial coronation at Rome (which actually occurred in 1014), and we must accept that the three crowned figures of the ruler page in the Pericopes Book are most likely to be *Germania* and *Gallia*, as these two feature in the Gospel Book of Otto III, and *Roma*, with the crown in the form of a city wall (*Mauerkrone*), between them.[72]

Opposite this page on the left are written, in golden letters within a Regensburg-like frame, verses which begin:

> Great King Henry, shining exultantly in the splendour
> of the faith, prosperously enjoys the dominion of his
> great grandfather [i.e. Henry I].
> In the generosity of his heart and full of love,
> he has devoutly offered from the variety
> of his royal treasures this book, replete with the
> divine law, for the sanctuary of the Temple, there to
> beautify it for ever.[73]

106. The Three Women at the Tomb. Pericopes Book of Henry II, 1002-12.
Munich, Bayerische Staatsbibl., Clm. 4452, ff. 116v

107. The Angel on the Empty Tomb. Pericopes Book of Henry II, 1002-12.
Munich, Bayerische Staatsbibl., Clm. 4452, f. 117

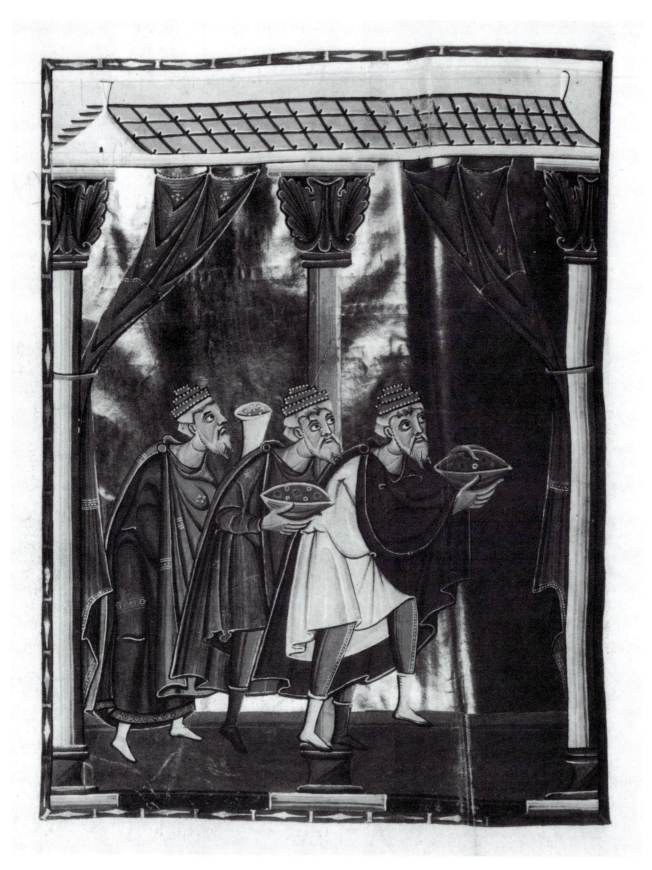

108. Adoration of the Magi: The Magi. Pericopes Book of Henry II, 1002-12.
Munich, Bayerische Staatsbibl., Clm. 4452, f. 17v

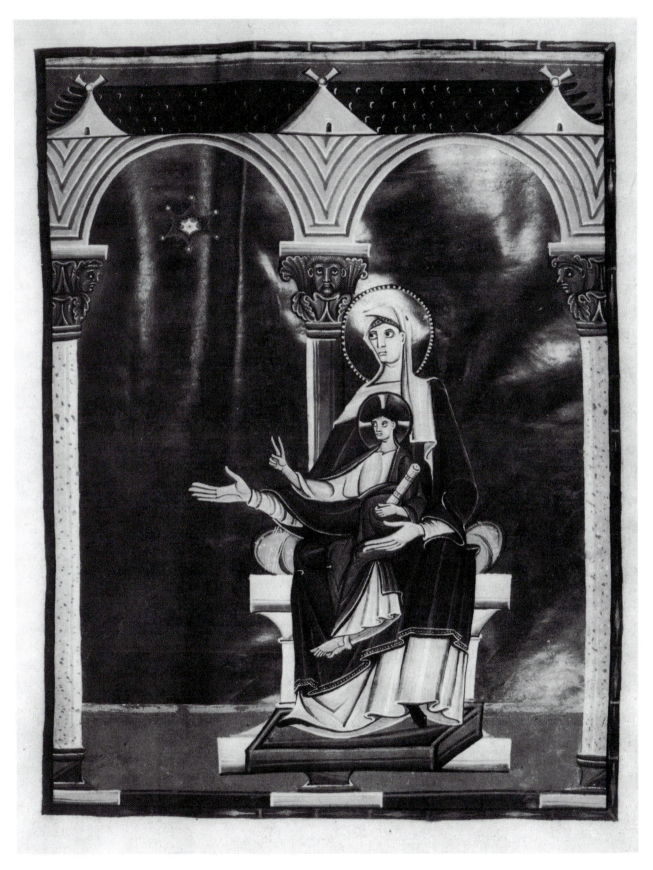

109. Adoration of the Magi: Virgin and Child. Pericopes Book of Henry II, 1002-12.
Munich, Bayerische Staatsbibl., Clm. 4452. f.18

In the New Testament illustrations of this book, 'the will to solemnize' confronts us at every turn.[74] We notice it in the *Maiestas* of its Dormition of Mary (p. 149), in its Last Judgement which Fauser calls 'a display of the might and splendour of Christ as ruler of the world', and in its Martha and Mary picture which falls little short of the same description (p. 147-49). Hans Jantzen in his magisterial work, *Ottonische Kunst*, of 1947, regarded this Pericopes Book as the culminating achievement of Ottonian book art. It had broken with the dramatic intensity of the Gospel Book of Otto III, and in its uncluttered pages, its monumental forms, its expansive gestures depicted on spacious gold backgrounds, and its statuesque calm and majesty, he saw a wonderwork of painting. He saw it particularly in the

106
107 apparition of the angel to the Three Women at the Tomb, a subject given unusual weight by the division into two pages, by the absence of almost all the normal stage properties — built-up tomb, winding cloth, sleeping guards — and by the marvellously composed group of women with their thurible.[75] Jantzen was followed in his admiration some years after 1947 by Boeckler, who commented finely on many of the scenes, in which all form was embodied in clear strong lines; for instance, in the illustration

108,109 of the Magi and the Epiphany he saluted its great simplicity and referred to the enthroned Mary as 'raised up high, a goddess who takes tribute from mortals'.[76]

The iconography of the birth of John the Baptist is very unusual. The two pages illustrating this subject, each in two vertical registers, show: on

Col.Pl. XXIV the left, Zachary and the Angel in the temple with the altar between them, and below the dumb Zachary facing a crowd; on the right, Elizabeth and

Col.Pl. XXV Mary, with John in a cot between them, and below Zachary writing John's name for the crowd. It is not the Zachary scenes which are unconventional here, but the birth of John the Baptist, a figure most often represented in western and eastern art as a preacher, or baptizer of Christ, or martyr (as in the Gospel Book of Otto III), or as a standing figure with the symbol of the Lamb.[77] In fact the Nativity of John is so rare a subject before the twelfth century that only one example comes to mind, in the eleventh-

110 century Byzantine Gospel Book at Paris (BN, grec. 74), and the subject here is handled in a completely different manner from that of the Reichenau book, showing the new-born babe being bathed.[78] If Reichenau used a Byzantine model at this point, it was actually more likely to have been an Entombment of John the Baptist, as MS grec. 74 has it, than a Nativity (Theodore the Studite, in a sermon on the Beheading of John, maintained that one of the martyr's disciples had restored his head to his body before the burial).[79] Moreover, in the Pericopes Book, with the cot tipped up to enhance the dignified appearance of the 'baby' inside it, and with the symmetry between the two upper registers of the pages whereby the cot between Elizabeth and Mary is made to correspond to the altar between Zachary and the Angel, the object of illustrating this birth is clearly to give John the Baptist a share in the general elevation of might and majesty towards which our book persistently drives. We shall see the likely reason

186

for his receiving this share shortly, and the reason why, extraordinarily, two pages should be deployed to highlight the subject.

There is in this book, then, a grandiloquent vocabulary of gestures and forms, a fearlessness in the use of space and the separation of figures from each other, to express the manifestation of divine rule in the world. No artistic means of conveying divine rule is more revealing than the deportment of those eminently hierarchical beings, angels. The Pericopes Book represents the apogee of angelic power in Ottonian art. We shall have occasion later to comment on this apropos the angel announcing Christ's birth to the shepherd: we have already noted it in the case of the angel confronting the Three Women at the Tomb from the monumentally dignified distance of a separate page; and it is clear when one considers the forceful angel who deals with Zachary. The unearthly light green of this *Col.Pl. XXIV* angel's overgarment against the mauve of his wing is a colour modulation from the normal keys of the book which achieves the surprise effect of a sudden apparition.[80] Once again angelic dominance and force is experi- *111* enced at the end of the book in the angels of the Last Judgement, especially those two whose scrolls and wings have the visual function of carrying the eye upward from the blessed and the damned below to the heavenly host with Christ the judge holding his triumphant cross in their midst.

One small but striking example of the angelic expression of divine power comes in the Nativity scene, striking because it is out of line with *113* normal Reichenau iconography. There are many variations in the deployment of angels, all on a fairly constant theme, in Reichenau Nativity scenes. In some, as in the Pericopes Book in Wolfenbüttel, a group of angels, placed *114* under the crib, appears as if out of the sky to the shepherds in the bottom of the picture, announcing the birth of Jesus to them. The Annunciation to the Shepherds of the Pericopes Book is on a separate page, and the *112*

110. Entombment of John the Baptist. Gospel Book, Byzantine, C10. Paris, BN, MS Grec. 74, f. 28v

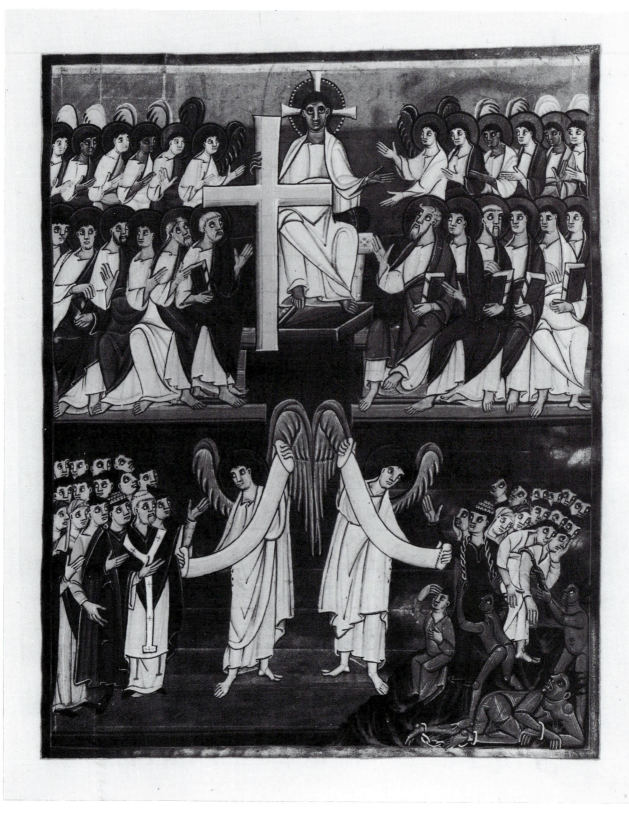

111. Last Judgement. Pericopes Book of Henry II, 1002-12.
Munich, Bayerische Staatsbibl., Clm. 4452, f. 202

extraordinary feature of this Nativity is an angel in bust underneath the crib, with no shepherds to receive his good news, holding up his hands *113* in a posture of such hieratic stiffness as to be less a gesture of praying (*orans*) than of making the divine birth manifest to the world at large. This small figure is a worthy colleague to his counterpart domineeringly announcing the news to the shepherds on the opposite page.

Hieraticism is by no means absent from the Gospel Book of Otto III, but it is tempered by pathos, moral earnestness, and the dramatic manipulation of supernatural power for human purposes; in the Pericopes Book of Henry II it is an objective pursued with wonderful artistic means indeed, but with awesome single-mindedness as well. One can hardly doubt that this huge contrast represents the influence of Henry II himself and his closest circle of chaplains. For Henry had been educated in the church of Regensburg,[81] with which he always remained closely in touch, and as we have seen from the Regensburg Sacramentary (pp. 65-67), the Uta Codex (pp. 126-29), and the Monte Cassino Gospels (p. 128), Regensburg under Henry II represented the summit of Christ-centred and sacral kingship as expressed in art. There were connections between the schools of Reichenau and Regensburg, while a letter of Abbot Berno of Reichenau (*c.* 1016) shows that the Emperor's knowledge of the community there was not confined to its abbot,[82] and we shall come shortly to Henry's actual stay at Reichenau in 1002. We have every reason to suppose that it was Henry who pushed Reichenau in a direction which was ideologically entirely congruent with that of Regensburg as seen by its art during his reign.

If we extend the discussion to who influenced Henry, his closest adviser in the first decade of his reign was Tagino, a high-born Bavarian educated at St Emmeram, Regensburg, who had been a chaplain of Henry while he was still Duke of Bavaria, and whom Henry appointed to be Archbishop of Magdeburg in 1004. As archbishop there is evidence that Tagino retained close links with St Emmeram and Henry appointed him to be Provost of the Ancient Chapel of Regensburg in November 1002 (which suggests that he and Leo of Vercelli must have been able to talk with each other at that time).[83] His appointment to the archbishopric did not weaken the *familiaritas* between him and Henry; if anything it strengthened it because it helped to make Magdeburg one of the most important places on the king's itinerary.[84] Tagino was a man of great religious earnestness; Thietmar of Merseburg, who knew him well, said of him that he was a canon by habit but a monk in every point of life. Thietmar also mentions, in an illuminating vignette on his personality, that before he celebrated mass he was severe, while afterwards he was all smiles and cheerfulness; and then, in another little stroke of the pen which adds a whole vista, he goes on to tell us that he often chanted the *kyrie eleison* with his clergy, as though this were an unusual mark of devotional commitment to the celebration of mass by a bishop.[85] Thus when Florentine Mütherich writes that in the Sacramentary of Regensburg (1002-14) every artistic means, every model,

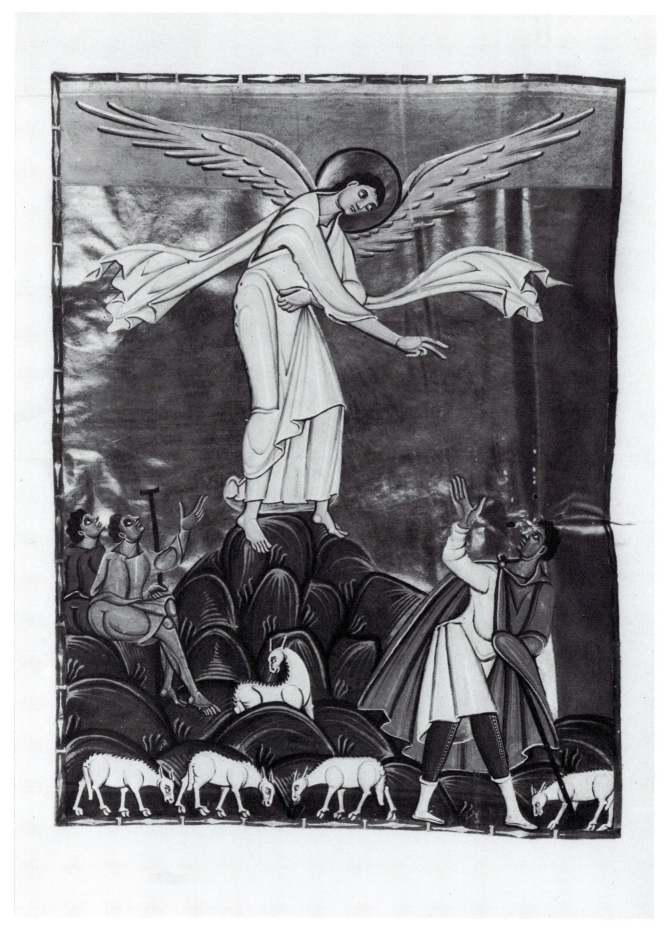

112. Annunciation to the Shepherds. Pericopes Book of Henry II, 1002-12.
Munich, Bayerische Staatsbibl., Clm. 4452, ff. 8v

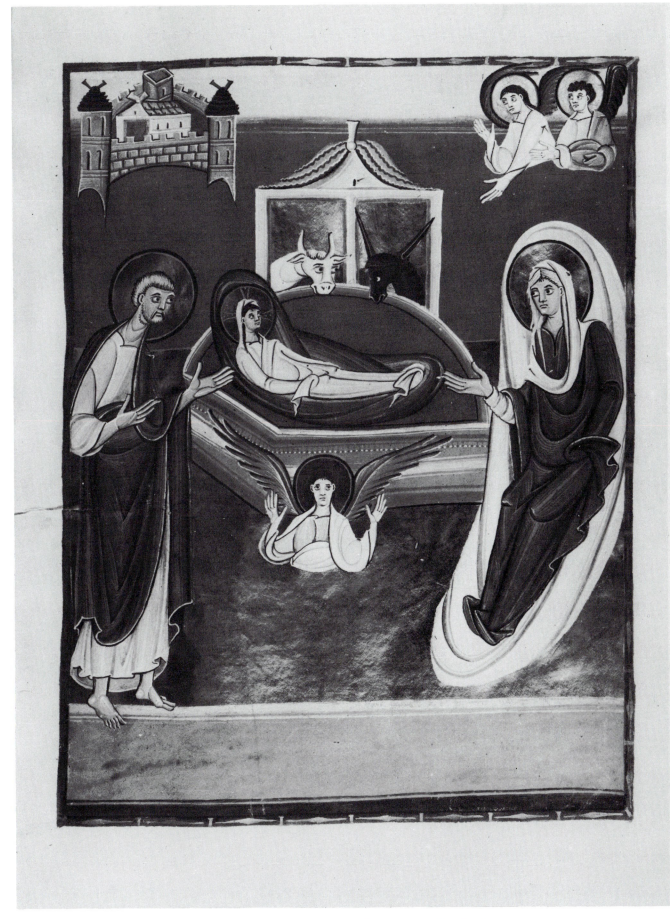

113. Nativity of Jesus. Pericopes Book of Henry II, 1002-12.
Munich, Bayerische Staatsbibl., Clm. 4452, f. 9

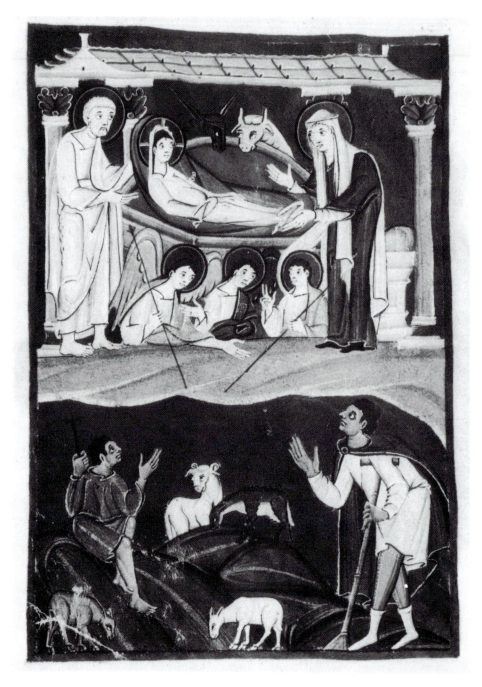

114. Nativity and Annunciation
to the Shepherds. Pericopes Book,
Reichenau, early C11. Wolfenbüttel,
Herzog August Bibl.,
MS 84.5 Aug. 2°, f. 63v

every sort of expertise, was employed to anchor the many-sided symbol-
ism of early medieval rule in the prayers of the mass, whose high point
was the Canon of the Mass:[86] who could better have focussed Henry's
mind on the conjunction of ruler symbolism and mass than the Regens-
burger Tagino, to whose life the celebration of mass and his *familiaritas*
with the ruler were both central experiences?

192

Why was there this marked heightening of the ideology of divine and kingly rule under Henry II compared (even after taking account of the Aachen Gospels) with the reign of Otto III?

From the start we must put aside two ideas in particular. One is that Henry intended to mark a change from Otto III in his mode of ruling. In every ascertainable point the hallmark is continuity between the two reigns,[87] except, as in the *Gnesenpolitik*, where circumstances forced a change on Henry, whose diplomas often refer to his predecessor, *noster senior*, and always with respect.[88] The other is that Henry was somehow more religious than Otto. It does not at all follow that the more religious a ruler is in feeling or the more earnest in his moral purposes the more sacral will be the character of his art. Charlemagne would appear to have been a person of strong religious feeling, stronger than we would realize from Einhard alone, and he was certainly anxious to bring religious and moral standards to bear on government; but compared with his grandson, Charles the Bald, there is very little attempt to project through art a sacral image of him. The fact that the Aachen Gospels (*c.* 996) projects Otto III in a highly sacral image, while the later Gospel Book of Otto III (998-1001) represents him according to a more 'profane' tradition, is no sign that his religious fervour was cooling. We have to make a distinction between aspirations to sanctity and projections of sacrality. There are indications that religion was important to Henry II at a personal level, but this cannot legitimately be read from the art which he commissioned.

The first and most important answer to our question about Henry's ideological heightening would appear to be the struggle for the succession after Otto III's death. It is true that Henry was anointed and crowned king within six months of his predecessor's death in January 1002, but the trauma of those six months clearly left an indelible impression on his mind. It is also true that there had been a sharp succession dispute after Otto II's death in 983 when Otto III was challenged by Duke Henry of Bavaria, Henry II's father, but Otto III had been a small boy of three at that time and he had not had to experience the struggle for himself; all had been done for him by Theophanu, Adelaide his grandmother, and Archbishop Willigis of Mainz. Moreover Henry was the first Saxon ruler who lacked both advantages of kingly unction and/or designation by his predecessor when he succeeded.[89] In addition, Schlesinger has pointed out in connection with Henry II's succession, that while the principles of both inheritance and election were important in such a situation, the need to submit to election assumed much the greater weight where the succession of a collateral like Henry was concerned, than it did in the case of a son.[90] The odds were heavily stacked against Henry in 1002. A majority of the nobles who were present at the funeral of Otto III promised their support to Duke Hermann of Swabia, falsely maintaining (says Thietmar after the event) that Henry was for many reasons unsuitable.[91] Perhaps the great but vain attempts of his father and grandfather to achieve the kingship stood against him; perhaps the view that as Duke of Bavaria he rode roughshod

over the rights of bishops with regard to monasteries, a failing which nobody could accuse him of reproducing in his kingly rule;[92] perhaps the colic from which he must have suffered and been known to have suffered before he became king.[93] Two of the four major metropolitans within the imperial church also supported Duke Hermann at least initially, namely Archbishops Gisiler of Magdeburg and Heribert of Cologne.[94] Nor should the strength of Ekkehard of Meissen's challenge be underrated before he was ambushed and murdered at the instigation of Boleslav of Poland on 30 April 1002. Besides his great courage and stupendous military achievements against the Slavs on the eastern marches, it has recently been argued by Hlawitschka that he was indeed related to the Liudolfing family, and that when Count Liuthar in response to Ekkehard's asking why he was against him uttered his famous taunt, 'do you not see that your carriage is lacking the fourth wheel?', he referred not to Ekkehard's lack of royal blood, as had always been thought, but to his lack of one of the four cardinal virtues, regarded as essential for rule, namely *temperantia*.[95]

The protestations of Henry II's publicists, such as Leo of Vercelli, Adalbold, a royal chaplain before he became Bishop of Utrecht (1010-26), and the author of the second *Vita Mathildis* (see p. 11), would be enough in themselves to suggest the strength of the opposition which Henry had had to face in his bid for the kingship. We have mentioned that Leo's poem was at once a lament for Otto III and an acclamation of Henry II, and in the strophes which mark the transition it is suggested that 'wolves' would have devoured the population had Henry not been there, that his succession was the divine plan (*contra deum consilium nec magnum nec minimum*), and that Henry had achieved the monarchy (*praefecit monarchiae*) without bloodshed, the last scarcely untrue since decisive for him was not military action but the support of Willigis of Mainz.[96] Adalbold of Utrecht derived most of his matter from Thietmar of Merseburg, but since it was probably Henry himself who acquired a manuscript of Thietmar's chronicle for him shortly after the latter's death, he presumably reflected Henry's own attitudes closely, and his *Vita Heinrici II* has been described as the first official work of historiography since Carolingian times. Adalbold would have it that the only true mourners of Otto III were the *sanior pars* who chose Henry II; he stresses Henry's blood relationship to Otto and, more remarkably, to Charlemagne (whereby he continued Otto's veneration for the great Emperor), saying that Henry was related to Charlemagne in the seventeenth degree through his father and in the sixteenth through his mother (Adalbold, who was something of a mathematician, was thinking here of the symbolism of the number 33); and he highlights the ritualist aspects of Henry's campaign for the crown.[97]

It is vital for an understanding of Henry's art to remember not only that he had to surmount strong opposition to become king, but also that his primary method of prosecuting his claim was through ritual. When the body of Otto III, who had died in Italy, reached Polling in Bavaria on its way north, Henry assumed control of it and of the royal insignia,

subsequently carrying the body on his own shoulders into Neuburg and burying the intestines at Augsburg.[98] All this was the attempt of an aspiring successor to associate himself with the honourable burial of his predecessor. Less than a year earlier, when the eminent Abbot Ramwold of St Emmeram, Regensburg, had died, Henry had insisted on carrying the coffin himself at the funeral; it was the sort of ascetic work and ritual act designed to increase his tutelary power over the church.[99] Now, in 1002, he was following his own suit in the case of Otto III. Heribert of Cologne, who was accompanying Otto's body on its northward journey and was naturally wise to the jockeying for position involved in Henry's efforts to commandeer the royal insignia, sent on ahead what had been the most important symbol of kingly rule since Henry I's time, the Holy Lance. He was forced to return it, however, after Henry had first taken him into custody and then released him in order to send it back on the security of Heribert's brother, Bishop Henry of Würzburg. This was not the only time that the lance figured in the succession of 1002. When Henry, having been accepted king by the Franconians and anointed and crowned at Mainz on 6 June 1002, came the following month to Merseburg in Saxony on his *Umritt* to secure the homage of the Saxons, there was a great gathering of bishops and noblemen, and after he had promised to recognize Saxon laws he was acclaimed, and Duke Bernard committed to him the Holy Lance and thereby the rule of the kingdom (*regni curam*).[100] No wonder, then, that Henry should be shown invested by an angel with the Holy Lance in the Regensburg Sacramentary, at the same moment as he is crowned by the hand of Christ.[101] Art, including its general elevation of Christ's Majesty which Henry's own earthly rule reflected, was a continuation of the ritual by which he had struggled for the kingship.

The importance which German historians attach to the *Umritt*, the travelling around the stem-duchies by a new king to show himself and to be acclaimed at great assemblies and crown-wearings, has not passed without questioning. Reinhard Schneider, for instance, would not see Henry's *Umritt* as a continuation of his election by the various stem-lands or an initiation into rule, rather arguing that Henry came to the Saxons at Merseburg already a king, that he needed no act of election, no constitutive act of making him a king such as the investiture with Holy Lance, and that the assembly at Mainz was the important 'legal-constitutive' event in the kingly succession.[102] But this is to import an element of constitutionalism into early eleventh-century attitudes which is probably anachronistic; the succession did not depend in so cut-and-dried a way on the single constitutive acts of election and anointing. Although in retrospect Henry II always claimed the kingship by hereditary right, in reality he had to rely on election by several stages,[103] and thus he needed every ounce of sacrality that he could muster in order to achieve and then maintain his election. Thietmar makes it clear that Henry still had to work for recognition on his *Umritt*.

One stopping-place on this *Umritt* is of especial interest for the Pericopes

Book of Henry II, namely Reichenau itself. After his coronation at Mainz and acceptance by the Franconians, his first move was into Swabia, where he attempted to spike the guns of the still resistant Duke Hermann. Thus it was that he celebrated the Nativity of St John the Baptist (24 June 1002) at Reichenau. He was still there on the Feast of Saints Peter and Paul (29 June), but this was an unscheduled prolongation of his visit while he waited for a duel with Hermann who in the event failed to appear. Henry's intention had been to mark this stage of his *Umritt* with the celebration of St John the Baptist's Feast. Here we must surely have the explanation for the exceptional grandeur and majesty with which the Nativity of St *Col.Pl. XXV* John the Baptist is treated in the Pericopes Book of Henry II. One of Henry's characteristics was to attach great importance to dates such as his birthday or the anniversary of his coronation.[105] On this showing 24 June 1002, celebrated at the very place where his book was subsequently made, must have come to seem a key date in his *Umritt* and in his struggle to be accepted as king.

If the ideological presentation of hieratic rule in art may often be regarded as a response to pressure on the ruler and conflict within the ruling *élite* rather than as a sober expression of political reality, then there was another pressure on Henry II, besides the struggle for his kingship, which has to be taken into consideration in assessing the significance of the image-projections in the art which he patronized, namely his tarnished reputation arising from his alliance with the pagan Liutizi Slavs in 1003 and again in 1007 against the Christian Slav, Boleslav of Poland. One may hold the view of Dietrich Claude that this *démarche* of Henry away from the Slav policy of Otto III (see pp. 160-62), a policy which had been based on the balance of Poland and Bohemia and on the buffer of Ekkehard of Meissen's margraveship against Slav aggression, was necessitated by circumstances. Boleslav had occupied Meissen lands after Ekkehard's murder: he had annexed Bohemia to Poland as a result of political tumults in the former which quite fortuitously coincided with the period immediately after Otto III's death; and he had refused to pay homage to Henry II for Bohemia once he was in the saddle there.[106] Boleslav was the one, Claude maintains, who dealt the death blow to the grand conception of imperial/Polish relations of friendship held by Otto III. Be this as it may, however, Claude also says that the Liutizi alliance could not have been expected to find favour with churchmen, least of all with such a great hater of the Liutizi as Archbishop Gisiler of Magdeburg.[107] In a famous letter of 1008 to Henry II, the missionary and former Magdeburger Bruno of Querfurt urged the king to abandon the alliance with pagans.[108] Furthermore there is evidence that Henry, perhaps mainly for propaganda purposes though probably not solely, put forward Slav conversion as a motive for founding the bishopric of Bamberg in 1007 (there were clearly settlements of Slavs in the region),[109] as if redressing his attack on Christian Slavs elsewhere. Considering that all Henry II's surviving liturgical books, whether from Reichenau, or Regensburg, or Seeon, or elsewhere, were

made for Bamberg, there may well have been some element in them of hoping to repair the damages done to an ideal of Christian kingship by fighting alongside pagans against Christians.

Henry maintained a high profile in ecclesiastical affairs, even by Ottonian standards, and not everyone approved of his dealings;[110] this was perhaps another, if instinctive rather than conscious, reason for pitching the ideology of his Christ-centred rule on a high note in his liturgical books. He developed an almost co-ordinated approach to the filling of bishoprics. He attached importance to appointing only persons who had previously served in his chapel, to the extent of sometimes taking into his chapel a person elected by the clergy and people of a see, and appointing an experienced royal chaplain instead.[111] When he passed over Odda in this way and appointed Unwan at Bremen in 1013, for instance, the Quedlinburg Annalist said of him: 'the king's soul was harsh and thirsty for unhappiness; he declined the prayers of the supplicants (i.e. the clergy and people of Bremen) and showed contempt for their weeping voices'.[112] Henry initiated a system of building up bishoprics economically — in order to impose his own burdens of military service and hospitality[113] — and appropriating monasteries to them. To poor bishoprics he appointed rich men. Thietmar himself was subjected to some typical questioning by Archbishop Tagino on Henry's behalf, about whether he would help the church with his own inheritance, before he was appointed to Merseburg in 1009.[114] In the same year Meinwerk, an old friend, schoolfellow and chaplain of Henry who came from one of the greatest Saxon families, was appointed at Paderborn, and there was an amusing exchange between the two. H: 'Accept'; M: 'What is there to accept?' H: 'The bishopric of Paderborn'; M: 'I could build a better bishopric from scratch with my own resources'; H: 'True, and so I desire you to relieve its poverty'… etc. Meinwerk cheerfully accepted, showing no appetite for a more prestigious see.[115] When a rich bishopric came up, however, particularly if he intended to fleece it, he would put in a poor person. In 1014 he appointed Gundekar, *custos* of Bamberg and a *servilis persona*, to the bishopric of Eichstätt, intending to consolidate the endowments of Bamberg with some of Eichstätt's lands in the Regnitz-viertel. When Gundekar made difficulties Henry said, according to the anonymous chronicler of the bishops of Eichstätt:

> What is this that I hear from you, Gunzo? Do you not know that I made you bishop of this place so that I could fulfill my will with you, being the sort of person you are, without delay, which I could not fulfill with your predecessor. Take care that I never hear any such thing from you again if you want to retain your bishopric or my favour.[116]

These words were more than likely invented, but they show the behaviour of which Henry was thought capable. They are of a piece with some

197

115. Charles the Bald standing between (?)Saints Gelasius and Gregory. Sacramentary fragment, Metz, 869. Paris, BN, MS lat. 1141, f. 2v

of his abbatial appointments, which give the impression that Henry only regarded a monastic reformer as worth his salt if the monks uniformly loathed him.[117]

On a more positive note, Henry was many things to many men in the church. He has been seen as a brother of monks in his gifts of liturgical books and vessels to monasteries,[118] and he was a canon amongst canons (following thereby a practice of Otto III) in the cathedrals of Bamberg, Magdeburg, Strasbourg, Paderborn and Hildesheim.[119] He is seen for ever in the posture of a worshipper, placing gospel books, golden chalices, silver candlesticks on altars, like his contemporary in England, Cnut, who had his own insecurities to contend with.[120] Above all, however, we see him ruling in conjunction with bishops, even departing from his predecessor's custom of celebrating the great festivals at royal palaces (like Quedlingburg, Ingelheim and Frankfurt) to celebrate them at episcopal churches, to the apparent displeasure of the unfavourably disposed Quedlingburg Annalist.[121] The collection of canon law made by Burchard of Worms in Henry's reign, loose as is its organization, makes episcopal power and a church ordered around bishops its constant refrain.[122]

198

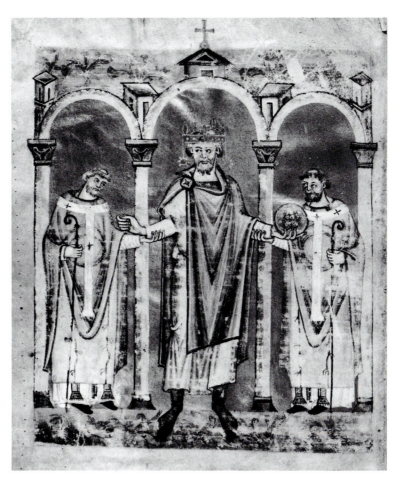

116. Henry II supported by
two Bishops. Pontifical,
Seeon 1014-24. Bamberg,
Staatsbibl., MS Lit. 53, f. 2v

Twice in his art Henry is seen with his arms supported by bishops, once
in the Regensburg Sacramentary where the two sainted South German
bishops, Udalric and Emmeram, hold up his arms in prayer, and once in
a pontifical made at Seeon, an offshoot of Regensburg. In this latter book
the king stands against a golden background within a symbolically repre- *116*
sented three-aisled church, crowned with a splendid crown having *pendilia*
which are typical of Byzantine crowns,[123] and carrying orb and sceptre.
The *ordo* for a coronation in this very book refers to the ruler being ac-
companied into the church by two bishops, but our picture need not be
showing a coronation scene. It could be an entry into church for the cel-
ebration of any great festival.[124] Its aim is to depict Henry in a scene of
eternal validity for rule and order in the world, which raises him above
all particularity of time and place and person. The motif of a king standing
between two bishops goes back at least to the art of Charles the Bald. In
a Metz sacramentary of 869 (Paris, BN, lat. 1141), a king stands between
two bishops while he is crowned by the hand of God; this was a page *115*
surely known to the Regensburg and Seeon artists of Henry's time. Who
these figures were intended to be is a matter of doubt,[125] but it is worth
our noting that while the king is somewhat smaller in stature than his
episcopal companions in 869, Henry II looms like a giant over his in both
scenes.

199

Henry's attendances at the consecrations of great churches, occasions frequently exploited by him for their image-making potentialities, were ritual acts in which he could show himself forth in the company of many bishops, receiving thence a lustre almost like that received by the ancient emperors, present at the games, from the triumphs of the arena. At Nienburg in August 1004 he used the ceremony of the consecration to call upon the help of heaven in his forthcoming Slav campaign, and for the favour of a more certain triumph (*pro certioris gratia triumphi*).[126] This was rather like the presence of Otto III at the consecration of Walbeck before the Slav campaign of 997,[127] but Henry went much further than Otto in this matter. For instance, there was nothing under Otto like the consecration of Bamberg Cathedral on 6 May 1012. This date was no great feast of the church, and in that year it was not even a Sunday but a Tuesday. Nonetheless it was Henry's own birthday. Which birthday has been a matter of doubt, though Ferdinand Geldner, by minute scrutiny of the evidence of when his parents were together and when they were apart, has concluded that it must have been his 39th (and so he was entering his 40th year). In any case, the spotlight was very much on the person of the king and his influence over an ecclesiastical occasion. Moreover, every metropolitan of the empire north of the Alps except Archbishop Lievizo of Hamburg-Bremen was present and participated in the consecration of the various altars, whose relics and dedications were themselves representative of all the regions and principal churches of the *Reich*. The crypt was consecrated by Archbishop Aschericus of Hungary, where Otto III's former chaplain, Bruno of Querfurt, had been a missionary.[128]

Perhaps we have been over-political and under-religious in our interpretation of Henry II's manuscript art and its historical context. But the evidence gives us little choice. The Rule of St Benedict, which Henry must have known from his early training at St Emmeram, Regensburg, spends Chapters 8 to 19 on the performance of the public liturgy, only to say in Chapter 20 that private prayer should be short. Henry's art was, as we know it, almost entirely an art of liturgical ceremonial and public gesture, not of private religion. It is possible, however, to end on a different sort of public note. Henry celebrated the Feast of the Nativity of Mary (8 September 1004) in Prague on the Slav campaign, and Bishop Godescalc of Freising preached so moving a sermon on the servant who was forgiven a debt of 10,000 talents by his master and then imprisoned his own debtor who owed him but 100 pence (Matthew 18:23-34), that Henry in tears was persuaded to release Count Henry of Schweinfurt whom he had imprisoned after his rebellion of the previous year.[129] The very same parable is the subject of a lively full-page illustration in a small Reichenau Pericopes Book (Munich, Clm. 23338) roughly contemporary with the Pericopes Book of Henry II, and it features nowhere else in the whole surviving corpus of Ottonian art. The scene is known in Byzantine art, but except in a few essentials, this miniature so differs from the lifeless Byzantine examples, having more kinship with the free narrative style of Fulda, that

117

200

117. Parable of
the Indebted Servant.
Pericopes Book, Reichenau, early C11.
Munich, Bayerische Staatsbibl.,
Clm. 23338, f. 158v

one wonders whether the artist had much truck with any model.[130] It is true that there is nothing to associate this Pericopes Book directly with Henry, but the story of the sermon and its upshot could not have failed to gain wide circulation; to be seen responding to a moving sermon (and this is in no way incompatible with genuine religious devotion on Henry's part) was the kind of enabling factor which made it possible for a ruler to reverse a political decision (which perhaps he wanted to reverse anyhow) without too much loss of face.[131] Its potency as a factor, however, can only be derived from its echoing religious feeling in at least some quarters of society. This is what seems to be expressed in this small illustration of Reichenau, a monastery which has also given us a masterpiece of exterior art and religion in the Pericopes Book of Henry II.

201

118. Frontispiece of the Codex Egberti, 977-93. Trier, Stadtbibl., MS 24

The Reichenau Problem

W AS REICHENAU, the most famous of all Ottonian schools of
manuscript illumination, truly located at the monastery on the island
of Reichenau in Lake Constance? After Vöge (1891) had doubted it in
favour first of Cologne and then Trier, Haseloff (1901) seemed to put the
affirmative beyond argument; but Bauerreis (1957) patriotically raised his
head for Regensburg, though not convincingly, and Schiel (1961), with
more force, in his facsimile edition of the Codex Egberti put the case for
Trier. In 1965, C. R. Dodwell and D. H. Turner put the strongest question
mark against Reichenau, and Dodwell hoisted again the Trier banner. The
work of these two authors, *Reichenau Reconsidered*, has always deserved to
be taken seriously, and besides casting much light on Ottonian art in
general by their learning, they showed that there was a case to be
answered. The greatest Reichenau manuscripts, these perhaps because
they were destined for the ruler's use, sedulously covered their original
tracks, as did the subsequent 'school manuscripts' such as the pericopes
books in Munich (Clm. 23338), Augsburg (MS 15a) and Wolfenbüttel
(Guelf 84.5. Aug.2°0) the Sacramentary in Oxford (Canon. Liturg. 319); the
school manuscripts did so because they were always intended for export
from Reichenau, it was presumed.

We may sketch some of the points made by Dodwell and Schiel. In
Purchard's encomium of Abbot Witigowo's building and artistic achieve-
ments (985-97) there is no mention of manuscripts, nor do any notable
illuminated manuscripts survive from Reichenau itself although a goodly
part of its library is preserved at Karlsruhe (Dodwell scoffs at the provin-
ciality of the manuscript illustration at the head of Purchard's own text).
One should not be so impressed as Haseloff and others were by the con-
tinuity of initial ornament in the Reichenau manuscripts from the 960s to
at least the 1030s, since initials were easily imitable at various centres. Nor
should one suppose that the wall-paintings at Reichenau, especially in the
church of St Georg, Oberzell, constitute an important argument for loca-
ting the manuscripts there, close as these were to each other in style and
iconography, since these wall-paintings might be fortuitous survivals at
Reichenau from the work of secular and peripatetic artists, and there is
no proof that they were painted by Reichenau monks. Both Dodwell and
Schiel try to counteract the great play which hads been made of the frontis-
piece to the Codex Egberti, a pivotal manuscript in Reichenau develop-
ment, where two monks named Kerald and Heribert, who are explicitly
stated to be from Reichenau (i.e. *Augigenses*), present the book to Arch-
bishop Egbert of Trier (977-93); not to mention the dedication verses which
seem to say clearly that the book is a gift from Reichenau to Egbert. Here

was trouble indeed for the anti-Reichenau lobby, but it was neatly deflected by the argument that the monks would be so designated only if they were working *away* from Reichenau. People were presumably not called such surnames as Appleby or Louth until they had left those places. Moreover, speaking ·palaeographically, Schiel pointed out that the Codex Egberti in its text showed scribal characteristics of other Trier, not Reichenau, manuscripts. Finally, both Dodwell and Schiel stress the importance of Trier for its artistic traditions, its central place in tenth-century monastic reform, and the dominating figure of Archbishop Egbert in Ottonian culture.

There are other planks in the argument, but except for one or two matters of palaeography raised by Turner to which we shall shortly come, they bear less weight than those which we have mentioned. None of the above points, indeed, seem entirely satisfactory. We have already observed (p. 49) that no accounts of monastic beautification under the Ottonians mention manuscript illumination; it was not a feature of the genre of such writings. The lack of fine manuscripts amongst the surviving Reichenau books is to be accounted for by making a distinction between the early medieval library, which in large part survives, and the treasury of the church which has totally disappeared. Illuminated liturgical books of the kind in which Reichenau specialized would have been kept in the treasury or sacristy, especially if they had fine covers. Haseloff and Boeckler and others were surely right to be impressed by the continuity of development in the initial ornament of the books in question; the inventiveness and freedom with which the ornamental repertoire is deployed in manuscript after manuscript speak strongly for the living practice of men working together, or in succession to each other, in one community and scriptorium, rather than for imitation of ornament regardless of human relationships. The wall-paintings, too, are impressive, because so much work has been discovered in Reichenau or its vicinity that, as Kurt Martin has argued, it is difficult to suppose that Reichenau was not the centre of a school of wall-painting, and wall-and manuscript-painting were two closely associated occupations.[1]

The arguments which press the case of Trier are not more soundly based. It is not necessary to suppose that Kerald and Heribert were working in Trier rather than Reichenau to be named *Augigenses*, only that they knew that Trier was the destination of their manuscript. Besides, the dedication verses, making the book a gift from Reichenau to Egbert, have also to be got over. It is true that Schiel has been vindicated in his palaeography by Hoffmann, who shows that the two principal hands in the Codex Egberti were Trier hands, though a Reichenau hand also contributed;[2] but Nordenfalk pointed out in 1972 that there was nothing to have stopped the Trier-based Gregory Master, who contributed seven of the early miniatures to the book, from visiting Reichenau — presumably with at least one scribal colleague from Trier. This master was clearly free to move about and had artistic associations with several great monasteries (see p. 39). Nordenfalk made a good case for suggesting that his connection with Reichenau may

well have been stimulated by an earlier visit of Reichenau artists to Trier.[3] As to the importance of Trier and Egbert, while that is undoubted, it is stressed by Dodwell at the cost of seriously underrating the importance of Reichenau and its closeness to the Ottonian court during the great developments of Reichenau art (see pp. 37, 78, 141, 155).

To argue, however, that points made against Reichenau are unconvincing is very different from establishing that Reichenau was positively a great centre of manuscript art. Here the palaeographical and liturgiological work of scholars such as Hoffmann, Klein and Schuba, have greatly enlarged our possibilities since Dodwell and Turner wrote a quarter of a century ago. Reichenau went through various phases of development in its great period, *c.* 960-1030, to which art historians have given the names of scribes/artists who appear in the dedication pictures of each phase. Anno is associated with the Gero Codex, to which are closely connected by style the Petershausen and Hornbach Sacramentaries (all *c.* 965-75/80). Ruodpreht is associated with the Egbert Psalter, to which are connected the Poussay Pericopes and a sacramentary with ornamented initials in Florence as well as various other manuscripts with fine initials (*c.* 975-95). The Codex Egberti is the vital link manuscript between the Ruodpreht and Liuthar Groups. Liuthar appears in the Aachen Gospels (*c.* 996), and his name is associated with the high-water marks of Ottonian art: the Gospel Book of Otto III, the Bamberg Apocalypse, the Pericopes Book of Henry II and several subsequent 'school manuscripts'. Our essential business is to see whether we can establish one or more manuscripts in each group to be Reichenau, which will carry the rest with them on the grounds that nobody doubts the very close stylistic and palaeographical relations to each other of the manuscripts in each group.

One manuscript of the Liuthar Group which stands above the fray as of indubitably Reichenau origin is the Bamberg Troper (MS Lit. 5); it is not one of the great manuscripts of the group (it is mentioned only *en passant* in a footnote by Dodwell,[4] but for once it is a manuscript which does not cover its tracks. In this book, apart from the celebrations of feasts with general ecclesiastical significance, there are tropes for St Januarius, a distinctive Reichenau cult in the tenth century, and St Pirmin, Reichenau's founder. There are sequences for Januarius and Pirmin again, as well as for Saints Otmar and Blaise (Swabian cults), Saints Senesius and Theopontus, patrons of Radolfzell near Reichenau on Lake Constance, St Pelagius, venerated with a chapel on the island of Reichenau since around 900, and St Verena, whose burial place and shrine was at Zurzach which became a dependent church of Reichenau in 888.[5] The whole ensemble of saints bespeaks Reichenau quite clearly. Moreover, Peter Klein has pointed out that physiognomy, figural style and colour scales, all bind this troper, the Aachen Gospels and the Bamberg Commentaries, closely together. He draws attention, also, to the Old High German interlinear glosses in the Bamberg Commentaries (an integral element of the original manuscript) which are of Alemannian character, i.e. from the Reichenau/St Gall region.[6]

Using Hoffmann's catalogue of the Reichenau manuscripts and his identification of the various scribes, we can now start, through a network of overlapping hands, to pull other manuscripts into the Reichenau scriptorium. The main writer of the Bamberg Troper also wrote some pages in the Bamberg Josephus (with an Otto III frontispiece), and another writer in the Josephus also wrote in the Gospel Book of Otto III. The scribe of a few lines in the Bamberg Troper also wrote a few lines in the Aachen Gospels. Yet another scribe of the Bamberg Troper also wrote both in the Bamberg Josephus and the Paris Sacramentary (Paris, lat. 18005). The main scribe of the Gospel Book of Otto III also wrote in the Hildesheim Collectar and the Wolfenbüttel Pericopes Book.[7] We may certainly now draw in the Bamberg Apocalypse and the Pericopes Book of Henry II, since nobody has questioned that these belong to the same scriptorium as the Aachen Gospels and the Gospel Book of Otto III.

The Paris Sacramentary is another manuscript with clear signs of Reichenau origins, not in its calendar which was made for the use of Trier (and is thus another connecting link between Reichenau and Trier), but in its mass prayers, which include formulae for Saints Pirmin and Januarius, Saints Gall and Otmar, and again St Verena.[8] Turner in fact agreed that this was an inescapably Reichenau book, with its New Testament cycle of illustrations in Liuthar style.[9] This book and the Bamberg Josephus share another scribe, besides the one mentioned in the previous paragraph. If we now add the Tonarius of Berno of Reichenau (1008-48) in Cleveland, the Berno manuscript of the *Life of Udalric* in Vienna, both with Liuthar style miniatures,[10] and from the eve of the Liuthar period, the Codex Egberti, whose Christ cycle leads us iconographically into Liuthar, and which mentions Reichenau specifically as we have seen, there is surely every assurance that the Reichenau heartlands of the Liuthar Group are indeed Reichenau.

What of the Anno group, to jump back to the early period? Nobody questions the closeness of the Gero Codex, the Petershausen Sacramentary and the Hornbach Sacramentary to each other, judged by ornamented initials and frames and by the literary relation of the dedication verses for the relevant pages in *Gero* and *Hornbach*. Hornbach was, like Reichenau, a Pirmin foundation, and the dedication verse of its Sacramentary says that the codex was made by the scribe Eburnant (hence the Anno Group is sometimes known as the Eburnant Group) for Abbot Adalbert of Hornbach, an abbot during the second half of the tenth century. Since *Petershausen* would clearly seem to originate from the diocese of Constance, whether or not from Reichenau, on account of its stress on St Pelagius, one is struck by the Swabian rather than Lotharingian or Rhineland pointers of the whole group.

There has seemed to be one serious obstacle, however, to bringing the Anno Group into the Reichenau camp, namely the Calendar of the Petershausen Sacramentary. This is very much a Calendar of the Reichenau Use, but the Sacramentary itself generally has only the normal Roman feasts

and lacks those peculiar to Reichenau. Furthermore, the folios of the Calendar constitute an entirely separate quire from the rest of the manuscript. Turner implied that not only were Calendar and Sacramentary written by different hands, but also that they came from different scriptoria and may only have been bound together as late as the twelfth century. Dodwell goes so far as to say, 'if the calendar was made at Reichenau, then the main body of the text (which is the illuminated part of the manuscript) probably was not'.[11] In other words, the anti-Reichenau lobby seeks to drive the strongest possible wedge between the Reichenau Calendar and the liturgically neutral Sacramentary (neutral as to any place other than Rome) in order to advance an agnostic viewpoint on the localization of the latter. But they have been too eager with their wedge. First, it is not easy to prove that two hands must be from different scriptoria unless one can positively localize both, particularly if there may be a time gap of several decades between one and the other. Secondly, Schuba has given good reasons why we should not completely separate Calendar and Sacramentary from each other. For 28 August, the Calendar has 'Ermetis, Augustini, et Pelagii', the last being, as we said, very much a Reichenau cult. The Sacramentary has prayers only for St Hermes on that day. The rubric, however, an integral part of the Sacramentary text, has, 'in natale sanctorum Hermetis, Pelagii, Augustini'. Again, the variant readings of the Petershausen Sacramentary as from the Roman Hadrianum accord most closely with two in particular of the early manuscripts which Deshusses used to establish the text of the Roman Sacramentary, Vienna lat. 1815 and Donaueschingen 191; both are ninth-century Reichenau manuscripts.[12] The fact is that the Calendar is quite likely to have been put with the Sacramentary from the start. Reichenau had many sacramentaries in the ninth century,[13] and thus no doubt many liturgical calendars, and probably the Calendar had already been long in existence when the Sacramentary was made. Oechelhäuser dated the Calendar to before 925 with some later additions, and Ludwig Schuba kindly informs me by letter that he would put its first and main hand to c. 900. That, rather than different origins, is the probable explanation of why Calendar and Sacramentary (c. 965-75) seem to hold their distance from each other.

The Anno and Liuthar Groups are thus clearly Reichenau, and there is no escape for the Ruodpreht Group (c. 975-95) from between them. Turner was ready to agree with Bloch that the hand of the initials in the Egbert Psalter, Ruodpreht's most important manuscript, had also created the initial D for Easter in the Petershausen Sacramentary. The Ruodpreht Group is tied by its ornament to the Anno Group as well as to the Codex Egberti,[14] and (as Haseloff long ago compellingly argued) by the Christ cycles of the Poussay Pericopes and the Codex Egberti, iconographically to the Liuthar Group. If we do not elaborate, it is because all parties are broadly agreed that wherever the Ruodpreht Group is to be localized, there also is Liuthar, and vice versa. That is why the Codex Egberti has been an important battleground. Was it Trier or Reichenau?

The prayer *Veneranda* gives us another positive indicator of Reichenau localization. It appears to have originated in Rome under Pope Sergius I (687-701) for the beginning of the procession of the feast of the Assumption of Mary which he initiated, the feast itself having been introduced there between 604 and 687. It found its way into the mass prayers and was the normal collect for the feast in Ottonian times, though it was later dropped from the Roman sacramentary. Its text is as follows:

> *Veneranda nobis, Domine, huius est diei festivitas,*
> *in qua sancta Dei genitrix mortem subiit temporalem, nec*
> *tamen mortis nexibus deprimi potuit, quae filium tuum*
> *dominum nostrum de se genuit incarnatum.*

> To be venerated, O Lord, is the feast of this day, on
> which the holy Mother of God underwent earthly death
> although she could not be put down by the constraints
> of death, who bore thine incarnate son Our Lord.

Capelle argued that the phrase, 'although she could not be put down by the constraints of death', must refer to the constraints of bodily death and thus implicitly Mary's bodily assumption.[15] He took the antithesis in the prayer to be between earthly death, the *mors temporalis*, and the lack of the normal physical effects of death,[16] whereas the less strained interpretation is that it implies a contrast between temporal death and eternal life.

Capelle drew attention to a variant of the prayer which became quite common, but of which the earliest known instance is in the Fulda Sacramentary of *c.* 975 at Göttingen (MS theol. 231). The words *opem conferat sempiternam* were here added after *festivitas*, thereby turning it into a normal impetratory prayer, which in its original form it was not: 'may the feast bring eternal succour, on which,' etc.[17] These words also appear in the Fulda Sacramentaries at Bamberg and Udine, though not in that of Cologne (MS 88) and so may be considered a normal if not invariable Fulda form.[18] He failed to encounter another Ottonian variant, however, which may be particularly associated with Reichenau. Here the Fulda phrase, if we may call it that, does not feature, but another petition instead is added at the end of the prayer: *cuius intercessionem quaesumus, ut mortem evadere possimus animarum* (whose intercession we ask so that we may escape the death of our souls). This variant is found at least in the early eleventh-century Reichenau Sacramentaries now at Heidelberg and Paris, which have clear liturgical indications of Reichenau as we showed above, in that at Oxford and in the Collectar at Hildesheim.[19] It suggests that at least one Ottonian monastery understood the constraints-of-death phrase to refer to the assumption into heaven of Mary's soul. We have argued that, stimulated in their interest and excitement as Reichenau might have been by the Byzantine literature in their library on the bodily assumption, they did not use art to propagate this doctrine, but on the contrary rather

deliberately confined themselves to the safe theological basis of the spiritual assumption in what they painted for public liturgical purposes. Their favoured variant of *Veneranda* seems pointedly to reinforce this lesson.

More than this, however, the variant in question looks as if it might be an important liturgical indicator of Reichenau origins, for in my searches (admittedly not comprehensive, but I think indicative) I have not found it outside a Reichenau source. The case of Fulda is already on the table. Trier, so often credited with art, otherwise attributed to Reichenau, had the Fulda not the Reichenau form, to judge by at least one Sacramentary of demonstrably Trier origins (Paris, BN, MS lat. 10501 f. 98v).[20] Regensburg, judging by the Sacramentary of Henry II, used the oldest form of the prayer without variants.[21] Corvey, on the showing of the Sacramentary in Munich (Clm. 10077), used the prayer *Concede quaesumus omnipotens deus ad beate Marie semper virginis gaudia aeterna pertingere, de cuius veneranda assumptione tribuis annua festivitate gaudere*, which suggests that its liturgy was derived from Corbie, since with some verbal variants this is the prayer found in a late ninth-century Franco-Saxon (i.e. North French) Sacramentary now in Vienna (Codex Vindob. 958).[22] Besides the Reichenau manuscripts mentioned above, Hartmut Hoffmann has placed the Sacramentary of Abraham of Freising in the Ruodpreht Group of Reichenau on account of its script and calligraphy; it too has the Reichenau variant of *Veneranda*.[23] This variant, therefore, unites manuscripts of the Anno, Ruodpreht and Liuthar Groups of Reichenau, as well as distinguishing these from all manuscripts which can be localized elsewhere than at Reichenau.

Of the whole period from the Gero Codex and the Karlsruhe Homeliary (Karlsruhe MS Aug. XVI) to the 'school manuscripts' of the Liuthar Group, a period of more than six decades, *c.* 965-1030, we may conclude that Reichenau was indeed Reichenau.

EXCURSUS II:

The Byzantine Problem

I T IS NOT NECESSARY to write at length on this issue, particularly as there is a model discussion of it by Florentine Mütherich in her superb facsimile edition of the Munich Gospel Book of Otto III.[1] The present writer, however, has found the question of Byzantine influence on Ottonian art to be so often raised, that some general answer with slightly more elaboration than we have given in the body of the book (see p. 74; and Part II, ch. 3) seems called for. A systematic survey of the occurrences of Byzantine and late antique/Carolingian/western influences in the miniatures of Ottonian manuscripts would be well beyond the scope of this

excursus or of the book. Indeed, following Bloch and Schnitzler who des-paired of unravelling these influences in the Cologne school, an Ottonian school which looks more influenced by Byzantine style and iconography than most, and following also Mütherich, who entirely concurs with them about the difficulty, it would be our argument that such a survey (though attempted by some scholars)[2] is bound to lack sufficient scientific basis. That is not to say that one should never hazard the likelihood of Byzantine models operating in particular cases. When, for instance, Cames points to a similar figural style of the Hebrews carrying the Ark of the Covenant in the tenth-century Bible of Leo Patricius (f. 85v), and of the Ascension in the St Gereon Sacramentary of Cologne (*c.* 1000), with the tall bodies and small heads of the apostles;[3] or when Boeckler draws an analogy between the slanting construction of the group of Israelites in the miniature of the Passage through the Red Sea in the same Byzantine Bible, and the group of those entreating Jesus in the picture of the Healing of the Possessed Son in the Aachen Gospels (*c.* 996),[4] these are obviously meaningful compari-sons in which it would be difficult to deny the probability of Byzantine influence. Moreover, one can scarcely doubt the importance of Byzantine ruler imagery in Ottonian ruler portraits. We have shown above that while Otto III is cast in a late antique, western mode in the Gospel Book of Otto III (pp. 158-60), there are strong Byzantine perceptions in the manner of his representation in the Aachen Gospels (p. 61, 65).

In general, however, art historians have not found a sufficiently precise control to determine the derivation of iconography, particularly Christ iconography, from late antique western sources, perhaps *via* Carolingian art, as distinct from Byzantine, or *vice versa*. Nor are they ever likely to do so. When the Macedonians (C9 and C10) after the Iconoclastic Controversy put together a new canon of Christ illustrations in great number for their gospel lectionaries or pericopes books, as Weitzmann showed that they did, they were using the same kind of late antique Mediterranean sources (eastern and western was not always a vital distinction then) as Ottonian artists came to use.[5] Thus a common antique source is often as likely to explain the similarity between Ottonian and Byzantine iconography as is direct influence. Boeckler and others have called parable illustrations rare in the Ottonian West but common in the Byzantine East, and have thus argued that they are a particular sign of Byzantine influence in the West when they appear in the books of Reichenau and Echternach. But leaving aside whether they were such a rarity in the West, they were a common feature of gospel illustration in late antiquity and, therefore, we must suppose that illustrations of them could have been widely diffused by the tenth century. That is one point which creates problems about identifying Byzantine influence in particular cases.

Another point is, and it is well made by Mütherich, that there is a great shortage of surviving Carolingian Christ cycles, but this is not to say that more antique iconography had not come down to the Ottonians in Carol-ingian clothing than we can now know. We know enough to get an inkling

of what we might not know. Boeckler compared the Healing of the Leper in the Codex Egberti and the Gospel Book of Otto III with Byzantine examples, most of all that in the eleventh-century Byzantine Gospels, Paris, BN grec. 74. There were good parallels here, not, it may be said, in the very bent knee of the leper (at least in the Gospel Book of Otto III) and the drinking horn on his back, but certainly in the disposition on the page of the apostles, Jesus and the Leper.[6] In this discussion, however, Boeckler omitted to mention the Carolingian drawing of this subject now at Düsseldorf in a gospel fragment. Yet here are to be found the bent knee and the drinking horn. This is a very good example of the Byzantine problem because it shows that the model used by the Ottonians could as easily have been a Carolingian as a Byzantine one; and despite Carolingian inhibitions about Christ cycles in manuscripts (see pp. 80-83), the Düsseldorf fragment was probably not as isolated in the ninth century as it looks today. Again, the Flight into Egypt was in origin very much an eastern subject, but it is no use arguing that that speaks for Byzantine influence when it crops up in the Speyer Gospels of Echternach (c. 1050),[7] for the wall-paintings of Müstair (c. 800) show that it was domiciled in the West (in very similar form to *Speyer*) much earlier. If we consider early medieval Italian art (which is essentially what Müstair is), it is clear that many subjects were well known, which some art historians still continue to call rare, and whose occurrence they explain with reference to Byzantine influence. A case in point is the Harrowing of Hell, which features in various forms in early Exultet Rolls, the Stuttgart Psalter (c. 830) with its agreed Italian basis, and the Sacramentary of Warmund of Ivrea (c. 1000), which is unlikely to have much iconographic originality.[8]

We are driven back to a situation, therefore, in which Byzantine influence is undeniable as a general proposition, but in which we have too little knowledge of antique and Carolingian sources in the West to rule out these as an alternative possibility to Byzantine sources in many cases. Both could have been employed simultaneously, as we have suggested in the case of the Footwashing of Peter in the Gospel Book of Otto III (see pp. 71-73). That would not be surprising, considering the way that the Ottonians used Byzantine political and ceremonial forms of their own day to vitalize their revival of antique Rome in the West (see p. 160).

Notes to the Text

Bibliographic references are generally given in abbreviated form. For full bibliographic information readers are referred to the Bibliography.

Notes to the Introduction

1. I have not provided references in this introduction where it is easy to refer directly from text to bibliography.

2. Bornscheuer, pp. 76-93.

3. Widukind, iii, ch. 56, p. 135. The Saxon military build-up which constituted the basis of these victories has been brilliantly analysed by Karl Leyser, 1982, ch. 2 and 3.

4. Beumann, 1972, esp. pp. 383-85; Thietmar, ii, ch. 17, p. 58.

5. Ruotger, ch. 8, p. 8, lines 20-22. See H. Hoffmann, 1957, pp. 49-54.

6. Büttner, pp. 261-65.

7. DOI, 135, issued immediately after Otto I's coronation as king of the *Regnum Italicum* at Pavia, and referring to the imperial *bulla* or seal, shows that the 'application' for the emperorship was made in 951.

8. Thietmar, iv, ch. 32, pp. 169-71. I have abridged the Latin in my translation, but have tried to keep its strict sense.

9. See the excellent discussion in Hoffmann, pp. 42-79, esp. pp. 54-55, 58-59, 66-69. For an English C11 example of a scribe and painter, Erwin, *In scribendo et quidlibet in coloribus effingendo peritum*, see *Vita Wulfstani*, ed. R. R. Darlington (Camden 3rd ser. 40, 1928), p. 5.

10. Bede, HE I,1; and Bede, Acts, pp. 8-9.

11. See Dodwell, 1961; D. V. Thompson, pp. 51-53; for e.g. Marbod of Rennes on precious stones, Thorndike, i, 775-82.

12. Vita Johannis Gorz., ch. 83, p. 360. For the relevant quotation, see Part II, ch. 3 n.42

13. For examples of Prudentius drawings of C9-C11, see Richard Stettiner, *Die illustrierten Prudentius-Handschriften*, Textband & Tafelband (Berlin, 1895, 1905), often vague about localization. For drawings illustrating Terence, mostly of the same period, L. W. Jones & C. R. Morey, *The Miniatures of the Manuscripts of Terence prior to the Thirteenth Century*, 2 vols, Texts and Plates (Princeton, 1931).

14. Thietmar, vi, ch. 102, p. 394.

15. The nearest I know are the men climbing up the central pillar of one of the pages of canon tables in an early C11 Reichenau pericopes book, Munich, Clm. 4454, f. 17.

16. Lerche, pp. 30-31.

17. Alexander, 1978A, p. 66.

18. For the differences between the two candlesticks, see Algermissen, pp. 98, 105.

19. e.g. Gregory, Moralia, xxvii, ch. 25; PL 76.

20. Ibid., vii, ch. 12, PL 75, col. 736B, cf. Algermissen, p. 105.

21. Thietmar, vi, ch. 16, p. 294, lines 5-6.

22. In R. Gameson, *The Role of Art in the late Anglo-Saxon Church* (Oxford D.Phil. thesis, 1989, unpublished)

23. Best treated by Bloch, 1956, pp. 57-69.

24. Fleckenstein, pp. 179-80, 186.

Notes to Chapter 1

1. Gero Codex, pp. 34-37. The full strength of Schmidt's arguments for Gero the archbishop before he was archbishop was not recognized by Dodwell & Turner, pp. 10, 36-37. The Gero Codex is firmly attributed to Reichenau; Gero is identified as Gero of Cologne in Bischoff, 1974, p. 59.

2. Gero Codex, f. 8.

3. Gero Codex, pp. 9-10.

4. Sauerland & Haseloff, pp. 125-32.

5. Köhler, 1926.

6. Mütherich, 1965, p. 47 and pl. XIX

7. Boeckler, 1961, pp. 22-23.

8. Pächt, 1986, p. 184.

9. Cames, pp. 230-38.

10. Widukind: for Conrad, esp. iii, ch. 9-47, pp. 102-28; and the Wichmanns, ii, ch. 4, 11, pp. 70-71, 75-76, iii, ch. 24-29, 50-53, 64-69, pp. 116-17, 129-33, 139-45; for Otto I, books ii and iii.

11. E.g. the Mark evangelist page, Clm. 4453, f. 94v; the Limburg Gospels, Cologne MS 218, the Luke evangelist page, Schulter, 1980, p. 55.

12. Thietmar, iii, ch. 21, p. 124.

13. DOII, 277; DOII, 283 (esp. p. 330, line 16).

14. Codex Wittekindeus, pp. 15-16.

15. Ibid., pp. 17-18.

16. Folz, 1950, p. 67

17. Widukind, i, ch. 15, p. 25.

18. DOI, 316, p. 430, lines 2-5: ... *ad capellam quam dive memorie Karolus imperator augustus ob culmen et fastigium sui imperii ... construxerat.* Also, e.g., DOI, 323, 417.

19. See above, note 1.

20. For what is known of the origins of the St Gereon Sacramentary, see Bloch & Schnitzler, i,43.

21. Fleckenstein, pp. 42, 52-56.

22. Ruotger, ch. 10, p. 10.

23. Fleckenstein, pp. 49, 57.

24. Continuatio Reginonis, 939, p. 161.

25. Hallinger, i, pp. 187-99; Wehlt, pp. 43-44.

26. Wehlt, p. 88.

27. The list of monks was added to a C9 Italian MS of St Ambrose on St Paul, Vat. Pal. 169, f. 151, see Reifferscheid, 1867, pp. 442-44. Wehlt surveys Otto I's grants to Lorsch, some of them clearly to gain the support of the monastery at the time of the 953 rebellion, at pp. 41-43. Further on the Lorsch library, Bischoff, 1974, and Duft in Büttner & Duft, esp. pp. 37-39.

28. Dodwell & Turner, p. 7.

29. Beyerle, pp. 112/15, 18.

30. Ibid., p. 112/14; DOI, 160, 161, 277. But see Fleckenstein, p. 37.

31. DOI, 275, 276; DOII, 25.

32. See Gero Codex, pp. 29-30. Contrast non-New Testament feasts in the Poussay Pericopes Book (Paris, BN, MS lat. 10514), including Saints Fabian & Sebastian, f. 23v, S. Vitalis, f. 59, St Pancras, f. 64, S. Apollinaris, f. 88, Saints Abdo & Sennen, f. 88v, the Maccabees, f. 91v, St Stephen, bishop, f. 92, St Cyriacus, f. 93v, Saints Protius & Iacintus, f. 103v, Saints Cornelius & Cyprian, f. 105, S. Nicomedis, f. 106v (all of course from the Roman sanctorale).

33. E.g. in the Utrecht Psalter before Psalm 33, f. 22. There is also a Carolingian model implicit in the C10 Fulda representations of St Lawrence.

34. See Dunbabin, 1985, esp. p. 35.

35. Merton, pp. 65-66. See also below, ch. 4 n.42.

36. Much is made of this by Thietmar of Merseburg, ii, ch. 10, p. 48, since Otto I is said to have vowed the foundation of a cathedral church at Merseburg dedicated to St Lawrence if he were granted victory. Thereafter Thietmar misses no opportunity to mention the saint. Given the importance, however, attached to the relation between liturgical days and public events, see H. M. Schaller, the association of St Lawrence and Lechfeld is unlikely to have been a late effort or a solo effort by Thietmar. That Otto I himself made the connection is shown by his having spent the tenth anniversary of the Battle of the Lechfeld, i.e. the feast of St. Lawrence, 965, at Merseburg (DOI 307). This fact seems to be missed by Weierich in his excellent study of the Ottonian cult of St. Lawrence.

37. Israel & Möllenberg, no. 28, pp. 41-43, Bull of Pope John XII, 12 Feb. 962: *Nunc vero dei operante clementia carissimus et christianissimus filius noster rex Otto, devictis barbaris gentibus, Avaribus scilicet ceterisque quam pluribus, ut ad defensionem sancti Dei ecclesie triumphalem victorie in inperii culmen per nos a beato Petro apostolorum principe susciperet coronam, summam et universalem, cui deo auctore presidemus, adiit sedem ...* Further references to Hungarians and Slavs are to be found in the same document.

38. F. M. Fischer, 1938, pp. 89-98; Wehlt, pp. 274-77.

39. Wehlt, p. 362. For Otto I's intervention to secure the election of Abbot Hatto of Fulda as Archbishop of Mainz in 968, see Hildesheim Annals, p. 23.

40. Hoffmann, pp. 9-10.

41. Widukind, ii, ch. 36, p. 96, lines 15-17.

42. As is proved by the letter of Archbishop William of Mainz to Pope Agapetus II of 955, see Claude, i, pp. 66-73.

43. Gesta Arch. Magd., p. 380, quoted by Dodwell & Turner, p. 94, note 197.

44. DOI, 361, and Codex Wittekindeus, pp. 1-3.

45. Thietmar, ii, ch. 30, p. 76: *Pro remedio autem animae suae tradidit postera luce ineffabilia Deo munera invictissimoque eius duci* [i.e. as patron saint of the church of Magdeburg] *Mauricio in prediis, in libris caeteroque apparatu regio.*

46. See further in Part II.

47. Hoffmann, pp. 122-26, argues cogently against any of the previous identifications with known artists.

48. Part II, ch. 2. See Nordenfalk, 1972. For the Codex Egberti, ibid., p. 67, where he stresses that the book as a whole would have been inconceivable without the Gregory Master's guidance.

49. Nordenfalk, 1972, p. 68.

50. Hoffmann, pp. 103-16.

51. Ibid., pp. 176-77.

52. DOII, 21. Facsimile reproduction with explanatory booklet, Matthes, 1980. For documents written in gold on purple, a Byzantine practice, see Brühl, 1977.

53. Matthes & Deeters, no. 41, p. 49.

54. E.g. in writing about the Wichmanns, see note 10 above. Beumann, 1950, pp. 21-24, is clearly right to point out that Widukind's declared aim to write about the deeds of 'our princes' (*principum nostrorum*) must include the ruling Liudolfings, but it is not confined to them.

55. Mütherich, 1963, esp. p. 38.

56. Thietmar, iii, ch. 1, p. 96, cf. also the Cologne ivory (Christ with Saints Victor and Gereon) *c*.1000. Goldschmidt, 1969, ii, no. 47.

57. Jolliffe, 1955, esp. chapters 7-9, 13. See also Brühl, 1968, esp. i, pp. 118-32 for the Ottonians; and the fundamental contribution of Leyser, 1982, ch. 4.

58. Leyser, 1982, p. 75 (1981, p. 727), where he refers to 'illuminators of distinction' in this connection, and pp. 94-100. Leyser has also written about *familiaritas* in connection with a sermon of Liudprand of Cremona, Leyser, 1985, pp. 53-54. Relevant in this connection is Fleckenstein, p. 219, on the *iter*.

59. Thangmar, ch. 6, p. 760, lines 32-37. For the sense of the word *curtis* as 'royal court', see Niermeyer, 1984, p. 296, no. 13.

60. Jantzen, 1940, esp. pp. 511-13; see, along similar lines, Pächt, 1986, pp. 67-76. For a colour reproduction of one of the whole-page initials in the Egbert Psalter, see Bologna, p. 82. See also Col. Pl. XXIV in Part II. The historiated initial, which seems to take its rise in C8 England (e.g. Alexander, 1978, figs. 143, 144), is not much in evidence in Ottonian art, at least until a very late period, except in the Bamberg Commentaries, see Part II, ch.1.

61. Boeckler, 1925, p. 964, writes of the way in which interlace can cover St Gall initials 'like a net', and Bloch, 1956, p. 39, refers to the 'formlessness' of St Gall initials. See also Landsberger, p. 2 and Pl. 1.

62. For this whole development, see Bloch, 1956, pp. 38-48, and Florentine Mütherich in Grodecki et al., pp. 118-24. For a description of the Reichenau Homeliary (Karlsruhe MS Aug. XVI), and several plates, and for the C9 background of Reichenau book production, see Engelmann, 1971, whose arguments for an early C10 date, however, (esp. pp. 23, 26) have now been displaced in favour of the third quarter of the century, see Hoffmann, p. 322.

63. For minium red, a pigment made from lead, see D. V. Thompson, pp. 100-102.

64. Text: Libri Carolini. Some good discussions, Folz, 1974, pp. 91-95; Wallace-Hadrill, 1983, pp. 219-25; Freeman, 1957.

65. Libri Carolini, iii, ch. 23, p. 153: *Pictores igitur rerum gestarum historias ad memoriam reducere quodammodo valent, res autem, quae sensibus tantummodo percipiuntur et verbis proferuntur, non a pictoribus, sed ab scriptoribus comprehendi et aliorum relati demonstrari valent.* A similar passage is ii, ch. 30, p. 93, lines 1-11.

66. See the masterly paper by Ganz, 1987, esp. pp. 30-31, 33.

67. See the remarks of W. Braunfels in Lorsch Gospels, p. 15.

68. Bischoff, 1967A, no. 23, p. 32, line 10; no. 125, p. 128, line 6; no. 130, p. 132, line 6 (a psalter).

69. Ibid., i.e. in lists drawn up *c*. 900-1130: nos. 3, 6, 11, 16, 18, 23, 24, 25, 28 (C9), 34, 36, 42, 43, 46, 54, 55, 61, 68, 70, 77, 83, 84, 92, 130, 134.

70. See Kahsnitz et al., 1982, pp. 38-71; Metz, 1957, pls. at pp. 41, 61; Clm 4453, pp. 27-30; Küppers, 1975, p. 65.

71. Paris, BN, MS lat. 9448.

72. Bischoff, 1967A, no. 74, p. 81, lines 58-59.

73. Ibid., no. 6, p. 17, lines 3-4, and p. 18, lines 49-51.

74. Dodwell, 1982, esp. chapters 1-3.

75. Purchard, esp. pp. 272-76, lines 302-458; Glöckner, i, ch. 69, 76, 78, 91, pp. 352, 353, 359, 373; Thangmar, ch. 6, 8, pp. 760-62; Petershausen Chronicle, quoted by Cames, p. 17.

76. Andrieu, ii, 89 (Ordo I, ch. 62).

77. Andrieu, v, 177 (Ordo L, ch. 37).

78. Metz, 1957, p. 21.

79. *Miracula S. Fidis*, i, ch. 13, pp. 47-49. I owe this and the next three references to the doctoral thesis of Patricia Morison, *The Miraculous and French Society circa 950-1100* (Oxford D.Phil. 1983, to be published in revised form).

80. Ibid., i, ch. 11, p. 40; iii, ch. 17, p. 157.

81. *Translatio S. Corentini*, ed. J. Martene, Hist. de l'Abb. Marmoutier, i (Tours, 1874), p. 199.

82. Helgaud, ed. R. Bautier & G. Labory (Paris, 1965), p. 76.

83. E.g. Purchard, on the altar of St Mark at Reichenau, p. 276, lines 455-58; or the reliquary of St Andrew's sandal at Trier, Jantzen, pp. 142-43; and also the shrine of Bishop Gauzlin of Toul, ibid., p. 136. See Part II, ch. 2.

84. Dunbabin, pp. 143-50.

85. A good insight into how this could happen is Geary, 1983, esp. pp. 132-34. Also for the cult of saints to invoke divine punishment on wrong-doers, see Sigal, esp. pp. 41-42, 48-50.

86. E.g. the bishops of Mâcon themselves, the local diocesans of Cluny, two of whom in C10 were of the Evrard lineage, as were various seigneurs and vicomtes locally, Duby, 1953, pp. 41-42.

87. See the lovingly represented thurible, finely picked out in gold, in The Two Women at the Tomb, Poussay Pericopes (Paris, BN, MS lat. 10514, f. 50v). This was the sort of thing which mattered: cf. the liturgical play on this subject in the Regularis Concordia, p. 49: 'three brethren, vested in copes and holding thuribles in their hands, shall enter ...'

88. Küppers, 1975, p. 69.

89. Thietmar, ii, ch. 28, pp. 74-75 (a *torquis aureus*).

90. Leyser, 1979, p. 88.

91. Reichenau, Fulda, Liège, Regensburg and Seeon were certainly all drawn in. Best of all on Henry II's casting a wide net for books in general to build a library at Bamberg is Fischer, 1907.

92. For the Sacramentary of Sigibert of Minden, see Ruth Meyer; but her argument for localizing the manuscript at Bamberg is not convincing, and it has become clear that this is either a St Gall manuscript or a Minden manuscript strongly influenced by St Gall, Hoffmann, p. 374. For the Bamberg Gregory on Ezechiel, see Schramm & Mütherich no. 129, p. 219. The conjecture that the manuscript was 'a primitive testimony to a new Bamberg scriptorium' was first put forward by Fischer, 1907. Colour reproductions of the dedication page are in Fuhrmann & Mütherich, pl. 22, Cat. 12, and in de Hamel, 1986, p. 62, pl. 56, and see p. 72. In the latter, however, the idea that the manuscript is from Seeon, and that the scribe Bebo is the person offering the book to Henry II, and that the Bebo who is mentioned elsewhere had anything to do with Seeon, seems all to be the result of a multiple confusion.

93. Vie de Gauzlin, e.g., ch. 38-39, pp. 75-76; ch. 44, p. 83; ch. 54-55, p. 95; ch. 65, p. 135. For examples of relations with King Robert the Pious, whose half-brother he was, see pp. 40, 52, 136.

94. Ibid., ch. 62-63, pp. 119-29.

95. For the Valenciennes Apocalypse (from St Amand) and related manuscripts, see Part II, ch. 1.

96. PL 93, col. 456B-C. For the suggestion that the manuscript was Arator, Traube, 1901, pp. 276-78. See also Henry Mayr-Harting, *The Coming of Christianity to Anglo-Saxon England* (London, 1972), p. 191.

97. Vie de Gauzlin, ch. 65, p. 132, and note 2 on pp. 132-33. Nordenfalk, 1964, p. 54, traces the influence of Nivard in some other French manuscripts of the early C11. For the commissioning of the Gaignières Gospel Book (Paris, BN, MS lat. 1126) by King Robert the Pious, see ibid., p. 49.

98. See below, pp. 74-78.

99. Though, under Anglo-Saxon influence, there are late C10 Fleury initials which are insular in style, see Micheli, 1939, p. 155, note 1, and p. 157, note 2.

100.. See Grabar & Nordenfalk, pp. 129-31, and Nordenfalk, 1964, p. 49. For a good conspectus of illustrations of C10/C11 French manuscript art, see Porcher, 1959.

101. For the manuscripts of St Martial, Limoges, see Gaborit-Chopin, 1969, for the First Bible, pp. 42-52.

102. E.g. one may compare the standing figure of St Thomas beside an initial B in the Limoges Lectionary, BN, MS lat. 5301, f. 279v (see Lauer, 1927, i, 82-84, and Gaborit-Chopin, pp. 63-70 and fig. 54), with the figures of standing apostles in the Stuttgart Psalter (probably Saint Germain-des-Prés, c.830) f. 22 (illustrated, Belting, 1967, fig. 55). See also Seebass, 1973, pp. 72-75, 78.

103. Seebass, 1973, pp. 63-67, 77-78. For 'primitivism' and *rusticitas* in French illumination of this period, see Mütherich, in Grodecki et al., pp. 189-90. St Bertin, with its mixture of Anglo-Saxon influence and Franco-Saxon tradition, was of course a different matter, ibid., p. 197, Boutemy, 1950A, and Dodwell, 1971, pp. 78-82.

104. E.g. Robb, 1973, pp. 176-77, writing of the Moissac Josephus of mid C11 (Paris, BN, MS lat. 5058). Cf. the apparently novel references to Anglo-Saxon manuscript influences in the Council of Limoges, 1031, in Mansi, Concilia, 19, col. 521D-E.

105. Cahn, 1982, p. 97.

106. Robb, 1973, p. 175.

107. E.g. for a splendid initial of a lion with an orange tongue, in a C10 Narbonne canon law manuscript, see Kirchner, 1926, abb. 26. For a fine example of a Clermont-Ferrand initial of the turn of C10 and C11 from a homeliary see Bibliotheca Phillippica: Medieval Manuscripts, New Series, Eighth Part, Sotheby's Sale 28 November, 1973: Catalogue of Manuscripts, colour pl. A, opposite p. 18.

Notes to Chapter 2

1. Sauerland & Haseloff, pp. 84-108.

2. Smaragdus, PL 102, cols. 945A-B (prudence), 946B (simplicity), 941-45 (wisdom).

3. Kantorowicz, 1957, pp. 61-78.

4. Mütherich, 1966, pp. 68-69, would date it to *c.* 990, but since the word *auguste* is used by Liuthar, which implies the emperorship, so early a date (as she recognizes) raises difficulties. In our opinion the whole iconography argues that the imperial coronation was at least in prospect when the manuscript was made, and we would consider the four or five years after 996 to give sufficient time for the development of certain ornamental motifs in the initial letters (one of Mütherich's worries about a later dating than hers) which distinguish later Liuthar manuscripts from the Aachen Gospels (see Clm 4453, pp. 77-78). We would therefore follow Hoffmann in dating the Aachen Gospels to *c.* 996, see Hoffmann, p. 307 (who actually dates it *c.* 996-1002, but it is certainly earlier than Clm. 4453).

5. See Boeckler, 1925, pp. 982-98, and Dodwell, 1971, pp. 60-63.

6. See Leyser, 1979, p. 78.

7. Grodecki, et al., Mütherich at p. 135.

8. Deshman, 1976, esp. at pp. 377-96; Leyser, 1979, pp. 75-107.

9. See Leyser, 1979, esp. at p. 84.

10. Leyser, 1979, esp. pp. 78-79, 84-85, 104.

11. Examples are DOIII, 344, 346-48, 350, 352-53, 355, 358-59, 361, 366, 375, all of the year 1000, see Ullmann, 1955, pp. 239-40.

12. Cormack, 1985, pp. 96-98; Grabar, 1936, pp. 19-20, 165-66, and pls. XXX, 9 and 13.

13. Cameron, 1987, p. 116.

14. Messerer, 1959, p. 37.

15. Kessler, 1977, pp. 74-78, and also Grimme, p. 17.

16. Leidinger, 1921, Bd 1, pl. 10.

17. Liudprand, Antapodosis, vi, 5, p. 154.

18. Bischoff, 1951, pp. 48-49; Drögereit, 1953, where not Theophanu but liturgical contacts with Rome would be the preferred explanation of Greek symptoms, pp. 113-14.

19. Ruotger, ch. 6-7, pp. 7-8.

20. MacCormack, 1981, esp. pp. 43-44.

21. Smalley, 1952, pp. 44-45. Significantly, Althoff, p. 143, finds that examples of ruler ceremonial used in a provocative way (e.g. p. 120 below) abound under the Saxons, thus showing how highly charged it was, but are absent under the Carolingians earlier or the Salians later.

22. Cormack, 1985, p. 10, Cf. MacCormack, 1981, who warns against seeing a 'unilateral influence' of literature on art or vice versa, and against seeing one as the 'reflection' of the other. 'We are dealing', she writes, 'with a convergence and a collaboration that is as intimate as a mode of perception', p. 12.

23. A similar point is made by Grimme, p. 16.

24. Kahsnitz, 1987, pp. 110-111, and fig. 19 and 20.

25. H.M. Schaller, 1974, p. 17.

26. Thietmar, vii, ch. 1, pp. 396-97. See also Ullmann, 1955, pp. 255-56. There is something of the imperial *adventus* of antiquity in Henry II's coronation procession; 'need I describe how the freed nobility solemnly came to meet you outside the walls, the senators distinguished by their white garments'... (MacCormack, quoting Pacatus on how the people of Haemona received Theodosius I, p. 51).

27. Kitzinger, 1956, p. 266 and p. 266, note 2, for examples. Kitzinger takes the common sense view that this practice is done 'to relieve the monotony of the group'. See also Wilpert, I, pl. xvii, 1; xxix, 1; xxxv, 1-3, lxxxii, 1.

28. The lintel of St Genis des Fontaines, dated to 1020, depicts Christ in Majesty and six apostles (to represent the twelve), half of them bearded and half clean-shaven. Roussillon Roman, pp. 76-77, 86-87, pl. 2; Clapham, 1932, pp. 57-60.

29. Mütherich & Dachs, pp. 26-27, 32, and no. 16, and pl. 6. For the ornamental influence of the Codex Aureus of Charles the Bald, though with some distinctive changes in colour tones and introduction of zig-zag bands in frames, see Swarzenski, 1901, pp. 70-71.

30. See, for instance, Schramm & Mütherich, no. 39, pp. 56-7, 169-70, i.e. a Metz sacramentary fragment. Given the nature of the manuscript, we would differ from this work in interpreting the figures as Charles the Bald with Saints Gelasius and Gregory.

31. MacCormack, 1981, p. 8.

32. Grabar, 1936, pp. 98-106. See Const. De Ceremoniis, I, 1, pp. 14-15.

33. See Mütherich & Gaehde, pl. 12 and p. 55; Mütherich, 1980, pp. 95-97; Holter, 1973, Komm. pp.14-15; Keller, 1985, pp. 302-05. I have to thank Peter Johanek for lending me an offprint of Hagen Keller's paper and drawing my attention to its importance.

34. For colour reproductions of the whole cycle, see Grimme.

35. The best discussion of the development of gold grounds in Ottonian art is Cames, pp. 230-38.

36. The word is used by Jantzen, p. 73, in connection with the Gospel Book of Otto III in Munich, Clm. 4453, and the phrase of Grimme is at p. 40.

37. The whole group opposite Jesus here has been appropriately compared to a group of Israelites in the Passage through the Red Sea in an early C10 Byzantine MS, the Bible of Leo Patricius (Vat. Reg. Gr. 1). There seems to be a strong case for Byzantine influence here, see Boeckler, 1961, p. 29.

38. For the Rubens, see Christopher White, *Peter Paul Rubens* (Yale, 1987), pp. 110-13.

39. Grimme, p. 49.

40. Quoted by Grimme, p. 49.

41. Schiller, ii,43.

42. Giess, pp. 38-41.

43. The earliest examples seem to be at St Gall, e.g. the Antiphonar of Hartker, Giess, p. 66. To avoid possible confusion it should be pointed out that fig. 93 (p.95) in Demus is a Doubting Thomas not a Foot-Washing. The Foot-Washing of the Leningrad Gospels (Leningrad, Public Library, Cod. gr. 21) is of this normal Byzantine type with Peter sitting and pointing to his head, see Cames, pp. 126-27, and for other Byzantine examples, ibid., pp. 156-69 and p. 96.

44. Brown, 1971, p. 75. The Vatican Vergil of C5 shows a similar style, e.g. Grabar & Nordenfalk, p. 94.

45. Schnitzler, 1962. See also Wilpert, I, pl. xvi, 1, 2; cxxi,1; xii,4,5.

46. Alexander, 1978, no. 65, p. 83, and fig. 298; also Giess, p. 61.

47. Alexander as in the note above; Traube, 1901, pp. 276-78; McDonald, 1933, pp. 150-56. For wide circulation of Sedulius manuscripts in C9-C11, see Lesne, pp. 192, 495, 532 (10 copies at C11 Cluny), 549, 575, 596, 601, 603, 625, 633 (11 copies at C11 St Bertin), 674, 683, 711, 757, 777.

48. PL 93, col. 456B-C, and for the literature, see references in Henry Mayr-Harting, *The Coming of Christianity to Anglo-Saxon England* (London, 1972), p. 309, notes 1-3.

49. E.g. Johannes Italus painted for Otto III at Aachen and subsequently moved on to Liège, see Vita Balderici, pp. 729-30.

50. Giess, pp. 14-15, 32-33, 61-64, and also pp. 45-46, 101 (Katalog, no. 25) and fig. 14. See also Schiller, ii, fig. 120, 122-24; also Cames, figs. 15, 56. The only earlier example in the West is an ivory (Goldschmidt, i, no. 147b); but it is not clear that there are good grounds for dating this isolated example (as it would be) to the early C10.

51. Vöge, esp. pp. 259-70, but his discussion of the repertoire of speech and other gestures (pp. 295, 298, 304), dress (p. 315), and ornament of the canon tables (p. 359), in Liuthar Group manuscripts, also shows quite clearly that he thought the origins of this art to be late antique western.

52. Weitzmann, 1971.

53. Cameron, 1987, esp. pp. 120-22, 132, 135-36.

54. Weis, 1974.

55. Magnani, 1934, pp. 41, 46. I would think that the Annunciation to the Shepherds (f. 20), the Martyrdom of St Stephen (f. 21), Pentecost (f. 82), the Naming of John the Baptist (f. 88), the Martyrdoms of Saints Peter and Paul and St Lawrence (ff. 90v, 98) in this Sacramentary might all show northern influence.

56. Belting, 1967.

57. Boeckler, 1949, pp. 8-16.

58. Sauerland & Haseloff, pp. 50-52.

59. Belting, 1967, pp. 125ff; Stuttgart Psalter, esp. pp. 180-99.

60. Grimme, p. 80.

61. Examples are Stuttgart Psalter, ff. 32v, 42v, 43v, 46v, 49v, 65v, 66v, 94v, 141v, 158v.

62. Stuttgart Psalter, f. 83, and see ibid., Textband, pp. 167-69.

63. Cames, pp. 230-38 on gold grounds; but while recognizing the existence of the Egino Codex, he is dismissive of its importance in this context, p. 232; he does not mention the Lorsch Gospels in it.

64. Belting, pp. 125ff.

65. Berlin (East), Staatsbibliothek, MS Phillips 1676, see Valentin Rose, i, no.50, pp. 77-95, esp. pp. 77-81, 85; also Bischoff, 1984, p. 174.

66. Fleckenstein, pp. 67, 69, 71.

67. Gibson, 1969.

68. Bischoff, 1984. His view is that more C9 than C10 Italian books came north, ibid. p. 193, but his paper shows that there must still have been many such which came north in C10.

69. Trans. S. Epiphanii, ch. 1,2, p. 249.

70. See Dodwell & Turner, p. 92, note 124.

71. Gesta Treverorum, p. 170, cf. Codex Egberti, pp. 27-28 and pp. 178-79, note 69. This makes it likely that Egbert was with the Ottos at Reichenau on their return to the north in August 972 (DOII,25).

72. Fleckenstein, p. 69.

73. DOII,298.

74. See note 71 above.

75. Florentine Mütherich is excellent on this aspect in Grodecki et al., 1973, pp. 126-33, where she points out that the Gregory Master must have known both antique and Carolingian manuscripts.

76. Weis, 1974, esp. pp. 326-48.

77. Weis, 1974, p. 328.

78. F. Wormald, 1954.

79. Ibid., pp. 3-5.

80. Grabar, 1948; the 43 surviving leaves are all from St Matthew. Also Weitzmann and Kessler, see pls. II-VIII.

81. Haseloff, 1898; note the brilliant reconstruction of the orginal quire with these illustrations at pp. 5-9.

82. Rabbula Gospels, plates of ff. 3b to 9a. It also has full-page illustrations of the Crucifixion and Women at the Tomb and the Pleading of Lazarus's sisters with Christ (13a), the Ascension (13b), Seated Christ with Four Saints (14a), and Pentecost (14b).

83. Useful on the history of pericopes books is Weis, 1974, at pp. 326-27, with further references.

84. MGH, Legum Sectio II, Capitularia i, no. 29, trans. King, pp. 232-33. For the Ada Group and the Court School of Charlemagne more generally, see Mütherich, 1965; Dodwell, 1971, pp. 25-30; Hubert et al., pp. 75-91.

85. See Weitzmann, 1971. Whatever relative emphasis one would give to western antique and Byzantine influence on Ottonian art, there can be no doubt that these lectionaries had an effect in the C10 West, see esp. Boeckler, 1961, and Buchtal, 1966.

86. Because the Pentecost illustration of the Codex Egberti and the Release of Peter from Prison in the Reichenau Pericopes Books at Wolfenbüttel and Augsburg could only come from Epistolars, in the opinion of Weis, 1974, pp. 333, 336, he would have it that the full model must have been a pericopes book and epistolary combined. But it seems most unlikely that the Peter scene comes from a late antique book at all. Representations of this scene are not at all easy to find before C10/C11, but the Fermo sarcophagus and later Byzantine depictions would suggest that the norm was Peter with the angel inside and outside the prison, rather than his sitting hieratically above it as at Reichenau; see Wilpert, i (text), p. 118, and pl. cxvi, 3, and for a later Byzantine example, a C14 fresco at Staro Nagoricino in Yugoslavia (Bongers, Reckling-

hausen, card, no. 717). The Reichenau scene has all the appearance of an Ottonian invention in an art which delighted to multiply hieratic postures and which magnified the image of St Peter. Weis's suggestion, p. 336, note 1, that the apse picture of S. Pietro in Vincoli could have been the source, is a long shot. Not the model, but the then acceptable practice of illustrating some feasts in a pericopes book with a scene associated with the feast generally rather than with the gospel passage in particular (e.g. also the feast of the Assumption of the BVM) is what is at issue here.

87. As emphasized by Bullough, 1965, p. 137; Mütherich, 1963, p. 29; F. Wormald, 1984, p. 172, note 40. Carolingian ivories and late Carolingian metal-work are a different matter from manuscripts; I hope to discuss this in a forthcoming number of *Studies in Church History.*

88. Drogo Sacramentary, facsimile edition.

89. Libri Carolini, i, ch. 19, p. 44, makes this clear where it says, for instance: *Quantum eminet umbrae corpus, imagini veritas, figurae res gesta, tantum eminet veteri testamento novum.* See Meyvaert, 1979, pp. 53-54.

90. See the general survey of Laistner, 1957, pp. 289-91.

91. See, for instance, the fine discussion in Bullough, 1983, pp. 39-59. At p. 59 he quotes Alcuin's commentary on St John on how the evangelist 'without doubt was particularly concerned to make manifest the divinity of Our Lord Jesus Christ, being equal to the Father'. See also Wallace-Hadrill, 1983, pp. 209-11.

92. E.g. *Capitula de Causis Diversis,* ?807: instructions to *missi* to enquire amongst other things into the state of pictures in churches, Capitularia, i, p. 136, lines 11-13.

93. This is my conclusion from Birchler, 1954, particularly in his analogies to C8 frescos at S. Salvatore, Brescia (cf. Weis, 1977) and mosaics in the chapel of Pope John VII (705-07); also from the Italian character of many of the names in Müstair's earliest monk-list, a feature understandable in the light of geography, see Sidler, 1906, p. 335.

94. Walafrid Strabo, De Exordiis, ch. 8 (*de imaginibus et picturis*), the classic statement of the balanced Carolingian view, esp. pp. 483-84.

95. Epp. Gregorii I, ix, no. 208, p. 195.

96. Jonas of Orleans, PL 106, col. 310D.

97. Hom. in Evang., PL76, col. 1110C.

98. Ermold, lines 2062-2163, pp. 156-64, most conveniently translated in Davis-Weyer, pp. 84-88. The Christ cycle fits into a scheme of Old Testament, New Testament, and Orosian history.

99. Fundamental for mapping this reform in time and place is Hallinger, i, pp. 43-416.

100. John Nightingale, *Monasteries and their Patrons in the Dioceses of Trier, Metz and Toul, 850-1000* (Oxford D.Phil. thesis, 1988; to be published in the Oxford Historical Monographs series).

101. St Maximin, Trier, reformed in the 930s but further by Archbishop Egbert (977-93) using Gorze (Hallinger, i, pp. 59-60, and Boshof, 1972, p. 152, cf. pp. 25-26). Also Reichenau, where the Gorze Reform would appear to have affected the abbey under Abbot Ruodmann (972-85) (Hallinger, i,108, and Beyerle, pp. 112/16-18), although the evidence is not clear and Alawich I (934-58) already shows some of the Gorze traits of religious devotion and learning. For more on Reichenau, see below.

102. Hallinger, i, 187-91, 99-106, 122-24, 114-15, 142-43.

103. As Bullough, 1975, has put it: 'What was recognizably an abuse of a "family monastery" in the ninth and early tenth centuries was ... when the monastery and its estates were treated in such a way that the intercessory activity which they were supposed to maintain effectively ceased', pp. 28-29.

104. Hallinger, i, 92, 108, 611-15.

105. *Chronicon Suevicum Universale* for 1006, cited by Hallinger, i, 613, note 14.

106. Hallinger, ii, 765-69, 773-74. Cf. Leyser, 1982, pp. 69-101, on the relative lack of bureaucracy and constitutionalism in general in this patrimonially governed society.

107. Mütherich, 1963, p. 36.

108. Reichenau Confraternity Book, Facsimile, pp. 8, 54, 66.

109. Hallinger, i, 187-99. Cf. Wehlt.

110. See the nice passage of Dodwell in Dodwell & Turner, p. 2, and Purchard, lines 272-491.

111. Purchard, p. 270, lines 240-43.

112. Ibid., p. 266, lines 73-74, 84-86. It is not clear why Witigowo was deprived of his abbacy in 997, see Hermann, p. 118.

113. Vita Johannis Gorz., ch. 26, p. 344; ch. 44, p. 349; ch. 66, p. 355. For this Life, see Manitius, ii,pp. 189-95. It is not that Carolingian *vitae* fail to mention the name of Christ, but these mentions are usually rather few and formal. The most Christ-centred *vita* of the Carolingian period known to me is Eigil's Life of St Sturm, written in the time of Louis the Pious whose own image shows a development towards Christ orientation, not followed up until Ottonian times. Thegan's Life of Louis the Pious himself, however, shows scarcely any of this tendency.

114. Despite earlier uncertainties about the period of this work (Manitius, ii, 196), its C10 date as a Gorze text has been accepted since Levison, 1929-30. See H. Hoffmann, 1957, p. 38, who shows that the Vita Chrodegangi and Ruotger, another work written within the reform circle, have important ideas and language in common, such as the distinction between the *officium pastoris* and the *mercennarii vitium* (Ruotger, ch. 37 and Vita Chrodegangi, ch. 10, p. 559) and the emphasis on the hero's knowledge of the *artes liberales* (Ruotger, ch. 44 and Vita Chrodegangi, p. 557).

115. Vita Chrodegangi, ch. 3, p. 554; ch. 22, p. 564, lines 27-29; ch. 24, p. 566, lines 12-13; ch. 26, p. 568, lines 11-16; ch. 16, p. 561, lines 13, 26-34; ch. 27, p. 569, lines 27-29; ch. 21, p. 564, lines 8-11.

116. Vita S. Clementis, pp. 109-45. One may note the Christocentric piety also of Purchard, e.g. the prayer at lines 399-400, p. 275, and see also lines 223, 275, 329-30, 476-79, 538-39.

117. Wallace-Hadrill, 1983, pp. 384-85. Munich Cgm. 25 is the earliest (C9) manuscript of Heliand; Bischoff has shown that it is from Corvey, Bischoff, 1981, iii, pp. 112-19.

118. Tatian; for the manuscripts, beginning with the C9 St Gall manuscript, pp. 1-6.

119. Wallace-Hadrill, 1983, pp. 385-87. See also a beautiful passage by Haimo of Auxerre on the Song of Songs (*c.* 850): *Inter ubera mea commorabitur*, i.e. 'his memory shall be in my heart for ever and never shall I forget the greatness of his benefits; but whether in prosperity or adversity I shall be mindful of him who has loved me so much and died for me.' Quoted by Ohly, p. 75, note 1.

120. Utrecht Psalter f. 70 (before Psalm 115) and Drogo Sacramentary, f. 43v. See Schiller, ii, 105-07, figs. 357, 364. For the eucharistic controversy, see Bouhot, ch. 6.

121. For references to Alcuin's prayers and discussion of them, see Bullough, 1983, pp. 4-5, note 10, and 12-16. I am also thinking of the balance of prayers in the Carolingian collections edited in Wilmart, 1940, and of the prayer book of Charles the Bald in the Residenzmuseum at Munich, the text of which is so far as I know not yet published. The obvious exception from the Carolingian period is the English Book of Nunnaminster (BL, Harley MS 2965).

122. Einhard, MGH Epist. V, pp. 146-49.

123. It would be possible to give many examples, but I was thinking, for instance, of the letter to Einhard on the death of his wife when Lupus alludes to God's not sparing Absalom at the prayers of David, Lupus of Ferrières, pp. 26-28.

124. Godman, 1985, pp. 94-95, stanza 22, and pp. 27-28.

125. Daniel, pp. 79-87.

126. Thietmar, ii, ch. 41, p. 90.

127. R. Holtzmann, 1955, p. 255.

128. An excellent study of such episcopal handbooks has been made by McKitterick, 1977, esp. at pp. 35-44. Munich, Clm. 6426, Bishop Abraham's book, contains various patristic sermons, an exhortation to priests and deacons to preach to the people under them (f. 47recto and verso), an order for visiting and anointing the sick (f. 73) including the making of a confession (f. 76), the Slav Texts (ff. 78-79, 158v-161v), forms of excommunication, admonitions against various sins, an exchange of lands between Bishop Abraham and Adalbero (f. 146), a constitution of Duke Henry of Bavaria on absconding serfs (ff. 147v-148), fragments of Pope Gregory the Great's writings (ff. 155v-157v).

129. Bischoff, 1984; Leyser, 1985.

130. Bischoff, 1984, p. 28, lines 140-57; p. 33, lines 336-39; Leyser, 1985, pp. 49, 53.

131. Dümmler, 1902.

132. Rathier, Opera Minora, p. 39.

133. Ibid., pp. 79-87, esp. 79-80.

134. A. Hauck, iii, 294.

135. Candidus of Fulda, PL 106, cols. 103-08.

136. RDK, i, cols. 1152-53; Schiller, ii, 106, 134b, figs. 365, 383.

137. The *collobium*, or *colobion*, was a tunic of purple silk with gold embroidery and enriched with precious stones, worn by the Byzantine emperor, see Const. De Ceremoniis, i, 72.

138. Rabbula Gospels, f. 13a.

139. Schiller, ii,107, and figs. 356, 363, 370, 380, 381, 387, 389. Again in the Carolingian period this seems related to interest in eucharistic doctrine. Fig. 370 is the Vienna manuscript of the Gospel Harmony of Otfried of Weissenburg.

140. Hoffmann, p. 334, where the issue of the artist is detached from that of the scribes. See also Daniel, pp. 93-98.

141. E.g. Frederick of Mainz was sent to Hamburg, and Rothard of Strasbourg to Corvey after the rebellion of 939. The archbishops of Mainz normally consecrated the archbishops of Hamburg-Bremen (Adam of Bremen, ii, 1), and the relative friendliness of both 'gaolers' is implicit in Otto I's speedy pardon of both prisoners (Widukind, ii, ch. 25, p. 88). In C9 Archbishop Ebbo of Rheims was exiled in 834 to Fulda where the Abbot, Hrabanus Maurus, together with Drogo of Metz, tried to help him recover his See.

142. Hallinger, i, 133-34.

143. Leyser, 1985, p. 46; Vlasto, pp. 72-73.

144. DOI,279.

145. Vlasto, pp. 72-73, p. 341, notes 227-29.

146. Ibid., p. 341, note 229.

147. Thietmar, ii, ch. 35, p. 82.

148. HE, i, ch. 25: *imaginem domini salvatoris in tabula depictam.*

149. Thangmar, ch. 1, p. 758. For Thangmar, see note 170 below.

150. Tschan, ii, 176, 129, 127, 98, 29-30, 31-32, 46, 54, and i, 210.

151. Algermissen, 1960, p. 152, and pl. at p. 295.

152. See Panofsky, pp. 18-26. Egbert of Trier is dealt with in detail in Part II, ch. 2.

153. Janicke, no. 38. Testament quoted in Algermissen, 1960, p. 58.

154. *Hoc evangelicum devota mente libellum Virginitatis amor prestat tibi sancta Maria Praesul Bernwardus vix solo nomine dignus Ornatus tanti vestitu pontificali.*

155. H. Engfer, 'Die Bernwardinischen Kreuze', in Algermissen, 1960, pp. 83-84. Michael Brandt has recently shown, in his catalogue of the Hildesheim exhibition of church treasures, that the triumphal cross supposedly of Bishop Bernward is in fact C12, but that it re-used pieces of a smaller and genuinely Bernwardine reliquary of the Cross which was jewelled.

156. Von den Steinen, 1956, p. 333.

157. See von den Steinen, 1965, pp. 39-54.

158. Algermissen, p. 19, and Engfer, ibid., pp. 81-82.

159. Tschan, ii, 29-35; Härtel & Stähli, pp. 51-69, 75-98; Hoffmann, pp. 285-89.

160. Von den Steinen, 1965, pp. 151-52, and pl. 162 in colour.

161. Algermissen, 1960, pp. 169-83, esp. pp. 171, 175, 177.

162. Thangmar, ch. 55, pp. 781-82; see von den Steinen, 1956, pp. 331-32; Tschan, i, 205-11, and iii, pls. 260-67.

163. Hallinger, i, 122.

164. Algermissen, pp. 101-02, cf. ibid., pp. 67-68.

165. P. Wormald, 1988, p. 38.

166. Fleckenstein, p. 58. For the chapters see Klewitz.

167. Vita Burchardi, ch. 17, p. 840; see also Fournier & Le Bras, p. 394.

168. Haller, 1970, p. 10. Götting, pp. 173, 174-77.

169. Thangmar, ch. 24, p. 770, cf. Tschan, i, 109-10; and DOIII, 390.

170. Tschan, i, 157-99. It has been argued that Thangmar wrote primarily to provide a memorial for the Gandersheim dispute from the Hildesheim point of view. Of 57 chapters, 32 are devoted to this case, see Drögereit, 1959. Drögereit's argument, however, that the first eleven chapters are an addition to Thangmar possibly as late as C12 (ibid. pp. 12-16, 37-39) is unconvincing. For example, he says the emphasis on agreement in Bernward's election (cap. 4) smacks of the post-Investiture Contest period; whereas Ruotger, chs. 11, 46, pp. 11, 50, shows this same feature. The chronology in cap.2 does not necessarily have to be read in the sense that Bernward took time to look after his old grandfather *after* being ordained a priest. To take another of Drögereit's criticisms, the reason why his political activities in the 980s were ignored compared with this act of mercy was because the latter was more appropriate to a hagiography rather than because of the author's ignorance of the former. Virtually all Drögereit's other points are semantic. I take the near-contemporary date of the chapters, therefore to be assured. This does not necessarily mean that they were composed by Thangmar, for they appear to represent a separate block of material. See also Götting, pp. 193-97, who does not accept the 'hypercritical thesis' of Drögereit (ibid. p. 167).

171. Beissel, 1891, p. 10.

172. Schiller, ii, 45.

173. Beissel, 1891, pp. 23-24.

174. Schiller, ii, 45, and figs. 82, 83. Schiller comments on the iconography of Judas here but makes only passing reference to the reclining John. For the early C11 Byzantine representations, see Wessel, 1964, pp. 62-63, and more clearly in later examples, pp. 64, 67.

175. Wessel, 1964, pp. 22-23.

176. Grabar, 1972, Manuscript catalogue, no. 37 and fig. 283. MS Vat. Gr. 1554, f. 178v.

177. Rome, Bibl. Angelica, MS 123. See Garrison, iv (1960-62), pp. 93-107, esp. p. 103, fig. 75. The type, in Garrison's view which I do not share, 'is probably western in origin and can have been transmitted through a nexus of western models' (p.107).

178. Pauler, pp. 83-84.

179. E.g. Bamberg MS Lit. 50, f. 28.

180. Schiller, i, figs. 423, 434.

181. E.g. front man of the group in the Stuttgart Psalter, f. 90, and hand of the figure on the left at f. 4v.

182. Cf. Sauerland & Haseloff, pp. 48-49.

183. Messerer, 1959, p. 43.

184. E.g. Laws of King Ine of Wessex, ch. 38 (English Hist. Docs., ed. Dorothy Whitelock, 1955, p. 368); *De Duodecim Abusivis Saeculi* (Irish, 630-50) (Laistner, 1965, p. 144); *Vita Walae* (C9) (Fichtenau, 1957, pp. 116-17).

185. Leyser, 1979, p. 36.

186. Though naturally going back in general to antique models. See comparison of Codex Egberti, Aachen Gospels, and Clm. 4453, by Boeckler, 1961, p. 19.

187. For the Crowning with Thorns as a rarity until C11, see Bornscheuer, pp. 226-27, and Goldschmidt, i, no. 133. For the Aachen altar and the Salzburg manuscript, see Schnitzler, 1957, pp. 85-88, and 1965, pp. 10-11, and figs. 10-11. For the Codex Aureus, see Kahsnitz et al., 1982, pl. 35. One should note, however, that this theme is the subject of one of the prayers in the English Book of Nunnaminster (BL,Harley MS 2965), pp. 70-71.

188. Messerer, 1959, p. 43.

189. Jantzen, p. 68. He is followed in this by Weis, 1974, pp. 318-19, who points out that in the Codex Egberti, the earthly yellow zone is sometimes scarcely distinguishable from the middle zone in the strips of background colour, thereby already adumbrating Ottonian *Unraum*.

190. Jantzen, pp. 68-69.

191. Grimme, pp. 40, 93.

192. Cames, pp. 230-38.

193. Browning, 1966, p. 19,y.

194. Jantzen, pp. 73-74, refers to the 'supra-spatial' and 'supra-temporal'. For good observations on this subject see also Grimme, p. 94.

Notes to Chapter 3

1. MacCormack, part 1, pp. 17-89. For a C5/C6 ivory of an emperor arriving in procession at a city, see for instance, Haussig, pl. 36.

2. Thietmar, iv, ch. 53, pp. 192-93. See Bornscheuer, pp. 208-11.

3. Thietmar, iv, ch. 50-54, pp. 188-95, and Mikoletzky, pp. 12-14.

4. Bornscheuer, pp. 100-01; Kantorowicz, 1944, p. 207, also has something on the Roman ritual.

5. Thietmar, ii, ch. 28, p. 75. Althoff, pp. 151-52, argues that Hermann's action was more a warn-

ing to Otto I about his long absence in Italy than an act of rebellion, but Thietmar still says that Otto was angered by it and calls it pride. Thietmar says of Hermann that 'he sat amidst bishops in the emperor's place at table and slept in his bed'.

6. Leyser, 1979, p. 90.

7. Bishop, 1962, pp. 321-22.

8. See esp. Gräf, pp. 33-38; for the Essen exorcism, ibid., p. 37. The Beneventan mass formulae and blessings for Palm Sunday became more generally known in the West in C10/C11, ibid., pp. 55-56. For the dominating Roman-German Pontifical in C10, ibid., pp. 86-98.

9. DHI, 1: *quando primitus causa illo orationis venimus*. See Wehlt, p. 238.

10. Cameron, 1987, p. 116.

11. Leroquais, 1937, ii, pp. 376-85 (no.219), i.e. a late-C10 Worms pontifical, Troyes, Bibl. Mun. MS 2141. The *ordo* for Palm Sunday is at ff. 66-69v. See ibid., pp. 384-85 for interesting topographical details of Mainz and Worms.

12. Troyes, Bibl Mun. MS 2141, f. 69 (as in note above). See Gräf, p. 99.

13. Kemp, pp. 57-58, 62, 146.

14. Gerhard, ch. 1, p. 386, lines 20-35.

15. Ibid., ch. 4, p. 391, line 25 to p. 392, line 2: *cum effigie sedentis Domini super asinum* (p.391, l. 28).

16. Jonas of Orleans, *De Cultu Imaginum* incorporates passages of Claudius of Turin, *Apologeticum atque Rescriptum adversus Theutmirum Abbatem* for purposes of rebuttal. Claudius launches into 'those sluttish abominations, images' at PL 106, col. 315A: *Inveni omnes basilicas (i.e. in Turin) contra ordinem veritatis sordibus anathematum et imaginibus plenas.*

17. A gospel for a mass *in adventu episcopi* immediately precedes that for the dedication of a church, which has the subject of Jesus's entry into Jericho and the Zachaeus story (illustrated), in the Reichenau Pericopes Book at Munich, Clm. 23338, ff. 183v-184. There seems to be a connection of ideas here.

18. Ordo L, a basis of the Roman-German Pontifical, ch. 40, Andrieu, v, p. 178.

19. Sauerland & Haseloff, p. 102.

20. Demus, pp. 93-94.

21. For the motif of men up trees in Ottonian art, see pp. 20-21.

22. For references and discussion of later examples, see Korteweg, pp. 196-99. In Brescia, Cod. Membr. 2, f. 29v, only one man is up a tree, but the whole 'reception committee' numbers seven and the architecture is elaborate. For the likely

deviation of Clm. 4453, see also the Antwerp Sedulius, which is of the normal late antique type and shows what the Ottonian norm might be expected to be (Alexander, 1978, fig. 297), considering the relation of other of its illustrations to Ottonian miniatures (cf. pp. 72-73).

23. Maximus's sermon, PL 57, cols. 327-32: Bede's PL 94, col. 123 (for the relevant passage). For the Homeliary of Paul the Deacon, see Grégoire, 1966, p. 91. The C9 Reichenau MS is Karlsruhe, Aug. XIV, see Holder, pp. 30-31.

24. Clm 4453, p. 108.

25. Vienna, Cod. 573, with Berno's letter to Bishop Friedebold of Augsburg. Merton, p. 84, and pl. XCII, 1, thought that this MS was an Augsburg copy of Berno's exemplar, but Hoffmann, pp. 346-47, leaves no doubt that it is a Reichenau manuscript.

26. These particular words clearly owe something to the collect for Easter Sunday morning (as found, for instance, in the Hildesheim Collectar, MS 688, at f. 57v, and indeed in the Roman sacramentaries), where the phrase *devicta morte* and the word *aspiras* appear: *Deus qui hodierna die per unigenitum tuum aeternitatis nobis aditum devicta morte reserasti, vota nostra quae praeveniendo aspiras etiam adjuvando prosequere.* Thus this Crucifixion looks for its meaning to the Easter liturgy.

27. See Swarzenski, 1901, pp. 93-99; and Mütherich & Dachs, pp. 27-28, 33-34. The unusual feature of this book is that while it has only the gospel texts used for liturgical readings, they follow the order of the texts in the gospels and not as used during the year, a sort of cross between a Gospel Book and a Pericopes Book.

28. Boeckler, 1954; Bischoff, 1967,ii, pp. 103-04. For the episcopal rationale, see Part II, ch. 2.

29. Bornscheuer, pp. 230-32, with Use of Deer, pp. 69ff.

30. Bischoff, 1967, pp. 77-89.

31. Hallinger, i, pp. 114-15; Bauerreis, 1950, ii, pp. 15-30. Considering the musical diagram here, it is noteworthy, as Swarzsenski, 1901, p. 97, pointed out, that one of the most distinguished musical theorists of the Middle Ages, namely William of Hirsau, was educated at St Emmeram.

32. Mütherich & Dachs, pp. 26-27.

33. Schramm & Mütherich, pp. 212-13, 370 (nos.20, 21).

34. Another Reichenau Crucifixion easily to hand in illustration is that of the Bodleian Sacramentary, Canon.Liturg. 319, see Pächt, 1986, colour pl. XVII. Christ does not here wear the *collobium*

and there are no symbols of divinity; but he is fully clothed, has his eyes open, and is straight in posture.

35. Bloch & Schnitzler, ii, pp. 119.

36. Wessel, 1966, esp. p. 27; for a similar, Wessel, 1969, no. 10, pp. 53-54 and facing plate (probably C9). See also the review by E. Lucchesi-Palli of L. H. Grondijs', *L'Iconographie Byzantine du Crucifié Mort sur la Croix*, in *Zeitschrift für Katholische Theologie* 70 (1948), pp. 369-75.

37. Achten, no. 2, and pl. 1, p. 48.

38. Bloch & Schnitzler, ii, p. 119.

39. Thietmar, iii, ch. 2, pp. 98-101.

40. Vita Johannis Gorz., ch. 29, 66, 69, pp. 345, 355, 356. For Frederick in 953, see Widukind, iii, ch. 27, p. 117. On the tension between secular affairs and the pastoral office, see Udalric of Augsburg's nephew Adalbero, who took over some of the former (including the organization of the bishop's militia), to leave his uncle freer to attend to his pastoral duties and prayers, Gerhard, ch. 3, p. 389, lines 30-35. A C10 Metz manuscript of St Augustine on John, has at f. 3 a draft episcopal letter in a C11 hand, excusing the bishop from attendance at an Easter court at Ravenna and from leaving his diocese, Valentine Rose, 1893, cat. no. 26, p. 31; cf. the Gorze Life of St Chrodegang on the bishop's always returning to his diocese for Easter. A major reason for Ruotger's writing the Life of Bruno of Cologne was to parry the criticisms that one should not combine religious and secular affairs in the way that Bruno did.

41. Brown, 1971, pp. 185-87.

42. Vita Heriberti, ch. 12, pp. 751-2.

43. Bornscheuer, esp. pp. 68-71, 73-74, 78-80, 82-86. But Deshman, 1980, shows this intertwining already under Charles the Bald, where (as I am increasingly conscious) lie significant roots of Ottonian art and ritualism.

44. Stancliffe, 1983.

45. Bornscheuer, pp. 232-39. For this phrase, p. 238. See also Haussherr, pp. 54-55.

46. Bornscheuer, quoting at p. 238, Imdahl, p. 18. See also good remarks in Henderson, p. 238.

47. Translatio Sanguinis Domini, pp. 447-49, in Karlsruhe, Aug. MS LXXXIV, ff. 125-36; Manser & Beyerle; for the manuscript, see Klüppel & Berschin, pp. 115-17, and notes 9, 13.

48. Manser & Beyerle, pp. 373-74.

49. DOI, 116.

50. Beyerle, p. 112/14. For a very good discussion of 'the problem of the duchies', and in particular of Otto I and Swabia, see Gillingham, 1971,

pp. 16-17. The forthcoming work of Nightingale on Gorze will show the large degree to which the life, interests and possessions of a regional aristocracy might focus on monasteries.

51. E.g. Helmstedt MS 427 (Wolfenbüttel), f. 191, or Berlin, Theol. qu. 198 (C10 Herford, the list could be written a little later), p. 234, the latter including relics from the Lord's cradle, sponge, tomb and cross.

52. See Barré, pp. 67-70, and for an example of a C10 Homeliary, BN, MS lat. 5301, beginning at f. 118.

53. Barré, pp. 72-73, 103-13, who seeks consolation in the Pseudo-Jerome's not rejecting bodily assumption out of hand (text PL 30, cols.122-42). For attribution to Pascasius Radbertus, Lambot, 1934. Adomnan and Bede both show caution over the bodily assumption in describing (C7/C8) the holy places, see Sinding, 1903, pp. 22-23. For Pseudo-Jerome, and for the scepticism of Isidore and Bede, see also Jugie, pp. 270-71, 276-85.

54. See note 70 below.

55. Pseudo-Aug., PL 39, col. 2130: Pseudo-Jerome, PL 30, cols. 126B-C, 128C-D, 129C-D; Hrabanus, PL 110, cols. 55ff; Pseudo-Ildephonsus, PL 96, col. 263B. In the Pseudo-Jerome, *Cogitis me*, the issue of Christ's being of Mary's flesh is raised to block the argument of Mary's corporeal assumption, PL 30, cols.133-34.

56. Printed in Strecker & Silagi, pp. 466-68, from Bamberg MS Lit. 54, ff. 152v-154; see F. Schneider, 1926, pp. 151-52, and Schramm, 1929, i, p. 150.

57. Strecker & Silagi, pp. 468-69, from Bamberg MS Patr. 88, f. 16v. It is clear that *Heinrici* is written over an erasure which is probably *Ottonis*, though this cannot be seen now with the naked eye. Cf. the Bamberg Josephus, MS Class. 79, Schramm & Mütherich, no. 109, p. 205.

58. See, Dalton, pp. 224, 226. Remarkably, the hand of God crowns the soul of Mary in the Dormition scene of the late C10 Prüm Antiphonary (Paris, BN, MS lat. 9448, f. 60v). This is an isolated example and totally different in format from the iconography of Mary's coronation which developed in C12.

59. Llewellyn, 1986, p. 47. One may also note that the same pope, John VII, provides us with the earliest known example in the West of the Byzantine practice of writing solemn documents in letters of gold, Brühl, 1977, pp. 9-10. For 626, see Wenger, p. 122. Already the Emperor Justin II (565-78) had dreamed that he was crowned by the *theotokos*, see MacCormack, p. 256. For

Mary as queen of heaven, in the East, and in the poem *In Laudem Mariae* by Venantius Fortunatus, with his Constantinople connections in C6, see Cameron, 1978, pp. 90-93.

60. *Hrothsvithae Opera*: Mary is *unica spes mundi dominatrix inclita caeli* (Maria, p. 5, line 13); Oda is *Oda nimis felix, nostri spes et dominatrix* (*Primordia Coenobii Gandeshemensis*, p. 245, line 574).

61. The two emperors were at St Gall on 14 August, at Reichenau on 17 August, and at St Gall again on 18 August: DOII, 24, 25, 26. It would be quite feasible for them to have covered on horseback the thirty miles or so between St Gall and Reichenau in a day, and scarcely conceivable that they made the journey there and back for any other reason than to celebrate the Assumption, the patronal feast, at Reichenau.

62. H. M. Schaller, 1974, pp. 15-16.

63. Leyser, 1979, p. 20.

64. Wenger, pp. 17-95 (analysis), pp. 245-56 (text). For the passage cited, ch. 25, 26, pp. 253-54.

65. Wenger, ch. 50, p. 256, cf. p. 91.

66. Wenger, p. 92.

67. Gregory of Tours in C6 refers to a form of *transitus* legend in his *De Gloria Martyrum*, Ch. 4, MGH, Script. Merov. 1, 2, p. 489. The Pseudo-Jerome *Cogitis me*, in C9 implies that such a legend was widely known.

68. Sinding, p. 31.

69. MS Aug. LXXX, Wenger, p. 140. For analysis of the works of Cosmas, the anonymous Reichenau homilist, and John the Geometrician, Wenger, pp. 140-201; texts, pp. 313-33 (Cosmas), 363-415 (John).

70. Wenger, pp. 163, 319, ch. 4. For Pseudo-Augustine and its date, see Barré, pp. 80-100. An excellent brief survey of the history of the doctrine of the bodily assumption in the twelfth century is in T. S. R. Boase, *The York Psalter* (London, 1962), pp. 8-12.

71. Wenger, p. 172.

72. Wenger, analysis pp. 173-76, text, pp. 341-62. For the passage cited, p. 347, ch. 14.

73. Berschin, 1980, p. 183, with the advice of Bernhard Bischoff.

74. Klüppel & Berschin, p. 116. A C9 Reichenau treasure-list mentions embroidered Greek textiles, Bischoff, 1967A, no. 80, p. 86, lines 17-19.

75. Beyerle, p. 112/11.

76. Blume, 1925. An antiphon rather like the later *Salve Regina*, combining the ideas of Mary as ruler and Mary in her mission to human beings

was already in existence at Reichenau in C11, ibid., pp. 822-23.

77. Schiller, iv, 2, pp. 94-95; in general on the Dormition and Assumption, ibid., pp. 83-114.

78. Kahsnitz, 1987, p. 99. As Kahsnitz points out at p. 118, note 41, there is no published study of this Prüm manuscript, and I have not yet been able to see the thesis of Dr Janet Teresa Marquardt (see Marquardt in bibliography).

79. E.g. the Baptism scene at f. 73, which looks beholden to a model of St Boniface baptizing, and also seems to show Fulda influence in its architecture and its use of light green for clothes; or the large white daub used for the over-garment of Mary in Majesty, illustrating the Ave Maria at f. 62v. One may note that Prüm alone followed Fulda in C11 (to our knowledge) in keeping the unusual form of (doubtless liturgical) record known as *Totenannalen*; see Part II, ch. 4, K. Schmid et al., i, pp. 364-84.

80. Kahsnitz, 1987, p. 103.

81. Ibid., p. 108.

82. See Part II, ch. 4, including note 17.

83. Kahsnitz, 1987, p. 92.

84. Schiller, iv, 2, fig. 595, and pp. 89-90, 98-99.

85. Cited by Sinding, pp. 33-34; Kahsnitz, 1987, p. 97.

86. Klein, 1986, p. 418.

87. See Excursus I.

88. Klein, 1986, p. 420 *and see* Part II, ch.1.

89. Kahsnitz, 1987, pp. 100-01.

90. Bamberg MS Lit. 5, f. 95v. A change has undoubtedly been made, to substitute (Babenberg)enses for presumably (Augi)enses, though none of the letters *Augi* are now visible to the naked eye. See Klein, 1986, p. 418. For a detailed discussion on Bamberg see Part II, ch. 1.

91. The Easter *laudes* are at f. 46recto-verso, the Adalbert sequence at ff. 96v-98; the text of the latter is printed in Maurer, 1974, p. 275, and see ibid., pp. 267-68.

92. See Andrieu, v, 69; and Strecker & Silagi, p. 466.

93. Klein, 1986, p. 418.

94. Schramm & Mütherich, no. 127, and p. 99.

95. Einhard, *Vita Karoli*, ch. 26: *Legendi atque psallendi disciplinam diligentissime emendavit; erat enim utriusque admodum eruditus* (Halphen, 1947, p. 78).

96. See Havet, nos. 91, 92, trans. Lattin, pp. 137, 140-41 (on organs and organ-playing) and Lattin, pp. 41-44 (on musical theory); see also Mütherich, 1986, p. 20.

97. Maurer, 1974.

98. In the Bamberg Troper (MS Lit. 5), there is a trope for St Maurice at f. 54v and two sequences for this saint at ff. 131recto-verso.

99. Maurer, 1974, pp. 269-70. For Otto III and the relics and church of St Bartholomew in Rome, see Mâle, 1960, pp. 101-07, and for an early C12 well-head depicting the saint and Otto III, ibid., pp. 105-06, and plates.

Notes to Chapter 4

1. This is an underlying argument of Fleckenstein in his chapter on the court chapel of Otto III, esp. at pp. 86-87, 109-10.

2. Vita S. Adalberti, ch. 21, p. 590, lines 41-43: *Decursis quippe puerilibus annis cum iam velut prima lanagine barbae floreret, tempus et virtus maior annis imperatoriam sibi exposcerant dignitatem.*

3. Vita Romualdi, pp. 47-48. For later dealings of Otto III with St Romuald in connection with the use of the monastic settlement of Pereum to provide missionaries for the Slavs, ibid., p. 61.

4. The phrases *Saxonica rusticitas* (which does not mean toughness but unlettered; I have read an implication here) and *Grecisca subtilitas* figure in a letter of Otto III himself to Gerbert of Aurillac, inviting the latter to be his tutor (Havet, no. 186).

5. Schramm & Mütherich, no. 110, pp. 84, 205-07.

6. Hoffmann, p. 307, and see ch. 2 n.4.

7. Clm 4453, pp. 23-24.

8. Ibid., pp. 67-71, esp. p. 68.

9. Vergilius Vaticanus, pp. 88-89. The illustration is to Aeneid vii, 192-200, at f. 60v.

10. I owe this point to a paper by Professor Florentine Mütherich on ruler representations in the early Middle Ages, read in Oxford in November 1983.

11. See Part II, ch. 2 and H. Beumann in Clm 4453, p. 146. For Sclavinia, see ibid., pp. 80-81.

12. Clm 4453, p. 83.

13. See Alexander, 1976, esp. pp. 12, 19; also Clm 4453, p. 81.

14. K. Hoffmann, 1973, esp. pp. 332-37.

15. Leidinger, and see Clm 4453, p. 81. The illustration of the Codex Aureus of 870 is conveniently reproduced in colour in Mütherich and Gaehde, pl. 37.

16. See Part II, ch. 1.

17. DOIII, 389, p. 820, lines 4-5; Cf. Schramm, 1929, i, 168. The phrase is in fact an ancient topos.

18. Havet, Appendix II, p. 237, trans. H.P. Lattin, p. 298.

19. Schramm, 1929, i.110-12.

20. Ibid., p. 112.

21. Ferdinandy, pp. 352-57, is interesting here, as on Gregory V and his elevation to the papacy by Otto III with reforming intentions, at pp. 323-26.

22. Ludat, 1968, esp. pp. 5, 15-16.

23. See also note 11 above.

24. Ludat, 1968, p. 9.

25. See Hamilton, esp. pp. 298-99.

26. Fleckenstein, 1974, p. 199. For the framework of Byzantine political thought and usage here, see Dölger.

27. Thietmar, iv, 47, p. 184.

28. Wenskus, pp. 101-15.

29. Beumann in Clm 4453, pp. 146-47.

30. Not the least brilliant point of K. Hoffmann, 1973, pp. 338-39, is that the Chantilly ruler representation, also with personifications of provinces, was also produced at a critical time for the ruler, namely the *Umritt* of the young Otto III in 983-84 after his accession. For Byzantine initiative, or western loss of it in Italy, see Loud, p. 28; Nicol, pp. 38-43; Ostrogorsky, in *Camb. Econ. Hist.* i (1966), p. 220.

31. Leyser, 1979, p. 78.

32. Vita S. Nili, ch. 88, PG col. 147A (Latin translation).

33. The observation is that of Ferdinandy, p. 375; see also, Vita S. Nili, cols.149-51.

34. Ibid., cols. 151-54. On Otto III's recapturing of the spirit of the intimate bonds between Greek monks and the great men of the world, see the fine passage in Leyser, 1973, pp. 118-19. For the Crescentii and Byzantium, ibid. pp. 112-13.

35. Thietmar, ii, ch. 45, p. 94. See Leyser, 1979, pp. 36, 153 (note 31).

36. E.g. the text in a C10 legal compilation, Clm 6241, at f. 104v.

37. Thietmar, iv, ch. 48, p. 186: *Quamvis exterius vultu semper hilari se simularet, tamen conscientiae secreto plurima ingemiscens facinora noctis silentio vigiliis orationibusque intentis, lacrimarum quoque rivis abluere non desistit.*

38. Arnoldus, chs. 31-33, pp. 566-67.

39. Vita Burchardi, chs. 3-4, pp. 833-34.

40. Thietmar, iv, ch. 62, p. 202.

41. Clm 4453, pp. 109-11, 115-16.

42. Ibid., p. 106. It should be noted that the late C9 Golden Psalter of St Gall has siege scenes similar to the siege of Jerusalem represented in this illustration, see Hubert et al., p. 172. Paul Binski has kindly drawn my attention to the Leiden Maccabees, f. 9, illustrating I Macc. 1, 29ff., representing an attack on Jerusalem (Goldschmidt, i, 1928, plate 72, and note Merton, plates LV,2 and LVI,2). This is a St Gall manuscript. The St Gall wall-painting, or something related to it, could therefore lie behind our illustration here. So far as the monks of St Gall were concerned, the Ottonians were only too familiar with its treasures.

43. See also Beissel, 1886, p. 97. Vöge, p. 289, showed that Peter's limp hands were one of the clichés of Ottonian gesture; but the cliché is used to good effect here.

44. Clm 4453, pp. 104-05.

45. The subjects of the column may be studied in Adamski, 1979, and Algermissen, pp. 191-201; in Tschan, ii, 271-350, and iii, plates 149-91.

46. See Thangmar for conversation between Otto III and Bernward: *praecipua itaque familiaritate magistrum suum amplectebatur (p.759); Episcopus quoque mellito affamine ut magisteriali moderamine ut quondam puero alludebat, agenda quaeque commemorabat, fugienda suadebat vicia, mores omnium aequitatis lance pensare, patientiam familiarissimam in cunctis vernaculam sibi conciliare, ante omnia, ne quid nimium pertinaciter intentet* (p.771). For Thangmar in general, see ch. 2, note 170. The passage about Bernward's arrival in Rome in 1001 is Thangmar ch. 19, p. 767. Drögereit, 1959, p. 20, shows that at this point Thangmar has abbreviated his source, but what he says stands on the best testimony.

47. This prayer book, MS 347, has recently been moved to the Staatsbibliothek in Bamberg, and so far as I am aware its text has never been published. There has been controversy over its date, but it is now generally accepted by scholars to be from Otto III's time; e.g. Dodwell, 1971, p. 74; Nordenfalk, 1957, p. 210; Schramm & Mütherich, no. 105, pp. 78, 203; Lauer, 1975, p. 64. The principal study of it is that of Irtenkauf.

48. The whole prayer covers ff. 31 to 34v in the prayer book, see esp. ff. 33v-34.

49. Besides the Pericopes Book of Henry II, see, for instance, on two pages but with Christ alone on the right-hand page, *Das Erste Jahrtausend*, plates 410, 411. Vöge, pp. 272-73, argued forcefully that there can have been only one single scene in the original model.

50. Clm 4453, p. 100.

51. Once again the closest parallels to the steep angle of faces which look at Christ are on the Bernward Column at Hildesheim, see Adamski, 1979, e.g. pp. 19 (Temptations), 21 (Calling of Apostles), 49 (Transfiguration), 59 (Healing of Two Blind Men), 73 (Entry into Jerusalem). A C12 Coptic manuscript, Paris, BN, MS Copte 13, has this same feature in its Healing of the Blind Man (See Boeckler, 1961, Abb. 45, and Chabot, no. 13). It is thus not impossible that our artist had an eastern prototype with the feature, but this is a long shot. On further scrutiny, the blind man (who stands) in the wall-painting at Reichenau (Martin, p. 43) has the same step angle of the face towards Christ. Perhaps after all it was a Reichenau cliché, but, if so, one handled superbly in the Gospel Book.

52. Martin, pp. 21, 32-34. See also Clm 4453, p. 113.

53. Clm 4453, p. 103; Weitzmann, 1979, fig. 480, p. 182.

54. Tacitus, Histories, iv, ch. 81; Suetonius, Twelve Caesars, X (Vespasian), ch. 7. I am grateful to Felix Mayr-Harting for pointing this incident out to me.

55. Reynolds & Wilson, pp. 93, 97, 274, and Pl. XIV; and for Gerbert of Aurillac's request for Suetonius from the Roman deacon, Stephen, see Havet, no. 40.

56. Cowdrey, 1983, p. xxx.

57. Clm 4453, pp. 92-94.

58. See Weis, 1974, pp. 333-34.

59. Boeckler, 1933, figs. 42, 62, 87-93, 112, 150.

60. DOIII, 341-73.

61. E.g. Good Samaritan (Luke 10, 24 etc.), 5th Sunday after Saints Peter & Paul; Widow of Nain (Luke 7, 11 etc.), 6th Sunday after Epiphany; Daughter of Jairus (Matt. 9, 18), 5th Sunday after Epiphany. The Weeping over Jerusalem (Luke 19, 41 etc.) appears for the feast of St Stephen, but in the Matthew version, whereas it illustrates the Luke version in the Gospel Book. See Clm 4453, pp. 221, 215, 219, 214, and Klauser, 1972, pp. 119, 105, 104, 105. The *Capitulare* in the Gospel Book is virtually Klauser's Type Σ, see Clm 4453, p. 46.

62. See, for instance, Binski, pp. 2, 13-15, 35-36.

63. Goetz, p. 73. A late antique cue here may be something like the C6 Augustine Gospels (F. Wormald, 1954, plate IX) where Christ looks at and extends his hand toward the fig-tree but the vineyard keeper lies prostrate before him. The prayer used in the ordination of exorcists, with the phrase *spiritales imperatores* to describe them, can be found in pontificals and sacramentaries, e.g. Bamberg MS Lit. 54, f. 27v. The para-

graph which ends here has benefited greatly from conversation between myself and Conrad Leyser.

64. Thangmar, p. 758, and see Tschan, i, 19.

65. Dodwell, 1982, pp. 48, 258 (note 40).

66. Bischoff, 1967, esp. pp. 80-83.

67. The text of the inscription which shows this is in Fuhrmann & Mütherich, p. 44.

68. The *Geleitmotif*, as it is called, is well discussed in Bloch, 1956, pp. 57-59.

69. Text in Bornscheuer, p. 174, strophes 10 and 11.

70. Bornscheuer, pp. 174-75, and strophes 12-13 of the poem. For Arduin's coronation and its challenge to the empire, see Schneider, p. 77.

71. This is suggested by Adalbold, see Bornscheuer, pp. 132-33.

72. Schramm & Mütherich, p. 94.

73. *Rex Heinricus ovans fidei splendore coruscans,*
maximus imperio fruitur quo prosper avito,
inter opum varias prono de pectore gazas
obtulit hunc librum divino lege refertum
plenus amore dei pius in donaria templi
ut sit perpetuum decus illic omne per aevum.

74. The phrase *'der Wille zum Feierlichen'* is that of Jantzen, p. 78.

75. Jantzen, p. 76.

76. Boeckler, 1960, p. 12.

77. An easily accessible example of John the Baptist as preacher and baptizer in Carolingian art is the spandrels of the Mark evangelist and *initium* pages in the St Médard of Soissons Gospels (*c.*810), see Mütherich & Gaehde, pls. 6 and 7, and pp. 44-45. Holding the symbol of the Lamb of God, the Baptist is seen on the C6 ivory chair of Bishop Maximian in Ravenna, Masseron, fig. 15, and pp. 24, 167. For the martyrdom in the Gospel Book of Otto III (f.107), see Clm 4453, pp. 101-02.

78. Omont, 1908, ii, fig. 94, f. 106v, with the naming of John at f. 107. Another C11 Byzantine MS (Florence, Bibl. Laur. VI,23, in Florence) has the subject in a sense, but it seems to represent the circumcision of John rather than the nativity, iconographically speaking (Masseron, pp. 54-55). It is a scene with many figures, narrative rather than iconic as in Clm. 4452.

79. See Masseron, fig. 123, and for this early C9 writer, ibid., pp. 29, 139; also Omont, 1908, i, fig. 69, f. 76 (Grec. 74). Leidinger, at pp. 41-42, is disappointing on the whole subject.

80. The ghostly appearance of those rising from the dead on the last day, their tunics in various shades of green, yellow, orange and light blue, mixed with various degrees of white, against a deep green/grey background, is another remarkable achievement of colouring in this book. The picture is headed by the last words of the preceding pericope, *in resurrectionem vitae* (John 5, 29).

81. It is possible, to put it no more strongly, that Otto II ordered him to be trained for the church in order to get the first-born of the hated Bavarian line (in his generation) off the political scene and to prevent a later challenge for the kingship, see Mikoletzky, 1946, p. 2.

82. Mütherich & Dachs, pp. 23-24, 29; Berno, no. 7, p. 33.

83. D HII, 26, of 16 Nov 1002; see Fleckenstein, p. 179, and Claude, p. 222.

84. Fleckenstein, pp. 179, 216, 219.

85. Thietmar, vi, chs. 64-65, p. 354.

86. Mütherich & Dachs, p. 25.

87. See esp. Fleckenstein, p. 218.

88. D HII, 13, 19, 20, 24, 34, 37, 38, 40, 50, to name only those of the first year of Henry's reign; they continue with great frequency.

89. The evidence is conveniently laid out in a book of selected texts, Böhme, 1970, esp. nos. 22 (pp.14-15), 44 (p.20), 62, 64, 66 (pp.26-27), 81 (pp.28-29).

90. Schlesinger, pp. 12-13.

91. Thietmar, iv, ch. 54, p. 192.

92. Suggested by Mikoletzky, pp. 12-14.

93. Suggested by Schneider, p. 84, and p. 84, note 39. Adalbold refers to an attack of colic already at Liège in 1003 (MGH SS IV, p. 689). Bornscheuer treats the subject interestingly, seeing it as giving the ruler an awareness of his humanity, an idea of *fragilitas*, pp. 134-36.

94. For Heribert, see below. For Gisiler, see Thietmar, v, ch. 39, p. 264. Claude would seem justified in suggesting that Thietmar was over-optimistic in saying that Gisiler, whom Henry at first hated, subsequently became one of his closest *familiares*, Claude, p. 203.

95. Hlawitschka, 1978, p. 295 for the reconstructed genealogy, and pp. 297-302 for the four cardinal virtues and for *temperantia* (as equivalent to Thietmar's idea of what Ekkehard lacked through *superbia*).

96. Bornscheuer, pp. 172-73, and see Mikoletzky, p. 14.

97. See Bornscheuer, pp. 127-31, and p. 131, note 675. For Adalbold as chaplain, Fleckenstein, pp. 159, 178.

98. For most of this story Thietmar is our authority, including the burial of the intestines, but Adalbold alone gives the detail of the entry into

Neuburg: *Tandem Nuveborg perveniens, ipse suis humeris corpus imperatoris in civitatem subvexit, pietatis exemplum et humanitatis exhibens debitum* (Adalbold, p. 684, lines 38-39).

99. Arnold, ii, ch. 39, p. 568, lines 9-11: *Ipse princeps propriis humeris non erubuit feretrum portare, necnon accuratius sepulturam parare.*

100. Thietmar, v, chs. 16-17, pp. 239-41.

101. The history of the Holy Lance under the Saxon rulers is dealt with by Schramm, 1955, ii, 501-12, where he points out that it is very rare to find rulers represented with the lance at this period. All the more significance ought therefore to be attached to the Regensburg Sacramentary in connection with the known facts of Henry II's succession. Schramm also points out at p. 504 that according to Thangmar, ch. 38, p. 775, Archbishop Willigis of Mainz invested Henry with the *dominica hasta* at his coronation; and also that Bruno of Querfurt contrasted the *sacra lancea* with the *diabolica vexilla* of the heathens in his letter of 1008 to Henry, ibid, p. 509. Further to the increasing prominence of the Holy Lance under Otto III and its peculiar importance in 1002, see Reinhardt, pp. 193-96.

102. R. Schneider, 1972, pp. 96-102, in criticism esp. of Roderich Schmidt, 1961, esp. at pp. 147-150. The more general context of Schlesinger, esp. expressed at p. 34, should be noted: that though in retrospect Henry II always claimed the kingship by hereditary right, in reality he had to rely on election by several stages.

103. See Schlesinger, esp. at p. 34.

104. Thietmar, v, ch. 13, pp. 234-36: *Regi autem apud Augiam insulam nativitatem sancti Iohannis baptistae commoranti*, etc.

105. For his birthday, see below on the consecration of Bamberg cathedral; Geldner, p. 535, shows that he tried to celebrate his birthday as often as possible in Bamberg. See also Hoffmann, pp. 32-33.

106. Claude, i, 201-04. There is a lively account of Bohemian politics in Dvornik, 1949, pp. 192-93. For a more detailed narrative, R. Holtzmann, 1955, pp. 400-08.

107. Claude, i, 204.

108. Wenskus, p. 191.

109. See Guttenberg, no. 34 (i.e. the synodal decree of Frankfurt, 1007) and good discussion at pp. 20-21, and no. 74 (letter of John, Patriarch of Aquileia, to Henry, bishop of Würzburg, where the motive is doubtless exaggerated). For Slavs in the region, ibid, no. 20 (letter of Arnold, bishop of Halberstadt, to Bishop Henry in 1008, recalling a conversation of the previous year

when they had ridden over to Bamberg from Würzburg).

110. Examples below, but here note that he felt it necessary to go to the lengths of prostrating himself before the bishops at the Synod of Frankfurt in November 1007 (where the opposition of the bishop of Würzburg was represented) in order to gain assent for establishing the bishopric of Bamberg (Thietmar, vi, ch. 31, p. 310; and Hoffmann, p. 34).

111. Fleckenstein, p. 182, and see Thietmar, v, ch. 26, p. 268, on the election of Walthard and his replacement by Tagino at Magdeburg in 1004.

112. Quedlinburg Annals, p. 81, lines 39-40: *Sed regis animus immitis, et habendi misera sitis, renuit supplicantium preces, contemnendo flentium voces.* Henry had curtailed the privilege of free election already in 1003 (DHII,50) by adding the words *aequo tamen regis consensu*, see Mikoletzky, p. 36.

113. Fleckenstein, p. 218.

114. Thietmar, vi, ch. 40, p. 323.

115. Vita Meinwerci, ch. 11, pp. 17-18.

116. De Episc. Eichst., ch. 25, p. 260, see Mikoletzky, p. 37.

117. For Immo of Gorze at Reichenau, see above pp. 84-85; for Poppo of Stavelot at St Maximin, Trier in 1024, and the stiff opposition which Druthmar of Lorsch at first encountered at Corvey in 1014 after being imposed by Henry II, see Mikoletzky, pp. 47-48.

118. Wollasch, 1984, raises at p. 17 the question why the *Herrscherbild* should be not only in pontificals and sacramentaries, where coronation *ordines* might be contained, but also in gospel books and pericopes books. His answer is that such pictures cannot be separated from the actual relations of the ruler with monasteries. Given the domineering mode of Henry's relations with many monasteries, there may be more to this argument than one might at first allow. We would also stress the Christ-centred character of the ruler image which would make its appearance in such books natural, though that of course does not explain the development of Christ-centred kingship itself.

119. Conveniently in Fleckenstein, p. 153; see also Fleckenstein, 1964.

120. Thietmar, vi, chs. 16, 102, pp. 294, 394: Wollasch, 1984, pp. 12-13, 18. There is the famous representation of Cnut and Emma placing a cross on the altar of the New Minster, Winchester, Hunter Blair, p. 89, plate V, and F. Wormald, p. 72. Interesting new light will be shed on this topic by Ken Lawson in his forthcoming book on King Cnut.

121. Brühl, 1968, pp. 129-30.

122. Fournier & Le Bras, esp. i, 390-94.

123. Schramm & Mütherich, no. 123, and p. 95. See Schramm, 1954-55, i, pp. 210-12 for *pendilia* and relations with the cope of Henry II (with cosmic symbolism) preserved at Bamberg. For the influence of Byzantine style and ideas at Regensburg, see Demus, 1970, pp. 95-96, where the interaction of Byzantine and Carolingian influences is stressed.

124. Führmann & Mütherich, p. 46. A ceremony to similar effect, but with the roles reversed, occurred when Henry II solemnly led Archbishop Gero of Magdeburg into his church after consecration, Thietmar vi, ch. 8, p. 372.

125. Schramm & Mütherich, p. 169 (no.39).

126. DHII, 83, p. 104, lines 33-38; Benz, 1975, pp. 118-20.

127. Benz, 1975, pp. 71-74.

128. Benz, 1975, pp. 131-33, 140-43, and see Geldner, pp. 520-38. For the relics and dedications, see the brilliant passage in G. Zimmermann, 1959, pp. 212-13.

129. Thietmar, vi, ch. 13, p. 290.

130. Korteweg, 1985, points out the rarity of the subject in general, the uniqueness of Clm. 23338 within the Liuthar Group in having it, and the likelihood that the artist, as in others of his miniatures, reduced whatever model he had, pp. 135-36, and p. 143, note 83, and also p. 126. For Fulda see Part II, ch. 4.

131. For such problems in Ottonian society, see Leyser, 1979, p. 95.

Notes to Excursus I

1. Martin, esp. p. 33.

2. Hoffmann, pp. 488-89.

3. Nordenfalk, 1972, p. 68.

4. Dodwell & Turner, p. 97. note 265.

5. Bamberg, MS Lit. 5, ff. 55v, 56, 136, 140v, 143, 155, 160v, 124v, 125v. For St Verena and Zurzach, see also Strecker & Silagi, pp. 95-99, and Zettler, pp. 107, 113.

6. Klein, 1984, pp. 419-20.

7. Hoffmann, pp. 310-12, 333.

8. Paris, BN, MS lat. 18005, ff. 138v, 136, 134, 140v, 124. See also Messerer, 1959A, p. 141.

9. Dodwell & Turner, p. 75.

10. Bloch, 1972, p. 58, where he also refers in passing to MS Lit. 5. For the Tonarius illustration,

c. 1030, see *Bulletin of the Cleveland Museum of Art*, March 1964, vol. 51, no.3, p. 44.

11. Dodwell & Turner, pp. 38-51, 12.

12. Schuba, esp. pp. 123-24.

13. Engelmann, p. 17.

14. See Bloch, 1972, pp. 57-58.

15. Capelle, 1950, pp. 390-95. His arguments were elaborated polemically in a paper of 1952, 'Mort et Assomption de la Vierge dans l'Oraison *Veneranda*', reprinted in his *Travaux Liturgiques*, iii, 398-407.

16. Capelle, 1950, p. 393.

17. Ibid., p. 395.

18. Bamberg, MS Lit. 1, ff. 146v-147; Udine, Archivio Capitolare, MS 1, ff. 54v-55; Cologne, MS 88, f. 79v. According to Hoffmann, pp. 156-57, there are also unusual features for Fulda in the script of the latter manuscript.

19. Heidelberg, Cod. Sal. IXb, ff. 143 recto and verso; Paris, BN, MS lat. 18005, f. 118; Oxford, Bodleian, MS Canon. Liturg. 319, f. 138r; Hildesheim, Dombibliothek, MS 688, f. 78r.

20. Munich, Clm. 4456, ff. 206v-207.

21. Vienna, Codex Vind. 958, f. 2r: Munich, Clm. 10077, f. 136v.

22. Hoffmann, p. 334; Munich, Clm. 6421, ff. 157 recto and verso.

Notes to Excursus II

1. Clm 4453, pp. 115-16.

2. e.g. Cames, pp. 118-41. Buchtal (1966) has a tendency to use the same method, interesting as are many of his actual comparisons.

3. Cames, pp. 185-86. Cames seems to me on less good ground in relating the iconography (as distinct from the style) of the Pentecost illustration in the Cologne St Gereon Sacramentary, depicting the peoples of the world in a group, to that of the forty martyrs of Sebaste on Byzantine ivories (ibid., p. 88). The Carolingians know such groups in their depictions of 'the nations'.

4. Boeckler, 1961, p. 29.

5. Weitzmann, 1971; see also his paper on the nature of the Macedonian Renaissance reprinted in the same book, pp. 176-223.

6. Boeckler, 1961, pp. 7-8.

7. Kahsnitz et al., pl. 12.

8. See for instance, Boekler, 1930, pl. 69; Stuttgart Psalter, f. 29v; and Magnani, 1934, plate XVIII.

OTTONIAN BOOK ILLUMINATION

PART TWO: BOOKS

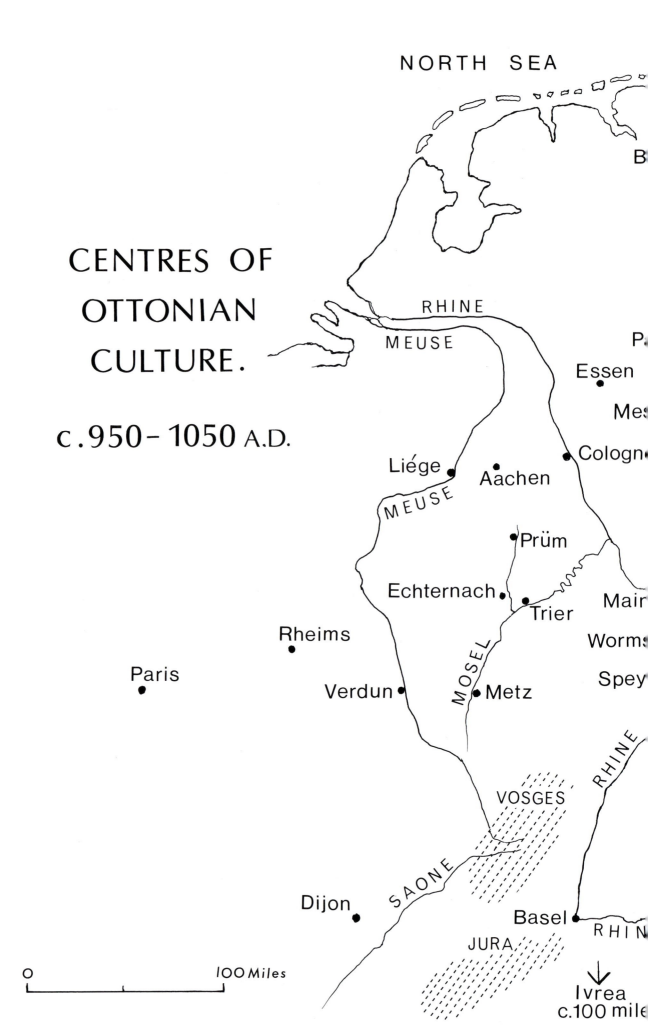

NORTH SEA

CENTRES OF
OTTONIAN
CULTURE.

c. 950– 1050 A.D.

RHINE

MEUSE

Essen

Mes

Cologn

Liége
Aachen

MEUSE

Prüm

Echternach

Mair

Trier

Rheims

Worm

Paris

Spey

Verdun
MOSEL
Metz

RHINE

VOSGES

SAONE

Dijon

Basel

RHIN

JURA

0 100 Miles

Ivrea
c. 100 mile

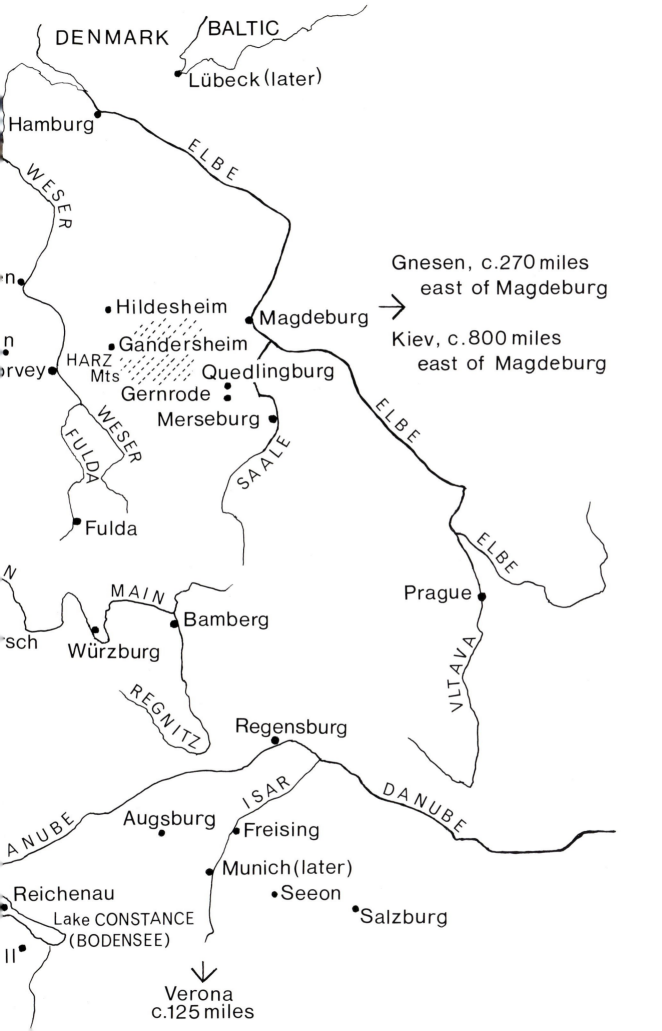

DENMARK

BALTIC

Lübeck (later)

Hamburg

ELBE

WESER

Gnesen, c.270 miles
east of Magdeburg

Kiev, c.800 miles
east of Magdeburg

Hildesheim

Gandersheim

HARZ
Mts

Quedlingburg

Gernrode

Merseburg

Magdeburg

ELBE

rvey

WESER

FULDA

SAALE

Fulda

ELBE

N

MAIN

Bamberg

Prague

sch

Würzburg

VLTAVA

REGNITZ

Regensburg

ISAR

DANUBE

ANUBE

Augsburg

Freising

Munich (later)

Seeon

Salzburg

Reichenau

Lake CONSTANCE
(BODENSEE)

ll

Verona
c.125 miles

1. The Angel with the Millstone. Bamberg Apocalypse, prob. 1001-2.
Bamberg, Staatsbibl., MS Bibl. 140, f. 46

Henry Mayr~Harting

OTTONIAN
BOOK
ILLUMINATION

AN HISTORICAL STUDY

PART TWO
BOOKS

HARVEY MILLER PUBLISHERS

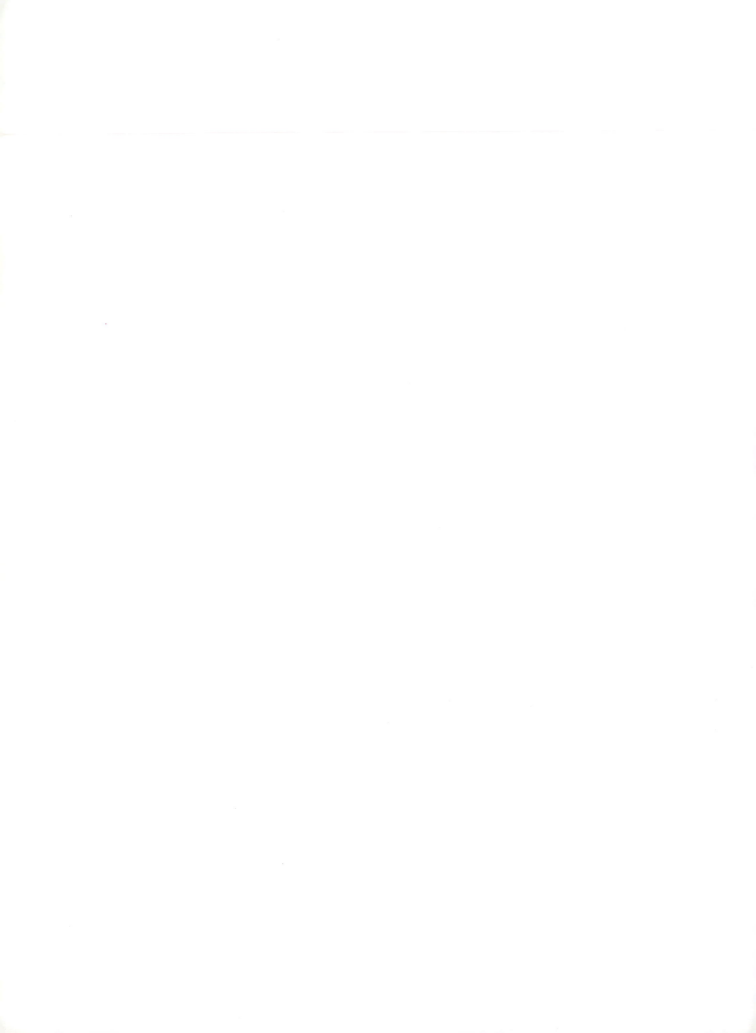

Contents of Part Two: Books

Preface to Part Two

FOR VARIOUS PRACTICAL REASONS it was necessary to divide this rather extensive study, which I regarded as an integral whole, into two parts. Part I, entitled *Themes*, dealt mainly with the themes of the interaction of religion and politics in an art closely connected with the court of the Saxon emperors in the tenth and early eleventh centuries. So also does the first chapter of this second edition, on the Bamberg apocalyptic manuscripts. Why, then, the break where it comes? First, to have effected a division only *after* the Bamberg chapter would have caused a marked unevenness in the size of the original two volumes, especially when one remembers that the lengthy Excursus on the Date of the Bamberg Apocalypse has to go with this chapter. Second, I hope the chapter on the Bamberg manuscript leads into Part II with a useful element of continuity: for thereafter this Part concentrates mainly on particular books from various centres, none of them far removed from the Saxon court and its ambience, but few of them so intimately associated with it as those considered in Part I. Thus this part of the study brings us into a world, perhaps less of the imperial court, yet still of great episcopal and abbatial churches within the Empire, and their politics and their religion.

In studying the art of these churches from a historical point of view, one has to balance carefully not only their religious culture against their political objectives, but also their connections with the imperial court against their desire to circulate their distinctive characters, one against the other, through artistic means of expression. This desire is not merely a historian's extrapolation derived from the actual observable differences between the various Ottonian schools of book illumination. One has only to think of how Ohtric of Magdeburg sought to project the image of his cathedral school against that of Gerbert of Rheims in their famous debate of 980 under the presidency of Otto II at Pavia, on the subject of the divisions or schemes of learning (when there appears to have been little ground for serious disagreement), to realize how likely it was that some at least of the great churches of the empire would wish through art to establish their *personae*.

For the balance between religious culture and political objectives, a mainline theme of the first part of this work, I would like to draw the attention of the reader particularly to the discussion of the Psalter of Archbishop Egbert of Trier (977 – 93) in Chapter 2 of this volume. This book (Cividale del Friuli, Museo Naz. MS CXXXVI) has appeared to me not so much a choir book as one made for the personal use of the archbishop himself; and one, moreover, that mirrors both Trier public traditions as well as private Benedictine piety. But now I see how it might be

thought that the so-called Small Psalter of Egbert (Trier, Stadtbibl., HS 7/9 octavo), a much smaller and more modest book, would be the true psalter of the archbishop for his private use. My view of the Cividale manuscript, however, remains unshaken. The Trier book was undoubtedly made in the circle of Egbert, and is of great interest for its interlinear Greek translations, but there is no evidence whatsoever that it was commissioned by or made for him, rather than for a lesser person.

On the balance between imperial connections on the one side and the distinctive *persona* of an individual church on the other, it seems appropriate to introduce (and advance) my point by way of a current event (May 1991), namely the fine exhibition of Ottonian manuscripts in the Schnütgen Museum in Cologne, which marks the millennium of the death of the Empress Theophanu, wife of Otto II and mother of Otto III. Her resting-place is the Church of St Pantaleon, Cologne. Not the least moving experience of this exhibition is to see eight manuscripts of the Cologne School, surely the largest collection of books from that school ever assembled in one place. From the altogether excellent catalogue of the exhibition, edited by Anton von Euw, I was drawn to the review by Carl Nordenfalk of the great work on the Ottonian Cologne School by Bloch and Schnitzler, a review previously unknown to me (Kunstchronik 24, 1971, 292 – 309). Unlike many other great churches of the empire, there is no evidence that Cologne ever worked for the court, and hence Nordenfalk would regard the strong Byzantine element in the style and iconography of Ottonian Cologne as unlikely to come directly from Theophanu. He would see the under-studied Mainz school, with its early absorption of Middle Byzantine (i.e. C9/C10) models, as a more important stimulus at Cologne (I have never meant to imply that the individualism of one's own church and openness to outside influences were incompatible). At the same time, Nordenfalk would see the Byzantine component at Cologne as most likely to have been encouraged by Archbishop Heribert (999 – 1021), for he had been an adviser of Otto III and sharer in his Greek asceticism. Nordenfalk also notes with approval the clever implication of Bloch and Schnitzler that the youthful but majestic priest, shown vested for mass and receiving the book from a group of monks in the dedication picture of an early Cologne Gospel Book (Milan, Ambrosiana, C 53 Sup), was none other that Heribert himself (*ill. 32* in this volume), when he was about to become archbishop.

The great bishops and abbots of the empire were impressive men — to their flocks amongst whom they were viewed with awe, to their fellow ecclesiastics who often remarked on their deep religious devotion, and to their artists who saw them as colossuses, perhaps not merely because they were told to.

The Bamberg Apocalyptic Manuscripts of *c.* 1000

T HE BISHOPRIC OF BAMBERG (1007) was founded by the Emperor Henry II in what seems always to have been his favourite place, and no wonder to anyone who has visited it and knows its surroundings. It is a place moreover of great strategic importance in linking Henry's former duchy of Bavaria to the River Main and the northern regions of the kingdom into which he had come in 1002. The build-up of its huge endowments of lands and rights can be followed in the register edited by Guttenberg; while its library, representing the collections of books of Henry II and his Ottonian predecessors, can be studied in the series of catalogues compiled by Leitschuh and Fischer. The group of manuscripts which we consider now, however, were so valuable, not least in several cases for their covers, that they are more likely to have formed part of the cathedral treasure and to have come under the *custos* rather than the librarian.[1]

1 The Bamberg Apocalypse

The Bamberg Apocalypse (Staatsbibl., Bibl. 140) is a book of violent expression and high drama. It is dramatic in its individual scenes and in its cumulative effect. Excitement and tension mount through its pages towards the climax of its Last Judgement, as they mount during the great finales of Mozart's operas. The recurring group of John the Evangelist and the angel, as they move through the fifty illustrations, has actually been compared with a *pas de deux* ballet duo.[2] The book has two main sections: the Apocalypse itself with a mixture of full-page and part-page illustrations, the latter brilliantly incorporated in the pages, and a pericopes section of roughly equal length to that of the Apocalypse but with only five rather conventional and unremarkable New Testament illustrations. Between these two is a separately quired double page. On the left, as this page lies open, is depicted a youthful ruler being crowned, *2* uniquely, by Saints Peter and Paul, and underneath, four 'peoples', personified by crowned females, bringing their gifts in an act of obeisance. On the right there appear personifications of four kingly virtues, accom- *3* panied in each case by an Old Testament exemplar of the virtue. Because the ruler was the *Jünglingstypus*, Schramm considered him to represent Otto III; and because Otto III adopted the style *servus apostolorum* in some of his diplomas of 1001, a style which so well fits the iconography of the crowning here, he dated the whole manuscript to 1001. This dating has

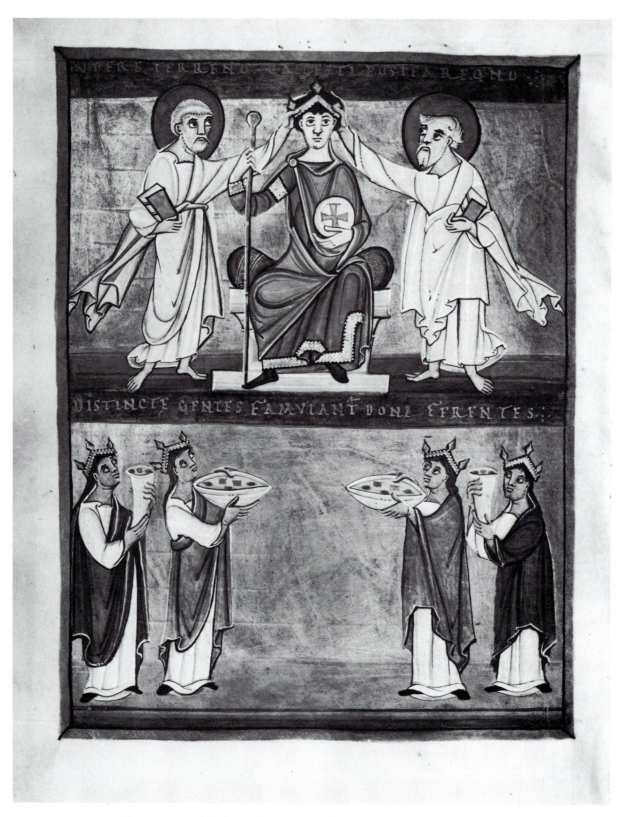

2. Otto III crowned by Saints Peter and Paul. Bamberg Apocalypse, prob. 1001-2.
Bamberg, Staatsbibl., MS Bibl. 140, f. 59v

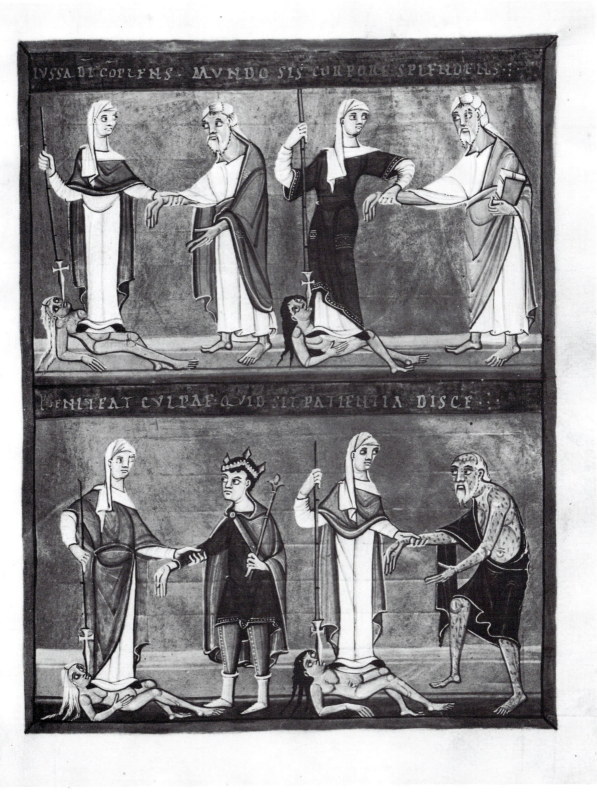

3. Personifications of the Kingly Virtues. Bamberg Apocalypse, prob. 1001-2.
Bamberg, Staatsbibl., MS Bibl. 140, f. 60

been widely contested, but we argue for its correctness in an Excursus. Nobody has ever questioned, in terms of script and art, that Apocalypse, ruler-page and pericopes section are an integrated whole. We are looking, therefore, at another of Otto III's books which passed through Henry II to Bamberg after its foundation in 1007.

The Bamberg Apocalypse is a masterpiece, not totally without a context of earlier artistic work. It is certainly related to the Carolingian apocalypses, even though these are relatively crude works of art and very far from being masterpieces. The nature and extent of the relationships is something which still requires more detailed work. We may, however, venture a few generalizations here. Leaving aside single-page illustrations of the Apocalypse in biblical manuscripts, there are four surviving illustrated apocalypses from the Carolingian age, and their names are derived from their present homes: Trier and Cambrai, Valenciennes and Paris. *Cambrai* (Cambrai, MS 386) and *Paris* (BN, nouv. acq. lat. 1132) are very closely related respectively to *Trier* (MS 31) and *Valenciennes* (MS 99),[3] and as it is out of the question that either *Cambrai* or *Paris* is closer to *Bamberg* than is its corresponding relation, we may safely confine our attention to *Trier* and *Valenciennes* (see stemma on p. 249).

Trier is a very early manuscript (*c.* 800) and is probably a direct copy of an early sixth-century apocalypse.[4] The relationship with *Bamberg* is there, but it is a very distant one. The Bamberg Apocalypse is much closer to *Valenciennes*. There are sufficient correspondences between the thirty-eight illustrations of *Valenciennes* and the fifty of *Bamberg*, in iconographic details and arrangement of the page, to show that the *Bamberg* artists must have had a relative of *Valenciennes* as a model. Moreover, if we look at the divisions of the text (the twenty-two chapters of the Apocalypse in our own Bible go back no earlier than the twelfth century), the Table on p. 250 shows how close the *Bamberg* organization of textual divisions is to *Valenciennes*; and the *Valenciennes* divisions are unique among all surviving texts of the Apocalypse, except that they were also followed in *Paris*.[5] It is possible that all three manuscripts were using an immediate parent of *Valenciennes*. For we need not assume that *Bamberg* had a younger rather than an elder relative of *Valenciennes* as prototype. The signs suggest an elder relative, since art historians have pointed out features in which *Bamberg* actually seems closer to early Christian art than does *Valenciennes*.[6]

Scholars have debated whether all the Carolingian Apocalypses go back to a common late antique cycle of Apocalypse illustrations.[7] Ultimately they clearly do, though *Valenciennes* is certainly separated by more intermediary stages than is *Trier* from its late antique prototype. But whether the *Bamberg* artists relied on an older or a younger manuscript than *Valenciennes*, what they did have available was evidently already of the Carolingian period rather than earlier. *Bamberg* has characteristic transformations of apocalyptic iconography, in particular the influence of Carolingian astrological manuscripts on the representation of the beast arising from the sea (with several coils round its body in the manner of Capricorn) and

of the Whore of Babylon (in the posture of Cassiopeia).[8] It is possible, also, *15*
that a Carolingian model was used for the *Bamberg* Last Judgement, the
first surviving, fully developed Last Judgement (with apostles, trumpet-
blowing angels, the dead rising from tombs, and groups of the saved and
the damned) in the whole of Christian manuscript art.[9] For although *Valen-
ciennes* has no Last Judgement, the dead arising from their tombs, as in
Bamberg, figure in the Last Judgement on the west wall of Müstair (*c.* 800)
and below one of the Crucifixion scenes of the Utrecht Psalter (*c.* 830).[10]

Nonetheless, the more apparent it becomes through comparisons that
the Bamberg Apocalypse has an important weight of late antique and
Carolingian tradition behind it, and the more its textual divisions attach
it textually to *Valenciennes*, the more impressed one is bound to be with
the originality of its art. In the first place there is the whole style of the
manuscript. The artists took their models of late antique derivation, with
figures of simple colouring which either crowded out the pages or were
scarcely related to each other in acres of plain parchment and lightly
coloured background; and they turned them into something which can
only be called quintessentially Ottonian, where the plentiful gold in the
backgrounds, the rhythm and movement of the figures in relation to each
other, and the unerringly apposite distribution of a brilliant repertoire of
colours, together brought about a wholly new coherence within the minia-
tures. That is what German scholars call *Flächenbeherrschung*, the mastery
of the surface space. The transformation does not always achieve the
highest art. Sometimes we must be content with nothing more than a
livelier visual design, as when the wings of the four angels holding back
the four winds of the world create in *Bamberg* a pattern which articulates *4*
the whole illustration (as nothing does in *Valenciennes*). Compare the *5*
deeper inspiration of the eleventh-century artist of the wall-painting at
Castel S. Elia, where the winds are represented as slender, naked boys,
blowing long horns, while the angels place restraining hands on their
shoulders.[11] Occasionally, the greater elaborateness of *Bamberg* and its
rhythmicizing of the page jettison the cruder but more dramatic effects of
the Carolingians. When the fifth angel blows his trumpet in *Bamberg* (Apoc. *7*
9:1-11), the rather unformidable 'locusts' which jump out of the distinctly
calm and possibly somewhat shallow 'bottomless pit', are no match for
the explosion of 'smoke' which has blown the lid off the same pit in
Valenciennes; and this in pictures whose relation to each other is demon- *6*
strated by the curling strands of ascending smoke and the nearby descent
of the falling red star.

But it would be wrong to look at the whole manuscript only in terms
of pattern and rhythm. Eschatological feeling runs high in this book, and
not surprisingly some of the most telling pieces of originality are prompted
by it. The representation of the 'one like unto the Son of Man', seated on
a white cloud, to whom the angel cried out that He should thrust in his
sickle, 'for the harvest of the earth is ripe' (Apoc. 14:14-15), is a virtually
new creation. The wonderful depiction of the angel with the millstone

15

4. The Four Winds of the World. Bamberg Apocalypse, prob. 1001-2. Bamberg, Staatsbibl., MS Bibl. 140, f. 17v

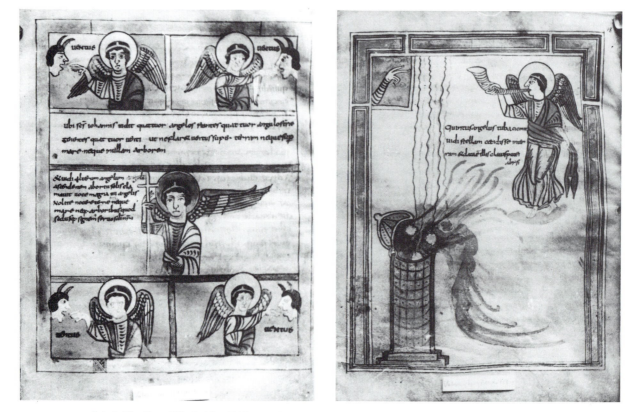

5 & 6. The Four Winds; The Fifth Angel blows his Trumpet. Valenciennes Apocalypse, early C9. Valenciennes, Bibl. Mun., MS 99, ff. 4, 18

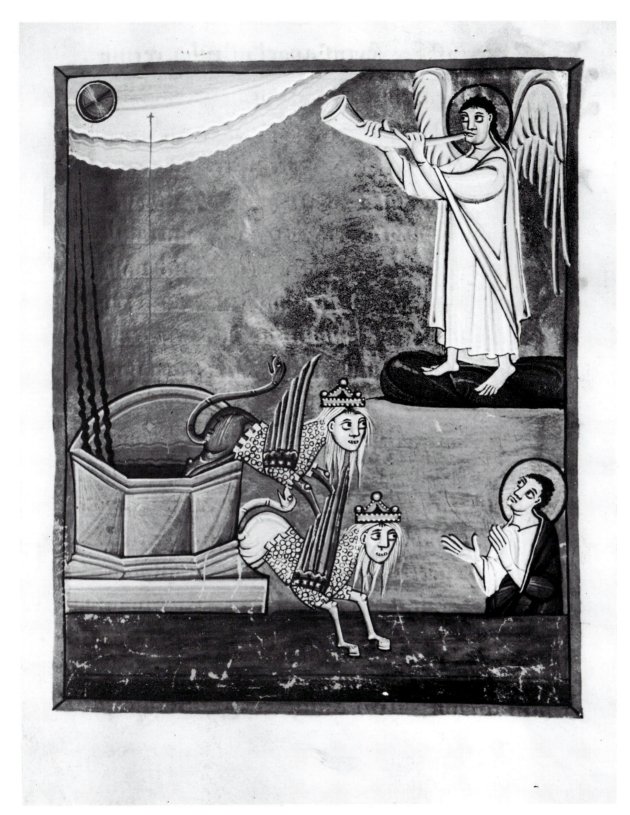

7. The Fifth Angel blows his Trumpet. Bamberg Apocalypse, prob. 1001-2.
Bamberg, Staatsbibl., MS Bibl. 140, f. 23

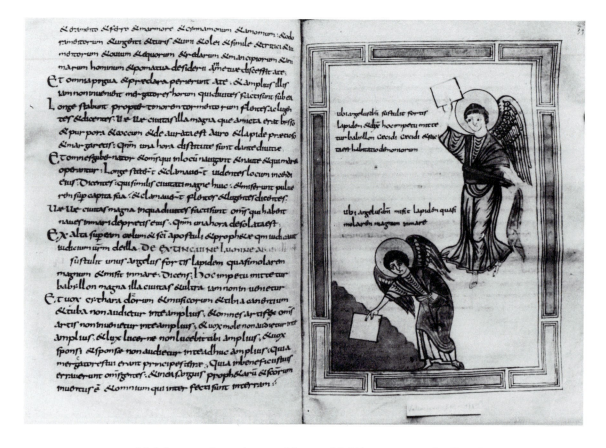

8. The Angel with the Millstone. Valenciennes Apocalypse, early C9. Valenciennes, Bibl. Mun., MS 99, f. 33

which he cast into the sea (Apoc. 18:21) comes as the Bamberg Apocalypse draws towards a close. In *Valenciennes* the angel is depicted twice, once labouring to raise the stone, and again about to dash it to the earth. These flat scenes have been turned, by the simplest means, into one of the most famous pages of *Bamberg*, and justly famous. In *Bamberg* there is but one angel, majestically proportioned to the page, with ominous glance, rolling a round stone, with hugely extended thumb and finger, his poise and balance apparently determined by the span of his wings. 'Heavy is his step, like Fate slowly closing in', says Fauser, who adds that the harmony of the colour tones produces a dusky solemnity.[12]

The dramatization of a positively millenniaristic theme marks the illustration of the beast and the false prophet (a type of Satan) being cast into a lake of fire and brimstone, and Satan being released again after one thousand years to deceive the nations (Apoc. 19:20-20:3, and 20:6-8). The tying up of beast and false prophet, and the impending release of the false prophet for the 'second death', are divided between two illustrations on separate pages in *Valenciennes*. This in itself has robbed them of the millenniaristic effect which they have in *Bamberg*. In *Bamberg* the two scenes are contained in one illustration. The picture is divided vertically, and in each section a gold ground and a dark fire cloud are arranged diagonally to their counterparts in the other section. We see the false prophet in front

18

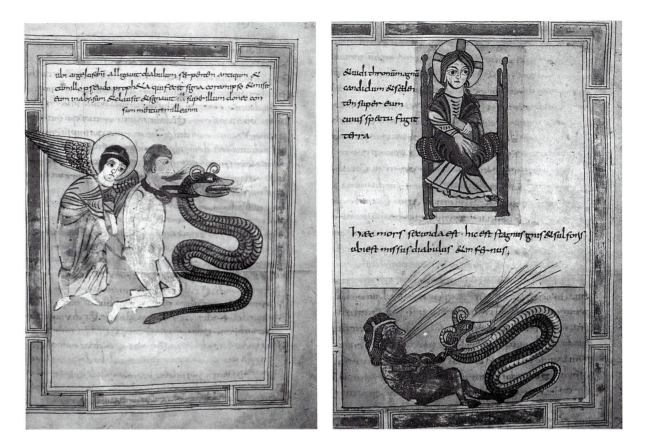

of the gold ground above, but in front of the fire cloud (the lake of fire and brimstone) below, which has the effect of thrusting him visually forward *when he is about to be released*. Moreover, in both sections the figures are weighted, as it were, towards the right of the picture, thus emphasizing Satan's turning towards the left and towards his own imminent freedom to wreak havoc in the world.[13]

Let us now look at a place in the Bamberg Apocalypse where the image of the Church is projected with peculiar force.

One of the most arresting pictures in the whole book is that illustrating the beginning of chapter 12 of the Apocalypse: 'and there appeared a great wonder in heaven, a woman clothed with the sun, and the moon under her feet, and upon her head a crown of twelve stars'. The next verses describe how a dragon having seven heads and ten horns attacked the child to whom the woman had given birth and who would rule all nations. At this time Bede's was a standard commentary on the Apocalypse and any educated cleric looking at this picture might see in it the general lines of his interpretation. In this, the woman represented the Church, the dragon the armed might of earthly kingdoms attacking the Church, and the boy also the Church obeying Christ and cleaving to Him despite the devil, 'for the Church daily begets the Church, ruling the world in Christ'.[14] The originality and force of this composition is striking compared with any

Col.Pl. IV

19

12 known forerunners. In *Valenciennes*, for instance, the woman is set above the dragon on the page in such a way as to exclude all connection between
13 the two figures. In *Trier* there is a connection but of a crude sort and the woman is an unimpressive figure packed into the top right-hand corner of the picture. In neither does the boy appear. In the Bamberg Apocalypse on the other hand, the twist of the dragon seems suddenly to create a tense relationship between the two apparitions as well as to threaten lethal danger to the frail-looking boy. As so often in Ottonian art, anyone who looks at the hands, in this case of woman and boy, will see how much they add to the movement and drama of the picture.

The upper plane of this picture illustrates the last verse of the immediately preceding chapter (Apoc. 11): 'and the temple of God was opened in heaven, and there was seen in his temple the ark of his covenant'. As this verse was also clearly taken to be a 'type' of the Church, one might think it obvious to illustrate it together with the beginning of chapter 12. Our own chapter divisions themselves, as we have mentioned, were of no account at this date, since these were only established later. Strangely enough, however, the conjunction is so far as we know totally original to the Bamberg Apocalypse. *Trier* illustrates the temple and the woman in separate pictures; *Valenciennes* and *Paris* lack the temple altogether. It begins to look as if behind the Bamberg Apocalypse lies some thinking about the Church.

One might hazard the suggestion that a possible influence in bringing together the temple and the woman as types of the Church in one picture
11 of the Bamberg Apocalypse was the Volturno Exultet Roll of 981-87.[15] Exultet rolls contained the text of the great *Exultet iam angelica turba* which the deacon sang after the blessing of the fire and candle at the Easter Vigil. The illustrations were upside down to him, so that as he sang and the parchment slipped gradually over the lectern, they would slowly come into the view of the congregation the right way up. And here is a woman with outstretched arms, sitting on the roof of a church, which like the Bamberg temple is of contemporary design and has open doors. The twelve candlesticks must signify the apostles as do the twelve stars in the apocalyptic woman's sun crown. Such an illustration is very suitable for the Exultet, which includes the words, *laetetur et mater ecclesia, tanti luminis adornata fulgoribus* (mother Church rejoices, adorned with the splendours of so great a light). Now the Ottonians had close connections with the monastery of S. Vincenzo, Volturno, from which this Exultet Roll comes. Volturno and Monte Cassino, the two great monasteries of the principality of Capua, had a perpetual struggle to protect their rights and possessions from the depredations of the local aristocracy. Traditionally they worked in alliance with the princes of Capua, but they also took advantage of the interest which external powers had in their strength. For the Ottonian emperors, support in Capua was essential if they were to have a bulwark between Rome (whence they derived their imperial status) and the rival

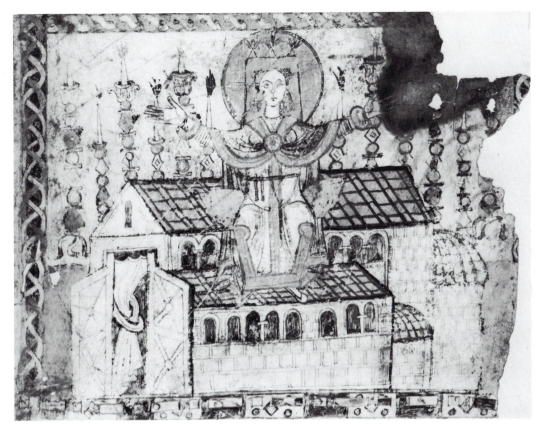

11. Mother Church. Volturno Exultet Roll, 981-87. Vatican, Bibl. Apost., MS Lat. 9820

12. The Woman in the Sky. Valenciennes Apocalypse, early C9. Valenciennes, Bibl. Mun., MS 99, f. 23

13. The Woman in the Sky. Trier Apocalypse, c. 800. Trier, Stadtbibl., MS 31, f. 37

Byzantines in the South; and it was essential if, as emperors, they were to look as if they had any kind of control over the old southern Italian imperial lands. To the Ottonians, support in Capua meant alliance with the princes of Capua and also support from the great abbeys.[16] Volturno had used its strategic position from Carolingian times to gain from the emperors ecclesiastical immunity, and Otto II in particular helped it in the early 980s, at the very time that the Volturno Exultet Roll was most likely being created, to recover a whole string of churches and castles.[17] Nobody can suppose that the artist of the Bamberg apocalyptic woman had the Volturno Roll in front of him as he worked, but it is highly likely that members of the court circle had seen the roll, and talked about it, and that it suggested the principle of the iconographic conjunction of temple and woman.

The very fact that such monasteries as Volturno had to fight hard to maintain the rights of their individual churches in the world around them seems paradoxically to have stimulated them to develop thoughts about the dignity of the Universal Church. Some such thinking must lie behind the striking use of the *Mater Ecclesia* image, old as this image was in itself.[18] It is not surprising to find it at Volturno, whose eighth-century abbot, Ambrosius Autpertus, had written a commentary on the Apocalypse between 758 and 769.[19] One of the contributions of this commentary to theology was to make distinctions between the *generalis ecclesia* and the *speciales ecclesiae* (i.e. the Universal Church on earth and in heaven, and particular churches like Volturno) in interpreting apocalyptic imagery. For instance, to Autpertus the Son of Man standing amidst the seven golden candlesticks figured the *generalis ecclesia*; whereas to Bede, whose earlier commentary he did not know, it figured simply the risen Christ.[20] This commentary had no more than a modest circulation between Autpertus's own time and the early eleventh century, but Reichenau itself had a ninth-century Italian copy of the work,[21] and Autpertus himself can hardly have

14. The Woman in the Sky. Apocalypse fresco in the Baptistery, Novara Cathedral, early C11

15. The Whore of Babylon rides the Beast.
Valenciennes Apocalypse, early C9.
Valenciennes, Bibl. Mun., MS 99, f. 31

been forgotten at Volturno, his bones together with those of Abbot Joshua (792-817) being translated probably some time in the ninth or tenth centuries to a large sarcophagus.[22] Once one has in mind that thinking about the Apocalypse has a bearing on the *Mater Ecclesia* of the Volturno Roll, it suddenly strikes one that the representation of *Mater Ecclesia* must itself be influenced by Apocalypse iconography. The twelve candlesticks seem an echo not only of the crown of twelve stars but also of the seven golden candlesticks of the Apocalypse, and above all *Mater Ecclesia* is seated on her purple cushion in a posture and with clothes which strongly suggest the Whore of Babylon seated on the beast with her arms spread wide in *15* Carolingian Apocalypses. That the Whore of Babylon should suggest a way of representing the Church need occasion no surprise, since each was the *Gegnerspielerin*, or counter-actress, of the other in the cosmic drama.

The conjunction of temple and apocalyptic woman, and also of the boy, in the same scene, occurs again among the Apocalypse frescoes in the baptistery of Novara Cathedral.[23] As these frescoes are considered to be *14* in a style very similar to those at S. Vincenzo of Galliano near Milan which can be precisely dated to 1007, they must be reckoned as contemporary with the Bamberg Apocalypse. They provide further evidence, with the cope which Otto III gave to the monastery of S. Alessio in Rome (see p. 219), that the Bamberg Apocalypse is not isolated as apocalyptic art in the empire at the turn of the millennium. The Novara frescoes are related, but only as a distant cousin, to *Trier*, *Valenciennes* and *Bamberg*. Nobody

23

comparing Novara and the Bamberg Apocalypse on the Woman in the Sky could suppose that they had a common model let alone a direct relationship, another indication of the probable independence of Bamberg in its original features. Their temples are of quite different designs; Novara has the child coming out of the tomb as if in a Last Judgement: and its woman is in the posture of an *orans* figure. Is it a coincidence, therefore, that it adopts the conjunction of temple, woman and boy, figures of the church as they are, at about the same time as *Bamberg*? Perhaps, but there is another possibility, namely direct conversation. The idea that iconographic developments might occur through talk is one which in the nature of the case cannot generally be proved in particular instances at this period, but it is not a new one to art historians. Collon-Gevaert, for instance, has shown how an ivory of Bishop Notker of Liège (972-1008) and the Gospel Book of Bernward of Hildesheim (*c.* 1015) have the same unique feature of the presentation of a book to the Virgin Mary, seated in Majesty, by its being placed on the altar, *par autel interposé*. There is obviously no direct visual connection between the two scenes, and the iconographic connection is set down to the friendly relations between the two bishops.[24]

Novara was an important bishopric for the Ottonians.[25] It has long been realized that the Ottonians, needing to secure their routes through North Italy to Rome, granted privileges to key bishoprics on these routes to win their support, bishoprics such as Parma, Reggio and Modena.[26] Less well appreciated is their application of the same policy to a little group of bishoprics, including Novara, ringing around Ivrea. Ivrea commands the exit from the Dora Baltea Valley into the Lombard plain, and the Dora Baltea leads by an easy road up through Aosta to the Great and Little St Bernard passes over the Alps; it was thus in the key position to control the routes from Burgundy to Italy. Whoever held it could play an important part in introducing, or impeding the introduction of, foreign warriors into North Italy. In the tenth century it was the stronghold of the family which led the challenge to Ottonian control of North Italy, Berengar and his son Adalbert of Ivrea in Otto I's day, and Berengar's grandson Arduin in Otto III's. Otto I responded by granting the monastery of Bobbio to Bishop Giseprand of Tortona and privileges of jurisdiction in the countryside round their bishoprics to the bishops of Asti and Novara.[27] A glance at a map will show how Ivrea is (so to speak) hemmed in to the Piedmontese Alps by the encirclement of Asti, Tortona and Novara. Novara's privilege was repeated by Otto II, and by Otto III when he was at Pavia in 1001.[28] This last occasion in particular may have provided an opportunity for a personal exchange of views between the representatives of the church of Novara and court chaplains about the rights of churches; about how full the world was of Antichrists, whores of Babylon, and horned dragons like Arduin of Ivrea, who would deny those rights if they possibly could; and hence quite naturally about the apocalyptic woman in the sky. Somewhere close to court circles, the Bamberg Apocalypse would probably have been at that very moment in the process of creation.

2 The Gospel Book of Otto III: The Evangelist Luke

This book, as we explained in the first part of this study, belonged to Bamberg, apparently from the beginning of its Cathedral's history, until 1803. A gospel book gives only limited opportunities to depict the apocalyptic or the eschatological, but the evangelist portraits in Otto III's book are remarkable examples of both, especially the celebrated St Luke. He *18* sits in a rigid posture on a 'rainbow' within a mandorla, his eyes staring wide as if he were in an ecstasy or trance, his stiff outspread arms holding up as if by a feat of weight-lifting a whole cosmos of Old Testament figures and angels with his own evangelist symbol (the winged bull) in their midst. This is very different from the staid late antique author portraits or late antique philosopher types receiving inspiration, to which most Carolingian and Ottonian representations of the evangelists conform. Unlike the emperor in the frontispiece of the Aachen Gospels, Luke sits low in the picture, but his green mandorla and rainbow throne, themselves drawn from the world of the Apocalypse, separate him as effectively as anything could from the earth with its streams and its lambs. These streams and lambs, featuring in the sixth-century apsidal mosaic of Sant' Apollinare in Classe, Ravenna, are themselves not so earthly[29], for they symbolize, according to the *titulus* of our picture, how Luke (the ox or bull) draws water (understanding) for the lambs (men) from the fount of the (Old Testament) fathers. The Old Testament persons 'held up' by Luke are David (Abraham, Moses, David and Solomon appear in turn as Old Testament ruler-figures in these four evangelist pictures) and Ezechiel, Nahum, Habakkuk and Sophonias (all the major and minor prophets being included across the four pictures).[30]

Bernhard Bischoff has given us a new way of understanding these evangelist pictures, for not only has he compared the evangelists to figures of Atlantus holding up the world in classical manuscripts, but he has also described them in the illuminating phrase from the Epistle to the Hebrews (12:1) referring to Old Testament witness of the Christian faith: 'we also have so great a cloud of witnesses over our head'. Our artist seems to have used a biblical metaphor to create a pictorial fantasy which unites the Old Testament with the New.[31] The sense of the unity of the whole Bible, which was to give so powerful an impetus to eleventh-century biblical art whereby Ottonian art was transformed out of itself (see chapter 6), was never absent from Ottonian art in its heyday. The metaphor and the fantasy here, however, are highly apocalyptic. The clouds of witnesses are clouds of glory, with rays of light shining from them, such as the Son of Man would appear in at his second coming; while the evangelist himself is seen like Christ as he would then be seated in Majesty.

Still further advances in our perceptions of this Luke picture have come from the masterly interpretation of Konrad Hoffmann.[32] To Hoffmann Luke is only an Atlas figure by formal derivation; he is depicted in truth with the visual vocabulary of inspiration and his real character is that of

25

16. Cross with the Lamb of God. Gelasian Sacramentary, France, C8. Vatican, Bibl. Apost., MS Reg. Lat. 316, f. 132

17. Crucifixion and St Luke. Gospel Book of Bernward of Hildesheim, *c.* 1015. Hildesheim, Cathedral Treasury, MS 18, f. 118v

a Moses unveiled, showing how the Old Testament is fulfilled in the New. He may be compared in posture and meaning to Moses being unveiled in the Apocalypse picture of the Carolingian Vivian Bible (Tours *c.* 846)[33], a book clearly known to the Reichenau artists of the Ottonian period. While the Luke picture in the Gospel Book has *lambs* drinking from streams emerging from rocks, the Matthew picture has *men* so drinking, a clear reference to Moses bringing water out of rocks in the desert (the *Quellenwunder*), which 'typified' not only the Eucharist but also the understanding of the Old Testament which had been brought forth by Moses for the church.

Moreover, the roundel containing Luke's symbol, the winged bull, is seen here by Hoffmann as the centre of a cross, formed of connected circles,

16 as is, for instance, the *Agnus Dei* cross of the eighth-century Gelasian Sacramentary. In the early Middle Ages the ox and the lamb were to some extent interchangeable symbols because both were sacrificial animals which could be associated with Christ's death on the cross. Thus the Gospel Book of Bernward of Hildesheim (*c.* 1015) depicts the Crucifixion

17 before St Luke's Gospel and above the evangelist portrait itself; and here at the feet of the crucified Christ is the winged bull once again in a roundel

26

18. St Luke. Gospel Book of Otto III, 998–1001. Munich, Bayerische Staatsbibl., Clm. 4453, f. 139v

19. St Luke. Pericopes Book, Reichenau, early C11. Munich, Bayerische Staatsbibl., Clm. 4454, f. 127v

(yet another iconographic link between the Gospel Book of Otto III and the art of Bernward of Hildesheim).[34] In a Reichenau Pericopes Book in Munich (Clm. 4454), bull and lamb both appear in the lunette above the Luke portrait, the bull as the evangelist symbol, the lamb in a roundel on a cross to symbolize Christ. In this manuscript, each evangelist page has a representation or symbol of Christ: Matthew — Christ victorious; Mark — Christ rising from the tomb; Luke — Christ crucified; John — Christ ascending into heaven. Thus the christological significance of the Luke page in our gospel book is one which points to the Crucifixion as well as to the Second Coming of Christ.

28

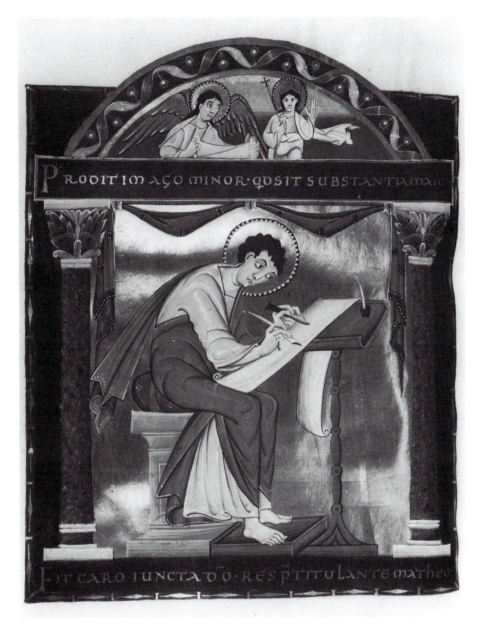

20. St Matthew. Pericopes Book,
Reichenau, early C11.
Munich, Bayerische Staatsbibl.,
Clm. 4454, f. 25v

Hoffmann sees the four outward-looking angels in the 'heavenly cloud' of the Luke picture as being a parallel to the four winged creatures and the busts of sirens beneath them in the Christ frontispiece of the Pericopes Book, Clm. 4454, which represents Christ in a lovely image as the Tree of Life; and he relates these creatures and sirens to the spheres of music in Platonic cosmology.[35] One might add that the angels are positioned in such a way to the rays of forked light emanating from the heavenly cloud, that the rays might almost be trumpets which the angels blow, as if the artists were alluding to the four trumpeting angels of the Last Judgement in a further burst of apocalyptic imagery.

21

29

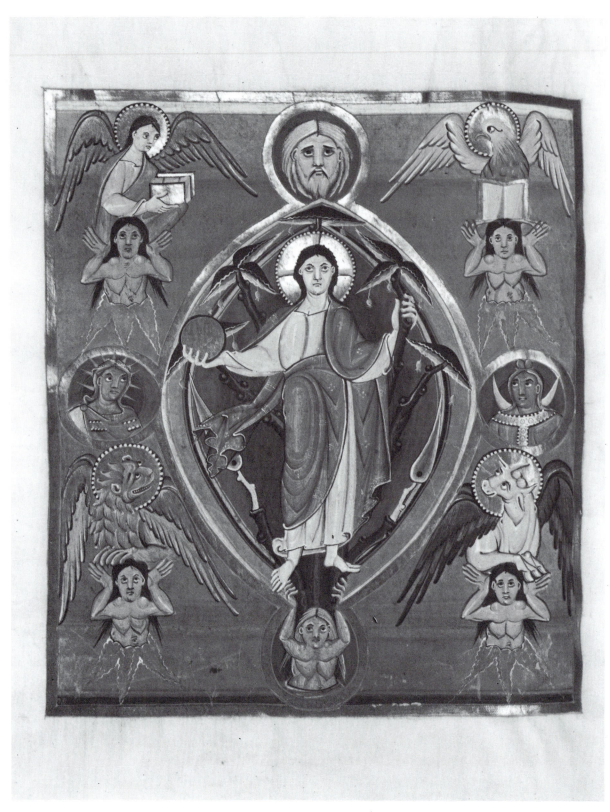

21. Christ the Tree of Life. Pericopes Book, Reichenau, early C11.
Munich, Bayerische Staatsbibl., Clm. 4454, f. 20

3 The Bamberg Commentaries

The Bamberg Library contains texts with marginal glosses of the Song of Songs and the prophecies of Daniel and Isaiah. We know for certain that they have been at Bamberg since at least the first half of the twelfth century.[36] They are all written in the same hand, and while the Song of Songs and Daniel are now bound together and Isaiah separately, there is some indication that originally they were intended to go together as a coherent group with the Song of Songs coming last.[37] The Song of Songs in fact precedes the prophecies in the canon of the Old Testament, but its illustrations can be taken as a mystical or allegorical interpretation of the prophetic books in depicting the glory of Christ and the risen Church to which Isaiah and Daniel had ultimately pointed. The glosses on the Song of Songs in this manuscript represent a commentary passing (in Migne's *Patrologia*) under the name of Isidore. The same commentary, written as a continuous text rather than as marginal glosses, is to be found in a ninth-century Fulda manuscript. It is in fact Alcuin's *Compendium in Canticum Canticorum* with some abridgements in the first four chapters.[38] As Alcuin's own work is nothing but a radical abridgement of Bede's commentary on the Song of Songs, our glosses are in fact essentially Bede. Such abridgements illustrate the student-help approach which characterizes so much Carolingian and Ottonian learning. The glosses on Isaiah and Daniel both consist of passages from Jerome's commentaries. Doubtless they too are extracts of extracts already conveniently assembled somewhere, but I have not so far succeeded in tracking down the particular *vade mecum* from which they come.[39]

The beginning of each Old Testament book is illustrated with just a double page of two miniatures, the right-hand side being also the *initium* of the text. These miniatures are in a direct line of succession from the Aachen Gospels as to colour and figural style and likely to date from the late 990s or *c.* 1000.[40] There are not the same clear signs in these manuscripts, as there are in the dedicatory pages of the Gospel Book of Otto III and the Bamberg Apocalypse, that they were close to Otto III himself. But neither is there anything to associate them with Henry II as there is in the case of his Pericopes Book. Moreover the subject matter of the Daniel illustration in particular, and arguably of the Isaiah as well, was such as to be of special interest to an emperor. One of the Song of Songs miniatures, too, contains a representation of four kings, who at first sight seem rather gratuitously included and whose number seems likely to have something to do with the four empires of the world prophesied in the Book of Daniel. Altogether, we are surely right to see these commentaries, with their illustrations, as books which belonged to Otto III's library or treasure before Henry II gave them to Bamberg.[41]

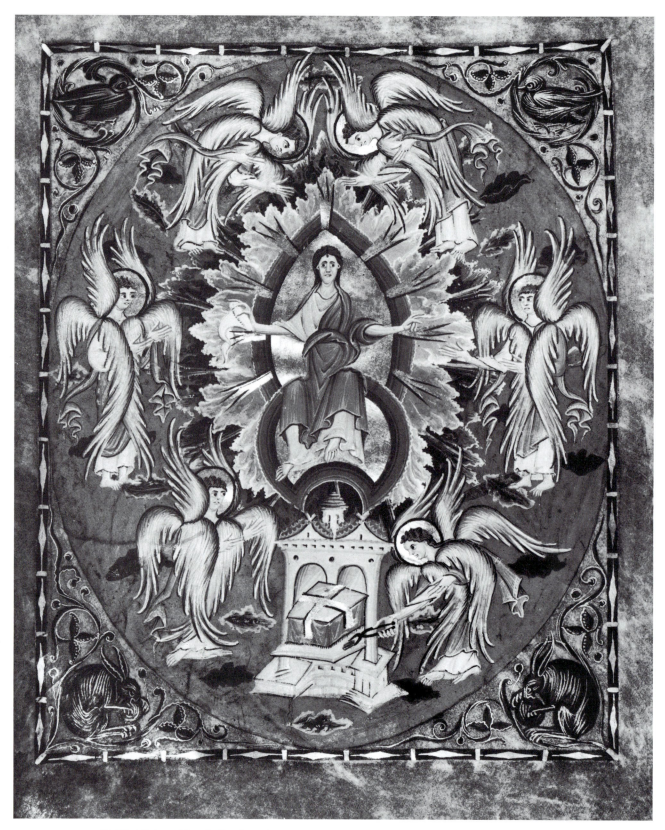

22. The Vision of Isaiah. Bamberg Commentaries, *c.* 1000. Bamberg, Staatsbibl., MS Bibl. 76, f. 10v

ISIO

23. The Vision of Isaiah. Bamberg Commentaries, *c.* 1000. Bamberg, Staatsbibl., MS Bibl. 76, f. 11

It may be said at once that these manuscripts are truly imperial in the majesty of their art with its brilliance of movement and its colours which seem to belong to a heavenly world, and in the majesty of their theme which is the glory of God in His own kingdom, the glory of His imperial Majesty, and the glory of the Church. The double-page illustration of Isaiah *22,23* presents the vision of the prophet (Isaiah 6:1-12) in which Isaiah, seeing God enthroned in heaven surrounded by six-winged seraphim, receives his mission to preach and has his lips purged by the glowing coal which one of the seraphim takes from the altar. Heaven is depicted by a background of cool sea-green light against which sits the youthful God (surely envisaged as the Son) in a golden mandorla from which springs a wreath of light blue and pink leaves. This wreath is a formation of clouds, like the effects of cloud and light described in Ezekiel (10:4): 'and the house was filled with the cloud, and the court was full of the brightness of the Lord's glory'. Into every leaf shoots a forked ray of light in gold, as if to illustrate the words of the Apocalypse (4:5): 'and out of the throne proceeded lightnings and thunderings and voices'. Around the throne are placed the seraphim, seeming to be still in themselves, but possessed of wonderfully rhythmic wings.

The left-hand side of the Daniel double-page depicts the prophet's interpretation of Nebuchadnezzar's dream (Daniel 2:31-45), and the famous image whose head was of gold, breast and arms of silver, belly and thighs of brass and feet of iron and clay. A stone, cut out without hands 'smote the image upon his feet that were of iron and clay and brake them in pieces'. Daniel interpreted this figure to represent four kingdoms, Nebuchadnezzar's own and the three which would come after it. The classic medieval interpretation of these kingdoms was derived from Jerome; they were the four great empires of the world, Babylonian (Assyrian), Mede and Persian, Greek (Alexander) and Roman. The fourth kingdom, said Daniel, would be as strong as iron, but it would be divided. It would be partly strong, and (its toes being part of clay) it would be partly broken. The Jerome gloss at the relevant point in the Bamberg text says that at first the Roman Empire was the strongest, but at the end none was weaker.[42]

Next to this apparition stands the figure of Christ on a high mountain. With his cross as a banner of victory and angels floating on either side of him as if receiving him into heaven, there is an obvious debt here to Ascension iconography, amidst the originality of this miniature. One naturally interprets this figure as Christ, for another gloss in the manuscript, on the stone cut without hands which is here illustrated, says that it represents Christ born without human intercourse, who, with the passing of all kingdoms, became a great mountain and filled the earth.[43] Moreover a very similar figure, clearly the risen Christ, occurs together with the symbol of the evangelist Matthew, within the lunette of the Matthew *20* portrait page, in the Reichenau Pericopes Book (Clm. 4454) of about the same date as, or a little later than, the Bamberg Commentaries.[44] Yet one

34

might be tempted to think that it represented the Church, *Ecclesia*. Banner and crown, the crown deriving very much from *Ecclesia* rather than from Ascension iconography,[45] could both be accoutrements of *Ecclesia*; they seem to give the figure a calculated ambiguity as between *Ecclesia* and Christ. The mountain itself, 'a towering, cactus-like pile, made up of individual bulbous components' (in Fischer's description), albeit symbolizing Christ, must also be an image of the Church.[46] 'And in the days of these kings', says Daniel 2:44, 'shall the God of heaven set up a kingdom, which shall never be destroyed: and the kingdom shall not be left to other people, but it shall break in pieces and consume all these kingdoms, and it shall stand for ever.' This is what the mountain represents in the Daniel illustration, and the passage was assumed by later commentators to refer *24* to the Church. The whole picture is in effect an apotheosis of the Church whose head is Christ.

The right-hand page depicts Daniel's vision of an angel (Daniel 8:15): *25* 'When I, Daniel, had seen the vision and sought the meaning, then behold, there stood before me as the appearance of a man ... he said unto me, Understand, O son of man: for at the time of the end shall be the vision'. As in the case of Isaiah, vision on the left-hand page is balanced by mission on the right. Vision and mission were both themes close to the heart of Otto III.

The double-page illustration to the Song of Songs is a magnificent de- *Col.Pls. II,III* piction of the earthly Church passing on its way to fulfilment in heaven. The left-hand page has a Crucifixion in the top right-hand corner; only *Col.Pl. II* through the death on the cross can men and women pass to their salvation. Christ, albeit in a near full-length tunic and not just in a loin cloth, is shown dead on the cross with blood flowing from His side. Next comes *Ecclesia* with her banner, passing a chalice with Christ's blood to another woman: 'for thus saith the Lord God of Israel unto me, take the wine cup of this fury at my hand, and cause all the nations to whom I send thee to drink it' (Jeremiah 25:15). Then come three women, doubtless the three women at the tomb, who were the first human beings to witness the saving effects of Christ's Passion on the morning of His Resurrection. These figures stand at the head of a long, snaky queue up to the cross, formed by priests, monks and laymen, of all ages to emphasize their universality, with the rear brought up by four youthful kings. The queue emanates, suitably enough, from a baptismal font, at which St Peter stands performing a baptism. From baptism does the salvation of every member of the procession, which winds its way round from the font, take its origin. Apart from the person actually in the font, St Peter's cleansing services are awaited by three young men, whose eager looks and dark-coloured flesh suggest that they are badly in need of them. The queue walks on a cloud of billows, which encloses a rusty red background of various shades, as if one were looking down from it towards the red-coloured earth; while outside the billows the background is a shaded cool blue, as if to suggest the unearthly atmosphere through which the Church passes on its pilgrimage towards its heavenly homeland.

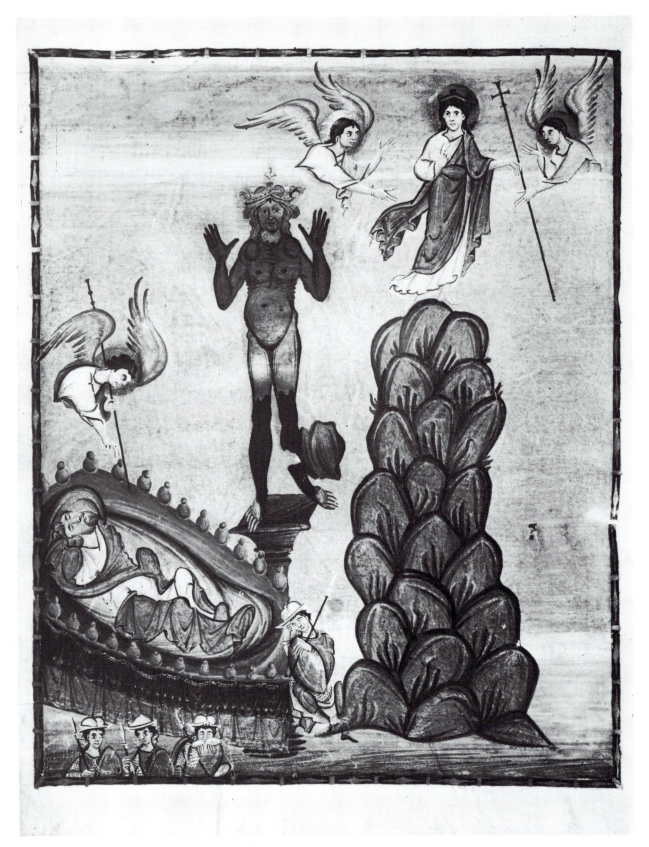

24. The Vision of Daniel. Bamberg Commentaries, *c.* 1000. Bamberg, Staatsbibl., MS Bibl. 22, f. 31v

25. The Vision of Daniel. Bamberg Commentaries, *c.* 1000. Bamberg, Staatsbibl., MS Bibl. 22, f. 32

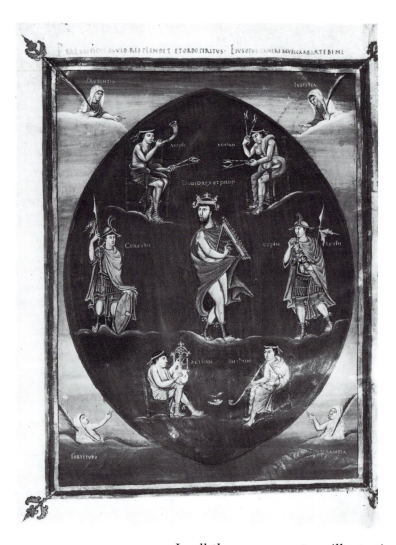

26. David dancing. Vivian Bible, Tours, *c.* 846. Paris, BN, MS lat. 1, f. 215v

In all these commentary illustrations we seem to be dealing with very original iconography. Isaiah and the Seraphim, it is true, are depicted in the Vivian Bible, a magnificent Carolingian Bible clearly known to Ottonian artists.[47] But the Daniel looks like nothing so much as a series of improvisations from the Life of Christ, Nebuchadnezzar himself reminiscent of Joseph's dream,[48] his sleeping guards of those at the tomb in Resurrection iconography, *Ecclesia*/Christ of Ascension scenes, and the angel appearing to Daniel (as scholars have noted) of representations of Matthew with his symbol, particularly as in the Aachen Gospels.[49] Nothing, however, looks more strikingly unusual than the Song of Songs illustration with the procession of the Church between earth and heaven. No doubt we are a long way here from anything which could be called a model, but we must reckon that our artist was a person of high visual awareness by no means impervious to earlier works of art, and I would propose various sources of inspiration working on each other in the composition of this page.

38

First, there is the Vivian Bible, made at Tours (846-51) for Charles the
Bald (Paris, BN, lat. 1). This manuscript belonged during Ottonian times
to Metz Cathedral, and Metz was an important literary centre of the Gorze
Reform. The mutual advance of Ottonian art and the Gorze Reform (see
Part I, pp. 83 - 88) is reaffirmed by the fact that the Reichenau artists clearly
knew this manuscript. Its influence is particularly in evidence within the
artistically close-knit group of manuscripts consisting of the Aachen Gos-
pels, these commentaries and also the Bamberg Troper (MS Lit. 5). The
Unveiling of Moses in the Vivian Bible has been seen as a prototype for
the evangelists, with scrolls held above their heads by their symbols, in
the Aachen Gospels.[50] We have mentioned that the same Bible provides a
Carolingian precedent for the Ottonian Isaiah iconography. Here we may
compare the colour scheme of the Song of Songs page with that of the
Dancing David in the Vivian Bible.[51] Both are based primarily on a com- *26*
bination of deep blue with various shades of pink. True that the tones are
not exactly matched and that in the Vivian Bible the inner area of the
picture is blue and the outer pink while in the Bamberg manuscript it is
the reverse. But looking at the two pages, it is hard not to think that the
Bamberg artist had seen the Vivian Bible and been affected by its colours.

Second, the grouping of standing figures in circular or semi-circular
form was common in Carolingian art. One example again is the Vivian
Bible, where courtiers and monks, represented with a liveliness similar to
that of the members of the *Bamberg* procession, stand round the seated *Part I,30*
Charles the Bald.[52] Another example comes from the Lorsch Gospels of
the early ninth century where, to illustrate a passage in the *argumentum* *27*
to St Matthew, the ancestors of Christ are illustrated, saluting Him with
outstretched hands. They are arranged in three groups of fourteen each.

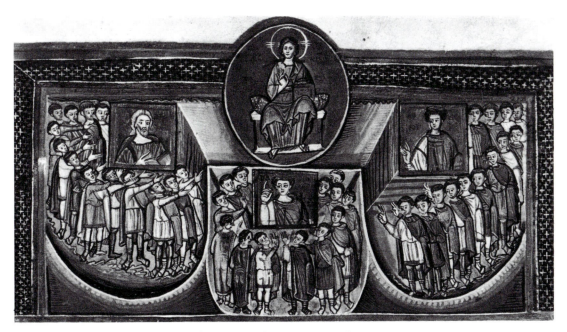

27. The Generations of Christ, St Matthew. Lorsch Gospels, *c.* 815. Alba Julia, Bibl. Doc. Batthayneum, f. 14

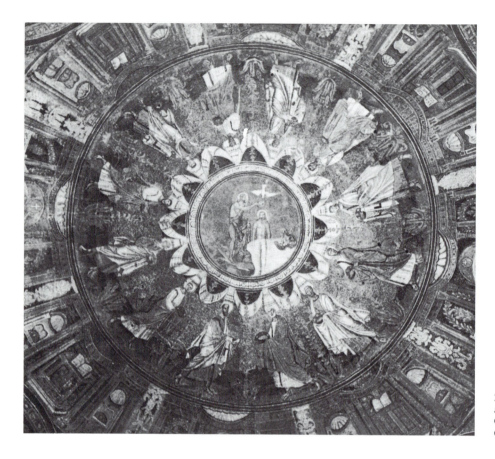

28. Baptism of Christ,
and the Twelve Apostles.
C5 Mosaic in the Dome of the
Orthodox Baptistery, Ravenna

The group of ancestors around David, immediately below the seated Christ, has particular affinities as a composition to the bottom half of the Bamberg miniature.[53] Now Köhler showed that the Lorsch Gospels, a late manuscript of Charlemagne's Court School, was the very model used by the Reichenau artists at the outset of their revival of book art under the Ottonians. Moreover Otto III himself had close connections with Lorsch. He stayed at the abbey as a boy in late September 992, perhaps on a hunting visit, and shortly afterwards Abbot Salmann of Lorsch was sent as Theophanu's legate to Pope John XV. Salmann was again in Rome in 998, with Otto III. A conflict occurred when Otto tried to place Lorsch under the protection of Bishop Franco of Worms, but in 1000, while Otto made a long stay in the Hohentwiel, he granted privileges, including mints and markets, to Abbot Werner of Lorsch.[54] So the emperor and members of his entourage could well have seen the Lorsch Gospels themselves.

Thirdly, it is worth considering the Orthodox and Arian baptisteries of Ravenna. Both of these are circular domed buildings of the fifth century, and the mosaics of both domes depict the twelve apostles standing round the base of the dome. If one thinks of the billow cloud in the Bamberg manuscript as representing the base of a dome (albeit extended at the top to make a figure of six), and of the onlooker gazing through the dome to the dusky red earth below, with the cool blue air on its outside, one can, I believe, see how the artist could have adapted the perspective of the

28

40

Ravenna domes to serve his purpose. The apostles stand on slightly undulating terrain in the Arian Baptistery, but the billow cloud might also have been suggested by the billowing curtain between each apostle in the Orthodox Baptistery. It is true that the Bamberg manuscript does not depict the twelve apostles but the *Heilsgemeinde*, the community of the whole Church, or the heavenly city. Following the idea, however, that we have only a suggestion from one scheme to another here, one suggestion not exclusive of another as each worked on the artist's mind, the apostles were often taken in exegesis to signify the *Heilsgemeinde*.[55] There was, also, another line of thought which might have caused the Ravenna apostles to suggest the Bamberg procession. This was expressed, for example, by the Carolingian Haymo of Halberstadt in his commentary on the Apocalypse. He pointed out that the twelve stars in the crown of the heavenly woman signified the twelve apostles, through whom all peoples came to believe in Christ.[56]

Nothing could in general be more natural than the influence of Ravenna on Ottonian art. It was an important stopping place both of Otto II and of Otto III and their courts;[57] three of Otto III's protégés were in succession archbishops of its see: namely St Romuald, Gerbert of Aurillac and Abbot Leo of S. Alessio. Near Ravenna at Pereum was one of Otto III's missionary training centres; and to his hero Charlemagne Ravenna had already been a fundamental source of artistic and architectural inspiration for his work at Aachen.[58] Hitherto art historians have by no means ignored the possibly direct effect of Ravenna mosaics on Ottonian manuscripts, least of all when considering the Gospel Book of Otto III. The sheep drinking from springs of water at the foot of the Luke evangelist picture have been likened to a *18* mosaic at San Vitale; Otto III seated in Majesty and the procession of *Part I,Col.Pls.* women approaching him have been compared to the Epiphany and a *XX,XXI* procession of saints at Sant' Apollinare Nuovo.[59] The Sant' Apollinare processions could indeed have been in the mind of our artist. But the idea that in the Bamberg Song of Songs we are dealing in particular with the inspiration of the Ravenna baptisteries is greatly strengthened by St Peter's performing a baptism virtually in the centre of the scene. For the central mosaic at the top of the dome in each baptistery has as its subject the Baptism of Christ by John the Baptist. Both at Ravenna and in the Bamberg manuscript, therefore, it is baptism which gives meaning to the whole scenes; Christ's charge to the apostles, 'go out and teach all nations, baptizing them in the name of the Father and of the Son and of the Holy Ghost', is the central theme of each work of art. We must think of the Bamberg picture as a kind of baptistery on a flat surface, in which the sons and daughters of mother Church pass as it were through a domed space on their journey to heaven.

The main point of our picture as an illustration of the Song of Songs is clear, therefore. By the Bride, the Song of Songs signified the Church, as the gloss in our manuscript on the verse, 'behold thou art fair, my love', (Cant. 4:1) stresses. The gloss reads, 'the peace of Holy Church flowers in

its holy virtues and is multiplied in its spiritual progeny'.[60] There are, however, interesting problems of detail. Everyone agrees, for instance, that the figure next to the cross is *Ecclesia*, and the motif of her catching the blood flowing from the side of Christ in a chalice goes back apparently to the ninth-century Metz Drogo Sacramentary (Paris, BN, lat. 9428) and the Utrecht Psalter.[61] But who is the woman who receives the chalice from her hand? There is some doubt about this, Gertrud Schiller saying elusively that *Ecclesia* offers the chalice to *'der ersten der geistlichen Jungfrauen'* (the first of the sanctified women).[62] Surely there can be no doubt that this is Mary, the first (by anticipation) to experience the saving effects of Christ's redemption. The Sacramentary of Bishop Sigebert of Minden (1022-36) *59* shows the bishop passing a chalice over the altar to *Ecclesia* and next to *Ecclesia* stands a woman who can in this case hardly be other than Mary, as a type of the Church (see p. 92). This Sacramentary seems to be another example, therefore, of how *Ecclesia* and Mary may be shown together. The association of Mary with the three women at the tomb, on her other side, may be suggested by the Acts of the Apostles (1:14): 'these (the apostles) all continued with one accord in prayer and supplication with the women and Mary the mother of Jesus'.

If the woman next to *Ecclesia* is indeed intended as Mary, the fact is not without significance. For while Ambrose had interpreted the Bride in the Song of Songs as Mary, this line of approach had been almost completely abandoned in the Dark Ages, not to reappear until Rupert of Deutz in the early twelfth century. Not only was the Mariological significance totally lacking in Bede's commentary, for he interpreted the Bride as the Church, but it was once even explicitly repudiated, and the Carolingian commentaries are no different. From 850 to about 1050 there was in fact no single new interpretation of the book at all. Ohly, the author of a learned study on Song of Songs commentary, takes such a lack as a bad sign, and confides to us, albeit in a footnote, that this was a time when the sources of mystical power in the religious life of the West dried up.[63] Otto III would certainly have been surprised to hear it! There would be something in the observation only if one took the composition of speculative theological works as the principal yardstick of mystical power. Our picture is the kind of evidence which enables us to make a less gloomy estimate of the religious state of the West in an age not much given to literary theologizing. For it must show a certain interest in and sensitivity to religious themes when the Marian theme, overlooked in this manuscript by the whole tenor of the Bedan glosses, is allowed to creep into its art, and thereby no doubt to help keep alive an idea which would become very powerful again later.

Another problem about our picture is why there are kings and why they bring up the rear in the procession making its way towards heaven. Hans Fischer, the former librarian of Bamberg, doubted that these were kings, contrasting the type of crown which they wear with that in which *29* Otto III is generally represented (Type A), and comparing it with that of *30* the 24 Elders of the Bamberg Apocalypse (Type B) as a vaguely honorific

symbol.[64] This argument is critical and salutary, but an analogy may show that it is not so easy to dispose of these four persons. The Magi as depicted in art first came to be assigned crowns in the ninth century but more commonly in the tenth.[65] In the Sigebert Sacramentary whose style is Liuthar-derived, they wear Type A; in the Pericopes Book of Henry II, of the Liuthar Group of manuscripts, they wear Type B. This suggests that one can attach too much significance to different types of crowns.[66] It would be hard to believe that the four crowned figures in the Bamberg Song of Songs were there for any other reason than to typify earthly rule, particularly as there are four of them. This gives a natural correspondence with the four empires of the world typifying earthly rule in the Book of Daniel, the Bamberg manuscript of which is so closely connected with that of the Song of Songs.

As to why the kings bring up the rear of the procession, this is a great puzzle. It must be remembered that our artist appears to have been in the situation of improvising his own iconography, and as with the Ravenna baptisteries, I propose something which can have done no more than yet again have suggested an idea to him. There is in the Pommersfelden Prayer Book of Otto III (MS 347, see Part I, p. 173) a Prayer to the Apostles. Given what has already been said about the apostles in the Ravenna baptisteries and the association of ideas between the apostles and the *Heilsgemeinde* here represented, one might be forgiven for supposing that one was on the right kind of track with this prayer. After invoking the names of all the apostles (fourteen of them according to the list of Eusebius and Jerome) as well as the two evangelists who were not also apostles,[67] it concludes, *Orate pro me ut abstrahat me dominus a mundo sicut abstraxit vos et donet mihi sequi vestigia sua vel in extremo agmine vestro* (pray for me that the Lord may draw me away from the world as he drew you, and that he may grant to me to follow in your footsteps *or in the rear of your column/procession*).[68] There is no need to suppose that this prayer could only have been known from Otto III's Prayer Book, since it features in the collection of prayers attributed to Alcuin, and it can also be found in the Prayer Book of Archbishop Arnulph II of Milan, in a little known collection of prayers in the tenth-century Fulda manuscript of *Saints' Lives* now at Hanover (see p. 139), and, best of all, in the little collection of prayers (integral to the original manuscript) at the end of the Psalter of Archbishop Egbert of Trier.[69] Obviously it was a well-known prayer, a favourite choice in tenth-century anthologies of private prayers. But as the prayer of an emperor or king, in Otto III's Prayer Book, it would nicely explain why rulers feature in our picture, and why they feature in the particular position which they occupy at the rear of the column. Once again we are drawn back to the religious culture of Otto III.

In this remarkable and highly original illustration of the Song of Songs, therefore, the worlds of Ravenna mosaics, Carolingian Bibles and gospel books and Ottonian prayer books all seem to have played their part in the visual and religious consciousness of the artist.

29 & 30. Magi with Crowns.
Type A (*above*), Sigebert Sacramentary, 1020-36. Berlin,
MS theol. lat. fol. 2, f. 19v
Type B (*below*), Pericopes Book of Henry II 1002-14. Munich, Bayerische Staatsbibl., Clm. 4452, f. 17v

The Bamberg manuscript of the Song of Songs also contains the text of the last verses of the Book of Proverbs (31:10 ff.), which begin, 'Who can find a virtuous woman? For her price is far above rubies'. The gloss comprises the whole text of Bede's commentary on these verses, which came to be detached from his commentary on Proverbs as a whole and to pass as a separate tract under the title *De Muliere Forti*, the Virtuous or the Strong Woman. In fact the Bamberg manuscript must rank as the earliest known manuscript version of the separated tract, by more than a century.[70] It will be noticed in our illustration that while the figure of *Ecclesia* is graceful, the face is given a somewhat stern and masculine *Col.Pl. IX* appearance. The same is true of the *Ecclesia* in the Aschaffenburg Pericopes Book (MS 2). The masculine *Ecclesia* par excellence in Ottonian art, described by one writer as *kämpferisch* on account of her pugnacious face and *31* posture,[71] is that in Sigebert of Minden's Sacramentary (Berlin, East, Staatsbibl., MS theol. lat. fol. 2). It may well be that this was the Ottonian way of depicting the Church as the *mulier fortis*. Our picture must be taken to be an illustration of the tract as well as of the Song of Songs. Its beginning fits the illustration well:

> The *mulier fortis* is called the Catholic Church,
> which John is said to have seen in the Apocalypse
> arrayed with the sun; a woman because she has
> given birth to spiritual sons in God through
> water and the Holy Ghost, strong because she
> spurns the success and adversities of the world
> for the faith of her Creator.

Its ending and the *two* Song of Songs illustrations fit together with quite particular appositeness;

> The sons of the Church will rise at the last
> day and will be given immortality in the flesh;
> the glory of the resurrection then will reveal her
> praises. Her sons will be led *through the air of*
> *this world to the heavenly kingdom* [my italics].[72]

Col.Pls. II,III This is exactly what is happening in the Bamberg double-page opening of folios 4 verso and 5 recto. On the left the sons of the Church are passing through the air (as we have said) of this world. On the right they are being led by an angel (who on arrival is conversing with a heavenly colleague) up the final ascent into heaven. Heaven is completely golden. Nothing in the whole of Ottonian art is more dramatic than the contrast here between the left-hand page with its dusky red and airy blue, and the right-hand page with its deep shimmering gold, between the somewhat straggling group of humans and the martial order of the nine choirs of angels in heaven, between late antique traditions of illusionism and Ottonian inventiveness in the use of gold. This right-hand picture could represent the nine choirs of angels, notwithstanding the limited manu-

script circulation of John Scotus Eriugena's Latin translation of Pseudo-Dionysius before the twelfth century.[73] The Cherubim and six-winged Seraphim must be above and to the side of Christ seated in Majesty, while the Thrones hold up a footstool at his feet. The six lesser choirs are grouped round the mandorla, the Virtues, Principalities and Powers, the Dominations, Archangels and Angels.

As a postscript, it might be observed that the female *Roma*, with shield and lance, on the reverse of Otto III's *bulla* with the legend *Renovatio Imperii Romanorum*, is somewhat reminiscent of the *mulier fortis*.[74]

4 The Millennium

Here, then, is a group of manuscripts probably dating from 998 to 1002 and all belonging to the Emperor Otto III. Are they, as a group, connected with the millennium? To raise the question may be to risk sensationalism. But given their stress on contrition, penance and purification, the apocalyptic character of the evangelist portraits, the highlighting of certain millenniaristic themes, and the recurrent eschatological interest, it would be disingenuous to ignore it. Yet attractive as the easy connection is between art and the millennium, there are powerful reasons why it should be resisted. In the first place, the development of imperial ideology led naturally, always of itself, to eschatology in the Middle Ages. In such ideological soil eschatology had no need for the artificial fertilizer of a significant date in order to flourish. This can be seen from Podskalsky's work on Byzantium.[75] Byzantine scholars took a considerable interest in the four empires of Daniel, and in 969, well before the millennium, Liudprand of Cremona describes a genre of apocryphal Daniel visions to which this interest had given rise, containing prophecies about emperors and how long they would live.[76] Of course he affected to despise this literature, which he branded as Sibylline and hence pagan, but his protestations carry about as much conviction as those of persons who thrust a tabloid newspaper from them in disgust after an avid perusal. On the occasions when Byzantine writers did bring forward the problem of the millennium in particular, they tended to deny its significance for their own empire, and rather to use it as a stick with which to beat the Jews. It was the empire of the Jews (beginning with David), said the author known as Pseudo-Athanasius Sinaites, writing in the ninth or tenth century, which had come to an end with the Roman conquest after one thousand years; whereas the last empire of Daniel, the Roman Empire which the Byzantines viewed as theirs, would remain regardless of numbers of years until the second coming of Christ. The study of Josephus, whose *Jewish Wars* dealt with the fall of Jerusalem and the end of the Jewish state, was relevant to this line of argument, so it is worth noting that Otto III had a Josephus manuscript which ended up at Bamberg (Class. 79). This has a frontispiece similar to that of the Gospel Book of Otto III, albeit not of the quality, though there can be no certainty that it was originally intended for this manuscript (see p. 217).[77]

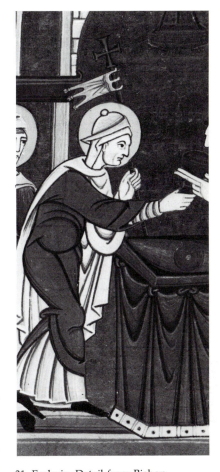

31. Ecclesia. Detail from Bishop Sigebert of Minden celebrating Mass. Sigebert Sacramentary. 1020-36. Berlin, Staatsbibl., MS theol. lat. fol. 2, f. 9

In the second place, Augustine of Hippo, discussing the *Regnum Christi* of one thousand years in a celebrated passage of the *City of God* (20:9), had attributed a purely mystical significance to the number one thousand, and hence the precise time of Christ's second coming could never be known. Ottonian churchmen were good Augustinians. Their official doctrine was that the end of the world could not be foretold in its exact time and that the Antichrist, whose appearance marked the end, could be staved off by a strong Empire and Church. It is worth repeating the oft-quoted Lotharingian Adso of Montier en Der, writing his *Liber de Antichristo* for Otto I's sister Gerberga between 949 and 957:

> The Apostle Paul says that Antichrist will not
> come into the world unless the apostasy comes first,
> that is unless all the kingdoms which long ago were
> subject to the Roman Empire secede from it. This
> time, however, is not yet come, because even though
> we see that the empire of the Romans is for the
> most part destroyed, nevertheless as long as the
> kings of the Franks, who possess the Roman Empire by
> right, survive, the dignity of the Roman Empire will
> not perish altogether, because it will endure in the
> Frankish kings.[78]

These apocalyptic books, rightly understood, were not really about the end of the world in the year 1000, except in the negative sense that they pointed up the wrong-headedness of the whole notion.

This negative sense is again admirably expressed by Abbo of Fleury in a letter which he wrote to Kings Hugh and Robert, the West Frankish Capetians, in 998, making an *apologia* for himself and his theological opinions:

> About the end of the world: once in my youth I heard
> a sermon in a Paris church, to the effect that as
> soon as 1000 years were over the Antichrist would
> come, and that not long afterwards would follow the
> universal judgement. I have resisted this preaching
> to the best of my powers from the Gospels, the
> Apocalypse and the Book of Daniel. Finally my Abbot
> Richard of blessed memory acutely attacked the error
> which had grown up about the end of the world; and when
> he received letters from the Lotharingians about it he
> ordered me to reply to them.[79]

Thus grouped together, the Gospels, the Apocalypse and the Book of Daniel might almost be the same programme as that of Otto III's Bamberg manuscripts!

It may be thought that with this letter of Abbo of Fleury, nicely as it fits our manuscripts with regard to scriptural books and date, we have im-

ported evidence remote from the imperial milieu to illustrate the possibly anti-millenniaristic intentions of the imperial manuscripts. But it is not remote at all. In general, although the Cluniac movement which included Fleury made little impact on the East Frankish kingdom in the tenth century, the Ottonians encountered it in Rome where it had been introduced by Odo of Cluny at the invitation of Alberic.[80] Another link was Odilo of Cluny's dedication of his Commentary on St Paul to Otto III.[81] Otto III seems to have secured from Rheims, presumably through Gerbert of Aurillac, a copy of Abbo of Fleury's commentary on Victorius of Aquitaine's *Calculus*.[82] In art, Fleury as well as Reichenau experienced a common Carolingian influence, for the early eleventh-century Reichenau Pericopes Book (Munich, Clm. 4454), formerly a Bamberg manuscript, has the most unusual feature of the zodiacal signs in the lunettes of its last six canon tables; this finds a parallel in a late tenth-century West Frankish manuscript localized by Nordenfalk at Fleury in connection with Abbo (Baltimore, W 3).[83] Furthermore, the reference in Abbo's letter to the Lotharingians also attaches it to an imperial milieu. By far the most relevant connection between Abbo of Fleury and imperial circles for our present purposes, however, is Abbo's visit to Rome in 997, the year before his letter, to deal with the question of the Rheims archbishopric on behalf of King Robert the Pious. He secured a pallium for Archbishop Arnulph and at the same time a privilege for Fleury. He spent eight days with Pope Gregory V, Otto III's uncle, at Spoleto, during which the two men got along very successfully together.[84] They could have spent happy hours talking about the Gospels, the Apocalypse and the Book of Daniel, and they would have shared much common ground about the kind of cooperation needed between secular and ecclesiastical authorities in order to hold the Antichrist at bay.

It would be simple to point out that the Bamberg Apocalypse, at least, probably dates from after 1000, and that this fact alone must show that the programme of this group of manuscripts as a whole could not be positively millenniaristic. But that would be over simple. Who can say what momentum is generated by millenniaristic fears and anticipations once aroused in whatever way? The idea of the universal sigh of relief after the passing of the crucial date, as if a siren were sounded and everything returned at once to normal, is surely a great crudity, whether enunciated by medieval or modern historians. Moreover, even if it is true that Otto III's court and the painters of these manuscripts are more likely to have been against than for attaching any significance to the year 1000, we should beware of underrating the millenniarism of the manuscripts in the more general sense of their reflecting a feeling of the imminence of the end of the world. The more emphatically churchmen stressed that men could never know the exact times and seasons ordained by God, the more *strongly* they often felt that they were living in the last days of the world. Pope Gregory the Great and the Venerable Bede were amongst the authors most familiar to educated Ottonians; for both writers the sureness of God's

purposes combined with the uncertainty of his timing only heightened their sense of impending doom. Nor should we pass over a point which may seem small, but represents the kind of factor which can have an effect on political sentiment at the time out of all proportion to its triviality as it appears retrospectively. It was a commonplace of apocalyptic and Sibylline literature that the Antichrist or evil one, signalizing the end of the world, would come from the East.[85] He would be a Babylonian, and Otto III's hero Charlemagne had castigated the Byzantine Empire for its Babylonian pride in the *Libri Carolini*.[86] Now John Philagathos, the anti-pope of Crescentius in the Roman rising of 998 against Otto III, who was punished by Pope and Emperor with a savagery which neither their own former close relationship nor the pleadings of St Nilus could restrain, had the support during this time of the Byzantine Emperor, Basil II.

There are those who seek to maintain that fear of the end of the world in the late tenth century was a mere romanticizing fiction of nineteenth-century historians. The argument is not too convincing. Bruno Barbatti, for instance, overlooks the novelty of such a Last Judgement as appears in the Bamberg Apocalypse, and fails to note that while Abbo of Fleury writes against millenniarism, his letter is evidence that there was something to contend with, something which could carry to a Parisian pulpit.[87] Furthermore, responsible churchmen might argue against the teaching of millenniarism, but that by no means excluded them from a share in its mood. If the Bamberg manuscripts were anti-millenniaristic, then the method of inoculation was to administer a moderate dose of the germ itself.

We say that Ottonian churchmen believed it possible to stave off the Antichrist with a strong Empire and Church. With Adso of Montier en Der in the 950s, however, we hear nothing of the Church; it is the Roman Empire, upheld through a Frankish ruler, which will prevail. By now it will be obvious that what characterizes the Bamberg manuscripts, in contrast to Adso, is the emphasis time and again on the Church. Here it is very much the combination of strong Emperor and strong Church which will hold the Antichrist at bay. The idea of the Church has come flooding into these manuscripts.

Do we say, with Walter Ullmann in one of his most brilliant passages, that in this way Otto III sowed the seeds of his own (viz. his Empire's) destruction? That if he claimed to be the divinely appointed leader of a universal body politic which was both Roman and Christian, the question was bound to arise sooner or later whether the Emperor rather than the Pope was 'functionally qualified' to lead such a body whose substratum was a spiritual element, the Christian faith? Was not 'his own Romanism' the tacit acceptance of the papal theme?[88] Perhaps in the long perspective of history. But Otto III was unable to study Pope Gregory VII (1073-85)! He had little reason to see a strong emperor and a strong pope as presenting him with a dilemma.

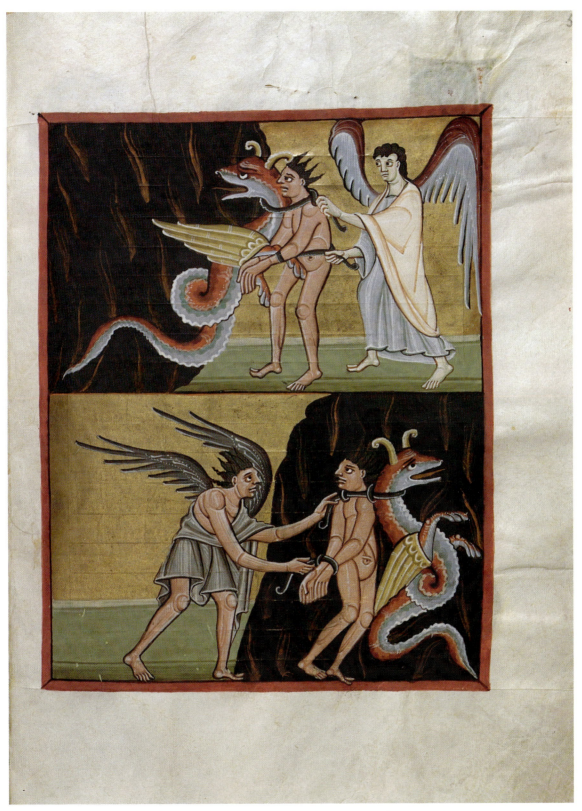

I. The Beast and the False Prophet. Bamberg Apocalypse, *c.* 1001.
Bamberg, Staatsbibl., MS Bibl. 140, f. 51

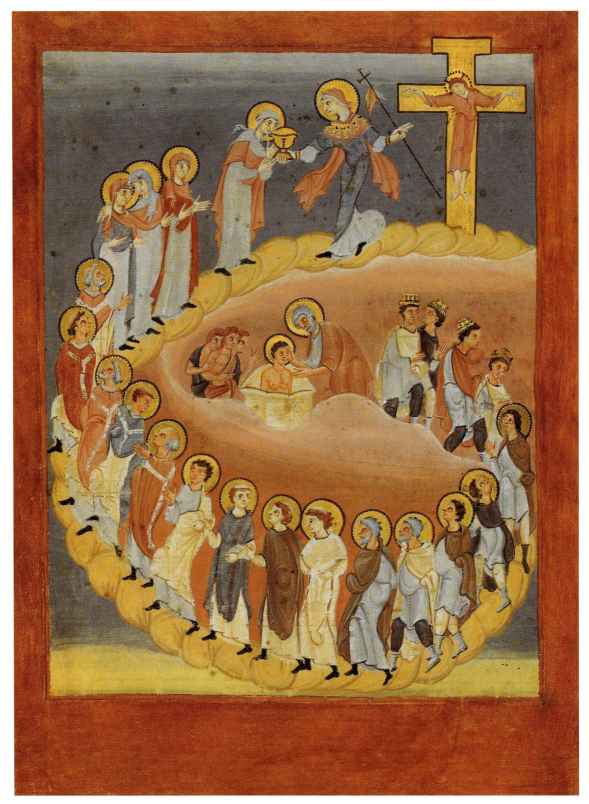

II. Procession of the Baptized to Heaven. Bamberg Commentaries, *c.* 1000.
Bamberg, Staatsbibl., MS Bibl. 22, f. 4v

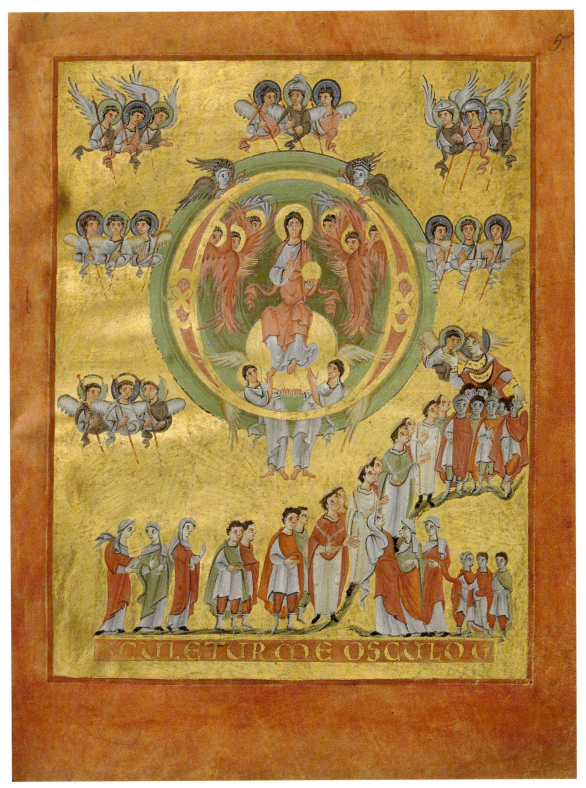

III. The Arrival of the Baptized in Heaven. Bamberg Commentaries, *c.* 1000.
Bamberg, Staatsbibl., MS Bibl. 22, f. 5

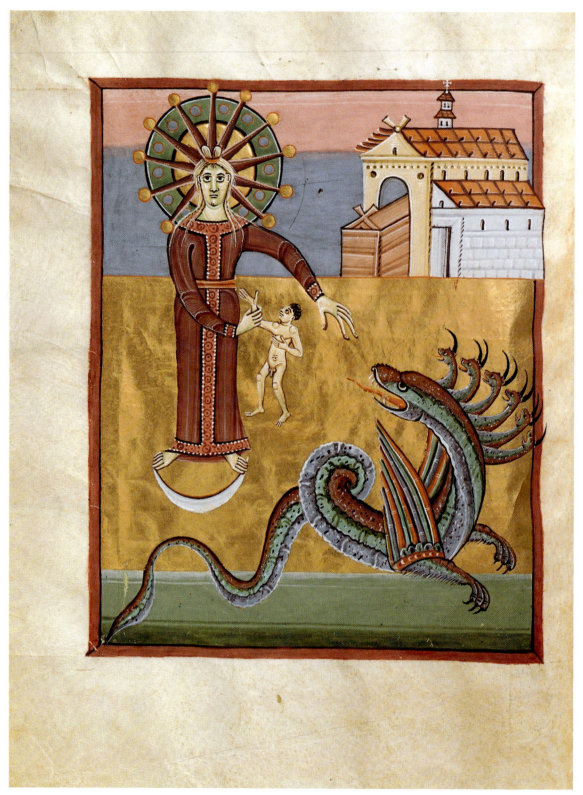

IV. The Woman in the Sky. Bamberg Apocalypse, *c.* 1001.
Bamberg, Staatsbibl., MS Bibl. 140, f. 29v

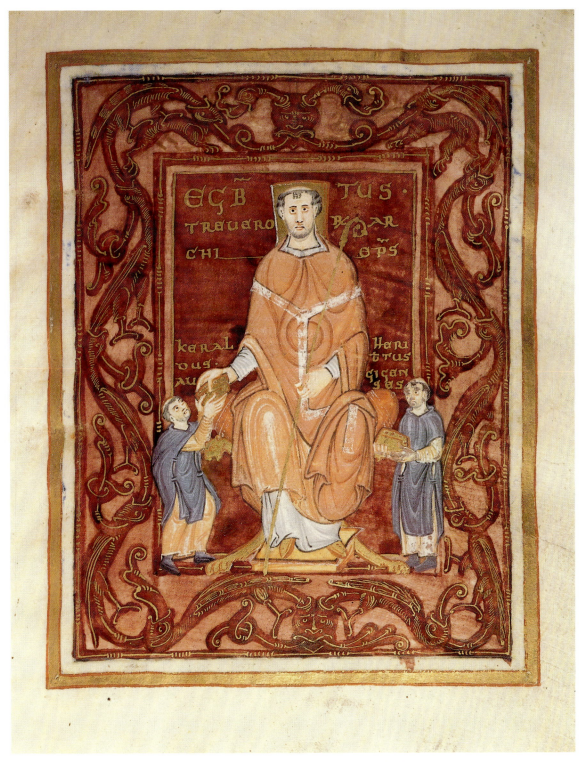

V. Archbishop Egbert of Trier. Frontispiece of Codex Egberti, 977-93.
Trier, Stadtbibl., MS 24, f. 2

sco est Pariet autem filium · et uocabis nomen ei
ihm · Ipse enim saluum faciet populum suum · a
peccatis eorum ·

IN NOCTE · STATIO · AD SCAM MARIAM
SEQUENTIA SCI EUANGL · SECDM LUCAM

N ILLO TEMPRE · Exiit edictum a caesare
augusto · ut describeretur uniuersus orbis · haec
descriptio prima facta est · a preside siriae cirino
Et ibant omnes · ut profiterentur singuli in suam
ciuitatem · Ascendit autem et ioseph a galilea de ci
uitate nazareth · in iudaeam ciuitatem dauid · quae
uocatur bethleem · eo quod esset de domo et familia
dauid · ut profiteretur cum maria desponsata sibi
uxore pregnante · Factum est autem cum es
sent ibi · impleti sunt dies ut pareret · Et pepe
rit filium suum primogenitum · Et pannis eu
muoluit · et reclinauit eum in presepio · quia
non erat eis locus in diuersorio · Et pastores e
rant in regione eadem uigilantes · et custodi
entes uigilias noctis · supra gregem suum · Et
ecce angelus dni · stetit iuxta illos · et claritas
di circumfulsit illos ·

VI. Gospel for Christmas Night. Codex Egberti, 977-93. Trier, Stadtbibl., MS 24, f. 12v

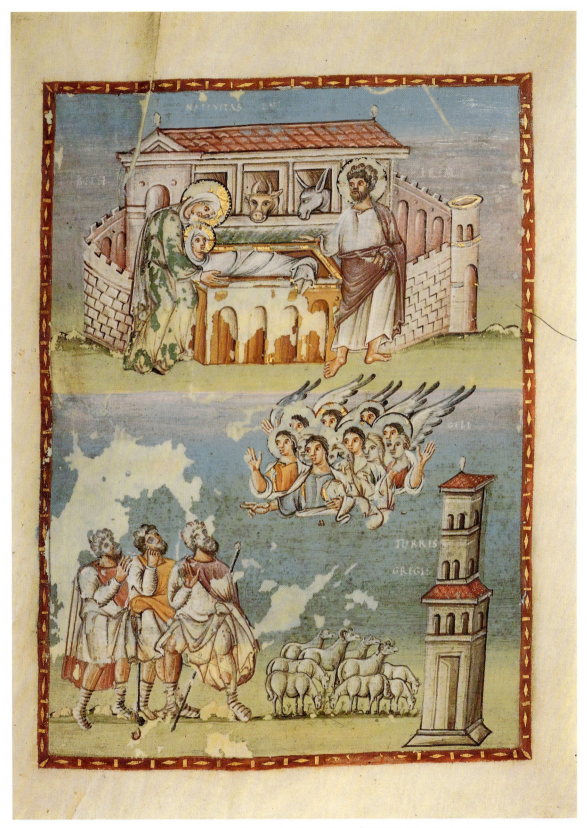

VII. Nativity and Annunciation to the Shepherds. Codex Egberti, 977-93. Trier, Stadtbibl., MS 24, f. 13

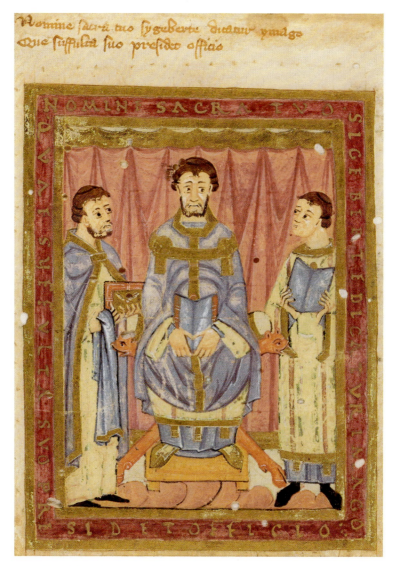

VIII. Bishop Sigebert of Minden seated between Priest and Deacon.
Single leaf of Pericopes, 1022-36. Berlin, Staatsbibl., theol. lat. qu. 3

THE BAMBERG APOCALYPTIC MANUSCRIPTS

5 Leo of Vercelli

One of the most ringing expressions of Otto III's *Renovatio* of the Roman Empire was the poem, *Versus de Gregorio Papa et Ottone Augusto*, composed in 998 by Otto's Italian chaplain, Leo (see Part I, p. 160).[89] He became Bishop of Vercelli in 999, and would doubtless have been considered by Bruno of Querfurt as one of the 'vain and secular men' at Otto's court,[90] particularly as he had a reputation for eloquence. Leo was exceptionally learned in Roman law and antiquity, but he did not put this learning exclusively to secular purposes, and he became apparently mentor of Bernward of Hildesheim, one of the most devout members of Otto's circle.[91] Nearly a century ago, Bloch proved that Leo was the author of some letters about North Italian politics (1015-18) addressed to the Emperor Henry II. He showed that in the same manuscript as these letters there survived a document also composed by Leo listing certain possessions of the church of Vercelli which it had lost and ought to have recovered. Once the authorship of these texts was securely established, they carried with them, on account of characteristic ideas and vocabulary and tricks of style, the draughtsmanship of a string of Otto III's most important documents. These documents included the capitulary against alienating church property and the celebrated diploma granting the pope, whom Otto had himself 'created', the eight counties around Ravenna.[92] Despite the almost romantic attachment of English historians to the notion of Gerbert of Aurillac's influence over the young emperor, the hard evidence suggests that Leo of Vercelli was even more influential in the formulation of Otto III's key policies.

It goes without saying that Leo was an ambitious and self-seeking clergyman. He was also very much an Italian,[93] a fighter for the rights of Italian churches (especially Vercelli) and a believer in the historic role of the city of Rome. But not every Italian could, as Leo did, so wholeheartedly see in Otto III a means to the fulfilment of his dreams and ambitions. By Otto III's time, the dilemma of the Frankish Empire (continued in the Ottonians) was an old one for Italians, and particularly Romans. Was this Empire, ruled by foreigners though always at least ideologically based on Rome, the best way to realize the power and aspirations of Romans and Italians in the old *Regnum Italicum*? Or was it the best way to stifle them? The author of the *Libellus de imperatoria potestate in urbe Romana*, written between 877 and 962, longed for another strong ruler like Charles the Bald who would make Rome 'the head of all Christians'. He would have approved of the Ottonians in Italy. Benedict of St Andrew at Monte Soratte took a very different view in his chronicle. He hated the domination of Rome by foreigners and believed that the Romans themselves were their own best means of renewal.[94] In this dilemma Leo was consistently on the imperial side.

One of the diplomas of Otto III which Leo drafted (or forged) contains words which convey precisely the high view of Otto's, and Leo's own,

Roman policy. In this diploma the Bishop of Vercelli is granted comital rights, 'so that the Church of God may always be free and secure, our Empire may prosper, our crown and its warriors may triumph, the power of the Roman people may be spread far and wide, and its republic may be restored'.[95] These phrases echo to perfection the political note struck by the dedication pages of the Gospel Book of Otto III (see Part I, pp. 158-62).

Leo's poem on Pope Gregory and the Emperor Otto is a celebration of the revival of Rome and of the Church and of the whole world through the collaboration of pope and emperor.[96] Given the stress on the Church in the Bamberg manuscripts it may be pertinent to add that the collaboration is seen very much as a Gelasian one; the pope is the master of all men, and Otto looks after him, watchful and powerful, having the care of souls and wielding the sword on the pope's behalf for the punishment of sins. Leo was no Erastian or Caesaro-papist. Let us take a few soundings from the poem:

> *E domo sponse exiens sicut sponsus rediens*
> *Antiqui patris munera repetis quam dulcia.*

Leaving the house of the bride you return as the bridegroom, and you take back the sweet rights of the ancient father (viz. St Peter).

This refers to Gregory's expulsion from Rome, the Bride being the Roman Church, during the rising of Crescentius when John Philagathos was made anti-pope; and to the pope's return when Otto III put down the rising in 998. The imagery of Bride and Bridegroom comes from the Song of Songs.

> *Omnes orbis ecclesie sunt in tua serie*
> *Babilonia ferrea et aurata Grecia*
> *Ottonem magnum metuunt, collis flexis serviunt.*

All the churches of the world are in your lineage
Iron Babylon and golden Greece
They all fear great Otto and serve him with bended necks.

The reference to Babylon and Greece here is unmistakably to two of the four empires of the world as derived from the Book of Daniel, despite the deviation from the normal associations of empires and metals, perhaps to play up Otto's known predilection for what was Greek or perhaps just for the sake of metre. The last line of our quotation is a reminder of the female personifications of Rome and provinces of Otto's empire who *Part I,Col.Pls.* approach the emperor precisely 'with bended necks' in the Gospel Book *XX,XXI* of Otto III.

50

Vos duo luminaria, per terrarum spacia
Illustrate ecclesias, effugate tenebras
Ut unus ferro vigeat, alter verbo tinniat.

You two luminaries, give light to the churches
throughout the world, and put darkness to flight,
so that one of you flourishes with the sword,
while the other resounds with the word.

The two lights of the world (an image of pope and emperor) are, of course, the sun and the moon, so graphically represented by the vision of the woman in the sky in the Apocalypse, who typifies the Church and who has the sun around her head and the moon at her feet. They were also taken to represent allegorically Saints Peter and Paul.[97] Leo brought forward Peter and Paul in another line of the poem and one must suppose that, Romanist and biblical scholar as he was, he did this deliberately when he wrote that Otto carried the unconquered sword of Christ for the punishment of sinners. For the two standard biblical texts which showed that the worldly sword had been entrusted to the Emperor came, one from St Peter's first epistle and the other from St Paul's epistle to the Romans.[98] Added to this, the style of *servus apostolorum* in some of Otto III's diplomas of 1001 is associated with Leo's draftsmanship.[99] Leo's poem, then, reminds us forcefully of the unique iconography of the Emperor's crowning by Saints Peter and Paul in the Bamberg Apocalypse. 2

The Song of Songs, Daniel, the bended necks reminiscent of the Gospel Book of Otto III, the Apocalypse: we are dealing with a poem which, however commonplace some of the individual items of imagery, may in ensemble be considered the veritable programme of Otto III's Bamberg manuscripts, even more than Abbo of Fleury's letter of the same year, 998. The only lack is any specific reference to Isaiah, but like Isaiah's prophecy (and Jerome's comments on it) the poem is full of the motifs of purgation and illumination of the world, the putting to flight of darkness, humble ministry, the bringing together of peoples.[100] Altogether, poem and manuscripts fit each other remarkably. Leo's poem has never, I believe, been considered alongside these illustrated Bamberg manuscripts. In this connection there is a fact about it, which in the first moment of realization comes with the effect of an electric shock. The poem survives in but a single manuscript, and the location of that manuscript is none other than Bamberg.[101]

Now we should not allow ourselves to be swept off our feet by this fact. A very large quantity of manuscripts came to Bamberg in the early eleventh century, including probably the whole library of the Emperor Henry II and the books collected by his predecessors, so that a sceptic might argue that no find at Bamberg should occasion any surprise. On the other hand, it is not quite satisfactory to invoke the large manuscript holdings of Bamberg in order to say that anything might have survived in a Bamberg manuscript and hence to write off the survival of Leo's poem

here as the merest coincidence. The imperial collections of books, illustrated and non-illustrated, were accumulated, eclectically indeed, but not without some sense of coherent interest. Amongst Bamberg books originally collected by Otto III, either certainly or probably in Italy itself, we have already mentioned the Josephus. There is also a tenth-century Julian of Toledo, *Prognosticon futuri saeculi* with an appendix on St Michael's apparition at Monte Gargano, and a copy of Justinian's *Institutes* to which was added a capitulary of Otto I dated 971.[102] Most interesting is a manuscript (Bamberg, Hist. 3) containing a selection of historical works: *De Regno Assyriorum*, culled from Orosius; *De Gesta Scytharum*, with a section on Darius; Paul the Deacon's *Historia Romana* as well as his history of the Lombards; *De Ventorum enumeratio*, derived from Isidore of Seville's *De Natura Rerum*, and one must remember that winds are a subject of apocalyptic interest;[103] a *Vita Alexandri Magni*; and Bede's *Ecclesiastical History*. This book then contains material useful to elucidate all Daniel's four empires of the world and (in the Bede) that empire of the Church which would overshadow them all. It was written under Archbishop Arnulph II of Milan (998-1018), but copied from a Beneventan, i.e. South Italian, model. If it only came into the imperial collection under Henry II, it is nevertheless still of interest for us, since we have already said that the continuities between Otto III and Henry are not to be played down in favour of the discontinuities; but there are reasons to think that at least the model was acquired by Otto III.[104]

The South Italian manuscript (Bamberg, Canon. 1) which contains Leo's poem itself (see the catalogue of Leitschuh and Fischer), shows quite clearly that the poem cannot be regarded as a random or late intruder into the manuscript.[105] It has a collection of writings by two South Italians, Auxilius and Eugenius Vulgaris. Both had written polemical works on the election of Pope Formosus (891-96), where the point at issue was one affecting Gisilher of Magdeburg, a notable opponent of Otto's policy of Roman *renovatio*, namely whether a bishop could be translated from one see to another.[106] Eugenius, also, like Otto III and Leo, was interested in the praise of Rome. His *Nunc gaudeat aurea Romana* in this manuscript corresponds to Otto's seal used by Leo as logothete (itself the revival of a Byzantine and thus quasi-antique Roman office) with its legend *aurea Romana*.[107] And immediately before Leo's poem in the original arrangement of the manuscript came Eugenius's encomium of Pope Sergius III, beginning *Roma caput mundi rerum suprema potestas*. Eugenius had not at all taken the imperial side in the imperial/Roman dilemma that Leo took, but their questions and interests were the same, as was their Roman patriotism.[108] Before ever the bishopric of Bamberg was founded in 1007, therefore, the illustrated manuscripts and the text of Leo's poem, which would both pass to its library, had their places in a coherent policy of imperial book accumulation, informed by the intellectual and political interests of Otto III's circle.

It is fairly clear that the same mind, or the same approach, is at work in Leo's poem and the accumulation or commissioning of Otto III's illustrated manuscripts. Can one go further and say that Leo actually had a hand in determining what might broadly be called the programme of these manuscripts? There is unfortunately no evidence for this, but there is one pointer to his possible influence. The Cathedral of Ivrea owns to this day a Sacramentary made under Bishop Warmund (*c.* 969-1011). It is generally accepted that this Sacramentary (Cod. LXXXVI) dates from 999-1001 and refers in its miniatures to Otto III. Before the mass for kings is a picture of the Virgin crowning a ruler, whose frame inscription reads:

55,56

56

> *Munere te dono Ceasar diadematis Otto*
> *Pro bene defenso Warmundo presule facto*

In the gift of the crown, Emperor Otto,
is your reward for defending Bishop Warmund well.[109]

This surely refers to Otto III. There is no sign of any defence of Warmund by Otto I such as that of Otto III against Arduin of Ivrea. On 9 July 1000 Otto III issued an immunity for Ivrea after he had put down Arduin and recovered his usurpations for the cathedral. Another miniature in the book represents the crowning of Constantine and his baptism by Pope Silvester I, symbolizing the golden age for the Roman Church and Empire of Otto III and Pope Silvester II, who jointly presided over the Easter Synod of Rome in 999 which condemned Arduin.[110] It is not surprising that this manuscript has hardly been brought into the discussion of the great court manuscripts of Otto III, because in style it is very provincial work, evidently executed in the Ivrea scriptorium itself. But it has been pointed out that in so far as it reflects a court connection in its iconographic programme, that connection must have been above all through Warmund's episcopal neighbour Leo of Vercelli, who from 999 was especially charged by Otto III to lead the struggle against Arduin. A near-contemporary source describes Warmund as a follower of Leo.[111] Moreover, in his own library at Vercelli, Leo could have found a late Carolingian collection of canon law, just the kind of book he liked, illustrated with drawings whose interest connects them with both Warmund's Sacramentary and Otto III's manuscripts.[112] They include the Finding of the Cross, the gatherings of several ecumenical councils, Saints Peter and Paul, and a Christ in Majesty below whom stand a crowned man and a woman, probably Constantine and Helena. It looks as if Leo of Vercelli could well have been interested both in political ideology and in iconographic programmes.

6 Poppo of Trier

It is very likely, as mentioned earlier, that the Emperor Henry II's library became the Bamberg library. That is to say, the imperial library (including Ottonian family possessions like the ninth-century Isidore *De Natura Rerum*, the tenth-century Italian Chalcidius on the Timaeus, the autograph of Richer of Rheims which probably came to Otto III through Gerbert of Aurillac, and the selection of fathers which had Otto II's military levy of 981 written on the fly-leaf) was transferred to Bamberg.[113] Bamberg was so specially a base or centre for Henry II that not only did he constantly stop there on his itinerary, but he also merged completely into the episcopal scene when he was there. He had no separate royal rights in the area; they were all exercised by the bishop in what might be called a palatinate jurisdiction. He had no separate palace, and it has even been impossible to establish that in his time there was any distinction between the royal and episcopal parts of the palace.[114] He was a canon of the Cathedral, calling the other canons his brethren, and his stall had no vicar; in this he followed Otto III who was a canon probably of Aachen and certainly of Hildesheim. To Henry, as a former Duke of Bavaria who had held Regensburg (which continued its self-image as the leading city of the Carolingian east in the eleventh-century *Translatio S. Dionysii*) and as a successor of Otto III with his Roman palace, the idea of his having a capital would not be a complete novelty. Gerd Zimmermann has shown how the relics deposited in the various altars of the Cathedral consecrated in 1012 represented the saints of Rome, Byzantium and every major region of the *Reich* (see Part I, p. 200).[115] This feeling that Bamberg was Henry II's special place, his *Hauptstadt*, is very much expressed in its endowment of books. *Caput orbis*, or head of the world, is how his *fidelis* Gerhard, Abbot of Seeon, described it in an encomium of Henry II; and he also called it *Kiryath Sepher*, after the Old Testament city of books. On top of the books already in the imperial library, the scriptoria of Reichenau, Regensburg, Seeon, Fulda and Liège were all pressed into service to provide more books, and from Liège came Durand, the first of an eminent line of masters at the cathedral school.[116]

How, or through whom, did Otto III's books reach Bamberg? This is speculative ground for there is no positive evidence, but I should like to suggest the name of Poppo as worthy of consideration. Poppo was a chaplain of Otto III, he became first provost of Bamberg Cathedral, and he was promoted to the archbishopric of Trier in 1016. I do not say that he was appointed provost for no other reason than to build up the Bamberg book collection. He was a member of the most powerful family in the East Main region, the Babenberger, and although his cousin and brother had rebelled against Henry II early in his reign, the family was soon high in royal favour again. Henry probably needed their support against the Luxemburgers, the family of his queen Kunigunde; they rebelled arguably because they were disappointed of the inheritance of her morning gift

which, but for the foundation of the bishopric of Bamberg, would have fallen to them as a result of Kunigunde's childlessness.[117] The actual reasons for Poppo's appointment at Bamberg, therefore, may have been in no small part political. Like Henry himself, however, he was an alumnus of the Regensburg school, which would have recommended him on educational grounds; and between Otto III's circle and the new foundation of Bamberg, Poppo provides just the right element of continuity.[118] He was the kind of channel by which the books, under Henry II's patronage of course, might have passed to Bamberg.

Poppo was in Italy with Otto III as a chaplain. Indeed he was present at Ravenna in 1001, as a *Beisitzer* (assessor), when Otto III held a court of which a leading member, a *Vorsitzer*, was Leo of Vercelli himself.[119] Moreover, he was chaplain at a time when court chaplains were growing in importance outside their immediate court functions: in justice like Leo, in art and theology like Bernward of Hildesheim (whom Fleckenstein considers to have remained a chaplain after becoming a bishop) or in the practice of medicine like Thieddag.[120] This is a period when a chaplain might easily have had a librarian's responsibilities, or those of a sacristan/treasurer, under which finely illustrated books might equally come. As provost of a cathedral, he would have had responsibility for its material possessions in general.

Two postscripts may be allowed to shed further possible glimmerings of light — no more can be claimed for them — on Poppo's connections with these manuscripts. First, the inscription on the former binding of the Bamberg Apocalypse associated Kunigunde with Henry II in its gift (although there is no evidence to what period this binding belonged, see pp. 220-21); and in the two diplomas of Henry II granted to Poppo's church of Trier in 1020 Kunigunde appears as *Interveniehtin* (i.e. requesting the grants), which implies a close connection between Poppo and the Empress.[121] Second amongst the *Carmina Cantabrigiensia* is a poem in which the church of Trier apostrophizes its archbishop, as a bride addressing her bridegroom. It dates from 1029-35 when Poppo was archbishop. It is full of talk about the revival or recovery of Trier, as Leo's poem is about the revival of Rome. It has the same mingling of profane and religious elements as Leo's poem, with the spiritual sphere given the primacy as it was by Leo. In characterizing it as 'the first non-Italian city poem in the Middle Ages', Heinz Thomas may do less than justice to Alcuin on York, but he thereby points up the relative rarity of the genre at this period.[122] The Trier poem and Leo's poem, therefore, may be significant pointers to the shared thought world of Leo of Vercelli and Poppo of Trier.

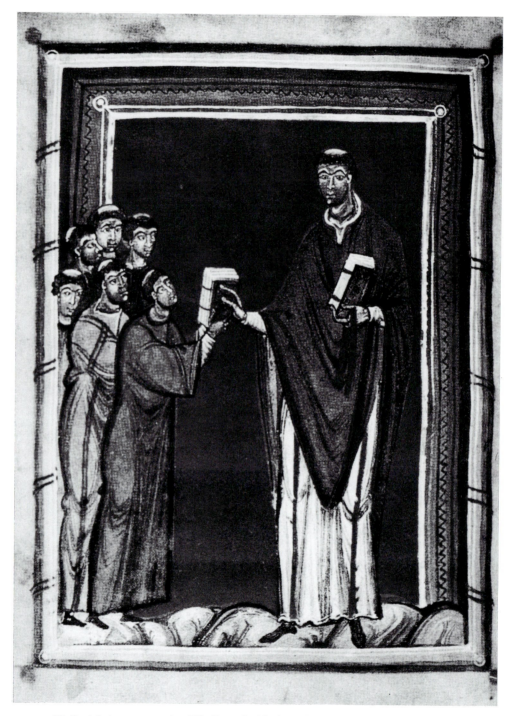

32. Book being presented to ?Heribert, Archbishop of Cologne. Gospel Book, *c.* 1000.
Milan, Ambrosiana, MS C53 Sup., f. 2v

CHAPTER TWO
The Manuscripts of Archbishop Egbert of Trier

1 Episcopal Might

So far we have dealt mainly with royal and imperial art; now we turn to the patronage of bishops and abbesses. The ideals and the role of episcopal rule were pitched high in Ottonian times. The power of bishops may have derived in practice from the ruler, but this was not something of which they were ashamed. It was their glory. They gladly acknowledged their reflection of kingly rule. The chronicler Bishop Thietmar of Merseburg, writing around 1018, declared how right it was that Otto I should have wrested the appointment of bishops in Bavaria from the hands of Duke Arnulph of Bavaria:

> For our kings and emperors, who take the
> place of the almighty ruler in this world,
> are set above all other pastors, and it is entirely
> incongruous that those whom Christ, mindful
> of his flock, has constituted princes of this earth
> (i.e. bishops), should be under the dominion
> of any but those who excel all mortals by the
> blessing of God and the glory of their crown.[1]

In the 1080s, when Archbishop Siegfried of Mainz wanted to retire to a monastery, his cathedral clergy wrote to him in horror, stressing a traditional view of episcopal majesty: 'Nothing in the world surpasses the life of a bishop; every monk or recluse and every hermit, as being of lesser importance, must give way to him.'[2] Thietmar of Merseburg himself, though interested in the role which his own family had played in Saxon history, and not differing in many of his attitudes from his secular aristocratic kinsmen and counterparts, never allowed his strong line on episcopal and clerical power to drop from sight. He disapproved of Otto I judging Pope Benedict VII who was 'greater than himself'; he regarded jokes against clerics as sinful; he loved to cite prelates who were models in their celebration of mass; and, despising Lotharingians in every way (being himself a staunch East Saxon), he despised them most of all because of their contempt for episcopal excommunication.[3]

Bishops were also subject to the papacy. Metropolitans received their pallia from the pope and all bishops acknowledged his primacy as a matter of course. The popes pressed their primatial and jurisdictional claims with impressive continuity in this period.[4] As the Ottonian Church was shot

57

through with rivalries between sees, no less bitter than the feuds of secular magnates, the papacy had the constant advantage of being useful for its backing in these disputes. But the papacy had not yet made itself the working centre of the Church in the way it became after the Gregorian Reform of the eleventh century. Nor had the popes yet achieved a central place in the minds of other bishops. Bishop Rathier of Verona wrote in the 930s that the Church was one in all its bishops; that not Jerusalem, not Rome, not Alexandria had received a special prerogative of rule to the exclusion of the others.[5] One notices how Rome is not given a primacy in his list but is tucked pointedly into the middle. This world was a world of bishops, whose mentality was elliptical rather than circular (to use the terms of Henry Chadwick).[6] The Church was not a circle ruled from a centre, but a non-centralized ellipse, the points on which were the bishop-rics of the world. The principal claim to greatness of even the popes themselves, before the mid eleventh century, lay in their conduct as Bishops of Rome, building and beautifying churches, organizing poor re-lief, and resisting the attempts of every tin-pot contender for the Roman Empire to dominate the city and its people.[7]

Previously historians have tended to regard bishops and abbots as having been worked by the tenth-century German rulers into a system of government through the Church.[8] Wide local powers, it was said, were transferred from semi-autonomous secular magnates to wealthy and dis-ciplined ecclesiastical corporations which had a natural interest in sustain-ing royal power. Now the Church is still seen as the upholder of kings. It is generally recognized, however, that many Ottonian bishops were related to the most powerful aristocratic families of their region, even when it looks from the sources as if the kings were choosing them with *carte blanche*, and that this was an important basis (though not the only one) of episcopal rule. No more, nowadays, is there necessarily seen to be a strong antithesis of interest between kings and secular magnates.[9] Tenth-century kings were happy to see a balance of secular and ecclesiastical powers in the localities (if they thought in these categories at all) rather than try to crush the former. This was demonstrably the aim of Otto I and Otto II, for instance, when disposing of the tributes exacted from the Slav peoples in the Elbe region.[10] Moreover, before we speak of the transfer of powers, we should remember that these men were not nineteenth-century constitu-tional lawyers. The juristic aspects of power were not always uppermost in their minds. Karl Leyser has shown that this was a 'patrimonially', not a 'bureaucratically' governed society; rule was by the personal presence of an itinerant ruler, the exercise of his patronage, the close bonds which he could establish with his followers, and the ceremonial projection of his sacrality.[11] No more than kings, did bishops and abbots rule primarily through bureaucracies or closely defined legal powers. If their power was anything, it was the power of Holy Men. Not every bishop could be a Holy Man, of course, but it is remarkable how many in the Ottonian Empire were.

We must understand the meaning of holiness in early medieval society. Naturally the interior life of prayer and personal austerity are central to every biography of saintly Ottonian churchmen, but equally important were practical virtues, and more so, the visible manipulation of supernatural power by men and women who wielded authority. Before the mid eleventh century we do not find large numbers of saintly ascetics, withdrawn from the world and not exercising ecclesiastical authority.[12] There was no obvious gap, such as one can perceive in the twelfth century all over Europe, between ecclesiastical and spiritual power. Under the Saxon rulers, spiritual power was still securely earthed, for the most part, in the *Adelsheiliger*, the holy aristocrats who held ecclesiastical office. The vast majority of bishops in this age were aristocrats. Those who were not, but rose by exceptional ability, were invariably the subject of unfavourable comment,[13] and when successful (as in the case of Archbishop Willigis of Mainz, 975-1011, or Bishop Wolfgang of Regensburg), it was because their rule drew on the capital of the *Adelsheiliger* tradition.

The classic example of an Ottonian bishop was Archbishop Bruno of Cologne (953-65). He was Otto I's brother, and Ruotger, his biographer, was not slow to apply to him the biblical phrase, 'a royal priesthood'. To Ruotger, one of Bruno's most admirable qualities was a capacity to inspire terror. The purity of his prayer and his gift of tears would have counted for less than it did without this.[14] He was by no means alone. Willigis of Mainz was 'the horror of all his enemies' though 'an impregnable wall for the flocks committed to him'.[15] Udalric of Augsburg caused a gardener called Adalpold, who disobediently stored his tools and vegetables in a subterranean cave to the east of St Afra's church where there were relics, to be struck blind and deaf, and he could only be cured by the bishop's own blessing. Remarkable to relate, the gardener could never again find the cave![16] Such powers did not stop at the modest level of gardeners. Wolfgang of Regensburg, not an aristocrat, had an extraordinary effect on a snobbish knight, who had thought to himself during the bishop's mass: 'how unwise of the emperor of the time to promote this despicable rag-amuffin to episcopal rule over the powerful persons in his diocese'. Something in the gospel at once reduced him to jibbering fear, and again, only the blessing of the bishop could calm him.[17] The power of the gospel book, incidentally, is once again visible for more than the purely didactic force of its text.

It is true that bishops had other powers than those deriving purely from their holiness. Every Ottonian bishop could raise an army from his estates, and this not only when contingents for the emperors' military expeditions were needed, but also (and perhaps more important) for the exercise of local power. Bruno's biographer says of the archbishop and his learned colleagues of Trier and Mainz, 'we have seen these three not only in study and discussion, but also in the line of battle'.[18] Udalric of Augsburg stoutly directed the defence of his city against the Hungarians before the Battle of Lechfeld in 955, although 'during the battle he sat on his horse, vested

with stole, unprotected by shield, armour or helmet, while stones and javelins flew all round him'.[19] Generalship was a normal activity of these men. They justified it against critics (whose existence should not be overlooked) in Augustinian terms.[20] The citizens of the heavenly city, during their pilgrimage through this earth towards their fatherland of the world to come, had a duty to secure earthly peace in order to facilitate this pilgrimage. They could not opt out. That is why Bruno was prepared to be Duke of Lotharingia and Archbishop of Cologne at the same time. If one asks what was the justification of his military activities, says his biographer, one has only to look at the peace which he secured in Lotharingia.[21]

Bruno inspired awe, however, not only because of his military resources, but also because of his lavishly spent wealth, his splendid building projects, the perception of his learning, the magnetism of his personality which brought him a large following of other ecclesiastics.[22] This consideration also applies to Ottonian bishops who were great patrons of art. One way in which these bishops visibly manipulated, or commanded, spiritual power was by commissioning fine golden book covers and reliquaries, shimmering gold on the pages inside gospel books, impressive figural art, calligraphic wizardry in the splendid initials of texts. It was even an aspect of early medieval holiness, and it is into this Ottonian world that Archbishop Egbert of Trier (977-93) makes his distinctive entry.[23]

2 The Manuscripts

Archbishop Egbert of Trier (977-93) was a nobleman from Lower Lotharingia. His father was Count Dietrich of Holland, and his grandfather had founded a monastery at Egmont.[24] Many an Ottonian bishop was doubtless a patron of manuscript art, but Egbert was distinctive in wishing to ensure that he was remembered as such. Only Bernward of Hildesheim and Sigebert of Minden, and south of the Alps Warmund of Ivrea, match him in this respect. The initial promptings to record his own memory in books may have come from his parents. A ninth-century Franco-Saxon Gospel Book now at the Hague had two pictures of lively draughtmanship added to it when Count Dietrich and his wife, Hildegard, gave the book to the family monastery of Egmont c. 940-70. The first shows the couple placing the book, open, on the altar of the church, rather as Bernward of Hildesheim offers his book to the Virgin by placing it on the altar. In the other they appear in intercessory postures before the towering figure of St Adalbert, patron of Egmont, who mediates their prayers to Christ in Majesty. This has been called 'the earliest western representation of the mediation of prayer through the saints'. A contemporary inscription above the first scene states that Dietrich and Hildegard gave the book to St Adalbert, adding, 'may they be remembered, as is their right, for ever' (*quorum memor ut sit iure per evum*). It is conceivable that in the enormous stature of Archbishop Egbert as depicted in the Codex Egberti

33
34

Col.Pl. V

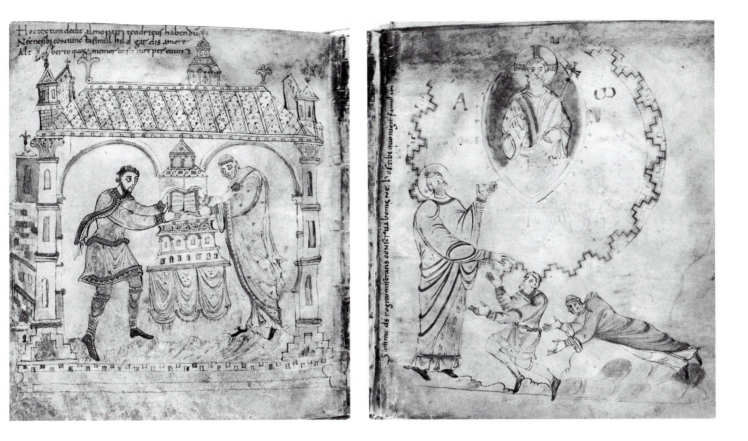

there is a touch of realism owing to his heredity. For in both pictures in The Hague his mother is represented as much taller than his father.[25]

Egbert was one of the group of royal chaplains of Otto I and Otto II during the period after Bruno of Cologne's death, when the chapel became an important avenue to bishoprics.[26] He was perhaps the greatest episcopal patron of art in the whole Ottonian period. In his own day his fame as such rested first and foremost on the metal workshop which he developed at Trier, and which specialized in gold work and the laying of enamels, jewels and red glass into cells of gold.[27] Surviving examples include the reliquary encasing a part of St Peter's staff, now at Limburg Cathedral, the reliquary of St Andrew's foot, still in the Trier Cathedral Treasury, and the magnificent cover of the later Gospel Book of Echternach now at Nürnberg. These works show great liveliness and invention in absorbing the art of various models, some of them manuscript sources such as those of Carolingian Tours or mid tenth-century Trier which are discussed in a later chapter (see pp. 209-10). As we shall see, the Gregory Master had access to the same sources, though as an artist he was different from the master or masters of Egbert's metal workshop, with his solid, monumental figures, specially when compared to the wispishness of the Rheims figures on the Nürnberg cover.[28] Trier's claims to greatness as a metropolitan see were based on its apostolic foundation; its relic of St Peter's staff was vital 'proof' for this claim, and St Andrew's foot was valuable supporting cor-

33 & 34. Count Dietrich of Holland and his Wife Hildegard giving their Gospel Book to the Monastery of Egmont; and before St Adalbert. Gospel Book, Lotharingia, *c.* 940-70. The Hague, Royal Lib., MS 761/1, ff. 214v, 215

35

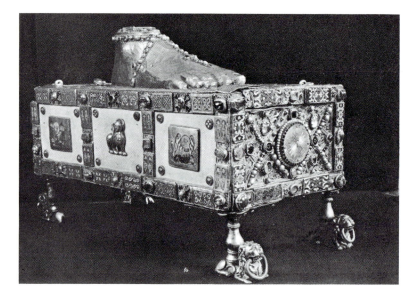

roboration. There must have been a large output of this workshop which has not survived. We know, for instance, that the original covers of the Codex Egberti itself, characteristically of gold with cells of enamel, were replaced only in the 1770s.[29] But the artistic importance of Trier stands revealed in the written evidence of the time. Archbishop Adalbero of Rheims sent a (presumably golden) cross to Egbert in 987. 'Your exceptional and famous talent', he wrote, by the pen of Gerbert of Aurillac, to his colleague, 'will enoble our mean material not only through the addition of glass, but also by the skilful design of a fine artist.'[30] While the account of the translation of the relics of St Celsus at Trier in Egbert's time refers to the festive procession arranged by the archbishop, 'with crosses, candles, thuribles, gospel books set with gems, and every kind of ecclesiastical beauty'.[31]

When we turn from metalwork to book illumination, we find that the greatest amongst the first generation of Ottonian book artists, the Master of the Gregory Register, worked at Trier under Egbert. The manuscript of Gregory's letters, with the double frontispiece showing Gregory dictating *Part I,13* to Peter the Deacon, and opposite Otto II seated in majesty surrounded by personifications of the provinces of his empire, was commissioned by Egbert for Trier Cathedral.[32] The picture of Gregory is a classic instance of the denial of spatial illusionism in Ottonian art, and yet the space is intriguingly organized into various planes by means of subtle variations of colour.[33] The dedication verses of this manuscript, written in golden majuscules on a purple ground, speak of the times of peace and tranquillity when Otto II ruled Italy and the Franks, and of the commission by Egbert. The manuscript must have been begun under Otto II and still been incomplete at the time of his death in 983. Carl Nordenfalk, referring to the likelihood that Egbert had himself in mind when he caused the great pope to be shown on one page counselling the emperor who was represented on the opposite page, has written of this as 'an allegorical depiction of the

imperial chancellery suggesting how well the empire is being administered under the joint rule of the monarch and the highest ecclesiastical power'.[34]

We have referred earlier to the fact that Egbert visited Rome and Italy at least twice (Part I, ch. 2), and also that his protégé, the Gregory Master, was well versed in antique models which he handled with aplomb. In the tenth century no city in northern Europe had such impressive remains of classical antiquity as had Trier, with its Porta Nigra, its basilica, its amphitheatre, and its bridges. Hiltrud Westermann-Angerhausen (1983) has shown that the Gregory Master must have derived a motif of masks with leaf ornament, which feature on capitals of a number of his architectural depictions in manuscripts (especially canon tables in the Sainte-Chapelle Gospels, Paris, BN, lat. 8851), from actual antique capitals placed in Trier Cathedral by Archbishop Nicetius (522-66) and apparently covered over in building works of Egbert's own time. Thus Egbert and his greatest manuscript artist combined their sense of ancient Rome from what they could see around them in Trier, with that from their Italian visits, in a two-fold source of inspiration.

The two manuscripts most closely associated with Egbert are a Psalter, now in the Archaeological Museum at Cividale, and a Pericopes Book (the Codex Egberti), still at Trier.

(a) THE EGBERT PSALTER

The Egbert Psalter begins with a series of full-page miniatures. The first two show a monk called Ruodpreht giving the book to Archbishop Egbert, seated frontally and hieratically on a jewelled throne, dressed in mass vestments and pallium, holding a pastoral staff, his head backed by a square nimbus. These pictures, like those of the Gero Codex, follow the tradition of presentation scenes set by the Carolingian manuscripts of Hrabanus Maurus's *De Laudibus Sancte Crucis*, but the divergence from the tradition in the stiff, erect figure of the archbishop itself makes a point about episcopal might. The next two show Egbert offering the book to St Peter, the apostle being seated somewhat less majestically than was the archbishop in the previous pair of illustrations, and being surrounded by a much less brilliant border. Then follows King David, the putative author of the psalms, playing a lyre and a splendid initial B for the *Beatus vir* of the first psalm. Thereafter before every tenth psalm, there is a pair of fine pages, the left-hand side representing a former bishop of Trier, fourteen of them in all, or fifteen if St Peter is counted as the first, and the right-hand side being devoted to a full-page initial letter of the ensuing psalm. There are no literal illustrations of the psalms, and no appropriate Old or New Testament scenes. To have a series of bishops illustrating a psalter was most unusual.[35] As they are all dressed in much the same way, all have similar faces, adopt in each case an *orans* posture (although some have their arms stretched out while others hold them against their chest as a small concession to variety), and are distinguishable from each other

36
37

40

38
39

Col.Pls.
XXIII,XXIV

36 & 37. Ruodpreht presents his book to Archbishop Egbert of Trier. Egbert Psalter, Reichenau, 977-93.
Cividale del Friuli, Museo Archaeologico, MS CXXXVI, ff. 16v, 17

38 & 39. Archbishop Egbert of Trier presents his book to St Peter. Egbert Psalter. Reichenau, 977-93.
Cividale del Friuli, Museo Archaeologico, MS CXXXVI, ff. 18v, 19

only by the golden uncials which announce their names, one might feel that all this was a form of magnificent monotony. If so it was a monotony eagerly espoused by other artists, particularly Italian ones, of the same period. That is relevant because Boeckler pointed out various features in which the Ruodpreht Group of manuscripts were influenced by early medieval Italian art, and it is certain that Archbishop Egbert himself paid at least two visits to Italy.[36] Both the prayer book of Archbishop Arnulph of Milan (*c.* 1000 A.D.) and the late tenth-century Psalter of Bishop Warmund of Ivrea have series of standing saints or Old Testament figures, looking imposing, and most of them hardly distinguishable but for the immediate text or their being named.[37] The square nimbus is also characteristically Italian, to distinguish an important ecclesiastical personage living or dead.[38] And the Ivrea Psalter may be added to Haseloff's examples of psalters with fifteen-part divisions, in this case effected by especially elaborate initials before every tenth psalm as in the Egbert Psalter.

It is doubtful, however, whether any tenth-century archbishop of Trier would have found a series of his predecessors, in any shape or form, monotonous. In the Carolingian and Ottonian ages the occupants of this see made a determined bid for primatial status in Germany and Gaul, and in this case 'Gaul' meant more than just Lotharingia to the west of the Rhine.[39] Trier traditions stated that St Peter himself had founded the see, that he had consecrated its first bishop, Eucharius (giving him his own pastoral staff), and that he had ordained Valerius and Maternus, the second

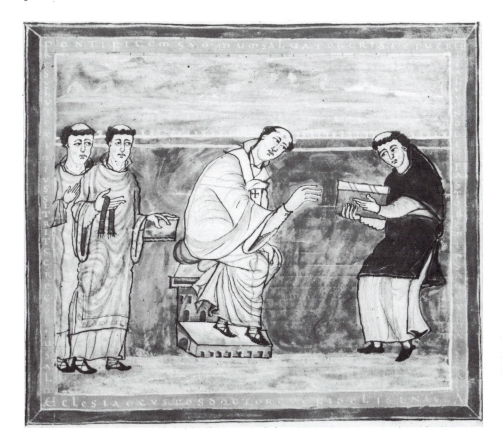

40. Hrabanus Maurus presents his *De Laudibus Sancte Crucis* to Pope Gregory IV. Vatican, Bibl. Apost., MS Reg. Lat. 124, f. 3v

and third bishops, respectively as deacon and subdeacon. With these claims, embodied in Pope John XIII's primatial privilege of 969 and in a forged bull of the same period attributed to Pope Silvester I (314-35, pope at the time of the Emperor Constantine), Trier trumped (*übertrumpft*, to use Egon Boshof's word) the claims of Mainz to be the leading see of the empire. The claims of Mainz went back only to St Boniface in the eighth century, and to Pope Zacharias; what was this compared to St Peter? We may here pass over the contemporaneous efforts of Trier to score off Rheims as well as Mainz. Since the ninth century Trier had claimed primacy over Rheims, because the old Roman province of Belgica was divided into two, and Trier was the metropolitan see of Belgica Prima, while Rheims held the same position only in Belgica Secunda. The foundation myths of Rheims had it that their city was founded by Remus, brother of Romulus founder of Rome. But the Silvester Privilege maintained that Trier, the city of the Treverer, had been founded by Trebeta, son of Ninus, founder of Nineveh; and that was the beginning of the patriarchal age, and so virtually of the world. Thus was Rheims, as well as Mainz, *übertrumpft*.[40]

Col.Pl. XXIII

But the present point for us is that Eucharius, Valerius and Maternus are the first three bishops of the Egbert Psalter (after St Peter). They appear also in the enamels on the staff reliquary, with others. They and others were all the subjects of hagiographies, written at Trier in the mid tenth century.[41] One of the other bishops concerned was Paulinus, whose *Vita* dwelt on his opposition for doctrinal reasons to Constantius, the fourth-century emperor of his day[42] — shades of Egbert's own opposition (if not doctrinally based) to the party of Otto III in 984 and 985. There was much for an archbishop of Trier to think about when he contemplated the statuesque and enigmatical representations of his predecessors. A whole row of them represented the antiquity of his see, and its continuity, which the raids of ninth-century Vikings and the vagaries of tenth-century politics had threatened to shatter.

There is a danger of becoming so mesmerized with the succession of bishops, that one will overlook the real excitement of the Egbert Psalter, which lies in the initials. The glory of the book is its calligraphic, not its figural, art. The full-page initials are ornamented with swirling tendrils of bulbous leaves and arrow-head ends, intertwined with each other, and strategically placed knots of interlace ornament: in other words, they are fine examples of what has come to be considered the classic Reichenau calligraphy. But they are unusually restless examples. Their wild movement and the patter of their innumerable bulbous leaves were characterized by Haseloff as resembling 'the racket of a rain storm'.[43] Their letter-shapes, however, are clearly delineated in minium red as well as the gold also used for the tendrils, while behind the letter itself are cleverly disposed patches of blue and green. They are remarkable, therefore, both for brilliance of colour and for clarity of form. In an immediate sense these initials give lustre to the Trier pontiffs opposite each one of them as the

41. The Footwashing of St Peter.
Aachen Gospels, *c.* 996.
Aachen Treasury, p. 440

42. The Footwashing of St Peter.
Poussay Pericopes, Reichenau,
c. 970-90. Paris, BN,
MS lat. 10514, f. 46v

book lies open, because in each case the frame and background of the bishop and that of the initial letter of the psalm are exactly the same. In the case of St Paulinus, for instance, the frame with a corn-cob pattern picked out in gold, and the purple background with bird/dragon orna- *Col.Pl.* ments which looks as if they were stitched in gold on purple textiles *XXIV* (f. 86v), are both applied equally to the initial N of Nonne, the first word of Psalm 61, on the opposite page (f. 87). Thus text and illustration are given a strict equality throughout.[44]

 Fine calligraphy is the most important feature of every significant manu-script of the Ruodpreht Group, and very much so of the Poussay Pericopes Book (Paris, BN, lat. 10514). Haseloff established that the artist of the *43* miniatures, with his *mouvementé* but heavy linear style, was the same in *Poussay* and the Egbert Psalter. Indeed this was very important in his argument (see Part I, p. 207), for he could thereby relate the Egbert Psalter to *Poussay* by style, and Poussay with its Christ cycle to the Egbert Codex (and thence to the whole Liuthar Group of Reichenau) by iconography.[45] *41,42* Thus *Poussay* was the lynch pin between the Egbert Psalter and Reichenau, just as the calligraphy of the Egbert Psalter made it the lynch-pin between the later Reichenau and the early Reichenau of the Gero Codex and the other manuscripts of the Eburnant Group.[46] We have already spoken of the importance of calligraphy in emphasizing the role of the written word

43. Initial M.
Poussay Pericopes, *c.* 970-90.
Paris, BN, MS lat. 10514, f. 60

as against figural art, apropos of the Gero Codex (Part I, pp. 44-47). The Poussay Pericopes Book is very much an instance of this. Its illustrations are very early as a Christ cycle in Ottonian art, possibly the earliest to survive. They are not without vividness and force on the page, and stand out well when looked at from afar. But they are crude compared with the great Liuthar cycles of the next generation, and it is difficult to resist the impression that the *raison d'être* of the art is the initials. There are sixteen full-page initials, either in conjunction with the seven miniatures of New Testament scenes or with full-page framed titles of the feast. In addition there are 105 smaller initials (cf. the beginnings of individual psalms in the Egbert Psalter) with the same style of letter shapes in minium red and gold, the same bulbous leaf tendrils and arrow-heads as in the Egbert Psalter (but differentiated from the Psalter by use of silver as well as gold), the same blue and green backgrounds. These initials are executed with extraordinary inventiveness and variety, so that no two have exactly the same design, even for the same letter, and virtually every gospel starts with one. The calligraphy here displays a sureness and lightness of touch, which is not at all matched by the figural art. The same is true of the whole scribal aspect of the manuscript. The script throughout is a firm and well-spaced minuscule, observing normally the discipline of sixteen lines to the page. We are surely within the same scriptorium as the Egbert Psalter, though whether the scribe is the same person in both manuscripts cannot be established with certainty.[47] Nor do we know whether the Poussay Pericopes ever belonged to Egbert. It seems improbable, considering that the donor is shown presenting the book directly to Christ.

A book of epistles now at Mainz (Mainz Cathedral, Kautsch 3) belongs 44 to the same group of manuscripts. Its initial letters, comparable to those of *Poussay*, give an idea of the smaller initials in the Egbert Psalter.

Sauerland, co-author of Haseloff in 1901, was disposed to see the Egbert Psalter as a book for use in the liturgical choir offices at Trier Cathedral, though he allowed in this case that it would probably have been intended for the use of Archbishop Egbert himself.[48] The last is surely an essential corollary of the first. The book surprises one with an unexpectedly small format (238 × 188 mm). Its pages are only slightly larger than those of a standard writing pad. It gives the impression of being for individual rather than for group use. That impression is reinforced by a collection of private prayers written after the psalter and canticles, written (it is true) not by either of the scribes who worked on the main body of the manuscript but nonetheless by their contemporary and colleague.[49] This section of the manuscript has to be regarded as integral to the Psalter. One must ask, therefore, which individual, other than the archbishop himself, could have arrogated to himself so exceptionally splendid a book, with so many previous archbishops represented in it. But the book could well have been made for the private use of Archbishop Egbert, regardless of whether or not he attended the choir offices (and presumably he was often not in Trier at all). Gerhard's *Life of Udalric of Augsburg* gives us the perfect episcopal

44. Epistles for the Vigil and Feast of All Saints. Epistolary, Reichenau, *c.* 970-90.
Mainz, Cathedral Treasury, MS Kautsch 3, ff. 135v, 136

context for such a use, when he says that Udalric recited the whole psalter daily unless there were some unavoidable impediment to his doing so.[50] Although not a monk himself, Udalric was here shown as fulfilling an ideal of the Rule of St Benedict, where it is laid down that the whole psalter must be recited during one week's offices, yet 'our holy fathers fulfilled in a single day what I pray that we lukewarm monks may perform in a whole week'.[51] In the same passage Gerhard again alludes to the Rule when he refers to Udalric's manner of receiving guests, 'knowing that in them he received Christ'.[52] In his Psalter, therefore, Egbert could look into a mirror of Benedictine holiness, a sort of holiness which he perhaps sought to foster in himself (as Udalric did) and certainly as a monastic reformer to develop in his city.[53] At the same time he could look into a mirror of Trier holiness, whose legends he no doubt sought to employ to the advantage of his church in his external life. In a double sense, ownership of the book enhanced the power of the archbishop as a Holy Man.

(b) THE CODEX EGBERTI

The Codex Egberti is a Pericopes Book with fifty-one gospel illustrations.
It thus represents a far larger cycle of the Life of Christ than anything in
surviving book illumination which had gone before it.[54] Its frontispiece
Col.Pl. V has a remarkable representation of Archbishop Egbert seated frontally
and hieratically in majesty, dressed in mass vestments and pallium, hold-
ing his crozier, with his head backed by a square nimbus. His rigid
posture and staring eyes remind one of the evangelists in the Gospel Book
of Otto III (some fifteen years later). In his gigantic size he towers over
the two monks presenting the book to him, as Otto III towers over the
Part I,29 two sub-kings in the Aachen Gospels (some ten years later), or as Christ
Part I,34 himself towers over the little figures of Henry II and Kunigunde in the
Basel Altar. This is indeed a *Maiestas*, as if the archbishop were Christ
seated in Majesty. It is an example of the high-pitching of episcopal ide-
ology, and the approximation of the bishop's image to that of the emperor,
in the Ottonian period. The two monks in the picture are named as
Keraldus and Heribertus Augigenses (i.e. Reichenau monks). Contrasting
with the stillness, not to say stiffness, of Egbert in the centre of the picture,
is a border of powerful motion, with masks and elongated winged dra-
gons in gold on the purple ground. On the page opposite Egbert is a
dedication inscription, which reads, in Dodwell's admirable translation,
'O Egbert, on taking this book full of divine teaching, fare thee well. And
do thou, O fortunate Reichenau [Dodwell leaves this as *Augia*], rejoice
for evermore in the honour which the prelate pays thee'.[55]

There are some points of contact between the art of the Codex and the
Psalter — the border of the Egbert page in both manuscripts and the
winged creatures on the purple grounds of some other pages of the Psalter,
for instance; but by and large the Codex is very different. For the most
part it lacks the calligraphic initials of the Psalter, and its figural art is
almost another world. The Psalter figures are heavily lined in dark colours;
Haseloff called them 'coloured drawings rather than paintings'.[56] The mod-
elling of the figures in the Codex is achieved much less by line and much
more by colour.

The Codex figures were described as 'colour silhouettes' by Jantzen, but
not silhouettes which formed homogeneous surfaces. There was a fine
inner modelling of colour, and the silhouettes set each other off with
jewel-like beauty. Jantzen regarded this 'colour art', standing somewhere
between the antique and the gothic, as quintessentially Ottonian and the
jewel-like quality is very much what Egbert's goldsmiths strove to
achieve.[57] The way in which the pictures are related to the text is antique
in inspiration, suitably, since this was a period in which Trier became very
46,47,48 conscious of its own history in antiquity. Rarely are these pictures full-
page, they subserve the text in the sense that they illustrate it and are
separated from it by only very plain frames, they are in the horizontal

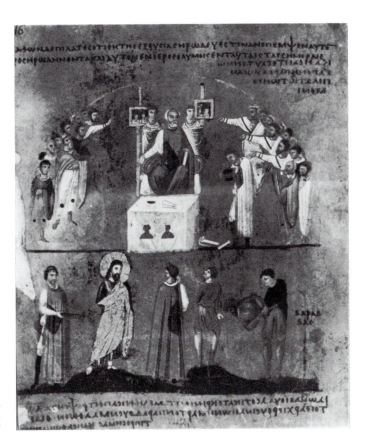

45. Christ before Pilate. Rossano Gospels,
Eastern Mediterranean, C6.
Rossano, Cathedral Library, f. 8v

format of antique narrative pictures, and the figures are set in lightly
coloured backgrounds which give the illusion of space.

One feature of the Codex which should be noted, however, is the relative
lack of narrative bustle and of numerous figures in many of its illustra-
tions. In contrast to the Pilate scene in the sixth-century Rossano Gospels, *45*
for instance, no other figures but those of Jesus and Pilate occupy the stage
here, and the 'set' consists of but a rudimentary building to represent the *Part I,Col.Pl. VI*
praetorium in Jerusalem. There was no *horror vacui* here. It is as if, to keep
the picture as empty as possible, the onlookers of the illustration them-
selves formed the crowd to whom Pilate said, 'behold the man'. The words
Ecce Homo which immediately precede this picture in the Passion narrative
have been turned into a title of the picture, because the scribe has changed
from minuscule to uncial script at this point.

It is not hard to see what the placing of a few 'jewel-like' figures in so
much uncluttered space was designed to achieve. This was art for con-
sumption at public ceremonies. The subject of the *Ecce Homo* illustration
is quite clear, and the impact which it makes is considerable, from several
metres away. In the way our artists have incorporated the illustrations into
the text, in the amount of space around the figures or groups of figures
which makes them stand out, and in the manner these are related to

71

CHANANEA.

PETR

IHC XPC

IN ILLO TEMPRE: Egreffuf ihf. feceffit in
partef tyri et fidonif Et ecce mulier chananea
afinibuf illif egreffa clamauit dicenf ei miferere
mei dñe fili dauid. filia mea male ademonio uexa
tur. Qui non refpondit ei uerbu Et accedentef dif
cipuli eiuf. rogabant eu dicentef. Dimitte eam.
quia clamat poft nof. Ipfe autem. refpondenf ait
Non fum miffuf. nifi ad ouef que perierunt domuf ifrahel.

46. Jesus and the Canaanite Woman. Codex Egberti, 977-93. Trier, Stadtbibl., MS 24, f. 35v

IHC XPC · APLI · CHANANEA

At illa uenit · et adorauit eum dicens · Dñe adiu
ua me Qui respondens ait Non est bonum sumere
panem filiorum · et mittere canibus · At illa dixit ·
Etiam dñe · Nam et catelli edunt de micis · quae
cadunt de mensa dominorũ suorum Tunc respon
dens ihs · ait illi · O mulier · magna est fides tua fiat
tibi sicut uis · Et sanata est filia illius · ex illa hora

47. Jesus and the Canaanite Woman. Codex Egberti, 977-93. Trier, Stadtbibl, MS 24, f. 36

48. Feeding of the Five Thousand. Codex Egberti, 977-93. Trier, Stadtbibl., MS 24, f. 47v

each other by gesture, the Codex Egberti is reminiscent of the celebrated Carolingian manuscript of Terence plays (the latter's lack of frames is not an important contrast), itself based like the Codex on an antique model, whose purpose must have been to be held up at rehearsals so that the cast could see its pictures. The lay-out of every page is most carefully planned, and if scribes and artists were not the same, they certainly had to work in the closest collaboration. The gospel narrative of the Canaanite woman, for instance, takes up two facing pages. There are two illustrations. In the *46,47* first the woman approaches, in the second she bows low to Jesus to make her request, and as she does so the space around her most effectively increases: for the scribe found that he required one less line on the second page than on the first nicely to complete the gospel text.[58] Again, if one compares the crowd scenes of the Feeding of the Five Thousand in the *48* Codex Egberti and in the Gospel Book of Otto III, the delightful human *Part I,62* details of the latter invite a close and intimate study of the page (see Part I, pp. 108-9); whereas in the Codex there is nothing to distract attention from the symbolism of the event as a whole, as if it was all intended to be taken in at a glance during a service. The pages of the Codex, it is true, shimmer with gold, in the borders of clothes, the letters of names, haloes, and in the lozenges decorating the picture frames. But always and in every circumstance the jewelled silhouettes stand out, mostly with classical calm, against the preternaturally clear atmosphere of the backgrounds.

The Codex Egberti was evidently intended to contribute to the splendour of episcopal ceremonial. Its last illustration is the full-page miniature of Pentecost at folio 103, not yet two-thirds of the way through the book. *49* Why were there no illustrations after this? Schiel's answer is that the book aimed to produce a chronological narrative of Christ's life in pictures; this would exclude any illustration after Pentecost.[59] All the scenes had to be packed in between Advent and the Ascension, rather densely packed in, not least on the weekdays of Lent.

The determination to preserve chronology, in a way only matched by the Gospel Book of Otto III in Munich, is undoubtedly a prime principle in these illustrations. For instance, there is no scene depicting the Temptations of Christ in the Codex, which are included in the Echternach Pericopes Book, now at Bremen, for the First Sunday of Lent. They must therefore (as Weis points out) have been in the model of the Codex Egberti. But the Codex has the Baptism of Christ to illustrate the gospel for the octave of the Epiphany and the Marriage Feast of Cana for the second Sunday after the Epiphany. Biographical chronology would therefore necessarily have been breached if the Temptations, which were earlier than the Feast at Cana, had appeared where they should come in the liturgy. Rather than this, the Temptations are dropped altogether.[60]

There are other considerations, however, besides the chronological, liturgical ones for instance, which also had weight in determining why illustration stops at Pentecost in the Codex Egberti. They applied in this

book made for Archbishop Egbert where they did not apply in later Reich-
enau pericopes books made for recipients unknown to us.

The period from Pentecost to Advent, about half the year, was the low
liturgical season. The popes in Rome did not celebrate mass in public
during this season, although they celebrated on every weekday in Lent.[61]
Ottonian bishops, as part of the expression of their majesty, imitated papal
ways and papal ceremonial, just as the emperors imitated Byzantium
though disavowing any political superiority of the Byzantine emperors
over themselves. The tenth-century bishops of Constance, for instance,
built up a pattern of churches and church dedications in their city which
corresponded as closely as possible to that of Rome.[62] In Trier itself, the
title *Roma Secunda* first shows up in Egbert's own time or a little before,
in the *Vita Deicoli* written by Theoderich, a monk of St Eucharius.[63] Theo-
derich was thinking mainly of ancient Rome at that moment, but tenth-
century people did not draw too sharp a distinction between pagan and
Christian/papal Rome. Thus, if the pope did not celebrate the Sundays
after Pentecost in public, the Archbishop of Trier probably followed suit.
The pictures graced the archbishop's celebrations; the pictorial desert after
Pentecost was good enough for ordinary priests.

Midnight mass at Christmas is an example of a celebration which was
indeed pictorially graced. It is clear from *The Deeds of Charlemagne*, written
by Notker of St Gall in the 880s, that Christmas was the festival for hearing
the finest musical chants at Trier.[64] The visual experience of the Codex
Egberti could have matched this a century later. The miniature of the
Col.Pl. VII Nativity and the Annunciation to the Shepherds is one of those few early
ones in the book actually by the Gregory Master himself.[65] It is full-page,
and though it contains more figures than many of the later illustrations,
the groups (as well as the buildings) are so finely drawn and disposed
against the cool lights of the background, that the page makes a wonderful
impression from afar. As the book stands open, the gospel text, beautifully
Col.Pl. VI written as ever, is on the left-hand page, the illustration on the right, and
the text is completed on the back of the illustration. Compared with the
higgledy-piggledy arrangements for the illustration of the three Christmas
masses in some pericopes books,[66] this is beautifully clear and simple, and
very much geared to the solemn celebration of just one of the three masses,
the first. The most important and comprehensive ritual order of the tenth
century, emanating from Mainz, describes how the Romans celebrate
Christmas, and makes it clear that the pope himself celebrates at least the
first mass of Christmas night.[67]

Naturally one asks what is the evidence that this book would have been
open and visible during mass, apart from the reading of the gospel itself?
Would anyone but the deacon have ever seen the pictures? We have noted
that the gospel book was carried closed in the procession before the gospel,
and carried into the pulpit still closed (see Part I, p. 49). We know that the
Codex once had splendid covers which would be eminently displayable
when the book was closed in public ceremonies. The ritual orders would

49. Pentecost. Codex Egberti, 977-93. Trier, Stadtbibl., MS 24, f. 103

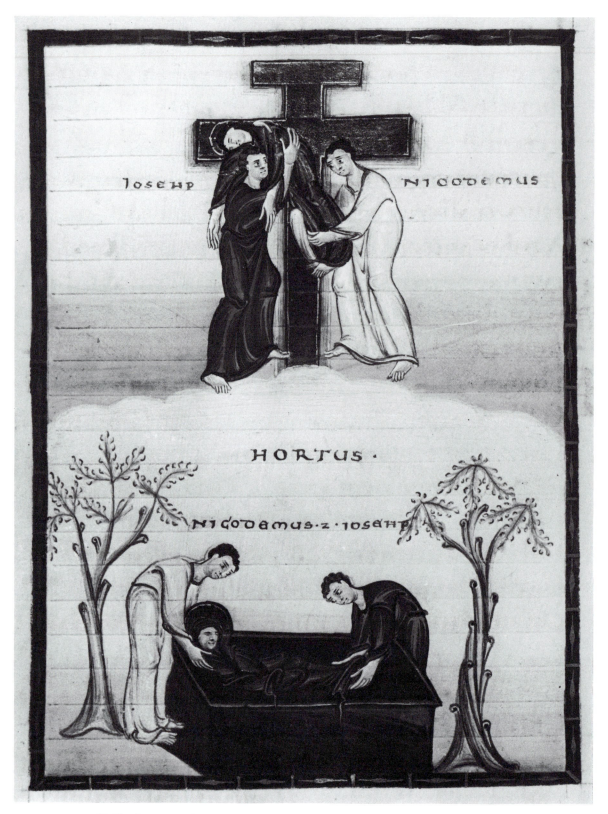

50. The Deposition from the Cross. Codex Egberti, 977-93. Trier, Stadtbibl., MS 24, f. 85v

allow for the gospel book to be exhibited to bishop and clergy, and kissed by them, open, *after* the gospel reading. When it was subsequently placed on the altar, they would also allow for it to be placed there open.[68] But equally they would allow for it to be closed during all this part of the mass. When Carolingian and Ottonian illustrations show the gospel book on the altar, they show it sometimes closed and sometimes open.[69] It is not unrealistic to propose that a church might own a magnificently illustrated gospel book for no other reason than simply that of possession. The Pericopes Book of Henry II at Bamberg, with its superb illustrations and their thick application of gold, may be a case in point; its huge format and great weight would have needed a physically fit deacon to carry it closed. It is doubtful whether a single person could have carried it open during a ceremony. It was a treasure, and that was enough.

In the case of the Codex Egberti, however, which is a much more manageable volume,[70] we do not need to start from the evidence of the ritual orders. After all, those on which we depend pre-date the great Ottonian pericopes books. The character of these books themselves might have caused a later variation of liturgical practice. Why should we not ask what the art itself implies? Enough has already been said to convey the implication that this book was intended to be seen open as well as closed. That is the rationale of its art. It may be that many of the congregation would only catch a fleeting glimpse of it as it was carried in procession after the gospel, or would see it imperfectly from afar as it stood on the altar. But a glimpse or a distant vision, as if of something which was really intended for others in their Olympian world, could have had a greater impact on the mind than the luxury of a close-up view with all the time in the world to enjoy it: like a few words, illicitly overheard from a secret conversation, which sear themselves on the memory.

It would be wrong to imagine that there was nothing more to this book than external magnificence or display. There is a poignancy about many of its pictures, seen at its noblest in the Deposition from the Cross, which *50* shows that religious feeling was not absent. The study of the Egbert St Andrew shrine by Hiltrud Westermann-Angerhausen has shown that in its original state it too was much more than a Trier prestige object; its Christology, eucharistic imagery and missionary connotations, gave it a far-reaching religious significance, as we have also argued above that the Egbert Psalter had. Egbert played his part in the spread of the Gorze monastic reform, bringing monks from St Bavo, Ghent, into the Trier monastery of St Eucharius; while a thirteenth-century forgery in his name from the collegiate church of St Paulinus shows his importance in the traditions of this house.[71] There are traces of reformed monastic ideals in the miniatures of the Codex. The Pentecost picture shows, in the midst of the *49* apostles, a table with (golden) bread loaves on it, labelled *communis vita*. Another depiction of the *communis vita* from Reichenau, executed with naïveté but originality, is the Pentecost of an early eleventh-century sacra- *51* mentary at Paris, where below the apostles standing in a line, three peas-

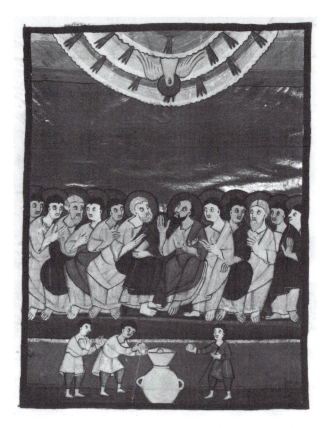

51. Pentecost. Sacramentary,
Reichenau, early C11. Paris,
BN, MS lat. 18005, f. 94v

ants are bringing bread to put in a dish set on top of a pitcher. The reference
in both cases is to the sharing of goods in common by the early Christians,
but this is a very unusual feature of Pentecost illustrations, and the mon-
astic *vita communis* (as to worship, property, common dormitory and re-
fectory) is a signature tune of the *Life of John of Gorze*, being composed in
Metz about the very time of the Codex (see Part I, pp. 85-86).[72] Further-
more, Heinz Thomas has pointed out that the walls erected by Archbishop
Henry of Trier (956-64), an *alumnus* of Reichenau, were not town walls,
but walls to separate the cathedral clergy from the laity so that they would
lead the *vita communis*.[73] At two points where Christ is shown preaching
52 to the seated apostles, the front row of apostles has a cloth spread over
their knees, like the long linen cloths described by the ritual orders to be
spread over the altar (altar cloths are apparently alluded to in our account
of Egbert's refurbishment of his cathedral). Doubtless there is here a ref-
erence to eucharistic devotion in monastic circles; in one of these pictures,
illustrating Christ explaining why he eats with publicans and sinners, the
three front apostles each has a loaf of bread before him.[74]

Was the Codex completed to Egbert's order, or was he handed a manu-
script already finished except for the dedication pages? There is no cer-
tainty here, but the probability is that he had some influence over its
making.[75] That is the likeliest explanation of a demonstrable change of
plan, when at first the manuscript was apparently destined to have no

80

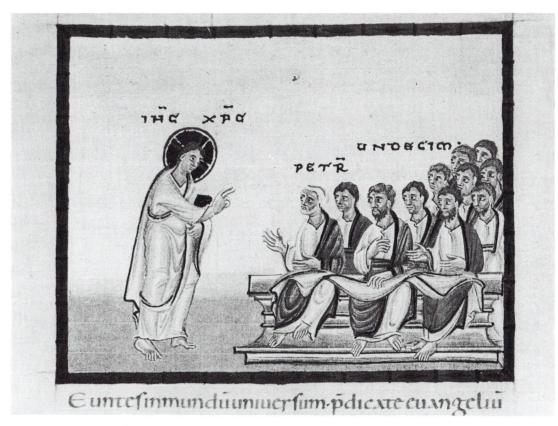

IHC XPC

PETR

UNDECIM

E untes in mundu uniuersum · pdicate euangeliu

52. Jesus addresses the Apostles before the Ascension. Codex Egberti, 977–93. Trier, Stadtbibl., MS 24, f. 100v

illustrations of gospel scenes at all.[76] It would also fit with the clear evidence of his personal interest in Trier metalwork. If he had his say, then, we are at once confronted with a large paradox: Egbert himself elicited two books, both of them beginning with an image of himself, which are worlds apart from each other in artistic style and aesthetic purpose. The paradox is sharpened if he acquired both books from Reichenau, and whatever one makes of the puzzle of its Trier script in the circumstances (another indicator of Egbert's influence),[77] the dedication verses appear to provide strong evidence that the Codex came as a present from Reichenau. Yet it is a genuine paradox and not a contradiction. Haseloff, who wrote under the spell of the Impressionists and before the Expressionists began to change the predilections of Ottonian art critics, much preferred the book-painting of the Codex, articulated by areas of colour (*Deckmalerei*), to the heavy linearism of the Psalter.[78] But we can have no idea whether or not Egbert himself shared this preference. We do not need to assume that, in the way of some more modern patrons, he had stylistic fads of any sort. Perhaps he judged a style first and foremost by what it was intended to achieve in his religious and ecclesiastical life, and here the Psalter and Codex had very different roles, albeit in the common purpose of exalting Trier and its archbishop.

81

3 Art and Politics

One would be in for a jolt if one supposed that all this patronage of art and projection of his image by Egbert indicated a high-water mark for the archbishopric of Trier in the ecclesiastical politics of the time. It was the reverse. Under the three archbishops before Egbert, the fortunes of the see had indeed been in the ascendant. Ruotbert (930-56), the clever lawyer and cousin of Otto I, played a leading role in the councils of 947-48 convened to deal with the Rheims Schism. He was probably accorded this prominence because of the superiority of Belgica I with Trier as its metropolitan to Belgica II with Rheims (see p. 66). Henry (956-65) made good the claim to participate in the royal coronation of Otto II in 961 which had been lost at Otto I's coronation in 936. Theoderich (965-77), who had been previously provost of Mainz Cathedral and knew exactly what was required to spike the primatial guns of Mainz, secured a privilege from Pope John XIII in January 969 granting to Trier the primacy of Germania and Gallia. This is the earliest genuine primacy privilege of the Ottonian Church. It was renewed by Pope Benedict VII in 975, with various rights including that of Trier to have a cardinalate clergy (as at Rome), superior to the rest of the cathedral clergy, wearing dalmatics and sandals.[79] All the historical writing, the hagiography and the forgery of the mid century, was paying off.[80] It pulled Otto II along, too. On 27 August 973, after a stay at Trier, he granted a diploma acknowledging its primacy of Gallia and Germania.[81] No wonder Egbert's dedication verses in the Gregory Register speak so elegiacally of the times of peace under Otto II. No wonder that it is about Archbishop Theoderich that Boshof has chosen to write a book illustrating the *expanding* power of Trier and its ideology in the Ottonian church, a book in which Egbert (quite reasonably) figures hardly at all.[82]

All this changed when Willigis replaced the nonentity who had preceded him as archbishop at Mainz in 975. Willigis at once secured a privilege from Benedict VII, whose powers of diplomacy must have been severely tested by all this, acknowledging his pre-eminence among the German episcopate, which he later (997) consolidated into the title of *vicarius* of the papacy.[83] This may not seem much, particularly as it was only an *ad personam* privilege rather than for his see. But it was a gain. In the tenth century phrases such as primacy, pre-eminence, vicariate, seem to lack a precisely defined legal content, and rather to be like pieces in a game of rival prestige politics, which if skilfully deployed could be very effective. At the same time as the pre-eminence of Mainz was confirmed, this archbishopric made a much more tangible advance; the newly founded bishopric of Prague in Bohemia was placed under its metropolitan authority. This was a great change especially after the blow which Mainz had received to its prestige in 968, when Magdeburg was given independent status as a new metropolitan see, thus cutting off the authority of Mainz from the whole expanding missionary world to the east of

the Elbe. That was only a few months before Trier received its primacy privilege of 969, suggesting that Trier had seized an opportunity created by the temporary weakness of Mainz. On the other hand, in the fifty years after 975 there is no evidence that Trier's privileges were renewed by pope or emperor.[84]

It is tempting to think that if Trier lost ground in the primacy stakes under Egbert, his own unsound political sense was to blame, grand as is the impression of him which we get from his art. Should he have espoused the cause of Duke Henry of Bavaria (the Quarrelsome) as he did in the succession dispute of 984-85? Having espoused it, should he not have made his peace with the party of Otto III earlier than he did? But one must remember here that Henry had secured the support of Lothar V of France by promising to cede Lotharingia to France if he were successful. In 984 this could have enhanced the sense of Trier that its destiny was tied up with the West Frankish rather than the East Frankish, or German, kingdom. We have already said that Trier had the option, so to speak, of a whole area of authority to the West, encompassing Rheims. In other ways also, Trier's traditions looked more to France than to Germany. Zender has shown that the cults of its great saints, like Maternus and the Aquitainian Maximus, were much more prevalent to the west than to the east of Trier.[85] The traditions of a see were bound to influence an incumbent, even though Egbert's antecedents in Holland and in the Ottonian chapel had not earlier prepared him for this western orientation. The rights, traditions and privileges of his see gripped every normal medieval bishop, wherever he had been and whatever he had done beforehand. There is evidence in Gerbert of Aurillac's letters that Egbert had actually contemplated transferring himself and his see to the French kingdom in 984-85.[86] It looks an extreme step now to historians who observe the long history of Trier in Germany, or even to those who see that many other Lotharingians of the time (as well as Gerbert himself) thought that their bread was buttered on the Ottonian side; but from Egbert's viewpoint there was a logic in his policy. Willigis of Mainz was the staunchest ecclesiastical champion of Otto III's succession, and under Otto III Mainz was always bound to be the greatest obstacle to the primacy of Trier. Moreover, in purely geographical terms, had an archbishop sitting on the River Mosel, which could easily take him down into the plains of Champagne, a realistic chance of ever making good his aspirations to primacy in the German Church, over the head of an archbishop sitting on the Rhine where the River Main joins it?

The fact is that in the whole period of Egbert's archiepiscopate, after decades of greatness, Trier was under pressure. His art must be seen more as a response to that pressure, than as a victory salute.

4 Egbert of Trier: Contrasts and Analogies

(a) WILLIGIS OF MAINZ

We do not seek to argue from the previous section that *only* bishops whose sees were in difficulties produced episcopal art, nor that episcopal art was a *necessary* product of sees which were under pressure. Perhaps this is the moment to raise the question why we cannot match Egbert of Trier with many more like him.

Partly the problem is one of the survival of evidence. If we take Mainz as an example,[87] this church lost books in twelfth-century fires, in their being carried off by armies of occupation such as the Swedes in the 1630s, and in the huge fire caused by the French bombardment of June 1793.[88] But this can hardly be the whole answer to the exiguous survival of Mainz manuscript art from the Ottonian period or to the surprisingly low quality of what survives. Cardinal Albrecht von Halle, who visited Mainz in 1540, took manuscripts to Gotha where they have survived. The Swedes were well capable of treasuring and ensuring the survival of manuscripts which they acquired at the time of the Thirty Years War. The French attacks of the 1790s were anticipated in time for various precious Mainz manuscripts to be transferred to the safety of Aschaffenburg Castle.[89] It is scarcely conceivable that had Mainz produced fine illuminated manuscripts for itself let alone for export (or had the same interest to acquire them) as Egbert had at Trier, nothing more would have survived — somewhere — than in fact has.

53 The best surviving manuscript of the Mainz school is a sacramentary *c.* 1000, now in the Cathedral Treasury (Kautsch 4) but originally from the monastery of St Alban.[90] It has attractive gold initials on blue or green or even occasionally light pink grounds, and some of its more important collects are written in golden capital letters on purple grounds, a sort of writing done by Ekkehard II of St Gall whom Willigis welcomed to Mainz in the 970s.[91] Indeed, in its script and calligraphy it represents the high standards of the Willigis school.[92] It has but three full-page miniatures, illustrating the Two Women at the Tomb for Easter, Pentecost, and the Martyrdom of St Peter. These miniatures show a mixture of St Gall, Reichenau, Fulda and Carolingian influences; they are executed in pleasant colours mainly of green, orange and silver. But these are not masterpieces of Ottonian colour, and their heavy draughtmanship makes them entirely second-rate.[93] One notices, too, that the miniatures include no scenes of the Life of Christ.[94] We have already said that it was the monasteries of the Gorze monastic reform which seem to have been principally responsible for stimulating much of the Christ-centred art (see Part I, pp. 83-88), and this reform came very late to St Alban's, Mainz, indeed late to Mainz at all.[95] Nor, *pace* Hallinger, does Willigis, for all his religious and cultural concerns, seem to have been very interested to promote it.[96]

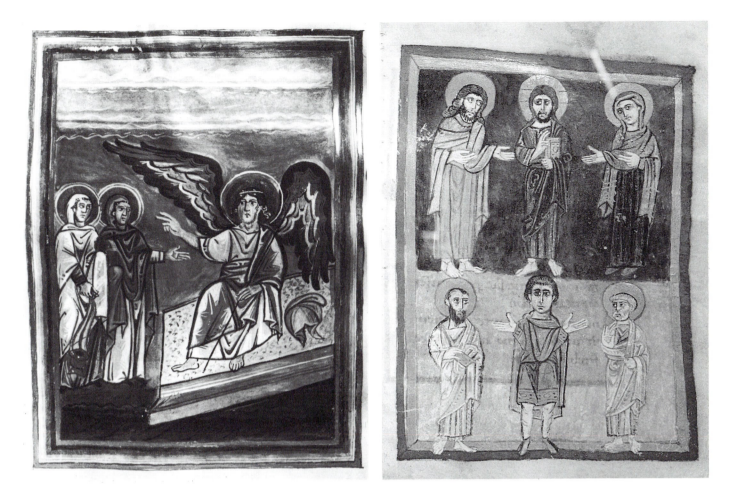

Another significant manuscript emanating from Mainz, perhaps also from St Alban's, is the Prayer Book of Otto III (Pommersfelden, MS 347). This small book is entirely written in golden minuscule on purple grounds. It has five full-page miniatures: the Crucifixion; a *Deesis* and underneath, the *orans* king standing between Peter and Paul, reminiscent of a sacramentary of Charles the Bald where that king is shown standing between Gelasius and Gregory; a double page showing the young ruler worshipping, in the act of *proskynesis*, Christ in Majesty; and a dedication page in which a cleric presents the book to a seated ruler. A remarkable range of sources, Byzantine and Carolingian, was required for the iconographic scheme of this sumptuously conceived little book. There must have been a cycle of ruler pictures at Mainz on which it drew, probably connected with one of the coronation orders in which St Alban's specialized. But the execution is uniformly derisory and shows a failure to capitalize artistically on the available resources.[97]

One cannot avoid the impression that Ottonian Mainz could have done much better than it did in the field of manuscript painting, and that what was lacking was the enthusiasm. The tenth-century archbishops of Mainz were men of strong religious and literary interests. Regino of Prüm dedicated his *De synodalibus causis* to Archbishop Hatto I (891-913). Archbishop

53. The Two Women at the Tomb. Mainz Sacramentary, *c.* 1000. Mainz, Cathedral Treasury, MS Kautsch 4, f. 84v

54. *Deesis* and *orans* King between Peter and Paul. Prayer Book of Otto III, *c.* 990. Pommersfelden MS 347, f. 2

Frederick (937-54) was the recipient of a letter of high moral tone about his office from the priest Gerhard. Hrotswitha of Gandersheim dedicated her *Carmen de Gestis Ottonis* to Archbishop William (954-68). Willigis (975-1011) took a personal interest in the writing and correction of a copy of Augustine's *City of God*.[98] The most comprehensive liturgical orders of the empire were almost certainly compiled at Mainz in the mid tenth century.[99] But perhaps when it came to the liturgy, the archbishops had other priorities than manuscript painting for its ennoblement; metalwork and fine vestments, for instance, or indeed the architectural setting, which was obviously the principal preoccupation also of Bishop Meinwerk of Paderborn.[100] Furthermore, when one reads the Prayer Book of Otto III, one would not expect great artistic cycles of the Life of Christ necessarily to come from its milieu. This is a book of old-fashioned, Carolingian piety, God-centred rather than Christ-centred.[101]

Other sees which were not productive centres of manuscript art may not have been uninterested, but may have been satisfied to import. Magdeburg seems to have been in this category and there is a strong implication that Paderborn under Bishop Meinwerk also was.[102] Sometimes imports may have stimulated subsequent local production. At Augsburg, for instance, we have Reichenau manuscripts, a pericopes book and Berno's *Life of Saint Udalric*, and probably later, an indigenous sacramentary illustrated in a provincial version of the same style.[103]

Egbert was not, however, entirely singular in his age. The closest parallel to him is Bishop Bernward of Hildesheim (see Part I, pp. 95-105). Both presided over well-organized ateliers and patronized a whole range of the arts, manuscript painting only one amongst them. Both were clearly men of religious earnestness, though one perhaps misses the strong Egbertian ecclesiastico-political strand in Bernward's artistic activities. No doubt Bernward wished to grace and glorify the churches of Hildesheim, but what comes through more insistently is that artistic creativity was for him something in the nature of a mystical experience, as it was in the twelfth century for Abbot Suger of St Denis, who was equally not innocent of all political intention. Above all, both Egbert and Bernward were alike in their conscious desire to be remembered for their art and their patronage (see p. 60). From how many bishops, who may have commissioned fine manuscripts but showed no special desire to be remembered, Egbert and Bernward were in this respect distinguished, we cannot in the nature of the case know. Not, certainly, from Warmund of Ivrea or Sigebert of Minden. Egbert will become more intelligible if we support him, so to speak, and give him depth of roots in his society, with these other examples, albeit lesser lights of episcopal patronage.

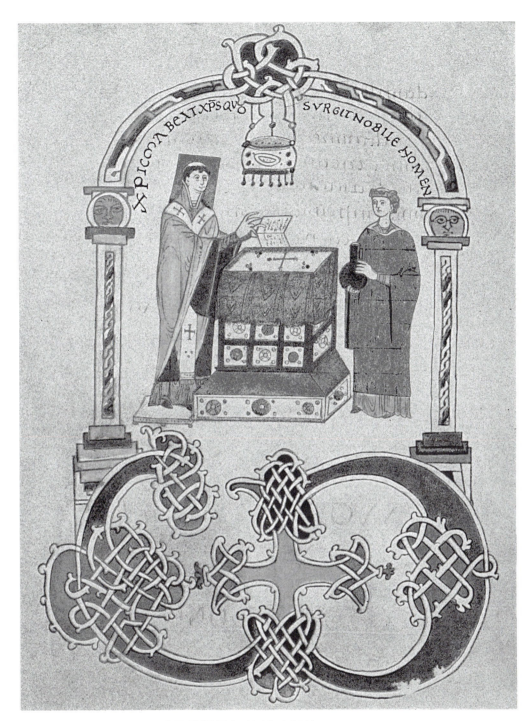

55. Bishop Warmund of Ivrea places his Book on the Altar. Sacramentary of Bishop Warmund, *c.* 1000. Ivrea, Bibl. Capitolare, Cod. LXXXVI, f. 11v

(b) WARMUND OF IVREA (969-1011)

A visit to the diocesan library of Ivrea, a city with fine views of the Alps (for its strategic importance see p. 24 above), enables one in a remarkable way to recreate the *persona* of a long-lived bishop at the turn of the millennium. The most lavishly decorated of the Warmund manuscripts, in figural art and calligraphic initial letters, is his Sacramentary (Cod. LXXXVI).[104] Here, above the letter V at the Preface of the Canon of the 55

Mass, the bishop places his book open on the altar. He is dressed in mass vestments and pallium, and has the typically Italian square nimbus behind his head. Opposite him stands a deacon. There is nothing of Reichenau in this picture. The colour tones of blue, green, pink and yellow are similar to those in the contemporary wall-paintings of the Cathedral Baptistery at Novara,[105] and the interlace of the initial is a continuation of Insular/Carolingian style. Scene and letter are enclosed by a frame with the inscription, which would read in translation: 'Bishop Warmund gives you this book as yours, O Virgin Mary (to whom Ivrea Cathedral was dedicated). Grant him in turn life eternal'. Two pages further on, at the beginning of the canon itself, stands the bishop once again, his arms outstretched in prayer, and here we read in the frame: 'Clothe with the gift of heavenly devotion, O Christ, the mind of him who has striven to bring you (the fruits of) his labour'. The book is very close to Otto III, not in art but in politics, and an illustration to the mass for kings shows *56* the Virgin Mary crowning Otto III; the inscription reads: 'I reward you with the gift of a crown for your good defence of Bishop Warmund'.[106] As we have seen (p. 53), this would date the manuscript quite precisely to 1000-01. A detailed iconographic study is still needed of the large cycle of New Testament and hagiographic scenes in this book. Provincial as they are in style compared with the Gospel Book of Otto III from exactly the same years, they clearly draw on a wealth and variety of Carolingian, Ottonian, and Italian antecedents — or an immediate model drew on them.

56. The Virgin Mary crowns Otto III. Sacramentary of Bishop Warmund, *c.* 1000. Ivrea, Bibl. Capitolare, Cod. LXXXVI, f. 160v

A Psalter (Ivrea, Cod. LXXXV) evidently from the same scriptorium as the Sacramentary, though without specific mention of Bishop Warmund this time, has interlace initials in gold and orange and a series of Old Testament figures, penitents receiving forgiveness from God, etc., by way of illustration. Every tenth psalm is preceded by an interlace initial, sometimes with finials of biting beasts' heads, contained within a purple and gold frame with interlace projections. One is tempted to think that this is an earlier manuscript than the Sacramentary, because the initial ornament of the latter seems more evolved, with firmer handling of the foliage interlace and a greater variety of colours. But this would be a dangerous line of argument, because the simpler ornamentation might have been thought by the scriptorium more appropriate to the Psalter than to the Sacramentary.

57. Bishop approaching the Altar. Prayer Book for Mass, *c.* 1000. Ivrea, Bibl. Capitolare, Cod. IV, f. 4v

57 One other of these manuscripts is worth singling out for mention on account of its illustrations, a book of private prayers for the bishop to say before and during the celebration of mass (Cod. IV). Near the beginning of this book (*57*), badly damaged by water, are three illustrations, showing the bishop ceremonially washing his hands before vesting; the bishop vested (his vestments including a prominent pallium), standing frontally with his arms outstretched in prayer, supported by two deacons while thurifer and candle-bearer stand behind; and the bishop, maniple in hand, in humbler posture, approaching a splendidly marbled or jewelled altar. Again there is no specific reference to Warmund, but style and palaeography alike closely relate this manuscript to the Sacramentary. It is not clear that the two deacons are actually holding the bishop's arms in prayer, but this scene puts one in mind of the tradition which represents a king *Part I,* with bishops or saints on either side of him, a tradition which reached its *115,116* apogee in the Regensburg Sacramentary with Henry II supported by Saints Emmeram and Udalric who hold the king's outstretched arms (see Part I, *Part I,35* pp. 66, 199).[107] The thought of appropriating ruler iconography to the bishop cannot be absent here.

To have a series of scenes depicting a liturgical celebration is not unusual; we have only to think of the ivories on the Drogo Sacramentary in the Carolingian period, or the illustrations to the Canon of the Mass in the Ottonian Reichenau sacramentary at St Paul, Lavantthal.[108] But the *58* collection of prayers in this book is not at all easy to parallel. It opens with 'Here begin the prayers by which the bishop should prepare himself for mass.' Some examples from further on are as follows:

> *Rubric in capitalis rustica*: when he comes
> before the altar he shall say this prayer:
>
> O God [an interlace initial for *Deus*, here]
> who maketh of the unworthy the worthy,
> of sinners [water damage], of the unclean
> [presumably *the clean*, more water damage],
> make me a worthy minister at your holy altar ...

Rubric in minuscule: When the *Gloria in excelsis deo* is chanted, he shall say these prayers:

O God who desires not the death but the life of sinners [and there follows a prayer for his own sins to be taken away].

Rubric: When incense is put into the thurible before the gospel is read, the bishop shall say:

Kindle our hearts, O Lord, and fill them with the odour of heavenly inspiration

Later on there are prayers for the members of his household, for the sick, and for others, as if the bishop were taking a responsibility for the whole Christian society in these mass-prayers.[109]

One turns from this remarkable book to a manuscript of episcopal blessings (Benedictional, Cod. XX), with typical Warmundian initials, some of them in square frames as in the Psalter. The first encounter in this manuscript, paradoxically, is with a lengthy and sonorous curse against Arduin of Ivrea and his party. It is not written in the same hand as the rest of the manuscript, but it is an eleventh-century hand and the text clearly emanates from Warmund. A sample of it reads, 'We curse all the knights holding land of St Mary, Ivrea, who by any means gave counsel and help to Arduin and Amadeus'...[110] There is pressure on the bishop here; the other side of the coin, perhaps, from the projection of his image in art.

58. Priest celebrating Mass. Sacramentary, Reichenau, *c.* 970-90. St. Paul im Lavantthal, Stiftsbibl., MS 20/1, f. 13v

(c) SIGEBERT OF MINDEN (1022-36)

But for the manuscripts which cluster round his name, and by contemporary standards these are not of the first order, Sigebert of Minden would be an entirely unnoteworthy bishop. He was a worthy internal candidate for the bishopric, having risen through the Minden cathedral school. He had never been a royal chaplain. His see stood in the heartlands of the most important family in Saxony after the royal Liudolfings, the Billungs. His one moment of political prominence was when he received the newly-elected Conrad II in Minden at Christmas 1024. The Saxon princes came here to recognize the ruler, and afterwards Sigebert accompanied him on his *Umritt* to Paderborn, Corvey and Merseburg. Thus he played his part, at the change from the Saxon to the Salian dynasty, in the *rapprochement* between the first Salian and the Saxon aristocracy. But perhaps even here he was thinking most of his own diocese. For very shortly afterwards, in May 1025, he received from Conrad II the estate of Kemne as well as privileges for the canonesses of his diocese; and in 1029, when Sigebert founded St Martin's as a house of canons, confirmed by Conrad, Kemne became the basis of its endowments. Thus Minden was made a more important pastoral centre than previously; it had an important church besides the cathedral as, on the recent analogy of Bamberg (founded 1007), a self-respecting bishopric should have; and the two churches together now came to dominate the view on the Hochufer, the high bank of the River Weser.[111]

In 1683, by order of the Great Elector of Brandenburg, an inventory was made of the Cathedral Treasury of Minden, including the manuscripts. Soon after 1683 several of the manuscripts were transported to Berlin, where those which survived the Second World War remain divided between the libraries of East and West Berlin, while two manuscripts found their way to Wolfenbüttel. We can thus identify eight manuscripts of Sigebert, two of which were lost during the Second World War.[112] It is an established fact that these manuscripts are in the script of St Gall, though whether they were produced at St Gall, or at Minden by scribes trained at St Gall, is not clear.[113] No fewer than four of the eight manuscripts are books of chants (two graduals, a hymnal, and a troper), and thus reflect the dominant position of St Gall in tenth/eleventh-century music.[114] The gradual at Wolfenbüttel, with its orange initials on golden grounds and its inclusion of Sigebert in the Laudes ('salvation and perpetual life to Sigebert, bishop of this church'), contains verses of Notker Balbulus of St Gall for receiving a king, of Ratpert for receiving a queen, and of Hartmann for the gospel procession and the eucharist.[115] Ratpert and Hartmann were both ninth-century monks of St Gall.[116] The troper, now lost, had a picture of Notker Balbulus at work. An ivory made for the Sacramentary of Bishop Sigebert, depicting the four great Fathers of the Church, shows a similar figural style to this picture, and other similar features, like the writing-desks.[117]

The one Sigebert manuscript with a cycle of illustrations is the Sacramentary. Apart from some splendid initials, this has a Nativity, Epiphany, Three Women (here actually four, apparently a literal interpretation of 'other women' in Luke, 24:10) at the Tomb, Ascension and Pentecost, the figures very much in the contemporary style of St Gall. The special glory of this work, however, resides in the three illustrations to the Canon of the Mass; the Crucifixion at the *Te Igitur*; the seven-horned apocalyptic lamb, with book before him and blood flowing from his side, and with the evangelist symbols in semi-circles around him, for the Agnus Dei; and

59 above all, the celebration of mass by Bishop Sigebert at the end.[118] Ruth Meyer, in her excellent study of these full-page illustrations, offers a theological interpretation of the three 'canon' pictures.[119] One would not dissent from it, but it may also be noted that three pictures in this place would make an especial impact in a not very large cycle, since this section of the book was used at every mass.

In celebrating mass the bishop is shown standing in his cathedral against a golden ground at an altar, behind him a deacon. Across the altar, which is covered with a purple cloth and has on it the host, he is offered a chalice by a figure of the Church, *Ecclesia*. This *Ecclesia* looks very masculine and carries a banner; his or her whole expression and bearing are of vibrant energy. A cloak is slung over her shoulders and her head gear is helmet-like, but underneath the cloak is a garment of the same colour as the bishop's chasuble. *Ecclesia* and the bishop are not represented as if they belonged to two different planes of being. Behind *Ecclesia* stands Mary, a 'type' of the church (see p. 42). Ruth Meyer has described this picture well, with its Reichenau conception of space and colour (albeit not figural style) and the sacred *Innenraum* created by the architectural forms for the altar and its hanging lamp. Around the frame are inscribed words which in translation read: 'Take, Sigebert, the gifts of eternal life through which the mother of graces gently refreshes you'.

It would have been more usual in the early Middle Ages to illustrate the Canon of the Mass with the sacrifices of Abel, Abraham and Melchisedech, the sacrifices mentioned in the prayer *Supra quae*. But the portable altar of Henry II now at Munich dating from 1014-24 and thus a little earlier than the Sigebert Sacramentary, has engraved on its silver dorse the apocalyptic lamb, *Ecclesia* holding a chalice to receive its blood, and the sacrifice of Abraham below. Despite the absence of Abel, therefore, and of Melchisedech, unless he could be identified with the figure behind *Ecclesia* offering host and chalice, this portable altar seems to illustrate the *Supra quae* of the canon, and thus to be pointing in a new direction of illustration of the mass which Sigebert follows.[120]

Unimportant as Sigebert himself may have been in the imperial church, the peculiar distinction of the bishop in liturgical celebration, as exemplified by this picture, the awe which he inspired, like Melchisedech set apart from other men, is also expressed in the principal ritual order of Sigebert's time, in a rubric for Maundy Thursday. This rubric is written into many

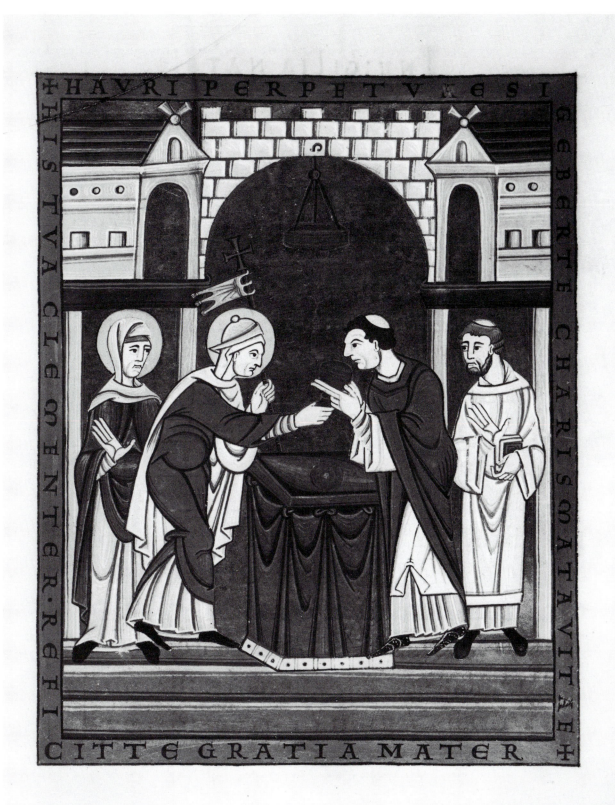

59. Bishop Sigebert of Minden celebrating Mass. Sacramentary of Bishop Sigebert of Minden, 1022-36.
Berlin (East), Staatsbibl., MS theol. lat. fol. 2, f. 9

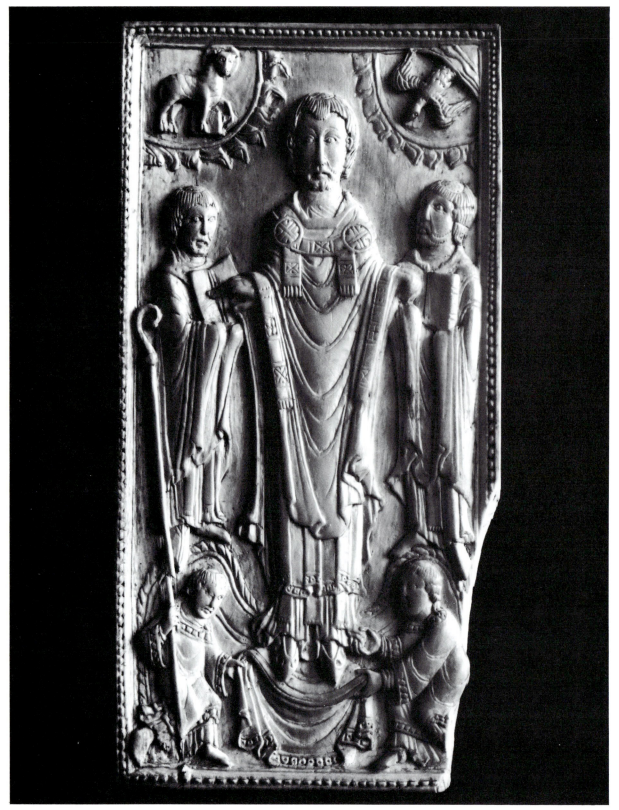

60. Bishop Sigebert of Minden, as if transfigured. Ivory book-cover, 1022-36.
Berlin, Staatsbibl., MS Germ. Qu. 42.

sacramentaries, Sigebert's included. The picture here shown is an illustra-
tion to the Canon of the Mass, not to Maundy Thursday, but it so captures
the spirit of the rubric, with its sonorous resonances, that we presume to
cite the latter:

> Then shall communicate the bishop alone before
> the altar, and the deacon shall offer him the
> chalice and shall not break the hosts, except that
> one only from which the bishop communicates. On this
> particular day, after the bishop has taken communion,
> the deacon shall place the chalice on the altar. Then,
> receiving the paten from the subdeacon, he shall set
> it next to the chalice on the left ...[121]

In the same order is a tenth-century Maundy Thursday hymn, probably
composed at the monastery of St Alban, Mainz. This, too, seems to have
reverberations in Sigebert's mass. I give the Latin of one verse and my
own rhythmical translation:

> *Stans ad aram immo supplex*
> *Infulatus pontifex*
> *Debitum persolvit omne*
> *Consecrato chrismate*

> At the altar in entreaty
> Stands the famous *pontifex*
> He pays every debt and duty
> With the chrism consecrate
> [*lit.* when he has consecrated the chrism]

Two other images of Bishop Sigebert survive, one in manuscript, the other
in ivory. The one in manuscript is a single leaf (now at West Berlin, theol. *Col.Pl. VIII*
lat. qu. 3), probably but not certainly intended to be the frontispiece of a
book of gospel readings. The bishop, whose face has turned out a par-
ticularly miserable-looking specimen of St Gall physiognomy, is frontally
seated between a priest in cope and a deacon. All three hold books, the
priest's closed, and those of the bishop and deacon open. The inscription
in the frame, translated, reads: 'This sacred image is dedicated to your
name, O Sigebert. May it sustain and preside over your office'.

The ivory panel, probably intended for the cover of the Sacramentary *60*
now at Wolfenbüttel, is far more remarkable, though scarcely less provin-
cial as art. The gigantic figure of the bishop, with enormous head, stands
bolt upright, or rather floats, between two deacons, one of whom holds a
closed book and the other a book open, as if the bishop, vested in mass
clothes, were being proferred it to read the collect. He presses its pages
flat with his right hand, indeed, but in his frontal and hieratic posture, he
cannot of course look, and seems almost disdainful of it. At the bottom of
the panel, half crouched, are two clerical figures holding a cloth under-
neath the bishop's feet. This is a classic symbol for depicting the heavenly

apotheosis of the person above the cloth. One of the clerics in addition holds the bishop's crozier, for the clerical familiars of Sigebert of Minden are hard-worked men. Two fiery segments above the scene contain the apocalyptic lamb, this time with sealed book (in the Sacramentary its book is open, as if the mass revealed its secrets), and a dove.

The intention of this ivory is perfectly clear. It is to represent the bishop as if he were Christ in a Transfiguration scene — once again Christ-centred episcopacy! The two deacons take the place of Moses and Elias, the crouching clerics below that of dazzled apostles. The cloth is a means of expressing the idea of transfiguration,[122] and such a scene required a dove. Who was impressed by all this at the time we cannot know, but we may hazard the suggestion that it impressed at least Sigebert of Minden himself. That is not historically unimportant. If bishops were to rule in the informal circumstances of the time as holy men, inspiring in their dioceses a sense of *tremendum* (and a bishop of Minden had few enough tangible resources from which to create this) they needed self-confidence and a high sense of their own position. To see themselves reflected in such images surely helped them to sustain their office.

In both manuscript and ivory the bishop's rationale (the shoulder garb deriving from the finely embroidered ephod made for Aaron as priest) is prominently displayed. Almost the whole of Exodus chapter 28 is taken up with describing the symbolism and the jewelled richness with which the ephod should be made. It seems that Sigebert was not slow to seize the opportunity which the Book of Exodus had given him. The rationale can already be found in Carolingian depictions of Aaron,[123] but it made its greatest advances in the Ottonian period. The earliest surviving example is at Bamberg, made probably for its first bishop, Eberhard (1007-41).[124] This is a piece of dark blue silk embroidered with medallions in gold. Its symbolisms derive partly from Exodus, as with the twelve patriarchs of Israel, or the inscription *Doctrina et Veritas* because the ephod was the breastplate of judgement, and partly from the New Testament, as with (again) the seven-horned Lamb of the Apocalypse. A treatise on the Divine offices attributed to Alcuin, which Andrieu would date to the tenth century, has much to say about the rationale, a subject completely passed over by the ninth-century Amalarius in a similar treatise, for all the latter's interest in vestments and his rhapsodizing about the variety of sandals worn by the different orders of clergy. This is a passage from the Pseudo-Alcuin:

> The rationale, which was worn by the pontiff on
> his front, shows that the pastor must be
> endowed with wisdom and doctrine. Therefore it
> is called the rationale of judgement, because a
> ruler of the Church ought with subtlety and
> deliberation to distinguish good and bad
> Hence is the saying, 'put on the rationale of
> judgement, doctrine and truth (*doctrinam et
> veritatem*)'.[125]

The rationale, says the author, is the mirror of virtues within the breast of the pontiff. One must remember that the mitre did not become an object of episcopal head-gear until the late eleventh or twelfth century. In Sigebert's time, therefore, the rationale was a distinctive adornment of a bishop. It was also, as Pseudo-Alcuin reminds his readers, the symbol of pastoral duty. We have shown reason to believe that both were matters of concern to Sigebert of Minden.

Sigebert himself and the artist of the single leaf at West Berlin surely knew what Pope Gregory the Great had to say about the rationale in his *Pastoral Care*, the greatest book on the pastoral office written in the Middle Ages. Gregory said that it was rightly enjoined that the humeral veil (or rationale) should be made of gold, hyacinth and purple: gold, because in his vesture the priest should shine resplendently with wisdom; hyacinth, the colour of the skies, so that he might rise to the love of heavenly things; purple because with kingly power he should reject vice, 'ever setting his gaze on the nobility of his interior regeneration'.[126] In the picture, Sigebert's *Col.Pl. VIII* rationale is only gold in colour, but his vestments are blue and the backdrop to the figures is purple, so that the colour scheme as a whole is biblical and Gregorian. Perhaps, after all, what we earlier characterized as the bishop's 'miserable looking' face is intended to represent the 'interiority' of his religion, the artist's attempt to realize the setting of his gaze on the nobility of his interior regeneration.

Finally we may ask why this modest efflorescence of provincial art should have occurred particularly in connection with Minden. Perhaps the only real answer to this is that the spirit bloweth where it listeth. But there is a little more to it than that here. We know from a single survivor, a gospel book with ornamented initials and some gold lettering, that one of Sigebert's predecessors, Bishop Milo of Minden (969–96), was interested in acquiring fine books.[127] Furthermore, a correspondence happens to survive between Milo and Abbot Immo of Lorsch. The bishop, after a visit to Lorsch, had dug out of his cathedral library the texts of *passiones* of Saints Gorgonius and Dorothy, patrons both of Minden Cathedral and Lorsch.[128] In 1006 Immo became Abbot of Reichenau. Could not the promptings and stimuli of St Gall, so closely intertwined in art and culture with its near neighbour Reichenau, have arisen from this connection of Minden? Ruth Meyer has shrewdly said that the miniatures of Sigebert's Sacramentary were 'as if the artist had translated St Gall composition into Reichenau painting'.[129]

61. Abbess Hitda of Meschede presents her Book to St Walburga. Hitda Codex, Cologne, *c.* 1000-20. Darmstadt, Landesbibl., Cod. 1640, f. 6

CHAPTER THREE
Cologne

1 The Hitda Codex

The great centres of Ottonian manuscript art, such as Reichenau, Fulda and Regensburg, seem positively to vie with each in establishing their distinctive artistic personalities. It was almost as if the honour of their churches were at stake in art, as it was in the integrity of their landed endowments. Perhaps the greatest antidote to any monolithic, Reichenau-centred, idea of Ottonian art is the Cologne school. The bases of this school have been finely analysed by Bloch and Schnitzler. They are three-fold: a gospel book made by the Gregory Master (see Part I, p. 39), now at Manchester (John Rylands Library, MS 98); Byzantine models of the Macedonian Renaissance, or the middle period of Byzantium; and Carolingian manuscripts like the Turonian Jerome cycles and late Carolingian New Testament cycles such as those on the golden book cover of the Munich Codex Aureus (Clm. 14000) and on the Arnulph Ciborium. The Manchester Gospel Book was principally important for its ornamental *63,64* pages, the Byzantine models for their figural style and probably for their iconography, the Carolingian works partly for style and ornament and partly for their iconographic contribution.[1] Yet so thoroughly were these external influences absorbed (Bloch and Schnitzler constantly and rightly despair of unravelling them in their interpenetration of various illustrations),[2] so little were they slavishly imitated, that in the end one can only speak of something typically Cologne.

It would be difficult to improve on Dodwell's description of Cologne manuscript art:

> Byzantine influences are expressed in the figure-style, the backgrounds, and even the colour harmonies, but the spirit of the original Byzantine style has been transformed by the influences from Trier and Carolingian art: in particular, the Byzantine composure has been psychologically disturbed by the Trier intensity of eye and gesture, and physically disturbed by the Carolingian tremulousness of the brush-strokes. This tremulousness derives from the Rheims School, but, whereas the Rheims painters extended the perturbation to the whole scene, the Ottonian artist restricts this feeling to the figure. What chiefly differentiates Cologne work from other German art is its painterliness. The Cologne illuminators often worked direct with a brush, without making a preliminary sketch. What is more, they often worked with an overloaded brush, so that the colours sometimes run slightly. This feeling for the fluid qualities of paint, combined with a dramatic use of colour, gives Cologne illumination much of its individuality.[3]

We are concerned with the two finest and most elaborately illustrated manuscripts of the Cologne school. One is the Sacramentary of St Gereon

62. *Titulus* page for the Presentation in the Temple. Hitda Codex, Cologne, *c.* 1000-20. Darmstadt, Landesbibl., Cod. 1640, f. 21v

67,77 (Paris, BN, lat. 817), with a series of eight New Testament illustrations, a Christ in Majesty, a monumental picture of Pope Gregory the Great as the putative author of the Roman Sacramentary, and some very fine ornamental pages with initial letters. These last seem to be based on the Manchester Gospel Book which cannot be earlier than 996, but the Sacramentary is probably not many years after that date.[4] The other is the Hitda Codex, a Gospel Book which is the undoubted masterpiece of the whole school. This book was made for Hitda, Abbess of Meschede, a nunnery in Westphalia with close Cologne connections. On external evidence Hitda, in her function as abbess, cannot be more closely dated than some time between 978 and 1042, but art historians are agreed on *c.* 1000-1020 for the Codex. In any case one has only to glance at it to see that it has to be later than the St Gereon Sacramentary.[5] Its first illustration shows

61 Hitda herself, in black gown and a white laced veil, presenting the book to a statuesque St Walburga, patron of Meschede, the whole scene being underneath an elaborate architectural superstructure of a kind which characterizes the whole book.[6] No image could more effectively have emphasized the power of the abbess over her church and nuns. For when a gift is given, the giver exercises a hold over the recipient; the obligations attaching to the gift itself are not 'inert'. Early medieval monks and nuns certainly believed that through gifts they could hold patron saints to their obligations of protection and advancing the interests of their houses. By

100

giving the book to St Walburga, Hitda shows that she is the authoritative channel of access to the patroness; by receiving the book St Walburga is seen to invest Hitda with the power which a donor has over a recipient. The picture in itself represents a form of gift exchange.[7] This same manuscript contains a finely written list of the other treasures which the abbess gave to the saint.[8]

In front of each gospel, are three or four full-page scenes from the Life of Christ (fourteen in all), each accompanied by a full-page *titulus*, in which the letters of gold written on a purple ground are enclosed by a frame in such a way as to make it look as if a carpet is laid out on the page. The *titulus* is on the left, the gospel scene on the right, as the book lies open. After these scenes, there follow before each gospel a series of pages, whose pattern is derived from the Manchester Gospel Book: *titulus* to the evangelist portrait; evangelist portrait itself; carpet page announcing the *initium*, or beginning, of the gospel; and carpet page enclosing the initial letter (or letters, in monogram form) of the gospel.[9] Finally, after a text beautifully written in minuscule, the illustrations end with a typical Cologne Crucifixion (see Part I, pp. 131-33), though with the eternal symbols of sun and moon above it. The whole impression of sumptuousness, jewelled brilliance and painterly drama defies description.

If we ask where in Cologne this artistic activity was based, the likeliest answer is that of Bloch in his facsimile edition of the Hitda Codex, namely

63 & 64. *Titulus* and *Initium* pages of St Mark's Gospel. Gospel Book. Manchester, John Rylands Lib., MS lat. 98, ff. 64v, 65

Col.Pls. X,XI

62

63,64

65,66

65. *Initium* of St John's Gospel. Hitda Codex, Cologne, *c.* 1000-20.
Darmstadt, Landesbibl., Cod. 1640, f. 172v

66. Opening of St John's Gospel. Hitda Codex, Cologne, *c.* 1000-20.
Darmstadt, Landesbibl., Cod. 1640, f. 173

the monastery of St Pantaleon.[10] This monastery was rebuilt and affiliated to the Gorze Reform by Archbishop Bruno, who brought in a monk called Christian from St Maximin of Trier to be its abbot. Given the importance of these affiliations for the development of art, it at least makes sense to think of a Trier manuscript, i.e. the Manchester Gospels, having a profound and early influence at Cologne through the St Maximin/St Pantaleon axis. But one can add another strong argument that the St Gereon Sacramentary, which was made for a canon of the collegiate church of St Gereon in Cologne, was executed at St Pantaleon: and therefore the Hitda Codex also, for despite some important iconographic differences, one can hardly doubt that *St Gereon* and *Hitda* come from the same stable. There was evidently a close liturgical connection between the churches of St Pantaleon and St Gereon. When the body of Otto III was in Cologne for Holy Week in 1002 (see Part I, p. 119), it was carried in solemn procession from the one to the other on the Wednesday. Moreover, in the Calendar of the St Gereon Sacramentary, one of the few feasts given in capitals is St Pantaleon on 28 July. That very day was also the feast of the dedication of the church of St Gereon, a fact recorded in the Calendar with the word *Gereonis* in capital letters, i.e *PANTALEON et Dedic GEREONIS Eccl.*[11] A book made for St Gereon could scarcely mark the connection with St Pantaleon in a more pointed way.

A sacramentary was a book for liturgical use by the celebrant at mass; a book with the whole text of the four gospels was not necessarily so. But there can be no doubt that the Hitda Codex was intended for liturgical use from the start, because its *Capitulare*, which comes at the end and lists the gospel readings for the liturgical year, is in the same handwriting as the text of the gospels.[12] Moreover, the book is smaller in size and more manageable to handle than one expects it to be. Yet, unlike the illustrations of the Codex Egberti, or indeed those of the Gospel Book of Otto III which are in the textually relevant places throughout, the full-page miniatures of the Hitda Codex were not intended ever to be seen during the mass itself. When a reading is one page away from a picture, let alone on the same page, the picture could have been meant to be at least glimpsed at the celebration. But the Hitda illustrations, gathered before each gospel and with the complex of evangelist-portrait and *initium* pages between them and the text, could only with difficulty have been turned up by a deacon, anxious to keep his finger in the right place for the gospel reading, in accordance with the ritual orders (see Part I, p. 49).

It may seem paradoxical to say it of an abbess whose finely worked veil hardly signified 'humility of heart and contempt of the world', to quote an eleventh-century benedictional (Bamberg, MS Liturg. 50, f. 53) and its prayer for blessing a nun's clothes, but the illustrations of the Hitda Codex seem clearly to have been intended for meditation outside the public ceremonies of the church (whatever their actual use or non-use). Their subject-matter implies it. If these illustrations were intended for pericopes, several of them would be pericopes in the low liturgical season, like the

Sundays after Pentecost, where, as we have seen, the Codex Egberti lacks *Col.Pl. XI*
all illustration. The Storm at Sea would illustrate the votive mass for rain,
not the most vital celebration in the Cologne region! The *tituli* imply an
intended use for meditation even more strongly. These are not liturgical
texts, nor for the most part bald and literal descriptions of the event on
the opposite page. They contain a thought for the day (so to speak).
Implicitly or explicity they draw morals. Of the four levels of scriptural
interpretation, literal, allegorical, moral and spiritual, they are most akin
to the moral. They are *moralia*, to use the word in the title of Pope Gregory
the Great's famous book on Job. Let us give a few examples of these *tituli*.
For the Nativity we have:

> *Hic in presepis imo iacet natus, qui in*
> *caelo sedet altus, nullo loco*
> *comprehensivus.*

> Here in the cradle lies the child whose
> seat is high in heaven; he is not
> limited by any place.

This is the same idea as Bede's in his commentary on St Luke, but put
the other way round:

> He whose seat is heaven is contained within
> the narrow confines of a hard cradle.[13]

For the Presentation in the Temple:

> *Hic turturum libamine a sancta Maria impletur*
> *scriptura, et Christus a Symeone*
> *portatur in ulnis, quem non capit*
> *quantitas spere celestis.*

> Here with the offering of turtle doves
> by holy Mary the scripture is fulfilled, and
> Christ, whom the whole sphere of heaven
> cannot contain, is carried by Simeon in
> his arms.

The idea in this is very similar to that for the Nativity. Once again Bede,
writing on the Presentation, refers not only to the fulfilment of scripture
and the stipulations of Leviticus, but he also says:

> Great indeed is the power of the Lord,
> but not less does his humility shine forth,
> so that He who is not contained by heaven and
> earth, is borne whole and entire in the
> arms of an old man.[14]

105

For the illustration of the Woman taken in Adultery:

> *Mulier peccatrix hic erit exemplum*
> *christianis, iudice vero iudicante nulli*
> *peccatori misericordiam denegari.*

> The sinful woman is here an example to
> Christians, the just judge denying mercy
> to no sinner.

The same idea, though in different words, appears in Gregory the Great's *Moralia in Job*:

> The Lord ... neither loses his justice in
> his leniency, nor his leniency in his
> justice (and Gregory then gives the
> woman taken in adultery as an example of
> this principle).[15]

One begins to see how these Cologne *tituli* look like nothing so much as free variations on similar Gregorian/Bedan themes.

Tituli and inscriptions, as will be apparent by now (see pp. 148, 199; and also Part I, pp. 25, 94, 126) were very common in Ottonian art. Such historical, moral and theological guidance was often felt to be necessary in order that manuscript art might realize its full religious purpose for the onlooker. To give no such lead might even be to risk levity or unorthodoxy in the case of illustrations which were not always straight illustrations of an accompanying text, and might be highly symbolical. Images which were deeply impressive but not made intelligible might occasion too much awe and too little advance in knowledge. They might give rise to iconodulism. The illustrations of the Hitda Codex, as we have said, are not straight illustrations of the text, because (unlike those of the Reichenau Gospel Books) they are not positioned to be; but necessary as *tituli* were, several of the *tituli* of this book (and of the St Gereon Sacramentary, as we shall see) are unusually pregnant with theology and moralism. One can see this by comparing the Hitda *tituli* with the recorded *tituli* of the lost ninth-century wall-paintings of St Gall. Here there is virtually no theologizing in any of the *tituli* (as also there is not in several of the Hitda ones) and distinctly less moralizing; they are all essentially descriptive. For the Woman taken in Adultery we read:

> *Hic scribae domino sistunt in crimine captam*
> *Quam placidus censor damnatis solvit*
> *eisdem.*

> Here the scribes produce for the Lord the
> woman taken in sin.
> The mild judge releases her from these
> men, themselves damned.[16]

HIC ERIT CONTEMPLANDUM.
QUO MODO ANGELUS CELESTIS. TES
TABAT APM RESURREXISSE
AMOR TUIS ⁊

67. The Two Women at the Tomb. St Gereon Sacramentary, Cologne, *c.* 1000.
Paris, BN, MS lat. 817, f. 60

On the Healing of the Possessed Man of Gerasa (compare *Hitda*, below, p. 117) the text is:

> You drive the fearful spirits from the
> body of man
> And ordain that a herd of
> beasts shall rage, o just judge.[17]

The address to the just judge is perhaps faintly theological, but in general these two (typical) St Gall *tituli* give an idea of how little we can assume those of the Hitda Codex to be commonplace.

The illustrations and *tituli* of the St Gereon Sacramentary are also of a meditational character. An extraordinary feature of this Sacramentary is that the Annunciation and the Nativity, each with *titulus* page, are placed immediately after the liturgical calendar and before the preface to the Canon, and completely detached from the feasts to which they belong.[18] Perhaps the idea was to give the scenes of the Life of Christ in due order through the book, though this was not a principle strictly adhered to in *Hitda*, where the Marriage Feast of Cana comes before the gospel of St John and thus late in the cycle. In any case, most unusually in a sacramentary, illustrations are here placed where they could not be seen, even by the celebrant, when the book was in use for the mass of the relevant feast. When we move on, we find, all in one group before the Easter mass, the *titulus* to the Crucifixion, Christ on the Cross, Pilate giving Orders to the Guards of Christ's Tomb (a very rare subject),[19] and Two Women at

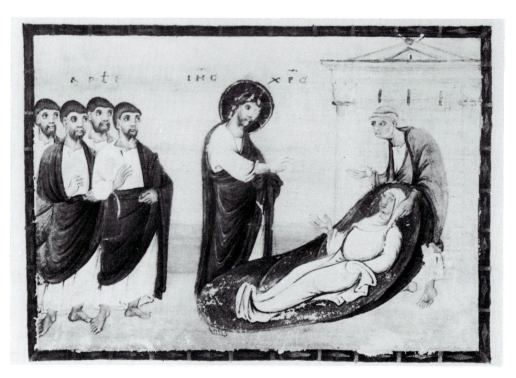

68. Healing of Peter's Mother-in-Law. Codex Egberti, 977-93. Trier, Stadtbibl., MS 24, f. 25

the Tomb. Once again, the Crucifixion does not illustrate directly any of the liturgy of Holy Week, nor is it in its usual place for a sacramentary, at the beginning of the Canon of the Mass. The whole group seems rather designed to make a point for meditation on the Passion and Resurrection. This is particularly so with the Two Women at the Tomb, where the angel *67* sitting on the tomb is close to Byzantine prototypes, though the tomb is western in character.[20] The *titulus*, written in this case above the scene in gold, reads: 'Here one should contemplate (*hic erit contemplandum*) how the angel of heaven testifies to the rising of Christ from the dead'.

The 'Prayer of St Ambrose' shows that in general, matter for the private devotions of priests was coming into sacramentaries during the great period of Cologne. This is a passionate eucharistic prayer, attributed by André Wilmart to John of Fécamp. It began to find a regular place in sacramentaries/missals, as a prayer to be recited by the priest before mass, from the mid eleventh century onwards.[21]

What were the principles on which the fourteen gospel subjects of the Hitda Codex illustrations were selected, apart from the obvious ones that the childhood scenes and the miraculous elements figure large? The more one seeks an answer, the less does it have to do with liturgical effectiveness. Bloch points out that the Healing of Peters' Mother-in-Law, one of the illustrations before Mark's Gospel in *Hitda*, is according to its *Capitulare* *69* the pericope for the twenty-second Sunday after Pentecost; that the Raising of the Widow's Son at Nain, before Luke, is the pericope for the sixteenth *70* Sunday after Pentecost; and that the Woman taken in Adultery, placed before John's Gospel, is the pericope for the fourth Saturday in Lent.[22] Is it not much more important, however, in a book made for a woman, or for a nunnery, that every group of pictures contains at least one that illustrates a significant encounter of Christ with a woman? In a famous article, Herbert Grundmann showed how women had helped to bridge the gap between Latin and vernacular culture in the Middle Ages. He mentioned as an example the manuscript of an Old Saxon psalm commentary of the tenth century which comes from the nunnery of Gernrode. Implicit in his whole argument was the fruitfulness of this link for developing the religious sensitivities of medieval society.[23]

In every one of the pictures which we have just mentioned, the known iconography is markedly manipulated to lay stress on the element of human relationship and the psychological aspects of the scene. The Codex Egberti and the Gospel Book of Otto III illustrate the Healing of Peter's *68* Mother-in-Law in the spirit of Luke (4:38-39): 'and standing over her, he commanded the fever, and it left her'. Jesus is here the *Wundertater*, standing at the foot of the bed, with arm outstretched and commanding demeanour. The Byzantine scenes are rather in the spirit of Matthew and Mark, where Jesus takes the woman by the hand and lifts her from her couch (Mark, 1:31). In *Hitda* the roles are reversed. He sits (albeit still every *69* inch the wonder-worker) and she stands as he takes her by the hand; 'by the word *and touch* of Christ', says the *titulus*, 'the fever flees from Peter's

109

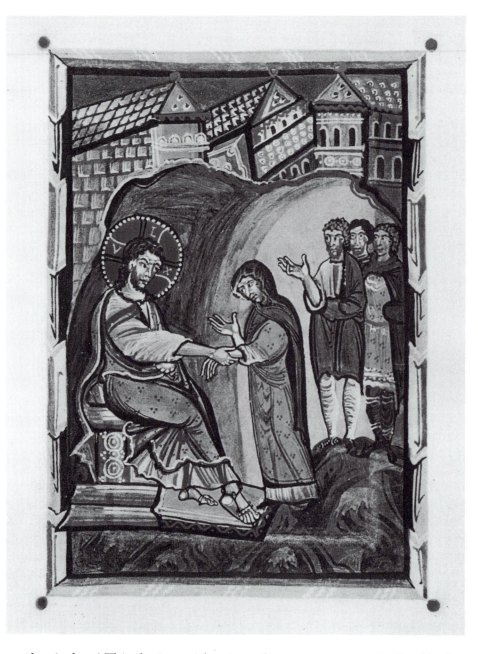

69. Healing of Peter's Mother-in-Law.
Hitda Codex, Cologne, *c.* 1000-20.
Darmstadt, Landesbibl.,
Cod. 1640, f. 77

mother-in-law.' This device, without any known prototype in Carolingian or Byzantine art,[24] was surely intended to bring Jesus and the woman into a poignant relationship with each other in a picture full of tenderness.

On the Raising of the Son of the Widow of Nain, Bloch and Schnitzler make some telling iconographic points. The character of the buildings of Nain and the relation of buildings to the human scene follow western, Carolingian prototypes; but the figures behind the bier with their heads under an arch show up somewhere behind this picture a Byzantine model where people are seen coming out of one of the gates of Nain behind the

70

110

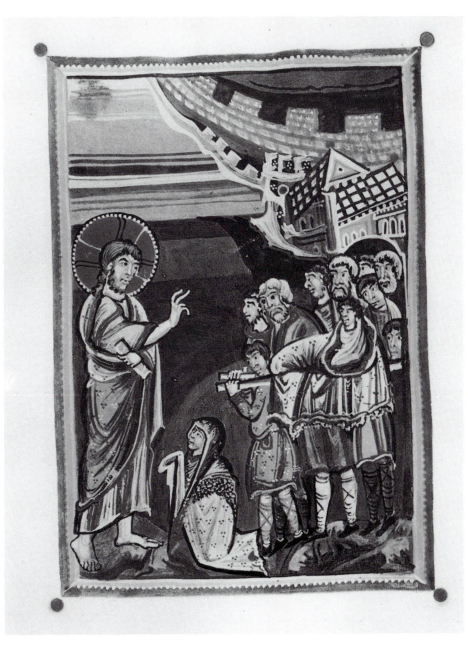

70. The Widow of Nain.
Hitda Codex, Cologne, *c.* 1000-20.
Darmstadt, Landesbibl.,
Cod. 1640, f. 115

bier. Boeckler had earlier pointed out that the figure of the widow herself
in the two most notable Reichenau depictions of this scene follows a model
of the Raising of Lazarus.[25] In the Gospel Book of Otto III the widow, a
tiny but strikingly placed figure, turns back to look in wonder at her son, *71*
as does one of the sisters of Lazarus in the same book. In the Reichenau
wall-painting at Oberzell, she is prostrate before Christ, looking up at him, *72*
a posture similar to that of the other sister in the Lazarus scene. The
beseeching widow of the Hitda Codex is less dramatically portrayed than
in either of the Reichenau scenes, but she is given more prominence in the

111

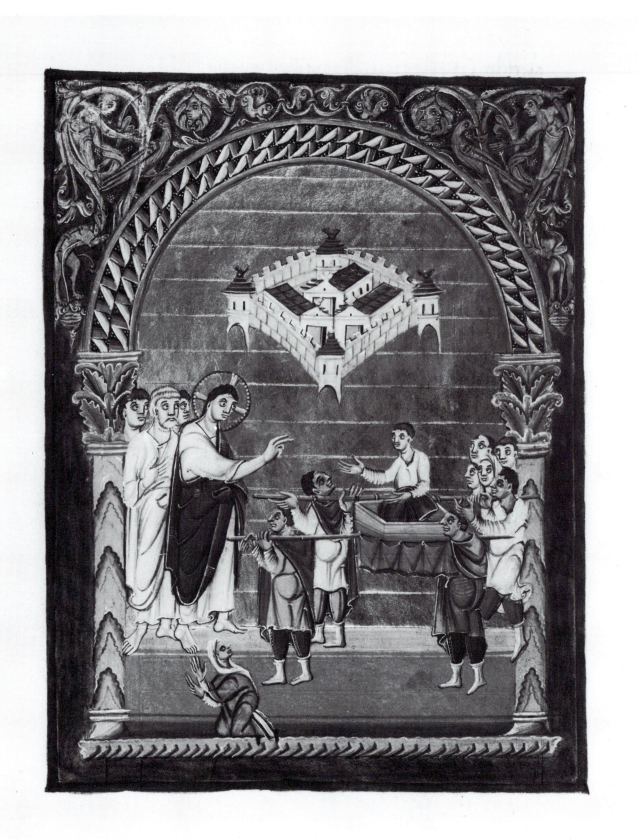

71. The Widow of Nain. Gospel Book of Otto III, 998-1001
Munich, Bayerische Staatsbibl., Clm. 4453, f. 155v

composition, and her quiet demeanour and face as she looks up at Jesus are (when studied closely) more moving. One supposes that this was the figure, and here we are no longer obviously in the world of iconographic models, which would have been of most interest to the nuns of Meschede, many of whom must easily have been able to identify themselves with the widow of Nain, especially the aristocratic widows amongst them whose warrior sons had a short life expectancy. Karl Leyser has written about the demographic aspects of Ottonian society 'which left mothers the heir-esses of their own sons'. There is a poignant moment in a diploma of Otto I, dated 960, when Aeddila, a widow, transferred *curtes* for the endowment of the nunnery of Hilwartshausen, having received them as an inheritance from her sons Falcmer and Bunica as they were dying.[26]

The Woman taken in Adultery, if a comparison is made between the Codex Egberti and the Hitda Codex, exemplifies how the whole character 73,74 of the art can be affected by whether it is conceived for public or private consumption. In the Codex Egberti, Christ has said 'let him who is without sin amongst you cast the first stone', and the woman's accusers are very ostensibly departing. The woman now stands alone before the gate of a 74 building, while the accusers leave by another exit. In the first glance at this picture, the effect of Christ's words on the external actions of others is highlighted. In the Hitda Codex, Christ also writes on the ground and all but three of the woman's accusers are also beginning to steal away. But 73

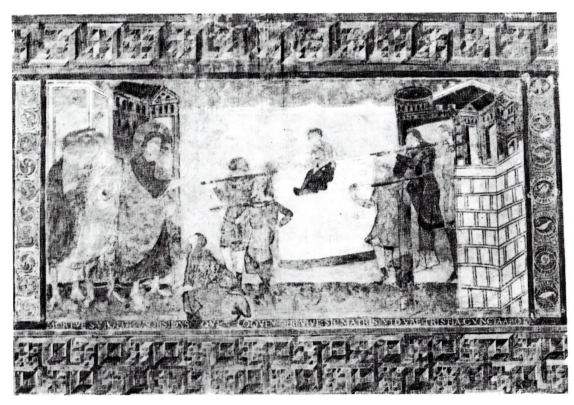

72. The Widow of Nain. Wall-painting, late C10. Reichenau-Oberzell, St Georg

73. The Woman taken in Adultery.
Hitda Codex, Cologne, *c.* 1000-20.
Darmstadt, Landesbibl.,
Cod. 1640, f. 171

here the artist has used his beloved motif of many heads crammed together in a crowd, a motif itself derived from Byzantium,[27] to give a psychological interpretation of the incident, and the sense that the woman is hemmed in by those who wish her ill. Many of the heads show that physically their owners are departing; but, unlike the Codex Egberti, psychologically they are still there.

All these scenes put one in mind of Ailred of Rievaulx, writing for his sister in the twelfth century, advising her how female recluses should pray and meditate, by identifying themselves with the feelings of the women around Christ.[28]

114

Throughout the Hitda Codex, although Christ remains very much the majestic *Wundertater,* the emphasis is on the moral significance behind the events illustrated. This is particularly so of the most famous of all its illustrations, the Storm at Sea. Christ lies, larger than life, asleep on the *Col.Pl. XI* side of the boat facing the onlooker. The apostles, almost to a man, look anxiously at the mast, a remarkable human atmosphere being created by their concentration on it. The sail, as it is torn to shreds by the wind, provides the occasion for one of the most painterly creations of the Cologne school. The sense of turbulence on the water is given only by the boat, half hammock and half sea monster, which with a twist of its neck and a swish of its tail, is taking a downward plunge. It will not long stay in the frame which barely contains it. The whole picture gives an astonishingly vivid idea of a storm, without sky, water, physical atmosphere, landscape, or any of the normal props and illusions which make up storms in representational art.

The normal Ottonian Storm at Sea, the model of which is undoubtedly based on a Byzantine prototype, shows two scenes in the one boat; one in which the sleeping Christ is aroused by the nervous Peter, the other in which Christ orders two late antique personifications of wind to cease from blowing. A perfect example is the Codex Egberti except that there *75* the artist has dispensed with the mast and sail. Bloch and Schnitzler have been very ingenious, and are surely right, to suggest that the *Hitda* and *Egbert* models for this scene are related to each other, far apart as the two scenes look at first sight. Both have the sleeping Christ being roused by

74. The Woman taken in Adultery. Codex Egberti, 977-93. Trier, Stadtbibl., MS 24, f. 46v

75. Storm at Sea.
Codex Egberti, 977-93. Trier,
Stadtbibl., MS 24, f. 24

an apostle to the left of the boat. Where the Codex Egberti has Christ calming the winds on the right, the Hitda Codex has the mast instead, as one can see by comparing the hand of the Peter-figure behind Christ in the Codex Egberti and the hand of the Peter-figure behind the mast in the Hitda Codex. Bloch and Schnitzler say that the suggestiveness of the *Hitda* picture depends on the antithesis between 'the Sleeping One' and the disciples seized with anxiety.[29] If they are right about the model, one must go further and say that this effect is achieved by flying in the face of the model. The model showed the miracle happening, when Christ calmed the storm. *Hitda* does not show it. Obviously it was intended that it should be shown here, for the *titulus* reads, 'the sea and winds obey the command of the Almighty'. But for once *titulus* and picture do not correspond; the Almighty remains asleep. It is easy to see why this was so. The moral of the picture is that all the apostles concentrate anxiously on the mast, which will bring them no good, but at the last moment one of them thinks, in his troubled situation, to turn to Christ. The face of this apostle is partly obscured, and yet geometrically it is in the centre of the picture. The moral metaphor of ships and shipwreck was a commonplace. Moreover it was a commonplace in a text much beloved by the Ottonians, Pope Gregory the Great's *Moralia in Job*. In the introductory letter to the *Moralia* Gregory uses the metaphor, referring to the 'escape from the shipwreck of life' and to 'a safe port from the currents and waves of earthly affairs'.[30] Ruotger, schoolmaster of St Pantaleon, also used it, in his *Life of Bruno of Cologne*.

116

Bruno, he says, would often set the day of death before his heart and would hope without fear for the troubled ship of this world to arrive safely at the shore of God's mercy.[31]

An intriguing possibility opens up that the idea for this boat, which except for its peculiar movement appears to be derived from a Carolingian model, comes from the *Navigatio Sancti Brendani*. This account of the Irish wonders of St Brendan's voyages arose in the circle of Irish monasteries in Lotharingia and the Rhineland during the tenth century.[32] No manuscript, amongst the many, happens to survive from Cologne, but in the late tenth-century Archbishop Everger (985-99) founded there the Irish monastery of St Martin.[33] One of the marvels of the voyages occurred when St Brendan and his companions came across an island and spent the night on it. When they made a fire and started to cook their breakfast in the morning, 'the island began to move like a wave'. The brethren said, 'a huge fear has entered us', but St Brendan sought to reassure them; the island, he said comfortingly, was a fish, the first of all swimming things in the ocean.[34]

2 Gregorian Themes

Anyone at all familiar with the writings of Gregory the Great will see how the Cologne *tituli*, both of the Hitda Codex and the St Gereon Sacramentary, are suffused with his language and ideas. We have already mentioned the Woman taken in Adultery as an example. The *titulus* for the Healing of the Man with a Withered Arm refers to the triumph over the thoughts of unbelievers, while the *Moralia* speaks of the cruelty of unbelievers towards preachers, and says that God frames his exhortation to the darkened hearts of unbelievers.[35] The *titulus* of the Storm at Sea, 'the winds and sea obey the command of the Almighty', echo a story in Gregory's *Dialogues*, whose point is to contrast the disobedience of man with the obedience of the unreasoning elements to the commands of a saint.[36] On the Healing of the Possessed Man of Gerasa, the *titulus*, 'the unclean spirit seeks the darkness when he flees from the man at the word of the light', may be compared with the *Moralia* on how the impure spirits, which fell from the ethereal heaven, roam abroad in the midspace between heaven and earth.[37]

The *titulus* of the Nativity in the St Gereon Sacramentary (see p. 108) is particularly shot through with Gregorianism.

> This material picture demands diligent
> scrutiny from the eye of the human
> mind, exemplifying in itself, through
> the humble birth of his incarnation,
> how he who lives immortal and timeless
> in heaven, sought out the mortals of
> the world as a mortal himself.[38]

On 'the eye of the mind', the *Moralia* asks 'what is the office of the body save to be the organ of the heart?' On time and eternity, the *Moralia* declares that Christ is at once eternal from the Father and a temporal being from his mother, and also that neither past nor future time is appropriate to God. On Christ's seeking out mortals, the *Moralia* says that by taking on himself human nature and toiling in this mortal state, he opened a way for men to return to God. He came on earth in human nature to be seen; he wished to be seen in order to be imitated. On the humility of the Incarnation, the *Moralia* takes the Incarnation as exhibiting to the proud a pattern of humility. The proud 'pride themselves on the glory of this present life; they have not seen the loftiness of the Lord's humility'.[39] The whole idea of the function of art expressed in this Nativity *titulus* fits with the principles of Gregory enunciated in a famous letter to Bishop Serenus of Marseilles, that pictures were not for adoration but for the instruction of minds, ignorant minds, he adds.[40] Any one of these thoughts, taken on its own, is doubtless too commonplace to be demonstrably derived from one particular writer, but taken *in toto* it seems hard to deny their Gregorian inspiration.

It goes almost without saying that amongst the fathers Gregory had a commanding importance and influence in the Ottonian Empire. His *Pastoral Care* was a blueprint for Ottonian bishops on their office, not least in its recognition of 'laudable ambition' in churchmen. The association of Gregory with the composition of the Roman Sacramentary, exaggerated as we now know it to be, ensured him a stream of 'author portraits' in an age of strong liturgical consciousness.[41] John of Gorze, who appreciated Gregory's writings above those of all others, was said to have committed almost all the *Moralia* to memory so that he seemed to have recourse to it in his talks to the brethren and in all his prayer.[42] Whether this claim can be taken seriously or not, it is yet another sign (see p. 209) of the importance attached to this text in monastic reform circles, whose Cologne centre was St Pantaleon, the likeliest atelier of its manuscript illumination. In surveying the intellectual culture of the Carolingians and the Ottonians (though this may be an impressionistic generalization), Augustine and Gregory were important in both; yet when we move into the Ottonian world the primacy seems to pass from Augustine to Gregory, the latter a practical ruler and thinker *par excellence*. Whatever we may say about Gregory in the Ottonian Empire as a whole,[43] however, there appears to have been a particular tradition of Gregorian veneration and study at Cologne. This seems to go back to the eighth century. The oldest surviving manuscript of any collection of Gregory's letters, a collection of two hundred of them, is a Cologne manuscript of that period.[44] It may be no coincidence that within a year or two of the abortive plan for St Boniface to be Archbishop of Cologne (late 745) he was in a position to send Egbert of York texts of Gregory's letters which he had copied in the Roman archives.[45] Certain it is that the tradition was carried on at St Pantaleon in the tenth century. In his generally admirable study of Ruotger's *Life of*

Bruno, Lotter has drawn attention to an important allusion by Ruotger to Gregory's *Dialogues* to justify his not presenting Bruno as a miracle worker,[46] but otherwise he underestimates how heavily impregnated with Gregorianism this hagiography is.

In fact the mould of an ideal pastor, in which Ruotger casts Bruno, is derived from Gregory, especially the balance of the inner spiritual life and the outer political and administrative one, which Ruotger stresses. 'His one aim and his one endeavour', says the biographer, 'was to defend and adorn holy mother church, to defend it in secular matters and to adorn it in spiritual.' Or again, 'he was an indefatigable warrior of the Lord, internally and externally, at home and abroad (*intus et foris, domi militiaeque*)'. Ruotger never allows us to forget that amidst all his battles and building works, Bruno was a man of thought and prayer. 'His prayer was short, but intent and pure,' he says in the words of St Benedict's Rule. All this exactly accorded with Gregory's idea that men who performed 'outward works' should always be returning to the fire of inner contemplation in order to revive the flame of their holy zeal.[47] No less does Ruotger's picture of Bruno accord with Gregory's *Pastoral Care* when he describes him as the refuge of the destitute, a pastor than whom none was humbler with the meek or more tough (*vehementior*) with the wicked. The poor had to be encouraged and consoled, said Gregory, the rich inspired with the fear of being proud (he goes on to say, however, that the rich might be humble and the poor proud).[48] High-handed Bruno might have been considered when he forcibly moved some canons from their previous house into St Andrew's Church in Cologne, but again, as Ruotger and Gregory (in his *Responsiones* to Augustine of Canterbury) both said in only slightly different ways, it was men or good customs which counted, not places.[49]

It may seem that the most un-Gregorian feature of the Hitda Codex is its strong emphasis on the element of the miraculous in Christ's life, an element not even diffused by a balancing emphasis on his teaching, as it is (at least to a much greater extent) in the Gospel Book of Otto III. After all, when Ruotger wrote that those who visited Bruno's tomb 'did not seek miracles (*signa*), but paid attention to his life and recollected his teaching', he was alluding (see above) to Gregory's *Dialogues*, where Gregory writes 'the way of life and not signs are to be looked for'. Yet on closer consideration, the miracles of the Hitda Codex, far from flouting the spirit of Gregory, accord most faithfully with it. Gregory himself, writing the *Dialogues*, filled them with miraculous narratives. He wanted to show that the power of God had not deserted Italy in those days of economic upheaval and barbarian invasion. But the important point was that nobody could work miracles except from a basis of virtues and holiness of living. 'Corporeal miracles show up a holiness already there, they do not make it', says the pope.[50] Now of course the virtues and holiness of Christ did not need demonstrating, as they did in sixth-century Italian saints or in Ottonian bishops, but what the virtuous response to his power should be did need demonstration. By looking at these pictures with their *tituli*, the

latter an integral part as their splendid frames show,[51] and seeing how Peter's mother-in-law allowed Christ to touch her or how one should trust Christ in the storms of life or how the dead son of the widow of Nain sat up and recognized Christ as his maker, it was possible to learn some very Gregorian lessons. If the *tituli* are not direct quotations from Gregory (or Bede), the freedom of use only serves to underline the depth of penetration into his mind. The whole book is as much in a Gregorian mould of thought as Ruotger's.

Fortified with this idea, we may attempt an interpretation of the Nativity as this scene appears in both the Hitda Codex and the St Gereon Sacramentary. The colour repertoire of *Hitda* is rather limited compared with contemporary Reichenau manuscripts, but the shades of blue and violet, the white lights and the reds and gold, are never in the whole book more harmoniously deployed than in this quiet and gentle scene, where humans and animals alike all appear to be engaged in meditation. The buildings of Bethlehem and the crib follow an established western pattern, but the stooped and thoughtful Joseph, and even more the couch of Mary, are Byzantine insertions.[52] The particular iconographic point which we might observe is the absence of angels, and the lack of any scene in which angels announce the Nativity to the shepherds. *Hitda* is by no means unique in this. The early Christian depictions often have no angels, and also later ones, especially ivories where there was a shortage of space.[53] But Nativities without angels are very much in a minority within the context of Ottonian culture.

It was possible to take two views of angels in Ottonian times. One was apparently that of Thietmar of Merseburg. On this view angels as messengers of God had some kind of beneficial dominion — but dominion nonetheless — over men, analogous to the evil dominion which the devil and the wicked angels exercised. Thietmar tells how when Otto I was delaying to give Gero the archbishopric of Cologne, and the Emperor was in Pavia on Easter Sunday 970, ready except for his crown to go to church, an angel with unsheathed sword appeared to him and warned him sternly, saying, 'unless you complete the election of Gero to-day, you will not leave this city in safety'.[54] The other view was that of Gregory the Great. This was expressed most clearly in a (for him) unusually succinct and crisp sermon on the Nativity. Before our Redeemer was born, he says, there was discord between angels and men, and they despised us; but all that was changed with the Nativity, when angels had come to regard men as fellow-citizens of the heavenly kingdom. Angels had allowed both Lot and Joshua to adore them in the Old Testament, but when John the Evangelist had tried to adore an angel (Apocalypse, 22:9), the angel had prevented him, saying, 'I am your fellow servant'. Before Christ took human nature, the angels despised it; now they do not dare. Let us therefore preserve the dignity of our nature and remain worthy of the respect of angels, Gregory ends.[55]

But somehow not every Ottonian artist could think, or bring himself to

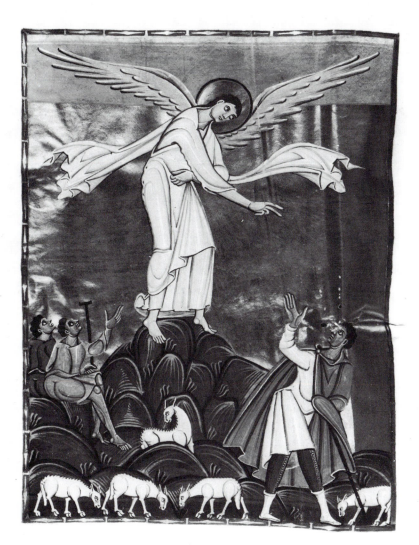

76. Annunciation to the Shepherds. Pericopes Book of Henry II, Reichenau, 1002-12. Munich, Bayerische Staatsbibl., Clm. 4452, f. 8v

think, that the Nativity had entirely put angels in their place. The Thietmar outlook had many subscribers. It is true that the announcing of the good news to the shepherds was to their advantage, and could be seen as a service rendered by angels to these men, but they sometimes performed this service in an extremely dominating, not to say overbearing, manner. An example is the angel announcing to the shepherds in the Pericopes Book of Henry II, with his towering size, his high position, his windswept *76* garments, huge spread of wings, and his threatening glance and gesture. The Bamberg Apocalypse also extracts all possible mileage from the more masterful angels of that biblical book, notwithstanding the politeness of John's own angelic companion. The Hitda Codex here steps outside the Thietmarian, Reichenau norm of angelic dominion. The St Gereon Sacra-

121

mentary seems positively to espouse the Gregorian ideal, for it has angels, but their faces and demeanour have no place for anything but worship of
77 the new-born babe. They are 'marvelling at the mystery of the incarnation', to use the words about angels of the *Moralia*. They are 'the morning stars' (note the remarkable light in which they are set), who praise together with those of evening the power of the redeemer.[56]

Gregory's views concerning angelic dominion were very much of a piece with his views about episcopal dominion. He did not, of course, disclaim his own primatial authority as pope; no pope could have done that. But he was no devotee of dominion in any form. In correcting a bishop he preferred to speak with fraternal charity rather than with papal authority;[57] he vigorously opposed the use of the style 'universal bishop' by John, Patriarch of Constantinople. He did not desire so to style himself. He thought all the bishops (*universi episcopi* was his clever turn of phrase) were equal like clouds; they poured themselves out in the rain of preaching and glistened in the light of good works. In particular he implied that the four ancient patriarchates of Rome, Alexandria, Antioch and Constantinople were equal. Did not the Patriarch of Constantinople know, he asked, that the Council of Chalcedon had offered the title of 'universal' to the Bishop of Rome, but that neither Gregory nor any of his predecessors had wished to arrogate to themselves this temerarious name to the derogation of their colleagues.[58] In their internecine struggles for precedence, there was a lesson here for the principal metropolitans of the Ottonian Church, again four of them (Mainz, Trier, Cologne, and from 968 Magdeburg).[59]

Does this lesson show any sign of having been learned at Cologne, given that the text of Gregory's letter to John of Constantinople was amongst those in its eighth-century collection? One can say that there are signs. Ruotger refers to Bruno's pallium coming from the universal pontiff (*ab universale pontifice*). Another early medieval Cologne manuscript of Gregory's Letters has a marginal note in a roughly contemporary hand drawing attention strikingly to the same letter, with the words, *quid dicat de Johanne qui se universale dixit* (what he says of John who calls himself the Universal).[60] Of course this was exactly what Gregory said the pope would not be called. Yet in Ruotger's world of ecclesiastic organization, four centuries after Gregory and in the world of the West, Rome was the only one of the four ancient patriarchates which counted for anything. It was surely a venial fault to use the title where there could be no rival for it. What it does suggest, in a writer so aware of Gregory's works, is that Ruotger knew the letter in question. The clearest sign that the lesson actually had some effect is in the papal privileges of 968 and 981 for the new archbishopric of Magdeburg. Magdeburg was to be equal in all things (*aequalis per omnia*) to the Archbishops of Mainz, Trier and Cologne.[61] Now we know next to nothing about the role of Cologne in the primatial struggles of the late tenth century, but it is difficult to see how the idea of equality between the metropolitan churches, including Cologne, could have been sustained at the papal *Curia* without the representations of the

church of Cologne, since Trier and Mainz both claimed some kind of ecclesiastical superiority to the other churches.[62] One may observe that Archbishop Warin of Cologne thought it no diminution of his church to restore to Trier a part of the relic of St Peter's staff, important as this relic was in the primatial claims of Trier (see pp. 61, 65).[63]

The St Gereon Sacramentary and the Hitda Codex have nothing directly to do with the Archbishops of Cologne, in the way the Trier manuscripts have to do with Egbert. But if the surmise that the church of Cologne adopted an idea of *aequalitas* amongst the metropolitan churches commends itself, the archbishops showed a Gregorian spirit, which also manifests itself with such variety in the Ottonian manuscript art of Cologne.

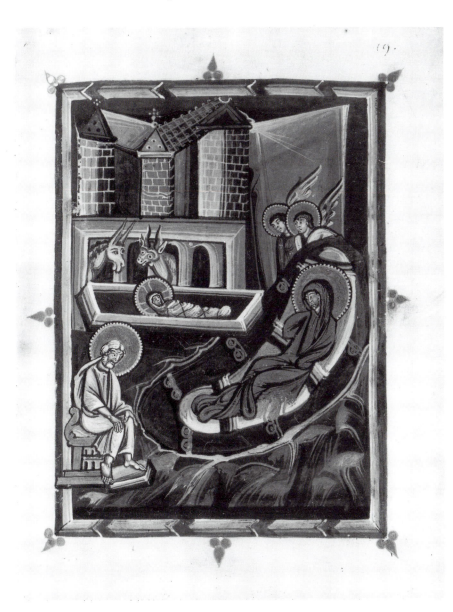

77. Nativity. St Gereon Sacramentary, Cologne, *c.* 1000. Paris, BN, MS lat. 817, f. 13

123

78. Preface and Canon of the Mass. Sacramentary, Fulda, late C10.
Cologne, Dombibl., Cod. 88, ff. 25v, 26

CHAPTER FOUR

Fulda: Saints and Sacramentaries

1 Introduction

With Fulda we move into a very different aesthetic of manuscript art from that of Reichenau or Cologne or Regensburg, and also into a world no longer dominated by gospel books (after the early Codex Wittekindeus, Berlin, East, theol. lat. fol. 1) but rather by sacramentaries. Thus we may expect a somewhat different function of art. The pictures in a sacramentary, or book of mass prayers, were intended to be seen primarily by the priestly celebrant during the mass, like the scenes inside the historiated initials of the Drogo Sacramentary (*c.* 845), which may well have *86* been known (or something like it) in tenth-century Fulda. Fulda manuscript art has less to do with ritualist display or private perusal than other schools, more with helping to focus the celebrant's mind. It has a more practical illustrative purpose. The sacramentaries with figural art now at Göttingen, Udine and Bamberg, all of them made at Fulda, occupy the centre of the stage; others with little or no figural art, but still handsome books, survive at Cologne, Mainz, Vercelli and elsewhere. There must *78* once have been many more, mostly made for export to other churches. The light airy scenes of the miniatures, in which golden backgrounds are almost unknown, and the lively penmanship, which (unlike at Reichenau) takes precedence over coloration or command of the surface space, are reminiscent of the Stuttgart Psalter and other works of Carolingian provincial art.

But there were cross-currents between Fulda and other centres of art. It has been rightly pointed out that there was probably no large enough cycle of sacramentary illustrations yet available to Fulda artists to serve as a model for their whole New Testament cycle in the late tenth century, and that therefore they would have had to use the same kind of late antique cycles as did the Reichenau artists.[1] Certain iconographic themes besides the gospels also relate Fulda and Reichenau. The latter used the Christ seated in Majesty very sparingly, and in its usual place as a frontispiece of the Gospels not at all, yet it occasionally figures in unusual contexts such as the Dormition and Assumption of Mary in the Pericopes Book of Henry II (see Part I, p. 47). The same is true of Fulda, where it is used for the dream of St Martin in the illustrations for his feast. There is also a clear connection between the sources for the Worship of the Lamb in the Bamberg Apocalypse and in the Fulda sacramentaries.[2] The relations of Reichenau and Fulda were cemented when Walafrid Strabo, a pupil of Fulda's most famous ninth-century abbot, Hrabanus Maurus, became Abbot of Reichenau, and they persisted in the tenth century as the Reichenau Con-

fraternity Book shows. Moreover the impulses towards a revival of manu-script art in the tenth century were probably similar at both Reichenau and Fulda — the desire to recreate Carolingian glory (see Part I, pp. 34-35), an awareness of earlier Italian art (Abbots Hadamar, 927-56, Hatto, 956-68 and Werinher, 968-82, made between them seven visits to Italy on royal/imperial business),[3] and not least the promptings of Otto I's court circle (see Part I, pp. 36-42).

Fulda was one of the very richest and most important monasteries in the Ottonian Empire. It had been founded by St Boniface in the 740s and claimed exemption from episcopal jurisdiction in order to be under the direct authority of the papacy according to a privilege which Boniface had secured from Pope Zachary in 751. There is a fascinating account in the *Vita* of St Sturm, a Norican disciple of Boniface and first abbot of Fulda; it tells of Sturm's travels by boat in the heavily forested regions of the River Fulda, and his wanderings on an ass which he protected from wild beasts at night by the erection of wooden fences, in order to find a suitable site for the monastery.[4] Boniface wrote of the site which was finally chosen, using a *topos* of earlier monastic writing, that it was a wooded one in a desert (*heremo*) of vast solitude; but it was also in the midst of the peoples to whom he was preaching the Christian faith.[5] These were the Hessians, the Saxons (as he hoped), the Thuringians and the Bavarians (and later the East Frisians). Fulda is indeed a central point of communications in the German world. The River Fulda is a tributary of the Weser and thus forms part of the arterial river system in the whole area between the Rhine and the Elbe; also we know that in the early Middle Ages a frequented trade route from Mainz on the Rhine to Erfurt (and onwards to the Elbe) crossed the Fulda somewhere near the monastery.[6] By the ninth century at the latest, Fulda was attracting to itself members of aristocratic families from all the regions which we have just mentioned.[7]

The monastery fought staunchly to preserve its independence from the bishops of Würzburg, who would have been its diocesans in the normal way, and from the archbishops of Mainz as metropolitans. This must be a reason for its resistance to the Gorze monastic reform, since in many cases this reform had been used by bishops to strengthen their influence over monasteries.[8] Thus Fulda, and also Corvey, are clear examples of how manuscript art did not *need* this reform in order to flourish, however important it might have been elsewhere as a stimulus. Yet we should be on our guard against supposing that monasteries which resisted the reform had a lower religious standard than those which accepted it. This no more follows than does the idea that progressives of our own century were somehow more religious than conservatives at the time of the Second Vatican Council or since. What caused Henry II to think that Fulda needed reforming in 1013, when the Quedlinburg annalist says (perhaps sarcasti-cally) that its life displeased him, is not apparent from the sources.[9] It is inconceivable that Henry would not have moved sooner than 1013 had there not been the full *vita communis* there, to which he attached great

importance.[10] Probably it had to do with Henry's feeling that the powerful aristocratic community with its formidable *ésprit de corps* needed opening up to outside influence, or that so much wealth ought to be more closely harnessed to the purposes of the *Reich* than it was, or that monasteries ought to be more under the thumb of bishops than Fulda had been, rather than being occasioned by irreligion or any lax way of life.[11]

It is not a historian's job to measure religious devotion. It may be his job to reconstruct a religious culture and religious traditions; and if one applies such an effort to Ottonian Fulda with the help of its art, by no means a despicable picture emerges.

2 The Göttingen Sacramentary

The earliest surviving Fulda sacramentary is now in the Göttingen University Library (MS theol. 231); it has a large cycle of mainly part-page illustrations. Zimmermann dated it *c.* 975; Hoffmann would put it to the second third of the tenth century or somewhat later.[12] One cannot better set the context of its illustrations to the various feast days and their mass prayers, or to the various sacramental and quasi-sacramental rites whose texts it contains, than by considering its frontispiece. This is arranged in three registers. The uppermost consists of a framed horizontal panel depicting from left to right the sacrifices of Abel, Abraham and Melchisedech, the three Old Testament sacrifices mentioned in the Canon of the Mass and 'typifying' the sacrifice of the mass. The central register contains two roundels with author portraits of Popes Gregory and Gelasius, Gregory on the left with the traditional dove on his shoulder representing his inspiration by the Holy Ghost, the roundels placed in an arcade of Corinthian columns which holds up the panel above it. These two popes were the two authors to whom the 'mixed' Roman sacramentary which developed in the eighth century was traditionally attributed,[13] and if confirmation of their identity here were needed, it would come from the later Fulda Sacramentary at Bamberg which actually names the popes in similar portraits, also within roundels. The lowest register has another panel with a picture which at first sight looks like a piece of ritual in the mass, and so far as I know no attempt has hitherto been made to realize a precise explanation of its unusual subject matter, but the figures standing on the left and in the centre can certainly be identified as Popes Gregory and Gelasius again, since, both vested for mass, their vestments are in exactly the same colours as they respectively wear in their roundels immediately above. At the feet of Gelasius a monk in monastic habit, not in vestments, prostrates himself, apparently to receive the sacramentary, and Gregory standing before a lectern makes a gesture associating himself with the handing over of the book by Gelasius. The prostrate monk is not represented with nimbus, but behind him, on the right, is another monk with nimbus, who in a semi-seated posture seems to receive and study the sacramentary. A nimbus was not at this period, before the

Col.Pls. XII,XIII

Col.Pl. XII

79

Col.Pl. XII

127

79. Saints Gelasius and Gregory. Fulda Sacramentary, 997–1024.
Bamberg, Staatsbibl., MS Lit. 1, f. 12v

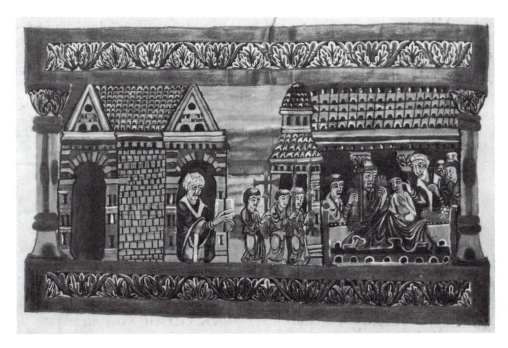

80. The Sacrament of Extreme
Unction. Sacramentary, Fulda,
c. 975. Göttingen, Universitätsbibl.,
Cod. 231, f. 192v

formal canonization process had developed, a mark of authorized saint-
hood; it might be assigned to anyone of holy character out of respect.

In this case it is most likely to be Hrabanus Maurus, fifth Abbot of Fulda
(822-42), who is intended, since not only was he an influential scholar of
wide learning in general, one of the great figures of the second generation
of the Carolingian Renaissance, but he was also an important student of
the mass in particular, especially in his *De Institutione Clericorum* (below
pp. 132, 157). Thus we might see the picture as the generic Monk of Fulda
receiving the Sacramentary from its famous Roman authors, which is then
digested by the scholarship of Hrabanus, who is represented in very much
the figural style of the ninth-century dedication pictures in his own well-
known *De Laudibus Sanctae Crucis*. The swivel lectern with two stands at
which Hrabanus (if it is he) is positioned might suggest the two Sacra-
mentaries of the popes before they became mixed, an amalgamation which
very likely first occurred in Bonifatian circles. The whole page is of har-
monious design, with the pleasing rhythms, or, in the case of Abraham
with his sword above and the prostrate monk below, counter-rhythms, of
its figures; the contrasting tones of colour between the backgrounds of the
upper and lower panels; and the gold of the medallions in the middle,
which are a rare case of golden background appearing in Fulda art.

If we now move to the other end of the manuscript, there is a remarkable
series of illustrations for the rites of visiting the sick, public confession,
extreme unction and the *scrutinium* before baptism. This series is charac-
terized by heavy architecture, dark colours, tight acanthus frames, and *80,81,82*
figures who appear strikingly large in relation to the picture surface and
have over-sized heads. It constitutes most of the miniatures of Group I in

129

Zimmermann's stylistic analysis of the manuscript into three groups. The faces are phlegmatic and quite lack the elevation of Reichenau faces, just as the figures lack the Reichenau tension, moving (so Zimmermann put it) with *steife Plumpheit* or ungainly stiffness. Zimmermann labelled this group as Group I because these were the scenes which must have kept most closely to their Carolingian models, not because they were the first to be painted, which there is no reason to suppose.[14] Certainly if one looks at Fulda's own ninth-century copy of Hrabanus Maurus's *De Laudibus Sancte Crucis*, the excessive size of the figures, their hair-styles, their phlegmaticism and their *Plumpheit* are already there.[15] Only the architecture is lacking.

There is an element of the Ottonian retreat from spatialism in this almost oppressive architecture, which seems to cramp space and inhibit movement. It corresponds to a milder elaboration of the architecture which Peter Klein noted in the early tenth-century Cambrai Apocalypse as against the early ninth-century Trier Apocalypse of which it was a direct copy. He noted other features in *Cambrai* even more destructive of the spatial illusionism of the earlier manuscript.[16]

The most unusual of the 'sacramental' illustrations is that of the *scruti-*
82 *nium*. One can find parallels of a sort to the extreme unction,[17] and of course there are many depictions of baptism in this period, but I know of no other illustration of the *scrutinium*. The fact that the disposition of this illustration and its architecture is so similar to that of the upper half of
81 the Death of John the Evangelist, much earlier in the same book, only serves to suggest that the artist need have had no previous illustration of

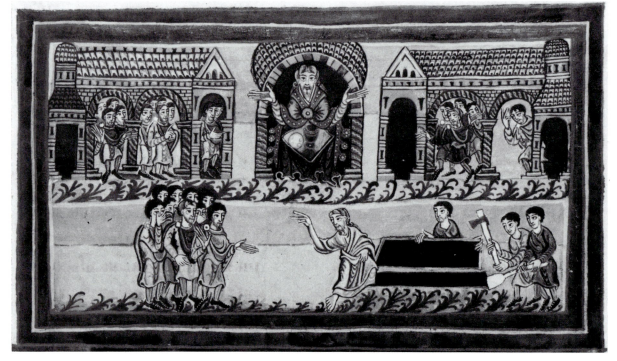

81. The Death of John the Evangelist. Sacramentary, Fulda, *c.* 975. Göttingen, Universitätsbibl., Cod. 231, f. 15v

explceo annopducere dignatuf
ef· gratia incouirce longioris
augmta · &dicseuis annorum
numerosicace mutaplica · ucce

annuence pfelicon puceeuisaccace·
adprincipacum celesaum gau
diorum puenire mereacur · p

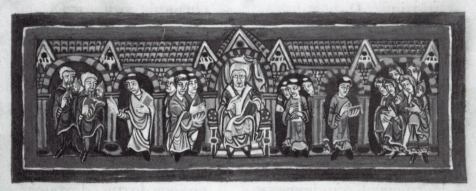

DENUNTIATIO SCRU
TINII IN DOM · III · QUA
DRAGESIMAE ·
SCRUTINII DIEM DI
lecassim fr̄ quo decann
diuintus infcruancur immi
nere cognoscece · ideoq: solli
cita deuoaone succedence·
ii· feria circa horā diei terciam
conuenire dignemini ad ec
clesiā· ill· uel· ill· ut decao
nis myfterūu quodiabolus
cum sua pompa defcruitur
&ianua regni celesfasapent̄
inculpabili dō iuuance mm

sceno pagoce ualeamus·
FERIA· II· ORDO SCRU
TINII·
Vt aut uenerint ad ecclesiā hora
tercia· scribant̄ nomina infan
tū· t eorū qui eos suscepturi
sunt abacolito ica dicence·
Siquis intran cupit sacramas̄
sce̅ fidei det nomen·
Secundus acolituf: S iquif
ronasci ad uitā aecernā desiderat
det nomen· T oraus accot
Siquis ad pascha uult baptzari
det nomen· Ɛ ruocare
ipsi infances ab accolito in

the *scrutinium* itself in front of him, and might have been quite original in the fact of illustrating this subject without being very original in the way he did it.[18] The *scrutinium* was a rite, held on a series of days in Lent, originally to prepare candidates for baptism (catechumens) and to test their knowledge of the Christian faith.[19] The full Roman *ordo* of the late sixth or seventh century was copied into the Göttingen Sacramentary (followed by the order of baptism), with our illustration at its head.[20] The

82. The Scrutinium. Sacramentary, Fulda, *c.* 975. Göttingen, Universitätsbibl., Cod. 231, f. 214

real work of preparation and testing for baptism must always, or at least from an early stage in the history of the rite, have been done beforehand. The *ordo*, with its prayers of exorcism and brief expositions of the evangelist symbols, the creed and the Lord's Prayer, is more a *ritual* act of instruction and initiation, which could remain a rite of reaffirmation for those already initiated, not least the parents and godparents, when those being baptized came normally to be infants rather than adult converts.

82 In our illustration of the *scrutinium* a bishop is majestically seated in the centre, his ritual stateliness marked by the highly wrought architecture before which he sits. On either side of him, in the first bays of an arcade, stand his supporting clergy (the sense of ordered hierarchy in this picture corresponds to that of the Drogo Sacramentary, *c.* 845, where a bishop is shown celebrating mass),[21] and beyond these clergy are the acolytes, each under his own arch, who according to the rubric call the names of the children to be baptized. The children are here shown in the arms of their godparents, males on one side and females on the other. The initial rubric of the *scrutinium* which says that an acolyte shall call the infants by name in written order, and that males are to be placed on the right and females on the left is thus illustrated to the letter. We by-pass the implicit contradiction in this rubric between a rite envisaged as being for infants and the clear signs which remain of its having been originally developed for adults,[22] in order to observe that in the tenth-century situation the *ordo* could easily have been adapted either to infant baptism in Christianized regions or to adult conversion in the mission fields.

The reason for embellishing these rites with such illustrations (unusual at least in Ottonian times) can only be that the missionary and pastoral traditions going back to St Boniface and embodied in the writings of Hrabanus Maurus (Abbot of Fulda, 822-42) were still prominent in tenth-century Fulda. By then the *scrutinium* itself can have had no practical importance even for the examination of the godparents,[23] but it still points up ritually the importance which Fulda had attached to its function of teaching the Christian faith to the German peoples. The Göttingen Sacramentary contains within the *ordo scrutinii* an eloquent sermon on the redemption of the human race, which is not in the Roman rite or *ordo*, and can be identified as a Spanish composition, probably of the seventh century, which is found in a Toledan homeliary.[24] The monastery's finding and including such a sermon in the Sacramentary is as good a sign as the illustration itself that Fulda took seriously this rite and what it symbolized. These sacramental illustrations bring to mind Wallace-Hadrill's observation on Hrabanus Maurus's *De Institutione Clericorum*: 'The mass is for him, what it always was, the great sacrament [and the *scrutinium* occurred within the context of the mass] but not far behind it in Hraban's eyes is the sacrament of baptism'.[25] The spirit of that most famous of all early Fulda scholars seems to breathe in the Göttingen Sacramentary.

It is one thing to speak of missionary traditions in Fulda, it is another to know how active its involvement was in actual missionary and pastoral

work. There is even some doubt about whether monks were normally allowed to act as parish clergy in their own region during the ninth and tenth centuries; they appear to have needed special permission to do so.[26] However Mechthild Sandmann has pointed out that Hrabanus's whole system of administering the Fulda *Eigenkirchen*, for which priests had to be found, implies that he was running a pastoral organization behind that of the property and tithes,[27] an idea supported by the monk Rudolf in his *Miracula Sanctorum in Fuldenses Ecclesias Translatorum* (840s) where he says that Hrabanus administered some of the monastic estates through bailiffs, and others, especially where there were churches, through priests.[28] Perhaps, indeed, we should speak rather of a property organization behind the pastoral one. It is natural to apply the same consideration to the tenth-century abbots, even though we lack extant writings from this period which would match those of Hrabanus with their strong sense of pastoral responsibility. Moreover, a monastery could be a kind of institute for pastoral and liturgical affairs, or a training school for missionaries, even if its monks did not directly serve the neighbouring parish churches. So far as we know, for instance, Bede was never a pastor himself, but he wrote little or nothing without an eye to its pastoral usefulness. There are some telling signs, amidst a desert of evidence, that similar concerns were still a practical reality in tenth-century Fulda: for instance the Old High German confession in the Göttingen Sacramentary.[29] Another example is the Latin/Old High German glossary of words for parts of the body, parts of the house, household equipment, articles of clothing, etc. — exactly the sort of words which would be needed for visiting the sick and administering the sacrament of extreme unction — in a ninth-century Bavarian manuscript (Kassel, theol. 4° 24) of Fulda provenance (we have already noted Freising's missionary orientation under Bishop Abraham, Part I, pp. 94-95).[30]

If the texts of the *scrutinium* and the other sacramental *ordines* are lacking in later Fulda sacramentaries, and so obviously illustrations as well, that is not to say that the subject after all lacked the importance at Fulda which we have attributed to it. The Göttingen Sacramentary is a huge compilation of everything which could conceivably go into a sacramentary, more comprehensive than any of its extant successors, with a large collection of votive masses, including even one to ask for tears, and another large collection of blessings, including one to purify 'vessels found in ancient places'.[31] Many alternative prayers for the mass are also given. It has the character of a conglomerate master-copy of a Sacramentary, which is also suggested by its large format (340 × 270mm) as against 225 × 165mm of the Fulda Sacramentary at Bamberg. One must reckon that portions of its material would have been copied into ephemeral *libelli*, practical and much easier to handle on particular occasions, so that the *scrutinium* and the other sacramental orders could have been copied into booklets of the sort which would later be known as the *rituale*. That is not to say that the master-copy itself would have failed to grace the high days of the liturgy.

Such booklets would in the nature of the case be unlikely to survive. The Göttingen Sacramentary shows no signs, unlike some Fulda sacramentaries, of having been made for export; before it was in the Helmstedt University Library, whence it came to Göttingen, we have no idea of its provenance.[32] It could have remained at Fulda for a long time after it was made, a treasured symbol, and a venerated ancestor of the various manuscript sprigs which it (or its prototype) sprouted.

In Zimmermann's Group II, which includes all the miniatures from the beginning to f. 79, and thus all scenes of Christ's Life except the Ascension, amidst general continuity of idiom we encounter some marked differences from Group I. The compositions have more air; the architecture is much lighter or is absent altogether; the figures are smaller and more nervous; the heads are reduced to a more normal size, although the over-large hands remain.[33] The colours, especially of the clothes, are in general brighter, for while the heavy blues and oranges of Group I are by no means abandoned, they tend to give place to the typical blue-greens and lilacs of tenth-century Fulda. The styles of Group II and III, not Group I, dominate the later Fulda sacramentaries. Most of the Group II miniatures are illustrations for the mass prayers of important festivals, and are placed on the page before the collect of the relevant day. A particular feature of this group is that the illustrations, in plain or striped rectangular frames, in many cases rest on a pair of columns which enclose the text of the collect itself, an architectural placement faintly reminiscent of the small rectangular New Testament mosaics placed above the clerestory windows in the church of Sant' Apollinare Nuovo, Ravenna, which could easily have been known at Fulda from the Italian journeys of its abbots.

83. Illustration to Psalm 80. Stuttgart Psalter, Northern France, c. 830. Stuttgart, Württembergische Landesbibl., Bibl. Fol. 23, f. 97v

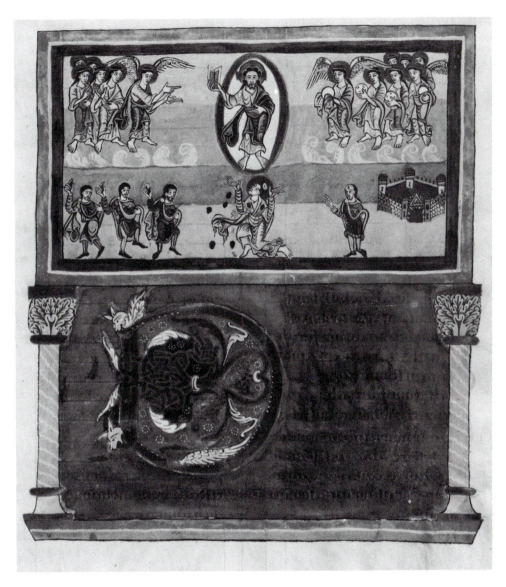

84. Martyrdom of St Stephen. Sacramentary, Fulda, *c.* 975. Göttingen, Universitätsbibl., Cod. 231, f. 14v

A typical Group II scene, stylistically speaking, is the Stoning of St Stephen. The background consists of three stripes of colour, rather heavy *84* as in some of the illustrations of the Carolingian Stuttgart Psalter, but nonetheless a residuum of late antique illusionism. The earth (with the symbolic, Reichenau-like town) is yellow, the middle stratum deep blue-green, and the background to Stephen's vision of heaven which he saw as he was being martyred is pink/lilac. From the surviving Carolingian examples of this scene, a popular one, it looks as if there must have been various types of model. One can discern a relationship, not perhaps closer than cousinly, between the illustration of the ninth-century Pauline Epistles at Munich (particularly in the figures of St Paul and the front *85* stone-thrower) and that of the Göttingen Sacramentary. But the lively, *84*

135

85. Martyrdom of St Stephen. Epistolary, Northern France or Rhineland, mid C9. Munich, Bayerische Staatsbibl., Clm. 14345, f. 1v

83

86. Martyrdom of St Stephen. Initial in the Drogo Sacramentary, Metz, *c.* 850. Paris, BN, MS lat. 9428, f. 27

86

differentiated little figures of the stone-throwers in the latter are a far cry from the monumental groupings in the Epistles or in the ninth-century wall-paintings of the Auxerre crypt, though they are reminiscent of other provincial Carolingian works, particularly the Stuttgart Psalter.[34] The heavenly vision of Stephen does not feature in either of the two aforementioned Carolingian scenes. It could easily have been suggested by some of the illustrations of the Utrecht Psalter (Rheims, *c.* 830), or similar; and the Drogo Sacramentary of Metz (*c.* 845), the surviving Carolingian representation closest to Göttingen, has this vision in the form of the Hand of God and angels.[35] We are surely dealing, therefore, with Carolingian inspiration, though probably not the slavish use of a single Carolingian model. The domination of Ottonian Fulda by its Carolingian religious and cultural traditions (see also Part I, pp. 34-35) stands out on almost every page of this book. Indeed when we seek the origins of Fulda style, they seem most nearly represented in the surviving fragment in the British Library of the otherwise lost pericopes book from the Ada Group of the Charlemagne Court School, itself based on a lost late antique prototype, both as to the liveliness of the small figures and the relation of strips of illustration to the page as a whole.[35a]

The Christ-cycle contains the following scenes: Nativity; Massacre of the Innocents; Visit to the Temple for the Circumcision; Epiphany, Cana and Baptism of Christ, all three within one frame; Presentation in the Temple; Annunciation (one sees the scant regard for chronology); Entry into Jerusalem; Last Supper and Footwashing of Peter; Christ before Herod

136

and Crucifixion (full-page); Deposition from the Cross and Entombment; Three Women at the Tomb; and Noli Me Tangere; Ascension; and, we may add, Pentecost.[36] This is quite considerable, but it is by no means one of the great Ottonian cycles of the Life of Christ, because after the Infancy and beginning of the Public Ministry, it lacks any scene until the Passion.

On the other hand the Göttingen Sacramentary (as with its Fulda successors) is remarkable for the number of saints and saintly martyrdoms depicted. There is the death of John the Evangelist, St Martin's sharing his *81* cloak with a poor man and his vision of Christ; in addition to that of Stephen, there are four martyrdoms: i.e. Boniface, Peter and Paul, Law- *Col.Pl. XIII* rence and Andrew. The martyrdom of St Boniface is in two scenes, horizontally arranged on either side of a pillar. In one he baptizes; in the other he is felled by his pagan East Frisian assailants, holding above his head a gospel book (as described in the *Vita* of Radbod of Utrecht), 'so that in death he would have the protection of that book which he loved to read in life', a detail said by Radbod to have come on the testimony of a certain woman, 'now very decrepit', who had witnessed the martyrdom.[37] With these four martyrdoms we are in Zimmermann's Group III, which has the sketchiest figures, uses liberal daubs of white to paint them, and is the farthest away — stylistically — from any Carolingian prototypes.[38] Stylistically but not iconographically: for it is inconceivable that Carolingian prototypes of the life and death of St Boniface were lacking, and their existence for the martyrdoms of Saints Peter and Paul, and Lawrence is proved by the Utrecht Psalter and the Drogo Sacramentary, produced respectively under Ebbo of Rheims and Drogo of Metz, both of them friends of Hrabanus Maurus.[39] The overwhelming fact (at Fulda) of St Boniface's martyrdom, both as the crowning of his missionary endeavour and as leading to immediate saintly veneration, was certainly the impetus to all this interest in martyrdom; it became part of the Fulda hagiographic tradition which emphasized Boniface's own determination, against any other idea or vested interest (such as at Utrecht or Mainz), that Fulda itself should be his resting-place.[40]

What place had martyrdom in the Fulda ethos outside the sacramentary illustrations? It may be as difficult to imagine martyrdom as a real prospect in the tenth-century empire, as it is to think of it for Roman Catholics in the England of 1851, when Newman dramatically hinted in his sermon, 'The Second Spring', that the newly restored hierarchy might be called upon to lay down their lives for their faith.[41] It must have been almost as remote a prospect as that of Cardinal Wiseman's being lynched. The ninth and tenth centuries, it is true, afford occasional examples of the martyr or near-martyr, such as the priest, Poppo, who had been forced by King Harold of the Danes to undergo an ordeal of hot iron as validation of his religion;[42] or Blaithmac, a recent Irish victim of the Vikings on Iona when Walafrid Strabo, abbot of Reichenau (838-49) and an *alumnus* of the Fulda school wrote his *Vita*;[43] or Adalbert of Prague in 997, though he was notoriously tactless, and might have contributed to his own fate. Perhaps

137

the truth is, however, that in Fulda art as in Newman's sermon a remote possibility was played upon in order to give extra inspiration to those involved in pastoral and missionary work. Fulda illustrations of St Boniface always associated his martyrdom with his work of preaching and baptizing.

Fulda was demonstrably an exporter of sacramentaries,[44] and we have already mentioned that the archbishopric of Magdeburg was an importer of books, including, apparently, Fulda books (Part I, p. 39). Moreover, the archbishops of Magdeburg, as seen in their documentary traditions, were aware of an analogy between themselves as missionaries and St Boniface more than two centuries earlier. For Pope John XIII's bull of 18 October 968 setting up the archbishopric of Magdeburg, with Adalbert as its first Archbishop, refers to the knowledge of the archbishop, clergy and people of Magdeburg, 'that our predecessor Zachary of good memory enthroned blessed Boniface, an apostle of pagans (*ad gentes destinatum*), in the church of Mainz'.[45] Perhaps it was particularly at Magdeburg in the tenth century that the Bonifatian missionary traditions of Fulda, expressed in its art, fused with actual missionary work. Politics and economics doubtless played a large role in tenth-century proselytism, not least at Magdeburg, but we need not assume their universal primacy.[46] Adalbert himself figures very much as a political grandee in the pages of Thietmar of Merseburg, and as lord of vast estates and revenues on both sides of the Elbe in the Magdeburg *Urkundenbuch*.[47] He had headed a Christian mission, albeit in the end abortive, to Olga of Kiev and the Russians some years earlier. Previously, however, he had been a monk of the monastery of St Maximin, Trier,[48] and a patristic manuscript from this house, now in Berlin (Lat. fol. 759), contains a little catechism on the Trinity, *Pater Noster* and Apostles' Creed, evidently for the instruction of catechumens or the laity. A sample of it is the following:

> Q. What is the second petition (of the Our Father)?
> A. Thy kingdom come.
> Q. What is to be understood by it?
> A. We pray that Christ will reign in us and not the devil;
> and that the church of Christ, in which God reigns,
> may grow; and that the day of judgement may come
> when the devil ceases to rule in the world,
> and Christ with his saints will
> rule for ever.[49]

Countless catechisms and didactic treatises of this kind have survived in ninth- and tenth-century manuscripts,[50] but the interest of this one is that it comes from the milieu which produced the first archbishop of Magdeburg. According to Thietmar of Merseburg, Adalbert died (981) while Bishop Gisiler of Merseburg was with Otto II in Italy, and he was looking after Gisiler's diocese, travelling, teaching and confirming.[51] It is with

such a figure in mind that we venture to suggest that the Bonifatian traditions of martyrdom were turned into spiritual vitamins (so to speak) which could give impetus to the Ottonian missionary enterprise.

3 Saints and Saints' Lives

A small late tenth-century Fulda manuscript now at Hanover (MS I, 189) contains the illustrated *Vitae* of Saints Kilian and Margaret of Antioch, *87-91* together with a collection of private prayers. Its miniatures are entirely characteristic of Fulda style and colour, and its script is close to that of the Göttingen Sacramentary.[52] Preaching and martyrdom, once again, are the *Leitmotive* of the part-page miniatures depicting St Kilian. This manuscript is typical of the *libelli* containing saints' lives which became common in the eleventh century, yet according to Francis Wormald it is the earliest surviving example with illustrations. Such *libelli* would probably have been under the jurisdiction of the sacristan rather than the librarian; they were partly for edification, and partly title-deeds validating the shrine and property of a saint. We know of Carolingian saint cycles, such as that on the golden altar of St Ambrose at Milan, but none survive in manuscripts.[53] The Kilian cycle was probably an invention of Fulda — the cult was already firmly established there in the time of Hrabanus Maurus (822-42)[54] — and may even have been an invention of the tenth century. Behind it is a mixture of Carolingian motifs, and scenes and iconography which very much echo those involving Boniface himself. Boniface looms over the Fulda art world.

St Kilian was a seventh-century Irish martyr who worked in the region of Würzburg under Duke Gozbert of Thuringia. The bishopric of Würzburg, from which Fulda claimed exemption, was a Bonifatian foundation.[55] The policy towards it of the monks of Fulda seems to have been to remain steadily exempt from its jurisdiction themselves, to recognize its authority scrupulously elsewhere,[56] and to foster positively its religious traditions. The last came easily to them, for Kilian could readily be perceived in the image of Boniface. In the Hanover manuscript we see him receiving a commission to preach from Pope Conon (686-87), as did Boniface from *87* Pope Gregory II; the bowed figure before the altar, hands stretched out in prayer, suggests the possibility of a Consecration of St Stephen in the background (cf. the wall-painting of Müstair, *c.* 800). He preaches to an *88* enthusiastic audience. The Carolingians delighted to represent teaching and respectful or eager responses to it;[57] beyond believing in the didactic function of art, they canonized the portrayal of didacticism. We see him, as we see Boniface, baptizing, with a cleric holding open a sacramentary *89* from which he prays, while an eager young man in none too securely fastened trousers strips off his shirt in readiness for his turn. We see him martyred with his companions, by beheading, a witness called Burgunda (the narrator) standing by, just as Boniface is depicted being attacked by the sword. These illustrations may look naive, but they certainly give no

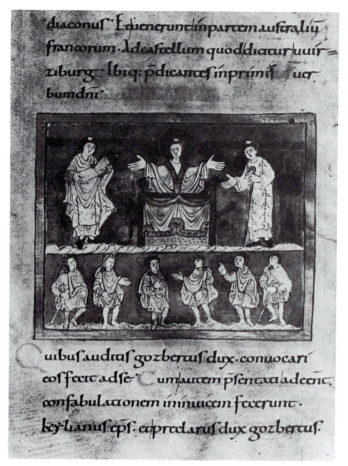

87 & 88. Pope Conon commissions St Kilian to preach; Preaching of St Kilian. Lives of Saints Kilian and Margaret, Fulda, late C10. Hanover, Landesbibl., MS I,189, ff. 4, 4v

impression of routine. They are all fitted, in plain gold frames, with a pleasing sense of proportion into the text. The final scene in the Kilian series represents the effect of the martyr's death and the punishments meted out to all concerned. Geilana, Gozbert's wife, who ordered the death because Kilian had criticized the legality of their marriage, was invaded 90 by a *spiritus malignus*, and is here shown going mad with great verve, while two staid matrons seek to restrain her. Gozbert is being killed by his servants, and his son is being driven from the kingdom of the East Franks.

Throughout the *Life of Kilian* and its illustrations, therefore, practical example and moral lesson take precedence over the merely wondrous and miraculous. That was typical of Fulda's attitude to sainthood. Hrabanus was a great collector of relics from Rome; in his time, and with all his poetic *tituli* commemorating saintly depositions, Fulda must have seemed a veritable heavenly (Roman/heavenly) city.[58] The monk Rudolf, his pupil and collaborator in the work of collection, wrote a fascinating account of the translations of these relics from Italy to Fulda, or from Fulda to its various dependent churches. Yet this account seems primarily aimed at establishing the access to the authority of Rome which Fulda had, and its

140

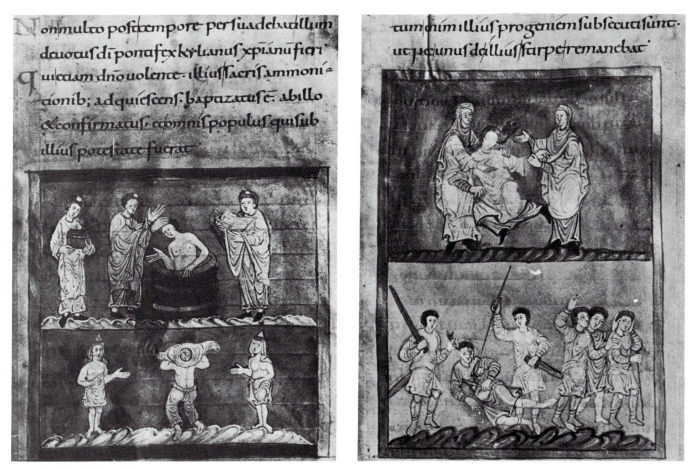

onmulto post tempore persuadebat illum daicis di ponti fex kylianus xpianu fiqi quicci dno uolente. illius sacris ammoni aonib; adquiescens. baptizatus e. abillo &confirmatus c omnis populus qui sub illius poctiate fucrat

cum nim illius progenicm subsecuta sunt. ut ucunus d illius se per eminebat

89 & 90. St Kilian baptizing; Madness of Geilana, Killing of Gozbert, Exile of Gozbert's Son. Lives of Saints Kilian and Margaret, Fulda, late C10. Hanover, Landesbibl., MS I,189, ff. 5, 10

exercise of its own authority over its dependencies, culturally expressed in the distribution of relics; the translations themselves constitute the main interest, and many of the miracles which are recounted occurred while the relics were in transit: with the miraculous taking second place to these aims and to the interest in the translations themselves.[59] Moreover, like most serious Carolingian churchmen,[60] Hrabanus strove to counteract the effects of superstitious excess in saintly cults. His sermon on St Boniface, amongst his Homilies for the Principal Feasts, is in effect a commentary on the eight beatitudes, simply and movingly done; and it ends with these words which are well aimed against any magical veneration of the relics:

> Let us commemorate his passion, and
> celebrate the glory of his triumph
> in the place of his relics in such a way
> that we do not set up an altar as if to a
> god Boniface, but make Boniface an altar to
> the true God, because his soul is indeed a seat
> of God.[61]

141

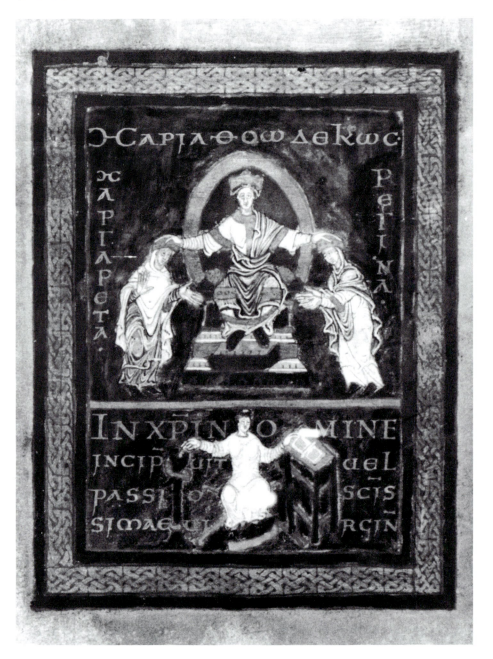

91. Coronation of Saints
Margaret and Regina.
Lives of Saints Kilian and
Margaret, Fulda, late C10.
Hanover, Landesbibl.,
MS I,189, f. 11v

Col.Pl. XVI

Hrabanus's sermon on St Martin, another brief and telling one, with much about the incident of Martin's cloak illustrated in the Fulda sacramentaries, also has a moral emphasis, namely that Martin shared his cloak with a poor man when he was still only a catechumen. In his dream, quoted by Hrabanus from the *Vita* of Sulpicius Severus, Martin heard Jesus say in ringing tones, 'Martin, as yet but a catechumen, has clothed me with this cloak'.[62] Here was food for thought during the *scrutinium*. The importance of Martin in the tenth-century iconography of Fulda is

142

another example of the monastery's looking back to a Carolingian herit-age, since this surely arises from Hrabanus's having been a pupil of Alcuin at St Martin of Tours.[63] When Eigil, Hrabanus's predecessor as Abbot of Fulda (816-22), wrote the *Life of St Sturm*, he too preferred to work in the tradition of hagiography which concentrated on practical virtues rather than wonders. 'How many miracles were performed there (at Fulda) and are still performed to this day I leave to writers better than myself to describe', he writes with Ciceronian dismissiveness.[64] Eigil presented Sturm in terms of his efforts to achieve harmony amongst the brethren, his correction of faults and establishment of discipline, his zeal in preaching, his diversion of the River Fulda in order to provide a water supply for the abbey workshops.[65]

There are hints in the evidence that the fluent and ready production of illustrated saintly *Vitae* at late tenth-century Fulda was a bigger industry than we can ever now know, and that Fulda had cornered at least a large sector of this market. About 970, the Abbess Hadwig of Essen (947-71) must have commissioned from Fulda an illuminated *Vita* of the Essen patrons Cosmas and Damian. The manuscript is now lost, but in 1597 drawings were made of the miniatures of the title pages, one of Hadwig being presented by St Pinnosa (another patron of Essen) to Mary seated in Majesty, the other showing Cosmas and Damian being crowned by the enthroned Christ.[66] Another manuscript, a Carolingian Prudentius from St Gall, now at Bern (Stadtbibl., Cod. 264), received in the tenth century the addition of some illustrations for the *Vita* and martyrdom of St Romanus, which Boeckler pointed out to be certainly done at Fulda and very much in the style of the Saints Kilian and Margaret miniatures.[67] These stray evidences are surely the iceberg-tip of Fulda hagiographical art, and more-over they point to connections from which Fulda in its turn could well have *taken* artistic ideas. The Cosmas and Damian has Greek inscriptions, and Essen was an important centre of Byzantine influence. The crowning of two symmetrically placed figures was a Byzantine motif, used for Saints Cosmas and Damian and also, in the Hanover manuscript, for Saints *91* Margaret and Regina, a motif which could have been derived from Essen.[68] As to the St Gall/Fulda connection, it offers the perfect explanation for the origin of the typical gloomy faces of Ottonian Fulda (cf. pp. 95, 97).

4 Fulda Painters, Scribes and Goldsmiths

After enjoying the vivacious penmanship of Fulda manuscript art, its nicely blended greens and lilacs and violets, the pleasing design of its pages, and the moral pointedness of its illustrations, it almost goes against the grain to say how secondary in importance manuscript painting must have been at Fulda in the context of its art as a whole. The evidence points overwhelmingly to metalwork, especially in gold, as having pride of place. Schnitzler argued strongly on grounds of style, ornament and icon-ography that the fine Aachen golden altar of *c*. 1000 was Fulda work.[69]

Another good case on the same lines was made by Fillitz for the golden book cover at Säckingen (*c.* 970-90).[70] Tilmann Buddensieg has noted the influence of Fulda on lower Saxon goldwork of the early eleventh century.[71] In fact, goldwork has a much poorer chance of survival than manuscript illumination, but the evidence in the written sources for its importance is inescapable. The eighth and ninth centuries point to a continuity in the gold workshop at Fulda. Sturm had the tomb of Boniface covered in gold and silver, Hrabanus had gold and silver vessels made for the altar as well as innumerable feretories for his relics, Abbot Sigehard (869-92) had a gospel book covered in gold and precious stones.[72] Abbot Hadamar (927-56) must be considered the prime mover in laying the foundations of wealth on which late tenth-century Fulda art was based. After the disastrous fire of 937 he set about organizing an economic recovery and raising again the number of monks which had dropped from 116 in 935 to 84 in 940. He apparently journeyed to Frisia, the region of Boniface's martyrdom, for instance, in 944 or 945, to raise Fulda rents there. The *narratio* of this journey in the Codex Eberhardi, a Fulda cartulary of *c.* 1160, is not formally authentic, but there are reasonable grounds for thinking that the journey itself was actually made.[73] Hadamar seems also to have gone in for sheep-rearing and flax, important commodities if a growing number of monks was to be clothed.[74] Above all from our point of view, there is a tradition, recorded by Eberhard, that Hadamar revived and re-endowed from the abbot's revenues the art workshop of the monastery, in one case even mentioning a specific place, Sunzenhausen, as the *beneficium* of one *artifex*, or craftsman. The terms of this *traditio*, which speak of engraving, smelting and smithing, make it absolutely clear that metalwork is primarily in question.[75] It is no surprise, then, to find the Emperor Henry II making a grant to Abbot Richard of Fulda in 1019 of a mint;[76] for if this was not a confirmation of an older right, Fulda must have been well qualified to run a mint by then.

Col.Pls.
XIV,XV,XVI

Not only metalwork but also scribal work would seem to have taken precedence over manuscript painting at Fulda. The two principal illustrated sacramentaries of Fulda, at Udine and Bamberg, which are of a later date than that of Göttingen, both show signs of taking the figural art of manuscript painting less seriously than they do the script and ornamented initials. It is not easy to say in what chronological order these two manuscripts should be placed in relation to each other, though it would seem that the Bamberg manuscript is the later of the two. *Bamberg* must be after 997 and is probably before 1024, but while it might seem obvious that it was secured by Henry II for his new bishopric around 1007, the book was apparently still at Fulda in or after 1031, though it was at Bamberg by the second half of the eleventh century.[77] *Udine*, though made for the Church of Bremen, belonged to the patriarchate of Aquileia at latest by 1031; it would date on palaeographical grounds from the late tenth century.[78] On grounds of its art, also, *Bamberg* looks the later of the two. It has broken away far more than has *Udine* from the light colours and page-format of

144

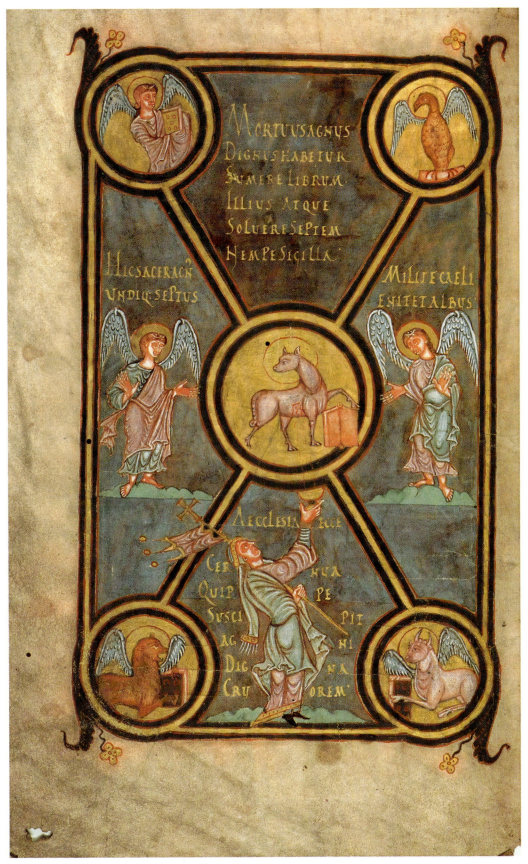

MORTVVSAGNVS
DIGNVSHABETVR
SVMERELIBRVM
ILLIVSATQVE
SOLVERESEPTEM
NEMPESIGILLA

HICSACRAE·ꝗᵈ
VNDIQ:SEPTVS

MILITECAELI
ENITETALBVS

AECCLESIA ECCE
CER HVA
QVIP PE
SVSCI PII
AG HI
DIG NA
CAV OREM

IX. Ecclesia and the Lamb of God. Frontispiece, Pericopes Book, Fulda, *c.* 970.
Aschaffenburg, Hofbibl., MS 2, f. 1v

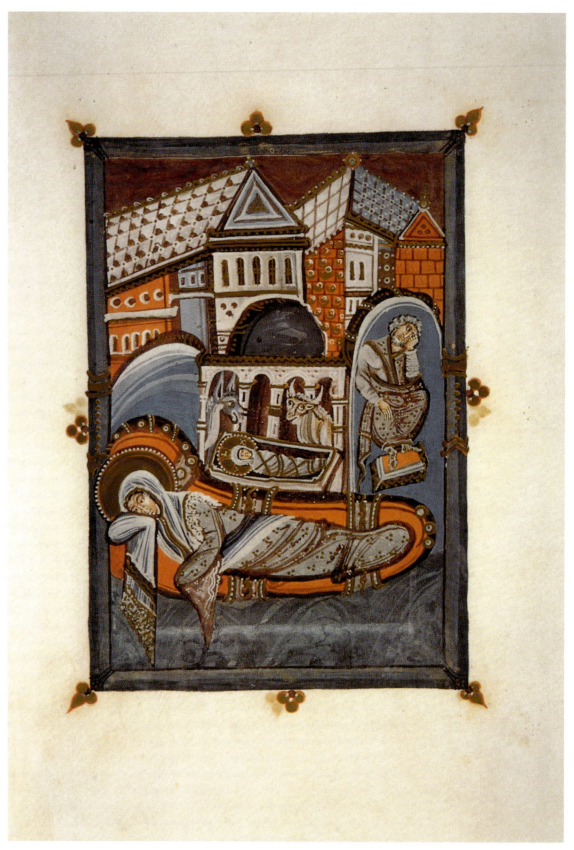

X. Nativity. Hitda Codex, Cologne, *c.* 1000-20.
Darmstadt, Landesbibl., MS 1640, f. 21

XI. The Storm at Sea. Hitda Codex, Cologne, *c.* 1000-20.
Darmstadt, Landesbibl., MS 1640, f. 117

XII. Frontispiece, Fulda Sacramentary, *c.* 970-75.
Göttingen, Universitätsbibl., MS theol. 231, f. 1v

XIII. St. Boniface baptizing; Martyrdom of St. Boniface. Fulda Sacramentary, *c*. 970-75.
Göttingen, Universitätsbibl., MS theol. 231, f. 87

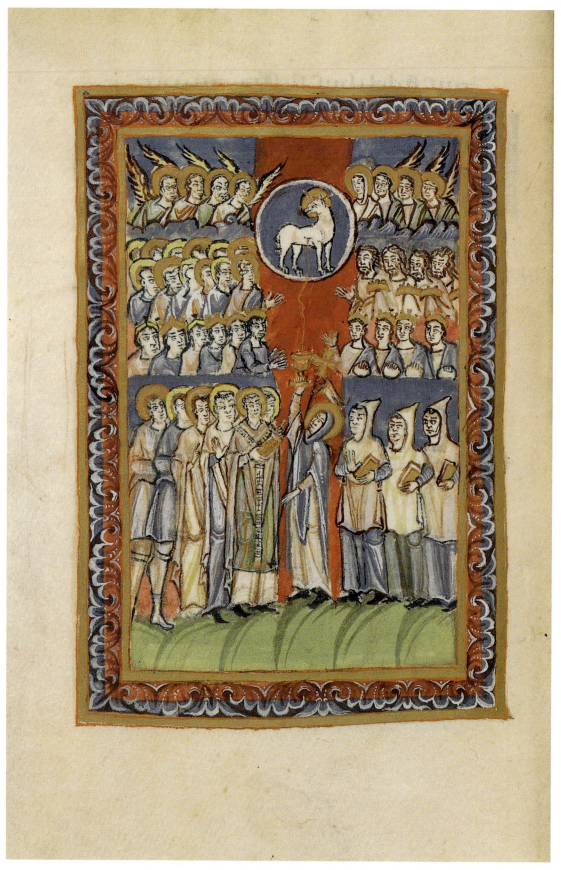

XIV. Illustration for All Saints. Fulda Sacramentary, prob. 997-1014.
Bamberg, Staatsbibl., MS Lit. 1, f. 165v

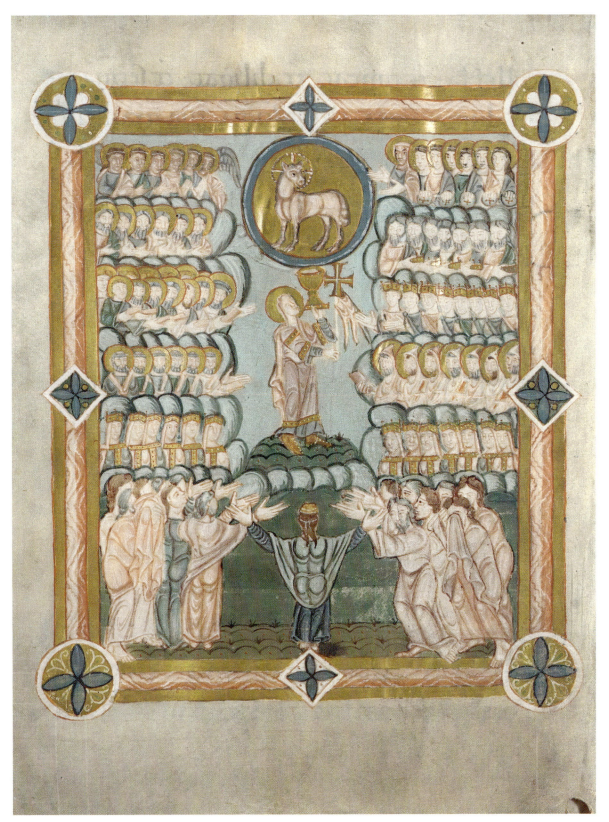

XV. Illustration for All Saints. Sacramentary, Fulda, late C10.
Udine, Archivio Capitolare, MS 1, f. 66v

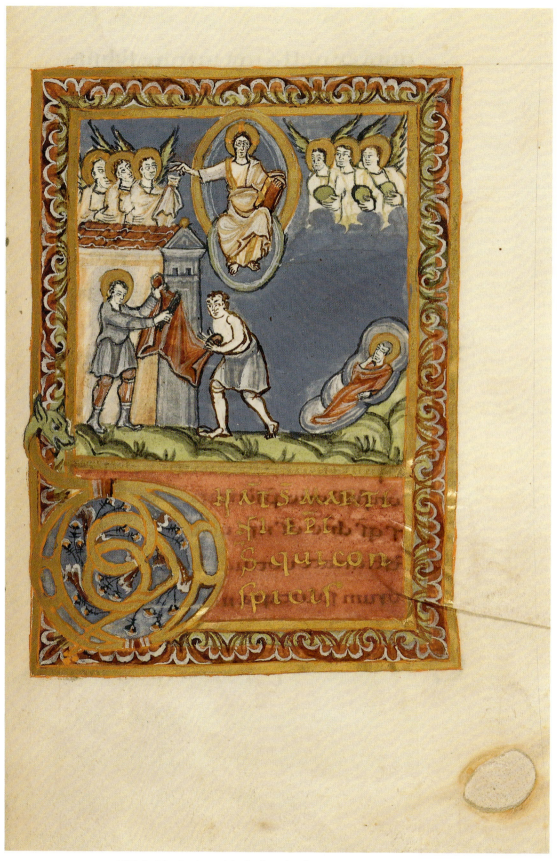

XVI. St. Martin shares his cloak with a beggar; his vision of Christ.
Fulda Sacramentary, prob. 997-1024. Bamberg, Staatsbibl., MS Lit. 1. f. 170

Göttingen. Many of its scenes indeed come in pairs (as in *Göttingen*), e.g. Boniface baptizing and his martyrdom, but now, in several cases they occupy together a full page and are arranged vertically rather than horizontally, as if the artists had been influenced by the interesting experiments in this format of the Gospel Book of Otto III (see Part I, p. 124). Its colours are deeper (with backgrounds of heavy blues and greens), than those of *Göttingen*, though it has to be admitted that the lighter coloured figures, with liberal use of white, stand out well, sometimes almost like ghosts, against these dark backgrounds. There is a certain feeling that whereas the miniatures of *Göttingen* and *Udine* were intended primarily for the eye of the celebrant at mass, the artists of *Bamberg* had more in mind the impact of the book as it stood open on the altar. But the intended impact was limited. Golden grounds are generally eschewed by all these books, for instance, as was the repertoire of brilliant colours and dramatic gestures used at Reichenau. That was not because Fulda lacked the material means to achieve the most sumptuous art, for the opposite is the case as we have seen. It can only be that their taste in manuscripts dictated something more sober and modest, more in the nature of penmanship, more Carolingian.

The placing of several of the *Bamberg* miniatures, moreover, is ill-considered if they were intended to make an impression during the performance of the liturgy. The scene of the Presentation, for instance, occupies a strip at the bottom of f. 35, at the end of the mass for the seventh Sunday after the Epiphany, whereas only on the turn of the page, at f. 35v come the mass prayers for the feast of the Purification, beginning with a nice initial. In *Göttingen*, on the other hand, miniature and collects of the feast are on the same side of the page. The Deposition and Burial of Jesus, relating to Good Friday, occupy the bottom third of f. 68v, at the *end* of the prayers for the Easter Vigil, a bizarre placing! But care has been taken to get St Boniface right. The full-page illustration comes on f. 126v, and opposite it as the book stands open, on f. 127, the mass for St Boniface begins with a decorated initial. Iconographic and draughtsmanly disciplines deteriorate in the course of the book. The Pentecost scene glories in no fewer than seventeen apostles, but their number should not be taken as a sign of artistic enthusiasm, for they are very skimpily represented. The drawing of the angel of the Annunciation at f. 119v is sloppy compared *92* with that of the angel in the Nativity scene at f. 25. Hartmut Hoffmann *93* says harsh things about the script of this manuscript: it is not very beautiful; it has lost much of the typical Fulda roundness; and it signals the decline of Ottonian calligraphy at Fulda.[79] But at least the standard of lay-out and script, such as it is, remains constant throughout the book; the quiring is regular, and the quires are carefully numbered in Roman numerals. The ornamented initials, with golden interlace and finials of foliage or animal heads, retain their interest. For the Fulda scriptorium, therefore, the figural art was apparently the least of its worries in this sacramentary.

The sense that the figural art takes second place to the script is only a little less marked in the manuscript at Udine (MS 1). The most striking

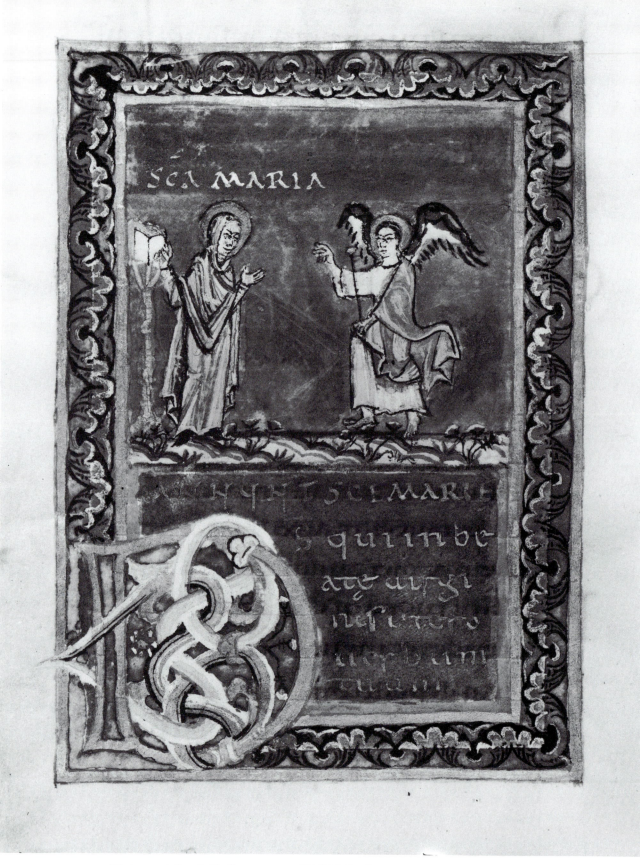

92. Annunciation. Fulda Sacramentary, 997-1024. Bamberg, Staatsbibl., MS Lit. 1, f. 119v

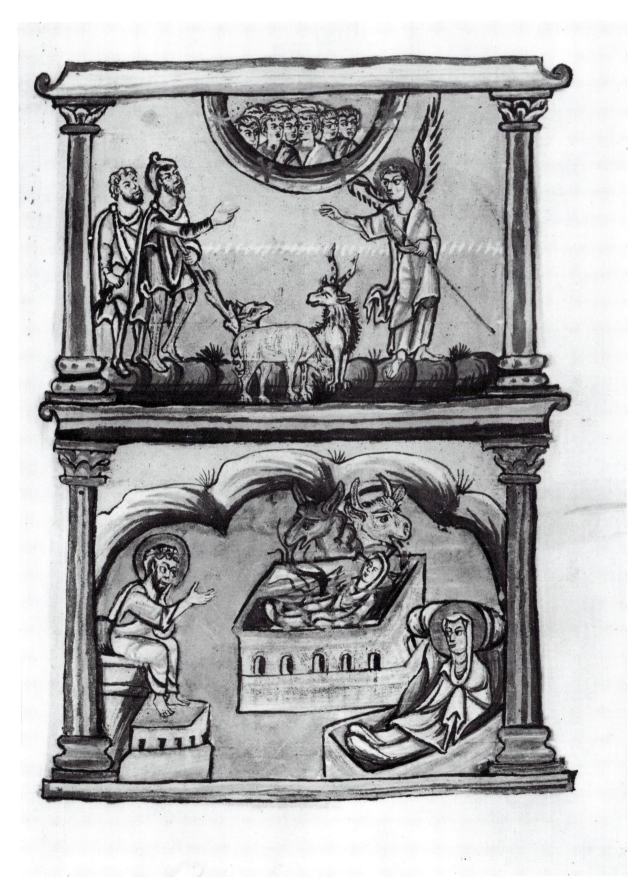

93. Nativity. Fulda Sacramentary, 997-1024. Bamberg, Staatsbibl., MS Lit. 1, f. 25

feature here is the highly irregular quiring. If one compares the diagram of the quires which contain miniatures (see p. 251) with Hoffmann's analysis of the scribal hands, one sees at once that this quiring can have little to do with enabling a number of scribes to share the labour in order to produce the text more speedily. There were but two scribes, one of whom wrote three-quarters of the text including virtually all the leaves with illustrations.[80] On the other hand, according to my quiring, there is only one double leaf in the whole book which has miniatures on both it pages. This would suggest that when the book had been written and before it was bound, its leaves could be distributed to more than one person each capable of working simultaneously in the same style at a second-class level to produce the illustrations quickly. The main function in life of such artists was doubtless not to mass-produce martyrdom scenes in sacramentaries. First and foremost they were probably metalwork craftsmen (*artifices*) or wall-painters; that would be congruent with the versatility of Fulda artists as we know it from other evidence (see p. 155 below).

5 The Imagery of the Church

One iconographic theme in particular was treated with a consistently imaginative interest, in fact with real absorption, in the Fulda sacramentaries, and it stands out all the more because so much else was handled mechanically. We refer to the worship of the apocalyptic Lamb by the company of the Risen Church in heaven, associated with the feast of All Saints and also with the Agnus Dei.

The Göttingen Sacramentary has a fine full-page Agnus Dei in its text of the Common of the Mass, in which *Ecclesia*, with banner, holds up a chalice to catch the blood flowing from the Lamb's side. The background is purple, but gold is heavily used in the frame and in the diagonals which link the four corners of the frame (formed of roundels containing the evangelical symbols) to the central roundel in which stands the Lamb. An even more remarkable representation of the same theme forms the frontispiece of a slim gospel book, in which the gospels for the principal feasts of the year are written in golden letters on purple grounds (Aschaffenburg, *Col.Pl. IX* MS 2). Although it is a pericopes book and not a sacramentary, it is undoubtedly Fulda work of the later tenth century, and the frontispiece was clearly made for the book, or booklet, as one might call it.[81] Here *Ecclesia* is of strikingly masculine appearance, the Lamb is bounded on either side by angels of firm and lively draughtsmanship,[82] and the page is studded with legends of theological character all written in golden rustic capitals. These theological texts are an early example in Ottonian art of a feature which would become common at Regensburg and Hildesheim, and, in the form of *tituli*, at Cologne. For what purpose the frontispiece with this subject was added to this lavish and lovingly created little book, which apparently lacked any permanent binding, we can only speculate. Perhaps it was to enable the subdeacon who would carry it in procession at the

factuif fidelibuf fuffragari p

AD MISS

S quif nos
beau cefaru
martyrif fuii
annua follen
nitate letificaf.
concede ppiuuf ut
cuiuf natalicia colim° etia
actiones imitemur p s̄ s̄ ō.
Hofuafabi dn̄e beau cefaru
martyrif fuii dicatas meritas
benignus affume & adp

peccuum nobif cribue pro
uenire fubfidium · p ΛΘC̄
Os omnipf d̄r ut qui celefua
alimenta percepimuf in
tercedente beato cefario mar
tyre tuo · perhec contra om
nia aduerfa muniamur
per d̄n̄m n̄r̄m ih̄m xp̄m filiu
tuum qui tecum uiuit &
regnat d̄f in unitate sp̄s̄ca
per omnia sc̄a sc̄torum ·

94. Illustration for All Saints. Sacramentary, Fulda, *c.* 970-75. Göttingen, Universitätsbibl., MS theol. 231, f. 111

95. The Worship of the Lamb.
Trier Apocalypse, Northern France, *c.* 800.
Trier, Stadtbibl., MS 31, f. 23

beginning of mass (according to an *ordo* of Fulda) to reflect on the mystery of the Church beforehand in the sacristy. Perhaps it was to enable the ministers of the altar to do likewise as it occupied a stand on the altar itself prior to the gospel reading. Its impact is undiminished at a distance of twelve metres, with its deep purple ground and the gold shimmering behind the rose-coloured Lamb in its roundel.

94 To return to the Göttingen Sacramentary, the feast of All Saints is illustrated with *Ecclesia* holding a chalice in order to catch the blood of the Lamb, and to either side, on tiers of light green clouds, are the ranks of the heavenly company, angels and patriarchs, kings and queens, clergy and laity, and in the lowest register on the right a row of monks with their hoods up. Boeckler saw, with brilliant intuition, the influence of the Court School of Charles the Bald, especially of the Codex Aureus of 870 (Munich, Clm. 14000) whose Ottonian home was Regensburg, in these ordered rows of saints, with their lively restlessness and baroque excitement. The Codex Aureus even has the same stars in the middle of the frames. From this school too, he forcefully argued, came the painterly treatment of the figures, weakly modelled and excessively lit-up with white.[83] Zimmermann's Group III was not so far removed from Carolingian influence as

150

he himself implied. The background of the Göttingen picture has shades of green, deepening as they descend, the darkest green being kept for the hummocks which represent the earth below. We are once again in the powerfully charged regions of the Apocalypse and the angels and the great multitude which no man could number, of all nations, who stood before the Lamb crying, 'Salvation to our God which sitteth upon the throne, and unto the Lamb' (Apocalypse, 7:9-11).

The later Bamberg Sacramentary (MS Lit. 1) has the same scene in full page. Again there is the Lamb and the heavenly company; but now there *Col.Pl. XIV* seems to be an earthly Church, too, with figures standing on what looks rather like a large green pipe (the earth) to either side of *Ecclesia*; on one side a bishop, clergy and laity — hierarchical order, as with the Carolingians, is never relaxed in these pictures — and on the other a group of monks, their hoods up, all with books in their hands. This picture must have its original prototype in one of the theophanies of the Carolingian apocalypses, something like the Trier Apocalypse of *c.* 800.[84] The most *95* prominent colours in the generally lightly coloured page of the Trier Apocalypse which we have in mind are a Pompeian red and a slightly greyish blue. These are exactly the colours which hit the eye in the All Saints page of *Bamberg*, the red in the vertical strip of colour against which *Ecclesia* and the Lamb are set. They are a marked change from the heavy blues and greens which dominate most of its pictures, and whether or not *Bamberg* took its colour tones here from a Carolingian prototype, the variation is a most refreshing one.

In between the Göttingen and Bamberg Sacramentaries, if our chronology was right, comes the Sacramentary in Udine (Archivio Capitolare MS 1), with the finest All Saints page of them all. The heavenly Church, whose *Col.Pl. XV* figures with the angels number 72, a mystical number in apocalyptic terms, is arrayed in the sky on either side of the Lamb like a Dürer Last Judgement; it is a very pale, airy green sky. *Ecclesia* stands on a deep-green mountain which rises from the earth. One could almost think of the heavenly sphere as pure light, the tinge of green being a reflection of the earth colour. On the earth stand members of the earthly Church, praying and pleading. There is nothing like this in the Göttingen manuscript. Those who are weeping should not be thought of as damned; they are pilgrims still in this vale of tears. The most arresting figure, to which the eye is irresistibly drawn, is the woman with her back to the onlooker at the bottom of the page, who stands like a conductor of a great choir, her arms thrown out in embrace of all the peoples, as if holding them together. This figure is surely not *Terra*, as suggested by Zimmermann,[85] but a personification of the earthly Church itself. Her head-gear is appropriate for *Ecclesia*. Thus there are two personifications of *Ecclesia* in the picture, one heavenly, the other earthly. Fulda was clearly familiar with Bede's Commentary on Solomon's Temple, which he treated allegorically as the duality of the Church on earth and the Church of the Resurrection, for Hrabanus Maurus lifted long passages from this work in his Commentary on the

151

Books of Chronicles. 'The house of God which King Solomon built in Jerusalem', he wrote, quoting Bede without acknowledgment, 'is a figure of the universal Church, partly in pilgrimage on earth, and partly, having escaped the hardships of exile, reigning with the king in heaven.'[86] The clothes of the terrestrial *Ecclesia* are a chasuble-like cloak of light green over a deep green undergarment; those of the celestial *Ecclesia* a light green undergarment, a lilac, dalmatic-like garb over it, embroidered with gold hems and orange dots, and over that a light orange cloak. Earthly and heavenly colours are contrasted with unusual significance, and nowhere else in the whole of Fulda art does colour achieve such wonderful and harmonious effect.

Why should Fulda, which fought as hard as any monastery for the rights and privileges of its own Church, have developed so vivid an art and imagery of the universal Church? Why Fulda, rather than the monasteries of the Gorze Reform (though these were not lacking images of the Universal Church, of course),[87] with their widespread geographical connections, their shared liturgical customs and spiritual aims, their confraternities of prayer, their movements of monks and abbots from one to another? These might be thought the likeliest milieu to achieve the highest artistic expression of an ideal which surmounts all ecclesiastical localisms.

We may suggest two answers to this question. The first is that the feast of All Saints, with its universalist connotations, was by a paradox intimately linked with the prestige of Fulda as a particular church in the tenth century, and not only through the vast relic-collecting of Hrabanus Maurus which seemed to make Fulda a veritable heavenly city, as we mentioned earlier. Abbot Ratger's great church building, modelled on St Peter's Rome, was consecrated on 1 November, the feast of All Saints, 819,[88] at a period when that celebration was only beginning to be established, thanks not least to the efforts of Alcuin,[89] and the feast of the church dedication was always an important expression of communal identity in an early medieval monastery. The Göttingen Sacramentary gives the mass prayers for it along with those for the feast of All Saints itself.[90] Moreover, after the great fire of 937 at Fulda, when the church was rebuilt, it was reconsecrated, again on the feast of All Saints, 948. This was the one occasion during his reign when we can be certain that Otto I was present at Fulda.[91] He rather owed them a good turn. It was a few months after the Synod of Ingelheim, where his dealings in French and Danish ecclesiastical affairs turned out well at the hands of the papal legates, thanks almost certainly to a preparatory visit to Rome by Abbot Hadamar in the preceding year.[92] We see Otto I, then, associating himself with the great cults and celebrations of the *Reichskirchen*, the Precious Blood and Assumption of Mary at Reichenau, and now All Saints at Fulda. His own religious aura, or sacrality, was advanced thereby; so was the standing within the *Reich* of the monasteries concerned.

The second answer to why Fulda developed so vivid an imagery of the Universal Church is, however, the more substantial and fruitful. Jacobi has

shown that the *Totenannalen*, a type of source virtually unique to Fulda, in which names of the dead are recorded year by year, a kind of apocalyptic *Liber Vitae*, were started in the eighth century mainly with the names of Fulda monks; friends and benefactors appeared only sporadically. Under Abbot Sigehard (869-92) there was a reorientation; magnates who held power within the Fulda orbit of Franconia, Thuringia and Saxony began to be systematically entered. By the time of Abbots Hiltibert (923-27) and Hadamar (927-56), as Jacobi has pointed out, we are beginning to see a constellation of rulers, potentates, bishops and abbots, which mirrors the whole *Reich* and the consciousness of Fulda's place as a *Reichsabtei* within it;[93] so that these *Totenannalen* came then to present a community of the whole empire, in heaven, and conceived to be united with Fulda. Oexle has seen the *Totenannalen* as a sign, a liturgical sign since they might well have been laid on the altar at mass, a sign of remembrance in summary (perhaps in this they could be compared with our war memorials). In masterly fashion he describes them as initially the product of the prayer agreements or conventions, made within the Fulda monastic community itself, having the object of settling the controversies which wracked the monastery in the Carolingian period.[94] In the ninth century the concord which they symbolized was a hope rather than a reality. Perhaps there was as much hope as reality in the tenth-century *Totenannalen*, symbolizing the unity of an imperial community with its nub at Fulda, as they comprehensively recorded the names of so many members of that wider community passing year by year from this life to the unity of the heavenly kingdom. But even hope can play a vital role in shaping the character and experiences of a community.

The imagery of the Universal Church in Fulda art of the late tenth century is surely a reflection of the same experience of a world-wide imperial society as meets us in the *Totenannalen*. It was an experience above all possible to a great *Reichsabtei*. Let us imagine a grid (to use a brilliant metaphor of Conrad Leyser from another context)[95] in which lines descend from the top, marked 'Universal Church', and other lines run across from the side, marked 'particular churches', for example Trier, Fulda, Volturno; and let us imagine these lines being lit up electrically, as in an illuminated advertisement, in such a way that light seems to play over the surface of the grid, giving emphasis now to the vertical now to the horizontal lines. It is possible to argue that the Saxon Empire and its churches did more even than the Gregorian Reform, which may be seen as the greatest of all struggles in the Middle Ages for the rights of a particular church (the church of Rome), to emphasize the lines representing the Universal Church.

153

6 The Mass and Mass Books

Finally we may ask the question: why was Fulda so addicted to the production of illuminated sacramentaries? Our answer cannot be exclusive to Fulda, for other centres put out fine sacramentaries, for instance Reichenau, Regensburg, St Gall/Minden, and Mainz. But the balance is tipped much more to sacramentaries at Fulda than elsewhere. Of course we cannot be sure that what survives represents anything like the ratio of sacramentaries to other manuscripts in the original output of the scriptorium. The air of professionalism, not to say routine, in the surviving sacramentaries, however, hinting almost at a production line, suggests that there must originally have been many more which have not survived. Florentine Mütherich has offered an answer to our question by observing that 'the particular mission' of Fulda to distribute sacramentaries may be an aspect of its close links with Mainz and the central role of Mainz in the reform of the Romano-German Pontifical during the tenth century.[96] This is surely right and important. We may build on this answer, based on the idea of external stimulus, to point up some internal features of the religious culture and interests of Fulda which would naturally make sacramentaries, i.e. mass books, most favoured there. But this does not mean that other monasteries, not in fact specializing in sacramentary production, lacked the cultural conditions to do so.

In the first place Fulda was accorded unusual authority in matters concerning the *ordo* of the mass. A letter written some time before 846 by Theotrochus, a monk-deacon and later Abbot of Lorsch (864-76), addressed to the priest Ootbert of the same monastery, and copied into a Lorsch manuscript containing mathematical material, shows this quite clearly for the ninth century.[97] In many places, Theotrochus maintains, the order of deacons has become diversified and thrown into confusion; partly because of the negligence of the prelates and partly because of lack of ministers; therefore he (Theotrochus) will intimate how the *ordo* of mass is carried out at Fulda where everything is performed in a reasonable and ordered way according to the Roman rite. 'Here in Fulda' — the author was evidently one of the many pupils drawn to study there in the time of Hrabanus Maurus — 'the *ordo* of priests is carried out with dignity and propriety, which is not so at Lorsch, and thus I will touch on this as well.'[98] It may be thought that an attempt to explain the phenomenon of late tenth-century Fulda sacramentaries by referring back to a mid ninth-century letter, for lack of nearer evidence, is to create a tenuous link indeed. The liturgical pre-eminence of one monastery over others, however, once established, is likely to be long-lasting. Nearer our own time the lead in Gregorian chant first given by the Abbey of Solesmes in the 1860s, for instance, has been sustained for over a century; and the monastery of Beuron has been second only to Solesmes in this respect since the 1890s.

The lack of ministers, says Theotrochus, could be a stumbling block to the performance of a proper ritual. He would have liked to see seven

deacons and the same number of subdeacons, as well as the ministering priests, involved in the celebration of a mass.[99] Fulda had a right to speak on the liturgy because it was a large and highly 'clericalized' monastery. This was true of others also. Lorsch, whence we have a list of monks from the abbacy of Gerbodo (951-72) had 48 monks beside the abbot, 12 of them priests, 12 deacons and 9 subdeacons, that is nearly three-quarters of them in higher orders (see Part I, p. 37). There seem unfortunately to be no reliable figures for Reichenau in the tenth century, but at some time in the 820s (when Fulda had double the number of monks which it had a century later) Reichenau appears to have had 112 monks, 52 of them priests and 15 deacons (subdeacons are not mentioned or not mentioned separately).[100] In 940, at probably its lowest ebb numerically in the whole tenth century, Fulda had 84 monks. In 935, before the fire of 937, it had 116. The list of 940 does not give grades in holy orders, but we can trace 68 of the 84 in the *Totenannalen*. Of these 68, 1 died a bishop, 49 died as priests, 15 died as deacons, 1 as a subdeacon, and only 2 without grades as simple monks.[101] There is no reason to suppose, so far as I am aware, that the 16 whom we cannot trace would have shown a different pattern. Obviously many of those who died as priests would once have been deacons, and those who died as deacons would once have been subdeacons, so that at any one time there would probably have been a far higher ratio of deacons and subdeacons to priests than can be gathered from the *Totenannalen*. From the *De Institutione Clericorum* of Hrabanus, it seems that twenty-one would be a normal minimum age for ordination to the subdiaconate, twenty-five to the diaconate, and thirty to the priesthood.[102] One should remember that the Lorsch list will represent an age range from fifteen upwards, and that many of the non-priests at any one moment, including those not yet subdeacons, would later move up into higher orders. It really looks as if every single Fulda monk, barring early death or some abnormal circumstance, could be expected to ascend through these grades. There could scarcely have been a more clericalized monastery than this in the *Reich*, nor probably a larger.[103]

It seems very likely, though it cannot be proved, that a subdeacon had the principal responsibility for organizing the painting of the Göttingen Sacramentary. The *Totenannalen* record the following deaths of artists:

> 977 Ruotbraht, subdeacon, monk and *pictor*.
> 983 Ratgis, *artifex*, *pictor*, and layman.
> 995 Erluin, *artifex* and layman.[104]

They make an interesting group: one monk and two laymen. Ratgis vindicates Schnitzler's close association of the book painter's and the goldsmith's work at Fulda.[105] Laymen artists, moreover, show why one of the monastery's *beneficia* should be available for an *artifex* (see above p. 144). Since Ratgis is referred to in one of the manuscripts only as *artifex*, and in another only as *pictor* and *laicus*, it is a reasonable possibility that Erluin, referred to only as *artifex* and *laicus*, was also a *pictor*, which could

have meant both a book and a mural painter. Could we have here, there-fore, the names of the three artists of the Göttingen sacramentary? It is true Zimmermann did not commit himself to the opinion that his three stylistic groups meant three artists, but he implicitly preferred this expla-nation to the idea that a single artist was developing his style as he proceeded with the illustrations. He did not mention the three names from the *Totenannalen*.

Three artists also seem to have worked on the early Fulda Gospel Book, the Codex Wittekindeus; this was Boeckler's conclusion from a stylistic analysis. His Hand I, responsible for the canon tables, corresponded to Zimmermann's Hand II in *Göttingen*. His Hand III was Zimmermann's Hand I, with its 'importunate' colours and lack of rhythm! But his Hand II was not Zimmermann's rather effete Hand III. On the contrary, Hand II was the finest hand in *Wittekindeus*, the hand only of the Matthew evangelist and ornamental page, where the body has most structure, the form of the initials is least broken up by interlace, and the frame has the greatest regularity, with its thick strands of intertwined gold. This Hand cannot be found in *Göttingen*.[106] All that does not necessarily mean, how-ever, that we are seeking at least four manuscript artists in the earliest years of the Ottonian revival at Fulda, since the Matthew master in *Witte-kindeus* could have been some distinguished outsider, connected perhaps with the court circle of Otto I (see Part I, p. 34). If so, he might simply have given an important initial impetus to Fulda manuscript painting and then died or moved on we know not whither. And of course Fulda manu-script art can have been far from finished by 995, and thus there must have been later artists not revealed by the *Totenannalen*; perhaps earlier ones not revealed by them, too. Let us tabulate our knowledge of early Fulda artists outside the *Totenannalen*:

Codex Wittekindeus		**Fulda Sacramentary**
Berlin, Staatsbibl.,		Göttingen, Universitätsbibl.,
MS theol. lat. fol. 1		MS theol. 231
	both *c.* 965-75	
HAND II (possibly an outsider)		
HAND I	=	HAND II (Fulda)
HAND III	=	HAND I (Fulda)
		HAND III (Fulda)

By the time of the sacramentaries from Udine (late tenth century) and Bamberg (993-1024), I have suggested that there was probably quite a proliferation of manuscript artists, though these may have been primarily metalworkers or muralists.

The leading hand of the Göttingen manuscript is clearly that of Zim-mermann's Group II; to this person fell the largest part of the miniatures, starting from the beginning of the book and covering the most important

part of the liturgical year. It is equally clear that if the three names which we have listed above were those of the *Göttingen* artists (always remembering that there may have been other artists not revealed as such by the *Totenannalen*), Ruodbraht the subdeacon must have been the leader of the group, because he was the only monk, and this was a book for the monastic liturgy. It is true that he is likely in that case to have been very young, perhaps only in his early or mid twenties. But Mechthild Sandmann has independently found evidence that young monks, at the beginning of their careers in the ninth-century monastery, would achieve early responsibility and act as principal clerks in the Fulda scriptorium,[107] so that a subdeacon in charge of sacramentary production would not be such an anomaly. Moreover, the letter of Theotrochus says much about the role of subdeacons, who should be the same in number as deacons, during the celebration of mass. A subdeacon carries the gospel book in the procession from the sacristy and lays it on the altar. When the deacon takes the book for the reading of the gospel, a subdeacon takes up the cushion on which it lies and accompanies the deacon with it to the ambo for the reading. During the gospel, the candle-bearers stand facing the deacon, with the principal subdeacon standing between them. Afterwards when the principal priest (i.e. the celebrant) has venerated the Gospel Book, another subdeacon (*alter subdiaconus*) carries the Gospel Book to be kissed by all the priests, and then leaving the choir, gives it to the doorkeepers to be replaced in the sacristy.[108] A subdeacon was, therefore, a man of liturgical responsibility, and so on this count also suitable to be in charge of sacramentary production.

Over and above all this, if we wish to understand the religious and cultural momentum which issued in the creation of lavish sacramentaries at Fulda, and their export from the monastery, we must take account of traditions going back at least to Hrabanus Maurus. We began our discussion of Fulda by saying that the function of its sacramentary art was to focus the mind of the celebrant at mass. Hrabanus, in a fine passage of his *De Institutione Clericorum* on the mass, wrote: 'The mass is a mediation (*legatio*) between God and men, in which the priest exercises the office of mediation, when he transmits the offerings of the people through his prayers and supplications to God'.[109] This places a heavy responsibility on a priest when he recites the mass prayers. Whereas the function of Reichenau art might be described as to make the soul quiver with the excitement and ritual of a cosmic drama, that of Fulda had more the classic function of antique and Carolingian times — to illustrate a text in such a way as to enhance the quality of mind with which that text was apprehended.

96. Opening of St Luke's Gospel. Gospel Book, Corvey, *c.* 900. London, BL, Egerton MS 768, f. 2

CHAPTER FIVE
Corvey

1 Ornamental Motifs and Drawings

Corvey on the river Weser was another monastery of strong missionary traditions, though this is not noticeably apparent in its art, and another monastery sternly resistant to the Gorze Reform, or to any kind of monastic reform imposed by bishops.[1] The confirmation of its exemption from all episcopal dues at the Synod of Mainz in 888 has been called the Magna Carta of Corvey.[2] It was not as large a monastery as Fulda, and probably not as rich, but it occupied a nodal point within the structure of the Saxon aristocracy, and it is famed above all in the tenth century for its historian Widukind and his trenchant history of the Saxons (probably 967-68). With this history, the *Res Gestae Saxonicae*, and its feeling for classical historical writing as well as for nearer models like Einhard's *Life of Charlemagne*,[3] Widukind has projected onto all his readers a forceful image of his monastery. So has the architecture of its church, whose formidable westwork (873-85) has survived to this day, and now gives us our best idea of what the west front of the famous Carolingian church of St Ricquier, a work of Charlemagne's time, looked like.[4] Its surviving Ottonian manuscript art nowhere succeeds in scaling the human heights of Reichenau, nor does it achieve the nervous sensitivity of Fulda at its best; but in its masterful handling of a limited repertoire of forms, it does not belie the impression created by Widukind and the westwork.

Corvey, founded in 822 from Corbie in northern France, is the one monastery of the empire, apart from St Gall, where we can see any continuous tradition of manuscript art from Carolingian to Ottonian times. A gospel book of *c.* 900, assigned to Corvey on palaeographical grounds and now incomplete (London, BL, MS Egerton 768), shows in its initial letters, such as the Q at the beginning of St Luke (*96*), the typical interlaced panels, insular finials, and zoomorphic motifs of the Franco-Saxon school, associated above all with St Amand at the turn of the ninth and tenth centuries.[5] We can follow on with at least two more surviving gospel books of the first half of the tenth century with similarly ornamented initials — no figural art — one of them in the Minster Treasury at the former Ottonian nunnery of Essen (*98*).[6]

In the mid-tenth century we arrive at the important gospel book (now in Wolfenbüttel, 84.3 Aug. 2°) from Klus near Gandersheim (*99*), another Ottonian nunnery; important because its script has been convincingly related by Bischoff to other certainly Corvey hands. This carries two more mid tenth-century gospel books with abstract ornament into the Corvey

97. West front of the Abbey of Corvey, 873-85

159

98. Opening of St Luke's Gospel.
'Small' Gospel Book, Corvey,
early C10. Essen,
Minster Treasury, f. 119

camp on palaeographical grounds (Pierpont Morgan, MS 755, Rheims MS 10 / Baltimore W 751). The *capitulare* of *Klus* confirms its Corvey origins, with St Vitus and St Justin, and also 'the dedication of the basilica of St Stephen'.[7] The church of Corvey was dedicated to St Stephen in 844, after relics of the protomartyr had been acquired from the Carolingian court chapel. St Vitus, whose relics had been translated from St Denis to Corvey in 836, did not thereby lose his central role in the Corvey cults. The Klus Gospel Book is also important because its initials, with their panels and interlace finials, and the page-borders of interlace panels with corner projections — still no figural art — are a recognizable continuation from the earlier books which we have just mentioned. In *Klus*, however, a new element begins to be prominent, a motif in the upper corners adopted

99

160

99. Opening of St John's Gospel. Klus Gospels, Corvey, *c.* 900. Wolfenbüttel, Herzog August Bibl., MS Guelf, 84.3 Aug.2°, f. 86v

from textiles, exemplified in the palmettes on the purple background of the initial page of St John. The Court School of Charles the Bald knew these patterned, textile-like, purple backgrounds.[8] It is thus not surprising that when we move on into the second half of the tenth century and the beginnings of Corvey figural art with a Christ in Majesty of a Pericopes Book now in the New York Public Library (Astor MS 1), this *Maiestas* has *104* its model in the Court School of Charles the Bald.[9]

This sense of continuity with the Carolingian/Frankish past, and the deriving of inspiration from it, is the dominant theme of the whole culture of Corvey as we know it in the tenth century. Widukind has sometimes been taken as a writer whose horizons were very much bounded by his patriotically Saxon point of view, a champion of Saxon particularism. That

161

is a grave oversimplification; he had a strong feeling for continuity with the Frankish past. He saw the power of the Ottonians as an *Imperium Francorum*; the whole idea of kingly power exercised over stem duchies, as seen in the ceremonies surrounding Otto I's coronation at Aachen in 936, was a Frankish import. Widukind believed that there had been a coalescence of Frankish and Saxon peoples, and so in many cases there had been. The Ekbertiner family, strong in the region of Corvey and its sister nunnery of Herford, had married into the Carolingian dynasty.[10] The Liudolfinger themselves, the ducal/royal dynasty of the Saxons, almost certainly had marital links with the Carolingian dynasty. Some years ago Hlawitschka made a new attempt to define these links, and to reconstruct so far as possible the whole genealogy of Henry I, the first Saxon king. He argued that Henry I's maternal grandfather, a Babenberger called Henry, had married a Carolingian wife of name unknown but descended from Ida, a daughter of Charlemagne's brother Karlomann. The argument is highly inferential, but one of its interesting features for our purpose is that it took Hlawitschka through a web of Corvey texts — Widukind, the Bardo *traditio* (i.e. a land grant), the *Translatio Sanctae Pusinnae* (862-75, another Corvey cult resulting from the translation of the relics to Herford), and the *Vita Hathumodae*, written by the Corvey monk Agius about 875.[11] Moreover, an early abbot of Corvey, Abbot Warin (826-56), who had himself been a pupil of the notable scholar Pascasius Radbertus, Abbot of Corbie, was a son of the same Ida.[12]

At tenth-century Corvey, continuity with the Carolingian past was not just an historical feeling; it was also a matter of present experience. One has to remember that, whatever the hazards of disease, monasteries were not subject to the ordinary factors reducing male life expectancy in a warrior society. From a tenth-century list of Corvey monks, it can be deduced that in 916, when the learned Greek and Latin scholar Abbot Bovo II (900-16), himself of Carolingian descent,[13] had just died and was succeeded by Abbot Folcmar (916-42), there were 62 monks in the monastery. Of these, no fewer than 11 went back 37 years or more. Put another way, they could remember the building of the westwork. One of them, Gerhard, actually went back as a monk to the abbacy of Abbot Warin (826-56).[14] That means that he might have met St Anskar, apostle of the Swedes, and must surely have known Rimbert, the saint's biographer, before the latter became Archbishop of Bremen (865-88).[15] He could also have overlapped with Gerold, former chaplain of Louis the Pious, who entered Corvey in 847 and brought with him a great collection of books.[16] Further witness to the continuing connections of Corvey with the West comes from the fact that of the 33 persons who entered the monastery under Abbot Bovo II, one, also called Bovo, became Bishop of Châlons-sur-Marne (916-47).[17]

The history of the Corvey community seems to be strongly impressed on its manuscript art in the second half of the tenth century, when (on the surviving evidence) it remains predominantly devoted to gospel books.

Two developments here are particularly striking: the flood tide of decorative motifs from oriental textiles, and the appearance of some splendid wash drawings.

 Already in the Pierpont Morgan Gospel Book (M. 755), of Quedlingburg provenance and generally dated to the mid tenth century, the palmettes on the purple grounds of the initial pages have become luxuriant and quite dominating,[18] but the most spectacular display of textile ornament is in a gospel book now in Wolfenbüttel. This manuscript (Helmstedt 426) came from the University Library of Helmstedt, and there is no evidence of its previous provenance, but it is known that Helmstedt had manuscripts from Saxon monasteries and nunneries,[19] so that as with *Essen*, *Klus* and *Pierpont Morgan* we could well be talking of another book made for a Saxon church. It begins with a series of canon tables. Some are of the late antique kind, with marbled pillars, acanthus in the arch, tree of life in the lunette, peacocks in the architrave. These pages certainly owe much to a ninth-century Prague Gospel Book which appears to have been at Corvey during the tenth century.[20] One page has purple palm fronds on a black ground in the lunette, and another has a black and purple check ground, of a sort much favoured under Bishop Bernward at Hildesheim,[21] with tendril work

100 & 101. Canon Tables. Gospel Book, Corvey, late C10. Wolfenbüttel, Herzog August Bibl., MS Helmstedt 426, ff. 3v, 5v

Col.Pls XVIII,XIX

100,101

163

102. *Initium* of St Matthew's Gospel.
Gospel Book, Corvey, late C10.
Wolfenbüttel, Herzog August Bibl.,
MS Helmstedt 426, f. 17v

of gold and minium red on blue superimposed upon it. But after the canon tables the best is still to come. Each of the four gospels begins with a series of three highly ornamented sides: *initium*, initial letter of the gospel, and first (or early) words of the gospel in gold on a colourful background. The

102 *initium* of St Matthew, i.e., *INITIUM SANCTI EVANGELII SECUNDUM MATHEUM* is written in gold on a black background as if embroidered with purple roundels containing stylized lions, like the Marriage Roll of

Part I,18 Theophanu (though the penmanship here is much less controlled and expressive than on the Theophanu roll). It is an obvious imitation of an oriental silk. Its border is in bands of grey, blue (in a nice pattern) and gold. In the *initium* of Luke, the golden letters in splendid bold capitals

164

103. Persian Rug, C19.

are written on striped backgrounds of black, blue and grey, and these *Col.Pl. XVIII* stripes are themselves set on a finely meshed background of purple stars on black, the whole page in a pleasing, simply ornamented border. It is possible to produce a nineteenth-century Persian Mir which makes a not *103* dissimilar impression with its close-packed pattern of purple *bota* (palm-leaves) on a dark ground.[22] The essential elements in the designs of these carpets go back to time immemorial. After the extraordinary monogram-mic page of the Luke initial letter, *QUONIAM QUIDEM*,[23] itself as much a carpet as any of them, we reach the striking page on which, in golden capitals, are written the next words of Luke's gospel, *MULTI CONATI* *Col.Pl. XIX* *SUNT*. The border of this page is composed of bands of grey, blue, black, minium red and gold. Its background is a series of zigzags in stripes of purple, black, scarlet and deep blue. Such zigzags are a common feature, in one form or another, of oriental carpets. In short, this is a lovely book, with no figural art, but full of Insular calligraphy (as in the Matthew initial letter), oriental textiles, and antique decorative motifs.

We have mentioned that textile-like patterned grounds were known in the manuscript art of the School of Charles the Bald. But this is certainly not a sufficient explanation for the burgeoning of the textile motifs of Corvey art in the second half of the tenth century, almost as if Corvey were in the grip of oriental-textile fever. It is clear that the Corvey scrip-torium knew such textiles at first hand, for there survives at Trier (Dom-bibl., MS 401) a late tenth-century sacramentary whose liturgical evidences mark it out as unquestionably from Corvey, and the back of its pigskin

165

binding was covered with a Byzantine silk, Persian-influenced, with eagles.[24] No student of Corvey art could overlook the textile element, but one relevant historical source, none other than Widukind of Corvey, seems to have eluded the discussion of it hitherto. Yet Widukind gives us the hint of what, if it did not actually set off, at least stimulated and added momentum to the whole fever. Like all writers of heroic epics, Widukind was interested in gift-giving, not least as it indicated the world-wide lustre which Otto I achieved after his victories against the Slavs and, on the Lechfeld, against the Hungarians in 955 (the date fits rather well for our purposes). These are his words on the subject:

> With numerous victories the emperor
> became glorious and famous, and earned
> the fear and favour of many kings and
> peoples. Thus he received many legates,
> of the Romans, the Greeks and the Saracens,
> and through them gifts of various kinds;
> gold, silver and bronze vessels, worked
> with a wonderful variety of ornamentation;
> glass vessels and ivory also; *rugs of all*
> *sorts and sizes (omni genere modificata stramenta)*;
> balsam and pigments of every kind;
> animals never before seen by the
> Saxons, lions and camels, monkeys and
> ostriches.[25]

Florentine Mütherich has pointed out that Corvey manuscripts with provenances such as Quedlingburg, Gandersheim and Essen, all of them nunneries closely connected to the Saxon ruling dynasty, suggest that Corvey was working to produce sumptuous manuscripts for the Ottonian court.[26] If that is so the artists would have been ideally placed to benefit from the visual stimuli which the enriched culture of Otto I's court had to offer. They appear to have been particularly interested in his oriental rugs and silks, and perhaps, to judge by the colours of the Wolfenbüttel Gospels (Helmstedt MS 426), in his new pigments also. They could also make a political return for these benefits — to reflect in their scriptorium, and to project, the glory which the king had achieved in his gifts.

There is a striking similarity between Corvey manuscript art of the tenth century and that of Hildesheim under Bishop Bernward in the first two decades of the eleventh century, so much so that there have been scholars to say that some Corvey manuscripts, especially the Wolfenbüttel Gospels, should be assigned to Hildesheim, or at least that Corvey and Hildesheim were so closely related in their scriptoria that it scarcely makes sense to distinguish the two.[27] This view has led to some good insights into the art itself at these two centres, but it does not entirely carry conviction, and attempts to localize some Corvey manuscripts at Hildesheim have proved at best inconclusive. It is true that most of the decorative motifs on which

104. Christ in Majesty.
Pericopes Book, second half C10.
New York Public Lib.,
MS Astor 1, f. 7

we have commented are found also at Hildesheim: roundels in the back-ground, finely meshed patterns, monogrammic and carpet pages, and chequered motifs. It is also demonstrable, from figural and decorative art, that Hildesheim under Bernward had the ninth-century Prague Gospels available as a model.[28] But the findings of palaeography are not favourable *Part I,67* to a Corvey transfer or a Corvey/Hildesheim merger. There is an established core of manuscripts from the former, and although the Wolfenbüttel Gospels are not of this core, the script and its ductus are very much of the general character of Corvey, if one examines the evidence produced by Hartmut Hoffmann who places the book unhesitatingly within Corvey.[29] The use of the Prague Gospels is not a factor favouring Hildesheim, because some indubitably Corvey manuscripts of the tenth century can also be shown to have used this manuscript as a model.[30] The relations between Corvey and Hildesheim were close indeed. As the crow flies they are only about 30 miles apart; Corvey held estates in the diocese of Hildesheim; Bishops Altfried (847-74) and Wigbert (880-903) had both previously taught at Corvey.[31] In these circumstances there is nothing against the Prague Gospels being at Corvey, and the Wolfenbüttel Gospels (or something else like it) being made there, in the tenth century, and then being

at Hildesheim in the eleventh under Bishop Bernward. Bernward was an indefatigable seeker-out of artistic exemplars wherever he could find them, and an inveterate copier of them, as we know from his biographer (see Part I, p. 44).

Part I,Col.Pl. XIII
Part I,Col.Pl. XII

Part I,68
104
105
107-109

105

We come now to the Corvey drawings. Corvey figural art in the later tenth century comprises principally the fine Crucifixion in the sacramentary at Munich (Clm. 10077) which was discussed in comparison with the Freising Crucifixion (see Part I, pp. 93-94); the Crucifixion and Gregory in Meditation of a sacramentary now at Leipzig (MS CXC);[32] a single surviving sheet from a gospel book illustrating the calling of Matthew, derived from the Prague Gospel Book just mentioned, the sheet now at Helsinki; a *Maiestas* and Evangelists of a gospel book in the New York Public Library (Astor MS 1); some superb full-page pen drawings in the Abdinghof Gospel Book at Kassel; and another fine series of drawings comprising six infancy scenes of the Life of Christ, placed before and after the canon tables of a gospel book now at Wolfenbüttel (MS 16.1 2°).[33]

On the Abdinghof drawings, particularly the Christ in Majesty, which certainly owes its origin to a Carolingian model, from Tours or even from the Ada Group under Charlemagne — but transformed into the style of tenth-century Saxony — we cannot better the words of Boeckler:

> The incomparable magnificence of the figure lies not only in its mighty proportions, the penetrating force of its gaze, and its severe frontality; but vitally also in the great, almost geometrically described, surfaces of white on the shoulders, knees and body, which, painterly in their handling and full of movement, stand out from the draperies as cardinal points in the structure of the figure. This style, represented also in some other manuscripts, is the earliest and most significant (artistic) achievement which the stemland of the Saxon ruling house brought forth.[34]

107,109

106

The heroic conception of Christ in this drawing is congruent with the milieu which produced the earliest manuscript of the *Heliand* a century before, a poem which apparently had a full measure of influence on Ottonian art in Saxony (see Part I, pp. 87, 102). The same monumentality, transforming Carolingian models by the same means, and also by the other typically Ottonian means of declamatory glance and gesture, characterizes the drawings of the Wolfenbüttel Gospels. This can all be seen to good effect for instance, in the Annunciation and the Presentation in the Temple, where the architecture is heavy and four-square compared with that of Carolingian drawings. These Corvey drawings unquestionably owe much to the tradition of drawings in the ninth-century West, exemplified by two drawings in the Rheims style, depicting Christ's Healing of the Leper and Healing of the Man with the Withered Hand, from a five-page fragment of a pericopes book now at Düsseldorf (MS B. 113).[35] But the Carolingian drawings are lighter and more sketchy, as if they were catching a rapid moment in the Life of Christ, while the Saxon drawings were attempting solemnly to eternalize its drama. This firming up and monumentalizing

105. Christ in Majesty.
Abdinghof Gospels, Saxon/Corvey,
c. 1000. Kassel, Hessische Landesbibl.,
MS theol. 2° 60, f. 60

is almost as if Corvey were trying to outdo its Frankish predecessors. We
are back to the translation of power from the Franks to the Saxons in the
notions of Widukind of Corvey. Widukind's attitude is most clearly seen
in his observations about the relics of St Vitus, and their translation from
northern France (in fact St Denis) to Corvey in 836. From this time, he
says, the affairs of the Franks began to go downhill, those of the Saxons
to take a turn upwards.[36] Many relics were translated from West to East,
most notably St Maurice (patron of Magdeburg) in 960-61, to build up

169

106. Healing of the Leper; Fragment of Pericopes Book, Rhineland, C9. Düsseldorf, Landes- und Stadtbibl., MS B. 113, f. 5

107. Annunciation. Gospel Book, Corvey, late C10. Wolfenbüttel, Herzog August Bibl., MS Guelf 16.1. Aug. 2°, f. 8

Saxon supernatural power in a way which contemporaries thought as integrally associated with the realities of political power as heaven and earth were with each other.[37] If Corvey believed itself, and the whole East Frankish kingdom, to be blessed in the power of its relics, it seems to have expressed that power or *virtus* in its drawings, exceeding the *virtus* of West Frankish drawings.

106 The drawings in the pericopes fragment at Düsseldorf allow us an interesting insight into how Carolingian drawings could be circulating in Saxony. The fragment has been used as the end-papers in which a copy of Hrabanus Maurus's *De Institutione Clericorum* was bound. According to Bischoff, both pericopes fragment and Hrabanus text are second half of the ninth century and come from the same scriptorium, not improbably a Rhineland scriptorium.[38] They can actually be proved to have been bound together not later than the tenth century and perhaps as soon as they were both written.[39] Eberhard Galley made the brilliant suggestion that the reason why the pericopes pages were abandoned for their original purpose and were used instead as end-papers to bind the Hrabanus, was that the

170

108. Annunciation to the Shepherds. Gospel Book, Corvey, late C10. Wolfenbüttel, Herzog August Bibl., MS Guelf 16.1. Aug. 2°, f. 9

109. The Presentation in the Temple. Gospel Book, Corvey, late C10. Wolfenbüttel, Herzog August Bibl., MS Guelf 16.1. Aug. 2°, f. 16

two drawings had each inadvertently been placed on the wrong side of the leaf as it was folded in relation to the texts of the gospels which they were supposed to illustrate.[40] What seems to have gone unnoticed in all this, even by those who would rightly argue that Fulda was the likeliest mediator of North French drawings to the Saxon scriptoria,[41] is that here we are glimpsing a perfect example of the kind of channel through which this mediation could have occurred. For if a North French or Rhineland scriptorium was copying the works of the Fuldan Hrabanus, presumably Fulda could as easily be receiving the drawings which that scriptorium was also producing.

Boeckler, in 1938, liked to think of the Corvey drawings as *characteristically* Saxon, with their rich spiritual feeling, grandiose postures, intensity of expression, and fine draughtsmanship; and thus he supposed that besides the Carolingian sources, there was a Saxon model for the Ottonian Fulda miniatures. If, for example, we were to compare the very similar exaggerated curvatures of the body in the *Ecclesia* of the Fulda Aschaffenburg Pericopes and the angel of the Annunciation to the Shep- *Col.Pl. IX*

171

108 herds in the Corvey Gospel Book at Wolfenbüttel, it would appear that the model had passed from the Saxon to the Hessian milieu rather than *vice versa*.[42] But the relationship was surely the other way around, since Fulda was the more original centre iconographically and the closer to Carolingian sources. We have already noted that relations between Fulda and Corvey were naturally close, geographically speaking, since both were on the river system of the Weser.

2 The Life and Martyrdom of St Wenceslas: Regensburg, Mainz and Corvey Influences in Prague

When the Saxon rulers extended their power to Slav regions such as Bohemia, saints' relics were again transferred as they had been between West and East Frankish regions. Thus relics of St Vitus were translated in 932, doubtless at the initiation of Henry I, to the church which Duke Wenceslas of Bohemia had recently built in Prague. Vitus remained its dedication when this church became a cathedral on the establishment of the bishopric of Prague in 973. The Saxons were also interested in Wenceslas himself, who was murdered by his brother Boleslav in 929; they played an important part in the development of his cult as a martyr. For Otto II commissioned Gumpold, Bishop of Mantua, who though not a well-informed historian had lived in Prague for a while, to write his *Vita, Passio* and *Miracula* some time between 967 and 973.[43] The earliest sur-

110,111 viving manuscript of this work is at Wolfenbüttel. This manuscript was commissioned by Hemma, wife of Boleslav II of Bohemia, perhaps at (or not long after) the time when her son Boleslav III (999-1002) was attempting to murder one of *his* brothers.[44] Hemma died in 1006 which gives us the *terminus ad quem* for the manuscript. Before the text come three lively illustrations in colour. The scenes in vivid narrative style are set against tiled backgrounds of Regensburg/Seeon type which impart their own extra rhythm and movement to the pictures.[45] First, a bearded Christ in

110 bust crowns Wenceslas (there is Byzantine influence here, again mediated surely from Regensburg as seen in the Sacramentary where Christ crowns Henry II, see p. 217 below and also Part I, pp. 66-67), while Hemma prostrates herself at the feet of the saint. Next, Wenceslas feasts with his brother during the latter's abortive assassination attempt. Finally Wen-

111 ceslas is ambushed on his way to church, in the doorway of which stands a cleric against an orange background, dressed in clothes of dark blue and green.

The Saxons were interested in Wenceslas because they saw him as a Saxon-loving prince who, during his life, sustained their influence in Bohemia against his anti-Saxon and pro-Bavarian brother (just as St Vitus did in his dead state, or rather in his heavenly existence).[46] Perhaps too much should not be made of colonial rivalry between Saxons and Bavarians in Bohemia at the time of Wenceslas's death, in what was principally a family feud. But at that time the Bavarians certainly thought that they had a

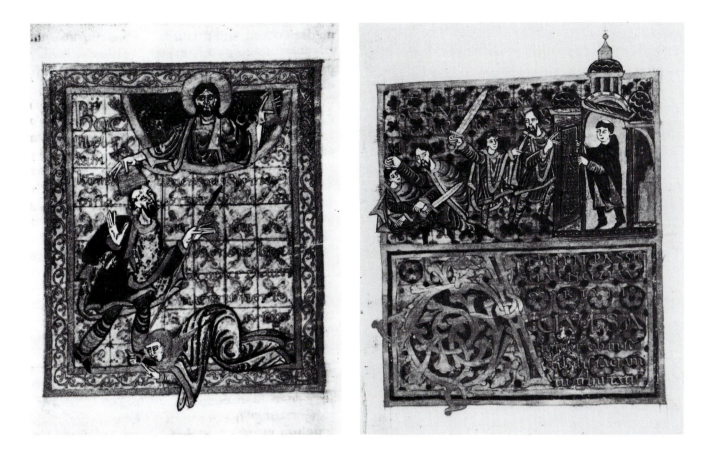

chance of establishing domination in the region. Few people around 930 believed that Saxon rule in the East Frankish kingdom would last, least of all the Bavarians, as a panegyric of Duke Arnulph of Bavaria from the time of Henry I shows,[47] and one cannot discount the element of Saxon/ Bavarian tension in the Bohemia of the 920s and 930s. It is suggested, for instance, by one of the early Wenceslas legends, which has it that Wenceslas originally intended to dedicate his Prague church to St Emmeram, the prime saint of Bavaria and of its ecclesiastical centre at Regensburg.[48] This cannot be nonsense, for the relics of St Vitus were translated to Prague (a translation which was very much a point scored by the Saxons) in 932 on 22 September, the feast of St Emmeram![49] Wenceslas clearly tried to perform rather more of a balancing act than would appear from later Saxon propaganda. Gumpold of Mantua himself did not express directly anti-Bavarian sentiments, but he went out of his way to stress Wenceslas's devotion to St Vitus, even maintaining that God foiled Boleslav in his murderous intentions for long enough to allow Wenceslas to build a church in honour of the saint.[50] With Gumpold, the intertwining of the cults of St Wenceslas and St Vitus is well under way as a form of validating and sanctifying Saxon authority in Bohemia.

110 & 111. Christ crowns St Wenceslas; Hemma, Wife of Boleslav II of Bohemia, before the Feet of St Wenceslas. Martyrdom of St Wenceslas. Gumpold's *Life of St Wenceslas*, early C11. Wolfenbüttel, Herzog August Bibl., MS Guelf 11.2 Aug. 4°, ff. 18v, 21

Why is the Wolfenbüttel manuscript discussed here when it is itself certainly not a product of the Corvey scriptorium? Only because it may have Corvey influence in it. It has in fact been proposed to localize it in Prague,[51] which at one time seemed to me unlikely, but now with the benefit of Hoffmann's work it makes more sense. Hoffmann himself does not deal with this manuscript since it is not directly relevant to his purposes, but if one studies his palaeographical analyses and his illustrations, the script of the Wolfenbüttel book looks most akin to Mainz. It has the same uprightness, the same sort of broadly arched **ct** ligature, similar letter forms (the **g** lacks the voluminous under-loop of the **g** in many Mainz manuscripts, but even here there is a close parallel with Vienna, Nationalbibl., Cod. 701, of the early eleventh century).[52] A script of Mainz character would fit well with Prague at the turn of the tenth and eleventh centuries, since Archbishop Willigis of Mainz endeavoured to make his metropolitan authority a reality there at that period.[53] Obviously Regensburg influence there makes sense too, given the old connections between Regensburg and Prague, where the Saxon/Bavarian tension had by now fallen away. But Corvey influence would also fit, since the first bishop of Prague, Thietmar (973-82), was probably a Corvey monk,[54] and the third bishop, Thieddag (998-1017) was certainly so. Thieddag had been educated at Corvey; he had been a chaplain of Otto III; and he also had a reputation for great learning in medicine.[55] There are hints of Hildesheim in the phlegmatic physiognomy and the stance of the cleric in the doorway, and of Fulda in other faces as well as in the lively narrative style and the architecture. A combination of these elements could bespeak Corvey, which had also shown itself adept at absorbing the ornamental motifs of others.[56] We suggest, therefore, that this is a Prague manuscript, with a subject matter of especial interest to Corvey, and made possible by the importation of Mainz script, and Regensburg and possibly Corvey or other Saxon art.

Politics played a part here. Beyond Hemma's devotion to him, St Wenceslas was a potent symbol of Saxon determination to sustain authority in Bohemia, threatened now, at the time of our manuscript, both by the ruling Bohemian Premyslids and by the ambitions of the Polish Piasts.[57] There had been politics in Otto I's association with the mid tenth-century art of Corvey, where the true origins of Ottonian art are to be discerned, as much as in the Gero Codex and the Codex Wittekindeus.

CHAPTER SIX
Some Eleventh-Century Trends

1 Bibles

How did Ottonian Art come to an end? We are in danger with this question of treating as a real-life entity what is after all only a historical construct. Ottonian style and iconographic motifs did not suddenly die, but lived on to influence Norman and English scriptoria, goldsmiths and enamel-workers all over Europe, and the great sculpture of Burgundian Romanesque.[1] Ottonian metalwork spread through the activities of the famous workshops of Liège and the Mosan region,[2] whose technical expertise is so vividly reflected by Folcuin in describing the *pulpitum* which Bishop Notker of Liège commissioned for his monastery of Lobbes. This was adorned with a magnificent gilded bronze eagle, whose wings could be closed or extended to receive a gospel book, and whose flexible neck enabled it by an ingenious mechanism at once to breathe out odorous clouds of incense in all directions and to cock its ear to the chants of the deacon.[3] Yet just as we can observe new beginnings in the Codex Wittekindeus and the Gero Codex, in the mobilization of the Christ cycles, and in the efflorescence of ornamental pages out of slender artistic continuities at Corvey, so we can detect an autumnal deciduousness in the great Ottonian schools (some critics have had less complimentary phrases for it)[4] before they finally go into the ground or (as at Regensburg) change their character and iconographical interests beyond recognition. No longer do we see the resplendent effigies of rulers, supported by sacral panoply and crowned by Christ or by the hand of God. The reform party of the Gregorian papacy started to show rulers crowned by the Church, that is by bishops, and after that, rulers dropped the theme of coronation from the repertoire of their own circles altogether. Around 1100 Regensburg produced a picture of the Emperor Henry IV, without any symbolical *Beiwerk*, standing between his two sons Henry and Conrad.[5] The dynastic consideration had begun to oust the sacral. Above all there was a shift from gospel books or sacramentaries to Bibles as prime objects of book production in the eleventh century. This shift marks the end of Ottonian art.

In the first place, it was a shift away from Christ-centred art, so closely associated with Christ-centred kingship. More than that, however, the Bibles, especially the Italian Giant Bibles of the eleventh century, in fact spread in the circles of the Gregorian Reform movement of the papacy (named after Pope Gregory VII, 1073-85). This reform movement fundamentally challenged the whole imperial system, and as we have shown, the theme of Christ and Christ-centred kingship was the backbone of

175

Ottonian art. It was Fichtenau who first pointed out that these Bibles were distributed particularly from the ateliers of Mathilda of Tuscany, the staunchest of Pope Gregory VII's supporters, and he drew attention to some leaves of such a Bible in huge format (about 70 × 45cm) which had been used for bookbindings in the sixteenth-century Starhemberg archive (now at Linz).[6] The reformers based their whole vision of a Christian society, led by the Church and churchmen, on biblical study, the *scientia divinarum litterarum*.[7] Furthermore, it would seem to have been Gregory himself, when as Hildebrand, Archdeacon of Rome, he was put in charge of the monastery of St Paul outside the Walls (San Paolo fuori le mura) by Pope Leo IX in order to reform it, who secured for it the great Bible from the time of Charles the Bald, known as the San Paolo Bible. which has remained there ever since.[8] One context of the spreading of Bibles was that resulting from the reformers' insistence, especially in the Lateran Council of 1059, that canons as well as monks should practice communal life and worship. Bishop Frederick of Geneva is an example of those who sought to implement this reform, and among the 26 books which he is recorded as having given to his cathedral library there was a Bible.[9] Henry IV himself gave a giant Bible to the monastery of Hirsau, which became the nerve centre of the Gregorian Reform in Germany, around 1075, shortly before the eruption of hostilities between himself and Gregory VII.[10] One could multiply examples.

Why should the Bible prove so fell a cultural weapon against imperial rule, even though nobody had in mind its use for this purpose with malice aforethought? Above all it highlighted the authority of the Church in Christian society, especially its sole authority to interpret the text of scripture. As Ian Robinson has said of the richly illustrated Giant Bibles, 'the very splendour of their decoration was intended to convince the reader of the power and authority of the church: they propagated in visual terms the teaching of the eleventh-century reform movement'.[11]

One may illustrate this theme of teaching authority and the Bible through the Bible of St Vaast, Arras, *c.* 1040, a manuscript which is as much an anticipation of the reform movement in terms of art as were the ideas about papal authority held by Bishop Wazo of Liège at the same period in terms of intellect.[12] This three-volume Giant Bible is strongly influenced in some of its miniatures by Anglo-Saxon art, and in the ornament of its initial letters by the Franco-Saxon school centred on St Amand.[13] Above *112* the initial letter and text which opens the Book of Ecclesiasticus, *Omnis sapientia a domino deo est* (all wisdom is from the Lord God, and hath been always with him, and is before all time), is a miniature which depicts Christ seated in the House of Wisdom. The house, set in a roundel, is held up on seven pillars, an allegorical image to indicate that wisdom is sustained by the seven liberal arts. Two figures, the enemies of wisdom, lie crushed at his feet, an iconographical adaptation of Christ trampling on the Beasts according to Psalm 90. Below the house is an arcade within which are the Veil of the Tabernacle in the Temple and the four evangelists,

XVII. Incipit Page to St. Matthew's Gospel. Ste-Chapelle Gospels, prob. 984.
Paris, BN, MS lat. 8851, f. 16

XVIII. Opening of St. Luke's Gospel. Gospel Book, Corvey, late C10.
Wolfenbüttel, Herzog August Bibl., MS Helmstedt 426, f. 86v

XIX. *Multi conati sunt*, from St.Luke's Gospel. Gospel Book, Corvey, late C10.
Wolfenbüttel, Herzog August Bibl., MS Helmstedt 426, f. 88v

XX. Inital B in Gregory's *Moralia in Job*, Trier, *c.* 950-75.
Trier, Stadtbibl., MS 2209/2328, vol. 2, f. 133

XXI. Initial A to the Apocalypse.
Turonian Bible fragment, *c.* 845. Trier, Stadtbibl.

XXII. Frontispiece to the Bible of Bishop Bernward of Hildesheim, *c.* 1015.
Hildesheim, Cathedral Treasury, MS 61, f. 1

XXIII. St. Paulinus of Trier. Egbert Psalter, 977-93.
Cividale del Friuli, MS CXXXVI, f. 86v

XXIV. Initial N, Opening to Psalm 61. Egbert Psalter, 977-93.
Cividale del Friuli, MS CXXXVI, f. 87

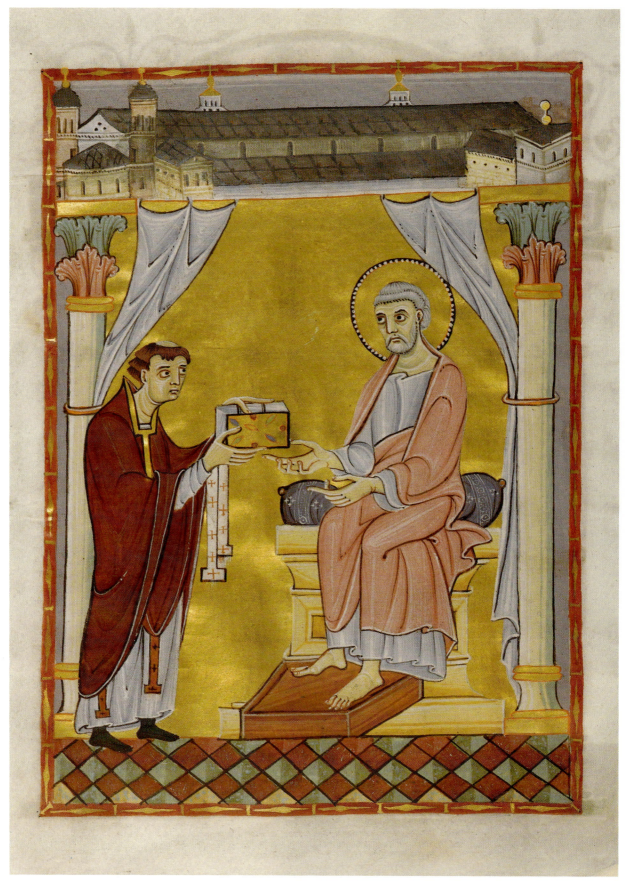

XXV. Hillinus presents his book to St. Peter.
Hillinus Codex, early C11. Cologne, Dombibl., MS 12, f. 16v

112. Opening of the Book
of Ecclesiastes.
Arras Bible, *c.* 1040. Arras
Bibl. Mun., MS 435, f. 1

signifying that the House of Wisdom is built on both the Old Testament
and the New Testament, in fact the whole Bible. Above the house are
represented the four cardinal virtues, so that the complete picture may be
seen as an allegory of the four ways of interpreting scripture; the bottom
arcade the literal, the House of Wisdom the allegorical, the four virtues
the moral, and Christ seated in Majesty the anagogical or mystical. The
crushed figures could represent those heretics condemned at Orleans

177

(1022), Arras itself (1025), and Rheims (1049), who rejected the Old Testament and claimed to do without the Church, particularly at Arras, or, as at Orleans, claimed direct knowledge of Scripture from the Holy Ghost apart from the teaching of the Church.[14]

In the Carolingian period, such representations of Divine Wisdom, as being based on the seven columns of the liberal arts, were common in literature and in art. They reappear in the eleventh century, but for the tenth there is virtually nothing. Marie-Thérèse D'Alverny, who has reviewed the whole subject from the ninth to the twelfth century, jumps from Heiric of Auxerre (c. 841-76) straight into the eleventh century without a word, except briefly on an anonymous late tenth-century poem of only marginal relevance.[15] Very often we find the intellectual interests of the ninth century dropped in the tenth century in favour of something of more liturgical slant, but taken up again in the eleventh century.

Some of the splendid initial letters of the Arras Bible are historiated; others are not, but they have a profusion of tendril ornament and tightly knotted interlace. The ornament, however, is everywhere concentrated on the text, being in some cases full-page miniatures before the opening of biblical books, in others fine initial letters of those books. The format of the manuscript is so large that initial letters can be designed on a grand scale and lavishly decorated, while still being left sitting in an expanse of beautifully laid-out text which they by no means overwhelm. The impression made by the text as a whole is that of being the top priority in the art of such a book. The calligraphic wizardry of the single isolated letter is no longer allowed to bewitch the onlooker with its magic, as in some earlier Ottonian manuscripts. The mind is kept firmly on what is to be read. With this sort of initial art in Bibles of large format, a feature of post-Carolingian, tenth-century French art, which we have remarked upon earlier, came again into its own. The 'First' Bible of St Martial of Limoges (Paris, BN, lat. 5, c. 1000) is a huge book in two volumes with highly wrought initials (see Part I, pp. 54-55), which looks back, as is well known, to the large-format Carolingian Bibles of Tours.[16] One can see the point by *113* comparing the P which opens St Paul's Epistle to the Romans in the Grandval-Moutier Bible, c. 840 (London, BL, Add. 10546), and that which *114* opens the Acts of the Apostles in the Limoges Bible[17] whether one considers the proportion of initial to page, or the ornamental panels and foliage in the outline of the letter, or the little foliated 'tradescantia' and vines hanging from the top corner in each case. Of course the eleventh-century initial here is not at all a copy of the ninth-century one. But the tradition which links them is obvious.

In some eleventh-century scriptoria, the functions of decorated initials were refined and advanced, as grades and sizes of initials were being used in a positive hierarchy to establish the importance of the various items or contents of a manuscript. Jonathan Alexander has shown this well in his fine study of the manuscripts produced at Mont-Saint-Michel, Normandy, in the later tenth and eleventh centuries. Mont-Saint-Michel affords the

178

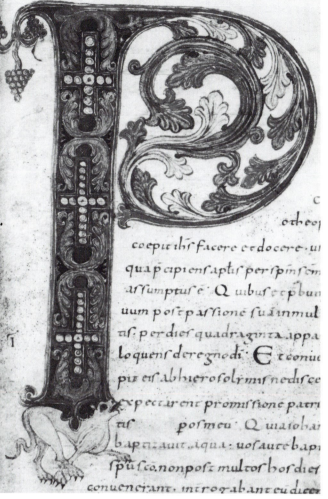

scholar a luxury to a degree that no Ottonian scriptorium can match — a numerous series of manuscripts, several of which can be accurately dated on external grounds, and the rest thus more or less set into reliable chronological order with reference to these. We may take Avranches MS 72 (probably 1040s), a collection of various patristic texts, to exemplify the function of initial letters and illustrations in these manuscripts. Some of the works have full-page frontispieces or first-grade initials. Ambrose's *De Bono Mortis*, however, has a small author portrait and also what Alexander categorizes as a 'second-grade' painted initial Q.[18]

The use of art to facilitate theological study, as exemplified in these manuscripts, is worth pointing out as something of a novelty (as against the previous hundred years) in the eleventh century. But again it has a familiar ring to anyone who goes back to the Carolingian Bibles. Let us consider, for instance, the huge New Testament volume (Paris, BN, MS lat. 250) of what was doubtless once a multi-volume Bible from the time of Abbot Fridugisus, Alcuin's successor as Abbot of St Martin, Tours (807-

INCIPIT LIBER

SCI AMBROSII

EPI ÐBONOMORTIS.

SUPERIORI LI

BRO SERMONE

ALIQUE C TEXUIMUS.

faciliorem uiam putamus de bono
mortis conficere aliquid

Quae si animę noceat malū
uider pot est

Si autem nichil officiat animę
ne malum quide m

Quod autem malum est non

id etiam bonum

Quoniam quod uiciosum

id malum. Quod autem
uitio caret id bonum.

115. Beginning of St Ambrose *De Bono Mortis*. Avranches, Bibl. Mun., MS 72, f. 182v

34). For the beginning of each gospel, of *Acts*, and of St Paul's Epistle to the Romans, it has a large interlace initial. Much plainer initials of red with strips of gold or black are used for the *argumenta* and St Paul's epistles other than that to the Romans. Other initials fall below the grade rated for St Paul to the Romans or the gospels, but above that of the lesser epistles. The initial letter I for the first of the Catholic Epistles, i.e. of St James, has a nice geometrical pattern in red, yellow and brown, with deep blue interstices; while the A for Apocalypse is in red and gold, embellished with scrolls of silver.[19] One notes the use of gold and silver as never before to make distinctions of status amongst initials. We describe here only the most obvious features of a hierarchy of initials, already well developed in this early ninth-century book. At the top of each page, helping the reader to find his place, are running titles in square capitals, such as EVANGL SECD MATT, or EPISTL AD TIMOTH SECD.

What we learn from the Mont-Saint-Michel manuscripts,[20] and from many other sources, is that the eleventh century witnessed a passion for subdivision and schematization, for classification and arrangement, for determining the function of parts within a whole. Theological schematizing is already present in some of the high points of Ottonian art of the early eleventh century such as the Uta Codex of Regensburg or the bronze doors of Bernward of Hildesheim, or (earlier) the evangelist pages of the Gospel Book of Otto III. But these elements are worked up into an intellectual *crescendo* during subsequent decades. The Gregorian reformers themselves believed in the superiority of the *sacerdotium* to the *regnum*, but even within the *sacerdotium* itself they were acutely alive to every shade of hierarchical distinction. Their collections of canon law highlight the fact. The collection known as the *74 Titles* begins with the primacy of the apostolic see, moves on to clerical privileges, especially those acquired from the papacy, and then on again to the rules for the election and consecration of bishops and the ordination and discipline of the other ranks of the clergy. Similarly Anselm of Lucca starts with the Roman primacy, and goes on to privileges, bishops, the ranks of the clergy, secular and regular, and lapsed clerics, in that order. Only then does he deal with the sacraments.[21] Classification and subdivision have been shown by Sir Richard Southern to have played a vital part in the eucharistic controversy of the 1050s (a significant subject in the early stages of a clericalist revolution) between Lanfranc and Berengar of Tours. In seeking to establish the corporeal presence of Christ in the eucharist, Lanfranc used Boethius's *Logica Vetus*, with its description of the world in terms of substance and accidents, genera and species. He attacked the assertion that the bread and wine remained after the consecration at mass *in principalibus essentiis*, and distinguished between *principales* and *secundae essentiae*, using Boethius's Aristotelian distinction of *prima* and *secunda substantia*.[22]

117 An architectural parallel to this intellectual approach suggests itself; it is again at Mont-Saint-Michel, in its abbey church (*c.* 1100). This church speaks the same intellectual language as Lanfranc on the eucharist, or the Gregorian canon law collections, or Mont-Saint-Michel's own forms of manuscript organization, only in stone. Early Romanesque has plain rough walls, however striking the arching of these walls into barrel vaults above piers may sometimes be.[23] At Mont-Saint-Michel the masonry is smooth. Three horizontal registers are distinguished from each other, the triforium itself subdivided by arches and columnettes. Each level has its own function and logical properties. The vertical registers are divided from each other by soaring, engaged columns, but these still leave the visual impact of the horizontal divisions very present. The wall space is entirely articulated with registers and all is life and motion. Compare this with Speyer

116 Cathedral, the mausoleum of the Salian emperors, as it was newly built in 1062. Here is a great succession of arches, reminding one of the rhythms of the baths of Caracalla, or Roman aqueducts, or the antique basilica at Trier. But within these arches there is much flat wall, and the clerestory windows are themselves flat to the wall, and thus the effect of articulation and subdivision is minimal. Despite the arches, perhaps even through them, this wonderful church still preserves the principle of spacial unity (*Raumeinheit*), which Jantzen regarded as the classic feature of Ottonian architecture.[24]

116. Interior of Speyer Cathedral, as in 1062 (Reconstr. K.J. Conant) 117. The Nave of the Abbey Church of Mont St.-Michel, *c.* 1100

Order and hierarchy, it goes without saying, were not new principles in the mid eleventh century, but there are grounds for thinking that in the second half of the century, a new degree of ordered logic was being applied to the business of statecraft itself, and was recognized by contemporaries (not always favourably) as such. Karl Leyser, interpreting the mentality of the Saxon nobility at the time of their risings against Henry IV in the 1070s, has pointed to their failure to understand the Salian emperors' exploitation of state rights and state laws, accustomed as they were to personal, patrimonial relationships in politics. 'What had been the relationship of gift and mutual obligation between the Liudolfingers and their Saxon followers', he writes, 'became attributes of kingship as such, impersonal and enforcible rules, menacing staging-posts almost on the way to statehood or at least institutionalized and legally concrete dealings as against the face-to-face arrangements between princely givers and their military *comitatus*.'[25] Exactly the same change has been observed by Jean Dunbabin in France under Philip I (1059-1108), namely a change from face-to-face relations between the king and his vassals of the royal demesne, to purchase of rights, witness by the household administrators of royal charters after 1077, and general development of bureaucratic efficiency.[26] Alexander Murray, in the pivotal chapter on Reason and Power in his book *Reason and Society in the Middle Ages*, describes a full-blown application of rationality to government and warfare by the twelfth and thirteenth centuries, which clearly takes its rise from the later eleventh-century period under discussion.[27]

Thus in Northern Europe, a new art of rationality and textual study (and with relatively little gold) looks back for inspiration to the Carolingians, and confronts the magical, ritualistic and iconic art of the Empire. One should not think, however, that Ottonian art in the eleventh century was simply left behind by what one may call a French/Gregorian art.[28] *It bore within itself some principles of transformation into Gregorian Reform art.*

Let us consider first the Bible of Bernward of Hildesheim (*c.* 1015). This, it is true, is a highly unusual work, in fact the only known ornamented Bible from the whole Ottonian period.[29] But it cannot be dismissed as a freak, because its one figural miniature represents a peculiarly deliberate statement of the biblical, as distinct from the purely evangelical, ideal, and because it embodies the influence of Carolingian Tours which became an insistent feature of the last phase of Ottonian manuscript art. Its initials are for the most part Ottonian in style, reminiscent of earlier Trier manuscripts.[30] But in text, whereas the Bernward Gospels go back essentially to the Court School of Charlemagne, the Bible fits almost perfectly with Tours before the Adalhard revision, and this goes also for the ordering of the biblical books.[31] It has long been well known that Bernward must have used a Turonian Bible, with an illustrated Genesis page like that of the Bible now in Bamberg or of the Grandval-Moutier Bible in the British Library, for the scenes of the Creation and Fall on the Hildesheim bronze doors of 1015.[32] It is conjectured that he obtained it on his journey to Tours

Col.Pl. XXII

118. Page illustrating Exodus. Grandval-Moutier Bible, Tours, *c.* 840. London, BL, Add. MS 10546, f. 25v

and St Denis when he participated in Henry II's French campaign of 1007. But the one illustrated page of the Bible, which forms its frontispiece, has little to do with ninth-century Tours art, at least on the surface, although I would argue that it has everything to do with this art in its intended *Col.Pl. XXII* meaning. In the Bernward miniature a large and dominating golden cross, with a foliated aura around its centre, is set under an arch of acanthus ornament placed on pillars. On either side of the arch in the architraves are two turrets, suggesting that this is the great arch of a church with the cross hanging in its apse. Beneath the cross to either side, in golden niches, stand a young man in priestly garb pointing to the book which he holds open, and a woman behind a low curtained screen; her hands suggest to most commentators the *orans* posture but I believe it to be a gesture of receiving the message of the open book, on which are inscribed the words *In principio creavit deus celum et terram*, the opening words of Genesis and thus of the whole Bible. Above the woman is seen the hand of God, as if to mark a revelation.

There is general agreement about the female figure; she is a personification of the Church, *Ecclesia*. No such unanimity attends the male, who

184

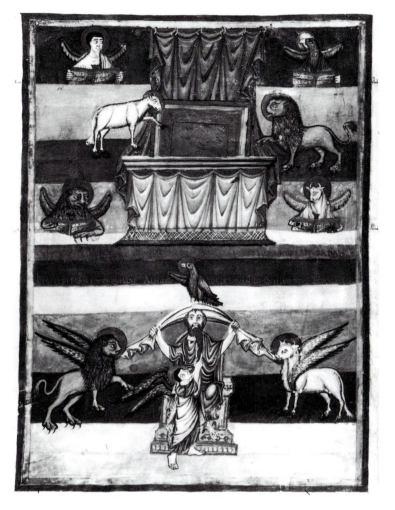

119. Apocalypse illustration.
Grandval-Moutier Bible, Tours, *c.* 840.
London, BL, Add. MS 10546, f. 449

has been variously, and unconvincingly, identified as Moses and St Jerome, the putative author of the Pentateuch and the translator of the Bible respectively. The two figures, standing under the cross, have an unmistakable analogy to Mary and John the Evangelist, except that each stands on the other side from the usual. Walter Cahn has noted this fact, but he still gives his vote for the Moses identification.[33] I assent to the *Ecclesia*, for although the 'typing' of Mary as the Church in these centuries was not especially favoured by scriptural exegetes (see p. 42), it was a known interpretation. But I would call the John the Evangelist figure — John the Evangelist. It has become a common understanding of art historians that the ninth-century Grandval-Moutier Bible, which has an Exodus page depicting Moses giving the Law to the Israelites, represents in its Apocalypse page the true revelation of that law, or its unveiling, in the New Testament. The two pages have to be taken together.[34] Above, in this Apocalypse picture, is the Lamb about to break the Seven Seals of the Book, which was taken to be an image of how the meaning of the Old Testament was opened up by Christ. Below is an old man, from whose head the evangelist symbols tug away a veil which he holds, an image of

118
119

185

the Unveiling of Moses and his Law. As Haimo of Auxerre, a Carolingian commentator on the Apocalypse put it: 'The Old Testament announces and veils the New; the New reveals and fulfils the Old.'[35] One could scarcely have finer images of the unity of the Bible and its two Testaments than these Exodus and Apocalypse illustrations taken together, and apart from the Genesis and the *Maiestas* they are the only full-page illustrations in the Grandval Bible.

It is impossible to believe that Bernward was unfamiliar with these ideas and this Carolingian Turonian iconography when his Bible was made. Indeed the comparatively simple scene of his book surely represents his own deep thought about, and extrapolation from, the rich and learned imagery of Tours. The male figure reveals the open Bible, beginning with the Old Testament, to *Ecclesia*, who accepts it, all this under the Cross, to which Bernward himself is known to have been especially devoted.[36] The male figure holding the Bible readily brings to mind Moses pointing to the tablets which he holds as if they were an open book while expounding them to the Israelites, as in the Turonian Bibles (especially the Vivian Bible in Paris). And although I cannot explain the curtained screen behind which *Ecclesia* stands, it is very reminiscent in style of the altar hangings of the Apocalypse picture in the Grandval Bible. Hence I would part company, though reluctantly, with Nordenfalk, and suggest that Bernward had a Turonian Bible with not just a Genesis picture but at least with the Exodus and Apocalypse scenes of that school as well.[37] And why should the male figure represent John the Evangelist? Not only because of his youthful appearance and his presence with Mary/*Ecclesia* under the cross — not only, even, because Bernward's Gospel Book shows the person of John the Evangelist to have been particularly meaningful to him — but also because it would be very suitable for John to hold open a book symbolizing the unity of the whole Bible, whose first words are written thereon and whose last words, the Apocalypse, were written by himself.

2 Echternach Gospel Books

It is to Echternach, however, that we must look even more to see the ways in which Ottonian art was 'transformed into Gregorian Reform art' (to use my earlier phrase), or rather, in its last great school, was changing subtly in that direction. Echternach was a monastery of great prestige and wealth, founded by the Anglo-Saxon missionary St Willibrord in the early eighth century. It accepted the Gorze/Trier Reform in 973 when Otto I caused Ravanger, a monk of St Maximin, Trier (only twenty miles away), to be appointed abbot (973-1007). He was succeeded by Urold (1007-28), who was deposed for incontinence, and then, after Conrad II had given the monastery a short dose of the tough Poppo of Stavelot, by Abbot Humbert (1028-51), another St Maximin monk.[38] It was under Humbert in the 1030s and 1040s that Echternach soared as a centre of manuscript art. It has been proved by Plotzek, however, in a brilliant

enquiry of detective character, that the Trier connection and the work of the Gregory Master at Trier had already begun to stimulate fine book production at Echternach under Ravanger. Our principal evidence of it is the ornamental pages of a pericopes book now in Munich (Clm 11327) and a single leaf (Paris, BN, lat. 10510) with an impressive representation of St Willibrord and two deacons which can be dated on palaeographical grounds to *c.* 1000. The art of its great period, therefore, clearly arose out of an earlier tradition,[39] but it was certainly given a boost by the patronage of Conrad II (1024-39) and more particularly Henry III (1039-56). Echternach was to Henry III what Reichenau had been to Otto III or Regensburg and Seeon to Henry II. The Saxon aristocracy experienced the rough end of Henry III's rule in his policy of resuming what he regarded as royal lands in that duchy.[40] But there was a saintly side to his rule also, and without of course envisaging the great struggle between *regnum* and *sacerdotium* in the later part of the century, which was a meaningless tension to him, he did much to create the religious conditions for the Gregorian Reform within the Empire. He placed reforming German bishops in the papacy; he strenuously opposed simony; he was exemplary in public prayer and penitence; and in one case, according to the chronicler Ralph Glaber, he even showed himself willing to abandon investiture, allowing a scrupulous abbot to receive his staff from a figure of Christ rather than from himself as a secular ruler.[41] In short, there is a parallel between principles of transformation within the empire which led to the Gregorian Reform and principles of transformation within Ottonian art which led to Gregorian Reform art.

In its high period Echternach produced gospel books or pericopes books, not Bibles.[42] The first Bible of which we know, with fine initials, comes only under Abbot Regimbert (1051-81). The following five books of the Echternach school, while by no means comprising its whole output of fine manuscript art, are of especial importance to us:

1. *Codex Aureus:* The Codex Aureus now at Nürnberg (MS 156142/KG1138), formerly at Gotha, and so known as *Gothanus* in the older literature. It dates from about 1031, the year of the re-consecration of the abbey church after it had been damaged by fire in the previous decade. There is no sign in it of a royal commission and it was probably made for the abbey itself. It contains the text of the four gospels, and as with *Speyer* below, it was clearly for liturgical use.[43]

2. *Bremen:* An illustrated pericopes book (Bremen MS b.21) made on the commission of Henry III, probably 1039-43.[44]

3. *Brussels:* Another pericopes book without sign of royal commission, related to *Bremen* and now at Brussels.[45]

4. *Speyer:* Now in the Escorial (Cod. Vitr. 17), a text of the four gospels made in 1045-46 on the commission of Henry III to be presented to Speyer Cathedral, the Salian house mausoleum. Its fine initial letters for the gospel pericopes, corresponding to the pericopes listed in its *Capitulare*, demonstrate that it was intended for liturgical use.[46]

5. *Goslar:* Again a text of the four gospels, made between 1047 and 1056 (*c.* 1050) on the commission of Henry III for the royal church of Saints Simon and Jude at Goslar in the Harz Mountains, which Henry III made his principal royal residence and centre for ruling Saxony and exploiting the silver of the Harz mines. The book is now in Uppsala (University Library, MS C. 93).[47]

Resplendent as it is, *Goslar* lacks a Christ cycle; the other four are the four manuscripts of the school which contain such a cycle. In *Speyer* and the two pericopes books, the illustrations are interspersed among the text, but in the Codex Aureus the scenes are gathered in groups before each gospel.

Let us look more closely at the wonderful Codex Aureus. It opens with
122 a Christ seated in Majesty. The artist of this page must have had the *Maiestas* of the Gregory Master in the Sainte-Chapelle Gospels (984) open
120 before him, considering its style and organization. The Gregory Master
121 and also the Echternach artist certainly had a *Maiestas* from Tours of the 840s in front of them. Kahsnitz has written well about the way in which the Gregory Master handled his Carolingian model, 'in the more solid, the cooler, the more abstract spirit of the Ottonian period' as to colour and forms, a change from the 'atmospheric' colour tones of the Carolingians.[48] The Echternach illuminator had not the artistic capacity of the Gregory Master, with his 'unusual understanding of the problems of space and the plasticity of figures'. There is one extremely significant iconographic difference, however, between the Gregory Master's *Maiestas* and that of the Codex Aureus. The Gregory Master had abandoned the representations of the four principal Old Testament prophets (Isaiah, Jeremiah, Ezechiel and Daniel), who were incorporated into the Turonian scheme along with the evangelists. The Codex Aureus reinstated them, indeed gave them the prominent place of the evangelists in the Tours model, and set the evangelist symbols in medallions on the frame. Thus in a gospel book it revived in its iconography the harmonization of Old and New Testaments which the Gregory Master in his Sainte-Chapelle Gospels had allowed to drop.[49]

Although the art of Echternach was still predominantly an art of the gospels in the mid eleventh century, the idea of concordance between the Old and New Testaments ran deep. Nordenfalk has discovered an eleventh-century Echternach poem, written onto the first leaf of a Carolingian manuscript, in which each one of the twelve minor prophets is related to one of the twelve apostles. They 'concord' with each other, to

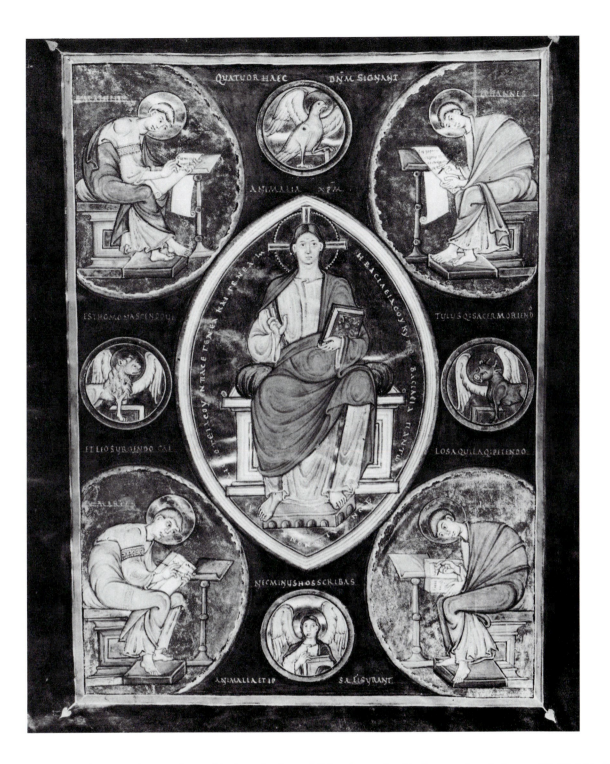

use the poet's word applied to Joel and Matthew. In *Goslar*, each of the twelve canon tables has a pair of figures in roundels on either side of the arch, appearing to converse with each other. Only one pair of figures, on the fifth table, is actually named, i.e. Micah and John. These are actually the fifth pair in the twelve of the poem. Obviously the scheme of concordance in the poem and the *Goslar* canon tables is the same.[50]

120. Christ in Majesty.
Ste.-Chapelle Gospels, prob. 984.
Paris, BN, MS lat. 8851, f. 1v

189

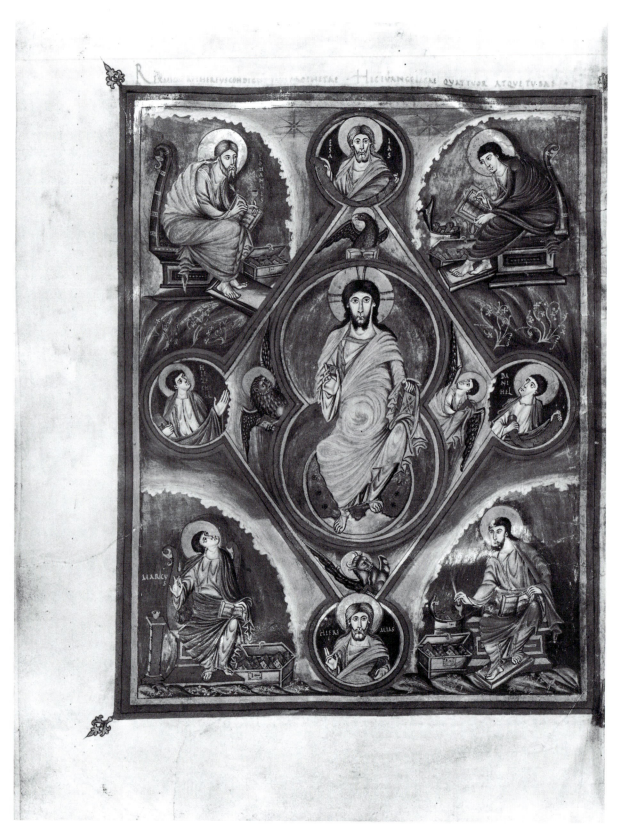

121. Christ in Majesty. Vivian Bible, Tours, *c.* 846. Paris, BN, MS lat. 1, f. 329v

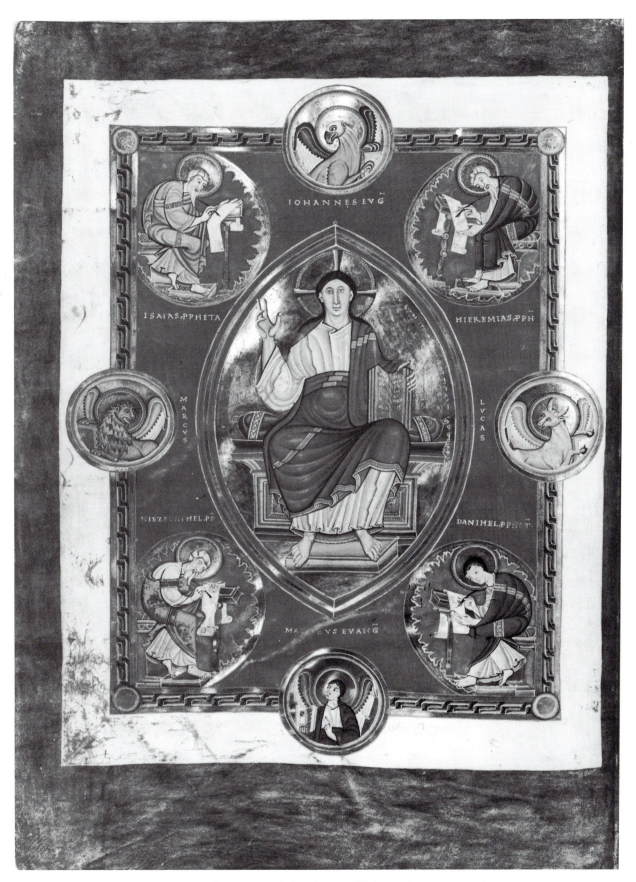

122. Christ seated in Majesty. Codex Aureus of Echternach, *c.* 1031. Nürnberg,
Germanisches Nationalmuseum, MS 156142/KG1138, f. 2v

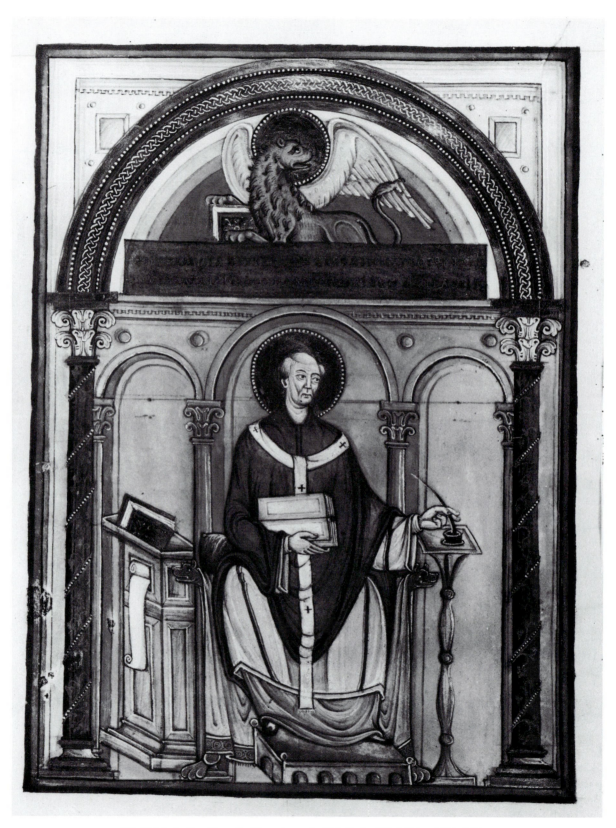

123. St Mark. Ste.-Chapelle Gospels, prob. 984. Paris, BN, MS lat. 8851, f. 52v

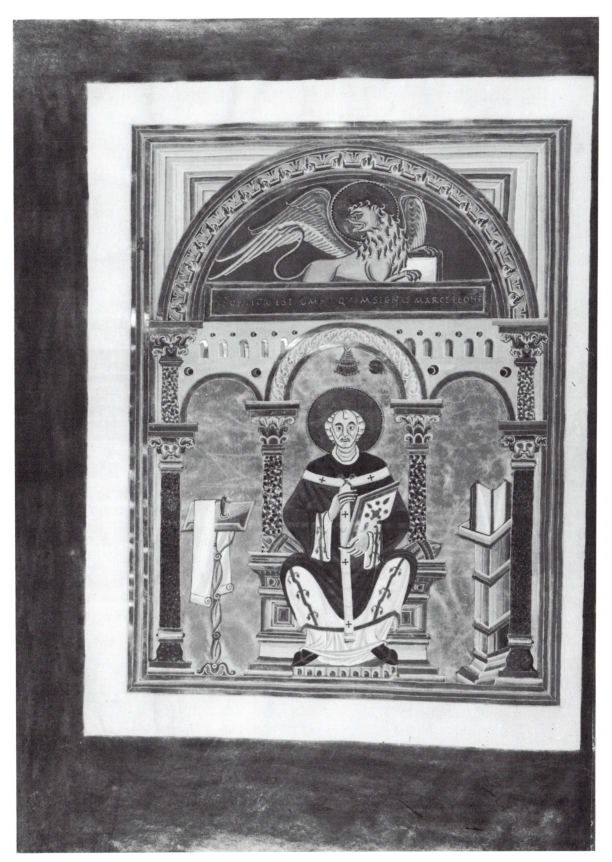

124. St Mark. Codex Aureus of Echternach, *c.* 1031. Nürnberg, Germanisches Nationalmuseum, MS 156142/KG1138, f. 54v

Col.Pl. XVII

123,124

Part I,103,117

After the *Maiestas* in the Codex Aureus, and a *titulus* page in which the inscribed tablet is held up by two tall and powerful angels, and after the canon tables with many reminiscences of Carolingian Tours in the figures on the arches, there comes before each gospel the magnificent series of textile, evangelist, and *initium* pages. They mark off one gospel from another with the greatest resplendence ever achieved in Ottonian art. The incipit pages here show a liking for gold written on purple bands against green backgrounds, which once again comes straight out of the colour scheme of the Sainte-Chapelle Gospels. The last feature may have come into the Sainte-Chapelle Gospels from Reichenau, with which the Gregory Master had an association, since it appears (though here with background of marine blue) in the title page for Pentecost of an early Reichenau Epistolary (Cambridge, Fitzwilliam Museum, McClean 30, f. 86v, *c.* 960 - 980), and the Gregory Master was good at picking up ideas from everywhere and improving on them. The evangelists, especially the St Mark in all Echternach books, are also derived from the Gregory Master. Before each gospel, between the textile-pages and the evangelist portrait, there are four pages of gospel illustrations arranged as a series of scenes in three strips on each page, 56 scenes in all. This is larger than any earlier Christ-cycle in Ottonian art, even larger than that of the Codex Egberti.

There has been much debate about the nature of the model or models for this cycle. In every way the miniatures are closely related to those of the Codex Egberti, and *Bremen* apparently used this Codex itself.[51] But although some scholars would like to see one grand, composite, pericopes book of late antiquity behind the Codex Egberti and the Echternach books (see p. 229 below and also Part I, pp. 78-80),[52] the latter making the more extensive selection from it, there are sufficient iconographic differences to make this doubtful.[53] It is safer to say, as Boeckler did, that the material used in both cases was closely related, but probably not the same, or at least not exclusively the same.[54] Boeckler wished to see a Byzantine cycle, or a western cycle which had incorporated an earlier eastern cycle, as a model, because he saw so many Byzantine elements in the Echternach books. His argument here was less strong, however. It was based to a large extent on the supposed rarity of the parable illustrations in the West (outside Echternach), their commonness in the East, and the analogies between Byzantine illustrations of the tenth and eleventh centuries and those of Echternach.[55] The analogies are not very close in style or detail, when carefully examined; they are in fact only of the most general character.[56] The parables are often said to be rare in the West, but they were clearly common in late antique gospel books, among which the distinction between East and West is not very meaningful,[57] and they could well have been quite common in the antique source materials from which Ottonian artists worked. This is also suggested by the fact that Reichenau, amongst its parable illustrations, added two to the surviving Ottonian stock which do not reappear in Echternach: the Withered Fig Tree and the Indebted Servant.[58] Finally on the models, we should be cautious in following the

125. Illustrations to the
Life of St Paul. Vivian Bible,
Tours, *c*. 846. Paris, BN,
MS lat. 1, f. 386v

suggestion of Boeckler that the Echternach model came to its artists with
the scenes in the antique form of pages of illustration organized in strips.[59]
We have observed in how many different forms late antique scenes could
have descended (see Part I, pp. 78-80), and the 'earth-billows' which some-
times distinguish one scene from another in strips are a device also found
(on Boeckler's own showing) in the separate square scenes of the sixth-
century Augustine Gospels.[60]

Indeed it is worth considering whence the format of the Codex Aureus
pages was in fact derived, namely from Carolingian Tours. Just as the
Codex takes its *Maiestas* from a Tours Bible of *Vivian* vintage, so it takes
its organization of the illustrated page into three strips (*Vivian* has three
strips for its Genesis page, whereas *Grandval* has four) from precisely such
a Bible also. The strips in the Codex are more crowded with figures than

195

126. Scenes from the Childhood of Christ. Codex Aureus of Echternach, *c.* 1031. Nürnberg, Germanisches Nationalmuseum, MS 156142/KG1138, f. 18v

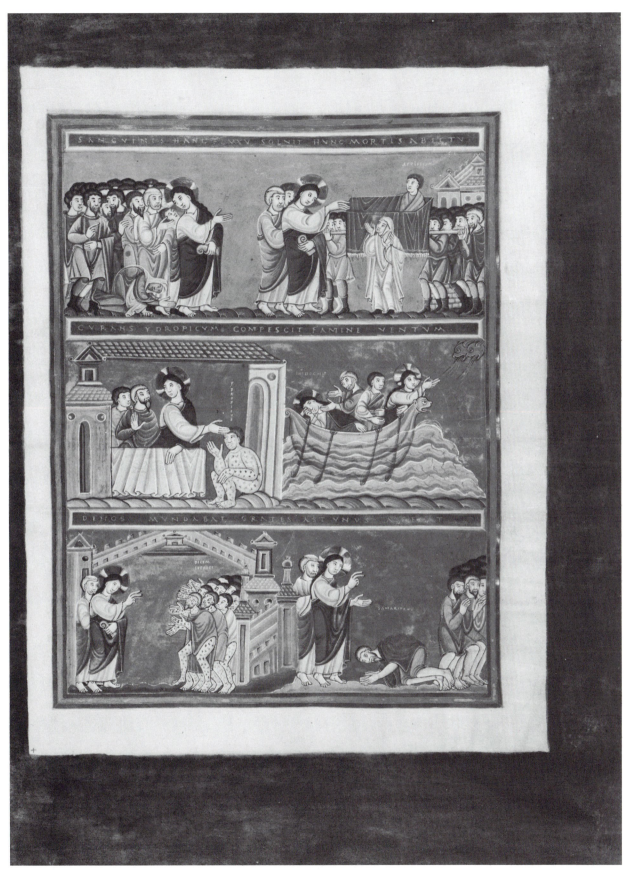

127. Miracles of Christ. Codex Aureus of Echternach, *c.* 1031. Nürnberg, Germanisches Nationalmuseum, MS 156142/KG1138, f. 54

125,126,127 in the Carolingian prototypes, the figures are more solid, and the whole effect is almost totally lacking the Carolingian spatial illusionism. But one is struck by the similar proportion of figures to space, by the architectural devices which are largely taken from Tours, and in particular by the Echternach taste for long extended architecture which is clearly a Turonian feature.[61] In *Speyer*, though not in the Codex Aureus, even the low, straight,

128 open arcaded building is occasionally essayed,[62] such as can be seen in the

125 St Paul frontispiece of the Vivian Bible, though the attempt is a poor one when considered alongside the spacial interest of the Gregory Master's arcades. Boeckler and Nordenfalk each demonstrated in the 1930s that there must have been a now lost Turonian Bible of *c*. 845 (i.e. slightly earlier than the Vivian Bible) in Trier which the Echternach painters, as well as the Gregory Master in Trier a half-century earlier, both used.[63] But to our knowledge the Gregory Master did not use it for its page-format as the artist or artists of the Codex Aureus did.

 There is, however, one completely new feature of Ottonian Christ cycles brought into view by the Codex Aureus: the thematic organization of the illustrations preceding the four gospels. Before Matthew come the infancy

126 scenes and the opening of Jesus's ministry; before Mark, his miracles, and

127 other public actions such as the Cleansing of the Temple; before Luke, his teachings, i.e. four parables each occupying a full page of three strips; before John, the Passion and post-Resurrection scenes. It was not un-Ottonian to gather the gospel illustrations in groups before the text, following antique example. This was done, for instance, in the Hitda Codex and the

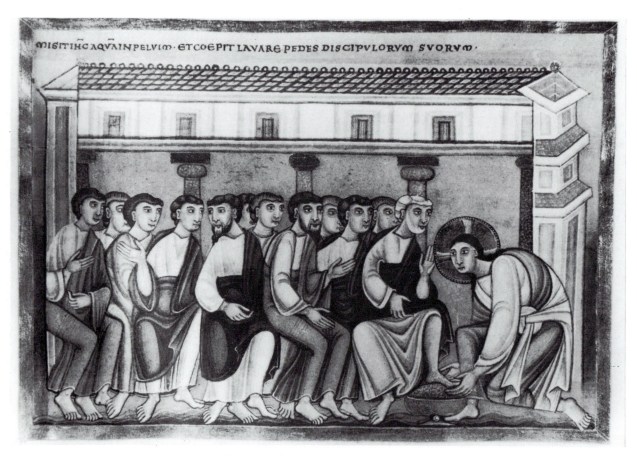

128. The Footwashing of St Peter. Speyer Gospels, 1045. Escorial, Cod. Vitr. 17, f. 152v

Gospel Book of Bernward of Hildesheim.[64] Nor was it un-Ottonian to give some chronological shape to a Christ cycle, as we saw in the cases of the Codex Egberti and the Gospel Book of Otto III; though, as Kahsnitz has pointed out, the order of miracles before Mark has more to do with a typically Ottonian, liturgical priority, the order of Lenten pericopes, than with chronology.[65] But in the Codex Aureus we have something more: a rudimentary form of eleventh-century theological schematization being imposed upon these pages of narrative strips.

Narrative they are. The kind of narrative in which Christ may appear in the action four, five, or even six times on a page is likely to be an enemy of Ottonian iconicism. The *tituli* which appear between the Codex Aureus strips, again following Turonian practice, are much more straight descriptive than the moralizing *tituli* of the Hitda Codex. These *tituli* modify the iconicism of the Hitda illustrations, but there is nonetheless a big difference between the fast-moving pages of the Codex Aureus with their *tituli* running along with them, like a swollen river carrying everything in its current,[66] and the glassy mountain-lake pages of *Hitda*, with their stillness, and their poignant and venerable images each on its own inviting contemplation.

In size and format the great gospel books of Echternach have not reached the proportions of the Italian Giant Bibles, but they are heading in that direction. The Codex Aureus is exactly the same size as the Gregory Master's Sainte-Chapelle Gospels, i.e. 44×31 cm, but that was large by Ottonian standards. *Goslar* is quite large (38×28 cm), while the largest of all is *Speyer* at 50×35 cm. Every bifolium of *Speyer* is therefore 50×70 cm, *128* and there are eighty-five of them, which means the slaughter of 85 calves for their vellum.[67] This is of course nothing like the 1545 calves required for the three biblical pandects which Abbot Ceolfrith had made at Wearmouth/Jarrow around 700, of which one, the Codex Amiatinus (now in the Laurenziana in Florence), survives;[68] but it is interesting that we are back in this sort of calculation. Moreover, as Fichtenau sensibly pointed out, in the case of Bibles the large format was needed to accommodate so much text,[69] while *Speyer* is not even a whole New Testament let alone a Bible, only a book of the four gospels. Yet splendidly extravagant as this makes it, the *raison d'être* of its size was not only 'sheer splendour',[70] unless that phrase means an emphasis on the majesty and importance of the text (see Part I, p. 175 for our observations about the subservience of the large cycle of illustrations to text in this volume). The Codex Aureus has 39 lines of text to the page, the much larger *Speyer* only 36. This suggests a direction in the Echternach scriptorium of the 1030s and 1040s, in its 'art of the book', towards beautifying the appearance of the text. Its real advances are in this sphere rather than in iconography or figural style.

The Bremen Pericopes Book (probably 1039-43) provides us with another example of careful consideration for the appearance of the text and the relation of text to picture at Echternach. In this extensive Christ cycle every illustration is placed before the pericope which it illustrates, so that

the picture is, in Plotzek's words, 'an announcement and a pictorial anticipation of what follows in the gospel word'. If the illustration is full-page, a part of the preceding page may be left without script in order to enable the text of a pericope to follow in its entirety immediately after the picture. The gospel for the third Sunday after the Epiphany (Matthew 8:1-13) is preceded by two half-page illustrations forming a whole page, whereas the Codex Egberti, which *Bremen* used as a model, has the Healing of the Leper before the text and the Healing of the Centurion's Servant at an appropriate place in the middle of it. I cannot quite see eye to eye with Plotzek here in the contrast which he draws between the Codex Egberti with an emphasis on the optical effect of the text to which the illustrations are directly related, and the Echternach book with its concentrated all-inclusive scenes placed before the pericopes, which thereby stresses the relative importance of the miniatures.[71] Both methods of incorporating illustrations go back to antiquity; they are exemplified in the two Carolingian psalters at Stuttgart, with small scenes interspersed in the text, and at Utrecht, with composite pictures before each psalm which leave the texts uninterrupted. These do not reveal contrasting priorities of text and illustration, but rather different ways of relating the two, in which if anything the latter gives even greater weight to the text.

As we have emphasized, Ottonian art was very much an art of initial letters, giving the text its due weight in manuscripts with illustrations. Now we say that there was almost a de-rationalizing and ritualizing of the text in some Ottonian initials, especially with single initials of wizard-like calligraphy, occupying the whole page to the exclusion of almost all text, 'something mystical or magical, to be contemplated not simply read', as Jonathan Alexander has described them.[72] Such an initial letter is the C *129* of the opening gospel reading in the Poussay Pericopes Book (Reichenau, 980s). A letter of gold and minium red, sitting on a purple ground and tied by dense interlace to a highly mercurial acanthus frame, it is filled with the most ebullient foliage of the Ruodpreht style, in silver and gold tendrils of bravura execution. Apart from the announcement of the gospel (for the vigil of Christmas), *sequentia sancti evangelii secundum Matheum*, only the words *Cum esset* appear on the page. *Goslar*, which is not a pericopes book but a gospel book, contains the same text, beginning at Matthew, 1:18, and starts it (obviously intending liturgical use) with an *132* initial C, with thick, controlled, tendril ornament of gold inside it. Here, however, the initial occupies only a tiny fraction of the large page, and the beautifully laid out text of the whole pericope can be taken in at a glance. The initial has the function of leading off into the text. Three-fifths of the way down the same page is a larger-scale initial C of similar character, set with the words *Cum ergo natus esset Jesus*, the opening of the Epiphany pericope, on a purple ground within a plain gold frame. Even here, however, the initial and frame are not allowed to swamp the text which is written to the side of them. Once again at Echternach, as in the eleventh-century Bibles, the text is given primacy.

129. Initial C for the Gospel
of Christmas Eve. Poussay
Pericopes Book, Reichenau,
c. 970-90. Paris, BN,
MS lat. 10514, f. 10

What we have just described is not entirely un-Ottonian, as we saw
from the Fulda Sacramentary at Bamberg, for instance (see p. 145). We are
not dealing, therefore, with absolute differences, but with tendencies and
directions of development. In any case the dedication pages in *Goslar*
show that we are still dealing in many respects with an Ottonian book. In
the dedication pages a magnificent elongated Christ, seated in a golden 130
double-mandorla, crowns the now standing, but still little and humble,
figures of Henry III and Agnes, while on the opposite page Henry 131
alone presents his book to Saints Simon and Jude, the patrons of the church

201

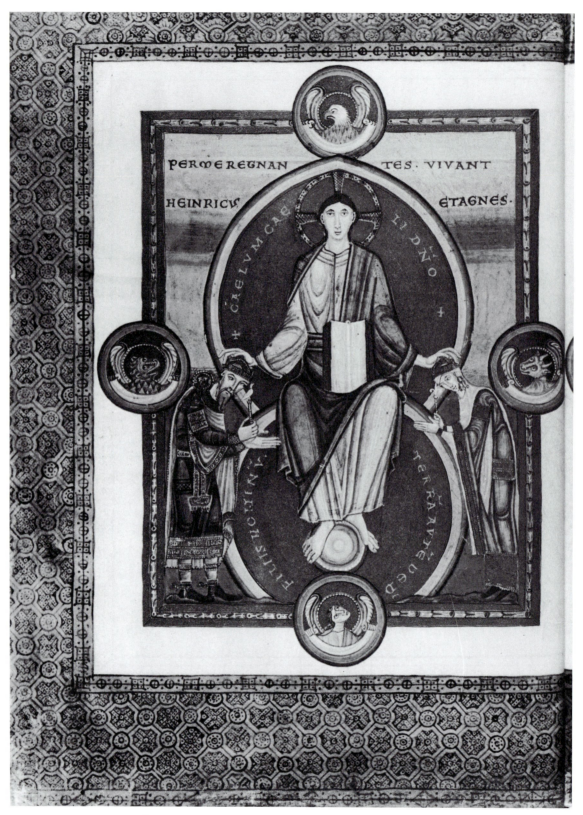

130. Christ crowns Henry III and Agnes. Goslar Gospels, Echternach, 1047-56.
Uppsala, University Lib., Cod. 93, f. 3v

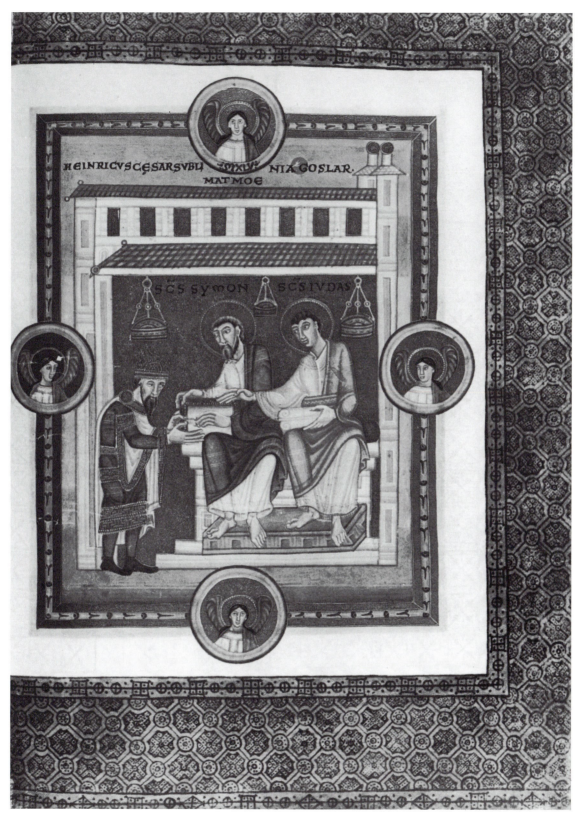

131. Henry III presents his book to Saints Simon and Jude. Goslar Gospels, Echternach, 1047-56. Uppsala, University Lib., Cod. 93, f. 4

...um esset desponsata mater eius maria ioseph.
antequam conuenirent inuenta est inutero
habens despu sco. Ioseph autem uir eius cum esset iustus & nol
let eam traducere uoluit occulte dimittere eá. Haec autem eo cogitante ecce ang̅ls d̅ni ap
paruit insomnis ei dicens. Ioseph fili dauid
noli timere accipere mariam coniu gem tuam. Quod eni̅
incarnatum est. despu sco est. Pariet autem filium. & uoca
bis nomen eius ih̅m. Ipse enim saluum faciet populum su
um apeccatis eorum. Hoc autem totum factum est. ut ad
impleretur quod dictum est a d̅no per prophetam dicente̅
Ecce uirgo in utero habebit. & pariet filium. & uocabunt
nomen eius emmanubel. quod est interpretatum nobiscum
d̅s. Exsurgens autem ioseph a somno. fecit sicut precepit ei
ang̅ls d̅ni. & accepit coniu gem suam. & non cognoscebat eám
donec peperit filium suum primogenitum. & uocauit nomen
eius ih̅m. Cum ergo natus esset ih̅c inbethleem iudae indi
ebus herodis regis. ecce
magi aboriente uenerent
hierosolymam dicentes.
Vbi est qui natus est
rex iudaeorum. Vi
dimus enim stellam eius
in oriente. & uenimus
adorare eum. Audi
ens autem herodes rex
turbatus est. & omnis
hierosolyma cum illo. Et congregans omnes principes sacer

at Goslar. This scene harks back to the Gero Codex, and further to the Carolingian dedication pages of Hrabanus Maurus's *De Laudibus Sanctae Crucis*. But there is more to it than that. The presentation is enacted inside the church, underneath hanging lamps, against a gold background, while reverently laid on the book are no fewer than five hands.[73] There is an important truth about Ottonian art here. The beauty of the script or the lay-out of the text did not mean that the mystical or magical sacredness of the book was diminished. Furthermore, we must remember that when the Codex Aureus was made it was placed, as if a sacred object and not only a text, in the resplendent golden, jewelled and ivory covers which Echternach had probably received from the Empress Theophanu half a century earlier.[74]

In Echternach of the 1030s and 1040s, therefore, we see an art which in some ways seems to be moving in the same direction as French and Italian book art, towards less magical more rational forms which we have called Gregorian Reform art: large format and focus on text, co-ordination of Old and New Testaments, and simple theological schematization of the Christ cycle. The art looks back to Carolingian Tours, as well as to the Gregory Master, but it is being pulled in some characteristically eleventh-century directions. However, we may nonetheless be right in calling it the last great school of Ottonian art. There are still the Christ cycles, with their vivid repertoire of colours and their exaggerated eternalized gestures; there are still the domineering angels and the virtuoso letters in whole-page frames; and there persists the sacrality of the book itself, which has more power than what it conveys by its text and illustrations alone.

3 The Moralia in Job of Pope Gregory the Great

We make one last sortie into the world of Ottonian manuscript art, in order to suggest that not only the gospel books of Echternach but also manuscripts of Pope Gregory the Great's *Moralia in Job* made an interesting contribution to preparing the ground for Gregorian Reform art from within Ottonian art. The *Moralia* became in the Middle Ages a quasi-Bible, partly because it seemed to have exactly the quality of the Old Testament as a whole, of being a mammoth book, composed of many books, loosely held together yet offering a mine of understanding about the Christian Church, and partly because Gregory's commentary ensured that Job himself would come to be seen, along with the Bride in the Song of Songs, as perhaps the principal 'type' of the Church in the Old Testament. Job expressed in his person, says Gregory in his preface, 'the burden of the Church which suffers the many wearinesses of the present life'.[75]

The giant Italian *Moralia* of the eleventh century at Bamberg (MS Bibl. 41), to start with a non-Ottonian book which has recently been well discussed by Larry Ayres, has the large format (51.5 × 34 cm) of the Italian Bibles from the same period, and like these, it is connected by Ayres to

INCIPIVNT CAP

LIBER QVARTVS.

De morte immortalis.
De tribulatione fauoris humani.
De uerali luce iustine.
De spe spernentis diem.
De nocte diei.
De egrauu mero re confusionis.
De impunitis peccatis.
De defensione peccati.
De animi aduersione penitentie.
De illis qui mente calcant mundum.
De diuina seruitio.
De obscuratione oculory mentium.
De modis peccatory.
De subiectione sensuum.
De usu cui parui.
De difficultate emendationis ad deterib. moratis.
I tem de mortuis.
De homo positu in paradiso.
De libero arbitrio uoluntatis.
De ordine insensibilium reru ad sensibilium reru.
Q uomodo unusquisq. se regat.
De uite liuaunt.
De solitudine mentis.
De cal calo uiruteis sparso.
De eloquia diui eloquia casta.
De sessu robore.
De concupiscentia diuinitatis.
De claudo pede.
De interno certamine.
De ocatore aludice.
De memoria in paradiso.

EXPLICIVNT CAP

INCIP LIBER IIII

VI TEX
TVM

CONSIDERAT ET SENSVM.

133. Job with his Wife. *Moralia in Job*, Italian, mid C11. Bamberg, Staatsbibl., MS Bibl. 41, f. 29

the reform initiatives in Italy. Indeed he assigns it to the same scriptorium as that which produced at least one of the great Bibles, with similar initial letters and the same practice of placing figures and scenes as *tableau* units between breaks in the columns of script or at the beginnings of chapters rather than historiating the initials. He points out, in fact, that Italian illuminators often placed less stress than those of the North on the integration of script and decoration.[76] At the beginning of Book 4 in the Bamberg manuscript, Job is seated, while his wife addresses him. To *133* Gregory's way of thinking, and to that of the papal reformers in the eleventh century, Job's wife represented much that was wrong in the Church; she was like a traitorous citizen, she was a 'type' of the carnal in the Church (as were priests who lived in concubinage), she was Satan's ladder to her husband's mind.[77] Much further on, at the beginning of Book 23, the company is joined by Job's three friends, friends branded by *134* Gregory's preface as heretics who, under the guise of counselling, seduce Job (and so the Church).[78] It is not surprising that the reformers, who saw themselves as heirs to the Early Church and were not always themselves, into the bargain, quite concise in their writings, should have found the *Moralia* an entirely congenial work, and that at least one of them, Bruno of Segni (Abbot of Monte Cassino, 1107-11, ob. 1123) should have tried his own hand at expounding this biblical book.[79] The Bamberg *Moralia* looks as if it might have been made for Bishop Gunther of Bamberg (1057-65); in any event it was apparently there in his time or soon after, and it must be seen as part of a general interaction between Northern Europe and Italy where manuscript production is concerned during the eleventh century.[80]

There is less chance of *Moralia* manuscripts surviving than of liturgical books or Bibles which contained the sacred text itself.[81] But if we look at

134. Job with his Wife and Friends. *Moralia in Job*, Italian, mid C11. Bamberg, Staatsbibl., MS Bibl. 41, detail of f. 191v

135. Preface to Pope Gregory's *Moralia in Job*, Trier, *c.* 950-75. Trier, Stadbibl., MS 2209/2328, vol.i, f. 1

the indirect Ottonian evidence, such as the claim that John of Gorze knew the work practically by heart (see p. 118), or the statement of the Lorsch chronicler that Abbot Salmann of Lorsch had a three-volume *Moralia* produced which he beautified with wonderful ivory and silver covers,[82] it becomes clear that within Ottonian culture, the work was treated in a manner approximating to that of the Bible itself. Luckily, however, we are not entirely dependent on the indirect evidence. For at Trier there survive two large pandects (46.5 × 36.5 or 35 cm) of the mid-tenth century (MS 2209/2328), approaching the Carolingian Bibles in size, and containing the text of the *Moralia*, with very fine initials for the openings of the thirty-five *Col.Pl. XX* books, the masterpiece of the St Maximin scriptorium in the period before the Codex Egberti, as Hoffmann calls it.[83] In this book, the opening of the preface, which takes the form of a letter from Gregory to Bishop Leander of Seville, is handled very much like the canon table of a biblical text, with *135* gold writing on purple bands placed under arches on which peacocks disport themselves. It is possible that the artist of the so-called Gospel Book of Bishop Hezilo at Hildesheim made use of a similar model for its actual canon tables.[84] Some of the initials in the Trier *Moralia* have a cousinly relationship with Reichenau, as in the Karlsruhe Homeliary *137* (Aug. XVI) and with Carolingian Tours; such is the Q opening Book 34, *136* whose letter form is in gold and minium red on a purple ground, with simple interlace knots on its sides and a winged dragon for its tail, while in the middle, reminiscent of the symbols within the initials of Carolingian Tours from the Rorigo Bible (Paris, BN, lat. 3) onwards, is the figure of the apocalyptic Lamb with victory cross.[85] Others, still with an obvious debt to Tours in their animal figures, have an elegantly curved tendril ornament from which the Gregory Master could have learned something. Such is the D at the opening of Book 29. Plotzek has made an overwhelming case *138* that the artist or artists of this book who worked in gold and silver tendrils on purple grounds had Alemannian manuscripts (i.e. from St Gall or Reichenau) available to them, with initial art such as that of the mid tenth-century Reichenau Homeliary now at Karlsruhe (Aug. XXXVII), the St Gall Psalter at Cologne (Dombibliothek, MS 45), and the St Gall Gospel Book at Trier (Priesterseminar, MS 106).[86]

We have mentioned that Nordenfalk and Boeckler brought forward proof that a Turonian Bible of the mid-840s had been in use as a model in Ottonian Trier and Echternach (see p. 198). Nordenfalk showed in addition that the fifteenth-century monks of St Maximin used the parchment of this very Bible to stuff into the bindings of their incunabula. A number of fragments of it had been recovered from the bindings by the 1930s, from which it could be deduced that the pages of the original Bible were large (47 × 35 cm), in fact very similar in size to the Ottonian *Moralia* at Trier. Amongst these fragments were three initial letters which Nordenfalk regarded as in a style which was short-lived at Tours but included the Vivian Bible.[87] The Bible whose existence could be inferred as a model at Trier and Echternach, and the Bible from which all these discovered fragments

136. Initial Q. *Moralia in Job*,
Trier, *c*. 950-75. Trier,
Stadtbibl., MS 2209/2328,
vol.ii, f. 189

137. Initial Q. Homeliary,
c. 950-70. Karlsruhe,
Landesbibl., MS Aug. XVI, f. 49v

Col.Pl. XXI

Col.Pl. XX

came, must have been one and the same book. But the 1930s did not mark the end of new discoveries, for whenever the entirely worthy activity of digging into these incunabula bindings has proceeded, more of the same Carolingian Bible has been discovered. In fact only a few weeks before my last visit to Trier in 1987, Reiner Nolden of the Stadtbibliothek had brought to light its initial A for the Apocalypse. A comparison of this A, with its hanging projections from the top, its foliated tendrils, and its acanthus panels in the shape of the letter, on the one hand, and, for instance, the B at the opening of Book 30 of the Trier *Moralia* on the other hand, leaves little doubt that, long before the Gregory Master or the Echternach painters were using it for their own purposes, the scribe/artist of the *Moralia* was drawing on precisely this Carolingian Bible for ideas about his own initial letters. The creation of a *Moralia* was already being seen as analogous to that of a Bible.

Furthermore, we should not pass over the fine lay-out of this book which surely also owes something to Carolingian Tours: the double columns of beautifully written minuscule, the *capitalis rustica* which enables the reader easily to identify the passages of the Book of Job being commented upon in the text, the splendid numeral in Roman capitals which marks off the end of each quire.[88] Whether the young monks of St Maximin, all aspiring to the heights of John of Gorze in his knowledge of the *Moralia*, worked avidly at this book, we cannot say, but it was certainly a book which would have lent itself well to group or classroom study.

It was one of the main lessons of Tellenbach's great work on the Gregorian Reform that the religious and moral principles of this reform were already deeply embedded in the imperial system and were born out of this system into the Rome of Leo IX, Nicholas II, and Hildebrand later Gregory VII, a system ruled until the death of Henry III by men of heroic

210

religious idealism, who never dreamt that churchmen would turn on the 'secular power' and the 'proprietary Church' as being antipathetic to their shared aims. There is much in the story of Ottonian art, and its relation to what followed it, which is congruent with this view, not least the ways in which it prepared the ground for Gregorian Reform Bible production. But however much Gregorian art grew out of Ottonian art, the two cultures were at heart in sharp antithesis to each other. The Gregorian ideal was a world ordered by intellectual logic, which found political expression above all in law and jurisdiction; against it stood the imperial world which we have studied, ordered by ritual, sacrality and magic.

138. Initial D. *Moralia in Job*, Trier, *c.* 950-75. Trier, Stadtbibl., MS 2209/2328, vol.ii, f. 119

Conclusion

I T MAY BE THOUGHT that a book on Ottonian Manuscript Illumination should be completed with a consideration of its subsequent influence, but there are dangers in this, because such a discussion would necessarily be mainly of an iconographic and stylistic character, and Ottonian Art was more than the sum total of its iconography and styles. It was part of, and helps to define, a culture which was transmogrified. It was the opening and closing of a door. It was a glimpse of heaven or eternity, however harsh the actual tensions and combats in the society which experienced it. It was a glimpse of heaven in the reconciling of the cosmic opposites of the Regensburg Crucifixion; in the resolution of great sins such as we see it with Christ's Healing of the Blind Man in the Gospel Book of Otto III; in the emergence of the straggling company of the baptized into the presence of God amidst the angelic choirs and shimmering gold of the Bamberg *Song of Songs*; in the regrouping of the pleading, troubled church on earth into the church of the Resurrection in the All Saints' illustration of the Fulda Sacramentary at Udine. The worth of such glimpses does not lie in their influence; it lies in their ever having been had at all.

139. *Humilitas*. Border illustration from the Opening of St John's Gospel.
Hitda Codex. Darmstadt, Landesbibl., Cod. 1640, f. 173

212

140. The Fall of Babylon. Bamberg Apocalypse, prob. 1001-2. Bamberg, Staatsbibl., MS Bibl. 140, f. 45

Note to Excursus I

This excursus was written in the summer of 1983 to clarify my own mind about the Bamberg Apocalypse and my perception of it within the context of Otto III's rule. This was before the paper of 1985 by Peter Klein had appeared. It may seem superfluous, in view of his finely argued opinion in favour of Otto III's reign for me to retain my excursus. But although we overlap on important points, especially the 'portrait'-types of Otto III and Henry II, we reach the same end by such different means that I have decided to retain my piece. In particular, although I am impressed by several of his arguments based on stylistic and iconographical development, which constitute a large part of his paper, to the point of feeling shaken in my opposition to such arguments, I still think it worth trying to establish the date of this great manuscript on purely historical and codicological grounds and at the same time pointing to the dangers of dating by style.

In one matter, however, I must take issue with Klein, namely in his (to my mind) exaggeration of the ideological pretensions of Otto III, and his contrasting these as expressed by the coronation of Otto III at the hands of Saints Peter and Paul in the Bamberg Apocalypse, with the modest demeanour and humility of Henry II in his Pericopes Book as he allows himself and Kunigunde to be ushered into the presence of Christ by Saints Peter and Paul. Klein sees here two contrasting modes. In this ideological world, however, humility and triumphalism are not so easily distinguishable. When the tiny Henry II kneels humbly at the feet of Christ in the Basel antependium he acknowledges, but at the same time *claims*, that his rule is directly derived from Christ's rule in the world. He does so equally in his Pericopes Book. When Otto III was styled *servus apostolorum* (i.e. the servant of Saints Peter and Paul) in some of his diplomas of 1001, the humility of the title in fact projects a claim to universal rule based on his Romanism. To allow oneself to be humbly ushered into the presence of Christ by the apostles is no more nor less humble than submitting oneself to coronation by them. If humility is a useful idea at all in this context, it is as an instrument of ideological pretension and political power.

214

The Date of the Bamberg Apocalypse

S URPRISINGLY LITTLE DETAILED STUDY has been devoted to the problem of dating the Bamberg Apocalypse, and there is still radical disagreement amongst scholars about whether the manuscript should be assigned to the end of Otto III's reign (1001-02) or rather to a late period of Henry II's (c. 1020). As recently as 1979 Florentine Müthe-rich, the greatest living authority on Ottonian art, could write: 'the as-cription to the second decade of the eleventh century [until recently her own preferred dating] has been repeatedly challenged in favour of the time of Otto III, but without finding the agreement of research'.[1] It is incumbent, therefore, on any writer discussing and using the Bamberg Apocalypse to give his view of the date, and his grounds for taking that view. To anticipate, mine is decidedly for the latest part of Otto III's reign rather than for Henry II's. But the interest of the debate is by no means confined to the narrow polemical issue of the date itself, for this issue has opened up a broader division between those who attached the greater weight to external historical criteria, which must give the advantage to Otto III, and those who attach it to considerations of stylistic develop-ment, which appear to give the advantage to Henry II. Hence radically opposed intellectual judgements and approaches are involved, both handled in masterly fashion by their best exponents.

The Bamberg Apocalypse is a manuscript of 106 folios, the first 58 giving the text of the Apocalypse with 50 full- or part-page illustrations, and folios 61-106 being a book of gospel readings, that is a pericopes book, with five full-page illustrations. In between, folios 59 and 60 contain two illustrations, opposite each other on the double page as it lies open. On the left is seated in majesty a youthful ruler being crowned by Saints Peter and Paul, and underneath personifications of four peoples, two of them dark and two fair as in the Gospel Book of Otto III, offering him their gifts. On the right are personifications of four kingly virtues, having con-quered their opposing vices after the manner of Prudentius's famous poem *Psychomachia*, leading by the hand Old Testament exemplars of the virtues (Job for patience, David for repentance, etc.). These pages are a form of homily addressed to the ruler, an exhortation to foster within himself the virtues of patience, repentance, obedience to God and purity; just as the Aachen Gospels has a prayer homily opposite the ruler portrait, exhorting him to clothe his heart with the Gospel. Once again there is here a par-ticularly strong echo of Otto III in the emphasis on repentance; *poeniteat culpae* (may he repent of his sin) says the legend to the picture.

Part I,
Col.Pl. XXI

The decisive argument for Otto III's rather than Henry II's reign, as the period of the manuscript, is indeed the ruler portrait. Most known representations of Otto III, in manuscripts,[2] on seals,[3] on coins,[4] on the golden cover of the Codex Aureus of Echternach,[5] depict him as youthful and beardless. The exception is his first imperial *bulla* of 998, and here the ruler is bearded because, as Schramm has shown, Charlemagne's imperial *bulla* was being followed exactly. If the ruler on the ivory *situla* of Aachen represents Otto III, which is a matter of some doubt, it is because this *bulla* was being followed there.[6] Otherwise there are no known exceptions to the youthful and beardless image of Otto III.

We may by-pass the question whether or not these were efforts at true-to-life portraiture. It is the type, the *Jünglingstypus*, which is invariable. Otto III's youthful appearance (even for his young age, it seems) especially struck contemporaries; may be it was a positively important element in the magnetic fascination which this great emperor exercised over them. His unhairy face was specifically commented upon. The *Life of St Adalbert*, referring to Otto at the time of his imperial coronation in 996, noticed that he was getting 'as if the first down of a beard'.[7] On the other hand, Henry II, who was twenty- nine when he was crowned king in 1002 and hence by the standards of the time was already approaching middle age in the earliest years of his reign, was virtually always represented as middle-aged and bearded. Half a dozen known manuscripts, equally divided between the two halves of his reign, depict him in this way;[8] likewise his seals, the more striking as his seal-types were in other respects influenced by those of Otto III;[9] likewise the Basel Altar.[10] We are not, therefore, unduly short of evidence in establishing these quite different ruler-types for Otto III and Henry II.

Part I; 116,
Col.Pl. XXVI
Part I,34

Only one exception has been noted to the normal ruler-type in Henry II's case besides the coins. Most of Henry II's coin-types show a beardless face, but as Vöge said, many of these were minted at places where he was little known because they featured only sporadically in his itinerary and where doubtless an earlier emperor-type was simply continued.[11] It is noteworthy that the coins minted in Regensburg, his place of education and the ecclesiastical centre of his Bavarian duchy, where he was obviously well known, are amongst the minority which depict him bearded.[12] He cannot have been little known in the circles which produced the Bamberg Apocalypse, which were manifestly close to the court. Otherwise, the one exception is a tiny image of a ruler being crowned by the hand of God, represented inside the initial P of a *graduale*, whose litany refers to Henry II as Roman Emperor and to Kunigunde as Empress and so dates it from between 1014 and 1024. The figure is youthful and beardless, and seems to be drawn from a model of the musicianly David, to judge by its lively posture. As art this illustration, and the manuscript in which it occurs, are of no importance. In any case Schramm brilliantly showed that there was a particular reason for this representation. The initial with the picture is that for the gradual chant of the first Sunday after Pentecost. Henry was

crowned king in Pentecost week, 1002, and the book, probably given to him by Kunigunde, commemorated his coronation as a younger man, certainly more than twelve years previously and perhaps as much as twenty.[13]

When Messerer asks, therefore in his *Literaturbericht* of 1963 on Ottonian art, why a manuscript school need be thought to have only one type for a particular ruler, when for instance the Codex Egberti represents more than one type of Christ within the one volume,[14] the answer is that whereas variations in the type of Christ are a well-known phenomenon, variations of the ruler-type under Otto III and Henry II respectively are not, and that were the Bamberg Apocalypse to represent such a shift under Henry II, it would be virtually the only known instance, and certainly the only known one without the reason declaring itself. In fact Otto III is always represented as Christ is in the western tradition, young and beardless, Henry II as the bearded Christ of the Byzantine tradition. Messerer may have drawn support from Vöge's observation that the Bamberg manuscript of Josephus lies against the conclusion that the beardless ruler at this period is virtually always Otto III, the bearded always Henry II.[15] But if so the support was delusory. The Bamberg Josephus is a tenth-century manuscript, with a separately quired double-page ruler-dedication which could have been joined to the manuscript later. The pages show a ruler of the *Jünglingstypus* seated in majesty, and personifications of the provinces approaching, very like that of the Gospel Book of Otto III, except that it is of lesser quality and has *Italia* where the Gospel Book has *Roma*. Vöge thought that this was an example of a switch from bearded to beardless type under Henry II because the name HEINRICUS is inscribed above the ruler, identifying him as Henry II. But this kind of thing was later done at Bamberg to exalt its devout and generous founder. Another tenth-century manuscript which belonged to Bamberg from its earliest years has had the name of Otto erased in a poem to the Virgin and the name Heinricus written over it.[16] Schramm was surely right, therefore, to assign the Josephus double page, notwithstanding doubts about when it was actually joined to the rest of the manuscript, to Otto III's reign.[17]

The reader may be moved to ask whether there are not also doubts about the relation of the double page with the ruler portrait to the rest of the manuscript in the case of the Bamberg Apocalypse. The two folios 59 and 60 in the latter are a double leaf separate from the quiring of the rest of the manuscript. Might it be, therefore, that even if the ruler was Otto III, the double page was only later bound together with the Apocalypse and the pericopes section, and so does not at all help to date these two? As far as I am aware, no scholar takes this view. The stylistic congruence of this double page with the rest of the book is too obvious to everyone, not only in colour tones, facial character, deployment of surface space, but also in every detail of drapery, hands, modes of depicting beards or hair. Not the staunchest supporter of the later date for the manuscript has sought to make capital out of the separate quiring of the double page and

110
Part I,35

217

out of the argument that it might be irrelevant to the dating of the Apocalypse itself. And if it is urged that, placed as it is in the manuscript, it might be conceived of as the dedication pages only of the pericopes section, that does not affect the issue since the script of the Apocalypse and the pericopes is the same.[18] There is no way round treating the manuscript as an integrated whole.

If the ruler portrait may be taken to date the Bamberg Apocalypse to Otto III's reign, the actual date is most likely to be the very end of it in 1001, as Schramm pointed out. For whereas in 1000 the Emperors' diplomas had styled him *servus Jesu Christi*, in 1001 the style *servus apostolorum*, namely servant of Saints Peter and Paul, appears on the scene. This style was a feature of Otto's Romanism, his personal piety, and doubtless his friendship with Pope Silvester II (Gerbert of Aurillac). But as Schramm went on to say, it was only on the outside a sign of humility; its kernel was a claim to limit the papacy to the spiritual sphere and to clothe the emperorship with an almost spiritual brilliance.[19] The representation of a ruler crowned by Peter and Paul in our manuscript does not of itself exclude Henry II, who figures in the company of these very saints on the dedication page of his Pericopes Book. But it does fit well with the last year of Otto III's reign, as a reflection of his advance in Romanism and of his new documentary style, if it be granted that the ruler portrait in any case argues for Otto rather than Henry.

Schramm's connecting the ruler portrait with Otto III's title of *servus apostolorum* undermines another supposition for Henry II, made by Chroust and Wölfflin, that the Bamberg Apocalypse could be no earlier than 1007 because the crowning by Saints Peter and Paul already refers to the foundation of Bamberg Cathedral (1007) whose patron saints these were.[20] Such a supposition is perhaps reasonable when applied to the *Part I, / Col.Pl. XXVI* presence of Saints Peter and Paul on the dedication page of the Pericopes Book of Henry II, where the small figures of Henry and Kunigunde are protectively ushered into the presence of Christ by the larger ones of the *Part I,105* apostles, like Otto I with St Maurice on the Magdeburg antependium, or like Pope Pelagius I with Saints Peter and Paul and St Lawrence in a sixth-century Roman mosaic at St Lawrence-outside-the-walls. This was an old motif of advocacy and patronage (see Part I, p. 22). The *crowning 2* of the ruler by Saints Peter and Paul in the Bamberg Apocalypse, however, is a totally different iconography, and unique. If the appearance of Saints Peter and Paul here does not necessarily indicate that Bamberg was already founded, therefore, might it not rather be that the dedication of Bamberg Cathedral to Saints Peter and Paul itself shows the influence of his predecessor on Henry II, who was not so non-Roman as is sometimes implied? Might not devotion to the apostles Peter and Paul be another of those points of religious continuity between Otto III, 'servant of the apostles' both in his 1001 style and in the Bamberg Apocalypse, and Henry II?

The crucial argument for dating the Bamberg Apocalypse to Otto III's reign, then, lies in the ruler portrait. But there are other pointers to Otto

218

III which merit consideration. When Otto was crowned emperor at Rome in 996, he was wearing a cope stitched in gold thread with scenes from the Apocalypse, which he subsequently presented to the monastery of S. Alessio.[21] I cannot find that this cope has been brought into the discussion of the Bamberg Apocalypse, or at least of its date, but it must have been a very striking and noteworthy object. It reveals quite clearly the interest in apocalyptic iconography within Otto's circle, and shows how likely it would be that a fine manuscript of the Apocalypse with many illustrations would be produced within that circle. Once produced such a manuscript would doubtless be treasured and would be likely to be handed on to Bamberg with Otto's other manuscripts *de luxe*. Again Henry II cannot be excluded, since the interest of his circle in apocalyptic themes is shown by the Last Judgement in his Pericopes Book and by the cosmology of his own cope, still preserved at Bamberg, which has in its whole theme a suggestion of apocalypticism about it. Indeed this cope may give a very good idea of what Otto's looked like. But Otto's cope does suggest that, even if one could argue that the Bamberg Apocalypse was made under Henry II, it would necessarily have owed something to iconographic efforts and interests advanced under Otto III. When, therefore, we bring the biblical book of the Apocalypse into the fundamental ways of thinking of Otto and his advisers, the case does not rest simply on the Bamberg Apocalypse's dating from his, rather than Henry II's reign.

Pat I,111

Another pointer to Otto III's reign, or at least to an earlier date than the Pericopes Book of Henry II, lies in the arrangement of the first quire of the manuscript.[22] Art historians who hold that the Bamberg Apocalypse dates from about 1020 are strongly influenced by the belief that on stylistic grounds it must be later than the Pericopes Book (1002-14). Fauser, editor of the 1958 facsimile edition of the former, argued for Otto III's reign, and thought that after Otto III's death, the manuscript must have remained for a while (before being given to Bamberg) in its scriptorium to serve as a model for the Pericopes Book, and even to be modified by the Pericopes artist. The very first illustration of the Bamberg Apocalypse, which shows John receiving the book from Christ, is plainly by a different hand from any of the others, and is remarkably close in style and colour tones to the Pericopes Book, particularly in what Wölfflin called the *feuerlilienrot* (tiger-lily-red) of John's cloak.[23] Fauser's idea was that this represented a *subsequent* working in the Apocalypse manuscript by the Pericopes artist, perhaps because by then some no longer appropriate dedication pages explicitly to Otto III were being removed, and a reworking of the first pages of the manuscript was thereby entailed. Messerer, on the other hand, proposed an idea which would have made the first page of the Bamberg Apocalypse, by the presumed Pericopes master, the *earliest* work in the manuscript. Rather than a change of plan necessitated by the removal of a dedication to Otto III, he asked, was this not a case of an important artist *starting off* the illustration of the book before leaving pupils or lesser men to continue, rather like the Gregory Master who painted seven of the

early illustrations in the Codex Egberti?[24] Messerer's analogy of the Codex Egberti is, however, a false one. The miniatures of the Gregory Master are spread over the second and third quires of the Codex where (despite some rearrangements affecting the first quire and the first leaf of the second) the quiring has settled down to what becomes its regular pattern throughout the volume. His work was therefore intended from the start to get the illustration of the Codex under way.

Not so with the illustrator of the first leaf of the Apocalypse. Whether or not it is plausible to suppose that a dedication page to Otto III had to be removed, the quiring makes it clear that this illustrator's work must have been an *afterthought*, replacing the original beginning of the manuscript. The body of the manuscript must be earlier than the first page, the page putatively by the Pericopes master. Folio 1 recto has the miniature of John receiving the book. The remaining three sides of folios 1 and 2, which start off the Apocalypse text, are written in a different script from the rest of the manuscript, though similar. With folio 3, continuing the text of the Apocalypse (recto) and illustrating the Christ-figure with sword in mouth (verso), the script and style of miniature found in the rest of the volume begin, and this is a single leaf. Obviously, therefore, the original first quire was for some reason removed, leaving only the right-hand side of the original double leaf on the outside of the quire (the present folio 3). A new start was then made to the text of the Apocalypse (the present folios 1 and 2), replacing that portion of the text which had been removed with whatever else was on the original first quire.

An inscription on the former binding, which no longer survives, shows

Original First Quire Present First Quire

that the manuscript was the object of a presentation by Henry II and Kunigunde. The Nürnberg customs officer and antiquary Christoph Gott- lieb Murr recorded what he could read of it in 1799 as follows: — *Henric et Kunigunt/Haec tibi munera promunt*.[25] Given that at the time of the secu- larization of 1803 the book appeared always to have belonged to the collegiate church of St Stephan in Bamberg, it has generally been thought, even by those scholars who date the Apocalypse to Otto III's reign, that it was most likely presented by Henry II to this church on the occasion of its consecration (at which both he and Pope Benedict VIII were present) in April 1020. But this inference is totally worthless. It is important to remember that St Stephan, unlike Bamberg Cathedral, was not directly the foundation of Henry II or Kunigunde but of the Bishop of Bamberg. The early records of St Stephan and of the Benedictine monastery of St Michael (only a few hundred yards from the cathedral) leave no doubt that both were founded as *Eigenkirchen* of the bishop, and that he had the free disposal of them.[26] The monastery on the Michaelsberg was to struggle against episcopal control in the twelfth century. It was also to become very conscious of its own book collections, but only after Bishop Otto of Bam- berg had given its library a fillip in the early twelfth century.[27] We cannot assume that the books and treasures of St Stephan, any more than of the Michaelsberg, were regarded as quite separate from those of the cathedral in the eleventh century. Its close connection with the cathedral in matters of books and learning is indeed demonstrable if Egilbert, master of the scholars at St Stephan, may be taken to be identical with the cathedral master of that name under Bishop Suidger (1040-47, Pope Clement II, 1046-47).[28] It is perfectly possible, therefore, that it was to the cathedral that Henry II presented this book, as well as many others which had previously belonged to Otto III, and that it was the Bishop of Bamberg who subsequently presented it to his proprietary church of St Stephan, perhaps in 1020 (which would have been appropriate), perhaps at another time. It should be noted and emphasized that the inscription on the bind- ing provided no evidence of *to whom* Henry and Kunigunde had originally presented the manuscript.

When considered closely, the binding inscription rebounds upon those who favour a Henrican rather than an Ottonian date for the manuscript.[29] For it raises the question, where is the representation of Kunigunde which one would expect if the manuscript itself were Henrician? She is particu- larly associated with the gift on the binding; she is particularly associated with the whole endowment of Bamberg since it was her dower; she is represented with Henry II, not always, but on some other occasions. Here, had this sumptuous manuscript been actually commissioned by the two of them, it would have been especially apposite to have depicted them together somewhere, as on the dedication page of Henry II's Pericopes Book. The absence of any such depiction is readily intelligible, however, if, as all the arguments not based purely on style strongly suggests, the manuscript was in fact commissioned by Otto III.

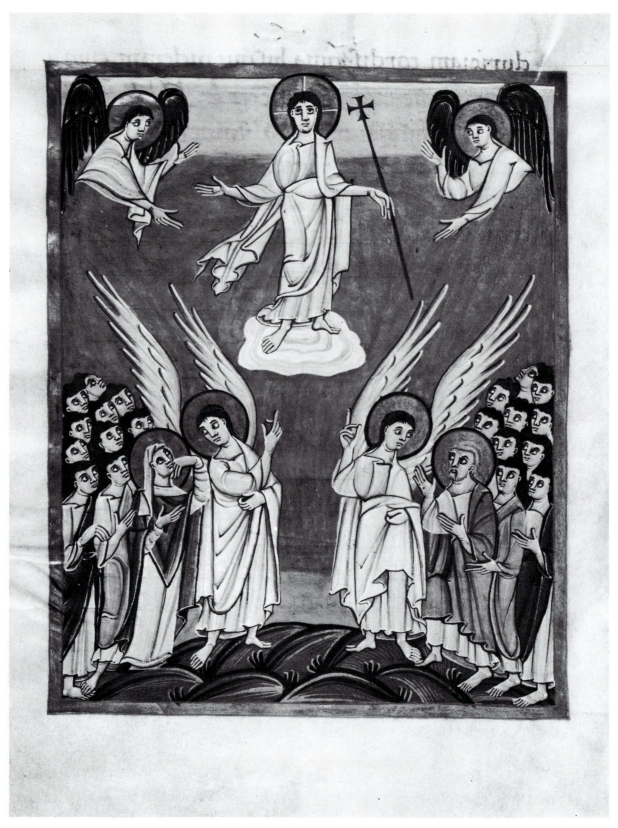

141. The Ascension. Bamberg Apocalypse, prob. 1001-2. Bamberg, Staatsbibl., MS Bibl. 140, f. 71v

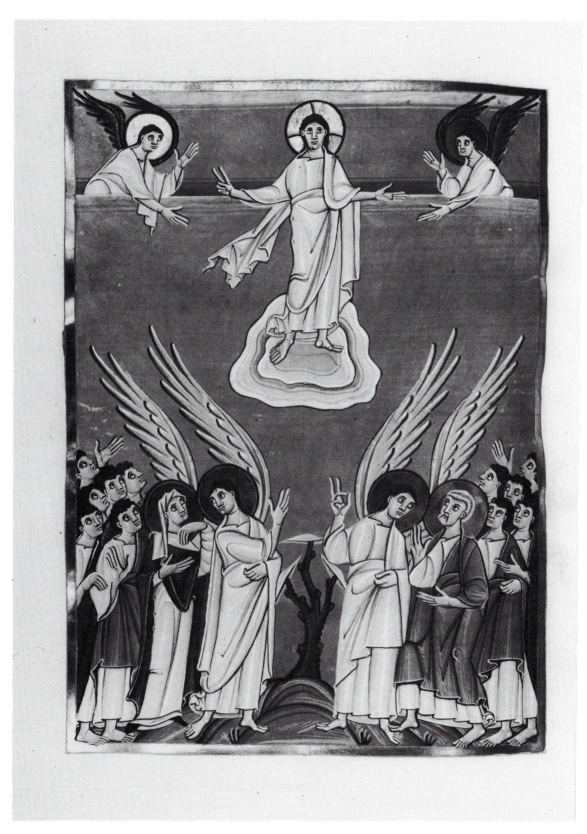

142. The Ascension. Pericopes Book of Henry II, 1002-12. Munich, Bayerische Staatsbibl., Clm. 4452, f. 131v

It is to the stylistic arguments that we must now turn. These have very much led art historians to date the manuscript to the second decade of the eleventh century. The case is that the manuscript can only be understood as a successor to, and not as a forerunner of, the Pericopes Book of Henry II (1007-14, or probably 1007-12), that its style shows certain features of deterioration from the high point of the Pericopes Book, which are characteristic of later Reichenau manuscripts. The most powerful proponent of this view was Hans Jantzen.[30] If one took as a yardstick distance from the forms of the Gospel Book of Otto III, he said, the Bamberg Apocalypse was further away from them than the Pericopes Book. The direct comparison, he continued, was less with the illustrations of the Apocalypse itself than with the pericopes section of the Bamberg Apocalypse manuscript. The gospel scenes of the latter were weaker representations than those of the Pericopes Book, the movements and gestures were a stage less tense, the forms emptier. Then in a few brilliant sentences,

141 Jantzen had a field-day with the Ascension in the Bamberg manuscript. The drawing within the figures (*Binnenzeichnung*) was much more full of

142 character in the Pericopes Book, as was the head of Peter; the heads in the Bamberg manuscript were a mere reiteration of popular schematized heads; the very number of the disciples depicted in the scene, twenty-one in all, showed the loosening relationship to the gospel text of the Bamberg manuscript. The same lamentable trends were said to appear in other Reichenau manuscripts, where the figures also became flabby and relaxed, losing their tension, their proportions, and their fine surface relationship to each other. Jantzen adduced the Limburg Gospel Book in Cologne (more recently dated on stylistic grounds by Peter Bloch to *before* the Pericopes Book of Henry II and to the first decade of the eleventh century!)[31] as an example of such a decline, the final depths of which were plumbed in the Berlin Gospels (Staatsbibl. Cod. 78 A2).

It might be tempting, but it would be too easy, to dismiss this kind of writing as mere subjectivity. Jantzen was heavily influenced by the expressionists. But he was also a most profound and sensitive observer of Ottonian art, with wonderful precision of phrase, and anyone who follows him in his comparisons will see how right they are and how the Pericopes Ascension has a concentrated discipline which the Bamberg Ascension, so close to it iconographically, just lacks. The problem lies in what chronological conclusions one is justified in drawing from such a comparison. The stylistic decline of Reichenau manuscripts is not one whose path is clearly charted or agreed, as is exemplified by the different conclusions of Bloch and Jantzen on the dating of the Limburg Gospels. Nor are relaxation and indiscipline of necessity posterior rather than anterior to tension and concentration.

Above all, in the Pericopes Book of Henry II we are dealing with one of the great masterpieces in all Ottonian art, and none has been more eloquent and persuasive in opening our eyes to its true quality than Jantzen himself. Can the work of other artists be satisfactorily fitted, *on merely*

stylistic arguments, into a chronological sequence with the highly individual achievement of such a master? Could not an *earlier* artist, with perhaps less ability or interest than that of the Pericopes Book, have shown some of the weaknesses, natural weaknesses after all, which would later become even more evident in other Reichenau manuscripts? But these weaknesses, this supposed decline, is in any case not at all apparent throughout the whole Bamberg manuscript. Jantzen confined his comparisons with the Pericopes Book to the relatively weak pericopes section of the Bamberg Apocalypse.[32] One cannot urge Jantzen's criticisms of the pericopes section against the main section of the Apocalypse itself, as he implicitly recognized, partly because the wholly different nature of the subject matter defies comparison with the Pericopes Book, and partly because they are not in fact valid criticisms. The Apocalypse illustrations are very far from lacking disciplined execution, intensity, or exciting surface relationship of the forms. The chronological arguments which put the Bamberg Apocalypse later than the Pericopes Book on grounds of formal disintegration and stylistic decline would never have occurred to anyone without the pericopes section of the Bamberg manuscript. Now whether or not the five gospel illustrations in the pericopes section are by the same artist as those of the Apocalypse itself — and they were evidently planned from the start — these five rather conventional illustrations cannot have had the interest for the artist or artists which the Apocalypse had. The Apocalypse has exactly 50 illustrations in 58 folios (true not all of them are full-page, but fitting the part-page ones to the text adds to the life and exhilaration); the pericopes section has 5 illustrations in 46 folios. The Apocalypse towers over the pericopes section in the book. Surely, therefore, one of the reasons why the pericopes section is such easy game for those who would argue that it shows a loosening of tension and discipline, is that creative stimulus had been exhausted by the Apocalypse. That, and not a later date than the Pericopes Book of Henry II, is the most plausible explanation.

Before Jantzen, neither Vöge nor Haseloff, who between them laid the foundations of Ottonian art scholarship, had written much about the style of the Bamberg Apocalypse. Vöge's arguments for dating it to Henry II's reign, as we have seen, were mainly historical. Haseloff (to whose theme the manuscript was very secondary) contented himself with observing — but it was an interesting observation — that whereas in the Aachen Gospels, the Bamberg Commentaries and the Gospel Book of Otto III a painterly approach, an application of colour like paste and vestiges of illusionism had celebrated a last triumph, all this gave way in the Pericopes Book of Henry II and related manuscripts such as the Bamberg Apocalypse to a treatment of colour governed more by consideration of form, draughtsmanship and surface relations.[33] This contrast is undoubtedly meaningful to any student of the manuscripts. Haseloff may have implied that the Bamberg Apocalypse was later than the Pericopes Book, but he warily avoided committing himself to this view.

225

Jantzen's most remarkable predecessor as a stylistic commentator was Heinrich Wölfflin. Wölfflin, while believing Apocalypse and Pericopes Book to be the work of one and the same artist (which, despite their closeness of style, few scholars would now accept), in fact adamantly held that the Apocalypse was the earlier work. The particular style, a surface style of great impact with firmly drawn lines, was to his mind more sharply and successfully developed in the Pericopes Book. But although the matured style of the latter had a certain classicism and monumentality about it, the Apocalypse had 'freshness and warmth' precisely because it was the earlier work. So wrote Wölfflin for the first edition of the Bamberg Apocalypse facsimile in 1918.[34] But this did not lead him to date the Apocalypse to Otto III's reign, partly because he believed on external grounds that it could be no earlier than 1007 (mistakenly, as we have argued), and partly because he believed that the stylistic development of both manuscripts from their predecessors needed all the time to mature which the time-scale *c.* 1000 to 1014 allowed. The aspect of slow maturing was even more stressed in the 1921 edition. Any naturalistic effect of perspective, modelling or anatomical correctness in the earlier manuscripts, he maintained, gave way in the Apocalypse, and still more consistently in the Pericopes Book, to 'externally heightened expression of line in the surface drawing', while all other principles — of form, colour, and composition — were determined by this one.[35] Moreover, here was no primitive effort of art seeking expression, but the culmination of a long tradition, with consciously established types and developed forms, which these later, stiffer-styled manuscripts show. Fischer, in his study of the Bamberg manuscripts (1926), emphasized the same point. He referred to the Apocalypse on the one hand as belonging to the thought-world of the commentary illustrations and even being intended as a complement to them, and on the other hand as being far from them stylistically and certainly a couple of decades later.[36]

The closeness of the Apocalypse to the thought-world of the commentary illustrations deserved more weight than Fischer gave it, the stylistic distance less. Nobody could doubt that the Apocalypse was a later manuscript than the Commentaries or the Gospel Book. The stylistic developments between them are real enough, as Haseloff described them. But they are hardly revolutionary. The fundamental, expressionistic features of the Liuthar Group, exaggerated gestures set off against surface space, sharply contrasted colours, surface representation taking precedence over illusionism, are all already present in the Gospel Book of Otto III. Maybe the Gospel Book does show (in the words of Messerer) 'inexhaustible richness in the inner movement of figure and scene', whereas the Apocalypse has more external and 'free movement of the figures against each other'.[37] But some such development of style would be almost a necessity as between the Gospels and the very different drama of the Apocalypse. Subject matter must be quite as important as lapse of time in explaining the stylistic novelties of the Bamberg Apocalypse. Furthermore when one thinks of

how rapidly some individual artists have developed in their painting, Picasso almost monthly at some points in his career, one need not suppose that in the active and alert school which produced the Gospel Book of Otto III, the conception of the Bamberg Apocalypse necessarily took more than a year or two to follow.

It is, I think, possible to suggest a reason why Wölfflin was so impressed with the notion that stylistic developments, or developments of form, such as we have just been discussing, needed so much time to mature: namely his observation of the Munich expressionists of his time. Wölfflin lectured and wrote in Munich at the peak of German expressionist influence there, and such Ottonian masterpieces as the Bamberg Apocalypse, with its expressive fantasies, distortions and gestures of terror, were just the kind of art to appeal to expressionist taste.

> I imagine the most magnificent things — apocalyptic crowd scenes, Hebraic prophets, and visions of mass graves.

These words were not in fact written by Wölfflin about the Apocalypse; they were by the Berlin expressionist critic Ludwig Meidner;[38] But his imagination would have been satisfied in every point by Wölfflin's facsimile edition of the Bamberg Apocalypse a few years later. Wölfflin set out to explain to his contemporaries, who had already rediscovered Grünewald, how they could absorb the Ottonian phase of their German heritage into their experience. Ottonian art was not 'correct' by nineteenth-century standards of three-dimensional illusion. Indeed there was deliberate negation of 'correctness', deliberate error of proportion — in the excessively bony gesturing fingers, the turning of a city upside down to represent the fallen Babylon, the tense confrontation between figures *140* in the drama.

But one should particularly note that Wölfflin thought arbitrary distortion justified, or valuable, because it gave 'a stronger assertion *to form*'. Another expressionist critic, Hewarth Walden, required that a picture should be treated as the 'unity of a formally shaped surface'. Now the expressionist painters were very conscious that the development of new forms was a great struggle. Kandinsky declared, when he painted his earliest 'non-objective' pictures in 1910-11 that he had been working towards this goal for almost a decade, and in his essay on the question of form in the 1912 edition of *Der Blaue Reiter* (the great organ of the Munich expressionists), he maintained indeed that the question of form was secondary to the free expression of 'inner necessity' on the part of the creative artist, but relative as this made form, he still stressed its importance in achieving such expression.[39] I am not aware of any direct comment by Wölfflin on Kandinsky himself,[40] but he might either have been impressed with the struggles of the *Blaue Reiter* artists over the 'Formfrage', or he might have feared the dissolving effects implicit in making form entirely relative to the inner necessity of the artist, particularly the abandonment

227

of all classical ideas of form, just as August Mayer in his Munich publication of 1918 on expressionistic miniatures of the German Middle Ages complained of the abandonment of rule-bound forms in his own day.[41] There are signs that, with the ambivalence of sensitivity, Wölfflin felt drawn in both directions at once. Either way, he would naturally be led to think that certain changes or developments in form were bound to be long, difficult and drawn-out, when in fact they could have been achieved at a stroke. His view could only have been strengthened by his turning from the study of individual artists and focussing on the struggle of whole cultures to achieve historical transformations of artistic forms.

Over and above all the detailed arguments stands the question: how can one resolve an impasse which is essentially between historical and art historical scholarship? I have argued that stylistic grounds are far from conclusive. To give them an automatic primacy can only be justified by the idea that a style must develop according to a particular, necessary, inner logic of its own, which can be analysed in objective and purely visual terms. The belief in such a logical, visual development of art was held by Wölfflin and by German expressionist writers. It is part of their legacy to Ottonian art criticism. But it is nonetheless a historicist fallacy. Fauser saw this in his facsimile edition. Those who regard the Pericopes Book of Henry II as the classic work of the Reichenau school, he said, are right if they mean that its master understood, as none other, the art of monumental expressiveness and how to give power to the gestures of excessively outstretched arms and hands expanded across the breadth of empty surfaces. On the other hand, he continued, those who argue that Reichenau art was *predestined* to come to this kind of surface style (*Flächenstil*), to reach its peak in it, and thereafter to tail off, have become the prisoners of their own terminology.[42]

It may seem as much an act of faith to put one's trust in the historical evidence of ruler types which we adduce as the principal grounds for dating the Bamberg Apocalypse to Otto III (at least in its conception and origin) as to put such trust in the visual logic of stylistic development. But anyone who calls to mind how K. B. McFarlane[43] made merry with the stylistic judgements of the greatest art historians on the subject of Memling's development, once he had conclusively dated the portrait of Sir John Donne to about 1480 (rather than the later 1460s) on biographical grounds, will feel that judgement of stylistic development alone is a treacherous basis for chronology even in the best hands. It cannot honestly be claimed that historical evidence allows one to date the Bamberg Apocalypse with the same conclusiveness as the Donne portrait. But I would submit that it speaks for Otto III's reign with fair probability.

EXCURSUS II
'Retractatio'

A *Retractatio* is a re-consideration, not necessarily a full recantation. I would like to reconsider two issues discussed in Part I. The first is where I argued against the hypothesis of Adolf Weis that the models for all the Ottonian Christ scenes must have come to them in one single late antique pericopes book containing a very large cycle of Christ illustrations (see Part I, pp. 78-80). Having re-read, in order to make a study of the Charlemagne Court School (to be published elsewhere) the brilliant paper by Wilhelm Köhler, 'An illustrated Evangelistary of the Ada School', *Journal of the Warburg and Courtauld Institutes* 15 (1952), 48-66, I can no longer doubt that the Ottonians, and the artists of the Codex Egberti in particular, had such a pericopes book available to them, with the illustrations incorporated into the relevant places of the text in very much the same way as they are in the Codex Egberti (or as the late antique Cotton Genesis [London, BL, Cotton Otho B. VI] incorporates its own illustrations), even if I strongly doubt that the Charlemagne artists made anything like as extensive a use of these self-same illustrations as Köhler argued; and that I was wrong to assert that a pericopes book was the *least* likely form of the Ottonian model. It was the fact that Weis himself, in his long article never cites this paper by Köhler, though it would certainly have constituted his best argument, that put me off the scent. I still would question, however, on grounds stated in Part I, whether a single pericopes book is likely to have been the *only* model of the Gregory Master and the other artists of the Codex Egberti, let alone of the later artists of the Reichenau Liuthar Group, or whether pericopes books are likely to have been the only *form* in which late antique models of their Christ cycles came to these artists.

The second issue bears on my point that the illustrations in the Gospel Book of Otto III cannot have been intended primarily to have the liturgical function of solemnizing with art the gospel reading of the mass, since too many of them illustrated pericopes for unimportant days liturgically, and that they must rather have been intended for the private perusal of the Emperor (see Part I, p. 176). There are mistakes in Part I, chapter 4, note 61, where I gave references from the *capitulare*, or list of gospel readings for the liturgical year, printed from the manuscript in the facsimile edition of the Gospel Book. Except for what I say about the reading of Christ's Weeping over Jerusalem and the Feast of St Stephen, I have confused the number of the ferial day of the week with the number of the week after the Epiphany. Once this is sorted out, however, my actual point is more dramatically vindicated than I would have imagined it could be. Leaving

229

aside the Childhood and Passion scenes, which obviously illustrate readings for important days, some of the others also do, e.g. the Temptations of Christ for the first Sunday of Lent, the Handing of the Keys of Heaven to St Peter for the Feast of Saints Peter and Paul, and the Beheading of John the Baptist for that feast. At least eight out of twenty-five scenes (listed below), however, would illustrate readings for weekdays, i.e. ferial days in the weeks after the Epiphany or the octave of Pentecost, which are low liturgical seasons.

Florentine Mütherich has shown that the *capitulare* of the Gospel Book of Otto III follows Klauser's Type Σ among Roman *capitularia*; all the above readings are duly as in Klauser. Likewise there are at least eight scenes illustrated in the Gospel Book which are not represented with readings at all in this type or our *capitulare* in particular, i.e. the Baptism of Christ, the Storm at Sea, the Transfiguration, Christ blessing the Children, the Blind Man of Jericho, the Merchants in the Temple, the Parable of the Fig Tree, and the Widow's Mite. Of course several of these subjects have readings from other gospels than those for which they are illustrated in Otto III's book (though not all of them), but this means that the illustration would be far removed from text when it was read at Mass, e.g. the Transfiguration illustrates Mark 9 in our book but the reading for Ember Saturday in Lent is from Matthew 17. Hence, outside the Nativity and Passion scenes, only a minority illustrate pericopes of important liturgical feasts.

List of Pericopes for Ferial Days

Daughter of Jairus, Wed after 4 Sunday Epiphany
Matthew 9:18-26 *Loquente Jesu ad Turbas*

The Leper Healed, Wed after 2 Sunday Epiphany
Mark 1, 40-44 *Venit ad Jesus leprosus*

Gadarene Swine, Fri after 5 Sunday Epiphany
Mark 5, 1-19 *Venit Jesus trans fretum*

Peter's Mother-in-Law, Sat after 2 Sunday Epiphany
Luke 4, 38-43, *Surgens Jesus de Synagogua*

Widow of Nain, Sat after 5 Sunday Epiphany
Luke 7, 11-16, *Factum est deinceps ibat*

Penitent Magdalen, Fri after 6 Epiphany
Luke 7, 36-47, *Rogabat Jesum quidam pharisaeus*

Feeding of Five Thousand, Wed after Octave of Pentecost
Luke 9, 12-17, *Accedentes discipuli ad Jesum*

Good Samaritan, Thurs 4th week after SS Peter and Paul
Luke 10,

Evidence from Klauser, 1972, pp. 102 - 30 and Clm. 4453, pp. 214 - 26.
Masses for the post-Epiphany period could be used equally in the
post-Pentecost period if Lent were early.

Notes to the Text

Bibliographic references are generally given in abbreviated form. For full bibliographic information readers are referred to the Bibliography.

Notes to Chapter 1:

1. Bischoff, 1967A, no. 6, p. 17, lines 4-5, p. 18, lines 49-51.

2. Van der Meer, 1978, p. 107.

3. Omont, 1922, esp. pp. 65, 74, 82, 84-86; Laufner & Klein, pp. 52-53, 84-89.

4. Laufner & Klein, pp. 52, 93-94, 107-11.

5. De Bruyne, 1914, p. 392-6. Fauser gives a list of the Bamberg text divisions, as marked out by small ornamental initials, at p. 8; but neither in this respect nor in style and iconography do the Carolingian apocalypses enter his discussion. See Henderson, pp. 179-81, for an example of Bamberg and Valenciennes iconography at their closest.

6. Laufner & Klein, pp. 107-08.

7. Ibid., p. 53, for references.

8. Juraschek, pp. 18-28, p. 38, note 14; and Laufner & Klein, p. 90, note 222: albeit without the 'star' in the hand depicted in Cassiopeia's and in that of the Whore of Babylon of the Paris Apocalypse, Juraschek, ills. 15, 16.

9. Lex. christ. Icon., iv, 514-19, B. Brenk on *Weltgericht*. Some interesting examples of early iconographic elements in various artistic media are given by Voss, 1884, pp. 14-42. Müstair's wall paintings, however, had not been discovered at this time, and Voss appears to have been unaware of the Bamberg Apocalypse.

10. Birchler, p. 229 (no illustration); Utrecht Psalter, Utrecht University Library, MS 32, f. 93.

11. Illustrated in van der Meer, p. 99.

12. Fauser, p. 35.

13. The weighting of the figures to the right, *Rechtslastigkeit*, is pointed out by Fauser at p. 36 (re plate 47).

14. Bede, Apocalypse, PL 93. col. 166. At least twenty-five manuscripts of this work dating before 1000 are listed by Laistner, 1943, pp. 25-30.

15. Avery, ii, 31-33, plate 140.

16. E.g. Leo of Montecassino, pp. 637-38, 642; Loud, pp. 28-31.

17. See esp. DOII, 261 (Oct 981); also DOII, 255, 262, 266, 288, 316. For Volturno's effective landlordship and *incastellamento* in C10, despite the ruinous state of its buildings, see Chris Wickham's contribution to Hodges and Mitchell, esp. p. 248, and for Otto II's support of Volturno against Landulph of Capua, ibid. pp. 238-39.

18. Schiller, iv, 1, p. 85.

19. Winandy, 1950, esp. pp. 93-97.

20. Autpertus, Apocalypse, 422F-H; Bede, Apocalypse, PL 93, cols.135-36. See also Winandy, 1953, p. 36, note 2.

21. Bischoff, 1984, p. 186. St Gall also had an early C11 manuscript, St Gall 245.

22. Volturno Chronicle, p. 287.

23. Al-Hamdani, 1972, i, 427-28; iii, pls. 112-22.

24. Collon-Gevaert, 1967, pp. 27-32.

25. Stephen of Novara was invited by Otto I to lead the cathedral school of Würzburg under Bishop Poppo. For him and Gunzo of Novara, who, with his books was also brought over the Alps by the Ottonians, see Bischoff, 1984, pp. 173-74.

26. Uhrlirz, 1934, p. 220. In fact Uhrlirz emphasizes more the situation of such places on trade routes and the exercise of political power by Otto I in Italy generally through such grants, ibid., pp. 207-34.

27. Ibid., esp. pp. 214-15, 218, 221 (on confirmations of pre-962 grants), 222-23. But Uhrlirz did not put the argument in relation to Ivrea.

28. DOIII, 374.

29. Von Simson, 1987, p. 62, for connotations of Divine Shepherd, Heavenly City and Second Coming, and pls. 21, 22.

30. Clm 4453, pp. 84-89.

31. Bischoff, 1967, esp. pp. 307-11.

32. K. Hoffmann, 1966, esp. p. 17, 20-30, 45-46.

33. Kessler, 1977, pp. 70-78, and fig. 108.

34. One may note the prominence given to the ox in some Reichenau Nativity scenes, where it is detached from the ass and placed immediately under the crib in an almost emblematic manner.

Examples are the Hildesheim Collectar, Hildesheim MS 688, f. 36v, and the Limburg Gospels, Cologne MS 218, the latter illustrated in Schulten, 1980, p. 53, which illustrates the Luke page of that MS at p. 55, where the winged bull also appears above Luke in a roundel. Both manuscripts are early C11, see Hoffmann, pp. 321-22, 329.

35. K. Hoffmann, 1966, pp. 29-30.

36. Fischer, 1926, p. 1.

37. Bamberg, MS Bibl. 22, f. 69.

38. Riedlinger, 1958, pp. 68, 89, note 1, 95, note 3; Ohly, pp. 71-72.

39. For one possibility, a certain Bebo, see Fischer's catalogue, p. 9. The glosses are not, for instance, from Jerome on Isaiah as in Wolfenbüttel Weissenburg MSS 33 and 49. I have not yet examined St Gall, Cod.41, which might be relevant.

40. Clm 4453, p. 117; also Fischer, 1929, p. 21, and Fischer, 1926, p. 6. Klein, 1986, pp. 419-20, dates them *c.* 1000.

41. Peter Klein, 1986, pp. 421-22, has compellingly argued that Reichenau would scarcely have lavished such art and so much purple and gold on these commentaries had they been merely for purposes of theological study within the monastery, and that this speaks for their having been commissioned by Otto III (and it speaks for a theological interest on his part comparable to that of Charles the Bald in C9).

42. Bamberg MS Bibl. 22, f. 38v.

43. Ibid., f. 39. Fischer, 1926, p. 4, takes the figure to represent Christ, so does Deshman, 1976, p. 371.

44. Hoffmann, p. 333; see also K. Hoffmann, 1966, pp. 20-23.

45. For an example of an earlier *Ecclesia orans* with crown (Rome mosaic of *c.* 700, now in S. Marco, Florence) see Anton Mayer, 1962, plate 3. Also Schiller, iv, 1, pp. 39-40 and figs. 98, 100. In none of the Ascensions in Schiller, iii, figs. 457-85 is Christ crowned.

46. Fischer, 1926, p. 4. As also assumed by later commentators, e.g. Otto of Freising in C12, Two Cities, vii, Prologus, p. 309, lines 10-17: *Verum quia regno decrescente, ecclesia, ut dixi, ... in presenti quoque in magnum montem crescens in magna auctoritate stare cepit.* Cf. Ibid. vi, ch. 36, p. 305.

47. Vivian Bible, Paris MS lat. 1, f. 130v, see Köhler, 1930, Pls. I, 89f.

48. Bamberg, MS Bibl. 95, f. 8v, showing Joseph's Dream, is illustrated in Grabar & Nordenfalk, p. 213.

49. Fischer, 1926, p. 3, emphasizes the originality of the Daniel illustrations, however, or their individuality in the use of models, citing Vöge as saying that there is no trace of a *schema*, ibid., p. 8.

50. Grimme, p. 93, K. Hoffmann, 1966, pp. 45-46. I doubt that it is necessary to posit an intermediary between the Vivian Bible and the Aachen Gospels.

51. Illustrated, Mütherich & Gaehde, plate 22, p. 78.

52. Illustrated in Porcher et al, p. 139.

53. Lorsch Gospels, f. 14, interpretation by Walker, 1948. Indeed, the main group in the Bamberg Song of Songs, between the three women and the four kings, actually comprises fourteen figures.

54. Wehlt, pp. 43-46, 97-98.

55. Schiller, iv, 1, p. 23.

56. Haymo of Halberstadt, Apocalypse, PL 117, col. 1081C-D.

57. Brühl, 1968, p. 466, note 71.

58. Bullough, 1965, pp. 149-50, 166; Folz, 1974, p. 105.

59. Clm 4453, p. 88; K. Hoffmann, 1973, pp. 330-31.

60. Bamberg, MS Bibl. 22, f. 6v.

61. Schiller, iv, 1, p. 47.

62. Ibid., p. 101.

63. Ohly, pp. 69-92, esp. pp. 69-70 and 92, note 1.

64. Fischer, 1926, pp. 4-5.

65. Deshman, 1976, pp. 381-82. The earliest known representation of the three Magi with crowns is in the Utrecht Psalter (*c.* 830), f. 41v before Psalm 71, see Utrecht Psalter, Kommentar, p. 46. They illustrate the kings of Tharsis mentioned in that psalm. It is true that this is not the ordinary Epiphany scene in that it lacks a representation of Mary and her Child, but in so far as these kings bearing gifts had traditionally been taken to typify the Magi, the Utrecht Psalter must be considered to illustrate the Magi with crowns. Nonetheless other C9 depictions, such as the Antwerp Sedulius (Alexander, 1978, fig. 291) or the Stuttgart Psalter (Schiller, i, p. 115 and fig. 264), still retain the Phrygian hats with which late antique artists depicted the Magi.

66. Sigebert Sacramentary, f. 19v; Pericopes Book of Henry II, f. 17v, both illustrated in Ruth Meyer, 1967, ills. 12 and 13, p. 189. Type B is a votive crown in Schramm's terminology, a sort of crown derived from Visigothic hanging-crowns, but used for heads also. Schramm gives no grounds for thinking that such crowns can-

67. For this number of apostles, see J. Myslivec, 'Apostel', in Lex. christ. Icon., i, 151. The fact that there are fourteen figures between the three women and the four kings in this illustration, see note 53 above, may be no coincidence.

68. Prayer Book of Otto III, f. 24v.

69. Alcuin, PL 101, col. 1400B; Arnulph II of Milan, BL, Egerton MS 3763, f. 118; Fulda Saints' Lives, Hanover MS 189, ff. 37v-38; Egbert Psalter, Cividale del Friuli, Museo Archaeologico Nazionale, MS CXXXVI, f. 228 (this prayer is not mentioned in Sauerland & Haseloff).

70. Bamberg, MS Bibl. 22, ff. 18-20v. See Laistner, 1943, pp. 61-62.

71. Ruth Meyer, p. 186.

72. Bamberg MS Bibl. 22, f. 18, for the opening: *Mulier fortis ecclesia catholica vocatur, quam Johannes in Apocalypsi amictam sole, id est Christo vidisse perhibetur quae spiritales deo filios ex aqua et spiritu sancto generare non cessat, quae ideo fortis vocatur*, etc. The ending is: *Surrexerunt filii ejus ... transcensis saeculi aerumnis, ad coelestia regna perducuntur*. PL 91, col. 1050D.

73. But too much has sometimes been made of this limitation; see, for instance, the obvious references to the Pseudo-Dionysius in the Regensburg Uta Codex (*c.* 1020) and its picture of Bishop Erhard of Regensburg, Boeckler, 1954, p. 223. On the contrast between the background colours of the two illustrated pages, Berno of Reichenau in one of his letters refers to the *ascensum purpureum* and the *reclinatorium aureum* of Song of Songs 3:10, see Berno, no. 11, p. 38.

74. Schramm & Mütherich, no. 101b

75. Podskalsky, 1972, pp. 44-59, esp. 44, note 275, p. 53, pp. 58-59.

76. Some of this literature, e.g. Pseudo-Hippolytus's Vision of Daniel, could apparently have been known to Adso of Montier-en-Der (see below) before Liudprand saw it in Constantinople, see Paul Alexander, 1985, pp. 98-122. A Latin translation of the Syriac Apocalypse of Pseudo-Methodius was circulating in the West by the late C8 (Sackur, *Sibyllinische Texte*, p. 57), which implied that the Byzantine Empire would last to the final consummation of the world, and one would think to read this text (English translation, Paul Alexander, 1985, pp. 36-51) that Adso must have known this also. Liudprand, *Legatio*, ch. 39, p. 195.

77. Schramm & Mütherich, no. 109.

78. Adso of Montier-en-Der, p. 101; for date of the work, see pp. 2-3. Adso surely refers to the *East*

Franks and not the West Franks here; the *Vita* of Radbod of Utrecht suggests that from a West Frankish point of view, the West Franks were undergoing a *humiliatio* at this time and the East Franks a *sublimatio*, see Bornscheuer, pp. 88-89. The medallions in the Ste Chapelle Gospels, f. 16, refer to tenth-century Saxon rulers as 'kings of the Franks'.

79. Abbo of Fleury, *Liber Apologeticus*, PL 139, cols.471-72. For an interesting discussion of millenniaristic phenomena in C10, including that mentioned by Abbo of Fleury, and also the limits to millenniarism then, see Henri Focillon, *The Year 1000* (New York, 1971), pp. 39-72.

80. Ferrari, 1957, pp. 30-31, 188, 256.

81. Bamberg, MS Bibl. 126, see Fischer, 1907, p. 372. For Odilo's relations with Otto III in general, see Hourlier, 1964, esp. pp. 61-67.

82. Fischer, 1907, p. 387.

83. Clm 4453, pp. 70-71.

84. Otto, 1881, pp. 17-18; Cousin, 1954, pp. 124-27.

85. Sackur, 1898; Pseudo-Methodius maintained that Anti-Christ would arise in Chorazim (p. 41), Adso that he would arise in Babylon (p. 102), the Tiburtine Sibyl that he would arise from the tribe of Dan and rule in Jerusalem (pp. 185-86). See also Paul Alexander, 1985, pp. 195-97.

86. Folz, 1974, pp. 92-93.

87. Barbatti, 1953, esp. pp. 132-33, 135-37.

88. Ullmann, 1955, p. 246. This poem was the third of the principal evidences for Otto III's *Renovatio Imperii Romanum* mentioned in Part I, p. 160. The other two were Otto III's seal of 998, and Otto III's Gospels.

89. Schramm, 1929, i,119-29; ii,62-64.

90. Fleckenstein, p. 95, note 249.

91. Ibid., p. 91, note 213.

92. Bloch, 1896-97, esp. pp. 62-73. Pauler, pp. 39-42, effectively defends the authenticity of Otto III's documents for Vercelli against Manaresi.

93. This is convincingly argued by Fleckenstein, p. 91, note 213.

94. Schramm, 1929, i, 64-67.

95. DOIII, 324.

96. Schramm, 1929, i, 119-30, and text, ii, 62-64.

97. Ibid., i, 124, note 4. The phrase *duo luminaria* was used, for instance, by Pope Nicholas I (858-67) in connection with papal and kingly powers, see Ullmann, 1955, p. 198.

98. *Ad vindictam peccantium fert invictum gladium*: St Paul to the Romans, 13:3, includes the phrase *gladium portat*, while 1 Peter, 2:13, includes the

phrase *ad vindictam malorum*. Hence according to Bloch, 1896-97, pp. 95 and 114, Peter and Paul were the saints from whom the worldly sword was entrusted to the Emperor.

99. Bloch, 1896-97, p. 95, note 1; for this style see DOIII, 389 (the first surviving example and a draft of Leo), 390, 391, 397, 404, 406, 407, 409, 410, 412-23.

100. Schramm, 1929, ii, esp. p. 64, lines 30-32, p. 62, line 3 (of poem), p. 63, lines 19-24.

101. Bamberg, MS Canon. 1, f. 13v.

102. Fischer, 1907, p. 383. See also Mütherich, 1986, p. 18.

103. Isidore of Seville, De Nat. Rerum, ch. 37, pp. 295-99, cf. Apoc. vii,1.

104. Blank, 1968, pp. 120-35. The view that Henry II most likely brought the book from Italy in 1022 (ibid., p. 120) would not be generally accepted, see Turner, 1960, pp. 388-89; J. W. Thompson, 1939, p. 216; by implication Fischer, 1907, p. 383; and en passant, Bischoff, 1984, p. 176, note 16, and p. 187.

105. Leitschuh, i(v)(1906), p. 851.

106. Bamberg, MS Canon. 1, ff. 14v-43, 60-87v, and 88-102v. Gisilher had effected the suppression of the bishopric of Merseburg in order to be translated thence to the archbishopric of Magdeburg, see Claude, 1972, i, 136-46, and Fischer, 1907, p. 381. It is perhaps relevant here that Gisilher was himself an opponent of Otto III's Rome policy, see Part I, p. 162.

107. Schramm & Mütherich, no. 102, pp. 199-200.

108. Schramm, 1929, i, 50-57.

109. Magnani, 1934, Tav. XXXV.

110. DOIII, 376, and Magnani, 1934, Pl. VIII, f. 23v.

111. Deshman, 1971, esp. p. 16.

112. Vercelli, Bibl. Capitolare MS 165, see Deshman, 1971, p. 16, and M.W. Evans, 1969, plate 28.

113. Bischoff, 'Zu Plautus und Festus', 1966, p. 143. Cf. Blank, 1968, pp. 102-03, and Fischer, 1907, p. 384.

114. T. Mayer, 1952, pp. 280-84; G. Zimmermann, 1959, pp. 208-09.

115. Fleckenstein, 1964, and DHII, 152-53; G. Zimmermann, 1959, p. 210.

116. O. Meyer, 1966, pp. 1-3; Fischer, 1907, pp. 371-72.

117. T. Mayer, 1952, pp. 272-74; Lesser, 1888, pp. 12-17.

118. Fleckenstein, pp. 178, 187.

119. DOIII, 396.

120. Fleckenstein, pp. 100-01.

121. DHII, 397, 493.

122. Thomas, 1968, pp. 182-83.

Notes to Chapter 2:

1. Thietmar, i, ch. 15, p. 34.

2. Quoted in Tellenbach, 1966, p. 54.

3. Thietmar, ii, ch. 28, p. 72 (Otto I); iii, ch. 6, p. 104 (jokes); iii, ch. 9, p. 108, and iv, ch. 28, p. 165, lines 24-25 (for examples of Liudolf of Corvey and Adalbert of Prague at mass); iv, ch. 14, p. 148 (Lotharingians).

4. See, for instance, H. Zimmermann, 1965.

5. *Praeloquia*, iii, ch. 9, PL 136, col. 224C.

6. H. Chadwick, 1959.

7. Cf. Journ. Theol. Stud. 24 (part 2) (1973), p. 605.

8. The work which most clearly reflects this tendency is Santifaller, 1964, esp. pp. 28-41, and for the secular aristocracy, pp. 38-39.

9. Fleckenstein, 1974, pp. 145-55; Leyser, 1979, pp. 98-107; Reuter, 1982, pp. 348-57.

10. Implicit e.g. in DOI 295: *sive nostro iuri aspiciat sive alicui fidelium nostrorum beneficiarum existant*; or in DOI 406: *ut antea quam comes earundem regionum partem sibi a nobis concessam auferat atque distribuat.*

11. See Leyser, 1981.

12. An attempt was made by Otto III to bring even such a recluse as St Romuald into the framework of ecclesiastical authority, see Part I, p. 157.

13. E.g. Ebbo of Rheims (816-34), Thegan, chs. 20, 44, pp. 595, lines 15-19ff., and p. 599; Wolfgang of Regensburg, see note 17 below; Willigis of Mainz and the comments from which Thietmar defended him, Thietmar, iii, ch. 5, p. 102.

14. Ruotger, ch. 20, p. 19, line 19 (royal priesthood); chs. 12, 30, pp. 12, line 25, 31, lines 16-18 (terror); chs. 9, 30, pp. 9, line 19, 30, lines 20-23 (prayer).

15. Thietmar, iii, ch. 26, p. 130: *hostibus cunctis horrendus commissisque gregibus inexpugnabilis murus.*

16. Vita Udalrici, ch. 14, p. 403.

17. Vita Wolfgangi, ch. 21, pp. 535-36.

18. Ruotger, ch. 37, p. 39, lines 7-8.

19. Vita Udalrici, ch. 12, p. 401, lines 29-32.

20. See Bernheim, and also Prinz, ch. 6, on Bruno of Cologne. For a manuscript of Augustine's *City of God* made on the order of Archbishop Willigis of Mainz, see Falk, 1897, pp. 8, 109, and Hoffmann, pp. 237-38.

21. Ruotger, ch. 23, pp. 23-24.

22. Ruotger, on last point esp. ch. 37, p. 39, and p. 39, note 4.

23. One is reminded of St Boniface's request to Abbess Eadburg (735) to send him a copy of St Peter's Epistles written in gold letters to secure honour and reverence for the holy scriptures in the eyes of carnal men, Epp. Bonifatii, no. 35, p. 60.

24. Codex Egberti, p. 22, and on Egbert's career in general, ibid., pp. 20-29, and Sauerland & Haseloff, pp. 10,14.

25. The Hague, Royal Library, MS 761/1, ff. 214v-215, see Prochno, pp. 63-64, and ills. 63* and 64*.

26. Fleckenstein, pp. 47-49, 52-58.

27. Codex Egberti, pp. 25-28.

28. Westermann-Angerhausen, esp. pp. 21-47, 63-72, 79-100; this is altogether a fine work of scholarship. See also, Lasko, 1972, pp. 95-99. On the Servatius Cross, a Trier work which gives the royal attribute of a crown to the crucified Christ, see Deshman, 1976, pp. 368-70.

29. Codex Egberti, pp. 30-36.

30. Havet, no. 104, trans. Lattin, no. 110, p. 145.

31. Trans. S. Celsi, p. 207, lines 4-8.

32. For this master, see Grabar & Nordenfalk, pp. 200-03; Hoffmann, pp. 103-26; and also pp. 188-94 above as well as Part I, pp. 39-42; for the connection of the Gregory Master and Trier, see Nordenfalk, 1972, esp. pp. 63, 66-69.

33. Pächt, 1986, p. 184; see also Sauerland & Haseloff, p. 71.

34. Grabar & Nordenfalk, p. 201. Nordenfalk, 1985, reinforces the case for Otto II against scholarly challenges.

35. Sauerland & Haseloff, pp. 45-46, for a list with folio numbers.

36. Boeckler, 1949, pp. 8-16. One should note that St Gall, whose initial ornament clearly influenced Reichenau, knew the figure of a saint standing en face giving a blessing, e.g. in the Psalterium Aureum, C9/C10, p. 14 (Merton, p. 39). For Egbert's visits to Italy, Sauerland & Haseloff, p. 14; Codex Egberti, pp. 23-24, 27-28, pp. 178-79, note 69.

37. Prayer Book of Archbishop Arnulph, BL, Egerton MS 3763, e.g. ff. 106v, 107v, 109v, 111v, 112v etc. For the Ivrea Psalter (Cod. LXXXV), e.g. ff. 229v, 230v, 231v, 232v, 234, etc.

38. Sauerland & Haseloff, pp. 50-52.

39. This is implicit in the primatial claims of Trier over Rheims in C10, see p. 66. For the use of such terms in general at this period, see Clm.

4453, pp. 145-46, and in connection with Richer of Rheims, Kienast, ii, 487-88.

40. Boshof, 1972, esp. pp. 46-80, and Boshof, 1978.

41. Thomas, pp. 137-41; Boshof, 1972, pp. 49-58.

42. Vita S. Paulini Trev., ch. 7, pp. 676-77, and for the date, see Boshof, 1972, p. 51, note 21.

43. Sauerland & Haseloff, p. 108.

44. As with the evangelist illustrations and initial letters in the later Aachen Gospels, see Grimme.

45. Sauerland & Haseloff, pp. 85-104, with an admirably clear summary of the method at pp. 103-04.

46. Ibid., p. 121. Haseloff also related the Gero Codex and the Eburnant Group in general to the Egbert Psalter by the use in both of the Ada Group MSS of the Charlemagne Court School, ibid., pp. 130-32.

47. Haseloff raised this question, pointing out that, given the same painter in the Egbert Psalter and Poussay, if the scribe were also the same, this might mean that scribe and painter could be equated. But though he saw similarities in the hands, he did not think it was clear that they were the same (Sauerland & Haseloff, pp. 86-87). The caution in this conclusion would certainly be echoed by Hoffmann, pp. 315, 337-38, who also points out that Ruodpreht, if he commissioned the manuscript, need not have been a Reichenau monk.

48. Sauerland & Haselofff, pp. 3, 14.

49. Ibid., p. 14, and Hoffmann, p. 315.

50. Vita Udalrici, ch. 3, p. 389, lines 40-41: totumque psalterium omni die explere solitus erat, nisi si eum impediret aliqua inevitabilis necessitas. The author, Gerhard, also mentions a small book with an abridged psalter and other prayers (cf. the other prayers in the Egbert Psalter), which Udalric used when he remained in church after prime: ipse remanens in aecclesia, codiculum breviatum ex psalmis cum aliis orationibus interim decantavit (ibid., ch. 4, p. 391, lines 7-8).

51. RB 18, last lines (trans. McCann, p. 67).

52. Vita Udalrici, ch. 3, p. 390, lines 7-10. Cf. RB53.

53. Boshof, 1972, p. 152, cf. ibid., pp. 25-26; Hallinger, i, 79-87.

54. Had all the small New Testament illustrations before the gospel texts in the C6 Augustine Gospels survived, it would presumably prove to have had more gospel illustrations than the Codex Egberti, and there must have been other late antique books like it; F. Wormald, 1954, p. 5.

55. Dodwell & Turner, p. 23.

56. Sauerland & Haseloff, p. 66.

57. Jantzen, pp. 68-70.

58. Codex Egberti, p. 41; Boeckler, 1961, pp. 33-34, where it is shown that the Byzantine representations of the scene are not close parallels to the Codex Egberti. For the Terence manuscript (Vatican, Lat. 3868), see L. W. Jones and C. R. Morey, *The Miniatures of Terence* (Princeton, 1931).The manuscript is designated C in volume 2 (plates).

59. Codex Egberti, p. 48.

60. Weis, 1974, p. 334.

61. For Lenten stations in Rome, already developed by C7, see Klauser, 1972, pp. 19-23, 65-69, 107-11, 146-50. See also Chavasse, 1982 (references at p. 17).

62. Maurer, 1973, esp. pp. 70-77.

63. Thomas, p. 162.

64. Notker, i, ch. 10, p. 14, lines 8-12.

65. Codex Egberti, p. 73.

66. E.g. the much later Berlin Pericopes Book, Cod. 78 A2 (for facsimile, see Bloch, 1972). The first mass has no illustration (ff. 8v-9). The illustration of the second mass, the Annunciation to the Shepherds (9v), would be more relevant to the first mass. There is an illustration of the Nativity for both the second and third masses as the book lies open (ff. 9v-10), in a not very impressive lay-out. In *Poussay*, the Nativity scene is attached, not very suitably, to the vigil of Christmas (ff. 9v-10). The gospel of the night mass, *Exiit edictum*, has only an ordinary initial, but the third mass has a splendid full-page title and full-page initial IN in monogrammic form (for *In Principio*, ff. 12v-13).

67. Ordo L, chs. 2-3, in Andrieu, v, pp. 84-85.

68. Ordo I, ch. 64, Andrieu, ii.89; Ordo IX, ch. 20, ibid., p. 332 (where after the gospel, the subdeacon *exhibeat* the book to be kissed; the word used at this point in Ordo I is *porrigit*; *exhibeat* is the more suggestive of an open book); Ordo X, ch. 34, ibid., p. 357.

69. E.g. Regensburg Uta Codex, Erhard picture, Mütherich & Dachs, pl. 11 (closed); Stuttgart Psalter, f. 108 (Psalm 91) (open); Benedictional of Bishop Engilmar of Parenzo (c. 1028-45), Regensburg (showing a book open on a stand behind the altar), Mütherich & Dachs, pl. 15. A C6 mosaic in the baptistery of the cathedral at Ravenna shows a gospel book open on an altar, see Bovini, pl. 9.

70. Codex Egberti, p. 37 (27 x 21cm); Pericopes Book of Henry II, Leidinger, 1918, p. 4. (42.5 x 32cm, and also heavy).

71. Hiltrud Westermann-Angerhausen, 'Spolie und Umfeld in Egberts Trier', *Zeitschrift für Kunstgeschichte* 3 (1987), pp. 305-36, esp. her remarks at

72. Schiel points out that *communis vita* refers to Acts 2,44-45, but he makes no mention of the monastic movement, Codex Egberti, pp. 146-47.

73. Thomas, p. 181; Heyen, p. 92; cf. Gesta Treverorum, p. 168, lines 8-10.

74. Codex Egberti, f. 29. The other is f. 100. See also the Reichenau sacramentary in Oxford, Bodl. Canon. Liturg. 319, f. 115v. On altar linen, e.g. Ordo X, ch. 33, Andrieu, ii, 357. For altar cloths at Trier, Gesta Treverorum, p. 169, ...*largissima liberalitate ditavit aureis et argenteis crucibus, plenariis, casulis, dalmaticis, tunicis, palliis, cappis, velis cortinisque et possessionibus auxit.* Given the placing of the word, *palliis* probably refers to vestments, but *velis* is likely to refer to altar cloths, see Niermeyer, 1984, pp. 756, 1069. A. A. Häussling, *Mönchskonvent und Eucharistiefeier* (Munster, 1973) largely concerns the Carolingian period, but this is obviously relevant to C10, and see also ibid., pp. 37-40.

75. Sauerland & Haseloff, p. 61.

76. Codex Egberti, p. 45.

77. Hoffmann, pp. 488-89; and for this puzzle, see Nordenfalk, 1972, p. 68.

78. Sauerland & Haseloff, pp. 66-68. Other passages where impressionist criteria show up are at pp. 72, 107, 130.

79. Boshof, 1978, pp. 27-30.

80. Thomas, pp. 136-41.

81. DOII 58.

82. Boshof, 1972.

83. Boshof, 1978, pp. 33-35.

84. Ibid., pp. 34-36. For Mainz and Prague, Büttner, 1975, pp. 306-07.

85. Zender, pp. 208-20. I owe my knowledge of this book to the kindness of Professor Heinz Thomas.

86. Havet, no. 63: *Trevirensem archiepiscopum ... aut se cum duce* [presumably Charles of Lower Lotharingia] *ac Lothariensi regno manibus Francorum velle tradere vosque celare, quod colloquium Virduni habendum verisimile facit, aut his maiora velle machinari.* (Gerbert of Aurillac, July, 985, trans., Lattin, no. 70, p. 111).

87. See now Lauer, 1987, an impressive and comprehensive iconographical study of the Mainz manuscripts, as well as Lauer, 1975.

88. Falk, 1897, esp. pp. 56-69.

89. Ibid., pp. 116-17. On the Swedes, see Nordenfalk, 1971, pp. 19-21; and for another C17 Swedish acquisition, see Alexander, 1978, no. 30, p. 57.

90. Lauer, pp. 258-74.

91. Falk, 1897, pp. 8ff.

92. Hoffmann, p. 244.

93. One may note the lack of influence, stylistic or iconographic, from the sacramentaries of Fulda, the great Ottonian centre of sacramentary production. Lauer, following Schnitzler, argues that Fulda and Mainz independently used New Testament cycles, which he would regard as Middle Byzantine, and which Reichenau also had, for their sacramentary illustrations, Lauer, 1987, esp. pp. 141-44, also e.g. pp. 122-26, Date, *c.* 1000, ibid., p. 262.

94. It is surprising that Lauer, ibid., suggesting a common model of the St Gereon Sacramentary (see pp. 108-9), because of the small number of illustrations in each, does not note this important difference between the two manuscripts.

95. Hallinger, i, 241. The fact that Archbishop Frederick of Mainz was an *Intervenient* for Gorze in a diploma of Otto I (ibid. p. 56, note 15) is given too much weight by Lauer as evidence of the Archbishop's friendly disposition towards Gorze.

96. Hallinger, 1975. Again this article seems to depend too much on documentary 'interventions' and other formal relations of Willigis with monasteries.

97. Lauer, 1987, suggests that it is the work of a man brought by Willigis as Arch-Chancellor to Mainz, a man intensively involved with Byzantine culture and with the legitimation of Otto III's rule in these terms; that he came to St Alban's, Mainz, where there was interest in and concern for western *Königstheorie*, i.e. royal ideology, but no artistic tradition; and that he was himself an inexperienced miniaturist, see esp. Lauer, pp. 157-59. Much of this seems reasonable, though it is not clear why the artist would not as likely be a Mainz resident as an import from the *Hofkanzlei*, nor why the manuscript should have to be before 991 because Theophanu died in that year, as if Byzantine influence at court did not outlive her.

98. Falk, 1897, pp. 4-9. See Hrotsvita, p. 202, line 17, and for a study of Gerhard's letter, Lotter, 1975, text, pp. 109-28.

99. Andrieu, i, 494-508; v, 64, 72-79.

100. E.g. for Meinwerk's use of Greek builders, Vita Meinwerci, ch. 155, p. 82.

101. The text of this important book has not yet been edited and published. Some of the more Christ-centred passages in it are cited above, p. 43 and Part I, p. 173.

102. For gifts of books to Magdeburg, see Part I, pp. 38-39. When Meinwerk discarded unsatisfactory liturgical books at Paderborn, the implication is that he had to import new ones, particularly as there is no mention of a scriptorium where one might otherwise expect it, Vita Meinwerci, ch. 12, p. 21, lines 15-20.

103. Merton, p. 84, suggested that the manuscript of Berno's *Vita Udalrici* (Vienna, Cod. 573) with its author illustration, was an Augsburg copy of a Reichenau exemplar. The palaeographical evidence is against this, see Hoffmann, p. 346, but the Augsburg Sacramentary in the British Library, Harley MS 2908, although written at Seeon, or by a Seeon scribe, was most likely illustrated at Augsburg. *Vermutlich stammt die Buchmalerei von einem bayrischen Provinzmaler*, says Hoffmann, p. 411. See Merton, pl. XCII, fig. 1. For this manuscript in connection with the Assumption of Mary, see Part I, p. 151.

104. The principal writings on the Warmund MSS are: Magnani, 1934, useful for its plates and iconographic notes but leaving much work to be done; Deshman, 1971; Casagrande, pp. 89-139, a palaeographical study with catalogue; and Professione, revised ed. Ilo Vignono.

105. The present writer had the advantage of seeing these paintings (see pp. 23-24) on the day he left Ivrea.

106. Magnani, pls. III, V, XXXV.

107. Lauer, p. 71; Schramm & Mütherich, no. 39, pp. 56-57, 169-70.

108. For a study of the Drogo ivories, see Reynolds, 1981; and for the Ottonian sacramentary, see von Euw.

109. Cod.IV, ff. 1v, 6 recto and verso, 11v-12v, 19v, 28 recto and verso, for my examples.

110. Cod. XX, ff. 4v-5.

111. Ortmanns, pp. 39-43.

112. Berlin MS theol. lat. fol. 2 (sacramentary); theol. lat. qu. 1 (epistles, lost); theol. lat. qu. 3 (gospel pericopes, now with miniature of seated Sigebert, see below); theol. lat. qu. 11 (troper and hymnal, lost); theol. lat. qu. 15 (graduale); theol. lat. oct. 1 (hymnal). Wolfenbüttel MSS Helmstedt 1008 (hymnal and antiphonal) and Helmstedt 1151 (sacramentary and *ordines*). For the surviving MSS see Kunst und Kultur, nos. 203-07.

113. Hoffmann, pp. 374-76, 398.

114. Clark, chapter 7.

115. Wolfenbüttel, Helmstedt MS 1008, ff. 258, 277v-280.

116. Clark, pp. 173-74.

117. Schroeder, pp. 20, 27.

118. Rietschel, plates at pp. 41, 45, 49.

119. Ruth Meyer, pp. 186-88.

120. Ibid., This admirable article is less than convincing only in arguing that the manuscript was painted at Bamberg rather than at Minden (or possibly at St Gall), of which the author is dismissive (... *an einem Orte wie Minden*, p. 194).

121. Ordo, L, ch. 77, Andrieu, v, 215; in Sigebert's Sacramentary at ff. 78 recto and verso. The hymn below is Ordo L, ch. 82, ibid., pp. 216-18.

122. See Kessler, pp. 77-78 for a discussion of this subject.

123. Ibid., fig. 88 (Vivian Bible, Tours, *c.* 846).

124. Messerer, 1952, pp. 67-70, pls. 72-73.

125. PL 101, col. 1241 B-C, and for the relevant place of Amalarius, PL 105, cols. 1100-01). For date, Andrieu, 1925, pp. 642-50. See also Hrabanus Maurus in C9 on the ephod, treating it as if it were a garment for priests in general, signifying their good works and duty to teach, in his De Instruct. Cler., col. 306. The rationale seems only in C10 to become considered a distinctive garb of bishops; also Ruth Meyer, p. 188.

126. Gregory, Regula Pastoralis, PL 77, col. 29A-B: ... *quatenus nobilitatem semper intimae regenerationis aspiciat.* Honselmann, 1975, gives the text of Gregory's Letter to the Eastern Patriarchs of 591 (similar to Reg. Past.) at pp. 101-2, a prayer relevant to the putting on of the rationale from a sacramentary of Bishop Sigebert at pp. 107-08; he discusses Sigebert's rationale (see pl. 13), without reference to colour or Gregorian texts at p. 51.

127. Berlin, Staatsbibliothek, MS theol. lat. fol. 3, a book of the gospels with ornamentation older than the Sigebert MSS, a fine script, and use of gold for canon tables and first lines of gospels. The book was described by the C15 antiquary, Hermannus de Lerbeche, who recorded the dedication verses about Bishop Milo, presumably on the gold cover which no longer survives. The ivories presently on the front are C11 Byzantine. See Schroeder, p. 18, and Valentin Rose, no. 263.

128. Text of Bishop Milo's letter, Kolberg, pp. 17-19.

129. Ruth Meyer, p. 191. At several points in this article, Meyer refers to the mingling of St Gall and Reichenau influences in the art of the sacramentary.

Notes to Chapter 3:

1. Hitda Codex, pp. 78-79.

2. Bloch & Schnitzler, ii, 93-97, 100, 102, 109-10. Also Hitda Codex, p. 79.

3. Dodwell, 1971, pp. 67-68. Note that most scholars (and also the present author) would now read 'Reichenau' for the second reference to Trier in this passage.

4. Bloch & Schnitzler, i, 43.

5. Abbess Hitda must fall between Thiezswied, mentioned in 978, and Gerburgis in 1042, Hitda Codex, pp. 76-77.

6. Hitda Codex, pp. 106-07.

7. Marcel Mauss, *The Gift* (London, 1974 ed), pp. 9-10, 13-14, 40-41.

8. Hitda Codex, Pl. 1.

9. For reproductions of the surviving pages of the Trier manuscript of the Gregory Master in Manchester (John Rylands Library Cod.98), Bloch & Schnitzler, ii, 15-21, and figs. 1-39. Its evangelist portraits have disappeared.

10. Ibid., pp. 106-07.

11. Hallinger, i, 99-106. Bloch & Schnitzler, i, pl. 82, Kalendarium, f. 7; Thietmar, iv, ch. 53, p. 192.

12. Hitda Codex, p. 82.

13. CC 120, p. 49, lines 1208-09; and also lines 1211-12: *... qui ad dexteram patris sedet in diversorio loco eget* ... Zoepf, 1908, p. 109, has shown that this motif was a topos in C10, citing several examples from the writings of Hrotsvitha and Rathier, but C10 schools were heavily influenced by Bede, who is thus likely to have been the common source. In any case the character of such *tituli* remains, whatever the source of their ideas.

14. CC 120, p. 66, lines 1852-54. On the fulfilment of scripture, i.e. the stipulations of Leviticus 12:6-8, see Bede, ibid., p. 63. Alcuin (PL 101, col. 1181) and Hrabanus Maurus (PL 110, cols. 19-20) are at the relevant points quite different from and clearly no source of the *titulus*.

15. Gregory, Moralia, i, ch. 12, PL 75, col. 534B. Alcuin on St John (PL 100, cols. 853-55) is quite different.

16. Carmina Sangallensia no. VII (C9 tituli of St Gall wall-paintings), p. 328.

17. Ibid., p. 327.

18. Bloch & Schnitzler, i, pl. 86, f. 12v, the illustration of the Nativity being f. 13.

19. Bloch & Schnitzler, ii, 95-96, where it is plausibly suggested that the scene is put together from Magi scenes (cf. ibid., i, pls. 100, 129) with Pilate having been drawn from a Herod in such a scene.

20. Ibid., ii, 96.

21. Wilmart, 1971, pp. 101-25.

22. Hitda Codex, p. 94.

23. Grundmann, 1936. I owed my knowledge of this famous article originally to Patrick Wormald.

24. Bloch & Schnitzler, ii, 104.

25. Boeckler, 1961, p. 27. For the Byzantine model, Bloch & Schnitzler, ii, 106.

26. Leyser, 1979, pp. 56-60; DOI, 206, p. 285, lines 2-3: *... hereditatem quam sibi Folcmer et Bunica filii ipsius moriendo reliquerunt.* Leyser also shows the way in which such nunneries as Meschede could build up huge possessions and how dispositions of inheritance favoured the institution, esp. ibid., p. 69.

27. 'The dense throng of heads' as well as the terse gestures are features of the dramatic vocabulary of the Hitda Codex noted by Bloch & Schnitzler, ii, 99b. See the Byzantine manuscripts mentioned ibid., and the remarks at ii, 106, about the bier-bearers of Nain, for the Byzantine aspect.

28. *Ailredi Rievallensis, Opera Omnia*, ed A. Hoste and C. H. Talbot, CC1 (Turnhout, 1971), pp. 662-73.

29. Bloch & Schnitzler, ii, 107-08.

30. Gregory, Moralia, PL 75, col. 511A-B.

31. Ruotger, ch. 30, p. 30, lines 23-30.

32. Navigatio Sancti Brendani, pp. xxviii-xxx.

33. Neuss, 1964, i, 173-74, 464.

34. Navigatio Sancti Brendani, ch. 10, p. 21.

35. Gregory, Moralia, xxx, 2, PL 76, cols. 522-23.

36. Gregory, Dialogues, on Bishop Sabinus of Piacenza, iii, ch. 10, pp. 154-56.

37. Gregory, Moralia, ii, 74, PL 75, col. 590B-C: *Et scimus quod immundi spiritus, qui e coelo aethereo lapsi sunt, in hoc coeli terraeque medio vagantur ... Sed tamen unus incolumis fugit ...*

38. Bloch & Schnitzler, i, pl. 86.

39. Letter to Leander of Seville, PL 75, col. 516A; Moralia, xviii, 85, PL 76, col. 90A-B, where also: *aeternus ante saecula, temporalis posset esse in fine saeculorum*, and Moralia, xxxiii, 35, PL 76, col. 272B-C; Moralia, xxii, 42, PL 76, cols. 237-38; Moralia xxv, 30, PL 76, cols. 340-41.

40. Epp. Gregorii, ix, 208 (ii,195), and xi, 10 (ii, 269-72).

41. See, for instance, the magnificent representations of Gregory, by the Gregory Master (Part I, p. 31), in the St Gereon Sacramentary (Bloch, 1963, pl. 6), and in the Regensburg Sacramentary of Henry II. See also Schnitzler, 1956.

42. Vita Johannis Gorz., ch. 83, p. 360: *In his primum Moralia beati Gregorii ordine quam sepissime per-*

currens, pene cunctas ex eo continentias sententiarum ita memoriae commendavit, ut in communibus exortationum sive locutionum confabulationibus omnis eius oratio ex eiusdem libris decurrere videretur.

43. Cf. the Gregory Register at Trier, for instance, and the references in note 41 above.

44. Epp. Gregorii, ii, p. XVII, i.e. Cologne MS 92.

45. Epp. Bonifatii, no. 75, p. 158: *fraternitati tuae direxi exemplaria epistolarum sancti Gregorii, quas de scrinio Romanae ecclesiae excepi, que non rebar ad Brittaniam venisse.* Ibid., no. 60, of Pope Zachary to Boniface (31. 10. 745) suggests that Cologne was to be his see, but there was opposition to this, and the deposition of Gewilib of Mainz in 746 made it possible for Boniface to become archbishop there. Only under Charlemagne did Cologne's metropolitan status become a reality for the first time since Roman times, Neuss, 1964, i, 143-44.

46. Lotter, 1958, p. 39, and p. 39, note 80; see also the interesting citation of Gregory's Homilies on the Gospels, ibid., p. 40, note 82.

47. Ruotger, ch. 14, p. 13; ch. 25, p. 26, line 15; ch. 9, p. 9; and ch. 30, p. 30. Gregory, Moralia, xxx, 8, see Butler, 1926, p. 178.

48. Ruotger, ch. 8, p. 8, line 19 (*refugium factus egenis*); ch. 30, p. 31; Gregory, Reg. Past. iii, 2, PL 77, esp. col. 52C.

49. Ruotger, ch. 34, p. 34, lines 31-32; HE, i, 27 (Responsio II); *Non enim pro locis res, sed pro bonis rebus loca amanda sunt.*

50. Lotter, 1958, p. 40, note 82.

51. Compare with the Egbert Psalter, where each pair of ornamented frames of the Trier archbishops and those of the first letter of every tenth psalm opposite are the same, affording another example of the integration and parity of text and illustration, see pp. 66-67.

52. Bloch & Schnitzler, ii, 95.

53. Schiller i, figs. 143-56.

54. Thietmar, ii, ch. 24, pp. 68-69.

55. Gregory, Hom. in Evang. viii, PL 76, esp. col. 1104.

56. Gregory, Moralia, xxviii, 33-34, PL 76, cols. 467-68, esp. 468A.

57. Epp. Gregorii, ii, 50, esp. p. 153, lines 3-15.

58. Ibid., v, 44 (i, 338-43, esp. p. 340, lines 21-22, and p. 341, lines 3, 6-10).

59. See Boshof, 1978. Fichtenau, 1984, pp. 18-36, discusses the whole issue of these struggles. Salzburg and Hamburg must come into the reckoning too as having papal privileges of pallium-wearing, but the Magdeburg privileges of

968 and 981 show that they were not in the same league as the other four, Zotz, pp. 159-63.

60. Ruotger, ch. 27, p. 27, line 18. Cologne MS 94 (dated in the catalogue C10/C11), f. 165v.

61. Beumann, 1972, esp. pp. 395, 407.

62. That Cologne and Magdeburg, at least, were regarded, and regarded themselves, as equals is suggested by the seating order of a general synod of the German church in 1027 at Frankfurt, when the episcopal *cathedra* in the east of the church was taken by Archbishop Aribo of Mainz, while flanking the throne of Conrad II in the west were the archbishops of Cologne and Magdeburg, see Fichtenau, 1984, p. 33. Fichtenau adds that fortunately Pilgrim of Cologne had consecrated Huntfrid of Magdeburg in 1023, so that there was no problem about Cologne being on the ruler's right and Magdeburg on his left. On the number of times the pallium might be worn, whereby metropolitans tried to increase the *honor* of their sees, Bruno of Cologne seems to have obtained a papal privilege granting him the right to wear it whenever he wanted, thus trumping all the other metropolitans. But this seems to have had no practical importance when Benedict VII's privilege for Archbishop Gisiler of Magdeburg in 981 granted Magdeburg, together with Mainz, Trier and Cologne, *aequalitas per omnia* (see Zotz, pp. 157, 163-64).

63. Boshof, 1978, pp. 31-32.

Notes to Chapter 4:

1. Lauer, pp. 142-44. For distinctively late antique, or early Christian, iconography in the Göttingen Sacramentary (e.g. the Baptism of Christ and the Ascension), see Zimmermann, pp. 54-55. There are also Byzantine elements in its Christ scenes, ibid., pp. 56-57.

2. Behind the Worship of the Lamb in C6 and Carolingian apocalypses which form the common background here (Laufner & Klein, esp. pp. 107-12) see C4 fresco in the cemetery of Saints Peter and Marcellinus, Rome, of a Lamb standing on a mound, for the sort of origins of this iconography in the West, du Bourguet, p. 171.

3. i.e. 936, 943, 947-48, 955, 961-62, 968-69, 981-82, see Wehlt, pp. 275-78.

4. Eigil, chs. 4-10, pp. 367-70, trans. Talbot, pp. 183-88.

5. Epp. Bonifatii, no. 86, p. 193: *Est praeterea locus silvaticus in heremo vastissime solitudinis in medio nationum predicationis nostrae.*

6. Eigil, ch. 7, p. 369, lines 6-7.

7. Freise in K. Schmid et al., esp. pp. 1012-13, 1029, 1062, 1067, 1073-77, 1098, 1102-04, 1166, 1176.

8. See Stengel, 1960, esp. pp. 253-54, 315-19. Stengel points out that Mainz was originally a refuge for Fulda from the authority of Würzburg, a connection strengthened when Hrabanus Maurus was archbishop of Mainz, but that in late C9 and C10 there was tension between Mainz and Fulda (though it was clearly not absent at the time of Boniface's death, see below). The same theme of struggles for freedom from episcopal control by monasteries, in connection with the archbishops of Trier and the bishops of Toul, has recently been discussed by Nightingale. From his work it is clear that the acceptance of the Gorze Reform did not stop monasteries struggling for their independence.

9. Quedlingburg Annals, p. 82.

10. See, for instance, the insistence on it in his early diploma for Memleben, DHII,25 (1002): *Sintque illis* [i.e. the abbot and monks] *per omnia iure stabilitatis similes et aequales ad regulam sancti semper Benedicti communiter viventes*, etc.

11. See Hallinger, i, 218-23.

12. Zimmermann, p. 3; Hoffmann, p. 150.

13. Klauser, 1969, p. 73.

14. Zimmermann, pp. 4-6. It is no argument for Group I miniatures belonging to an older tradition of Fulda art than do the other groups, however, that the style of Group I is not repeated in later manuscripts (Zimmermann, pp. 21, 53-54). The texts of the *ordines* with which Group I miniatures are associated do not themselves appear in the later Fulda sacramentaries, and the Group I artist may have been particularly associated with these texts.

15. For Fulda art of the period of Hrabanus, see Mütherich, 1980, and also the illustration in Hubert et al., p. 194.

16. Laufner & Klein, p. 89.

17. See, for example, the procession to a church with candle-bearers and thurifer in the Stuttgart Psalter, f. 118v, and the wonderfully original and lively illustrations for the *ordo in agenda mortuorum* in the Warmund Sacramentary, Magnani, pls. XXXV-XL.

18. This *contra* Zimmermann, p. 54, who supposes that there must be Carolingian models for the sacramental subjects because their style is so similar to Carolingian Fulda.

19. See Andrieu, ii, pp. 380-447, for discussion of the evidence and the text of the *ordo* from the Roman sacramentaries. Manuscripts of C9-C11, ibid., pp. 365-66. See also Chavasse, 1948.

20. Sacramentarium Fuldense, pp. 329-43 (Baptism, pp. 343-54).

21. Drogo Sacramentary, f. 87v, feast of St Paul, June 30.

22. Sacr. Fuldense, p. 330. The origin for adults is suggested by the placing of males on the right and females on the left. It is worth noting, however, that this sacramentary contains, after the *scrutinium* and baptism, a rite *ad catecizandum paganum*, i.e. prayers and liturgical signs for the beginning of a convert's instruction in the Christian faith, ibid., pp. 354-55.

23. For Hrabanus Maurus on godparents at baptism, see De Inst. Cleric. i,26, PL 107, col. 311B.

24. Sacr. Fuldense, pp. 330-32; Grégoire, p. 165, no. 19.

25. Wallace-Hadrill, 1983, p. 319.

26. P. Hofmeister. For the tendency against monks serving churches, pp. 242-53, but an example the other way is noted at p. 251. See also Berlière, 1927, esp. pp. 236-38 for C9-C10, and Constable, esp. pp. 373-74, where it is argued that during C11 the pastoral ministry of monks became normal.

27. K. Schmid et al., 2/2, pp. 743-44. On Burchard of Worms' opposition to monks serving parish churches, see Fournier & Le Bras, p. 395. But the size and wealth of Fulda would have given it unusual capacity to hold out against bishops in these and other matters.

28. Rudolf, Miracula, ch. 1, p. 330, lines 21-23. Cf. also his reference to Hrabanus's activities of church-building immediately before this, ibid., lines 16-19.

29. Sacr. Fuldense, pp. 282-83.

30. MS Kassel theol. 4° 24; see Lehmann, 1941, p. 231. For the general importance of Fulda in the development of Old High German, not least in the use of the vernacular for pastoral purposes, see Freydank, esp. For the Fulda OHG Baptismal Vows of *c.* 830, pp. 129-30. For the OHG translation of Tatian and for the Heliand, see Part I, p. 87. A Freising manuscript of C9, mainly devoted to Isidore's *De Officiis*, opens with a Latin/Slav vocabulary of pastorally useful words (Munich, Clm. 6325). At the end comes a list of what all ecclesiastics should know, followed by a section on what people must know for baptism, including a reference to Augustine's *De Rudibus Catechizandis*, followed at f. 137 by a short passage *De Scrutinio* on ascertaining that catechumens have remembered and understood what they heard and that they heard with good dispositions. It is one of the episcopal handbooks illuminatingly discussed by McKitterick, 1977, pp. 40, 211-15. For

our purposes, the conjunction of a passage on the *scrutinium* and a vocabulary, and the Freising origins of the manuscript, are relevant to notice.

31. Sacr. Fuldense, pp. 208, 369. The blessing at p. 369 comes, like many others, from the Gregorian Sacramentary (Deshusses, p. 476, no. 1460), but the selections from this compilation are very varied and thus not without significance. The masses, with intermission for the rites of confession, visiting the sick, and anointing the dying, are at pp. 202-329; the blessings, after the scrutinium and baptism, occupy pp. 354-80.

32. See Sacr. Fuldense, p. XI, where Richter supposes that it could still have been at Fulda in the sixteenth century.

33. Zimmermann, p. 10.

34. E.g. Stuttgart Psalter, ff. 31, 42v, 67v, 113v, 140v (where the swordsman is like the dancing figure in the middle of the stone-throwers).

35. E.g. for the standing Christ in mandorla ff. 26v, 55v; for the figure below, though standing where Stephen kneels, ff. 34v, 49 (several figures), 56v.

35a. The book was reconstructed brilliantly by Wilhelm Koehler; for reference (and also for my one reservation) see p. 229. The comparison, not made by Koehler himself, can best be considered at his pp. 61-66.

36. For descriptions of the picture cycles, subject by subject, in the Fulda sacramentaries, see Zimmermann, pp. 41-53.

37. See Greenaway, 1955, p. 80; Radbod, Vita Bonifatii, p. 73: *Michi ... relatum est adhuc superstitem esse quandam mulierem, sed iam valde decrepitam, que iureiurando asserebat, se decollationi militis Christi fuisse presentem, dicebatque, quod, cum gladio feriendus esset, sacrum evangelium codicem capiti suo imposuerit, ut sub eo ictum percussoris exciperet eiusque presidium haberet in morte, cuius lectionem dilexerat in vita.*

38. Zimmermann, pp. 12-13.

39. Hrabanus corresponded with the Empress Judith, Marcward of Prüm, and Drogo, in the 830s, about the release of Archbishop Ebbo, who had been his prisoner after being deposed from the archbishopric of Rheims. 'Gaolers' were generally of a friendly disposition in these circumstances. The correspondence was preserved by the Magdeburg Centuriators from a collection of Fulda Letters which they had but which are now lost, see Pfister, p. 111, and note 4. As Archchaplain Drogo helped Hrabanus to gain exemption from toll for Fulda, ibid., p. 108. See Drogo Sacramentary, ff. 86v, 89; Utrecht Psalter, f. 19 (Psalm 33).

40. Eigil, chs. 15-16, pp. 372-73.

41. John Henry, Cardinal Newman, 'The Second Spring', in *Sermons on Various Occasions* (London, 6th ed., 1891), pp. 178-80.

42. Widukind, iii, ch. 65, pp. 140-41.

43. To Walafrid, as Wallace-Hadrill, 1983, p. 323, remarked, 'martyrdom was a present reality and no longer a mere theme of the heroic past'. Martin Brooke is engaged in a study of Walafrid Strabo's hagiography.

44. Sacr. Fuldense, pp. XI-XIII. Also Bloch, 1963, p. 81, has revealed an export to Mainz, while Hoffmann has demonstrated that the sacramentary (in Cologne) about which Bloch wrote was itself destined for Trier, Hoffmann, pp. 157-58.

45. Jaffe-Löwenfeld 3728; Israël & Möllenberg, i, no. 62, p. 89. This is to be distinguished from the primatial privilege in Pope John XIII's name, which is a forgery, Jaffe-Löwenfeld 3729-3730.

46. See my comments about this in McManners, p. 99, referring to the missionary Boso who became bishop of Merseburg (Thietmar, ii, ch. 37, pp. 84-87 and DOI, 366).

47. E.g. Thietmar, ii, ch. 28; iii, ch. 9; pp. 74-75, 106-09. See also Claude, i, chapter 4. The best account of the material build-up of the church of Magdeburg, using the diplomas of Otto I, is R. Holtzmann, 1962.

48. Thietmar, ii, ch. 22, pp. 64-65; Claude, i, 115-17.

49. Berlin (West), MS Lat. fol.759 (= Görres 97), f. 23v.

50. Susan Keefe has compiled an inventory of no fewer than 61 texts, see Keefe.

51. Thietmar, iii, ch. 11, pp. 108-11.

52. Zimmermann, pp. 39-41; Härtel, pp. 63-65, where pls. I and III between pp. 16-17 provide illustrations from the Life of St Margaret of Antioch, including the crowning by Mary of Saints Margaret and Regina, whose model is surely Byzantine, cf. the Byzantine ivory of Christ crowning Otto II and Theophanu in the Musée de Cluny, Paris, Lasko, 1972, pl. 87.

53. F. Wormald, 1952.

54. Ibid., p. 255. For Hrabanus's dedicatory notices, see MGH Poet. Lat. ii, pp. 208, 221, and also Dienemann.

55. Levison, 1946, pp. 47, 80.

56. E.g. Hrabanus's care to obtain the authority of Bishop Humbert of Würzburg when he conducted relic depositions at Holzkirchen in 838 and at Rasdorf about the same time, Rudolf, Miracula, p. 337, lines 38-41, and p. 338, lines 50-51.

57. E.g. the illustration of Psalm 77/78, *Attendite populus meus*, in both the Utrecht Psalter (f. 48) and the Stuttgart Psalter (f. 90); the giving of the Ten Commandments in the Turonian Bibles Exodus illustrations (Kessler, 1977, figs. 87-89, where Stuttgart, f. 90 is also fig. 93). Otherwise in the Utrecht Psalter: Psalm 33, f. 19 (on the left); Psalm 92, f. 54v (*Testimonia tua credibilia facta sunt nimis*); Psalm 104, f. 60v. Stuttgart Psalter: Psalm 50, f. 62 (*Audi populus meus*); Psalm 145, f. 159v.

58. Lübeck, 1950. The monk Rudolf of Fulda (ob. 865) wrote *translationes* with *miracula* of early Roman martyrs whose relics were acquired, as he wrote of Leoba's *miracula*. Eigil on Sturm and Candidus on Eigil, on the other hand, did without miracles in their hagiography (see below). Also G. Zimmermann, 1975, pp. 827-30.

59. Rudolf, Miracula, e.g. on St Venantius, chs. 4-8, pp. 333-35; see also ch. 11, pp. 336-37.

60. E.g. Agobard of Lyon, see Wallace-Hadrill, 1983, p. 232; Claudius of Turin's *Apologeticum adversus Theutmirum abbatem*, PL 105, cols. 459-64 (trans. G. E. McCracken & A. Cabaniss, *Early Medieval Theology*, London, 1957, pp. 241-48); the remarks on the chapel of the Saviour in Angilbert's St Ricquier, Conant, 1959, p. 12.

61. Hrabanus, Homiliae, PL 110, col. 49B-C.

62. Ibid., cols. 63D, 64A.

63. For Hrabanus's connection with Tours and its art, see Lehmann, 1941, p. 223, where the connections between Fulda and the Alcuinian monastery of Ferrières should also be noted; and Mütherich, 1980, pp. 95, 98.

64. Eigil, ch. 15, p. 373, lines 26-27: *plus peritis*.

65. Eigil, ch. 16, p. 373, lines 31-32 (preaching); chs. 16, 17, p. 373, lines 33-34, p. 374, lines 8-11 (discords remedied by Sturm); ch. 20, p. 375 (correction of faults, implementation of Rule, diversion of the River Fulda). *Concordia, correctio, utilitas*, are the keynotes of this *Vita*.

66. Kahsnitz, 1979, p. 38 and fig. 284; and earlier, Schnitzler, 1967, pp. 115-18.

67. Bern, Stadtbibliothek Cod.264, discussed by Merton, p. 61, where it is dated mid C10, see Boeckler in Codex Wittekindeus, p. 23, and pls. XXXII, g and h.

68. See Drögereit, 1953.

69. Schnitzler, 1957; Schnitzler, 1965, pp. 8-10, 12-13.

70. Fillitz, 1965.

71. Buddensieg, 1965.

72. Gaettens, 1957, p. 127.

73. Freise in K. Schmid et al., 2/3, pp. 1095-96, note 3. On the rejuvenescence of Fulda *c.* 940, see Oexle on the monk-lists in K. Schmid et al., 2/2, pp. 677-80. See also Werner-Hasselbach, 1942, pp. 76-78 and Lübeck, 1949, pp. 121-25, who give reasons for thinking that, despite the inauthenticity of the Eberhard document as such, the journey was made and the list of rents is genuine. For the general picture of Fulda possessions in Frisia, see Staab, 1980, pp. 53-55, map p. 54 (for possessions generally, map, p. 51).

74. Lübeck, 1949, p. 121.

75. Dronke, 1844, cap.32b, p. 63: *Postmodum perficiente Hadamaro* [i.e. what Hrabanus had begun] *discretissimo abbate ad cameram abbatis ad faciendum omne opus artificum tam in fabricatura quam in sculptura et celatura et aratura fabrili non solum ad ecclesie ornatum,* etc. and further on ... *tam in eramentis et celaturis quam in fusili ac fabrili omnique arte ornatoria.*

76. Gaettens, pp. 21-22.

77. Perhaps its date is even 997-1014, since the calendar refers to Henry II, who was crowned emperor in 1014, as only king, Hoffmann, pp. 139-40.

78. Hoffmann, p. 169.

79. Hoffmann, p. 139.

80. Hoffmann, p. 169. Hand A wrote most; Hand B wrote only ff. 21-22, 34-39, 44-46, 49-51, 56-61, 64-65, 67v-70. Of these only f. 46 contains a miniature and f. 68v a full-page inititial, and none of the other folios is ever part of a bifolium with a miniature.

81. As shown by Hoffmann, p. 138, despite being a single leaf on its own in the quiring. Apart from the greatest feasts and saints' days of the year, the appearance of Saints Sergius and Bacchus suggests that this book was made for Mainz Cathedral; their cults had been important there since Archbishop Otgar (826-47) acquired the relics. There are 19 gospels in this book of ten folios. The quiring is 1×1, 2×8, 3×1(leaves not bifolia); so this is no fragment as has sometimes been said, but a complete book in itself, perhaps intended to be slipped into fine covers for use at mass. See Zimmermann, pp. 33-35, and for fine insights by Boeckler relating its ornament to that of the Matthew pages and the canon tables of *Wittekindeus*, and its *Ecclesia* to the style of the Corvey drawings in Wolfenbüttel (treated in the next chapter), see Codex Wittekindeus, pp. 23, 24, and 24, notes 99-101.

82. These angels, and those in the representation of the Trinity in the Göttingen Sacramentary, f.

136, are the Fulda figures closest in style to the Anglo-Saxon Winchester school.

83. Codex Wittekindeus, p. 20.

84. Which itself derived them directly from a late antique source, see Laufner & Klein, esp. pp. 97-112.

85. Zimmermann, p. 50.

86. Hrabanus on Chronicles, PL 109, col. 418A. These are the actual opening words of Bede's De Templo, CC119A, p. 147, lines 1-6. Other comparable passages on the same theme are PL 109, col. 423B and CC119A, p. 158, line 457; PL 109, col. 426A and CC119A, p. 167, lines 816-18 (*plena totius ecclesie felicitas in resurrectionis gloria complebitur*). The earthly church and the church of the Resurrection is actually the guiding theme of Bede's *De Templo*, whereas Hrabanus on *Chronicles* is not so coherent a work. But the theme cannot be missed in it, and in any case, Fulda clearly had, or had access to, Bede's own work. Apart from the writings of Hrabanus, C9 manuscripts of Erfurt and St Gall provenance add to this impression, see Laistner, 1943, p. 77. Knowledge of Bede's writings at Fulda clearly goes back to the time of St Boniface.

87. E.g. the seated *Ecclesia* in the Reichenau Sacramentary at Heidelberg, viz. the Petershausen Sacramentary (Hoffmann, p. 320, and Oechelhaeuser, pl. 2); the Bamberg *Song of Songs*, see pp. 35-45; the Pentecost illustration in the Cologne St Gereon Sacramentary, representing men of all nations, Bloch & Schnitzler, i, colour pl. VII, and pl. 106, and see ibid., ii, 97.

88. Hrabanus's poem on the dedication, MGH Poet. Lat, ii,205; and Fulda Annals, p. 21.

89. Levison, 1946, p. 160, and p. 160, note 1.

90. Sacr. Fuldense, pp. 161-62.

91. See Wehlt, p. 238.

92. Ibid., pp. 275-76 for the politics of 948 as concerned Fulda.

93. K. Schmid et al., 2/2, pp. 836-53. For Fulda as a church under the *tuitio* and *defensio* of the emperor, see also DOII, 64, and Fleckenstein, 1974A, p. 67.

94. Ibid., 1, pp. 136-77.

95. Conrad Leyser, in the work which he is preparing on the writings of Pope Gregory the Great and their monastic context. The grid metaphor is there used with particular reference to Cassian's concept of the relation between Church and Monastery.

96. Grodecki et al., p. 116.

97. Text printed from Vatican, Cod. Pal. 1341, beginning, *Incipit epistola qualiter officium missae agatur in monasterio Fulda*, in Wattenbach, 1897,

NOTES TO CHAPTERS FOUR AND FIVE

pp. 409-12. For discussion, and for date of the letter and manuscript, see Bischoff, 1974, p. 55.

98. *Quoniam in multis locis ordo diaconorum partim incuriam praelatorum partim per inopiam ministrantium in caelebratione missae diversus esse videtur: placuit mihi vobis per stili seriem intimare, quemadmodum in monasterio Fulda agatur idem ordo, ubi ordinabiliter et cum sufficientia rituque Romano eadem officia peraguntur, et quod huc usque erratum in hoc constat apud nos [i.e. Lorsch] inscienter ... et quia hic in Fulda decentissimus ordo est praesbiterorum ministrantium cum omni decore, apud nos vero non adeo, ob hoc eos parumper tangere curabo* (Wattenbach, 1879, p. 410).

99. *Diaconos septem simul aut quinque seu tres vel certe unum esse ratioprodit; septem namque, quinque triumve diaconorum par officium ministrationis fore videtur* (ibid.).

100. Reichenau Confraternity Book: the list as entered in one hand, i.e. Hand HB1 (see analysis of hands by Authenrieth, pp. XXIV, XXVI-VII, XXXIII) is at pl. 4. Subsequent additions were made. Schmid is surely right that such lists of names were already completed in written form before being entered into a confraternity book, ibid., pp. LXXV and LXXXI-II.

101. For the monk lists of 935 and 940, see K. Schmid et al., 1, pp. 225-26, and for the grades of the monks, ibid., 2/2, p. 673.

102. Hrabanus gives 25 as the minimum age for a deacon and 30 for a priest; he says that one should be a subdeacon for four years, De Inst. Clericorum, i, 13, PL 107, col. 306A.

103. For numbers at some other monasteries, we note below, p. 162, that Corvey had 62 in 916, Reichenau 112 in the 820s (but the number is unlikely to have been so high in C10), Prüm, probably the largest in the empire after Fulda, numbered 'approaching one hundred' in later C9, Tellenbach, 1962. There is a list of 70 monks of St Maximin, Trier, apparently the total number, under Abbot Ogo (934-45), MGH SS XIII, pp. 301-02. No grades are given in the Trier list, and I have not ascertained ratios of grades for Prüm.

104. K. Schmid et al., 1, pp. 341, 343, 348. See Werner-Hasselbach, 1942, p. 103, note 5. I have discussed this evidence in my review of K. Schmid et al., EHR 96 (1981), 379.

105. Schnitzler, 1957, pp. 55-56.

106. Codex Wittekindeus, pp. 18-19.

107. K. Schmid et al., 2/2, pp. 709-10, 714.

108. Wattenbach, 1879, pp. 410-12.

109. De Inst. Clericorum, PL 107, col. 322A.

244

Notes to Chapter 5:

1. Stüwer.

2. Ibid., pp. 7-8.

3. Beumann, 1962; Beumann, 1950, esp. ch. 5, and pp. 18-19, 45, 144-45; Beumann, 1970, esp. p. 874.

4. Conant, 1959, p. 25, and pl. 9b (interior); Hubert et al., pls. 51-54, and pp. 63-64.

5. Kunst und Kultur, ii, Cat. 159, p. 474, and for the Franco-Saxon school, see Boutemy, 1949.

6. Kunst und Kultur, ii, Cat. 160, 161, pp. 474-75. The beginning of St Luke's Gospel of the Essen book is illustrated in Küppers, p. 52. Also Leipzig, MS 76.

7. Kunst und Kultur, ii, Cat. 165, p. 479, and ill. 161.

8. Ibid., Cat. 162, pp. 476-77, and Köhler & Mütherich, v (Plates), e.g. pls. 39, 57, 66.

9. Kunst und Kultur, ii, Cat. 166, p. 480, and K.H. Usener, ibid., p. 465.

10. Beumann, 1962, esp. pp. 20-23, 24-25, and 36. For the marriage of Ekbert, *comite et duce* (Abbess Haduin of Herford's father), to Ida, daughter of Karlomann, see *Translatio S. Pusinnae*, AASS April III, p. 171a.

11. Hlawitschka, 1974, esp. pp. 104-07, 140-50, 162.

12. Ibid., pp. 147-49.

13. Beumann, 1962, p. 15.

14. Honselmann, pp. 71-73. The method of arriving at these numbers is to compare Corvey monklist C, which begins to list monks from some time during the abbacy of Folcmar, with List A, which has the names of monks in order of profession under the succession of abbots from the beginning of Corvey onwards (Philippi, 1916). Of 50 names under Folcmar (916-42) in List A, 26 are found in List C, suggesting to Honselmann that List C began c. 930. If this is correct (but it could easily be too late), Gerhard would have gone back some 75 years and the other 11 for over 50 years in c. 930.
Honselmann raises the issue of child oblates in these lists. There were some undoubted cases under Abbot Liudolf (965-83), ibid. p. 72, but it is doubtful what proportion of professed monks had been child oblates, and in any case the Rule of St Benedict deals with boys very much as a separate category from monks proper, e.g. RB 30, 37, 45, 63, 70 (where it is implied that fifteen is the age at which they could be professed as monks; for the profession, RB 58). Even if boys were sometimes included in these lists therefore (and it is questionable

whether it was normal), they are unlikely ever to have been a significant element of them.

15. Stüwer, p. 8 for both Anskar and Rimbert.

16. Lehmann, 1962, pp. 105-07.

17. Honselmann, p. 71.

18. Grabar and Nordenfalk, p. 196.

19. Sacr. Fuldense, p. XI; Zimmermann. p. 3.

20. Podlaha, esp. figures on pp. 7-8 for canon tables, and p. 12 for *Liber Generationis* initial for Matthew.

21. Härtel & Stähli, pp. 22, 38.

22. Erwin Gans-Ruedin, *Oriental Carpets* (Hallwag, Bern, 1965), pl. XIII. For an example of a similar fine-patterned background at Hildesheim, see Härtel & Stähli, p. 49.

23. Helmstedt MS 426. f. 87; black and white illustration in Kunst und Kultur, ii, ill. 168.

24. Kunst und Kultur, Cat. 167, 168, pp. 481-82, and K.H. Usener, p. 465.

25. Widukind, iii, ch. 56, p. 135.

26. Mütherich, 1963, p. 38.

27. For some references, see Kunst und Kultur, Cat.176, pp. 487-88. Most recently, Härtel would consider Helmstedt MS 426 (Wolfenbüttel Gospels) to be probably Hildesheim (Härtel & Stähli, pp. XV-XVI), while Gerd Bauer would prefer to emphasize the closeness to each other of the scriptoria of Hildesheim and Corvey, between which hard and fast boundaries cannot be drawn, and to leave the localizing of the manuscript an open question, see Bauer, 1985, pp. 345-46; but his discussion of its close relations to the Gospels of Bernward of Hildesheim and other Hildesheim manuscripts suggests that he leans towards Hildesheim *in angulo sermonis*, ibid., p. 331.

28. See Bauer, 1985, pp. 321-24.

29. Hoffmann, pp. 127-29, and Plate volume, 25.

30. Kunst und Kultur, Cat., 161, 164, 165, 170, pp. 475, 478-79, 482. Bauer, 1985, p. 344, has shown on liturgical grounds that the Prague MS was at Corvey in C10, and so recognizes a core of indubitably Corvey MSS, but refers to others somewhat vaguely as only indirectly influenced by it.

31. Tschan, 1942, i, 10-13, 78.

32. Goldschmidt, 1928, i, pl. 84.

33. Kunst und Kultur, Cat. 172, pp. 483-84; Milde, pp. 46-57, with all the drawings illustrated.

34. Boeckler, ed.1953, p. 77, and pl. 20. Several other Abdinghof drawings, including the poignant Harrowing of Hell, are illustrated in Goldschmidt, 1928, i, pls. 81 and 82.

35. Galley.

36. Widukind, i, ch. 34, p. 48, and see Beumann, 1962, p. 25.

37. Best on this is Beumann, 1972, esp. pp. 381-85.

38. Galley, p. 124.

39. Ibid., p. 121.

40. Ibid., pp. 125-26.

41. As would K. H. Usener in Kunst und Kultur, p. 466, and Cat. 172, pp. 483-84.

42. Codex Wittekindeus, p. 22.

43. See Vlasto, pp. 89-97; Gumpold; and Manitius, ii, pp. 182-84.

44. Thietmar, v, ch. 23, p. 247, lines 27-28. See also, Dvornik, 1949, p. 192. The legend of f. 18v of the manuscript reads: *Hunc libellum Hemma venerabilis principissa pro remedio anime sue in honore beati Venceslauvi martiris fieri iussit.*

45. As in a manuscript of monastic rules, and even more in a Seeon Pericopes Book, both at Bamberg, see Mütherich & Dachs, Kat. 14, p. 31, and Tafel III.

46. Christian of St Emmeram, ch. 7, p. 64, writing about 994, is explicit on the friendship: *Agebantur vero hec temporibus Henrici, regis Saxonum, qui primus inter ipsos, Christo sibi propicio, dyadema inposuit, cui felix isdem amicus iungebatur assidue.*

47. Leyser, 1983, p. 77.

48. Dvornik, 1949, pp. 25-26; Vlasto, p. 94. For a good survey of the development of the Wenceslas legends, see Vlasto, pp. 90-92.

49. Cosmas of Prague, pp. 37-38, and see p. 37, note 1.

50. Gumpold, ch. 15, p. 219, lines 8-12.

51. Milde, p. 64.

52. See Hoffmann, p. 228, and esp. his pls. 92, 113.

53. E.g. Cosmas of Prague, i, ch. 30, p. 54, on Archbishop Willigis's efforts in 995 to have Adalbert return from Rome to his bishopric of Prague or to have another appointed in his place. See also Büttner, 1975, pp. 309-10.

54. On this Thietmar, see Vlasto, pp. 100-01. The following grounds are suggestive of his Corvey origins: 1) Cosmas says of him, i, ch. 23, p. 44, that he was a monk who had come previously to pray at Prague, and the relics of St Vitus there from 932 onwards would make such a pilgrimage especially appropriate for a Corvey monk; 2) It often happened that kinsmen destined for a monastery would be given the same name as a relation of the older generation already in the monastery (e.g. K. Schmid et al., 2/3, pp. 1080-88). The year after Bishop Thietmar of Prague died, a person called Thietmar became Abbot

of Corvey (983-1001), see Thietmar, who could have been a relation of the abbot, pp. 242-43, note 3.

55. Thietmar, vi, ch. 12, p. 291, and vii, ch. 56, pp. 468-69. See Fleckenstein, pp. 90, 112.

56. The cleric in the doorway may be compared, in dress, stance and physiognomy, with the picture of Bernward of Hildesheim offering his Gospel Book (see Part I, ill. 49). For faces and narrative style, compare the Fulda Massacre of the Innocents, Göttingen Sacramentary, f. 16v. Similar turrets appear in Göttingen at several points, e.g. ff. 64v, 90v.

57. For a good brief account, Fleckenstein, 1974, pp. 204-07; also R. Holtzmann, 1955, pp. 405-07, for Henry II, Poland and Bohemia in 1003-04. See also H. Hoffmann, 1969, esp. pp. 22-24, on Henry II's response to the Polish attack on Bohemia, and on the largely successful but not unchallenged efforts of the Ottonians to exact tribute from the Bohemians in the late C10.

Notes to Chapter 6:

1. Alexander, 1970, esp. pp. 65-67, 90-97, 118-19, 122, 125-26; Beckwith, 1964, esp. pp. 170-71, 183-84. See also Henderson, p. 193 on the C12 wall-paintings of St Savin-sur-Gartempe.

2. H. Swarzenski, 1967, pp. 22-29.

3. Folcuin, pp. 70, line 47 to 71, line 1.

4. E.g. Jantzen on Reichenau; he refers to the Berlin Pericopes Book (Cod. 78 A2) as *das völlige Absinken*, Jantzen, p. 112.

5. Fuhrmann & Mütherich, pp. 29-30, cf. Mütherich & Dachs, p. 29, Cat. no. 26, Plate 18-19. See also Keller, 1985, pp. 301-02.

6. Fichtenau, 1975, esp. pp. 174-82.

7. Robinson, 1974, pp. 12-15, esp. p. 14.

8. Cahn, p. 102.

9. Ibid., pp. 102-03, and cat. no. 122, p. 284.

10. Cowdrey, 1970, pp. 196-210, esp. pp. 203-04.

11. Robinson, 1974, p. 12.

12. Tellenbach, 1966, pp. 102-05.

13. Cahn, pp. 109-14, cat., no. 51, pp. 266-67. For the influences, see Boutemy, 1950; and for the localization of the Franco-Saxon school at St Amand, Boutemy, 1949.

14. See the excellent discussion of Brieger, 1965, esp. pp. 158-60.

15. D'Alverny, 1946, pp. 255-59.

16. Cahn, p. 97. For the 'First' Bible of Limoges, Gaborit-Chopin, pp. 42-52.

17. For the initials in Grandval-Moutier, see Ellen Beer, in Duft, et al., pp. 121-48.

18. Alexander, 1970, pp. 76-77, and for the date of Avranches MS 72, ibid., p. 43.

19. Paris, BN, MS lat. 250, gospel initials, ff. 4, 17v, 27, 40; Acts, f. 50; Romans, f. 71v; St James, f. 62; Apocalypse, f. 100. See Köhler, 1930, esp. pp. 103, 106-07 for the practice of grading initials in the Tours scriptorium of Fridugisus's time, and for the effort to give an overall consideration and clarity to the organization of a manuscript. See also Plate volume, i, pls. 28 and 29, 29a for Romans, 29e for St James, in monochrome.

20. Alexander, 1970, refers frequently to the influence of Tours at Mont-Saint-Michel, but always in respect of initial ornament or canon tables or iconographic details.

21. Fournier & Le Bras, pp. 18, 28.

22. Southern, 1948, esp. pp. 33-34, 40-41.

23. Conant, 1959, pp. 57-66, esp. pp. 59, 61-63; Puig i Cadafalch, pp. 143-47.

24. For a reconstruction of the interior of Speyer in 1062 (before C12 alterations), Conant, pl. IIIa. Jantzen, pp. 18-22, speaks of *Die Ganzheit der Wand*.

25. Leyser, 1983, p. 437.

26. Dunbabin, pp. 165, 244.

27. Murray, chapter 5, esp. pp. 121-30.

28. In using the phrase 'Gregorian Reform art', I do not use it in the precise Central/South Italian sense of the fine paper by Kitzinger, 1972. It has here a more general cultural sense which I hope is sufficiently explained in my text.

29. Cahn, pp. 80-82; Härtel & Stähli, pp. 147-66.

30. Nordenfalk, *Turonische Bilderbibel*, 1971, p. 154.

31. Ibid., pp. 157-61.

32. Beissel, 1891, p. 12, noted the relation of the doors to the Alcuin Bible in Bamberg, where the Genesis scenes were concerned, though he doubted that it was a direct one.

33. For Jerome, see Nordenfalk, *Turonische Bilderbibel*, 1971, p. 155, but he admits that there is little similarity to the Jerome figure of the Turonian Jerome cycles or of the Ottonian frontispieces; see also Cahn, p. 82.

34. Excellent discussion in Kessler, 1977, pp. 73-78.

35. Quoted ibid., p. 76, from PL 117, col. 1013.

36. Engfer, in Algermissen, pp. 79-80; Von den Steinen, 1956, pp. 331-32; Von den Steinen, 1965, p. 167.

37. Nordenfalk, *Turonische Bilderbibel*, 1971, p. 162.

38. Kahsnitz et al., pp. 19-21, 29-30. (I have normally cited this more accessible work, rather than the fine facsimile edition of the Echternach Codex Aureus, Kahsnitz, 1982, after comparing them and finding the latter to contain only slight expansions in the commentary text from the former in the most important sections for our purposes).

39. Plotzek, 1970.

40. E.g. Leyser, 1983, pp. 435-36, 439-40.

41. Tellenbach, 1966, pp. 85-87, 171-76; Fuhrmann, 1986, pp. 38-40.

42. As Florentine Mütherich has pointed out, when Henry III commissioned a fine Bible he turned to Tegernsee, Mütherich & Dachs, pp. 28-29.

43. On liturgical uses, e.g. Kahsnitz et al., pp. 77-78, 90-91, and for date, ibid., p. 39. In general, Kahsnitz, 1982, facsimile.

44. Plotzek, Bremen, 1970.

45. Nordenfalk, 1971, p. 42; Boeckler, 1933, pp. 76-77, and abb. 180-84.

46. For an example, compare in Boeckler, 1933, the gospel for the Friday before the third Sunday in Lent, *Homo erat paterfamilias*, ibid., p. 86, and pl. 56.

47. Nordenfalk, 1971.

48. Kahsnitz et al., p. 82.

49. But which is present in the Gospel Book of Otto III, see p. 25.

50. Nordenfalk, 1971, pp. 95-96, text of poem, ibid., p. 96.

51. Boeckler, 1933, p. 55.

52. Weis, 1974, but Kahsnitz et al., pp. 90-91, where the good observations of Kahsnitz implicitly cast doubt on the composite character of the model.

53. Boeckler, 1933, p. 52, and p. 52, note 6.

54. Ibid., pp. 54-61.

55. Ibid., pp. 59-61.

56. Compare Boeckler, 1933, pl. 57, and Omont, 1908 (under Facsimiles, Byzantine), i, 78 (Vine Dressers); Boeckler, 119, and Omont, ii, 116 (Good Samaritan); Boeckler, 122, and Omont, ii, 123 (Wedding Feast and Excuses); Boeckler, 123, and Omont, ii, 126 (Dives and Lazarus, where there are a couple of striking similarities).

57. Called 'rare' by Kahsnitz, in Kahsnitz et al., p. 75; by Korteweg, 1985, p. 133; and by Boeckler, 1933, p. 59. See the variety of parable scenes in the Augustine Gospels (F. Wormald, 1954), and the Rossano and Sinope Codices.

58. See Part I, ills. 103, 117.

59. Boeckler, 1933, p. 58.

60. Ibid., p. 58, and p. 58, note 1 (i.e. *Erdwellen*, as for instance in the Garden of Gethsemane scene, F. Wormald, 1954, pl. 4).

61. As pointed out by Boeckler, 1933, p. 62.

62. E.g. Boeckler, 1933, pl. 149.

63. Ibid., pp. 61-63; Nordenfalk, 1937.

64. See pp. 101-104; and also Part I, p. 103.

65. Kahsnitz et al., pp. 90-91. By my calculation, using the Murbach Comes, 9 out of the first 15 miracles or wonders on the Mark pages are Lenten pericopes (not mainly derived from the Mark text rather than recounting the same incident from another gospel), and they are almost in the order in which they come in Lent, the Sunday being twice brought forward, viz. xxiiii, xxxiiii, xxviiii, xxxii, xlviii, xlvi, xlvii, li, lii (Wilmart, 1913, pp. 38-40).

66. A good example of a fast-moving and purely descriptive *titulus* is that for the Woman with an Issue of Blood and the Raising of the Widow's Son at Nain, text Kahsnitz, 1982, p. 154, from f. 54: *Sanguinis hanc fluxu solvit, hunc mortis ab ictu*, i.e. he releases the woman from an issue of blood and the man from the blow of death.

67. Nordenfalk, 1971, p. 48.

68. Bruce-Mitford, 1969, p. 2.

69. Fichtenau, 1975, p. 173.

70. Nordenfalk, 1971, p. 48. Nordenfalk deals finely with the script of the Echternach scriptorium, ibid., pp. 61-73.

71. Plotzek, Bremen, 1970, pp. 38-40.

72. Alexander, 1970, p. 75.

73. See Nordenfalk, 1971, esp. pp. 109-10, 117-19.

74. Kahsnitz et al., pp. 21, 38.

75. Gregory, Moralia, Preface, ch. 7, PL 75, cols. 525-26: *Job ... sanctae Ecclesiae labor exprimitur, quae multiplici praesentis vitae fatigatione cruciatur*. For a high medieval example of Job being used as the type of the church's sufferings, see A. Katzenellenbogen, *The Sculptural Programs of Chartres Cathedral* (New York, 1964), pp. 68-70.

76. Ayres, 1987, p. 35.

77. Gregory, Moralia, Preface, ch. 4, PL 75, col. 521D; iii, ch. 20, PL 75, col. 618B; iii, ch. 8, PL 75, col. 605A: *Cor igitur mulieris tenuit, et quasi scalam, qua ad cor viri ascendere potuisset invenit; occupavit animum conjugis, scalam mariti*.

78. Ibid., Preface, ch. 6, PL 75, col. 525B.

79. Ayres, 1987, p. 34.

80. Ibid., pp. 35, 40-42.

81. Though for another manuscript of the *Moralia*, again of Italian origin and also of large format,

already in Germany before the end of C10, see Bischoff, 1984, pp. 180-81, on the Augsburg Codex (Clm. 3842).

82. Glöckner, 1929, cap. 78, p. 359. Note once again the importance of Gregory's writings in Gorze Reform circles.

83. Hoffmann, pp. 493-94.

84. Compare Härtel & Stähli, p. 108, f. 15.

85. Ellen Beer in Duft et al., pp. 136-41, and see ibid., esp. pl. 20.2, f. 225v; pl. 32.3, f. 390v; pl. 34.2, f. 411v.

86. Plotzek, 1973, esp. pp. 105-15.

87. Nordenfalk, 1937, p. 291.

88. Compare the large red Roman numerals in capitals which mark the sections of text (presumably for purposes of study) in the Trier Apocalypse of c. 800, see Laufner & Klein, facsimile.

Notes to Excursus 1:

1. Clm. 4453, p. 65.

2. Schramm & Mütherich, nos. 105-110, pp. 203-205, 220-21. See also Vöge, p. 22.

3. Schramm & Mütherich, nos. 96-100, p. 199.

4. Ibid., no. 103, pp. 200-201.

5. Ibid., p. 77 and no. 104, p. 202.

6. Ibid., p. 82; no. 101, p. 199; p. 220. For the situla, no. 113, pp. 208-09.

7. MGH SS IV, p. 590, *Cum jam velut prima lanugine barbae floreret.*

8. Schramm & Mütherich, nos. 122-25, 129-30, pp. 215-16, 219.

9. Ibid., nos. 114-16, pp. 210-11; likewise the *bullae*, nos. 117-19, p. 211.

10. Ibid., no. 128, pp. 217-19.

11. Ibid., no. 120, pp. 213-14, and Vöge, pp. 22-24.

12. Schramm & Mütherich, no. 120 (20 and 21).

13. Ibid., p. 99; no. 127, p. 217.

14. Messerer, 1963, p. 67.

15. Vöge, p. 22.

16. Bamberg, MS Patr. 88, f. l6v.

17. Schramm & Mütherich, p. 83; no. 109, p. 205.

18. Fauser, 1958, p. 6.

19. Schramm & Mütherich, pp. 89-90.

20. H. Wölfflin, *Die Bamberger Apokalypse* (Munich, 1918, 1st ed.), p. 9.

21. E. Sackur, *Die Cluniacenser* i (1982), 339-40.

22. For this quiring, see Fauser, p. 6.

23. Wölfflin, p. 10.

24. Messerer, 1963; Codex Egberti, pp. 73-81.

25. Fauser, pp. 3-4.

26. Guttenberg, nos. 73, 119, 183.

27. Meyer, pp. 7-8.

28. Guttenberg, nos. 181 (p.84), and 219 (p.100).

29. Vöge, pp. 14-15, considered the inscription to tell against Otto III, but see Fauser, p. 15, for the following point.

30. Jantzen, pp. 111-12.

31. Bloch, 1959, pp. 27-28.

32. Fauser, p. 16, points out that Wölfflin in his second edition, and Jantzen, compared the Pericopes Book of Henry II with the pericopes section of the Bamberg Apocalypse manuscript, but he does not make the most of his observation.

33. Sauerland & Haseloff, p. 107.

34. Wölfflin, pp. 8-9.

35. Cited from Fischer, 1926, pp. 10-11.

36. Fischer, 1926, pp. 10-11.

37. Messerer, 1963.

38. Quoted by John Willett, *Expressionism* (London, 1970), p. 87. I am grateful to Gilbert McKay for my knowledge of this book.

39. Peter Selz, *German Expressionist Painting* (California, 1957), pp. 6, 15.

40. Peg Weiss, *Kandinsky in Munich: the formative Jugendstil Years* (Princeton, 1979), pp. 82, 191-92, note 17. Hanna Wolfskehl notes Wölfflin (1864-1945) as being a frequent visitor to the Wolfskehls even before he became permanently resident in Munich as a professor in 1912. Karl Wolfskehl and his wife (of the Stefan George circle) had a close relation with Kandinsky for several years before this.

41. August L. Mayer, *Expressionistische Miniaturen des deutschen Mittelalters* (Munich, 1918), pp. 6-7.

42. Fauser, p. 16 (left-hand column).

43. K.B. McFarlane, *Hans Memling* (Oxford, 1971), pp. 1-15.

Stemma of Early Medieval Apocalypse Manuscripts

(Single letters denote one or more putative, not surviving manuscripts)

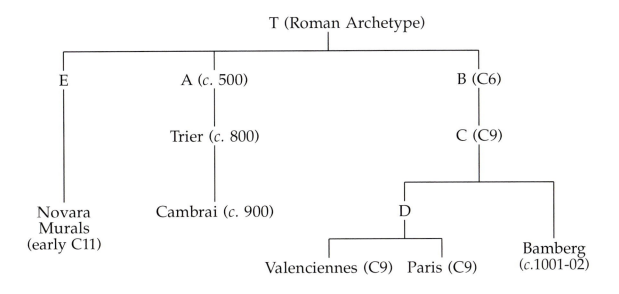

Simplified from the facsimile edition of the Trier Apocalypse, ed. R. Laufner and P. Klein (p.112)

The Bamberg and Valenciennes Apocalypses:
how their textual sections are related

In the Valenciennes Apocalypse the text sections are numbered (analysis in de Bruyn, 1914); in the Bamberg Apocalypse the sections are determined by the more important initial letters, and these are here numbered by me accordingly. In the Table below, references to our (post-1200) divisions of the Apocalypse text are given in the left-hand column by chapter and verse.

Apocalypse Text	Bamberg Apocalypse		Valenciennes Apocalypse
i: 1	1	↔	⎰1 / 2
i: 15			3
ii: 1	2	↔	4
ii: 8	3	↔	5
ii: 12	4	↔	6
ii: 18	5	↔	7
iii: 1	6	↔	8
iii: 7	7	↔	9
iii: 14	8	↔	10
iv: 1	9	↔	11
iv: 9	**10**		
v: 1			**12**
v: 6	11	↔	13
v: 11	12	↔	14
vi: 1	13	↔	15
vi: 3	14	↔	16
vi: 5	15	↔	17
vi: 7	16	↔	18
vi: 9	17	↔	⎰19
vi: 12			20
vii: 1	18	↔	21
vii: 9	19	↔	22
viii: 1	20	↔	23
viii: 7	21	↔	24
viii: 8	22	↔	25
viii: 10	23	↔	26
viii: 12	24	↔	27
viii: 13	25	↔	28
ix: 1	26	↔	29
ix: 13	27	↔	30
ix: 17	28	↔	31
x: 1	⎰29	↔	32
x: 9	30		
xi: 3	31	↔	⎰33
xi: 7			34
xi: 15	32	↔	35

Apocalypse Text	Bamberg Apocalypse		Valenciennes Apocalypse
xi: 19	33	↔	⎰36
xii: 3			37
xii: 7	34	↔	38
xii: 13	35	↔	39
xii: 18	36	↔	40
xiii: 11	37	↔	41
xiv: 1	38	↔	42
xiv: 6	39	↔	43
xiv: 8	40	↔	44
xiv: 9	41	↔	45
xiv: 13	**42**		
xiv: 14			**46**
xv: 1	43	↔	47
xv: 5			**48**
xvi: 2	⎰44		
xvi: 3	45		
xvi: 4	46		
xvi: 8	47		
xvi: 10	48		
xvi: 12	49		
xvi: 17	50		
xvii: 1	51	↔	49
xviii: 1	52	↔	⎰50
xviii: 4			51
xviii: 21	53	↔	52
xix: 1	54	↔	53
xix: 11	55	↔	⎰54
xix: 17			55
xx: 19	56	↔	56
xx: 1	57	↔	⎰57
xx: 5			58
xx: 7			59
xx: 11	58	↔	60
xxi: 1	59	↔	61
Text of 58 & 59 repeated!	60		
	61		
xxi: 9	62	↔	62
xxii: 1	63	↔	⎰63
xxii: 8			64

Thus only three sections in Valenciennes (V) do not correspond to Bamberg (B). These are shown in bold figures and are as follows: B 10/V 12; B 42/V 46; B 44/V 48.

There are several cases where one manuscript has two or more sections of text against an unbroken section in the other; in all but one case, however, corresponding precisely.

Quiring of the Fulda Sacramentary at Udine
Archivio Capitolare MS 1

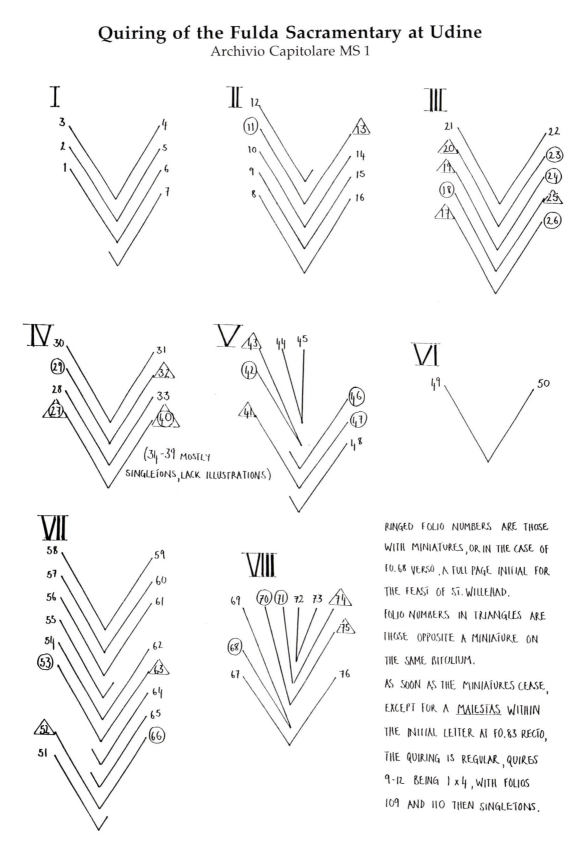

IV (34-39 MOSTLY SINGLETONS, LACK ILLUSTRATIONS)

RINGED FOLIO NUMBERS ARE THOSE WITH MINIATURES, OR IN THE CASE OF FO.68 VERSO, A FULL PAGE INITIAL FOR THE FEAST OF ST. WILLEHAD.

FOLIO NUMBERS IN TRIANGLES ARE THOSE OPPOSITE A MINIATURE ON THE SAME BIFOLIUM.

AS SOON AS THE MINIATURES CEASE, EXCEPT FOR A _MAIESTAS_ WITHIN THE INITIAL LETTER AT FO.83 RECTO, THE QUIRING IS REGULAR, QUIRES 9-12 BEING 1 x 4, WITH FOLIOS 109 AND 110 THEN SINGLETONS.

Abbreviations used in the Bibliography

AASS Acta Sanctorum Bollandiana (Antwerp, Brussels, 1643, ongoing)
BAR British Archaeological Reports, International Series, Oxford
CC Corpus Christianianorum, Series Latina or Continuatio Medievalis (Brepols-Turnhout)
Clm Codices Latini Monacenses, i.e. Latin manuscripts at Munich
DA Deutsches Archiv für Erforschung des Mittelalters
EHR English Historical Review
FS Frühmittelalterliche Studien
MGH SS Monumenta Germaniae Historica, Scriptores
PG Patrologia Graeca, ed. J.-P. Migne
PL Patrologia Latina, ed. J.-P. Migne
MIÖG Mitteilungen des Instituts für Österreichische Geschichtsforschung
RB Revue Bénédictine

Bibliography

Facsimile and Monograph Editions of Manuscripts

Late Antique

Grabar, 1948	A. Grabar, *Les Peintures de l'Évangeliaire de Sinope* (Paris, 1948).
Haseloff, 1898	A. Haseloff, *Codex Purpureus Rossanensis* (Berlin, 1898).
Rabbula Gospels	*Rabbula Gospels*, ed. C. Cecchelli, J. Furlani, and M. Salmi (Olten & Lausanne, 1959).
Vergilius Vaticanus	David Wright, *Vergilius Vaticanus: Facsimile: Commentarium* (Graz, 1984).
Weitzmann & Kessler	K. Weitzmann & H.L. Kessler, *The Cotton Genesis* (Princeton, NJ, 1986).
F. Wormald, 1954	*The Miniatures in the Gospels of St Augustine* (Cambridge, 1954). Now published in *The Collected Writings of Francis Wormald*, Vol. I, pp. 13-35.

Carolingian

Duft et al.	*Die Bibel von Moutier-Grandval, British Museum Add Ms 10546*, ed. J. Duft, et al. (Bern, 1971).
Drogo Sacramentary	*Drogo-Sakramentar, MS Lat. 9428*, ed. F. Unterkircher & Florentine Mütherich (Graz, 1974).
Holter, 1972	*Liber de Laudibus Sanctae Crucis, Faks-Ausgabe* (Rabanus Maurus), ed. K. Holter (1972).
Laufner & Klein	*Trierer Apokalypse*, ed. R. Laufner & P.F. Klein (Graz, 1975).
Leidinger	G. Leidinger, *Der Codex Aureus der Bayerischen Staatsbibliothek in München* (3 vols. Munich, 1921).
Lorsch Gospels	*The Lorsch Gospels*, ed. W. Braunfels (New York, 1967).
Stuttgart Psalter	*Der Stuttgarter Bilderpsalter*, ed. W. Hoffmann, Florentine Mütherich, et al., Faksimileband & Untersuchungen (Stuttgart, 1965).
Utrecht Psalter	*Utrecht Psalter: Facsimile & Kommentar*, ed. K. Van der Hoerst & J.H.A. Engelbregt (Graz, 1984).

Ottonian

Bloch, 1963	Peter Bloch, *Das Sakramentar von St Gereon* (Munich, 1963).
Bloch, 1972	*Reichenauer Evangelistar (Berlin)*, ed. Peter Bloch (Graz, 1972).
Boeckler, 1933	*Das Goldene Evangelienbuch Heinrichs III* ed. A. Boeckler (Berlin, 1933), Facsimile of Speyer Gospels in the Escorial.
Clm 4453	*Das Evangeliar Ottos III Clm 4453 der Bayerischen Staatsbibliothek München, Faksimile & Textband*, F. Dressler, F. Mütherich, H. Beumann (Frankfurt, 1977-78).
Clm 4454	*Evangeliarium aus dem Domschatz zu Bamberg (Cod. lat. 4454)*, ed. G. Leidinger, Series as in Leidinger 1918 below, Band 6 (Munich, 1921).
Codex Egberti	*Codex Egberti der Stadtbibliothek Trier*, ed. Hubert Schiel (Basel, 1960).
Codex Wittekindeus	*Der Codex Wittekindeus*, ed. A. Boeckler (Leipzig, 1938).
Fauser	*Die Bamberger Apokalypse*, ed. A. Fauser (Wiesbaden, 1958).
Gero Codex	*Die Miniaturen des Gerocodex*, ed. Adolf Schmidt (Leipzig, 1924).
Grimme	Ernst G. Grimme, *Das Evangeliar Kaiser Otto III im Domschatz zu Aachen* (Freiburg, 1984).
Hitda Codex	*Der Darmstädter Hitda-Codex*, ed. Peter Bloch (Berlin, 1968).
Kahsnitz, 1982	*Das Goldene Evangelienbuch von Echternach: Codex Aureus Epternacensis Hs. 156142 aus dem Germanischen Nationalmuseum Nürnberg*, Facsimile & Kommentarband von Rainer Kahsnitz (Frankfurt, 1982).
Kahsnitz et al.	Rainer Kahsnitz, Ursula Mende, Elizabeth Rücker, *Das Goldene Evangelienbuch von Echternach* (facsimile of reduced size) (Frankfurt, 1982).
Leidinger, 1918	*Miniaturen aus Handschriften der Kgl. Hof- und Staatsbibliothek in München: Heft 5, Das Perikopenbuch Kaiser Heinrichs II, Cod. Lat. 4452*, ed. Georg Leidinger (Munich, 1918).

Lerche	O. Lerche, *Das Reichenauer Lektionar der Herzog-August Bibliothek zu Wolfenbüttel* (Leipzig, 1928).
Magnani, 1934	Luigi Magnani, *Le Miniature del Sacramentario d'Ivrea* (Vatican, 1934).
Metz, 1957	Peter Metz, *The Golden Gospels of Echternach* (London, 1957).
Nordenfalk, 1971	*Codex Caesareus Upsaliensis: an Echternach Gospel-Book of the Eleventh Century*, ed. C. Nordenfalk (Stockholm, 1971).
Rietschel	Christian Rietschel, *Der Festkreis: Bilder aus dem Mindener Sakramentar* (Berlin, 1971).
Sacr. Fuldense	*Sacramentarium Fuldense*, ed. G. Richter & A. Schönfelder (Fulda, 1912, repr. Henry Bradshaw Society, vol. 101).
Schulten (1980)	See under Books and Articles. Colour reproductions of all full-page miniatures of the Hillinus and Limburg Gospels at Cologne (MSS 12, 218).

Byzantine

| Omont, 1908 | *Evangiles avec Peintures Byzantine du XIe Siècle: Reproduction des 361 Miniatures du Manuscrit Grec 74 de la Bibliothèque Nationale*, ed. H. Omont (2 vols., Paris, 1908). |

Primary Sources

Abbo of Fleury	*Liber Apologeticus* PL 139, cols. 461-72.
Adalbold	*Adalboldi Vita Heinrici II Imperatoris*, MGH SS IV, 679-95
Adso of Montier-en-Der	*Adso Dervensis De Ortu et Tempore Antichristi*, ed. D. Verhelst, CC 45 (1976).
Arnold	*Arnoldi Libri de Sancto Emmerammo*, MGH SS IV, 543-74.
Autpertus, Apocalypse	*Ambrosius Autpertus in Apocalypsim Libri Decem*, in *Maxima Bibliotheca Veterum Patrum* 13 (Lyon, 1677).
Bede, Acts	*Bedae Venerabilis Expositio Actuum Apostolorum et Retractatio*, ed. M.L.W. Laistner (Cambridge, Mass. 1939).
Bede, Apocalypse	PL 93, cols.129-206.
Bede, HE	*Historia Ecclesiastica Gentis Anglorum*
Bede, De Templo	CC 119A, pp. 141-234
Berno	*Die Briefe des Abtes Berno von Reichenau*, ed. F.J. Schmale (Stuttgart, 1961)
Böhme, 1970	Walter Böhme, *Die deutsche Königserhebung im 10-12 Jahrhundert*, Heft 1: *Die Erhebungen von 911 bis 1105* (Göttingen, 1970).
Candidus of Fulda	*Candidus, Num Christus corporeis oculis Deum videre potuerit*, PL 106, cols. 103-08.
Capitularia	*Capitula de Causis Diversis*, ?807, MGH Legum Sectio II, *Capitularia* I, ed. A. Boretius (Hanover, 1883), pp. 135-36.
Carmina Sangallensia	no. VII, in Julius von Schlosser, *Schriftquellen zur Geschichte der Karolingischen Kunst* (Vienna, 1892), pp. 326-31.
Christian of St Emmeram	*Christian, Vita et Passio Sancti Wenceslai et sancte Ludmile ave eius*, in *Legenda Christiani*, or *Kristianova Legenda*, ed. Jaroslav Ludvikovsky (Prague, 1978).
Const. De Ceremoniis	*Constantin VII Porphyrogenète, Le Livre des Cérémonies*, ed. A. Vogt, 2 vols. Texte et Traduction (Paris, 1935-40).
Continuatio Reginonis	*Reginonis Abbatis Prumiensis Chronicon cum continuatione Treverensi*, ed. F. Kurze, MGH Scriptores in usum scholarum (Hanover, 1890).
Corvey Annals	*Annales Corbeienses*, in *Monumenta Corbeiensia* i, ed. P. Jaffé (Berlin, 1864).
Cosmas of Prague	*Cosmae Pragensis Chronica Boemorum*, ed. B. Bretholz, MGH Script. rerum Germ. in usum scholarum (Berlin, 1955).
De Literis Colendis	MGH, Legum Sectio II, *Capitularia* I, ed. A. Boretius, no.29 (Hanover, 1883), trans. King, 1987, pp. 232-33.
DHI, DOI, DOII, DOIII, DHII	MGH *Diplomata Regum et Imperatorum Germaniae*, vols ed. T. Sickel (Hanover, 1879, 1884, 1888, 1893) and H. Bresslau (Hanover, 1900), i.e. of Henry I, Otto I, Otto II, Otto III, Henry II.
Dodwell, 1961	*Theophilus de Diversis Artibus*, ed. C.R. Dodwell (Nelson's Medieval Texts, London, 1961).
Dronke, 1844	*Traditiones et Antiquitates Fuldenses*, ed. E.F.J. Dronke (Fulda, 1844).
Dümmler, 1902	'Das Glaubensbekenntnis des Schulmeisters Rihkarius', *Neues Archiv* 27 (1902), 503-08 (text of Rihkar's letter).

Eigil	*Eigilis Vita Sancti Sturmi*, MGH SS II, 365-77, trans., C.H. Talbot, *The Anglo-Saxon Missionaries in Germany* (London, 1954), pp. 179-202.
Einhard, Halphen, 1947	*Eginhard: Vie de Charlemagne*, ed. L. Halphen (Paris, 1947).
Ekkehard IV	*Casus Sancti Galli*, ed. G. Meyer von Knonau (St Gallen, 1877).
De Episc. Eichst.	*Anonymus Haserensis De Episcopis Eichstetensibus*, MGH SS VII, pp. 253-66.
Epp. Bonifatii	*S. Bonifatii et Lullii Epistolae*, ed. M. Tangl, MGH Epistolae Selectae i (Berlin, 1955).
Epp. Gregorii	*Gregorii I Papae Registrum Epistolarum*, ed. L.M. Hartmann (MGH, Berlin, repr. 1957, 2 vols).
Ermold	*Ermold Le Noir: Poème sur Louis le Pieux*, ed. E. Faral (Paris, 1964).
Folcuin	*Folcuini Gesta Abbatum Lobiensium*, MGH SS IV, pp. 52-74.
Gerhard	*Gerhardi Vita Sancti Oudalrici episcopi Augustani*, MGH SS IV, pp. 377-428.
Gesta Arch Magd.	*Gesta Archiepiscoporum Magdeburgensium*, MGH SS XIV, pp. 361-416.
Gesta Treverorum	MGH SS VIII, pp. 111-200.
Glöckner, 1929	*Codex Laureshamensis*, ed. K. Glöckner, i (Darmstadt, 1929).
Gregory, Dialogues	*Gregorii Magni Dialogi*, ed. U. Moricca (Fonti per la Storia d'Italia, Rome, 1924).
Gregory, Hom. in Evang.	PL 76, cols. 1075-1312.
Gregory, Moralia (in Job)	PL 75, col. 509 to PL 76, col. 782.
Gregory, Regula Pastoralis	PL 77, cols. 13-128.
Gumpold	*Gumpoldi Vita Vencezlavi ducis Bohemiae*, MGH SS IV, pp. 213-23.
Guttenberg	*Die Regesten des Bischöfe und des Domkapitels von Bamberg*, ed. E. Frhr. von Guttenberg (Würzburg, 1963).
Havet	*Lettres de Gerbert (983-997)*, ed. J. Havet (Paris, 1889), cf. Lattin and also Weigle.
Haymo of Halberstadt, Apocalypse	PL 117, cols. 937-1220.
Helgaud	*Helgaud, Epitoma Vitae Regis Rotberti Pii*, ed. R.-H. Bautier & G. Labory (Paris, 1965).
Hermann	Herimanni Augiensis Chronicon, MGH SS IV, pp. 67-133.
Hildesheim Annals	*Annales Hildesheimenses*, ed. G. Waitz, MGH Script. rerum Germ. in usum scholarum (Hanover, 1878, repr. 1947).
Hrabanus on Chronicles	PL 109, cols. 279-540.
Hrabanus, Homiliae	PL 110, cols. 9-468.
Hrabanus, De Inst. Clericorum	PL 107, cols. 293-420.
Hrotsvitha	*Hrotsvithae Opera*, ed. Paul de Winterfeld, MGH Scriptores rerum Germ. in usum scholarum (Berlin, 1965).
Isidore of Seville, De Nat. Rerum	*Isidore de Seville: Traité de la Nature*, ed. Jacques Fontaine (Bordeaux, 1960).
Israël & Möllenberg	*Urkundenbuch des Erzstifts Magdeburg*, ed. F. Israël & W. Möllenberg (Magdeburg, 1937).
Jaffé-Löwenfeld	P. Jaffé and F. Löwenfeld, *Regesta Pontificum Romanorum*, 2 vols (Leipzig, 1881-85).
Janicke	*Urkundenbuch des Hochstifts Hildesheim und seine Bischöfe*, ed. K. Janicke (Leipzig, 1896).
Jonas of Orleans	*De Cultu Imaginum*, PL 106, cols.305-88.
Lattin	*The Letters of Gerbert of Aurillac*, trans. Harriet P. Lattin (Columbia, NY, 1961).
Leo of Montecassino	*Leonis Chronica*, MGH SS VII, pp. 574-727.
Libri Carolini	*Caroli Magni Capitulare de Imaginibus*, ed. H. Bastgen, MGH Legum Sectio III, *Concilia II, Supplementum*, (Hanover, 1924).
Liudprand	*Liudprandi Episcopi Cremonensis Opera*, ed. J. Becker, MGH in usum scholarum (Hanover, 1915).
Lupus of Ferrières	*Loup de Ferrières, Correspondance*, ed. L. Levillain (Paris, 1964).
Navigatio Sancti Brendani (Abbatis)	ed. Carl Selmer (Notre Dame University, 1959).
Notker	*Notkeri Balbuli Gesta Karoli Magni Imperatoris*, ed. Hans F. Haefele, MGH Script. rerum Germ. in usum scholarum(Berlin, 1962).
Oediger	*Die Regesten der Erzbischöfe von Köln im Mittelalter*, ed. F.W. Oediger (Bonn, 1954-61).

Otto of Freising, Chronicle	*Ottonis Episcopi Frisingensis Chronica sive Historia de Duabus Civitatibus*, ed. A. Hofmeister, MGH Script. rerum Germ. in usum scholarum (Hanover, 1912).
Purchard	*Purchardi Gesta Witigowonis*, in Strecker & Silagi, pp.260-79.
Quedlingburg Annals	*Annalium Quedlingburgensium Continuatio Anni 994-1025*, MGH SS III, 72-90.
RB, McCann	*The Rule of St Benedict*, ed. & trans. Justin McCann (London, 1952).
Radbod	*Radbod, Vita Sancti Bonifatii Archiepiscopi Moguntini*, ed. W. Levison, MGH Script. rerum Germ. in usum scholarum (Hanover, 1915).
Rathier, Opera Minora	*Ratherii Veronensis Opera Minora*, ed. P.L.R. Reid, CC, Cont. Med. 46 (1976).
Rathier, Praeloquia	PL 136, cols. 145-344.
Regularis Concordia	*Regularis Concordia*, ed. Thomas Symons (Nelson Medieval Classics, London, 1953).
Reichenau Confraternity Book	*Das Verbrüderungsbuch der Abtei Reichenau*, ed. Johanne Autenrieth, D. Geuenich, K. Schmid, MGH *Libri Memoriales et Necrologia*, NS 1 (Hanover, 1979).
Rudolf, Miracula	*Miracula Sanctorum in Fuldenses Ecclesias translatorum auctore Rudolfo*, MGH SS XV, pp. 328-41.
Ruotger	*Ruotgeri Vita Brunonis Archiepiscopi Coloniensis*, ed. Irene Ott, MGH Script. rerum Germ. in usum scholarum(Cologne, 1958).
Smaragdus	*Smaragdi Abbatis Via Regia*, PL 102, cols. 933-70.
Strecker & Silagi	*Die Lateinischen Dichter des deutschen Mittelalters: Die Ottonenzeit*, ed. K. Strecker & G. Silagi, MGH Poetae V (Leipzig/Munich, 1937-79).
Tatian	*Tatian: Lateinisch und Altdeutsch*, ed. Eduard Sievers (Paderborn, 1872).
Thegan	*Thegani Vita Hludowici Imperatoris*, MGH SS II, pp. 585-604.
Thangmar	*Thangmar, Vita Bernwardi Episcopi Hildesheimensis*, MGH SS IV, 754-82.
Thietmar	*Thietmari Merseburgensis Episcopi Chronicon*, ed. Robert Holtzmann, MGH Scriptores rerum Germ. in usum scholarum, n.s. 9 (Berlin, 1955).
Translatio Sancti Celsi	MGH SS VIII, pp. 204-07.
Translatio S. Epiphanii	MGH SS IV, pp. 248-51.
Translatio Sanguinis Domini	MGH SS IV, pp. 445-49.
Vita S. Adalberti	*John Canaparius, Vita Sancti Adalberti Episcopi*, MGH SS IV, pp. 581-95.
Vita Balderici	*Vita Balderici Episcopi Leodiensis*, MGH SS IV, pp. 724-38.
Vita Burchardi	*Vita Burchardi Episcopi Wormatiensis*, MGH SS IV, pp. 829-46.
Vita S. Clementis	Strecker & Silagi, pp. 109-45.
Vita Chrodegangi	*Vita Chrodegangi Episcopi Mettensis*, MGH SS X, pp. 552-72.
Vie de Gauzlin	*André de Fleury, Vie de Gauzlin, Abbé de Fleury*, ed. & French trans. R.-H. Bautier & G. Labory (Paris, 1969).
Vita Johannis Gorz.	*Vita Iohannis Gorziensis auctore Iohanne abbate S. Arnulfi*, MGH SS IV, pp. 335-77.
Vita Heriberti	*Vita Heriberti Archiepiscopi Coloniensis auctore Lantberto*, MGH SS IV, 739-53.
Vita Meinwerci	*Vita Meinwerci Episcopi Patherbrunnensis*, ed. F. Tenckhoff, MGH Script. rerum Germ. in usum scholarum (Hanover, 1921).
Vita S. Nili	*Vita S. Nili Junioris*, PG 120, cols.9-166 (with Latin translation).
Vita S. Paulini Trev.	*Vita Sancti Paulini Episcopi Treverensis auctore anonymo*, AASS Aug. VI, pp. 676-79.
Vita Romualdi	*Petri Damiani Vita Beati Romualdi*, ed. G. Tabacco (*Fonti per la Storia d'Italia*, 94, Rome, 1957).
Vita Wolfgangi	*Othloni Vita Sancti Wolfkangi Episcopi*, MGH SS IV, pp. 521-42.
Vogel & Elze	*Le Pontifical Romano-Germanique du Dixième Siècle*, ed. C. Vogel & R. Elze (Studi e Testi, 226, Vatican, 1963).
Volturno Chronicle	*Chronicon Vulturnense*, ed. V. Federici, i, (*Fonti per la Storia d'Italia*, 57, 1925).
Walafrid Strabo, De Exordiis	*De Exordiis et Incrementis Rerum Ecclesiasticarum*, in Capitularia (see Abbr. above).
Wattenbach, 1879	W. Wattenbach, 'Aus Handschriften', *Neues Archiv* 4 (1879), pp. 407-12.
Weigle	*Die Briefsammlung Gerberts von Reims*, ed. F. Weigle (MGH, Berlin, 1966), see above, Havet and also Lattin.

| Widukind | *Widukindi Monachi Corbeiensis Rerum Gestarum Saxonicarum Libri Tres*, ed. H.-E. Lohmann & P. Hirsch, MGH Script. rerum Germ. in usum scholarum (Hanover, 1935). |
| H. Zimmermann | *Papstregesten 911-1024*, ed. H. Zimmermann (Vienna, 1969). |

Books and Articles

Achten	Gerard Achten, *Das christliche Gebetbuch im Mittelalter* (Staatsbibl. Preussischer Kulturbesitz, Ausstellungskatalog 13, 1980).
Adamski, 1979	H.J. Adamski, *Christussäule im Dom zu Hildesheim* (Hildesheim, 1979).
Adamski	'Die Christussäule', in Algermissen, pp.191-201.
Alexander, 1970	J.J.G. Alexander, *Norman Illumination at Mont St Michel, 966-1100* (Oxford, 1970).
Alexander, 1976	'The illustrated manuscripts of the Notitia Dignitatum', in *Aspects of the Notitia Dignitatum*, ed. R. Goodburn & P. Bartholomew, *BAR*, Suppl. Series 15 (1976).
Alexander, 1978	*Insular Manuscripts 6th to the 9th Century* (London, 1978).
Alexander, 1978A	*The Decorated Letter* (London, 1978).
Paul Alexander, 1985	*The Byzantine Apocalyptic Tradition* (California, 1985).
Algermissen, 1960	*Bernward und Godehard von Hildesheim: Ihr Leben und Wirken*, ed. Konrad Algermissen (Hildesheim, 1960).
Al-Hamdani, 1972	Betty Al-Hamdani, 'The fresoes of Novara and the Bamberg Apocalypse', *Actes du XXIIe Congrès International d'Histoire de l'Art*, Budapest 1969, (publ. 1972).
Althoff	Gerd Althoff, 'Das Bett des Königs in Magdeburg: zu Thietmar II, 28', *Festschrift für Berent Schwineköper* (Sigmaringen, 1982), pp. 155-75.
Andrieu,	M. Andrieu, *Les Ordines Romani du Haut Moyen-Age* 5 vols in *Spicilegium Sacrum Lovanense*, 11, 23, 24, 28, 29 (Louvain, 1931, 1948, 1951, 1956, 1961).
Andrieu, 1925	M. Andrieu, 'L'*Ordo Romanus Antiquus* et Le *Liber de Divinis Officiis* du Pseudo-Alcuin', *Revue des Sciences Religieuses* 5 (1925), pp. 642-50.
Avery	M. Avery, *The Exultet Rolls of South Italy*, 2 vols (Princeton, 1936).
Ayres, 1987	Larry Ayres, 'An Italian Romanesque manuscript of Gregory the Great's *Moralia in Job,' Florilegium in honorem Carl Nordenfalk*, ed. P. Bjurström et al. (National Museum, Stockholm, 1987), pp. 33-46.
Bannasch	H. Bannasch, *Das Bistum Paderborn unter den Bischöfen Rethar und Meinwerk, 978-1036* (Paderborn, 1972).
Barbatti	Bruno Barbatti, 'Der heilige Adalbert von Prag und der Glaube an den Weltuntergang im Jahre 1000', *Archiv für Kulturgeschichte* 35 (1953), pp. 123-41.
Barré	H. Barré, 'La croyance à l'Assomption corporelle en Occident de 750 à 1150 environ', *Etudes Mariales* 7 (Paris 1950 for 1949), pp. 63-123.
Bauer	Gerd Bauer, *Corvey oder Hildesheim? Zur Ottonischen Buchmalerei in Norddeutschland* (Hamburg, 1977).
Bauerreiss, 1950	Romuald Bauerreis , *Kirchengeschichte Bayerns* ii (St Ottilien, 1950).
Bauerreiss, 1957	'Gab es eine Reichenauer Malschule um die Jahrtausendwende?' *Stud. und Mitt. zur Geschichte des Ben.-Ordnens* 68 (1957), pp. 40-72.
Beckwith, 1964	John Beckwith, *Early Medieval Art* (London, 1964).
Beissel, 1886	S.Beissel, *Die Bilder der Handschrift des Kaisers Otto im Münster zu Aachen* (Aachen, 1886).
Beissel, 1891	Stephan Beissel, *Das Hl. Bernward Evangelienbuch in Dom zu Hildesheim* (Hildesheim, 1891).
Belting, 1967	Hans Belting, 'Probleme der Kunstgeschichte Italiens im Frühmittelalter', FS 1 (1967), pp. 94-143.
Benz, 1975	K.J. Benz, *Untersuchung zur politischen Bedeutung der Kirchweihe unter Teilnahme der deutschen Herrscher im hohen Mittelalter.:unter Otto III und Heinrich II* (Kallmünz OPF, 1975).
Berlière	U. Berlière, 'L'Exercise du ministère paroissal par les moines dans le haut moyen-age', RB 39 (1927).
Bernsheim	E. Bernsheim, 'Die augustinische Geschichtsanschauung in Ruotgers Biographie des Erzbischofs Bruno v. Köln', *Zeitschrift für Rechtsgeschichte* (*Kan. Abt.* 2), 33 (1912), pp. 299-335.

Berschin, 1980 — Walter Berschin, *Griechisch-Lateinisches Mittelalter von Hieronymus zu Nikolaus von Kues* (Bern and Munich, 1980).

Beumann, 1950 — Helmut Beumann, *Widukind von Korvei: Untersuchungen zur Geschichtsschreibung und Ideengeschichte des 10 Jahrhunderts* (Weimar, 1950).

Beumann, 1962 — 'Einhard und die karolingische Traditio in ottonischen Corvey', *Westfalen* 30 (1952), repr. in H. Beumann, *Ideengeschichtliche Studien zu Einhard und anderen Geschichtsschreibern des früheren Mittelalters* (Darmstadt, 1962), pp. 15-39.

Beumann, 1962A — 'Das Kaisertum Ottos des Grossen: ein Rückblick nach tausend Jahren', *Historische Zeitschrift* 195 (1962), repr. in Helmut Beumann, *Wissenschaft vom Mittelalter: Ausgewählte Aufsätze* (Vienna, 1972), pp. 411-58.

Beumann, 1972 — 'Die Bedeutung Lotharingiens für die ottonische Missionspolitik im Osten', publ. 1969, repr. in *Wissenschaft* etc. (as above, Beumann, 1962A), pp. 377-409.

Beumann, 1970 — 'Historiographische Konzeption und politische Ziele Widukinds von Korvey', *Settimane di Studio*, Spoleto, xvii,2 (1970), 857-94.

Beyerle — *Die Kultur der Abtei Reichenau*, ed. K. Beyerle (2 vols, Munich, 1925).

Binski — Paul Binski, *The Painted Chamber at Westminster* (London, 1986).

Birchler — Linus Birchler, 'Zur karolingischen Architektur und Malerei in Münster-Müstair', *Frühmittelalterliche Kunst in den Alpenländern*, ed. L. Birchler et al., (Olten & Lausanne, 1954), pp. 167-252.

Bischoff, 1951 — Bernhard Bischoff, 'Die griechische Element in der abendländischen Bildung des Mittelalters', *Byzantinische Zeitschrift* 44 (1951), pp. 27-55.

Bischoff, 'Zu Plautus und Festus' — Bernhard Bischoff, *Mittelalterliche Studien* i, (Stuttgart, 1966), pp. 141-44.

Bischoff, 1967 — 'Das biblische Thema der Reichenauer *Visionären Evangelisten*', Bernhard Bischoff, *Mittelalterliche Studien* ii (Stuttgart, 1967), pp. 304-11.
'Literarisches und künstlerisches Leben in St Emmeram (Regensburg) während des frühen und hohen Mittelalters', ibid., pp. 77-115.

Bischoff, 1967A — *Mittelalterliche Schatzverzeichnisse* (Munich, 1967).

Bischoff, 1974 — *Lorsch im Spiegel seine Handschriften* (Munich, 1974).

Bischoff, 1981 — 'Die Schriftheimat der Münchener Heliand-Handschrift', in Bernhard Bischoff, *Mittelalterliche Studien* iii (Stuttgart, 1981), pp. 112-19.

Bischoff, 1984 — 'Italienische Handschriften des neunten bis elften Jahrhunderts in frühmittelalterlichen Bibliotheken ausserhalb Italiens', in *Il Libro e il Testo 1982: Atti del Convegno Internazionale* (Urbino, 1984), pp. 171-94.

Bischoff, 1984A — 'Eine Osterpredigt Liudprands von Cremona (um 960)', in *Anecdota Novissima: Texte des Vierten bis Sechsehnten Jahrhunderts* (Stuttgart, 1984), pp. 20-34.

Bishop, 1962 — Edmund Bishop, 'Angilbert's ritual order for Saint-Riquier', *Liturgica Historica* (Oxford, 1918, repr. 1962), pp. 314-32.

Blank, 1968 — Rudolf Blank, *Weltdarstellung und Weltbild in Würzburg und Bamberg vom 8 bis Ende des 12 Jahrhunderts* (Bamberg, 1968).

H. Bloch, 1896-97 — H. Bloch, 'Beiträge zur Geschichte des Bischofs Leo von Vercelli und seine Zeit', *Neues Archiv* 22 (1896-97), pp. 11-136.

Bloch, 1956 — Peter Bloch, *Das Hornbacher Sakramentar und seine Stellung innerhalb der frühen Reichenauer Buchmalerei* (Basel, 1956).

Bloch, 1959 — 'Die beiden Reichenauer Evangeliare im Kölner Domschatz', *Kölner Domblatt* 16 (1959), pp. 9-27.

Bloch, 1963 — 'Das Sakramentar Col. Metr. 88 in der Schatzkammer', *Kölner Domblatt* 22 (1963), pp. 81-88.

Bloch, 1963A — 'Das Reichenauer Einzelblatt mit den Frauen am Grabe im Hessischen Landesmuseum Darmstadt', in *Kunst in Hessen und am Mittelrhein* 3 (1963), pp. 25-43.

Bloch & Schnitzler — P. Bloch & H. Schnitzler, *Die ottonische Kölner Malerschule*, 2 vols (Düsseldorf, 1967, 1970).

Blume, 1925 — C.J. Blume, 'Reichenau und die Marianischen Antiphonen', in Beyerle, pp. 821-55.

Boeckler, 1925. — A. Boeckler, 'Die Reichenauer Buchmalerei', in Beyerle, pp. 956-98.

Boeckler, 1930 — *Abendländische Miniaturen* (Leipzig, 1930)

Boeckler, 1949	'Bildvorlagen der Reichenau', *Zeitschrift für Kunstgeschichte* 12 (1949), pp. 7-29.
Boeckler, 1953	*Deutsche Buchmalerei Vorgotische Zeit* (Die Blauen Bücher, Königstein im Taunus, 1953).
Boeckler, 1954	'Das Erhardbild im Utacodex', *Studies in Art and Literature for Belle Da Costa Greene*, ed. Dorothy Miner (Princeton, 1954), pp. 219-30.
Boeckler, 1960	*Das Perikopenbuch Kaiser Heinrichs II* (Stuggart, 1960).
Boeckler, 1961	'Ikonographische Studien zu den Wunderszenen in der ottonischen Malerei der Reichenau', *Bayerische Akademie der Wissenschaften, Phil-Hist. Kl. Abhandlungen neue Folge* 52 (Munich, 1961).
Bologna	Giulia Bologna, *Illuminated Manuscripts* (London, 1988).
Bornscheuer	Lothar Bornscheuer, *Miseriae Regum: Untersuchungen zum Krisen- und Todesgedanken in den herrschaftstheologischen Vorstellungen der ottonisch-salischen Zeit* (Berlin, 1968).
Boshof, 1972	Egon Boshof, *Das Erzstift Trier und seine Stellung zu Königtum und Papsttum im ausgehenden 10 Jahrhundert* (Cologne, 1972).
Boshof, 1978	'Köln, Mainz, Trier: Die Auseinandersetzung um die Spitzenstellung im deutschen Episkopat in ottonisch-salischer Zeit', *Jahrbuch des kölnischen Geschichtsvereins* 49 (1978), pp. 19-48.
Bouhot	J.-P. Bouhot, *Ratramne de Corbie: Histoire Littéraire et Controverses Doctrinales* (Paris, 1976).
du Bourguet	P. du Bourguet, *Early Christian Art* (London, 1972).
Boutemy, 1949	A. Boutemy, 'Le style Franco-Saxon, style de Saint Amand', *Scriptorium* 3 (1949), pp. 260-64.
Boutemy, 1949A	'Quel fut le foyer du style Franco-Saxon?', in *Miscellanea Tornacensia: Annales du Congrès Archéologique et Historique de Tournai* (1949), pp. 1-25.
Boutemy, 1950	'La bible enluminée de Saint-Vaast à Arras', *Scriptorium* 4 (1950), pp. 67-81.
Boutemy, 1950A	'Un grand Enlumineur du Xe siècle, l'abbé Odbert de Saint-Bertin', *Annales de la Fédération Archéologique et Historique de Belge* (1950), pp. 247-54.
Bovini	G. Bovini, *Ravenna Mosaics* (London, 1957).
Brieger, 1965	P. Brieger, 'Bible illustration and Gregorian Reform', *Studies in Church History* 2, ed. G.J. Cuming (London, 1965), pp. 154-64.
Brown, 1971	Peter Brown, *The World of Late Antiquity* (London, 1971).
Browning, 1966	Robert Browning, *Notes on Byzantine Prooimia, Wiener Byzantinische Studien, Band 1: Supplement* (Vienna, 1966).
Bruce-Mitford, 1969	R.L.S. Bruce-Mitford, 'The Art of the Codex Amiatinus', *Journ. Archaeol. Assoc. 3rd Series* 32 (1969), pp. 1-25.
Brühl, 1968	Carl-Richard Brühl, *Fodrum, Gistum, Servitium Regis* (Cologne, 1968), 2 vols.
Brühl, 1977	'Purpururkunden', *Festschrift für Helmut Beumann* (Sigmaringen, 1977), pp. 3-21.
de Bruyne	Donatien de Bruyne, *Sommaires, Divisions et Rubriques de la Bible Latine* (Namur, 1914).
Buchtal, 1966	H. Buchtal, 'Byzantium and Reichenau', *Byzantine Art: Lectures*, ed. M. Chatzidakis (Athens, 1966) pp. 45-60.
Buddensieg, 1965	Tilman Buddensieg, 'Beiträge zur ottonischen Kunst in Niedersachsen', as in Fillitz, 1965, pp. 68-76.
Bullough, 1965	Donald Bullough, *The Age of Charlemagne* (London, 1965).
Bullough, 1975	'The continental background of the reform', in *Tenth-Century Studies*, ed. David Parsons (Chichester, 1975), pp. 20-36.
Bullough, 1983	'Alcuin and the kingdom of heaven: liturgy, theology and the Carolingian age', in *Carolingian Essays*, ed. Uta-Renate Blumenthal (Washington, DC, 1983), pp. 1-69.
Butler, 1926	Cuthbert Butler, *Western Monasticism* (2nd ed., London, 1926).
Büttner	Heinrich Büttner, 'Zur Geschichte des Mainzer Erzstiftes im 10 Jahrhundert', *Jahrbuch f. das Bistum Mainz* 2 (1947), pp. 260-72.
Büttner, 1975	'Erzbischof Willigis von Mainz (975-1011)', in his *Zur frühmittelalterlichen Reichsgeschichte an Rhein, Main, und Neckar*, ed. Alois Gerlich (Darmstadt, 1975).
Büttner & Duft	H. Büttner & J. Duft, *Lorsch und St Gallen in der Frühzeit* (Konstanz, 1965).
Cahn	Walter Cahn, *Romanesque Bible Illumination* (Cornell, 1982).
Cameron, 1978	Averil Cameron, 'The Theotokos in sixth-century Constantinople: a city finds its symbol', *Journ.Theol.Stud.* n.s. 29 (1978), pp. 79-108.

Cameron, 1987	Averil Cameron, 'The construction of court ritual: the Byzantine *Book of Ceremonies*', in *Rituals of Royalty: Power and Ceremonial in traditional Societies*, ed. David Cannadine and Simon Price (Cambridge, 1987), pp. 106-36.
Cames	G. Cames, *Byzance et la Peinture Romane de Germanie* (Paris, 1966).
Capelle, 1950	B. Capelle, 'L'Oraison *Veneranda* à la Messe de l'Assomption', *Ephem. th. Lov.* 1950, reprinted in Bernard Capelle, *Travaux Liturgiques de Doctrine et d'Histoire* iii (Louvain, 1967), pp. 387-97.
Casagrande	Maria Casagrande, *I Codici Warmondiani e la Cultura a Ivrea fra IX e XI Secolo* (Pavia, 1971-74).
Chabot	J.B. Chabot, *Inventaire Sommaire des Manuscrits Coptes de la Bibl. Nat.*, *Revue des Bibliothèques* xvi (1906), no.13.
H. Chadwick, 1959	Henry Chadwick, *The Circle and the Ellipse: rival concepts of authority in the early Church* (Oxford, 1959).
Chavasse, 1948	A. Chavasse, 'Le Carême Romain et les Scrutins Prébaptismaux avant le IXe-Siècle', *Recherches de Science Religieuse* 35 (1948), pp. 325-81.
Chavasse, 1982	'L'Organisation stationnale du Carême Romain, avant le VIIIe siècle une organisation pastorale', *Revue des Sciences Religieuses* 56 (1982), pp. 17-32.
Clapham	A. Clapham, 'The Renaissance of Architecture and Stone-Carving in Southern France in the tenth and eleventh centuries', *Proc. Brit. Acad.* 18 (1932).
Clark	J.M. Clark, *The Abbey of St Gall as a Centre of Literature and Art* (Cambridge, 1926).
Claude 1972	D. Claude, *Geschichte des Erzbistums Magdeburg bis in das 12 Jahrhundert*, 2 vols (Cologne, 1972).
Collon-Gevaert, 1967	Suzanne Collon-Gevaert, 'Notker de Liège et Saint Bernward de Hildesheim: à propos d'un ivoire et d'une miniature', *Studien z. Buchmalerei und Goldschmiedkunst des Mittelalters, Festschrift für K.H. Usener*, ed. Frieda Dettweiler, et al. (Marburg, 1967) pp. 27-32.
Conant, 1959	K.J. Conant, *Carolingian and Romanesque Architecture, 800-1200* (Harmondsworth, 1959).
Constable	Giles Constable, 'Monasteries, rural churches and the *cura animarum* in the early Middle Ages', *Settimane di Studio* 28 (1982), pp. 349-89.
Corbet	Patrick Corbet, *Les Saints Ottoniens* (Sigmaringen, 1986).
Cormack, 1985	Robin Cormack, *Writing in Gold: Byzantine Society and its Icons* (London, 1985).
Cowdrey, 1970	H.E.J. Cowdrey, *The Cluniacs and the Gregorian Reform* (Oxford, 1970).
Cowdrey, 1983	*The Age of Abbot Desiderius: Montecassino, the Papacy, and the Normans in the Eleventh and Early Twelfth Centuries* (Oxford, 1983).
Cousin, 1954	P. Cousin, *Abbon de Fleury-sur-Loire* (Paris, 1954).
Dalton	O.M. Dalton, *Byzantine Art and Archaeology* (Oxford, 1911).
D'Alverny, 1946	M-Th. D'Alverny, 'La Sagesse et ses Sept Filles: Recherches sur les Allégories de la Philosophie et des Arts Libéraux du IXe au XIIe Siècle', *Mélanges dediées à la Memoire de Felix Grat* (Paris, 1946), i, pp. 245-78.
Daniel	Natalie Daniel, *Handschriften des zehnten Jahrhunderts aus der Freisinger Dombibliothek* (Munich, 1973).
Davis-Weyer	Caecilia Davis-Weyer, *Early Medieval Art 300-1150: Sources and Documents*, in translation, (Englewood Cliffs, NJ, 1971).
Deer	J. Deer, *Das Kaiserbild im Kreuz* (1955).
Demus	Otto Demus, *Byzantine Art and the West* (London, 1970).
Deshman, 1971	Robert Deshman, 'Otto III and the Warmund Sacramentary: a study in political theology', *Zeitschrift für Kunstgeschichte* 34 (1971), pp. 1-20.
Deshman, 1976	'Kingship and christology in Ottonian and Anglo-Saxon Art', *FS* 10 (1976), pp. 367-405.
Deshman, 1980	'The exalted servant: the ruler theology of the prayer book of Charles the Bald', *Viator* 11 (1980), pp. 385-417.
Deshusses	J. Deshusses, *Le Sacramentaire Grégorien: ses principales formes d'après les plus anciens manuscrits* (Fribourg, 1971).
Dienemann	J. Dienemann, *Der Kult des Heiligen Kilian im 8 und 9 Jahrhundert* (Würzburg, 1955).
Dodwell, 1971	C.R. Dodwell, *Painting in Europe 800-1200* (Harmondsworth, 1971).
Dodwell, 1982	*Anglo-Saxon Art: a new perspective* (Manchester, 1982).

Dodwell & Turner	C.R. Dodwell & D.H. Turner, *Reichenau Reconsidered* (London, 1965).
Dölger	F. Dölger, 'Die Familie der könige im Mittelalter', (1940) repr. in his *Byzanz und die Europäische Staatenwelt* (Darmstadt, 1964), pp. 34-69.
Drögereit, 1953	R. Drögereit, 'Griechisch-Byzantinisches aus Essen', *Byz. Zeitschrift* 46 (1953), pp. 110-15.
Drögereit, 1959	'Die Vita Bernwardi und Thangmar', in *Unsere Diözese: Zeitschrift des Vereins f. Heimatkunde im Bistum Hildesheim 28* (1959), pp. 2-46.
Dvornik, 1949	F. Dvornik, *The Making of Central and Eastern Europe* (London, 1949).
Duby	G. Duby, *La Société aux XIe et XIIe Siècles dan la Région Mâconnaise* (Paris, 1953).
Dunbabin	Jean Dunbabin, *France in the Making 843-1180* (Oxford, 1985).
Dunbabin, 1985	'The Maccabees as exemplars in the tenth and eleventh centuries', in *The Bible in the Medieval World: Essays in Memory of Beryl Smalley*, ed. Katherine Walsh & Diana Wood (Oxford, 1985), pp. 31-41.
Elbern	Victor H. Elbern, 'Über die Illustration des Messkanons im frühen Mittelalter', as in Fillitz, 1965, pp. 60-67.
Engelmann, 1971	Ursmar Engelmann, *Reichenauer Buchmalerei* (Freiburg, 1971).
Das Erste Jahrtausend	*Kultur und Kunst im werdenden Abendland an Rhein und Ruhr*, ed. Victor Elbern (Düsseldorf, 1962, 1964), 2 vols & Tafelband.
von Euw	Anton von Euw, 'Das Sakramentar von St Paul' in Maurer, pp. 363-87.
M.W. Evans, 1969	*Medieval Drawings* (London, 1969).
Falk, 1897	Franz Falk, *Die Ehemalige Dombibliothek zu Mainz: Zentralblatt für Bibliothekswesen* (Beiheft 18, 1897).
Ferdinandy	M. de Ferdinandy, *Der Heilige Kaiser: Otto III und seine Ahnen* (Tübingen, 1969).
Ferrari, 1957	G. Ferrari, *Early Roman Monasteries* (Vatican, 1957).
Fichtenau, 1957	H. Fichtenau, *The Carolingian Empire* (Oxford, 1957).
Fichtenau, 1975	'Riesenbibeln in Österreich und Mathilde von Tuszien', MIÖG 58, 1950, *Festschrift für Leo Santifaller*, repr. H. Fichtenau, Beiträge zur Mediävistik, i (Stuttgart, 1975), pp. 163-86.
Fichtenau, 1984	*Lebensordnungen des 10 Jahrhunderts* (Stuttgart, 1984), 2 vols.
Fillitz, 1965	H. Fillitz, 'Ein Fuldaer Goldrelief der ottonischen Zeit', *Miscellanea Pro Arte: Festschrift H. Schnitzler* (Düsseldorf, 1965), pp. 77-82.
Fischer, 1907	H. Fischer, 'Die kgl. Bibliothek in Bamberg und ihre Handschriften', *Zentralblatt für Bibliothekswesen* 24 (1907), pp. 364-94.
Fischer, 1926	*Mittelalterliche Miniaturen aus der Staatlichen Bibliothek Bamberg*, 2 vols (Bamberg, 1926, 1929).
F.M. Fischer	*Politiker um Otto den Grossen* (Berlin, 1938).
Fleckenstein	Josef Fleckenstein, *Die Hofkapelle der deutschen Könige*, ii, *Die Hofkapelle im Rahmen der Ottonisch-Salischen Reichskirche* (Stuttgart, 1966).
Fleckenstein, 1964	'Rex Canonicus: über Entstehung und Bedeutung des mittelalterlichen Königs-kanonikats', *Festschrift Percy Schramm* (Wiesbaden, 1964), pp. 57-71.
Fleckenstein, 1974	*Grundlagen und Beginn der deutschen Geschichte* (Göttingen, 1974).
Fleckenstein, 1974A	'Zum Begriff der ottonisch-salischen Reichskirche', *Festschrift für Clemens Bauer* (Berlin, 1974), pp. 61-71.
Folz, 1950	Robert Folz, *Le Souvenir et la Légende de Charlemagne dans l'Empire Germanique Mediéval* (Paris, 1950).
Folz, 1974	*The Coronation of Charlemagne* (London, 1974).
Fournier & Le Bras	P. Fournier & G. Le Bras, *Histoire des Collections Canoniques en Occident depuis Les Fausses Décretales jusqu'au Décret de Gratien*, 2 vols (Paris, 1931, 1932).
Freeman	Ann Freeman, 'Theodulf of Orleans and the Libri Carolini', *Speculum* 32 (1957), pp. 663-705.
Freydank	K. Freydank, 'Das Kloster Fulda und die althochdeutsche Literatur', in Hrabanus Maurus, etc. as under Mütherich, 1980, pp. 126-37.
Fuhrmann, 1986	Horst Fuhrmann, *Germany in the High Middle Ages, c.1050-1200*, trans. Timothy Reuter (Cambridge, 1986).
Fuhrmann & Mütherich	*Das Evangeliar Heinrichs des Löwen und das mittelalterliche Herrscherbild*, ed. Horst Fuhrmann & Florentine Mütherich (Munich, 1986).

Gaborit-Chopin	D. Gaborit-Chopin, *La Decoration des Manuscrits à Saint Martial de Limoges et en Limousin du IXe au XIIe Siècle* (Paris, 1969).
Gaettens	R. Gaettens, *Das Geld- und Münzwesen der Abtei Fulda im Hochmittelalter* (Fulda, 1957).
Galley	Eberhard Galley, 'Das Karolingische Evangeliarfragment aus der Landes- und Stadtbibliothek Düsseldorf', *Düsseldorfer Jahrbuch* 52, (1966), pp. 120-27.
Ganz, 1987	David Ganz, 'The preconditions for Caroline Minuscule', *Viator* 18 (1987), pp. 23-44.
Garrison	E.B. Garrison, *Studies in the History of Medieval Italian Painting*, 4 vols (Florence, 1953-62).
Geary, 1983	Patrick Geary, 'Humiliation of saints', in *Saints and their Cults*, ed. Stephen Wilson (Cambridge, 1983), pp. 123-40.
Geldner	Ferdinand Geldner, 'Geburtsort, Geburtsjahr, und Jugendzeit Kaiser Heinrichs II', DA 34 (1978), pp. 520-38.
Gibson, 1969	Margaret Gibson, 'The *artes* in the eleventh century', in *Arts Libéraux et Philosophie au Moyen Age: Actes de IVème Congrès International de Philosophie Mediévale* (Montreal/Paris, 1969), pp. 120-26.
Gibson & Nelson	*Charles the Bald: Court and Kingdom*, ed. Margaret Gibson & Janet Nelson, *BAR, International Series* 101 (1981).
Giess	Hildegard Giess, *Die Darstellung der Fusswaschung Christi in den Kunstwerken des 4-12 Jahrhunderts* (Rome, 1962).
Gillingham, 1971	J.B. Gillingham, *The Kingdom of Germany in the High Middle Ages, 900-1200*, Historical Association Booklet (London, 1971).
Godman, 1985	Peter Godman, *Poetry of the Carolingian Renaissance* (London, 1985).
Goetting	H. Goetting, *Die Hildesheimer Bischöfe von 815 bis 1221 (1227)*, Germania Sacra, n.f.20 (Berlin, 1984).
Goetz	O. Goetz, *Der Feigenbaum in der religiösen Kunst des Abendlandes* (Berlin, 1965).
Goldschmidt, 1928	Adolph Goldschmidt, *German Illumination*, 2 vols (Paris, 1928, 1929).
Goldschmidt, 1969	*Die Elfenbeinskulpturen aus der Zeit der Karolingischen und Sächsischen Kaiser* (Oxford, ed. 1969), 2 vols.
Grabar, 1936	A. Grabar, *L'Empereur dans l'Art Byzantine* (Paris, 1936).
Grabar, 1972	*Les Manuscrits Grecs enluminées de provenance Italienne IX-XI Siècles, Bibliothèque des Cahiers Archéologiques* 8 (Paris, 1972).
Grabar & Nordenfalk	A. Grabar & C. Nordenfalk, Skira Book of *Early Medieval Painting* (Lausanne & NY, 1957).
Gräf	Hermann J. Gräf, *Palmenweihe und Palmenprozession in der lateinischen Liturgie* (Kaldenkirchen, 1959).
Greenaway, 1955	G.W. Greenaway, *Saint Boniface* (London, 1955).
Gregoire, 1966	R. Gregoire, *Les Homéliaires du Moyen Age* (Rome, 1966).
Grodecki et al.	L. Grodecki, F. Mütherich, J. Taralon, F. Wormald, *Le Siècle de l'An Mil* (Paris, 1973).
Grundmann, 1936	Herbert Grundmann, 'Die Frauen und die Literatur im Mittelalter', in *Arch. f. Kulturgeschichte* 26 (1936), pp. 129-60, repr. in H. Grundmann, *Ausgewählte Aufsätze* (Schriften der MGH, 25, 3, 1978).
Haller, 1970	Winfried Haller, *Bischofsamt im Mittelalter: Bernward und Godehard von Hildesheim* (Hildesheim, 1970).
Hallinger	Kassius Hallinger, *Gorze-Kluny* (Graz, ed. 1971), 2 vols.
Hallinger, 1975	'Willigis von Mainz und die Klöster', in *Willigis und sein Dom*, ed. Anton Ph. Brück (Mainz, 1975), pp. 93-134.
de Hamel	Christopher de Hamel, *A History of Illuminated Manuscripts* (Oxford, 1986).
Hamilton	Bernard Hamilton, 'The monastery of St Alessio and the religious and intellectual renaissance in tenth-century Rome', reprinted in his *Monastic Reform, Catharism and the Crusades, 900-1300* (London, 1979), paper III, pp. 265-310.
Härtel	*Handschriften der Niedersächsischen Landesbibliothek Hanover*, ed. H. Härtel, 2 vols (Wiesbaden, 1982).
Härtel & Stähli	*Die Handschriften im Domschatz zu Hildesheim*, ed. H. Härtel & Marlis Stähli (Wiesbaden, 1984).

Hauck	A. Hauck, *Kirchengeschichte Deutschlands* iii (Leipzig, 1912).
Haussherr	R. Haussherr, *Der tote Christ am Kreuz: zur Ikonographie des Gerokreuzes* (Diss. Bonn, 1963).
Haussig	H.W. Haussig, *A History of Byzantine Civilization* (London, 1971).
Henderson	George Henderson, *Early Medieval* (London, 1972).
Heyen	F.J. Heyen, *Das Erzbistum Trier* i, *Das Stift St Paulin vor Trier*, Germania Sacra, n.f. 6 (Berlin, 1972).
Hlawitschka, 1974	Edward Hlawitschka, 'Zur Herkunft der Liudolfinger und zu einigen Corveyer Geschichtsquellen', *Rheinische Vierteljahrsblätter* 38 (1974), pp. 92-165.
Hlawitschka, 1978	'*Merkst du nicht, dass dir das vierte Rad am Wagen fehlt*?: Zur Thronkandidatur Ekkehards von Meissen (1002)', *Geschichtsschreibung und Geistiges Leben im Mittelalter, Festschrift für Heinz Löwe*, ed. K. Hauck & H. Mordek (Cologne/Vienna, 1978), pp. 281-311.
Hodges & Mitchell	*San Vincenzo al Volturno: The Archaeology, Art and Territory of an early Medieval Monastery*, ed. Richard Hodges and John Mitchell (*BAR, International Series* 252, 1985).
Hoffmann	Hartmut Hoffmann, *Buchkunst und Königtum im ottonischen und frühsalischen Reich, Textband & Tafelband* (Stuttgart, 1986).
H. Hoffmann, 1957	H. Hoffmann, 'Politik und Kultur im ottonischen Reichskirchensystem: zur Interpretation der Vita Brunonis von Ruotger', *Rheinische Vierteljahrsblätter* 22 (1957), pp. 31-55.
H. Hoffmann, 1969	'Böhmen und das deutsche Reich im hohen Mittelalter', *Jahrbuch für die Geschichte Mittel- und Ost-Deutschlands* 18 (1969), pp. 1-62.
K. Hoffmann, 1966	Konrad Hoffmann, 'Die Evangelistenbilder des Münchener Otto-Evangeliars' (Clm 4453), *Zeitschrift des Deutschen Vereins für Kunstwissenschaft* 20 (1966), pp. 17-46.
K. Hoffmann, 1973	'Das Herrscherbild im Evangeliar Otto III (Clm 4453)', FS 7 (1973), 324-41.
P. Hofmeister	Philipp Hofmeister, 'Mönchtum und Seelsorge bis zum 13 Jahrhundert', *Stud. und Mitteilungen z. Geschichte des Benediktiner-Ordens* 65 (1953-54), pp. 209-73.
Holder, 1970	*Die Reichenauer Handschriften*, ed. A. Holder (revised ed. Wiesbaden, 1970).
R. Holtzmann	Robert Holtzmann, *Geschichte der Sächsischen Kaiserzeit* (ed. 1955).
R. Holtzmann, 1962	'Otto der Grosse und Magdeburg' (1936), repr. in Robert Holtzmann, *Aufsätze zur deutschen Geschichte des Mittelelberaums* (Darmstadt, 1962), pp. 1-33.
Honselmann	K. Honselmann, 'Alte Corveyer Mönchslisten: Der Corveyer Konvent unter Abt Folkmar', *Ostwestfälische-Weserländische Forschungen zur geschichtlichen Landeskunde*, ed. Heinz Stoob (Münster, 1970), pp. 62-74.
Honselmann, 1975	*Das Rationale der Bischöfe* (Paderborn, 1975).
Hourlier, 1964	J. Hourlier, *Saint Odilon Abbé de Cluny* (Louvain, 1964).
Hubert et al.	J. Hubert, J. Porcher, & W.F. Volbach, *Carolingian Art* (London, 1970).
Imdahl	M. Imdahl, *Das Gerokreuz im Kölner Dom* (1964).
Irtenkauf	Wolfgang Irtenkauf, 'Die Litanei des Pommersfelder Königsgebetbuches (für Otto III)', *Festschrift für K.H. Usener* (Marburg, 1967), pp. 129-36.
Jantzen	Hans Jantzen, *Ottonische Kunst* (Munich, 1947; Rowohlt, Hamburg, 1959).
Jantzen, 1940	'Das Wort als Bild in der frühmittelalterlichen Buchmalerei', *Historisches Jahrbuch* 60 (1940), pp. 507-13.
Jolliffe	J.E.A. Jolliffe, *Angevin Kingship* (London, 1955).
Jones & Morey	L. W. Jones & C. R. Morey, *The Miniatures of Terence*, 2 vols (Princeton, 1931).
Jugie	M. Jugie, *La Mort et l'Assomption de la Sainte Vièrge* Studi e Testi 114 (Vatican, 1944).
Juraschek	F. von Juraschek, *Die Apokalypse von Valenciennes, Veröffentlichungen der Gesellschaft f. Österr. Frühmittelalterforschung*, 1 (1954).
Kahsnitz, 1971	Rainer Kahsnitz, 'The Gospel Book of Abbess Svanhild of Essen in the John Rylands Library', *Bull. John Rylands Library* 53 (1971), pp. 1-82.
Kahsnitz, 1979	Rainer Kahsnitz, *Der Werdener Psalter in Berlin* (Düsseldorf, 1979).
Kahsnitz, 1987	'Koimesis-dormitio-assumptio: Byzantinisches und Antikes in den Miniaturen der Liuthargruppe', *Florilegium Carl Nordenfalk*, as in Ayres, 1987, pp. 91-122.
Kantorowicz, 1944	E.H. Kantorowicz, 'The king's advent', *Art Bulletin* 26 (1944)

Kantorowicz, 1957	*The King's Two Bodies: a Study in medieval political theology* (Princeton, 1957).
Keefe	Susan Keefe, 'Carolingian Baptismal Expositions: a handlist of tracts and manuscripts', in *Carolingian Essays*, as in Bullough, 1983, pp. 167-237.
Keller, 1964	Hagen Keller, 'Das Kaisertum Ottos des Grossen im Verständnis seiner Zeit', DA 20 (1964), pp. 325-88.
Keller, 1985	'Herrscherbild und Herrschaftslegitimation: Zur Deutung der ottonischen Denkmäler', FS 19 (1985), pp. 290-311, pls. XXIII-IX.
Kemp	E.W. Kemp, *Canonization and Authority in the Western Church* (Oxford, 1948).
Kessler	Herbert L. Kessler, *The Illustrated Bibles from Tours* (Princeton, 1977).
Kienast	W. Kienast, *Deutschland und Frankenreich in der Kaiserzeit, 900-1270: Weltkaiser und Einzelkönige*, 2 vols (Stuttgart, 1975).
King	P.D. King, *Charlemagne: Translated Sources* (Kendal, 1987).
Kirchner, 1926	Joachim Kirchner, *Beschreibendes Verzeichnis der Miniaturen und des Initialschmuckes in den Phillips-Handschriften* (Leipzig, 1926).
Kitzinger, 1956	E. Kitzinger, 'The Coffin-Reliquary', in *The Relics of St Cuthbert*, ed. C.F. Battiscombe (Oxford, 1956), pp. 202-304.
Kitzinger, 1972	'The Gregorian Reform and the Visual Arts: a problem in method', *Trans. Royal Hist. Soc. 5th ser.* 22 (1972), pp. 81-102.
Klauser, 1969	T. Klauser, *A Short History of the Western Liturgy* (Oxford, 1969).
Klauser, 1972	T. Klauser, *Das Römische Capitulare Evangeliarum* (Münster, 1972).
Klein, 1984	Peter Klein, 'Zu einigen Reichenauer Handschriften Heinrichs II für Bamberg', *Festschrift Gerd Zimmermann, Bericht des Historischen Vereins Bamberg*, 120 (Bamberg, 1984), pp. 417-22.
Klein, 1985	'L'Art et l'idéologie impériale des Ottoniens vers l'an Mil: l'Evangeliaire d'Henri II et l'Apocalypse de Bamberg', in *Les Cahiers de Saint-Michel de Cuxa* 16 (1985), 177-207.
Klein, 1985A	'Zum Weltgerichtsbild der Reichenau', *Studien zur mittelalterlichen Kunst, 800-1250, Festschrift für Florentine Mütherich* (Munich, 1985), pp. 107-24.
Klewitz	H.-W. Klewitz, 'Königtum, Hofkapelle und Domkapitel im 10 und 11 Jahrhundert', *Archiv für Urkundenforschung* 16 (1939), repr. in H.-W. Klewitz, same title, as a small book (Darmstadt, 1960).
Klüppel & Berschin	Theo Klüppel & Walter Berschin, 'Vita Symeonis Achivi', in Maurer, pp. 115-24.
Köhler, 1926	W. Köhler, 'Die Tradition der Adagruppe und die Anfänge des ottonischen Stiles in der Buchmalerei', *Festschrift zum Paul Clemen* (Bonn, 1926), pp. 255-72.
Köhler, 1930, 1960	*Die Karolingischen Miniaturen* i: *Die Schule von Tours* (Berlin, 1930); iii (Berlin, 1960).
Köhler, 1952	'An illustrated Evangelistary of the Ada School', *Journal of the Warburg and Courtauld Institutes*, XV (1952), 48-66.
Köhler & Mütherich	W. Köhler & Florentine Mütherich, *Die Karolingischen Miniaturen*, v (Berlin, 1982).
Kolberg	A. Kolberg, 'L'Auteur et les sources de la Passion des SS Gorgone et Dorothée', *Analecta Bollandiana* 18 (1899), pp. 5-21.
Korteweg, 1979	Anna Korteweg, *De Bernulphuscodex* (Amsterdam, 1979).
Korteweg, 1985	'Das Evangeliar Clm 23338 und seine Stellung innerhalb der Reichenauer Schulhandschriften', *Festschrift für Florentine Mütherich*, as in Klein 1985A, pp. 125-44.
Kunst und Kultur	*Kunst und Kultur im Weserraum 800-1600*, ed. H. Eichler, 2 vols (Münster, 1967).
Küppers, 1975	L. Küppers, *Essen: Dom und Domschatz* (Königstein im Taunus, 1975).
Laistner, 1943	M.L.W. Laistner, *A Hand-List of Bede Manuscripts* (Cornell, 1943).
Laistner, 1957	*Thought and Letters in Western Europe, 500-900* (Cornell, revised ed., 1957).
Lambot, 1934	C. Lambot, 'L'homélie du Pseudo-Jerome sur l'Assomption et l'Évangile de la Nativité de Marie d'après une lettre inédite d'Hincmar', RB 44 (1934), pp. 265-82.
Landsberger	Franz Landsberger, *Der St.Galler Folchart-Psalter: Eine Initialenstudie* (St Gallen, 1912).
Lasko	Peter Lasko, *Ars Sacra 800-1200* (Harmondsworth, 1972).
P. Lauer, 1927	*Les Enluminures Romanes des MSS de la Bibliothèque Nationale* (Paris, 1927).

Lauer, 1975	Rolf Lauer, 'Mainzer Buchmalerei der Willigiszeit', in *1000 Jahre Mainzer Dom 975-1975*, ed. W. Jung (Mainz, 1975), pp. 58-69.
Lauer	*Studien zur ottonischen Mainzer Buchmalerei* (Universität Bonn, 1987).
Lehmann, 1941	Paul Lehmann, 'Die alte Klosterbibliothek Fulda und ihre Bedeutung', in his *Erforschung des Mittelalters* i (Leipzig, 1941), pp. 213-31.
Lehmann, 1962	'Corveyer Studien' repr. in Paul Lehmann, *Erforschung des Mittelalters* v (Stuttgart, 1962), pp. 95-178.
Leitschuh, Leitschuh & Fischer	F. Leitschuh & F.M. Fischer, *Katalog der Handschriften der königlichen Bibliothek zu Bamberg*, 3 vols (Bamberg, 1895-1912).
Leroquais, 1937	*Les Pontificaux Manuscrits des Bibliothèques publiques de France*, 2 vols (Paris, 1937).
Lesne	E. Lesne, *Histoire de la Propriété Écclesiastique en France*, iv, *Les Livres, Scriptoria et Bibliothèques, C8-C11* (Lille, 1938).
Lesser, 1888	Friedrich Lesser, *Erzbischof Poppo von Trier, 1016-47* (Leipzig, 1888).
Levison, 1929-30	W. Levison, Nachricht no.164, *Neues Archiv* 48 (1929-30), pp. 230-32.
Levison, 1946	W. Levison, *England and the Continent in the Eighth Century* (Oxford, 1946).
Lex. Christ. Icon.	*Lexikon der christlichen Iconographie*, ed. E. Kirschbaum (Freiburg, 1968-).
Leyser, 1973	Karl Leyser, 'The Tenth Century in Byzantine-Western Relationships', reprinted in Leyser, 1982, pp. 103-37.
Leyser, 1979	K.J. Leyser, *Rule and Conflict in an Early Medieval Society: Ottonian Saxony* (London, 1979).
Leyser, 1981	'Ottonian Government', EHR 96 (1981), pp. 721-53, repr. in Leyser 1982.
Leyser, 1982	*Medieval Germany and Its Neighbours, 900-1250* (London, 1982).
Leyser, 1983	'The crisis of Medieval Germany', *Proceedings of the British Academy* 69 (1983), pp. 409-43.
Leyser, 1983A	'Die Ottonen und Wessex', FS 17 (1983), pp. 73-97.
Leyser, 1985	'Liudprand of Cremona: preacher and homilist' in *The Bible in the Medieval World: Essays in memory of Beryl Smalley*, ed. Katherine Walsh & Diana Wood (Oxford, 1985), pp. 43-60.
Llewellyn, 1986	Peter Llewellyn, 'The Popes and the Constitution in the Eighth Century', EHR 101 (1986), pp. 42-67.
Lotter, 1958	Friedrich Lotter, *Die Vita Brunonis des Ruotger* (Bonn, 1958).
Lotter, 1975	*Der Brief des Priesters Gerhard an den Erzbischof Friedrich von Mainz* (Sigmaringen, 1975).
Loud	G.A. Loud, *Church and Society in the Norman Principality of Capua, 1058-1197* (Oxford, 1985).
Lübeck, 1949	K. Lübeck, 'Das Fuldaer Klostergut in Friesland', in his *Fuldaer Studien*, i (Fulda, 1949), pp. 121-25.
Lübeck, 1950	'Die Reliquienerwerbungen des Abtes Rabanus Maurus', in his *Fuldaer Studien*, ii (Fulda, 1950), pp. 113-32.
Ludat, 1968	Herbert Ludat, 'The Medieval Empire and the early Piast State', *Historical Studies* vi, ed. T.W. Moody (London, 1968), pp. 1-21.
MacCormack, 1981	Sabine MacCormack, *Art and Ceremony in late Antiquity* (California, 1981).
McDonald, 1938	A.D. McDonald, 'The iconographic tradition of Sedulius', *Speculum* 8 (1933), pp. 150-56.
McKitterick, 1977	Rosamond McKitterick, *The Frankish Church and Carolingian Reforms, 789-895* (London, 1977).
McManners	*Oxford Illustrated History of Christianity*, ed. J. McManners (Oxford, 1990).
Mâle, 1960	Emile Mâle, *The Early Churches of Rome*, trans. David Buxton (London, 1960).
Manitius	M. Manitius, *Geschichte der lateinischen Literatur des Mittelalters*, 3 vols (Munich, 1911-31).
Manser & Beyerle	A. Manser & K. Beyerle, 'Aus dem liturgischen Leben der Reichenau', in Beyerle, 1925, pp. 316-437.
Marquardt	Janet Teresa Marquardt, *Illustrations of Troper Texts: the painted miniatures in the Prüm Troper-Gradual, Paris Latin MS 9448* (unpublished Ph.D. thesis, 1986, University of California, Los Angeles, 192pp).
Martin	Kurt Martin, *Die ottonischen Wandbilder der St Georgskirche, Reichenau-Oberzell* (Sigmaringen, 2nd ed., 1975).

Masseron	Alexandre Masseron, *Saint Jean Baptiste dans l'Art* (Paris, 1957).
Matthes, 1980	*Die Hieratsurkunde der Kaiserin Theophanu: Faksimile-Ausgabe* (Müller & Schindler, Stuttgart, 1980), 23pp.
Matthes & Deeters	*Die Hieratsurkunde der Kaiserin Theophanu*, ed. Dieter Matthes & Walter Deeters, exhibition catalogue (Göttingen, 1972).
Maurer	*Die Abtei Reichenau*, ed. Helmut Maurer (Sigmaringen, 1974).
Maurer, 1973	H. Maurer, *Konstanz als ottonischer Bischofssitz* (Göttingen, 1973).
Maurer, 1974	'Rechtlicher Anspruch und geistliche Würde der Abtei Reichenau unter Kaiser Otto III', in Maurer, pp. 255-75.
A. Mayer, 1962	*Das Bild der Kirche* (Regensburg, 1962).
T. Mayer, 1952	'Die Anfänge des Bistums Bamberg', *Festschrift Edmund Stengel* (Münster, 1952), pp. 272-88.
van der Meer	Friedrich van der Meer, *Apocalypse* (London, 1978).
Merton	A. Merton, *Die Buchmalerei in St Gallen von neunten bis zum elften Jahrhundert* (Leipzig, 1912).
Messerer, 1952	W. Messerer, *Der Bamberger Domschatz* (Munich, 1952).
Messerer, 1959	'Zur Byzantinischen Frage in der ottonischen Kunst', *Byz. Zeitschrift* 52 (1959), pp. 32-60.
Messerer, 1959A	'Uber einen neuen Vorschlag zur Lokalisierung ottonischer Miniaturen', *Zeitschrift für bayerische Landesgeschichte* 22 (1959), pp. 139-45.
Messerer, 1963	'Ottonische Buchmalerei um 970-1070: Literaturbericht', *Zeitschrift für Kunstgeschichte* 26 (1963), pp. 62-76.
Messerer, 1974	'Reichenauer Malerei nach Jantzen', in Maurer, pp. 291-309.
O. Meyer, 1966	Otto Meyer, *Bamberg und das Buch* (Bamberg, 1966).
Ruth Meyer	'Die Miniaturen im Sakramentar des Bischofs Sigebert von Minden', *Festschrift für K.H. Usener* (Marburg, 1967), pp. 181-200.
Meyvaert, 1979	Paul Meyvaert, 'The authorship of the Libri Carolini', RB 89 (1979), pp. 29-57.
Micheli, 1939	G.L. Micheli, *L'Enluminure du haut Môyen Age et les Influences Irlandaises* (Brussels, 1939).
Mikoletzky, 1946	H.L. Mikoletzky, *Kaiser Heinrich II und die Kirche* (Vienna, 1946).
Milde	Wolfgang Milde, *Mittelalterliche Handschriften der Herzog August Bibliothek, Wolfenbüttel* (Frankfurt, 1972).
Murray	Alexander Murray, *Reason and Society in the Middle Ages* (Oxford, 1978).
Mütherich, 1963	Florentine Mütherich, 'Ottonian Art: changing aspects', *Romanesque and Gothic Art: Studies in Western Art: Acts of the 20th International Congress of the History of Art* (Princeton, 1963), pp. 27-39, pls. IX-XII.
Mütherich, 1965	'Die Buchmalerei am Hofe Karls des Grossen', in *Karl der Grosse, Lebenswerk und Nachleben*, ed. W. Braunfels, iii (Karolingische Kunst, ed. W. Braunfels & H. Schnitzler, Düsseldorf, 1965), pp. 9-53.
Mütherich, 1966	'Zur Datierung des Aachener ottonischen Evangeliars', *Aachener Kunstblätter* 32 (1966), pp. 66-69.
Mütherich, 1980	'Die Fuldaer Buchmalerei in der Zeit des Hrabanus Maurus', in *Hrabanus Maurus und seine Schule: Festschrift der Rabanus-Maurus-Schule 1980*, ed. Winfried Böhne (Fulda, 1980), pp. 94-125.
Mütherich, 1986	'The Library of Otto III', in *The Role of the Book in Medieval Culture*, ed. Peter Ganz (Brepols-Turnhout, 1986), Part II, pp. 11-25.
Mütherich & Dachs	*Regensburger Buchmalerei*, ed. Florentine Mütherich & Karl Dachs (Munich, 1987).
Mütherich & Gaehde	Florentine Mütherich & Joachim Gaehde, *Carolingian Painting* (London, 1977).
Neuss, 1964	W. Neuss, *Geschichte des Erzbistums Köln*, 2 vols (Cologne, 1964).
Nicol	Donald M. Nicol, *Byzantium and Venice: A Study in diplomatic and cultural relations* (Cambridge, 1988).
Niermeyer, 1984	J.F. Niermeyer, *Mediae Latinitatis Lexicon Minus* (Leiden, ed. 1984).
Nightingale, 1988	John Nightingale, *Monasteries and their Patrons in Lotharingia, c. 850-1000* (Oxford D.Phil. thesis, 1988, publication in preparation).
Nitschke	Brigitte Nitschke, *Die Handschriften Gruppe um den Meister des Registrum Gregorii* (Recklinghausen, 1966).

Nordenfalk, 1937	C. Nordenfalk, 'Beiträge zur Geschichte der turonischen Buchmalerei', *Acta Archaeologica* 7 (1937), pp. 281-304.
Nordenfalk, 1950	'Der Meister des Registrum Gregorii', *Münchener Jahrbuch der Bildendenkunst* 3 (1950), pp. 61-77.
Nordenfalk, 1964	'Miniature Ottonienne et Ateliers Capétiens', *Art de France* 4 (1964), pp. 44-59.
Nordenfalk, Turonische Bilderbibel, 1971	'Noch eine turonische Bilderbibel', *Festschrift Bernhard Bischoff*, ed. Johanne Autenrieth & Franz Brunhölzl (Stuttgart, 1971), pp. 153-63.
Nordenfalk, 1972	'The chronology of the Registrum Master', *Kunsthistorische Forschungen für Otto Pächt* (Munich, 1972), pp. 62-76.
Nordenfalk, 1985	'Archbishop Egbert's Registrum Gregorii', as in Klein 1985A, pp. 87-100.
Oechelhaeuser	A. von Oechelhaeuser, *Die Miniaturen der Universitäts-Bibliothek zu Heidelberg* (Heidelberg, 1887).
Ohly	F. Ohly, *Hohenlied-Studien* (Wiesbaden, 1958).
Omont, 1922	H. Omont, 'Manuscrits illustrés de l'Apocalypse aux IXe et Xe siècles', *Bull. de la Soc. Française de Reproductions de Manuscrits à Peintures* 6 (1922), pp. 62-95, and pls. XIV-XXXI.
Ortmanns	K. Ortmanns, *Das Bistum Minden in seinen Beziehungen zu König, Papst und Herzog bis zum Ende des 12 Jahrhunderts* (Bensberg, 1972).
Otto, 1881	A. Otto, *Papst Gregor V, 996-99* (Münster, 1881).
Pächt, 1986	Otto Pächt, *Book Illumination in the Middle Ages* (London 1986).
Panofsky	Erwin Panofsky, *Abbot Suger on the Abbey Church of St Denis* (Princeton, 1946).
Pauler	Roland Pauler, *Das regnum Italiae in ottonischer Zeit: Markgrafen, Grafen and Bischöfe als politischer Kräfte* (Tubingen, 1982).
Pfister	Ch. Pfister, 'L'Archevêque de Metz Drogon (823-56)', *Mélanges Paul Fabre* (Paris, 1902), pp. 101-45.
Philippi, 1916	F. Philippi, *Abhandlungen über Corveyer Geschichtsschreibung, Reihe 2*, (1916).
Plotzek, 1970	Joachim Plotzek, 'Anfänge der ottonischen Trier-Echternacher Buchmalerei', *Wallraf-Richartz-Jahrbuch* 32 (1970), pp. 7-36.
Plotzek, Bremen, 1970	*Das Perikopenbuch Heinrichs III in Bremen und seine Stellung innerhalb der Echternacher Buchmalerei* (Cologne, 1970).
Plotzek, 1973	'Zur Initialmalerei des 10 Jahrhunderts in Trier und Köln', *Aachener Kunstblätter* 44 (1973), pp. 101-28.
Podlaha	Anton Podlaha, *Die Bibliothek des Metropolitankapitels* (Prague, 1904).
Podskalsky	G. Podskalsky, *Byzantinische Reichseschatologie* (Munich, 1972).
Porcher, 1959	J. Porcher, *Französische Buchmalerei* (Recklinghausen, 1959).
Porcher et al.	J. Porcher, J. Hubert, W.F. Volbach, *Carolingian Art* (London, 1970).
Prinz	F. Prinz, *Klerus und Krieg in früheren Mittelalter* (Stuttgart, 1971).
Professione	A. Professione, *Inventario dei Manoscritti della Biblioteca Capitolare di Ivrea*, revised by Ilo Vignono (Alba, 1967).
Puig i Cadafalch	J. Puig i Cadafalch, *La Géographie et les Origines du Premier Art Roman* (Paris, 1935).
RDK	*Reallexikon der Deutschen Kunst*, ed. Otto Schmitt et al., 8 vols to date up to Firnis (Leipzig/Munich, 1937-87 —).
Reifferscheid, 1867	A. Reifferscheid, 'Die römischen Bibliotheken', *Sitzungsberichte der Kaiserlichen Akademie der Wissenschaften (Wien) Ph-Hist Classe* 56 (1867), pp. 441-556.
Reinhardt	Uta Reinhardt, *Untersuchungen zur Stellung der Geistlichkeit bei den Königswahlen in Fränkischen und Deutschen Reich, 751-1200* (Marburg, 1975).
Reuter, 1982	T. Reuter, 'The *imperial church system* of the Ottonian and Salian rulers: a reconsideration', *Journ. Eccl. Hist.* 33 (1982), pp. 347-74.
Reynolds & Wilson	L.D. Reynolds & N.G. Wilson, *Scribes and Scholars: A Guide to the Transmission of Greek and Latin Literature* (Oxford, 2nd ed., 1974).
Reynolds	Roger E. Reynolds, 'The ivory mass-cover of the Drogo Sacramentary', in Gibson & Nelson, pp. 265-89.
Riedlinger, 1958	H. Riedlinger, *Die Makellosigkeit der Kirche in der lateinischen Hohenliedkommentaren des Mittelalters* (Münster, 1958).

Ripberger, 1962	A. Ripberger, *Der Pseudo-Hieronymous-Brief IX, Cogitis me: Ein erster marianischer Traktat des Mittelalters von Paschasius Radbert, Spicilegium Friburgense* 9 (Fribourg, 1962).
Robb, 1973	David M. Robb, *The Art of the Illuminated Manuscript* (South Brunswick & New York, 1973).
Robinson, 1974	I.S. Robinson, 'The metrical Commentary on Genesis of Donizo of Canossa', *Recherches de Théologie Ancienne et Mediévale* 41 (1974), pp. 5-37.
Valentine Rose	*Die Handschriften-Verzeichnisse Königlichen Bibliothek zu Berlin, Lat. Handschriften* (Berlin, 1893-1903, vols 1, 2/1-3; vol. 3, ed. F. Schillmann, Berlin, 1919).
Roussillon Roman	M. Durliat & J. Dieuzaide, *Roussillon Roman* (Zodiaque, Paris, 1958).
Sackur, 1898	E. Sackur, *Sibyllinische Texte und Forschungen* (Halle, 1898).
Santifaller, 1964	Leo Santifaller, *Zur Geschichte des Ottonisch-Salischen Reichskirchen-systems* (Österreichische Akademie der Wissenschaften, Vienna, 1964).
Sauerland & Haseloff	H.V. Sauerland & A. Haseloff, *Der Psalter Erzbischof Egberts von Trier, Textband & Tafelband*, (Trier, 1901).
H.M. Schaller, 1974	'Der heilige Tag als Termin mittelalterliche Staatsakte', DA 30 (1974), pp. 1-24.
Schiller	Gertrud Schiller, *Ikonographie der christlichen Kunst*, vols i, ii, iii, iv,1, and iv,2 (Gutersloh, 1966-80); English translation of vols i and ii, Janet Seligman (London, 1971, 1972).
Schlesinger,	W. Schlesinger, 'Erbfolge und Wahl bei der Königserhebung Heinrichs II 1002', *Festschrift für Heinrich Heimpel* iii (Göttingen, 1972), pp. 1-36.
A.A. Schmid	'Die Reichenauer Handschrift in Brescia', in *Arte del Primo Millenio: Atti del IIo Convegno per lo Studio dell'arte dell'alto Medio Evo*, (Pavia, 1950), pp. 368-73.
K. Schmid et al.	*Die Klostergemeinschaft von Fulda in früheren Mittelalter*, ed. Karl Schmid, vols 1, 2/1-3, 3 (Munich, 1978).
Roderich Schmidt, 1961	*Königsumritt und Huldigung in Ottonisch-Salischer Zeit* (Constance/Stuttgart, 1961, printed together with Gerhard Baaken, *Königtum* etc.).
F. Schneider	*Rom und Romgedanke im Mittelalter* (Munich, 1926).
R. Schneider, 1972	'Die Königserhebung Heinrichs II im Jahre 1002', DA 28 (1972), pp. 74-104.
Schnitzler, 1939	H. Schnitzler, 'Südwestdeutsche Kunst um das Jahr 1000 und die Schule von Tours', *Trierer Zeitschrift* Jg 14 (1939), pp. 154-81.
Schnitzler, 1956	'Hieronymus und Gregor in der ottonischen Kölner Buchmalerei', *Kunstgeschichtlichen Studien für H. Kauffmann* (Berlin, 1956), pp. 11-18.
Schnitzler, 1957	'Fulda oder Reichenau?', *Wallraf-Richartz-Jahrbuch* 19 (1957), pp. 39-132.
Schnitzler, 1962	'Eine frühchristliche Sarkophaszene und die Reichenauer Buchmalerei', *Festschrift Friedrich Gerke* (Baden-Baden, 1962), pp. 93-102.
Schnitzler, 1965	*Der Goldaltar von Aachen* (Mönchengladbach, 1965).
Schnitzler, 1967	'Ein frühottonisches Fuldaer Kunstwerk des Essener Münsterschätzes', in *Festschrift für K.H. Usener*, as in Collon-Gevaert, 1967, pp. 115-18.
Schott	Max Schott, *Zwei Lütticher Sakramentare in Bamberg und Paris und ihre Verwandten: Zur Geschichte der Lütticher Buchmalerei im XI Jahrhundert* (Strasbourg, 1931).
Schramm, 1929	Percy Ernst Schramm, *Kaiser, Rom und Renovatio*, 2 vols (Leipzig, 1929).
Schramm, 1954-55	*Herrschaftszeichen und Staatssymbolik*, 2 vols (Stuttgart, 1954-55).
Schramm & Mütherich	P.E. Schramm, *Die deutschen Kaiser und Könige in Bildern ihrer Zeit, 751-1190*, ed. Florentine Mütherich (Munich, 1983).
Schroeder	J.K. von Schroeder, *Das Mindener Domschatzinventar von 1683* (Münster, 1980).
Schuba	Ludwig Schuba, 'Reichenauer Texttradition im Petershausener Sakramentar', *Bibliothek und Wissenschaft* 12 (1978), pp. 115-40.
Schulten, 1980	Walter Schulten, *Der Kölner Domschatz* (Cologne, 1980).
Seebass, 1973	Tilman Seebass, *Musikdarstellung und Psalterillustration im früheren Mittelalter, Textband und Bildband* (Bern, 1973).
Sidler, 1906	P.W. Sidler, 'Münster-Tuberis: eine karolingische Stiftung', *Jahrbuch für Schweizerische Geschichte* 31 (1906), pp. 207-335.
Sigal	P.A. Sigal, 'Un aspect du culte des saints: le châtiment divin aux XIe et XIIe siècles d'après la littérature hagiographique du Midi de la France', *Cahiers de Fanjeaux* 11 (1976), pp. 39-59.

Von Simson	Otto von Simson, *Sacred Fortress: Byzantine Art and Statecraft in Ravenna* (Princeton, 2nd ed., 1987).
Sinding, 1903	O. Sinding, *Mariae Tod und Himmelfahrt* (Christiana, 1903).
Smalley, 1952	Beryl Smalley, *The Study of the Bible in the Middle Ages* (Oxford, 1952).
Southern, 1948	R.W. Southern, 'Lanfranc of Bec and Berengar of Tours', *Studies in Medieval History presented to F.M. Powicke* (Oxford, 1948), pp. 27-48.
Staab, 1980	F. Staab, 'Der Grundbesitz der Abtei Fulda bis zur Mitte des 9 Jahrhunderts und seine Stifter', in *Hrabanus Maurus und seine Schule*, as in Mütherich, 1980, pp. 48-63.
Stancliffe, 1983	Clare Stancliffe, 'Kings who opted out', in *Ideal and Reality in Frankish and Anglo-Saxon Society: Studies presented to J.M. Wallace-Hadrill*, ed. Patrick Wormald (Oxford, 1983), pp. 154-76.
Von den Steinen, 1956	Wolfram von den Steinen, 'Bernward von Hildesheim über sich selbst', DA 12 (1956), pp. 331-62.
Von den Steinen, 1965	*Homo Caelestis: Das Wort der Kunst im Mittelalter*, 2 vols (Bern, 1965)
Stengel, 1960	E.E. Stengel, *Abhandlungen und Untersuchungen zur Geschichte der Reichsabtei Fulda* (Fulda, 1960).
Stüwer	W. Stüwer, 'Die Geschichte der Abtei Corvey', in *Kunst und Kultur* q.v. i, pp. 5-18.
Swarzenski, 1901	G. Swarzenski, *Die Regensburger Buchmalerei des X und XI Jahrhunderts* (Leipzig, 1901).
Swarzenski, 1913	*Die Salzburger Buchmalerei von den ersten Anfängen bis zur Blütezeit des romanischen Stils* (Leipzig, 1908, 1913).
H. Swarzenski, 1967	Hanns Swarzenski, *Monuments of Romanesque Art* (London, 2nd ed. 1967).
Tellenbach, 1962	G. Tellenbach, 'Der Konvent der Reichsabtei Prüm unter Abt Ansbald (860-86)', *Festschrift für Max Miller* (Stuttgart, 1962), pp. 1-10.
Tellenbach, 1966	*Church, State and Christian Society at the Time of the Investiture Contest*, trans. (Oxford, 4th impression, 1966).
Thomas, 1968	Heinz Thomas, *Studien zur Trierer Geschichtsschreibung des 11 Jahrhunderts* (Bonn, 1968).
D.V. Thompson	*The Materials and Techniques of Medieval Painting* (London, 1936, 2nd ed. 1956).
J.W. Thompson, 1939	*The Medieval Library* (Chicago, 1939).
Thorndike	Lynn Thorndike, *A History of Magic and Experimental Science*, 2 vols (London, 1923).
Traube, 1901	L. Traube, 'Palaeographischen Anzeigen', *Neues Archiv* 27 (1901), pp. 276-78.
Tschan	F.J. Tschan, *Saint Bernward of Hildesheim*: Vol. 1: *His Life and Times*; Vols 2 and 3: *His Works of Art* (Notre Dame, Indiana, 1942, 1951, 1952).
Turner, 1960	D.H. Turner, 'The prayer-book of Archbishop Arnulph II of Milan', RB 70 (1960), pp. 360-92.
Turner, 1965	'The *Reichenau* Sacramentaries at Zurich and Oxford', RB 75 (1965), pp. 240-76.
Uhrlirz, 1934	Mathilde Uhrlirz, 'Die Italienische Kirchenpolitik der Ottonen', *MIÖG* 48 (1934), pp. 201-321.
Uhrlirz, 1964	'Aus dem Kunstleben der Zeit Kaiser Ottos III', *Festschrift P.E. Schramm* (Wiesbaden, 1964), pp. 52-56.
Ullmann, 1955	Walter Ullmann, *The Growth of Papal Government in the Middle Ages* (London, 1955).
Vlasto	A.P. Vlasto, *The Entry of the Slavs into Christendom* (Cambridge, 1970).
Vöge	W. Vöge, *Eine deutsche Malerschule um die Wende des ersten Jahrtausends* (Trier, 1891).
Vogel,	C. Vogel, *Introduction aux sources de l'Histoire du Culte Chrétien au Moyen Age* (Spoleto, 1966).
Voss, 1884	G. Voss, *Das Jüngste Gericht in der bildenden Kunst des frühen Mittelalters* (Leipzig, 1884).
Walker, 1948	R.M. Walker, 'Illustrations to the Priscillian Prologues in the Gospel Manuscripts of the Carolingian Ada School', *Art Bulletin* 30 (1948), pp. 1-10.
Wallace-Hadrill, 1983	J.M. Wallace-Hadrill, *The Frankish Church* (Oxford, 1983).
Wehlt	H-P. Wehlt, *Reichsabtei und König* (Göttingen, 1970).
Weierich	Lorenz Weierich, 'Laurentius-Verehrung in ottonischer Zeit', *Jahrbuch für die Geschichte Mittel- und Ostdeutschlands* 21 (1972), pp. 45-66.
Weis, 1974	Adolf Weis, 'Die spätantike Lektionar-Illustration im Skriptorium der Reichenau', in Maurer, pp. 311-62.
Weis, 1977	*Die langobardische Königsbasilika von Brescia* (Sigmaringen, 1977).

Weitzmann, 1971 — Kurt Weitzmann, 'The narrative and liturgical gospel illustrations', in K. Weitzmann, *Studies in Classical and Byzantine Manuscript Illumination*, ed. Herbert L. Kessler (Chicago, 1971), pp. 250-64.

Weitzmann, 1979 — *The Miniatures of the Sacra Parallela, Parisinus Graecus 923* (Princeton, 1979).

Wenger — A. Wenger, *L'Assomption de la T.S. Vierge dans la Tradition Byzantine du VIe au Xe Siècle: Études et Documents* (Paris, 1955).

Wenskus — R. Wenskus, *Studien zur historisch-politischen Gedankenwelt Bruns von Querfurt* (Münster/Cologne, 1956).

Werner-Hasselbach, 1942 — T. Werner-Hasselbach, *Die älteren Güterverzeichnisse der Reichsabtei Fulda* (Marburg, 1942).

Wessel, 1964 — Klaus Wessel, *Abendmahl und Apostelkommunion* (Recklinghausen, 1964).

Wessel, 1966 — *Die Kreuzigung* (Recklinghausen, 1966).

Wessel, 1969 — *Byzantine Enamels from the 5th to the 13th Century* (Irish U.P., Shannon, 1969).

Westermann-Angerhausen — Hiltrud Westermann-Angerhausen, *Die Goldschmiedarbeiten der Trierer Egbertwerkstatt* (Trier, 1973).

Westermann-Angerhausen, 1983 — 'Blattmasken, Maskenkapitelle, Säulenhäupter: Variationen über ein vorgegebenes Thema', *Boreas*, Münstersche Beiträge zur Archäologie 6 (1983), pp. 202-11.

Westermann-Angerhausen, 1987 — 'Spolie und Umfeld in Egberts Trier', *Zeitschrift für Kunstgeschichte* 3 (1987), 305-36.

Wilmart, 1913 — A. Wilmart, 'Le *Comes* de Murbach', RB 30 (1913), pp. 25-69.

Wilmart, 1940 — André Wilmart, *Precum Libelli Quattuor Aevi Karolini* (Rome, 1940).

Wilmart, 1971 — *Auteurs Spirituels et Textes Dévots du Môyen Age Latin* (Paris, 1932, repr. 1971).

Wilpert — G. Wilpert, *I Sarcofagi Cristiani Antichi*, i, (Rome, 1929).

Winandy, 1950 — J. Winandy, 'L'Oevre littéraire d'Ambroise Autpert', RB 60 (1950), pp. 93-119.

Winandy, 1953 — *Ambroise Autpert, Moine et Théologien* (Paris, 1953).

Wisplinghoff, 1970 — E. Wisplinghoff, *Untersuchungen zur frühen Geschichte der Abtei S. Maximin bei Trier bis etwa 1150* (Mainz, 1970).

G. Wolf — 'Über die Hintergründe der Erhebung Liudolfs von Schwaben', repr. in H. Zimmermann, 1976, pp. 56-69.

Wollasch, 1984 — Joachim Wollasch, 'Kaiser und Könige als Bruder der Mönche: Zum Herrscherbild in liturgischen Handschriften des 9 bis 11 Jahrhunderts', DA 40 (1984), pp. 1-20.

F. Wormald, 1952 — Francis Wormald, 'Some illustrated Manuscripts of the Lives of Saints', *Bulletin of John Rylands Library* 35 (1952), 248-66, now published in *The Collected Writings of Francis Wormald*, vol. II, pp. 43-56, pls. 82-97.

F. Wormald, 1952A — *English Drawings of the Tenth and Eleventh Centuries* (London, 1952).

F. Wormald, 1984 — Francis Wormald, *Collected Writings*, (London & Oxford, 1984).

C.P. Wormald, 1988 — Patrick Wormald, 'Aethelwold and his continental counterparts: contact, comparison, contrast', in *Bishop Aethelwold: his Career and Influence*, ed. Barbara Yorke (Woodbridge, 1988).

Zender — Mathias Zender, *Räume und Schichten: mittelalterliche Heiligenverehrung in ihrer Bedeutung für die Volkskunde* (Düsseldorf, 1959).

Zettler — Alfons Zettler, *Die frühen Klosterbauten der Reichenau* (Sigmaringen, 1988).

Zimmermann — E.H. Zimmermann, *Die Fuldaer Buchmalerei in karolingischer und ottonischer Zeit* (Halle, 1910).

G. Zimmermann, 1959 — Gerd Zimmermann, 'Bamberg als königlicher Pfalzort', *Jahrbuch für fränkische Landesforschung* 19 (1959), pp. 203-22.

G. Zimmermann, 1975 — 'Strukturen der fuldischen Heiligenverehrung', *Stud. & Mitt. z. Geschichte des Benedikt-Ordens* 86 (1975).

H. Zimmermann, 1965 — Harald Zimmermann, 'Rechtstradition in Papsturkunden' in *XIIe Congrès International des Sciences Historiques, Vienna 1965, Rapports* IV, ed. H.L. Mikoletzky (Vienna, 1965), pp. 131-46.

H. Zimmermann, 1976 — *Otto der Grosse*, ed. H. Zimmermann, *Wege der Forschung* 450 (Darmstadt, 1976).

Zoepf, 1908 — L. Zoepf, *Das Heiligen-Leben im 10 Jahrhundert* (Leipzig/Berlin, 1908).

Zotz — Thomas Zotz, '*Pallium et alia quaedam archiepiscopatus insignia : Zum Beziehungsgefüge und zu Rangfragen der Reichskirchen im Spiegel der päpstlichen Privilegierung des 10 und 11 Jahrhunderts*', *Festschrift für Berent Schwineköper* (Sigmaringen, 1982), pp. 155-75.

List of Illustrations

271

11. St. John the Evangelist. Pericopes Book, Reichenau, c.965–70. Gero Codex, Darmstadt, Landesbibl., MS 1948, f.4v.

12. St. Matthew. Ada Gospels, c.800–815. Trier, Stadtbibl., MS 22, f.15v.

13. Pope Gregory the Great. Frontispiece to Gregory's Letters, Gregory Master, prob. 983–84, Trier, Stadtbibl., MS 171/1626.

14. Title page. Rossano Gospels, C6. Rossano Cathedral, f.5.

15. Christ in Majesty. Lorsch Gospels, c.815. Alba Julia, Documentara Batthayneum, f.18v.

16. Christ in Majesty. Pericopes Book, Reichenau, c.965–70. Gero Codex, Darmstadt, Landesbibl., MS 1948, f.5v.

17. St. Matthew. Gospel Book, Fulda, c.960–70. Codex Wittekindeus, Berlin (East), Staatsbibl., MS theol.lat.fol.1, f.l4v.

18. Marriage Roll of the Empress Theophanu, 972. Wolfenbüttel, Staatsarchiv, 6 Urkunde 11.

19. Christ in Majesty. Ste Chapelle Gospels, c.984. Paris, BN, MS lat.8851, f.1v

20. Initial Q for Psalm 51. Folchard Psalter, St Gall, mid C9. St Gall, Stiftsbibl., Cod.Sang.23, f.135.

21. Initial Q. Homeliary, Reichenau, c.950–70, Karlsruhe, Landesbibl., MS Aug. XVI, f.49v.

22. Reliquary of St Faith. Conques, C10.

23. Initial F. Troper of St Martial, Limoges, late C10. Paris, BN, MS lat.1121, f.24v.

24. Initial C. Lectionary of St Martial, Limoges, late C10. Paris, BN, MS lat.5301, f.90.

25. Initial P. First Bible of St Martial, Limoges, c.1000. Paris, BN, MS lat.5, vol.2, f.194v.

26. Initial A. Homeliary of Clermont–Ferrand, c.1000. Bibl. Municipale et Universitaire, Clermont–Ferrand, Homeliary, f.1.

27. Passion Scenes. Codex Egberti, 977–93. Trier, Stadtbibl., MS 24, f.80v.

28–29. Liuthar presents his Gospel Book to the Emperor Otto III seated in Majesty. Aachen Gospels, c.996. Aachen Cathedral Treasury, ff.15v and 16.

30. Presentation of Bible to Charles the Bald. Vivian Bible, Tours, c.846. Paris, BN, MS lat.1, f.423.

31. Apocalypse Illustration. Grandval–Moutier Bible, Tours, c.840. London, BL, Add. MS 10546, f.449.

32. Ascension of Christ. Byzantine ivory, C10. Florence, Museo Nazionale del Bargello.

33. Louis the Pious. De Laudibus Sanctae Crucis of Hrabanus Maurus. Vatican, Bibl. Apost., MS Reg.Lat.124, f.4v.

34. Henry II and Kunigunde at the Feet of Christ. Basel Altar Frontal, c.1020. Paris, Musée de Cluny.

35. Crowning of Henry II by Christ. Sacramentary of Henry II, Regensburg 1002–14. Munich, Bayerische Staatsbibl., Clm.4456, f.11.

36. Healing of the Possessed Boy. Aachen Gospels, c.996. Aachen Cathedral Treasury, p.197.

37. Footwashing of St Peter. Holy Water Bucket, Basilevsky Situla, Ivory, c.980. London, Victoria and Albert Museum.

38. Footwashing of St Peter. Mosaic, C11. Hosios Lukas, Greece.

39. Footwashing of St Peter. Sedulius, Carmen Pascale. Antwerp, Plantin–Moretus Museum, MS M.17.4, f.32.

40. Footwashing of St Peter. Sarcophagus, C4. Arles.

41. Moses at the Burning Bush. Bible of Leo Patricius, Byzantine, C10. Vatican , Bibl. Apost., MS Reg.Gr.1, f.155v.

42. Crucifixion. Aachen Gospels, c.996. Aachen Cathedral Treasury, p.468.

43. David swings his sling against Goliath, illustration to Psalm 143. Stuttgart Psalter, c.830. Stuttgart, Württembergische Landesbibl., MS Bibl.Fol.23, f.158v

44. Pope Gregory the Great. Homeliary , Verona, c.800. Egino Codex, Berlin (East), Staatsbibl., Phillips MS 1676, f.25v.

45. Initial with Temptations of Christ. Drogo Sacramentary, Metz, c.850. Paris, BN, MS lat.9428, f.41.

46. Initium to St Mark's Gospel; Baptism of Christ and Angels ministering to him after Temptations, in the spandrels. St Médard of Soissons Gospels, c.810–15. Paris, BN, MS lat.8850, f.82.

47. Crucifixion (detail of ill.79). Rabbula Gospels, Syrian, C6. Florence, Bibl. Laurenziana, MS Plut.I.56, f.13.

48. Crucifixion, Sacramentary of Henry II. Regensburg, 1002–14. Munich, Bayerische Staatsbibl., Clm.4456, f.15.

49. Bishop Bernward of Hildesheim presents his Gospel Book, c.1015. Hildesheim, Cathedral Treasury, MS 18, f.16v

50. Mary receives Gospel Book from Bishop Bernward of Hildesheim, c.1015. Hildesheim, Cathedral Treasury, MS 18, f.17

51. Triumphal Cross, C12, containing parts of Bishop Bernward's earlier cross of c.996. Hildesheim, Cathedral Treasury.

52. Silver Crucifix of Bishop Bernward of Hildesheim, early C11. Hildesheim, Cathedral Treasury.

53. Ringelheim Crucifix, c.1000. Ringelheim.

54. Christ before Pilate, Bronze Doors of Bishop Bernward of Hildesheim made for St Michael's Monastery, 1015, now Hildesheim Cathedral.

55. Opening of St John's Gospel. Gospel Book of Bernward of Hildesheim, c.1015. Hildesheim, Cathedral Treasury, MS 18, f.174.

56. Opening of St John's Gospel. Pericopes Book, Regensburg, c.1020. Uta Codex, Munich, Bayerische Staatsbibl., Clm.13601, f.89v.

57. Crucifixion and St Luke. Gospel Book of Bernward of Hildesheim, c.1015. Hildesheim, Cathedral Treasury, MS 18, f.118v.

58. The Last Supper. Franco–Saxon Gospel Book, C9. Prague Cathedral, Cim.2, f.185v.

59. The Last Supper. Greek Prayer Book of South Italy, c.1000. Vatican , Bibl. Apost., MS Gr.1554, f.178v.

60. The Widow's Mite. Mosaic, C6. Ravenna, S.Apollinare Nuovo.

61. The Widow's Mite. Gospel Book of Otto III, 998–1001. Munich, Bayerische Staatsbibl., Clm.4453, f.192.

62. Feeding of the Five Thousand. Gospel Book of Otto III, 998–1001. Munich, Bayerische Staatsbibl., Clm.4453, f.163.

63. The Scourging at the Pillar. Stuttgart Psalter, c.830. Stuttgart, Württembergische Landesbibl., MS Bibl.Fol.23, f.43v.

64. The Crowning with Thorns. Golden Altar of Aachen, prob. Fulda, c.1000. Aachen Cathedral.

65. The Crowning with Thorns. Gospel Book, Salzburg, c.1020–30, New York, Pierpont Morgan Library, MS M 781, f.84v.

66. The Crowning with Thorns and other Passion Scenes. Gospel Book, c.1030. Codex Aureus of Echternach, Nürnberg, Germanisches National–Museum, f.111.

67. Christ's calling of St Matthew. Franco–Saxon Gospel Book, C9. Prague Cathedral, Cim.2, f.23v.

68. Christ's calling of St Matthew. Single Leaf of a Corvey Gospel Book, late C10. Helsinki, National Museum of Finland.

69. Judas kisses Christ. Codex Egberti, 977–93. Trier, Stadtbibl., MS 24, f.97v.

70. Healing of the Leper. Codex Egberti, 977–93, Trier, Stadtbibl., MS 24, f.21v.

71. Christ and the Centurion. Codex Egberti, 977–93, Trier, Stadtbibl., MS 24, f.22.

72. The Storm at Sea. Gospel Book of Otto III, 998–1001. Munich, Bayerische Staatsbibl., Clm.4453, f.103v.

73. The Entry into Jerusalem. Pericopes Book of Henry II, Reichenau, 1002–12, Munich, Bayerische Staatsbibl., Clm.4452, f.78.

74. The Entry into Jerusalem. Byzantine, C6. Rossano Cathedral, Rossano Gospels, f.1.

75. The Entry into Jerusalem. Epistolary, Trier, c.980–90. Berlin (West), Staatsbibl., MS theol.lat.fol.34, f.15v.

76. St Erhard about to celebrate Mass. Pericopes Book, Regensburg, c.1020. Uta Codex, Munich, Bayerische Staatsbibl., Clm.13601, f.4.

77. Emperor Henry II seated in Majesty. Gospel Book, Regensburg, c.1022. Vatican, Bibl. Apost., MS Ottob.74, f.193v.

78. The Crucifixion. Fulda Sacramentary. c.975. Göttingen, Universitätsbibl., MS theol.231, f.60.

79. The Crucifixion. Rabbula Gospels, Syrian C6. Florence, Bibl., Laurenziana MS Plut.I.56, f.13.

80. The Crucifixion. Psalter of Louis the German, c.850. Berlin (West), Staatsbibl., MS theol.lat.fol.58, f. 120v.

81. The Crucifixion. Gospel Book, Cologne, c.1020. Giessen, Universitätsbibl., Cod.660, f.188.

82. The Gero Crucifix, c.975. Cologne Cathedral.

83. The Lothar Cross, c.1000. Aachen Cathedral. (Front)

84. The Lothar Cross, c.1000. Aachen Cathedral. (Back)

85. Dormition of Mary. C10 Byzantine Ivory on the cover of the Gospel Book of Otto III. Munich, Bayerische Staatsbibl., Clm.4453.

86. Dormition of Mary. Antiphonary, Prüm, late C10. Paris, BN, MS lat.9448, f.60v.

87. Dormition of Mary. Pericopes Book, Reichenau, early C11. Wolfenbüttel, Herzog August Bibl., MS 84. 5 Aug.2°, f.79v.

88. Dormition of Mary. Pericopes Book of Henry II, 1002–12. Munich, Bayerische Staatsbibl., Clm.4452, f.161v.

89. Assumption of Mary. Sacramentary, Augsburg, c.1030. London, BL, MS Harley 2908, f.123v.

90. Sequence with musical notation for the Feast of the Assumption of Mary. Bamberg Troper, c.1000. Bamberg, Staatsbibl., MS Lit.5, f.122.

91. Assumption of Mary. St Gall (Tuotilo) ivory, c.900. St. Gallen, Stiftsbibl.

92. Book cover of the Gospel Book of Otto III, 998–1001. Munich, Bayerische Staatsbibl., Clm.4453.

93. Christ weeps over Jerusalem. Gospel Book of Otto III, 998–1001. Munich, Bayerische Staatsbibl., Clm.4453, f.188v.

94. Peter's Denial of Christ. Aachen Gospels, c.996. Aachen Cathedral Treasury, p.458.

95. Peter's Denial of Christ. Stuttgart Psalter, c.830. Stuttgart, Württembergische Landsbibl., MS Bibl.Fol.23, f.49.

96. Peter's Denial of Christ. Gospel Book of Otto III, 998–1001. Munich, Bayerische Staatsbibl., Clm.4453, f.247.

97. The Repentant Mary Magdalen. Gospel Book of Otto III, 998–1001. Munich, Bayerische Staatsbibl., Clm.4453, f.157v.

98. Mary and Martha. Pericopes Book of Henry II, 1002–12. Munich, Bayerische Staatsbibl., Clm.4452, f.162.

99. The Repentant Mary Magdalen. Codex Egberti, 997–93. Trier, Stadtbibl., MS 24, f.65.

100. The Repentant Mary Magdalen. Bronze Column of Bishop Bernward of Hildesheim, early C11. Hildesheim Cathedral.

101. Christ hands over the Keys of Heaven to St Peter. Gospel Book of Otto III, 998–1001. Munich, Bayerische Staatsbibl., Clm.4453, f.60v.

102. Healing of the Blind Man. Codex Egberti, 977–93. Trier, Stadtbibl., MS 24, f.31.

103. The Withered Fig Tree. Gospel Book of Otto III, 998–1001. Munich, Bayerische Staatsbibl., Clm.4453, f.175v.

104. The Withered Fig Tree. Sinope Codex, Eastern Mediterranean, C6. Paris, BN, MS gr. suppl.1286, f.30v.

273

Colour Plates in Part Two

Monochrome Illustrations in Part Two

5. The Four Winds. Valenciennes Apocalypse, early C9. Valenciennes, Bibl. Mun., MS 99, f.4.

6. The Fifth Angel blows his Trumpet. Valenciennes Apocalypse, early C9. Valenciennes, Bibl. Mun., MS 99, f.18.

7. The Fifth Angel blows his Trumpet. Bamberg Apocalypse, prob. 1001–2. Bamberg, Staatsbibl., MS Bibl.140, f.23.

8. The Angel with the Millstone. Valenciennes Apocalypse, early C9. Valenciennes, Bibl. Mun., MS 99, f.33.

9. The False Prophet bound to the Beast. Valenciennes Apocalypse, early C9. Valenciennes, Bibl. Mun., MS 99, f.36.

10. The False Prophet about to be released. Valenciennes Apocalypse, early C9. Valenciennes, Bibl. Mun., MS 99, f.36v.

11. Mother Church. Volturno Exultet Roll, 981–87. Vatican, Bibl. Apost., MS Lat. 9820.

12. The Woman in the Sky. Valenciennes Apocalypse, early C9. Valenciennes, Bibl. Mun., MS 99, f.23.

13. The Woman in the Sky. Trier Apocalypse, c.800. Trier, Stadtbibl., MS 31, f.37.

14. The Woman in the Sky. Apocalypse fresco in the Baptistery, Novara Cathedral, early C11.

15. The Whore of Babylon rides the Beast. Valenciennes Apocalypse, early C9. Valenciennes, Bibl. Mun., MS 99, f.31.

16. Cross with the Lamb of God. Gelasian Sacramentary, France, C8. Vatican, Bibl. Apost., MS Reg.Lat. 316, f.132.

17. Crucifixion and St Luke. Gospel Book of Bernward of Hildesheim, c.1015. Hildesheim, Cathedral Treasury, MS 18, f.118v.

18. St Luke. Gospel Book of Otto III, 998–1001. Munich, Bayerische Staatsbibl., Clm. 4453, f.139v.

19. St Luke. Pericopes Book, Reichenau, early C11. Munich, Bayerische Staatsbibl., Clm. 4454, f.127v.

20. St Matthew. Pericopes Book, Reichenau, early C11. Munich, Bayerische Staatsbibl., Clm. 4454, f.25v.

21. Christ the Tree of Life. Pericopes Book, Reichenau, early C11. Munich, Bayerische Staatsbibl., Clm. 4454, f.20.

22. The Vision of Isaiah. Bamberg Commentaries, c.1000. Bamberg, Staatsbibl., MS Bibl.76, f.10v.

23. The Vision of Isaiah. Bamberg Commentaries, c.1000. Bamberg, Staatsbibl., MS Bibl.76, f.11.

24. The Vision of Daniel. Bamberg Commentaries, c.1000. Bamberg, Staatsbibl., MS Bibl.22, f.31v.

25. The Vision of Daniel. Bamberg Commentaries, c.1000. Bamberg, Staatsbibl., MS Bibl.22. f.32.

26. David dancing. Vivian Bible, Tours, c.846. Paris, BN, MS lat. 1, f.215v.

27. The Generations of Christ, St Matthew. Lorsch Gospels, c.815. Alba Julia, Bibl. Doc. Batthayneum, f.14.

28. Baptism of Christ; the Twelve Apostles. C5 Mosaic in the Dome of the Orthodox Baptistery, Ravenna.

29. Magus with Crown, Type A. Sigebert Sacramentary, 1020–36. Berlin (East), MS theol. lat. fol.2, f.19v.

30. Magus with Crown, Type B. Pericopes Book of Henry II, 1002–14. Munich, Bayerische Staatsbibl., Clm.4452, f.17v.

31. Ecclesia. Detail from Bishop Sigebert of Minden celebrating Mass. Sigebert Sacramentary. 1020–36. Berlin, Staatsbibl., MS theol. lat. fol.2, f.9.

32. Book being presented to ?Heribert, Archbishop of Cologne. Gospel Book, c.1000. Milan, Ambrosiana, MS C53 Sup., f.2v.

33. Count Dietrich of Holland and his Wife Hildegard give their Gospel Book to the Monastery of Egmont. Gospel Book, Lotharingia, c.940–70. The Hague, Royal Lib., MS 761/1, f.214v.

34. Count Dietrich and Hildegard before St Adalbert. Gospel Book, Lotharingia, c.940–70. The Hague, Royal Lib., MS 761/1, f.215.

35. Reliquary of St Andrew's Foot, 977–93. Trier, Cathedral Treasury.

36. Ruodpreht presents his book to Archbishop Egbert of Trier. Egbert Psalter, Reichenau, 977–93. Cividale del Friuli, Museo Archaeologico, MS CXXXVI, f.16v.

37. Archbishop Egbert of Trier. Egbert Psalter, Reichenau, 977–93. Cividale del Friuli, Museo Archaeologico, MS CXXXVI, f.17.

38. Archbishop Egbert of Trier presents his book to St Peter. Egbert Psalter. Reichenau, 977–93. Cividale del Friuli, Museo Archaeologico, MS CXXXVI, f.18v.

39. St Peter receiving a book from Archbishop Egbert of Trier. Egbert Psalter. Reichenau, 977–93. Cividale del Friuli, Museo Archaeologico, MS CXXXVI, f.19.

40. Hrabanus Maurus presents his De Laudibus Sancte Crucis to Pope Gregory IV. Vatican, Bibl. Apost., MS Reg.Lat. 124, f.3v.

41. The Footwashing of St Peter. Aachen Gospels, c.996. Aachen Treasury, p.440.

42. The Footwashing of St Peter. Poussay Pericopes, Reichenau, c.970–90. Paris, BN, MS lat. 10514, f.46v.

43. Initial M. Poussay Pericopes, c.970–90. Paris, BN, MS lat.10514, f.60.

44. Epistles for the Vigil and Feast of All Saints. Epistolary, Reichenau, c.970–90. Mainz, Cathedral Treasury, MS Kautsch 3, ff.135v, 136.

45. Christ before Pilate. Rossano Gospels, Eastern Mediterranean, C6. Rossano, Cathedral Library, f.8v.

46. Jesus and the Canaanite Woman. Codex Egberti, 977–93. Trier, Stadtbibl., MS 24, f.35v.

47. Jesus and the Canaanite Woman. Codex Egberti, 977–93. Trier, Stadtbibl., MS 24, f.36.

48. Feeding of the Five Thousand. Codex Egberti, 977–93. Trier, Stadtbibl., MS 24, f.47v.

49. Pentecost. Codex Egberti, 977–93. Trier, Stadtbibl., MS 24, f.103.

50. The Deposition from the Cross. Codex Egberti, 977–93. Trier, Stadtbibl., MS 24, f.85v.

51. Pentecost. Sacramentary, Reichenau, early C11. Paris, BN, MS lat. 18005, f.94v.

52. Jesus addresses the Apostles before the Ascension. Codex Egberti, 977–93. Trier, Stadtbibl., MS 24, f.100v.

53. The Two Women at the Tomb. Mainz Sacramentary, c.1000. Mainz, Cathedral Treasury, MS Kautsch 4, f.84v.

54. Deesis and orans King between Peter and Paul. Prayer Book of Otto III, c.990. Bamberg, Pommersfelden MS 347, f.2.

55. Bishop Warmund of Ivrea places his Book on the Altar. Sacramentary of Bishop Warmund, c.1000. Ivrea, Bibl. Capitolare, Cod. LXXXVI, f.11v.

56. The Virgin Mary crowns Otto III. Sacramentary of Bishop Warmund, c.1000. Ivrea, Bibl. Capitolare, Cod. LXXXVI, f.160v.

57. Bishop approaching the Altar. Prayer Book for Mass, c.1000. Ivrea, Bibl. Capitolare, Cod. IV, f.4v.

58. Priest celebrating Mass. Sacramentary, Reichenau, c.970–90. St Paul im Lavantthal, Stiftsbibl., MS 20/1, f.13v.

59. Bishop Sigebert of Minden celebrating Mass. Sacramentary of Bishop Sigebert of Minden, 1022–36. Berlin, Staatsbibl., MS theol. lat. fol. 2, f.9.

60. Bishop Sigebert of Minden, as if transfigured. Ivory book–cover, 1022–36. Berlin, Staatsbibl., MS Germ. Qu.42.

61. Abbess Hitda of Meschede presents her Book to St Walburga. Hitda Codex, Cologne, c.1000–20. Darmstadt, Landesbibl., Cod. 1640, f.6.

62. Titulus page for the Presentation in the Temple. Hitda Codex, Cologne, c.1000–20. Darmstadt, Landesbibl., Cod. 1640, f.21v.

63. Titulus page of St Mark's Gospel. Gospel Book. Manchester, John Rylands Lib., MS lat. 98, f.64v.

64. Initium page of St Mark's Gospel. Gospel Book. Manchester, John Rylands Lib., MS lat. 98, f.65.

65. Initium of St John's Gospel. Hitda Codex, Cologne, c.1000–20. Darmstadt, Landesbibl., Cod. 1640, f.172v.

66. Opening of St John's Gospel. Hitda Codex, Cologne, c.1000–20. Darmstadt, Landesbibl., Cod. 1640, f.173.

67. The Two Women at the Tomb. St Gereon Sacramentary, Cologne, c.1000. Paris, BN, MS lat. 817, f.60.

68. Healing of Peter's Mother–in–Law. Codex Egberti, 977–93. Trier, Stadtbibl., MS 24, f.25.

69. Healing of Peter's Mother–in–Law. Hitda Codex, Cologne, c.1000–20. Darmstadt, Landesbibl., Cod. 1640, f.77.

70. The Widow of Nain. Hitda Codex, Cologne, c.1000–20. Darmstadt, Landesbibl., Cod. 1640, f.115.

71. The Widow of Nain. Gospel Book of Otto III, 998–1001. Munich, Bayerische Staatsbibl., Clm. 4453, f.155v.

72. The Widow of Nain. Wall–painting, late C10. Reichenau–Oberzell, St Georg.

73. The Woman taken in Adultery. Hitda Codex, Cologne, c.1000–20. Darmstadt, Landesbibl., Cod. 1640, f.171.

74. The Woman taken in Adultery. Codex Egberti, 977–93. Trier, Stadtbibl., MS 24, f.46v.

75. Storm at Sea. Codex Egberti, 977–93. Trier, Stadtbibl., MS 24, f.24.

76. Annunciation to the Shepherds. Pericopes Book of Henry II, Reichenau, 1002–12. Munich, Bayerische Staatsbibl., Clm. 4452, f.8v.

77. Nativity. St Gereon Sacramentary, Cologne, c.1000. Paris, BN, MS lat. 817, f.13.

78. Preface and Canon of the Mass. Sacramentary, Fulda, late C10. Cologne, Dombibl., Cod. 88, ff.25v, 26.

79. Saints Gelasius and Gregory. Fulda Sacramentary, 997–1024. Bamberg, Staatsbibl., MS Lit. 1, f.12v.

80. The Sacrament of Extreme Unction. Sacramentary, Fulda, c.975. Göttingen, Universitätsbibl., Cod. 231, f.192v.

81. The Death of John the Evangelist. Sacramentary, Fulda, c.975. Göttingen, Universitätsbibl., Cod. 231, f.15v.

82. The Scrutinium. Sacramentary, Fulda, c.975. Göttingen, Universitätsbibl., Cod. 231, f.214.

83. Illustration to Psalm 80. Stuttgart Psalter, Northern France, c.830. Stuttgart, Württembergische Landesbibl., Bibl. Fol.23, f.97v.

84. Martyrdom of St Stephen. Sacramentary, Fulda, c.975. Göttingen, Universitätsbibl., Cod. 231, f.14v.

85. Martyrdom of St Stephen. Epistolary, Norther France or Rhineland, mid C9. Munich, Bayerische Staatsbibl., Clm. 14345, f.1v.

86. Martyrdom of St Stephen. Initial in the Drogo Sacramentary, Metz, c.850. Paris, BN, MS lat. 9428, f.27.

87. Pope Conon commissions St Kilian to preach. Lives of Saints Kilian and Margaret, Fulda, late C10. Hanover, Landesbibl., MS I,189, f.4.

88. Preaching of St Kilian. Lives of Saints Kilian and Margaret, Fulda, late C10. Hanover, Landesbibl., MS I, 189, f.4v.

89. St Kilian baptizing. Lives of Saints Kilian and Margaret, Fulda, late C10. Hanover, Landesbibl., MS I,189, f.5.

90. Madness of Geilana, Killing of Gozbert, Exile of Gozbert's Son. Lives of Saints Kilian and Margaret, Fulda, late C10. Hanover, Landesbibl., MS I,189, f.10.

91. Coronation of Saints Margaret and Regina. Lives of Saints Kilian and Margaret, Fulda, late C10. Hanover, Landesbibl., MS I,189, f.11v.

92. Annunciation. Fulda Sacramentary, 997–1024. Bamberg, Staatsbibl., MS Lit. 1, f.119v.

93. Nativity. Fulda Sacramentary, 997–1024. Bamberg, Staatsbibl., MS Lit. 1, f.25.

94. Illustration for All Saints. Sacramentary, Fulda, c.970–75. Göttingen, Universitätsbibl., MS theol. 231, f.111.

95. The Worship of the Lamb. Trier Apocalypse, Northern France, c.800. Trier, Stadtbibl., MS 31, f.23.

96. Opening of St Luke's Gospel. Gospel Book, Corvey, c.900. London, BL, Egerton MS 768, f.2.

97. West front of the Abbey of Corvey, 873–85.

98. Opening of St Luke's Gospel. `Small' Gospel Book, Corvey, early C10. Essen, Minster Treasury, f.119.

99. Opening of St John's Gospel. Klus Gospels, Corvey, mid C10. Wolfenbüttel, Herzog August Bibl., MS Guelf, 84.3 Aug.2°, f.86v.

100. Canon Table. Gospel Book, Corvey, late C10. Wolfenbüttel, Herzog August Bibl., MS Helmstedt 426, f.3v.

101. Canon Table. Gospel Book, Corvey, late C10. Wolfenbüttel, Herzog August Bibl., MS Helmstedt 426, f.5v.

102. Initium of St Matthew's Gospel. Gospel Book, Corvey, late C10. Wolfenbüttel, Herzog August Bibl., MS Helmstedt 426, f.17v.

103. Persian Rug, C19.

104. Christ in Majesty. Pericopes Book, second half C10. New York Public Lib., MS Astor 1, f.7.

105. Christ in Majesty. Abdinghof Gospels, Saxon/Corvey, c.1000. Kassel, Hessische Landesbibl., MS theol. 2° 60, f.60.

106. Healing of the Leper. Fragment of Pericopes Book, Rhineland, C9. Düsseldorf, Landes– und Stadtbibl., MS B.113, f.5.

107. Annunciation. Gospel Book, Corvey, late C10. Wolfenbüttel, Herzog August Bibl., MS Guelf 16.1. Aug. 2°, f.8.

108. Annunciation to the Shepherds. Gospel Book, Corvey, late C10. Wolfenbüttel, Herzog August Bibl., MS Guelf 16.1. Aug. 2°, f.9.

109. The Presentation in the Temple. Gospel Book, Corvey, late C10. Wolfenbüttel, Herzog August Bibl., MS Guelf 16.1. Aug. 2°, f.16.

110. Christ crowns St Wenceslas; Hemma, Wife of Boleslav II of Bohemia, before the Feet of St Wenceslas. Gumpold's Life of St Wenceslas, early C11. Wolfenbüttel, Herzog August Bibl., MS Guelf 11.2 Aug. 4°, f.18v.

111. Martyrdom of St Wenceslas. Gumpold's Life of St Wenceslas, early C11. Wolfenbüttel, Herzog August Bibl., MS Guelf 11.2. Aug. 4°, f.21.

112. Opening of the Book of Ecclesiastes. Arras Bible, c.1040. Arras, Bibl. Mun., MS 435, f.1.

113. Initial P to St Paul's Epistles to the Romans. Grandval–Moutier Bible, Tours, c.840. London, BL, Add. MS 10546, f.411.

114. Initial P to Acts of the Apostles. Limoges Bible, c.1000. Paris, BN, MS lat. 5, f.173.

115. Beginning of St Ambrose De Bono Mortis. Avranches, Bibl. Mun., MS 72, f.182v.

116. Interior of Speyer Cathedral, as in 1062 (Reconstruction by K.J. Conant).

117. The Nave of the Abbey Church of Mont–Saint–Michel, c.1100.

118. Page illustrating Exodus. Grandval–Moutier Bible, Tours, c.840. London, BL, Add. MS 10546, f.25v.

119. Apocalypse illustration. Grandval–Moutier Bible, Tours, c.840. London, BL, Add. MS 10546, f.449.

120. Christ in Majesty. Ste.–Chapelle Gospels, prob. 984. Paris, BN, MS lat. 8851, f.1v.

121. Christ in Majesty. Vivian Bible, Tours, c.846. Paris, BN, MS lat. 1, f.329v.

122. Christ seated in Majesty. Codex Aureus of Echternach, c.1031. Nürnberg, Germanisches Nationalmuseum, MS 156142/KG1138, f.2v.

123. St Mark. Ste.–Chapelle Gospels, prob. 984. Paris, BN, MS lat. 8851, f.52v.

124. St Mark. Codex Aureus of Echternach, c.1031. Nürnberg, Germanisches Nationalmuseum, MS 156142/KG1138, f.54v.

125. Illustrations to the Life of St Paul. Vivian Bible, Tours, c.846. Paris, BN, MS lat. 1, f.386v.

126. Scenes from the Childhood of Christ. Codex Aureus of Echternach, c.1031. Nürnberg, Germanisches Nationalmuseum, MS 156142/ KG1138, f.18v.

127. Miracles of Christ. Codex Aureus of Echternach, c.1031. Nürnberg, Germanisches Nationalmuseum, MS 156142/KG1138, f.54.

128. The Footwashing of St Peter. Speyer Gospels, 1045. Escorial, Cod.Vitr.17, f.152v.

129. Initial C for the Gospel of Christmas Eve. Poussay Pericopes Book, Reichenau, c.970–90. Paris, BN, MS lat. 10514, f.10.

130. Christ crowns Henry III and Agnes. Goslar Gospels, Echternach, 1047–56. Uppsala, University Lib., Cod. 93, f.3v.

131. Henry III presents his book to Saints Simon and Jude. Goslar Gospels, Echternach, 1047–56. Uppsala, University Lib., Cod. 93, f.4.

132. Text of St Matthew. Goslar Gospels, Echternach, 1047–56. Uppsala, University Lib., Cod. 93, f.21.

133. Job with his Wife. Moralia in Job, Italian, mid C11. Bamberg, Staatsbibl., MS Bibl.41, f.29.

134. Job with his Wife and Friends. Moralia in Job, Italian, mid C11. Bamberg, Staatsbibl., MS Bibl. 41, f.191v.

135. Preface to Pope Gregory's Moralia in Job, Trier, c.950–75. Trier, Stadbibl., MS 2209/2328, vol.i, f.1.

136. Initial Q. Moralia in Job, Trier, c.950–75. Trier, Stadtbibl., MS 2209/2328, vol.ii, f.189.

137. Initial Q. Homeliary, c.950–70. Karlsruhe, Landesbibl., MS Aug. XVI, f.49v.

138. Initial D. Moralia in Job, Trier, c.950–75. Trier, Stadtbibl., MS 2209/2328, vol.ii, f.119.

139. Humilitas. Border illustration from the Opening of St John's Gospel. Hitda Codex. Darmstadt, Landesbibl., Cod. 1640, f.173.

140. The Fall of Babylon. Bamberg Apocalypse, prob. 1001–2. Bamberg, Staatsbibl., MS Bibl.140, f.45.

141. The Ascension. Bamberg Apocalypse, prob. 1001–2. Bamberg, Staatsbibl., MS Bibl.140, f.71v.

142. The Ascension. Pericopes Book of Henry II, 1002–12. Munich, Bayerische Staatsbibl., Clm. 4452, f.131v.

Index of Iconography

Index of Manuscripts

282

Oxford, Bodleian Library

MS Canonici Liturg. 319, Sacramentary, Reichenau,
 c. 1020–30: **I**: 22, 145, 203, 208, ch.3 n.34; *ill. 5.*
 II: ch.2 n.74

Paris, Bibliothèque Nationale

grec. 74, Byzantine Gospel Lectionary, C11: **I**: 186–7, 211,
 ch.4 n.179; *ill. 110*
grec. suppl. 1286 Sinope Codex, Gospels, East
 Mediterranean, C6: **I**: 79, 178; *ill. 104.* **II**: ch.6 n.57
lat. 1, Vivian Bible, Tours *c.* 846: **I**: 61–2, 68, 77; *ill. 30.*
 II: 26, 38, 39, 186, 195–8; *ills. 26, 121, 125*
lat. 3, Rorigo Bible, Tours, 834–43: **II**: 209
lat. 5, `First' Bible of St Martial, Limoges, 2 vols. *c.* 1000:
 I: 54–5; *ill. 25.* **II**: 178; *ill. 114*
lat. 250, New Testament volume of a Tours Bible,
 c. 820–30. **II**: 179–81
lat. 817, Sacramentary of St Gereon, Cologne, *c.* 1000:
 I: 23, 36, 210. **II**: 99–100, 104, 106, 108–9, 117, 120–3,
 ch.2 n.94, ch.3 n.41, ch.4 n.87; *ills. 67, 77*
lat. 1118, Tonarius, S. France, late C10: **I**: 53
lat. 1121, Troper of St Martial, Limoges, *c.* 1000: **I**: 53;
 ill. 23
lat. 1126, Gaignières Gospels, Nivardus the Lombard for
 King Robert the Pious, Fleury, early C11: **I**: 52–3
lat. 1141, Sacramentary fragment, Metz. 869: **I**: 198–9,
 ch.2 n.30; *ill. 115.* **II**: 85
lat. 2077, Prudentius, Moissac, early C11.
lat. 5058, Josephus, Moissac, mid C11: **I**: ch.1 n.104
lat. 5301, Lectionary, mainly hagiographical, Limoges,
 c. 1000: **I**: 53, ch.1 n.102, ch.3 n.52; *ill. 24*
lat. 8850, St Médard of Soissons Gospels, Charlemagne
 Court School, *c.* 810–15: **I**: 80, ch.4 n.77; *ill.46*
lat. 8851, Ste Chapelle Gospels, Gregory Master, Trier,
 c. 984: **I**: 39, 40, 69, 75; *ill. 19.* **II**: 63, 188, 194, 199;
 ills. 120, 123; col. pl. XVII
lat. 9428, Drogo Sacramentary, Metz, *c.* 850: **I**: 180,
 ch.2 n.120; *ill. 45.* **II**: 42, 89, 125, 132, 136, 137; *ill. 45*
lat. 9448, Antiphonary, Prüm, late C10: **I**: 10, 48, 145–6,
 ch.3 n.58; *ill. 86*
lat. 10501, Sacramentary, Gregory Master, Trier, *c.* 1000:
 I: 39
lat. 10514, Poussay pericopes book, Reichenau, *c.* 970–90:
 I: 46, 57, 205, 207, ch.1 nn.32, 87; *col. pl. IV.* **II**: 67–8,
 200–1, ch.2 n.66; *ills. 42, 43, 129*
lat. 18005, Sacramentary, Reichenau, early C11: **I**: 206, 208.
 II: 79–80; *ill. 51*
nouv. acq. lat. 1132, Apocalypse, early to mid C9,
 N. France. **II**: 14, 20, ch.1 n.8
nouv. acq. lat. 1203, Godescalc Evangeliary, Charlemagne
 Court School, 781–83: **I**: 75, 79

Prague, Cathedral Library

Cim. 2, Gospel Book, N. France, late C9: **I**: 104–5, 111–12;
 ills. 58, 67. **II**: 163, 167, 168, ch.5 n.30

Rome, Biblioteca Angelica

MS 123, Gospels, Bologna or Nonantula, *c.* 1000: **I**: 105,
 ch.2 n.177

Rome, Vatican, Biblioteca Apostolica

Gr. 1554, Prayer Book, S. Italy, late C10: **I**: 105; *ill. 59*
Lat. 3225, Vatican Virgil, probl. Rome, *c.* 370–430: **I**: 158–9
Lat. 9830, Volturno Exultet Roll, 981–87. **II**: 20–2; *ill. 11*
Ottob. 74, Gospel Book, Regensburg, *c.* 1022: **I**: 128, 189;
 ill. 77
Pal. Lat. 50, Lorsch Gospels, Charlemagne Court School,
 c. 815 (Saints Luke and John): **I**: 26–32, 36–8, 46–7,
 75; *ill. 10; col. pl. V.* Saints Matthew and Mark are at
 Alba Julia q.v.; *ills. 7, 9;* (Christ in Majesty) *ill. 15.*
 II: 39, 40
Pal. Lat. 169, St Ambrose etc., Italian, C9: **I**: ch.1 n.27
Reg. Gr. 1, Bible of Leo Patricius, Byzantine, C10: **I**: 73,
 210, ch.2 n.37; *ill. 41*
Reg. Lat. 124, Hrabanus Maurus, *De Laudibus Sancte
 Crucis*, Fulda, *c.* 830: **I**: 68; *ill. 33.* **II**: 63, 205; *ill. 40*
Reg. Lat. 316, Gelasian Sacramentary, West Carolingian,
 C8: **I**: 53. **II**: 26; *ill. 16*

Rossano, Cathedral Library

Codex Purpureus Rossanensis, Gospels, E.
 Mediterranean, C6: **I**: 32, 79, 122–3; *ills. 14, 74.* **II**: 71,
 ch.6 n.57; *ill. 45*

St Gall, Stiftsbibliothek

Cod. 23, Psalterium Aureum, St Gall, C9: **I**: ch.4 n.42;
 ill. 20

St Paul in Lavanttal, Stiftsbibliothek

MS 20/1, Sacramentary, Reichenau, *c.* 970–90. **II**: 89–90;
 ill. 58

Solothurn, St Ursus

Cod. VI, Hornbach Sacramentary, Reichenau, *c.* 970–90:
 I: 57, 205–6

Stuttgart, Württembergische Landesbibliothek

Bibl. Fol. 23, Stuttgart Psalter, N. France (?St Germain des
 Prés), *c.* 830: **I**: 68, 75, 80, 109, 166, 211, ch.1 n.102,
 ch.2 n.181; *ills. 43, 63, 95.* **II**: 125, 135–6, 200,
 ch.1 n.65, ch.2 n.69, ch.4 nn.17, 57; *ill. 83*

Trier, Dombibliothek

MS 401, Sacramentary, Corvey, late C10: **II**: 165–6

Trier, Stadtbibliothek

MS 7/9, so-called `Small Psalter' of Archbishop Egbert,
 Trier, *c.* 977–93: **II**: 7
MS 22, Ada Gospels, Charlemagne Court School,
 c. 795/810: **I**: 28–9; *ill. 12*

General Index

Aachen I: 14, 35, 69, 73, 82, 119, 176. II: 41, 162, 216
 golden altar of I: 11, 124; *ill. 64*. II: 143–4
 Gospels *see* Aachen Minster
 Lothar Cross I: 135–8; *ills. 83, 84*
Abbo, abbot of Fleury I: 64. II: 46–8, 51.
Abdinghof Gospels *see* Kassel, Landesbibl. Cod. Theol. 2°
 60
Abraham, bishop of Freising (957–94) I: 88–95, 129. II: 133
 episcopal handbook of *see* Munich, Bayer. Staatsbibl.,
 Clm. 6426
 Sacramentary of *see* Munich, Bayer. Staatsbibl.,
 Clm. 13601
acolytes II: 132
Ada Gospels *see* Trier, Stadtbibl., MS 22
Adalbero I, bishop of Metz (929–64) I: 83
Adalbero, archbishop of Rheims (969–89) II: 62
Adalbert, abbot of Hornbach I: 206
Adalbert of Ivrea II: 24
Adalbert, archbishop of Magdeburg (968–81) I: 12, 51,
 102, 120. II: 138
Adalbold, bishop of Utrecht (1010–26) I: 194, ch.4 n.98
Adalhard Revision of Bible, Tours II: 183
Adalpold, gardener in Augsburg II: 59
Adelaide, wife of Otto I I: 193
Adelsheiligen I: 121
Adoptionist heresy I: 82
Adso of Montier en Der II: 46, 48
Aeddila, widow II: 113
Agius, monk of Corvey II: 162
Agnes, wife of Henry III II: 201
Agobard, bishop of Lyon (816–40) I: 122. II: ch.4 n.60
Ailred of Rievaulx II: 114
Alawich I, abbot of Reichenau (934–58) I: 138, 145, ch.2
 n.101
Alawich II, abbot of Reichenau (997–1000) I: 77, 154–5
Alberic of Rome II: 47
Albrecht von Halle, Cardinal II: 84
albs I: 52
Alcuin I: 82. II: 31, 43, 55, 96, 152, 179
Algermissen, Konrad I: 102
Alexander the Great II: 52
Alexander, Jonathan II: 178–9, 200
Alexandria II: 58, 122
All Saints, feast of I: 150. II: 150–2
Alsace I: 37
Alps II: 24
altar cloths II: 80
altar frontals I: 12, 52, 151; *ills. 34, 105*
altar hangings II: 186
altar linen II: ch.2 n.74
Altfried, bishop of Hildesheim (847–74) II: 167
Amalarius of Metz II: 96
ambo I: 49
Ambrosius Autpertus, abbot of Volturno (777–84) I: 139.
 II: 22–3 (ob. 794)
Ammianus Marcellinus I: 63
Andrieu, M. II: 96
Andrew of Fleury, *Life of Abbot Gauzlin of Fleury* I: 52
Andrew of Crete I: 143

angels I: 18, 22, 63, 91, 111–12, 139, 140, 146–7, 152, 188–9,
 195
Angilbert, abbot of St Ricquier (781–814) I: 120
Anglo-Saxon art I: 47, 53, ch.1 nn. 103 and 104. II: 176,
 ch.4 n.82
Anno Group (or Eburnant) of Reichenau I: 46, 57, 206–7,
 209
Anno, scribe I: 25, 205
Anselm of Lucca II: 181
Ansfrid, bishop of Utrecht (995–1010) I: 14
Anstey, archdeacon of Toul I: 86
anthropology I: 7–8
Antichrist II: 46–8
Antioch II: 122
antiphonary I: 48, ch.2 n.43
antiphons I: 121, 123
 Marian I: 145
Aosta II: 24
Apocalypse I: 52, 62, 147. II: 46–7, 51, 120, 186
 commentary on II: 22
 subjects *see* Index of Iconography
 textual divisions II: 14–15
Apostles, prayer to II: 43
Apostles' Creed II: 138
Aquileia, patriarchate of II: 144
Arator I: 52
architectural background II: 100
architecture II: 129–30, 132, 168. 198
Arduin of Ivrea I: 181. II: 24, 53, 90
arengae I: 103
Aribo, archbishop of Mainz (1021–31) II: ch.3 n.62
Aristocracy, secular II: 58, 126
Ark of the Covenant I: 117
Arles, sarcophagus from I: 72; *ill. 40*
Arnold, bishop of Halberstadt (996–1023) I: ch.4 n.109
Arnulph II, archbishop of Milan (998–1018) II: 43, 52
 prayerbook of *see* London, BL MS Egerton 3763
Arnulph, archbishop of Rheims (989–1021) II: 47
Arnulph, Duke of Bavaria (907–37) II: 57, 173
artifex II: 144, 155
artists I: 43, 151, 175–6, 178, intro. n.9
 transmission of ideas *see* conversation
Ascension Day I: 65
Aschericus, archbishop of Hungary I: 200
Asselburg I: 103
Assumption, doctrines of Mary's I: 139–44, 150–2, 208.
 II: 152
 feast of the I: 154, 158, 208
Asti II: 24
Astkreuz I: 91
Athelstan, king of the West Saxons (927–39) I: 38, 51
Aton I: 117
Augsburg I: 13, 121–2, 125, 195. II: 86
 diocese of I: 94
 church of St Afra II: 59
Augustine bishop of Canterbury, St II: 119
 Gospels of *see* Cambridge, Corpus Christi College
 MS 286
Augustine of Hippo I: 60, 175. II: 46, 60, 118